Italy in Early
American Cinema

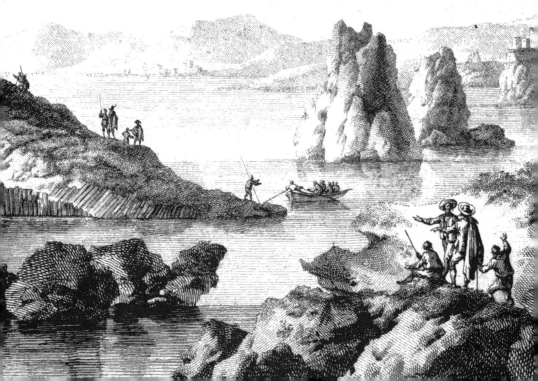

Italy in Early American Cinema

Giorgio Bertellini

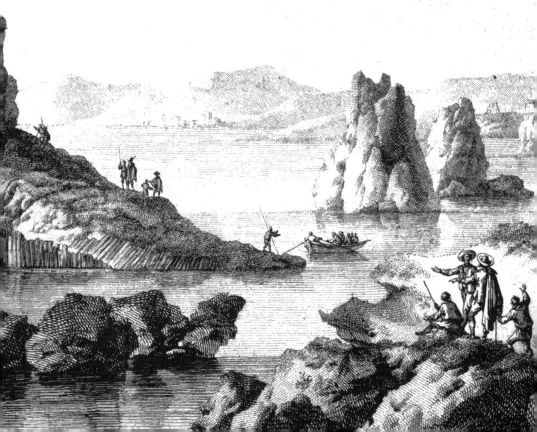

Race, Landscape, and the Picturesque

INDIANA UNIVERSITY PRESS

Bloomington & Indianapolis

The author and Indiana University Press gratefully acknowledge the generous assistance provided for the publication of this book by the Office of the Vice President for Research and the College of Literature, Science, and the Arts Publication Subvention Program of the University of Michigan.

Passages from chapters 5 and 6 draw on "Black Hands and White Hearts: Italian Immigrants as 'Urban Racial Types' in Early American Film Culture," *Urban History* 31, no. 3 (2004): 375–399. Portions of chapter 7 appeared in William Boelhower and Anna Scacchi, eds., *Public Space/Private Lives: Race, Gender, Class and Citizenship in New York, 1890–1929* (Amsterdam: VU University Press, 2004), 39–66. A portion of the afterword appeared in Richard Abel, Giorgio Bertellini, and Rob King, eds., *Early Cinema and the "National"* (London: John Libbey, 2008), 27–41.

This book is a publication of

Indiana University Press
601 North Morton Street
Bloomington, IN 47404-3797 USA

www.iupress.indiana.edu

Telephone orders 800-842-6796
Fax orders 812-855-7931
Orders by e-mail iuporder@indiana.edu

♾ The paper used in this publication meets the minimum requirements of the American National Standard for Information Sciences—Permanence of Paper for Printed Library Materials, ANSI Z39.48-1992.

Manufactured in the United States of America

Library of Congress Cataloging-in-Publication Data

Bertellini, Giorgio, date
 Italy in early American cinema : race, landscape, and the picturesque / Giorgio Bertellini.
 p. cm.
 Includes bibliographical references and index.
 ISBN 978-0-253-35372-6 (cloth : alk. paper) — ISBN 978-0-253-22128-5 (pbk. : alk. paper)
 1. Italy—In motion pictures. 2. Italian Americans in motion pictures. 3. Motion pictures—United States—History—20th century. I. Title.
 PN1995.9.I75B47 2010
 791.43'75845—dc22
 2009017096

1 2 3 4 5 15 14 13 12 11 10

To Jacqueline Reich, and in memory of Guido Lavagnini (1943–95)

CONTENTS

ACKNOWLEDGMENTS

While working on this book for more years than I wish to admit, I have incurred debts so numerous to friends, colleagues, and acquaintances that merely mentioning their names will not do them full justice. An initial and rather different venture into this book's subject was my doctoral dissertation, which I defended at NYU. I am tremendously grateful to my committee, Robert Sklar, Bill Simon, Barbara Spackman, Martino Marazzi, and especially my advisor Antonia Lant, for long years of insightful advice and generous friendship. If I became a scholar, it is thanks to them. I am also deeply grateful to the Society for Cinema and Media Studies for granting that thesis the 2002 Dissertation Award. This book began to take shape during my postdoctoral tenure at the Michigan Society of Fellows, under the aegis of James Boyd White, in close dialogue with many generous and talented fellows, none of whom worked on films. Thanks to Gaylyn Studlar and Peggy McCracken, the University of Michigan became my scholarly home. The exceptionally supportive and interdisciplinary profile of the Departments of Screen Arts and Cultures and Romance Languages and Literatures, later headed by Richard Abel and Michèle Hanoosh, has allowed my project to develop into its present form.

Over the years, several individuals have graciously enabled access to personal collections and institutional holdings, either directly or from afar. I wish to thank Maureen Brunsdale of Milner Library at the Illi-

nois State University (Normal, Illinois); Paolo Cherchi Usai and Patrick Loughney, respectively former and current curators, and Nancy Kaufmann of the Motion Picture Department at the George Eastman House (Rochester, N.Y.); Maria Chiba of Lobster Film Collection (Paris); Nico de Klerk of the Netherlands Film Museum (Amsterdam); Antonella Felicioni of the Cineteca Nazionale (Rome); Edi Gabbiani of the Archivio Fotografico Toscano (Florence); Giuseppina Gallucci of Soprintendenza per i Beni Architettonici, Paesaggio, Patrimonio Storico-Artistico ed Etnoantropologico delle Province di Caserta e Benevento; Elena Gay and Paolo Tappero of the Museo di Antropologia Criminale "Cesare Lombroso" (Turin); Steven Higgins, Charles Silver, and Ron Magliozzi of the Department of Film, Museum of Modern Art (New York); Madeline Matz and Rosemary C. Hanes of the Motion Picture, Broadcasting, and Recorded Sound Division, Library of Congress (Washington, D.C.); the late Gianfausto Rosoli and Matteo Sanfilippo of the Centro Studi Immigrazione (Rome); Giustina Scarola of Biblioteca Palatina (Parma); Federica Terrile of the Archivio Storico della Fondazione Corriere della Sera (Milan); Father Lydio Tomasi, Rev. René Manenti, and especially Mary Elizabeth Brown of the Center for Migration Studies (Staten Island, N.Y.); the late Rudy Vecoli and Donna Gabaccia, respectively past and present directors, and Halyna Maryuk, of the Immigration History Research Center (Minneapolis, Minn.); the staff at the Biblioteca Nazionale Centrale (Florence); and the interlibrary loan offices of NYU, the University of Michigan, and Harvard, whose patience I repeatedly and shamelessly tested. Thank you also to Mary Gibson, Nicky Rafter, and Renzo Villa for guidance on the photographs used by Cesare Lombroso; and to Clayton Lewis, curator of graphic materials at the William L. Clemens Library at the University of Michigan, for consultation on early American photography. I am particularly grateful to Laura Minici Zotti and Carlo Alberto Zotti Minici of the Museo del Precinema: Collezione Minici Zotti (Padua) and to Dietmar Siegert (Munich) for granting permission to use images from their famous collections; and to that special place that is the Museo Nazionale del Cinema, where I received invaluable advice and support from Donata Pesenti Campagnoni, Silvio Alovisio, Roberta Basano, Claudia Gianetto, and Marco Grifo.

I have greatly benefited from the insightful criticism of many past and present Michigan colleagues who offered cogent feedback on dif-

ferent versions of the manuscript: Catherine Benamou, Hugh Cohen, Alison Cornish, Manishita Dass, Dario Gaggio, Katherine Ibbett, Rob King, Mark Kligerman, Stashu Kybartas, Markus Nornes, Lucia Saks, Paolo Squatriti, Gaylyn Studlar, Johannes Von Moltke, Kristen Whissel, and Rebecca Zurier. Unique among them was the contribution of Richard Abel, superb advisor and friend, who instantly understood the premise and goals of my argument, checked multiple drafts, suggested crucial readings and references, and patiently corrected many mistakes. Over the years and in different measures I have also profited from the advice and support of numerous scholars and writers from both sides of the Atlantic Ocean. Whether they have read individual chapters or simply listened to my argument, they have all helped with questions, suggestions, or substantive criticism. They include Tony Ardizzone, Jennifer Bean, Richard Beban, Ruth Ben–Ghiat, Aldo Bernardini, Marco Bertozzi, Kevin Brownlow, Gian Piero Brunetta, Paolo Caneppele, the late Philip V. Cannistraro, Francesco Casetti, Monica Dall'Asta, Angela Dalle Vacche, Helen Day-Mayer, Raffaele De Berti, Philip Ethington, Mariagrazia Fanchi, Donna Gabaccia, Luca Giuliani, Lee Grieveson, Stephen Gundle, Tom Gunning, Sabine Haenni, Salvatore Inglese, Marcia Landy, Martino Marazzi, the late Vittorio Martinelli, David Mayer, Luca Mazzei, Dario Minutolo, Giuliana Muscio, Charlie Musser, Francesco Pitassio, Riccardo Redi, John David Rhodes, Kim Tomadjoglou, Maurizio Viano, John P. Welle, Enzo Zappulla, and Sarah Zappulla Muscarà. I have been extremely fortunate to spend the 2007–2008 academic year at the Radcliffe Institute for Advanced Studies at Harvard, where I regularly conversed on film and politics with, among others, Carla Mazzio, Magda Teter, and, especially, Timothy Rood, who generously offered countless references to picturesque aesthetics and a probing reading of the entire manuscript. I am extremely grateful to Barbara J. Grosz and Judith Vichniac, respectively dean of the Radcliffe Institute and director of its Fellowship Program, for their warm hospitality and for a year of unencumbered writing. At Harvard, Joanna Miller assisted with the filmography, and Caroline Jennings and, especially, Kelly Faircloth helped with an initial, cogent copyediting.

At Indiana University Press I have been quite fortunate to work with Jane Behnken, a superb acquisition editor who not only understood the architecture of the book right from the start but also immediately re-

alized how the images had to inform it in a sustained way. Any film book proposing an argument about visual culture may be regrettably impaired by a paucity of illustrations. If this risk has been avoided here, it is thanks to her. I am also deeply grateful to the Press's two anonymous readers, who offered cogent criticism and insightful appreciation: they made me much more aware of what I was trying to do. At Indiana University Press I also benefited to no end from the outstanding professional skills of Katherine Baber, June Silay, and Michele Bird, and the dazzling copyediting skills of Shoshanna Green, whose intellectual curiosity and wisdom saved me countless times from mistakes, blunders, and inaccuracies. Whatever remains is solely my fault.

For crucial help with frame enlargements, I wish to thank Margaret Kieckhefer, Simonetta Menossi, Gracia Ramirez, and Alan Young. Jeffery Masino, Alex McLaren, C. Paul Sellors, and Rob Walker helped me with the illustrations of *The Italian,* while David Shepard of Film Preservation Associates, Inc. graciously granted access to the film and permission to publish stills from it. Heartfelt thanks to Scott Simmon for munificently sharing his images and research. I also wish to express my special gratitude to Francis Ford Coppola and the Coppola Family Trust for generously granting permission to use the logo of Edizioni Pennino to a total stranger, and to Kathleen Talbert, Giselle Galper, and Barbara Beaulaurier of *Francis Ford Coppola Presents* for making it possible. I am also quite indebted to the courteous professionalism of Brian Palagallo of Paramount Digital Entertainments for ensuring permission to publish the frame from *The Godfather Part II.*

Writing about film at the University of Michigan is a unique pleasure when Phil Hallman effortlessly suggests and locates films that scholars have considered lost for decades; when Scott Dennis purchases periodicals and books of prohibitive cost after hearing you mention them just once; when Alan Young resolves every possible technical glitch with Olympian nonchalance; when many of your students realize that silent cinema could inspire their filmmaking endeavors; and when, with an amusing mix of theatricality and efficiency, Mary Lou Chlipala anticipates and resolves the countless logistical challenges of departmental life. Over the years, Richard Abel and Barbara Hodgdon have time and again opened their home to me and comforted my writing frustrations with wit, love, and sumptuous dinners. Their generosity never fails to

move me. My Italian family, particularly Argia, Benedetta, Enzo, Davide, Elena, Irma, Giorgio, and Teresa, and my cluster of best friends, Giovanni Cocconi, Pierluigi Ercole, Corrado Marmiroli, and, especially, C. Paul Sellors, have remained unwavering supporters and life coaches. In a few moments of discouragement, they have showered me with countless forms of help and affection, reminding me how lucky I continue to be.

I dedicate this book to Jacqueline Reich, who has given closure to this project and an opening to my life. Besides critiquing reams of chapters and listening to my doubts in both Italian and English, she has lovingly taught me the enlightening lessons of clarity and optimism with the wise and touching affection of a *mensch*. This book is also in memory of my never-forgotten uncle, Guido Lavagnini, a farmer-philosopher who spoke eloquently in dialect and loathed traveling, but who always took me somewhere.

Italy in Early American Cinema

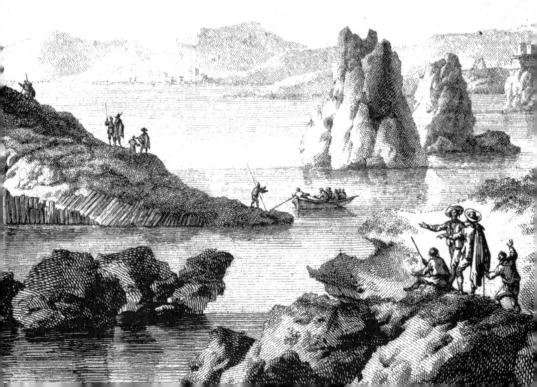

Transatlantic Racial Culture and Modern Visual Reproductions

Something significant has happened when
land can be perceived as "landscape."

MALCOLM ANDREWS

A volcanic formation puts all competition at
defiance in the way of the picturesque.

JAMES FENIMORE COOPER

[American] Indians, being primitive, must speak dialect.

ANONYMOUS SICILIAN STAGE PERFORMER

Less than an hour into Francis Ford Coppola's *The Godfather Part II*
(Paramount Pictures, 1974), a flashback titled "Vito Corleone, New
York City, 1917" showcases a young Vito, played by Robert De Niro,
being led by a friend into a crowded immigrant theatre in Little Italy.
On stage, in front of a painted backdrop representing an imaginatively
composite landscape of New York and Naples (fig. 0.1), two actors are
singing a light café melody, "Napule ve salute" ("Naples Salutes You").
As the backdrop rises, a Southern Italian actor recites the lyrics of a
tear-jerking immigrant melodrama titled "Senza mamma" ("Without
Mommy"). The protagonist receives a letter from his native Naples: his

mother has died. Inconsolable, he acts out his desperation and, with a gun to his head, seems ready to commit suicide. This sequence is often cited for both authorial and narrative reasons. The stage drama was based on the song "Senza mamma," authored in 1917 by none other than Coppola's maternal grandfather, songwriter and lyricist Francesco Pennino (1880–1952), who had emigrated from Italy in 1905.[1] Also, the scene marks Vito Corleone's first and unexpected encounter with the Black Hand, as the Mafia was then known. In the middle of the show, a local boss wearing an all-white suit, Don Fanucci, suddenly rises from his seat and insolently spoils the view of the performance for the theatre audience, including Vito and his friend, and for us, the film spectators. As these events unfold, the rarely noticed backdrop shrouds and houses both the stage shows and the entire film sequence. It is worth looking at it more closely.

The painted backdrop is a compound of the picturesque landscapes of New York and Naples. It speaks powerfully not just of places, but also of their visual arrangement as a form of representation and a system of meaning. It shows, on the left, the unmistakable and commanding New York skyline bordering on New York Bay. In the foreground are the Brooklyn Bridge, some manufacturing plants billowing smoke, and tenements. In the middle ground, the Statue of Liberty's out-of-scale towering radiance competes with the sun, behind it: the glorious sight clearly represents immigrants' idealized vision of New York and of America in general. To the right is the port city of Naples, with its celebrated spectacular bay foregrounded by the renowned Mediterranean pine tree and, in the distance, the smoky Mount Vesuvius next to a rising moon. The symmetry of the composite panorama reveals its symbolic significance while masking its iconic and indexical (or geographical) impossibility. Within the universe of the picture, what connects the two shores is the traffic of people and goods carried by ocean liners symmetrically positioned on the two sides of the foreground and steaming across the waters in between. The gesture of tying together the two panoramas into a single "Atlantic" composition is emblematic of the framework of this study, which looks at the formal transatlantic exchanges between landscape representations of the South of Italy and the comparable depictions of America's wide-open spaces, urban sites—particularly New York—and diverse populations.

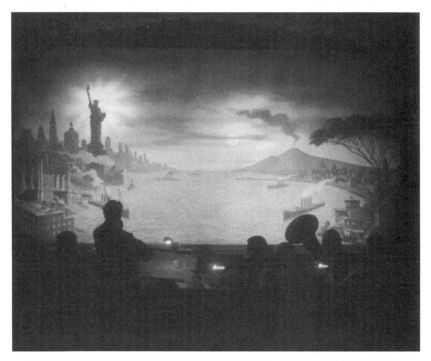

0.1 *The Godfather Part II* (1974), directed by Francis Ford Coppola, frame enlargement. Courtesy of Paramount Pictures. *The Godfather Part II* © Paramount Pictures. All rights reserved.

The whole image, however, exudes an air of simple familiarity. The backdrop relies on the long-established visual tradition of the picturesque, which defined but also broadly exceeded Pennino's and Coppola's design. Today the term "picturesque," mainly used as an adjective and generally signifying a quaint, scenic landscape (or a curious, striking individual), masks rather than reveals its rich formal and ideological history. It is a multifaceted history that encompasses practices of garden making, landscape design, theatrical scene design, and painting. Of post-Renaissance coinage, in the seventeenth century the term "came to describe a landscape that to the experienced viewer seemed either to have been composed after a painting or was designed to be the subject of one."[2] The new emphasis on painterly effects of irregularity, variety, and roughness of design strikingly contrasted with the harmonic symmetry traditionally desired in pictorial representations. Associated at first with Dutch landscape painting, the picturesque style

achieved broader international popularity in the eighteenth century, when it developed into the aesthetic correlative of the Grand Tour. It became, in fact, the pictorial style that Northern European élites most often adopted to render their cultural experience of Mediterranean Europe, which it translated into imaginative and comforting views of distant landscapes and exotic characters. In widely circulating paintings, prints, and illustrations of Italy, the violent wilderness of volcanoes became a charming spectacle of primeval force; a ruin-dotted countryside appeared as a mythical and pastoral heaven; and notoriously vicious bandits, or *banditti,* came into view as romantic and colorful outlaws. (*Banditti* is what cultured foreign travelers called both real-life and imaginary Italian bandits. The correct spelling is *banditi.*) Picturesque representations' formal and thematic cast, centered on the liminality of natural landscapes with urban views and historical ruins, visualized places and characters perceived to be distant in both space and time, and became influential and pervasive on both sides of the Atlantic.

As the backdrop shows, the picturesque traveled to America. Here it informed typologies of national scenery, both natural and urban, and of the populations inhabiting them, and it became, as John Conron has put it, "the first American aesthetic."[3] The American picturesque, while encompassing both Eastern cities and Western forests, often looked back across the Atlantic. Far from accidental, the two geographical ends of the *Godfather* backdrop (and of this study) are enlightening: through the cosmopolitan aesthetics of the picturesque, Italy and the United States came to signify in America two paradigmatic stages of civilization, diametrically opposed, yet dialectically related. Naples and the South of Italy represented an old place where, despite the magnificence of antiquity, civilization was losing ground to the primordial forces of nature. New York and America, by contrast, represented a new world where a young and bold civilization was conquering nature's wilderness.

In *Italy in Early American Cinema,* I illustrate how the formal and ideological repository of prephotographic picturesque representations informed how early American cinema visualized ideas of national identity and racial difference. Although this study devotes considerable space to how American films represented Italians—the original characters of the picturesque—and how, in turn, Italians reacted to such

representations, the goal of this work is not at all to focus solely on a single group. *Italy in Early American Cinema* recognizes that throughout the nineteenth century the picturesque's original association with exoticized images of Italian ruins and volcano-dotted scenes conveyed widely appealing ideas about nations' places in the past and in modern history in general. In one of its defining genres, the Western film, American cinema readily adopted the picturesque aesthetics to exalt the pristine character of its Western natural landscapes and the noble obsolescence of Native Americans. American films rarely relied on the picturesque to represent Latinos, African Americans, or Asian Americans: their exclusion from American citizenry made it impossible to depict them in ennobling or domesticating ways. Things were different for Southern and Eastern European immigrants. Although legally white, they were regarded as racially different from, and inferior to, the Anglo-Saxon and Teutonic core of American society. Yet their racial otherness did not make sympathy with them, and their inclusion in society, impossible (though both remained imperfect). As one of the largest immigrant groups in North America, but even more cogently as a population traditionally associated with picturesque imagery and characterizations, Italians found themselves constantly represented as temperamentally inconsistent, jealous, and vengeful, but also as artistically gifted, passionate, and generous in convenient stories of domesticated otherness and exoticism. Consisting of two parts and a methodological afterword, *Italy in Early American Cinema* tells, and reflects upon, the story of the resilience of picturesque modes of representation across different epochs and media, particularly in early cinema.[4] My goal here is to exemplify ways of reading early films that pay close attention to how landscape representations associated with narrative settings and filmmaking locations conveyed, on the basis of closely related painterly and photographic traditions, distinct ideas about racial difference and national destiny.

Part 1 ("Picturing Italy's Natural and Social Landscapes") traces the ideologically charged aesthetics of picturesque representations of Italian natural and urban landscapes across pictorial, print, and photographic media. Chapter 1 draws a general profile of how the pictorial style of the picturesque acquired racial and geopolitical significance. Since the seventeenth century, Italy had been the antithesis of what

the nations where most of those who made the Grand Tour originated (particularly France, England, and the Netherlands) were becoming: modern imperialistic powers, endowed with flourishing, highly urbanized capitals, centers of industrial enterprise, and a progress-oriented culture. To the prospective European ruling classes, touring the Italian peninsula was both educational and flattering. A voyage to Italy turned them into both the preferred consumers and the destined inheritors of Roman political culture and Renaissance artistic accomplishment. Italy's urban and natural landscapes, and the people who inhabited them, attracted broad attention not only for the ancient splendor they recalled, but also for their charming present-day backwardness—particularly the areas around Rome and in the South. Here geographic distinctions merit critical attention.

Writing about Italy means dealing with a set of starkly different, yet interrelated areas. While this study deals broadly with the Italian peninsula and its inhabitants as a single subject of geographical, artistic, antiquarian, and (proto)anthropological representations, it focuses more specifically on Southern Italy and Southern Italians as a distinct part of Italy, serving as both a synecdochic and a contrasting environment to Italy and Mediterranean Europe as a whole. The Southern regions' distance from the industrialized North (of Italy and of Europe in general) and their vulnerability to natural disasters such as earthquakes and volcanic eruptions informed representations that insisted on a high degree of anthropological difference, economic depression, and cultural primitivism. Imbued with ideals of modern industrial progress linked to the mastery of nature's most unruly devastations, Grand Tourists and artists ventured south of Rome to seek out landscapes that evoked archeological splendor, fated decay, and the inexorable power of natural forces. To their eyes, dangerous brigands and ancient ruins conveyed romantic and racialized ideas of exoticism and nostalgia. Whether produced by foreign or Italian image-makers, over the course of three centuries countless paintings, prints, and drawings crystallized images of Southern Italian sites and peoples as untouched by modernity, arrested in their development, and bathed in pristine archaism.

Chapter 2 shows how in the late nineteenth and early twentieth centuries the picturesque view of Southern Italy metamorphosed from an elitist aesthetic tradition into a popular, multimedia commerce of

national and racial representations. Crucial factors were the emergence of mass tourism and photography. The photographic ateliers of the Alinari Brothers, from Florence, and of the German Neapolitan Giorgio Sommer commodified and naturalized picturesque landscapes and peoples into appealing exhibits of environmental and anthropological history. A picturesque poetics of passionate love, betrayal, and brigandism "under the volcanoes" permeated the emerging Southern Italian official and popular culture, from theatre, music, and painting to printmaking and film. I call this poetics "Southernism." Although it did so differently than Orientalism, Southernism reworked a comparable prejudice of anthropological inferiority into affirmative artistic forms by turning violent instincts into the rough outpourings of quick-tempered but largely benevolent people. Widely circulating Southernist photographs, prints, postcards, and "view films" of *mafiosi,* urchins, lovers, and erupting volcanoes provided early Italian cinema, as well as international productions, with commercially viable conventions to visualize geographical and cultural distance for purposes of entertainment. This poetics of realism included numerous *actualités* devoted to devastating earthquakes and volcanic eruptions, such as *Eruzione del Vesuvio* [Eruption of Vesuvius, 1906] and *L'eruzione dell'Etna* (The Eruption of Mt. Etna, 1909–11), or ethnographic exposés, such as Gaumont's *Mangeurs de macaroni à Naples* (1897) and Edison's *Eating Macaroni in the Streets of Naples* (1903). In the mid-1910s, two remarkable fiction films, *Sperduti nel buio* [Lost in darkness, Morgana Film, 1914] and *Assunta Spina* (Caesar Film, 1915), combined the familiar picturesque aesthetic with such an achievement of artistic realism that, a few decades later, critics deemed them precursors of Italian neorealism.

Joining the transatlantic movement of goods and people, the picturesque tradition traveled to the United States. It was not an accidental move. "The appearance of an independent [painterly] genre exclusively devoted to landscape," as Leo Marx has noted, "coincided with the establishment of the first permanent European colonies in North America."[5] Part 2 of this book ("Picture-Perfect America") looks at how the picturesque affected the ways in which American art, photography, and motion pictures imaginatively visualized the country's "mission" to reconcile nature and civilization and to domesticate its striking racial diversity. Specifically, its chapters examine the picturesque visualiza-

tions of racial difference as they applied to American natural scenery and social landscapes in the context of imperialistic military campaigns, the end of the Western frontier, mass migrations, and urbanization.

Chapter 3 discusses how American painters, illustrators, photographers, and filmmakers adopted the formal repertoire of the picturesque to turn the Hudson River Valley and the Wild West into carefully landscaped images and actual sites that appealed to tourists and anthropologists alike. Projected onto the country's unspoiled prairies and its soon-to-be-tamed wilderness, the picturesque style codified and popularized a set of alluring and reassuring national scenes. Notable examples include the hundreds of images of quaint landscapes, peaceful natives, and, more rarely, cheerful slaves featured in printed drawings, photographs, and early film travelogues. Soon picturesque renderings of Niagara Falls, the Grand Canyon, and Yosemite became staple images in the catalogs of traveling lecturers and tourism promoters who, along with the ubiquitous slogan "See America first!," made consumption of the domesticated American landscape the ritual of American citizenship. In between Wild West reenactments and the release of such travelogues as *Picturesque Yosemite* (AM&B, 1902) and *Picturesque Colorado* (Rex Motion Picture Company, 1911), American filmmakers recognized the paradigmatic setting of national narratives in the Western landscape of pristine forests and tamed Indians. Early Westerns, shot in the familiarly lush and picturesque landscapes of the Northeast and Colorado, promoted an aesthetic reconciliation between nature and humanity, pastoral innocence and settlement, despite the territorial destructions and racial warfare of the Western expansion. In the early 1910s, the film industry progressively moved to the West, predominantly to Southern California. The new open, barren, and inhospitable spaces challenged American filmmakers, including D. W. Griffith, in the same way that, a few decades earlier, they had challenged painters and photographers. Crowded with wilder and more merciless Indians, the new topography promoted narratives of intense racial antagonism rarely produced in the East. Yet films often created stylized relationships between defeated Native Americans and their landscapes in order to invest the "battle of civilization" with romantic and melodramatic effects, from Griffith's *Ramona* (Biograph, 1910) to Thomas Ince's *The Invaders* (NYMPC, 1912). By devoting a limited, yet significant space to these productions, as well

as to the exemplary national ideology of Griffith's "pastoral" and Civil War films, including *The Birth of a Nation* (1915), this chapter seeks to offer a preliminary, purposely representative, way to read American cinema's correlation of natural landscapes with racial differences and national identity.

The American picturesque mold featured not just Western canyons and prairies, but also Eastern skyscrapers and tenements. In late nineteenth-century America the rise of urban culture enabled another formulation of the picturesque, which was linked to the variety and diversity of immigrants' customs, races, and lifestyles. Chapter 4 shows how the status of New York City as the most visible social and economic locus of American progress, industrialization, and social interest held significant aesthetic implications. If social reformers were focusing on immigrant ghettoes as gloomy sites of social problems, the city's commercial, artistic, and tourist boosters were assimilating the American metropolis to a topography of attractive sights. Yet the city's attractiveness consisted not only in the way skyscrapers and office buildings were modernizing the urban landscape along vertical lines, above the sprawling uniformity of rails and gridded streets. Bohemian critics, newspaper illustrators, Ashcan School painters, photographers, and early filmmakers also highlighted the city's street-level visual appeal by resorting to the notion of "urban picturesqueness," which, in the words of critic Peter Conrad, "tolerate[d] the city's social inequalities as a decorative enhancement."[6] In their works the picturesque meant pleasing compositional organization and, more cogently, the insertion of the spectacle of nature into the city's rational scenery, from the "natural island" of Central Park to the uncultured migrants barely surviving in the tenement-house districts. In this chapter I look closely at how writers William Dean Howells and Henry James and social photographer Jacob Riis promoted a characterization of the city, or parts of it, as an alluring foreign country and identified certain immigrant groups with "picturesqueness."[7] In the American metropolis, the familiar association of Italians with the picturesque confirmed their racial distinction within the disorienting diversity of white European immigrants. Operating at the level of visual productions and vaudeville routines, the "urban picturesque" identified a pleasing, manageable, and assimilable alterity that was not for everybody: being picturesque or "colorful"

meant that one was certainly not "colored." In New York, as mostly else-where, the picturesque aesthetic rarely applied to Chinese immigrants and hardly ever to African Americans.

Chapter 5 argues that the historical and geographic convergence of early American cinema and mass migrations in New York City at the opening of the twentieth century profoundly informed the racial fabric of the American film industry. By conversing with the work of race and immigration scholars, I contend that D. W. Griffith's negro-phobic *The Birth of a Nation* (1915) was merely the tip of the iceberg of a national cinema fascinated by race—not just by color—and by the semiotics of racial identifications. Whiteness was not a single, one-dimensional realm of privilege. Instead, it exhibited a wide spectrum of internal, highly racialized taxonomies of individual racial types. While engaging with racial difference for its entertainment value and not as a subject of scientific knowledge, motion pictures and other popular amusements encountered the same challenges faced by eugenics and American racial culture as a whole: how could one distinguish among the races of white European immigrants? Which racialized characters could be domesticated and Americanized, and which ones could not? Until the turn of the century, the typing practices of eugenics and nativ-ist narratives identified racial characters in rather deterministic ways. Italians' typecasting implied either unsuitability for civic inclusion or a tenuous, uncertain citizenship. A frequently recurring measure of racial characterization was the law, with its rules and regulations defin-ing a social contract that Italians were depicted as naturally breaching. Their allegedly "normal" affiliation with such criminal organizations as the Black Hand, popularized in vaudeville sketches and newspaper reports and cartoons, informed several early fiction films, from *The Black Hand* (AM&B, 1906) to *The Last of the Mafia* (Neutral Film, 1915), whose subjects and settings satisfied a growing ethnographic interest in Italians' ghetto life and customs. At the same time, however, Ital-ians were granted the possibility of redemption. Several of the same crime narratives featured Italians as heroic policemen who, by virtue of shared language and culture, were successful in their pursuit of fellow Italian brigands and Black Handers. The real-life deeds and tragic death of Lieutenant Joseph Petrosino of the New York Police Department inspired a number of such productions, including *The Detectives of the*

Italian Bureau (Kalem, 1909) and *The Adventures of Lieutenant Petrosino* (Feature Photoplay Co., 1912).

Italians' disposition to be responsible citizens was hardly an invention of the film industry. In the late 1900s, anthropologists, criminologists, sociologists, and reformers emphasized the role of the environment in helping immigrants tame their most alien traits and adapt to American ways of life. Seeking consensus from its diverse spectators, the film industry contributed to this view with stories of successful adaptation that complemented earlier deterministic narratives. Chapter 6 shows how Italians found themselves at the meeting point of the picturesque tradition of "agreeable pictures" and American cinema's need for "agreeable races." Their racial recognition was also their moral legibility as subjects capable of civic improvement. Most emblematic of this shift was the production of sentimental narratives about Italian immigrants experiencing terrible family disruptions and economic hardship, as in George Beban's 1915 *The Italian* and *The Sign of the Rose* (a.k.a. *The Alien*). Widely acclaimed as the most convincing and realistic portrayer of Italians for his costumes, mannerisms, and acting style, Beban eventually published a booklet titled *Photoplay Characterization* (1921) in which he explained his racially inflected, performative approach to playing "the Italian." "A very important part of most screen characterizations," he maintained ". . . is the quality of *picturesqueness*. . . . I like to play the Italian because his costume, his mannerisms, his gestures, and his unlikeness to the everyday people of the street make him stand out as a romantic and picturesque person."[8] Whether evoking audiences' curiosity or compassion, Beban's performances underscored comforting and entertaining racial stereotypes of harmless emotional excess and melodramatic manners.

Italy in Early American Cinema, however, is concerned not just with issues of racialized representations, but also with reception. In New York, Southern Italian immigrants' moviegoing experience was part of a cultural universe that included mutual-aid societies, a flourishing press, religious *feste,* and vernacular theatre. Chapter 7 discusses these various venues of intermedial experience as they engaged former local identities within wider regional, national, and multinational contexts. *Cafés-concerts* along the Bowery or in Harlem's Little Italy staged exilic melodramas and comedic sketches that were shorthand displays of

a community in transition. They satirized vernacular types and provided social critique through multilingual juxtapositions of Southern Italian dialects and Italian and American national idioms. Successful stage characters like the Neapolitan Farfariello and the Sicilian Nofriu popularized a poetics of Southernist mimesis, or autoethnography, which praised regional origins through a moderate adaptation while also expressing anxiety over the possibility of complete assimilation.

Between 1908 and 1918, the Italian vaudeville theatres of New York's Little Italies also exhibited hundreds of Italian films. These included worn-out prints of prestigious historical dramas, originally distributed for the city's most exclusive and Italophilic film audiences; newsreels documenting Italy's war efforts in Libya, such as *Italian-Turkish War* (Cines, 1911); and scenic views of artistic landmarks and tourist attractions that at times were commissioned by nostalgia-stricken local communities. In Italian American theatres, as local testimonies and the "ethnic press" reveal, the modern film medium was not necessarily perceived as an autonomous or even exotic amusement. Instead, Italian films' visual subjects, their narrative and performance routines, and the animated participatory response they elicited remained attached to the familiar format of picturesque representations and to the live spectacles of stage melodramas and vernacular songs. Ultimately, rather than blindly enforcing assimilation, motion pictures inspired patriotic pride in and vernacular appropriations of the familiar, yet updated mode of Southernism. This process became particularly intense when, beginning in 1916, numerous Neapolitan films reached New York. Such dark melodramas of hardship and love as *'A Santanotte* (The Holy Night, Dora Film, 1922) gave public recognition and visibility to immigrants' private lives by placing their struggles in well-known picturesque settings, featuring familiar sketches of urchins and *banditi,* and employing intertitles written in dialect. In addition, communal conditions of exhibition, including collective singing, loud comments, and a neighborhood atmosphere, furthered the sense of vernacular pride. A few years later, Italian American film companies produced comparable melodramas, including *Santa Lucia Luntana* (Cinema Productions, 1931) and the comedic biopic *The Movie Actor* (Roman Film Corp., 1932), starring Farfariello as himself. The former alternated postcard-like images of the Neapolitan Gulf and Vesuvius with fast montages of the New York

0.2. Logo of Francesco Pennino's music-publishing firm, Edizione Pennino®. Courtesy of the Coppola Family Trust.

architectural landscape, all tied together by a narrative of migration and nostalgia. The latter showcased Farfariello's impersonations of the Italian colony's most picturesque figures.

One of the Italian film exhibitors screening these Neapolitan melo-dramas was the young musician and songwriter Francesco Pennino. He also ran a music publishing business, whose logo (fig. 0.2) bears an iconic similarity to the backdrop that I described at the start of this introduction. The logo was probably the latter's source. Divided into two diamonds of picturesque landscapes featuring, respectively, Mount Vesuvius and the Statue of Liberty, the logo visualized a direct link between the Neapolitan homeland and the American metropolis. But unlike the backdrop used in *The Godfather Part II,* this logo inverts the order of the two locations. The conventional left-to-right movement of writing makes the logo seem to emphasize the authentic Neapolitan character of the commercialized music and lyrics—they come straight from Naples.[9] In the backdrop, by contrast, the nostalgia of the songs and the drama envisions a return from the New York harbor to the Neapolitan bay. Like the painted backdrop, Pennino's logo is emblem-atic of this book. *Italy in Early American Cinema* tries to engage both locations and directions in a single circuit of visual inquiry, embodied in a familiar image that audiences on both sides of the Atlantic Ocean were quick to recognize and draw on.

I conclude this study by teasing out the methodological implica-tions of acknowledging cinema's engagement with forms of racial vi-

sualization that preceded the inception of photography. The acknowl-
edgment that early films drew from racial representations present in
older media questions the often-repeated claim of cinema's novelty
as a medium uniquely capable of reproducing reality and movement.
Thus, it also questions the claim that films constituted the prototypical
embodiment of late nineteenth-century technological modernity. By
contrast, *Italy in Early American Cinema* places early cinema within a
much older geopolitical framework of modernity that calls for a consid-
eration of race as a long-lasting visual form, instead of simply as the sub-
ject matter of representations. In so doing, this study, while exploring
motion picture depictions and experiences at length, seeks to avoid the
familiar and still all-too-implicit teleological narratives that have hailed
cinema as the ultimate expression of modern aesthetics and a distinct
form of mass entertainment.[10] It thus seeks to undo the understanding
of "early cinema" as solely a "point of rupture," an attribution of novelty
that, as André Gaudreault has sensibly warned, isolates "cinema" from
earlier visual practices.[11] What defined cinema instead was, as Charles
Musser has aptly argued, "the reworking of the familiar—not only a
reworking of old subjects in a new register but of established methods
of seeing and reception."[12]

The awareness of early films' aesthetic connections with previous
representational forms does not, of course, diminish the acknowledg-
ment of early cinema's power in America's cultural life. Films captured,
in unprecedented, lifelike ways, distant events and characters and
broadcast them to local places and spectators. They transformed both
the production and the reception of America's visual media, stage rep-
resentations, print journalism, sports, and politics. Nevertheless, mo-
tion pictures emerged at a historical juncture that did not just feature
technological and industrial innovations and their impact on everyday
(urban) life, but also involved transatlantic migrations, nationalist ide-
ologies, and imperialistic formulations of racial difference, as well as
deep-rooted visual practices. Thus, the cinematic question of racial
depiction may not be reduced to subject matter; instead, it ought to
involve the analysis of formal conventions. When examined through
the lens of racialized representations and receptions, studies of early
cinema may profitably complicate medium-specific textual analyses,
with their penchant for closely defined time frames. Early film histori-

ography ought to consider larger geopolitical occurrences (including colonialism, imperialism, nationalism, and migration) and their related scientific rationalizations (e.g., anthropology, ethnography, and urban sociology). Such a methodological move does not abolish textual analysis. On the contrary, it reveals films' expressive, ideological, and commercial debts to a host of other representational practices, including paintings, theatre, literature, illustrated prints, caricatures, lantern slides, and photography. This broader approach ultimately reveals a dynamic, centuries-old network of intermedial representations constituting the lively terrain that defined an aesthetic of racial difference and which, at the turn of the twentieth century, cinema uniquely furthered, expanded, and popularized.

PART ONE

Picturing Italy's Natural and Social Landscapes

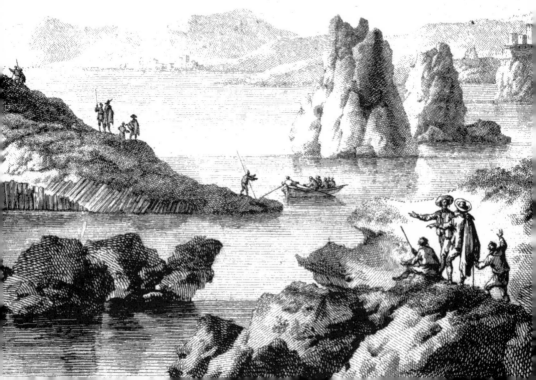

ONE

Picturesque Mode of Difference

My name is in the hut of the savage of Florida,
and in the hermit's book at Vesuvius.

CHATEAUBRIAND, "VOYAGE AU MONT-
VÉSUVE, JEUDI 5 JANVIER 1804"

Nothing, however, can be more picturesque than the
gestures and the physiognomies of these savage people.

PERCY BYSSHE SHELLEY, LETTER TO THOMAS
LOVE PEACOCK, NAPLES, 22 DECEMBER 1818

Since the seventeenth and, especially, the eighteenth centuries, the
aesthetic practices of the picturesque had correlated the depiction of
landscapes with ideas of social, national, and racial difference. While
picturesque representations may seem greatly distant from turn-of-the-
twentieth-century moving pictures, throughout the eighteenth and nine-
teenth centuries they informed an astonishingly wide range of visual
and dramatic practices—including painting, printmaking, magic lan-
tern shows, prose fiction, and theatre—which ultimately influenced cin-
ema's formal and ideological expression. Their popularity also signaled
a modern, geopolitical recasting of European culture, which the vast
literature of the picturesque has rarely addressed.[1] In fact, the economic

and technological wealth of Western Europe, generated by the com-
merce, expansion, and exchanges associated with colonial and (proto)
touristic expeditions, promoted visual and literary narratives contrasting
the Old World's modern present and glorious past with the level of civi-
lization both of Europe's outsiders and of its internal, marginal popula-
tions. Picturesque representations became an imaginative, intermedial,
and highly comparative currency used to visualize and domesticate the
new exotic landscapes and faces circulating in modern Europe's newly
race-sensitive public sphere.

GOING SOUTH

To me, Sicily implies Asia and Africa.

J. W. V. GOETHE, *ITALIAN JOURNEY*, 1787

Although during the Renaissance European culture had hailed Italy
as the center of intellectual, political, and artistic excellence, by the
second half of the seventeenth century a wide range of literary, artis-
tic, and political representations began to look at the land of Dante
and Machiavelli as an obsolete and lethargic region. In the burgeoning
climate of the industrial revolution and as commercial traffic shifted
from the Mediterranean to the Atlantic Ocean, Italy became "Europe's
South."[2] At the center of this geopolitical reframing was the Grand
Tour, the élites' journey of initiation to Southern Europe. Since the
turn of the seventeenth century, it had become common for the upper
classes of Northern and Western Europe, as well as of Poland and Rus-
sia, to travel to Italy. French *honnêtes hommes,* English gentlemen, and
German *Kavaliere* embarked on the Grand Tour to perfect their cultural
and political education and foster their national self-understanding.[3]
Writers and artists, themselves high-class Grand Tourists, generated
and inspired a massive range of literary and visual accounts which,
informed by new approaches to classical traditions, were initially ad-
dressed mainly to their peers. By the late eighteenth and early nine-
teenth centuries, however, these productions sought to appeal also to
bourgeois tourists and to the even larger audience of homebound but
curious readers and spectators, including Italians. In today's terms,

PICTURESQUE MODE OF DIFFERENCE · 21

the Grand Tour and its representations were an interdisciplinary affair with a lasting intermedial impact informed by an array of scholarly practices, from geography to ethnography, which was not exclusively related to Italy. As Mary Louise Pratt has noted, it is not surprising "to find German or British accounts of Italy sounding like German or British accounts of Brazil."[4]

From the second half of the seventeenth century, as Grand Tourists began to venture south of Rome with greater frequency than before, numerous accounts singled out Naples and Sicily as the "South" *par excellence.* Less common were the references to Calabria (and even less to Apulia), sometimes celebrated as part of the former Magna Graecia, but more often defamed for its forbidding natural landscape and ruthless brigands. The recognition of Italy's South as a territorial and discursive singularity and the election of Naples and Sicily as synecdoches for the entire region resulted from a combination of political and natural factors. First, the Southern mainland and insular regions had been part of the Kingdom of Sicily in the twelfth century, of the Kingdom of Naples (thus excluding Sicily) since 1282, and of the Kingdom of the Two Sicilies after 1816. Second, with Vesuvius near Naples and Mount Etna in Sicily, the South of Italy had Europe's major active telluric plains and volcanoes. Their earthquakes and eruptions, systematically recorded since the seventeenth century, projected onto the Southern Italian landscape a notion of primeval nature, capable of uniquely destructive force.[5] The ensuing exoticizing prose and visualizations of the South of Italy represented it as humanity's "primal scene," at once pristine and wild, containing antique and decaying ruins and inhabited by a backward, savage, and dissolute population. Comparisons with the New World were not uncommon. Reacting against Southern Italians' stark ritual unorthodoxies, members of the Jesuit order who were familiar with missions to Central and South America often referred to the South of Italy as the *Indias por acá* (Indies of here).[6]

The "imaginative geography" of the South of Italy, to use Said's familiar expression, mainly focused on two locations: Naples, whose identity synecdochically encompassed its surrounding region, and Sicily, whose isolation from the rest of Italy and historical proximity to Greece shaped its imaginative distinction.[7] For Naples, the widely celebrated

excavations of Herculaneum (1738) and Pompeii (1748) bestowed upon the region (and the South as a whole) the name of Europe's supreme archeological site. The concomitant European fascination with Helle-nism and the origins of European civilization, fostered by the influential work of the German art historian and archaeologist Johann Joachim Winckelmann, turned the old Magna Graecia into a unique, noble ves-tige of antique history and untamed (and untamable) nature, popu-lated by individuals who never sported "insignificant facial features," as Winckelmann put it.[8] Such paradisiacal idealizations—both literary and pictorial—could quickly be followed by infernal attributions. A well-known saying circulating since the sixteenth century hailed Naples as "a paradise inhabited by devils" (*un paradiso abitato da diavoli*), juxtaposing the pastoral beauty of the natural landscape with the alleged vicious-ness of the population of one of Europe's largest cities.[9] Still, the newly discovered ruins and the ancient volcanic firestorms that had destroyed Pompeii appeared frequently in engravings, magic lantern slides, draw-ings, and photographs. Ultimately, they configured an iconic motif that early American and Italian cinema readily adopted (through European literary mediations), both narratively and cinematically, in travelogues and fiction films, from W. K. L. Dickson's *Neapolitan Dance at the Ancient Forum of Pompeii* (Mutoscope and Biograph Syndicate, 1898) and Edi-son's *European Rest Cure* (1904) to such Italian blockbusters as *The Last Days of Pompeii* (Ambrosio, 1908 and 1913).

The other center of rhetorical intensity and mythical inspiration was Sicily. Represented since Homer and Virgil as the fertile garden of the Hesperides and the granary of the Roman Empire, its erupting volcano inspired associations from the Middle Ages onward with Hell on earth or a biblical fall from Heaven, a *regio infernalis* (infernal region).[10] The infernal and thus mythical trope of the underground fire also came to identify its inhabitants. Variously named, or "landscaped," after Mount Etna (*Aetnaei, Aetnenses,* or *Aethnaviri*), they were hailed as an excitable and ill-fated population, composed of pirates infesting the island's sur-rounding seas or brigands swarming the mountains and valleys of the interior. It was the dense exchange between travel writers and artists that, beginning in the seventeenth century, codified a distinct way in which cultured producers and consumers alike, whether Italian or for-eign, came to look at the South.

IMAGINARY LANDSCAPES AND THE PICTURESQUE VIEW

Whate'er *Lorrain* light touched with softening Hue,
Or savage *Rosa* dashed, or learned *Poussin* drew.

JAMES THOMSON, *THE CASTLE OF INDOLENCE,* 1748

The emergence of the "picturesque view" in post-seventeenth-century Europe is linked to the cultural secularization of the natural domain that occurred in the sixteenth century. The dislodging of nature from a predetermined geometric and religious design had far-reaching aesthetic, scientific, and political consequences. Nature became, in and of itself, the domain of new aesthetic experiences as well as a legitimate and highly valuable subject of scientific knowledge, enhanced by the use of perception-aiding devices (e.g., the microscope, the telescope, the thermometer, and the compass).[11] In a period of increased scientific and technological inquiry, economic development, and empire-building expeditions, nature also became an autonomous domain of geopolitical knowledge, power, and related aesthetic practices. One of the most radical aesthetic effects of the encounter between nature and politics was the cultural and artistic conversion of "land into landscape," natural environments into natural views. "Landscape is a natural scene mediated by culture," as W. J. T. Mitchell famously put it, adding, "It is both a represented and presented space, both a signifier and a signified, both a frame and what a frame contains, both a real place and its simulacrum."[12] Until the sixteenth century, landscape descriptions and painting had been regarded as merely imitative of inanimate objects and scenes and therefore inferior to narrative descriptions and painting—whether of mythological, historical, or religious subjects. In the seventeenth century, European painters, especially in Holland, began considering the landscape as a subject sufficient unto itself and landscape painting as an independent genre. Aesthetic sovereignty did not at all mean formal insularity; instead, it echoed geopolitical relevance. Natural landscapes and their representations indexed a nation's or a region's degree of modern civilization (or lack thereof). With the aid of established rules of perspectival composition, the Grand Tourist representation of distant landscapes opened the way for new relationships between art and nature and art and history.[13]

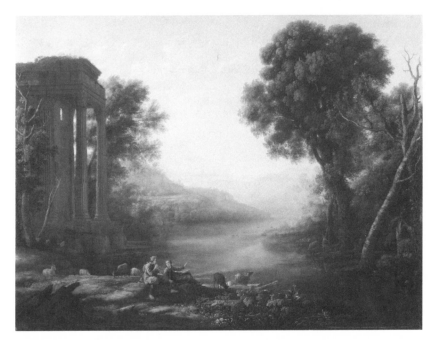

1.1. Claude Lorrain, *Pastoral Landscape,* oil on canvas, 1638. Used by permission of the Minneapolis Institute of Arts, The John R. Van Derlip Fund, and Gift of funds from Ruth and Bruce Dayton, SIT Investment Associates, Darwin and Geri Reedy, and Alfred and Ingrid Lenz Harrison.

With this reevaluation of the natural realm, the Italian landscape acquired geopolitical exemplarity. Various artistic and literary works addressed the degree of discontinuity between Italy's present-day conditions and its illustrious past or between the peninsula's backward condition and Western Europe's processes of modernization. The further south one went, the greater this distance appeared to grow; and the picturesque style, as the preferred mode of Southern Italian representation, showcased it by sustaining a geopolitical correlation between geographic setting and aesthetic experience. To modern and industrial nations, the selective framing of distant, exoticized lands and of their idle native populations enhanced feelings not only of superiority, but also of antiquarian nostalgia and suggestiveness.

The picturesque view of the Italian peninsula unevenly conflated two different, influential, and eventually intersecting forms of landscape representation: the suggestive and imaginative *paysage classique* and the rigorous and exacting *vedute* (singular *veduta*), or perspective view paint-

1.2. Salvator Rosa, *Bandits on a Rocky Coast,* oil on canvas, 1640. Used by permission of the Metropolitan Museum of Art, Charles B. Curtis Fund, 1934 (34.137). Image © The Metropolitan Museum of Art (New York).

ings.[14] The works most commonly associated with the *paysage classique,* which defined the early inception of the picturesque style, were Claude Lorrain's pastoral, heavenly, and brightly sunlit views of the Roman countryside, celebrated for their classical associations with a Golden Age and natural beauty (fig. 1.1); Nicolas Poussin's Arcadian, temple-punctuated countryside, and Gaspar Dughet's charming, ruin-dotted Roman Campagna.[15] In addition to these French artists, also particularly famous was the work of the Neapolitan Salvator Rosa, who favored darker, more atmospheric mountain scenes and forlorn wilderness, inhabited solely by "armed men" and wayward *banditti.*[16] Beloved by the romantics, his imaginative landscapes combined the sea-carved arches of the Neapolitan coast with the craggy cliffs, steep rocks, and even jagged vegetation found in central Italy (fig. 1.2).

As a pictorial genre of urban architectural views, *vedute* implied also a secular form of knowledge, although not one privileging mythical scenes. Associated with the fifteenth-century theorists Filippo Brunelleschi and Leon Battista Alberti, the urban *vedute* aimed at perspectival intelligibil-

ity, panoramic accuracy, and a historically significant positioning of ar-
chitectural monuments within a distinct cityscape. As such, *vedute* were
technically and discursively indebted to the geographical disciplines of
cartography and topography as well as the optical science of perspective
and its exacting instrument, the *camera ottica* or *camera obscura*.[17] The
veduta's viewpoint is positioned at a high level, enjoying the safety of
an aerial or bird's-eye view, and embodying what Svetlana Alpers has
termed a "mapping impulse": an ambitiously objective, yet not human,
perspective.[18] In truth, the intended panoramic representation matched
prevalent notions of architectural and political relevance as it depicted
noteworthy palaces, castles, and churches. Major exponents of this style
included the Italian Tiepolo, Paolo Veronese, Canaletto, and Antonio
Joli, as well as the Dutch Gaspar Van Wittel and the Flemish Hendrik
Van Lint. *Vedutisti* or view painters did not make use of the foreground
edge of the painting, as the exponents of the *paysage classique* did.

The ordinary and widespread understanding of the "picturesque"
as referring to objects or landscapes seen "as in or like a picture" masks
its distinct connection to both painterly traditions. On the one hand, as
Vasari writes in his *Lives of the Artists* (1568), the "picturesque" described
a drawing technique resulting in intense pictorial and *chiaroscuro* effects,
often associated with the *paysage classique*.[19] On the other hand, the pic-
turesque maintained profound links with the lasting and cosmopolitan
tradition of Italian view painting. Not all views or *vedute*, in fact, were
alike. Despite their apparent cartographic objectivity, many exhibited
remarkably picturesque traits. The eclectic and influential work of the
Italianized Dutch painter Gaspar Van Wittel (ca. 1653–1736), known in
Italy as Gaspare Vanvitelli, provides a map of the different, paradigmatic
views of the Italian landscape.[20] His Dutch background also reveals how
tightly intertwined picturesque and cartographic representations could
be. Idealized landscape views and topographic accuracy mattered a great
deal in a republic experiencing political consolidation and dramatic nat-
ural challenges to the land it was in the process of reclaiming. The usual
contrast between Italy and Holland, between the picturesque and the
mapping impulse, is to be reformulated within a common political dis-
course on landscape representation and city- or nation-state identity.

In his views of Venice, Van Wittel emphasized perspectival accuracy,
architectural splendor, and historical significance. Through the talent of

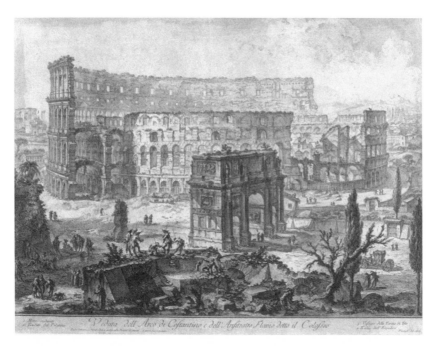

1.3. Piranesi, *Veduta dell'Arco di Costantino e dell'Anfiteatro Flavio detto il Colosseo (View of the Arch of Constantine and the Colosseum)*, etching, 1760, H56. Third state of six, from the series *Vedute di Roma (Views of Rome)*. Courtesy of the University of Michigan Museum of Art, Paul Leroy Grigaut Memorial Collection (accession number 1969/2.124).

Canaletto (1697–1768), these defining traits eventually became a visual tradition known worldwide through illustrated prints, topographical panoramas, and, later, tourist photographs and Lumière's filmed travelogues.[21] Canaletto's topographical prospects of London sights and bridges brought a Venetian style into the English conventions of view painting and crystallized the Italian city's status as reigning synecdoche for the Italian landscape.[22]

Van Wittel's Roman *vedute,* instead, like those of his followers, were antimonumental and thus closer to a picturesque style. They showcased his penchant for everyday life along the Tiber and in the Roman Campagna and his attraction to "the contrast between the blackest poverty, or the infiltration of pastoral life and rural atmosphere, and the proud display of wealth and pomp."[23] The results were paintings that, set in the city's surrounding countryside rather than among its monuments, captured the strength of natural forces against the transience of histori-

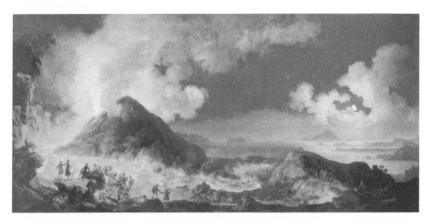

1.4. Pierre-Jacques Volaire, *The Eruption of Vesuvius,* oil on canvas, 1771. Charles H. and Mary F. S. Worcester Collection, 1978.426. Used by permission of the Art Institute of Chicago; Photography ©The Art Institute of Chicago.

cal excellence and the frailty of humanity. Images of decaying remnants of once-splendid buildings, now covered in vegetation, fashioned what Giuliano Briganti has described as a "pre-romanticism of ruins."[24] Meanwhile, as archeological excavations increased after the mid-seventeenth century, the city's antique but decayed architecture became an iconic attraction of expensive catalogs and portable illustrated guidebooks. Their painted views, etchings, and photographs codified a way to celebrate the monumental ruins of Rome—above all, the Colosseum—by duplicating viewing perspective and composition (figs. 1.3 and 2.1).[25]

Further south, the views of the Gulf of Naples and the Sicilian Magna Graecia revealed a picturesque contrast between peaceful natural scenery and the untamed force of nature. Soft valleys could easily alternate with tremendous precipices, pristine bucolic pastures with volcanic eruptions, desolate historical ruins with colorful and primitive locals. Through an emphasis on natural (rather than just architectural) scenes, a novel interest in human figures, and a systematic use of light and color contrasts, Southern Italian *vedute* associated the South with heightened visual perception and effect, dramatic depth, and proto-ethnographic voyeurism.[26] This imaginative crescendo is evident in Van Wittel's vibrant representations of the sun-drenched Southern coastline and in the daring atmospheric views of Joseph Vernet, which captured the continual (and primitive) danger of spectacular volcanic eruptions.

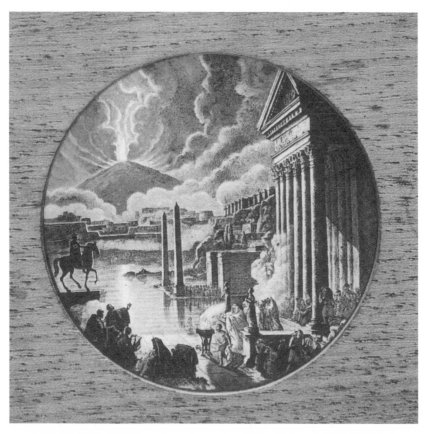

1.5. William Charles Hughes, *The Fire of Pompeii* (London), wood-framed and hand-painted magic lantern slide, 17.5 × 11.3 cm., ca. 1880. Used by permission of the Collezione Minici Zotti (Padua, Italy).

Likewise, the spectacular night scenes of volcanic eruptions by the Frenchman Pierre-Jacques Volaire, the German Jakob Philipp Hackert, and the Englishman Joseph Wright of Derby, which flooded the European market at the turn of the nineteenth century, relied on impressive pictorial effects and fantastic *à contre jour* effects which touched a multiplicity of chords. The horrific, devilish, and sublime effects of incandescent lava flows and bursts of flame contrasted, in something like a split-screen effect, with an undersized human presence of surprised and moonlit fishermen, as well as fleeing locals: peasants or aristocrats. As it will be clear in the next chapter, both the picturesque subject and the stylistic treatment of volcanic eruptions also pervaded engravings,

1.6. Claude glasses, late 1700s. Used by permission of the Science Museum/Science & Society Picture Library (London, UK).

illustrated prints, gouaches, lantern slides, and, later, photographs and films (figs. 1.4–1.5).[27]

Picturesque representations also differed starkly from view paintings in their framing and composition. In their search for accuracy, view painters relied mostly on the *camera obscura,* avoiding another instrument, variously called the "Claude glass," "black mirror," or "Claude mirror."[28] The Claude glass was a slightly convex, opaque, black-tinted mirror, commonly oval or circular and with a diameter of about 4 to 4.5 inches (enabling it to be conveniently encased in a wallet), which functioned as a portable frame (fig. 1.6). It literally framed and enclosed a view by reflecting it from over the shoulders of the beholder in a rather condensed and warped manner, with a darkened foreground and margins. The resulting landscape, manipulated and miniaturized, was thus obtained not by direct and frontal observation of the subject at hand, but instead by turning one's back to the real landscape while focusing on the dark surface of the mirror, and its darkened edges made the wide perspectival space of the view paintings seem enclosed. The Claude glass functioned by reduction. It could compress a large landscape into a small, manageable image or, in the words of British antiquarian and topographer Thomas West, "admit a field large enough for the eye to take in at one sweep."[29] It was popularized in England, Europe, and the United States by one of England's earlier Romantic poets and tourists, Thomas

Gray (1716–71), and at the turn of the nineteenth century its users and admirers included travel writers, tourists, and artists, some of whom, like Thomas Gainsborough, paid public homage to it.[30]

Through its slightly convex surface, the Claude glass structures the view into theatrical thirds: its use of foreground, middle ground, and background compares well to modern theatre's upstage, middle stage, and downstage.[31] Christine L. Oravec has eloquently described such a relationship in picturesque paintings: "The foreground bordered the edge of the frame, prosceniumlike, and was represented by a large tree or a side of a cliff, called a coulisse. The middle ground was illuminated and often contained a human or animal figure, a river, or a ruin to lead the viewer's eye into the scene. Finally, the background of the landscape led to the horizon, framed by the objects in the foreground."[32] Over time, the choreographed view of "scenery," "side-skips," and "screens" gained traction as a simple and realistic representation. Yet the realism of picturesque views resulted from a more immediate effect, the simplification, unification, and reconciliation of paintings' various grounds and figures. Again in Oravec's words: "In all, the effect signified benign domestication, with human beings inhabiting a friendly, harmonious domain."[33] The picturesque was therefore a way to frame distant, exotic worlds in a coherent view, in which roughness, wilderness, and variety were subsumed, tamed, and aestheticized into a single pleasurable prospect. In this way the picturesque became politically influential and aesthetically ubiquitous.

By the end of the seventeenth century, as art historians have traditionally argued, the picturesque had become a fashionable term, an index of sophisticated and cosmopolitan taste among Europe's art patrons, Grand Tourist writer-travelers, and their homebound readers. English poetry and prose fiction began to allude to the picturesque's combination of an exuberant and even rough nature with archeological ruins. Salvator Rosa's spectral imagery of dark foliage, rugged scenery, and terrifying bandits inhabited the eighteenth-century gothic novels of Horace Walpole and Ann Radcliffe. Once included within eighteenth-century English aesthetic debates, the picturesque experience augmented Edmund Burke's famous distinction between the beautiful and the sublime. During a time of pre-Romantic sentiment for nature, the celebrated works of Lorrain, Poussin, and Rosa prompted an understanding of landscape

art as devoted to a heightened appreciation of pictorial quality that was amplified neither by the reproduction of abstract ideals of harmony and proportion (beauty) nor by overwhelming sentiments of awe and terror (the sublime)—notwithstanding Rosa's inclinations toward macabre imagery.[34] Instead, this painterly delight derived from the attractive rendering of nature's broken and exuberant textures and varied shapes, all contained and unified through a smooth "agreement" of ancient architectural structures and exotic natural settings. The English Reverend William Gilpin (1724–1804), one of the earliest and most influential aestheticians of the picturesque, had fittingly defined its new aesthetic arrangement as "expressive of that peculiar kind of beauty, which is agreeable in a picture."[35] What art historians have rarely stressed is the geopolitical and, in time, racial significance of this practice of aesthetic domestication. The tension between freedom and constraint enabled the picturesque to express matters of landscape design through political metaphors and, in turn, to articulate notions of distinct national character through metaphors drawn from landscape design.[36] Referring to the range of European political models, from the excesses of liberty associated with the French revolution to the constraints of despotic regimes, in 1794 landscape architect Uvedale Price most eloquently paired landscapes with political regimes:

> A good landscape is that in which all the parts are free and unconstrained, but in which, though some are prominent, and highly illuminated, and others in shade and retirement—some rough, and others more smooth and polished, yet they are all necessary to the beauty, energy, effect and harmony of the whole. I do not see how a good government can be more exactly defined.[37]

Although a full discussion is outside the scope of this study, it is important to note that the picturesque operated in other nations, particularly France and Germany.[38] In post-Waterloo France, for instance, the state was keenly involved in the construction of a national identity centered on the land through such promotional activities as commissioning and buying landscape paintings. The picturesque entered the palette of a number of Parisian painters—including Jean-Baptiste-Camille Corot, Théodore Rousseau, and Jean-François Millet—associated with the Barbizon school (1830–70), which was named after their favorite vil-

lage, near the Fontainebleau Forest, where they gathered to paint local landscapes and peasants in an influential combination of romanticism and realism.[39]

Corresponding geopolitical and racializing manifestations of the picturesque also pervaded late eighteenth- and early nineteenth-century travel literature about Italy. Commonly concerned with the aesthetic rendering of national and regional differences, highly visual texts in this genre turned Southern Italian landscapes into fated, yet irresistible scenes populated by the ill-tempered and instantly recognizable "characters of the picturesque."

TELLING VIEWS

The capacity of [Neapolitans] to remain indifferent resembles the calmness of Vesuvius which after a long period of silence resumes its fury.

AUGUSTUS VON KOTZEBUE, *NEAPEL UN DIE LAZZARONI*, 1799

I no longer saw Nature, but pictures.

J. W. V. GOETHE, *ITALIAN JOURNEY*, 1817

The most popular accounts by those making the Grand Tour through the South of Italy at the turn of the nineteenth century included the widely translated works of Johann Hermann von Riedesel (1771), Patrick Brydone (1773), Jean Claude Richard Abbé de Saint-Non (1781–86), Jean-Pierre-Louis-Laurent Hoüel (1782–87), Henry Swinburne (1783–85), Madame de Staël (1807), and Johann Wolfgang von Goethe (1817).[40] Rather than directly documenting Southern life, these works projected onto Italy's South (and at times onto the entirety of the Italian peninsula)[41] novel aesthetic experiences of ancient and founding civilizations (Roman and Greek). They did so by combining learned references from highbrow literature with the iconic vocabulary of picturesque representations.

Ignoring the intricate historical heritage of Southern Italian culture linked to the Christian, Arab, and Spanish occupations, a number of writers climbed Mount Etna or Vesuvius, marveled at the distant views below, and idealized them by filtering their experience through learned

literary and visual allusions. Looking out from the top of Mount Etna, Goethe wrote, "The green of the plants is of a different shade, either more yellow or more blue, than the green we are used to. What gives this scenery its greatest charm, however, is the haze uniformly diffused over everything.... this haze is most instructive for a painter." From the same summit, he continued, "I no longer saw Nature, but pictures; it was as if some very skillful painter had applied glaze to secure a proper gradation of tone."[42] The overwhelming haze of the Sicilian landscape resonated for the German author with mythical precedents, which called for learned literary comparisons ("I hastened to purchase a *Homer*") and references to classic painterly traditions ("Now, at last, I can understand Claude Lorrain").[43] In a "Lettre à Fontanes," dated 10 January 1804, Chateaubriand spoke of the same haze as a "peculiar vapor ... spread over distant objects, which rounds them and removes all harshness," before concluding with an identical visual reference: "You have doubtless admired this sort of light in Claude Lorrain's landscapes.... it is however, the genuine light of Rome."[44] Whether in delectation or horror, educated travelers found themselves writing about Italy not as a real place, but as an image. In her *Corinne; ou, L'Italie* (1807), Madame de Staël described Italy's *meridione* in such a manner: "The countryside formed *a picture* together with the temple which was there as the centre or the ornament of everything."[45]

The most ambitious codification of the combined literary and pictorial representation of Italy's South came with the publication of Jean Claude Richard Abbé de Saint-Non's five-volume *Voyage pittoresque; ou, Description des royaumes de Naples et de Sicile* (1781–86).[46] A uniquely exhaustive collective and intermedial reportage of the South coordinated in Italy by writer Dominique Vivant de Non (also known as Denon),[47] the *Voyage pittoresque* was an exemplum of Grand Tourist literary and visual report and editorial teamwork, based on the model of the contemporary *Encyclopédie* by Denis Diderot and Jean d'Alembert. The volumes of the *Voyage pittoresque* prompted the appearance of dozens of similarly titled works for decades to come, devoted to Italy and other European nations, but soon also to American, Asian, and African regions.[48] As a best-selling collection of artistic drawings, the *Voyage pittoresque* combined an antiquarian tradition of documenting ancient artistic monuments and treasures, as in the classic works of Bernard de Montfaucon,

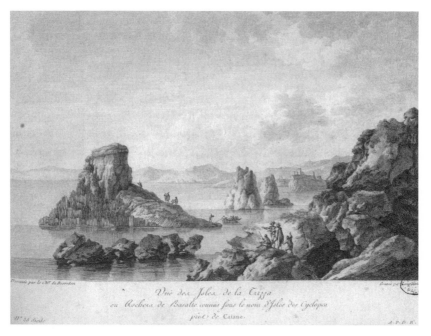

1.7. "View of the Island of Trizza [sic], near Catania," from Jean Claude Richard Abbé de Saint-Non, *Voyage pittoresque; ou, Description des royaumes de Naples et de Sicile* (1785), vol. 4, part 1, table 35. Used by permission of Biblioteca Palatina (Parma, Italy), F. Pal 8284/4 table 35; by kind concession of the Ministero per i Beni e le Attività Culturali (Rome, Italy).

with more recent practices of museographic cataloguing, aesthetic exoticization, and anthropological othering. The cultural activities of the ambitious Denon—who in 1798 joined Napoleon's colonial campaigns to Egypt, where he illustrated and catalogued artworks and monuments for notable publications—contributed to France's and Europe's aesthetic exoticization of non-European lands and Europe's "othered" peripheries (fig. 1.7).[49] Writing in his *Voyage en Sicile* about the effects of Sirocco in terms of an "atmosphere . . . so heavy as to overcome us," Denon admitted that he "experienced for the first time the influence of the climate upon the mind," which prompted him to a most significant and seamless pairing: "I now began to conceive the nature of oriental effeminacy and Sicilian apathy."[50]

The exoticization of the Italian landscape, particularly its Southern Italian scenery, implied an educated process of visual and literary referencing (e.g., of classical Latin poetry), as well as rhetorical "discovery,"

which distinguished the pastoral and idyllic South from the cultural and socioeconomic modernity of Northwestern European nations. The nation of Virgil and Horace belonged to a past that could be evocatively revealed, quoted, and celebrated because it did not exist any more. As a site of historical accumulation rather than renewal, inspiring profound reflections on human historicity and finitude, the pristine Southern Italian landscape made a vivid contrast to the youthful nations located north of the Alps and their modern mastering of nature. The emerging aesthetic experience of Italian picturesque views and the accompanying emphasis on antiquarian pleasure and contemplation at once elided and showcased forces of economic utility, class distinction, and (racialized) national ascendancy.[51] Predictably, the aestheticization of Italy and, particularly, its South also evoked a number of negative cultural, moral, and ultimately racial judgments, which questioned the long-sung mythical and literary refrain of a Southern European antiquity as a perpetual condition and sole ideal. The principle of the *translatio imperii* suggested that the genius of Rome had moved away from the Italian peninsula. Indeed, the actual state of Italian populations and monuments pointed to a dramatic discontinuity with the past, routinely formulated as a disheartening decline and decadence, and variously explained as resulting from historical, moral, and racial factors.[52]

The same writers who had idealized Southern Italian scenery often contrasted the ethereal beauty of the panorama with either the frequent outbursts of volcanic and telluric force or the miserable living conditions of the local populations. After marveling at the imposing natural beauty of the landscape, Baron von Riedesel looked down from the heights of Mount Etna and lamented the view of neglected valleys, squalid villages, and unpaved roads winding through abandoned ruins. "No country," he lamented, "has so much the appearance of desolation, or looks so like a picture of the dreadful avenues to hell itself, as the environs of Catania."[53] In his Gothic account of Sicily, the Irish preceptor Patrick Brydone described underground passages "so very dismal and gloomy" below ruins of ancient castles and temples, now inhabited by "devils and the spirits of the damned."[54] Henry Swinburne, who wrote of feeling "pity and regret" at the sight of the ruins of Syracuse, commented on the impenetrable and hostile wilderness of the thick forests, hidden precipices, and untamed rivers of Southeastern Sicily, saying it was "a place on which I should

wish to employ the powers of a Salvator [Rosa] or a Poussin."[55] In these panoramas of resentment and fascination, the volcano and the undomesticated forces of Southern Italian nature came to be prime objective correlatives: not only of humanity's tragic frailty, but, more specifically, of local populations' primitive helplessness.

Riedesel often interrupted his enthusiasm for Panhellenic historical findings to describe, with disappointment and a resilient combination of racial and misogynistic implications, his lay encounters with present-day Sicilians. A fervent follower of the materialistic theories of Montesquieu, who in *The Spirit of the Laws* (1748) had linked natural settings and climatic conditions to populations' moral "character," the German scholar projected both Mount Etna's volcanic qualities and the sweltering local weather onto the local populations' temperament. After contending that Sicilians "live in the original, simple state of nature," according to the Rousseauian tenet of primitive docility, Riedesel singled out the inhabitants of Sicily "for the violence of their jealousy and vindictive temper" and for their depraved moral state, defined by "effeminacy, voluptuousness, and cunning."[56] In order to reconcile the past with the present, Swinburne dissociated Hellenic cultural excellence from the local populations of Sicily by positing an irreversible rupture of cultural continuity. Speaking of the people of Syracuse, he noted that "the trophies of their victories, and the monuments of their skill, have long been swept away by the hand of time."[57] Likewise, captured by the sight of old ruins merging with nature and wishing to convey the absence of human presence and labor, Madame de Staël self-assuredly declared that "Italians are much more outstanding for what they have been and by what they might be than by what they are now."[58] Goethe similarly, and memorably, compared "Italy" with a "shadow of a nation."[59] In the early nineteenth century, the perception of Southern Italians' radical irrelevancy both to their mythic past and to modern European culture was eloquently crystallized by Augustin Creuzé de Lesser, a French traveler and author of *Voyage en Italie et Sicilie* (1806). In a book whose title already reveals the exclusion of Sicily from the rest of Italy, Creuzé de Lesser famously proclaimed, "Europe ends at Naples and ends there quite badly. Calabria, Sicily, all the rest belongs to Africa."[60]

In the positivist milieu of the nineteenth century, cultural and moral criticisms of Southern Italians relied more and more on systematic "natu-

ral" or protoscientific explanations. One of the most paradigmatic texts of this operation was *L'homme du midi et l'homme du nord; ou, L'influence du climat* (1824), by the Montesquieuian Charles Victor de Bonstetten, who methodically correlated Northern European industriousness and vigor with colder weather. By contrast, he posited that the warm seasons of the Mediterranean held Italians in a "constant disposition to enjoy impressions obtained through outward things" and a "perpetual excitement" that drew them "away from self-consciousness."[61] "The first perceptible effect of climate on man in Europe," he wrote, "is the feeling of renewed life, which every traveler experiences on crossing the Alps to visit the south of Europe." Yet, he added, "pass the Apennines on the way to Rome or Naples, and the characteristics of the South become more marked. The traveler imperceptibly enters volcanic regions." The main consequence of such close exposure to the volcano's eruptions is the presence of a population "ruled by the imagination" and thus imbued with superstition, impressionability, and an unstoppable inclination toward violence. "The most remarkable trait of Southern character," he concluded, "is a thirst for Vengeance. . . . This baneful passion has scarcely any existence in the North, and forms one of the sharpest lines of demarcation between the two climates."[62] As a primitive retaliation foreign to any notion of justice, vengeance, or *vendetta,* would become a major dramatic motif in the literary, theatrical, and cinematic representation of Southern Italian characters on both sides of the Atlantic.

THE RHETORIC OF BRITISH ITALY

Like good coaches and steamboats, the picturesque
comes to us from England.

STENDHAL, *MEMOIRS OF A TOURIST,* 1838

The worldwide circulation of images of picturesque Italy owes a significant debt to the British scene of art collectors, galleries, printmakers, and aestheticians. This is an influential case worthy of special attention. On the one hand, the "picturesque mode," as Rev. William Gilpin (1724–1804), one of these eloquent connoisseurs, called it, participated in the vast process of England's social, cultural, and national self-definition. On the other hand, however, it was the British institutionalization of

the picturesque as a pictorial practice, taste, and aesthetic theory that informed America's painterly, photographic, and cinematic uses of the picturesque aesthetic, including its ideological underpinnings. The British case, in fact, sheds a paradigmatic light over how the picturesque mode combined the aesthetic and the political realms.

In Great Britain the emergence of a sensibility for the picturesque was strictly linked to a major domestic agricultural and landscape transformation, known as enclosure. The growing concentration of the nation's once public land in the hands of a few hundred owners, and the ways this landed gentry set out to "improve" their estates, produced dramatic changes in the landscape as well as in social and working relationships. "Beneath this domination," as Raymond Williams argued, "there was no longer, in any classical sense, a peasantry, but an increasingly regular structure of tenant farmers and wage-laborers: the social relationships that we can properly call those of agrarian capitalism." What changed was also the idea of what the land represented: it was no longer a mere inheritance, but an "opportunity for investment, carrying greatly increased returns."[63] The laws of an organized market and the commodification of agricultural crops encouraged productive development ("improvement") of the estates. The transformation of the land into efficient property turned aristocratic landowners into countryside capitalists.[64]

While profiting from their newly efficient estates, the landed gentry formulated new ways to gain social prestige. These men of increasing means had been formed by a cosmopolitan education. As Europe's most regular and numerous Grand Tourists and most generous artistic patrons, and as active participants in the exchange and circulation of pictures and souvenirs, they were knowledgeable about the landscape representations of the countries they visited on the continent.[65] Particularly fond of what British poet William Cowper called in 1783 the "Italian light," they often returned home to acquire and exhibit pictorial samples of Claude's and Gaspar Poussin's hilly and peaceful countryside as well as Rosa's daunting precipices and broken bridges.[66] With an admiring eye for the Roman Campagna and a nostalgic ear for pastoral poetry, self-conscious landowners also returned home concerned for the aesthetic, and not just the economic, "improvement" of their own estate. Their commissioning of landscape architecture and paintings (also called "estate paintings")

converged in an "idealization of . . . the happy retreat," the search for what in the second half of the eighteenth century were identified as "pleasing prospects," and "a deep and melancholy consciousness of change and loss" as a result of the radical changes fueled by progress and productivity.[67] Several landowners sought prestige and grandeur by turning sections of their estates "into deer parks and into unproductive vistas in the manner of Claude for pleasure and show."[68]

The practice of landscaping implies a secularization and a major recasting of the relationship between nature and humanity. What is remarkable here, in fact, is not just the alignment of park design with literary and artistic culture, but the confidence that nature could be redesigned and "improved" to match an aesthetic goal and intensify a viewing experience. Balancing the agricultural improvement of a portion of an estate into a store of raw materials that could be profitably exploited, an equally rational *aesthetic* improvement of another portion allowed the appreciation of nature's wildest and most uncultivated manifestations (solitary peaks, impenetrable forests, deserted valleys).[69] As Raymond Williams most eloquently puts it, "we cannot then separate their decorative from their productive arts; this new self-conscious observer was very specifically the self-conscious owner."[70] These picturesque views were created to be consumed by the educated owner and his friends, and their bucolic lawns and watery prospects "quoted" pastoral paintings and poems while they elided laborers, barns, mills, roads, and all signs of production and exploitation. Here, in a single, harmonic Claudian vista and as in Virgil's *Eclogues* ("Et in Arcadia ego"), artful wildness and nature's spontaneous bounty could peacefully coexist.

From the second half of the eighteenth century, however, what the English men of taste saw through such devices as a *camera ottica* or Claude glass and the rich repository of Roman pastoral poetry was not just, respectively, Italian scenery or a reference to a Virgil poem. In the name of Gothic and Celtic revivalism, landscape architecture and picturesque tourism focused also on the diversity and distinctiveness of the British countryside. The Napoleonic wars between England and France (1793–1815) discouraged tourists from crossing the Channel. England's forced isolation crucially contributed to projecting both aestheticized nostalgia and national interest onto the untamed landscapes in Wales, the Lake District, and Scotland. Their hard-to-reach heaths,

moors, fens, and commons, dotted with the ruins of Cistercian abbeys, Norman castles, and Roman settlements, became well-organized tourist destinations.

Once the British landscape became "agreeable in pictures," to use a common definition of the "picturesque," romanticizations came to pervade English painting, poetry, and regional tourism. "A backward glance, upon the curling cloud," as William Wordsworth wrote in *The Prelude* (1850), could make the smoky and industrialized Bristol "by distance ruralized."[71] With their high percentage of unenclosed "waste land," the Scottish Highlands, Wales, and the Lake District conveniently lent themselves to touristic outings for the landed gentry, the patrons of estate painters, and the growing cohort of middle-class British tourists. The remains of Tintern Abbey in Monmouthshire, Wales, for instance, became an iconic pole of attraction for poets (including Wordsworth), painters, engravers, affluent visitors, and even critics with a modicum of artistic skills. Excavated in 1756, Tintern Abbey became the emblematic subject of a Wordsworth poem (1798), which concluded Wordsworth and Coleridge's *Lyrical Ballads,* and of numerous engravings, aquatints, and paintings by the likes of Edward Days, James Ward, and William Gilpin. The latter devoted to "the most beautiful and picturesque view on the river" a large portion of one of his influential aesthetic treatises, *Observations on the River Wye* (1782). Illustrating his words with sketches and paintings (fig. 1.8), he described the "noble ruin" of Tintern Abbey as occupying "a gentle eminence in the middle of a circular valley, beautifully screened on all sides by woody hills."[72]

These sightseeing journeys reproduced familiar picturesque viewing (and painting) strategies of visual control and appropriation, from the framing reductions of uncultivated land to the manipulation of receding wilderness.[73] These journeys also further popularized the characterization of various British natural settings as a distinct national landscape. By deploying the painterly imagery of local views as a symbol and a medium of national place, elitist producers and consumers of picturesque artworks, tourism, and park design effectively turned local sites into a political synecdoche of national identity.[74] Landownership, after all, embodied more than class distinctions: it defined political citizenship as it implied access to the British Parliament. The landed gentry's economic and aesthetic "improvement" of their parks and estates contributed to

1.8. William Gilpin, "Tintern Abbey," from *Observations on the River Wye and Several Parts of South Wales* (1782; 2nd ed., London: Blamire, 1789), vol. 1, facing p. 45. Courtesy of the University of Michigan, Special Collections Library, Ann Arbor.

the transformation of Britain from a conglomerate of jostling regions and estates into a single setting of natural and national prospects.

The political dimension of the picturesque did not escape the leading theoreticians of the subject—the amateur artist and acute critic Rev. William Gilpin, the country gentleman Uvedale Price (1747–1829), and the poet and squire Richard Payne Knight (1751–1824). With particular intensity between 1792 and 1795, these three writers discussed the terms of the picturesque as a distinct aesthetic mode. Their reflections are significant for our discussion of racial depictions, as they reveal the degree to which soon-to-be-racialized landscape representations were thought from early on to result from purposeful aesthetic constructions. Their contributions addressed the picturesque in terms of identity and mimetic representation. What does it mean to represent a landscape that is immediately recognizable as the image of a familiar subject? How do conventions of picturesque rendering unambiguously identify places and races clearly known to be "different"? Because of photography's appropriation, and thus naturalization, of picturesque arrangements, it is important to start from these demystifications.

From the outset, these men's writings reflect larger and converging philosophical reformulations of the relationship between nature and human knowledge, including aesthetic knowledge. Hume's theories of knowledge and aesthetic judgment, Berkeley's perceptualist antirealism, and Kant's notion of apperception placed greater emphasis on the knowing subject's perceptual practices (and on the intellectual elaboration of such sensorial experience) than on the mere object of the knowing experience. These debates occurred in a climate marking a radical departure from the neoclassical context in which both the production and the appreciation of artworks demanded that a series of unchanging rules of beauty and perfection be intellectually grasped. The emergence of the picturesque, just like Burke's, Hume's, and Kant's theorizations of the Gothic and the Sublime, thus belonged to a perceptual recasting of natural, cognitive, and aesthetic knowledge.[75] Despite some significant differences, Gilpin, Price, and Knight converged on an understanding of artistic production and signification as a creative, yet not arbitrary, process of coherent articulation, or characterization, opposite to mere reflection or imitation. I refer to such inventive characterization as *picturesque mimesis.*

In his works, Gilpin spends considerable time focusing on the pictorial strategies needed to render the rugged, irregular, and unspoiled surfaces of the stereotypical picturesque landscape, conveniently dotted by old ruins and decaying castles, and featuring old and heavily marked faces. His practical recommendations feature two aesthetic principles that manifestly acknowledge the idealistic and selective constructedness of the picturesque artwork. First, pictorial representations have to maintain a single unity of character, or "*leading subject . . .* [by which] we mean what *characterizes the scene,*" and animated figures (*appendages*) must be subordinated to the character of the whole picture. Second, addressing the amateur painter in need of guidance, the author of the *Three Essays* suggests that his "intention in taking *views from nature, may either be to fix them in your own memory*—or to *convey, in some degree, your ideas to others.*" For Gilpin, who was also a skilled painter, the transformation of a painting from "adorned sketch" to exemplar of picturesque mimesis required sensibility, imaginative accommodation, and the power to interpret, not simply imitate, the outside world. "The imaginary-view, formed on a judicious selection, and arrangement of

the parts of nature," he argued, "has a better chance to make a good picture, than a view taken in the whole from any natural scene." In the latter composition "the *character* of it is seldom throughout preserved." In a most explicit defense of aesthetic autonomy, Gilpin acknowledged that the artist "conceives the *very truth itself* concerned in his *mode* of representing it."[76] Similarly, Price considered the picturesque "as a separate character" of the world, whose "roughness, and sudden variations" "might be represented with *good effect* in painting."[77] Even more skeptically, Knight posited that pictorial mimesis was a creative process of skillful invention (or separation) of visual qualities, and thus a process of abstraction in the service of effective characterization. In the second edition of his essay on landscape architecture, *The Landscape* (1794), Knight exhibited a skeptical reasoning closer to that of Berkeley and Hume. He held that such notions as beauty and the picturesque could not be viewed as primary qualities of objects. Instead, he described the picturesque as the visible quality of bodies, by which he meant the impressions that objects make on a subject and that unify the outside world under the beholder's viewing sensibility.[78] For him, landscape paintings highlighted a human perceptual ability that artists and competent connoisseurs possess to a higher degree than most individuals, and that is much more than a background to human activity.

These writers' exchanges taught and popularized the most modern lesson of the picturesque: to look at and see nature from an aesthetic perspective and, conversely, to invest art productions and experiences with geopolitical reflections about nature.[79] Picturesque "abstractions" or "characterizations," in fact, conveyed and naturalized familiar ideas about distant geographical and human worlds. Ultimately, in the eighteenth century, reading the landscape as a whole and not just as the sum of its particular units was both an aesthetic and a political endeavor. "In so far as the representation of panoramic prospects serves as an instantiation of the ability of the man of 'liberal mind' to abstract the general from the particular," as John Barrell has pointed out, "it was also understood to be an instantiation of his ability to abstract the true interests of humanity, the public interest, from the labyrinth of private interests which were imagined to be represented by mere unorganized detail."[80] This resonated quite well with Emerson's emphasis on the kinship between man and nature, one that transcended individual deeds

and titles: "there is a property in the horizon which no man has but he whose eye can integrate all the parts, that is, the poet."[81]

Embarked on as a way of looking at nature through painterly eyes and originally associated with the Grand Tour and Italian scenery, by the late nineteenth century the "picturesque mode," as Gilpin called it, had become a common currency carrying intense political implications. At a time when reproductions of Italian landscapes "were present in almost every English home of means or culture,"[82] the picturesque mode involved both the contemplation of past architectural monuments and neoclassical treasures and a most glaring dissociation from the laws of economic utility and progress. This entailed both aesthetic and political or moral consequences. Picturesque landscapes aestheticized human figures as appealing ornaments, but also as morally suspect, when not plainly dissolute, because they were usually shown resting. "In a moral view," Gilpin noted, "the industrious mechanic is a more pleasing object than the loitering peasant. But in a picturesque light," he added, "it is otherwise. The arts of industry are rejected; and even idleness, if I may so speak, adds dignity to a character." Writing about Rosa's works, he further argued, "the lazy cowherd resting on his pole; or the peasant lolling on a rock, may be allowed in the grandest scenes. . . . Figures in long, folding draperies; gypsies; banditti; and soldiers . . . mixing with the magnificence, wildness or horror of the place, . . . properly coalesce."[83]

Half a century before, Montesquieu had famously argued that different geographical locations and climates "make very different characters." "If we draw near the South," crossing the Alps, "we fancy ourselves entirely removed from the verge of morality; here the strongest passions are productive of all manner of crimes, each man endeavoring, let the means be what they will, to indulge his inordinate desires."[84] Through the lens of the picturesque, however, Italy could be a place not entirely inhospitable or disagreeable. In 1826, Anna Brownhill Jameson, an English writer and art historian of the Italian Renaissance, described modern Italians as a "dirty, demoralized, degraded, unprincipled race—centuries behind our thrice-blessed, prosperous, and comfort-loving nation in civilization and morals." Yet, a few dozen pages later, she tempered her judgment on contemporary social life by focusing on the aesthetic dimension of the landscape, which in Italy

had its unique, paradigmatic presence: "it meets us at every turn, in town and in country, at all times and seasons. . . . the commonest object of every-day life here becomes picturesque, and assumes from a thousand causes a certain character of poetical interest it cannot have elsewhere."[85] In the nineteenth century, the emblematic aesthetic, moral, and political attractiveness of Italian scenery, which had found in Britain a paradigmatic and influential synthesis, expanded its reach into the wider domains of Western popular entertainments and dovetailed with discourses of racial difference.

The emergence of the picturesque aesthetics in the late eighteenth century, I argue in this study, is central to the semiotics of racial representation. In a period in which, to refer to Foucault's master synthesis, "the profound kinship of language with the world was thus dissolved,"[86] signs were no longer perceived as coterminous with the world. Once their referential power was thoroughly challenged, their arbitrary and conventional status *as signs* took center stage. What emerged was an understanding that representations, including picturesque ones, related to their objects not through imitation, but through a selective deployment of similar and defining features. This process of characterization implies both an abstraction of existing traits and an employment of artful pictorial effects. A representation well characterized thus entertained a mimetic relationship with the original object not by mere replication, but by a display of similar and selected traits, resulting in a morphological similitude. An *ars combinatoria* of analysis and synthesis of single qualities provided the means to compare and distinguish between individual subjects and general (racial) types. Beginning in the nineteenth century, racial characterizations walked a fine line between a referential ideology of factual signification and an aesthetic one of effective, structured, and ultimately realistic experience.

The Picturesque Italian South as Transnational Commodity

THE COURSE OF EMPIRE

In the late nineteenth and early twentieth centuries, picturesque views of the Italian South changed from a rather elitist aesthetic into a far more popular and intermedial paradigm of national and racial representation. What sustained, naturalized, and popularized the picturesque was the convergence of social practices (such as tourism, whether actual or vicarious), visual productions (both pictorial and photographic), and scientific discourses (such as anthropology).

Resonating with emerging anthropological discourses about the stark socioeconomic variance of the South within the newly formed Italian state, cosmopolitan tourism and photography commodified and naturalized the picturesque landscapes and peoples of the Italian South into appealing exhibits of environmental and social primitivism. The matching of anthropology with visual culture enhanced a realist aesthetic of long-lasting impact. Enabling this dynamic was a network of intensely competing Italian and international image-makers—painters, engravers, photographers, and filmmakers—driven by national and cosmopolitan market concerns. Their widely circulating images of brigands, urchins, and lovers, as well as of the erupting Vesuvius and Mount Etna, expanded former cosmopolitan Grand Tourists into middle-class consumer-ethnographers.

The picturesque, however, was not the only style used to represent Italy. While carrying the most realistic significance, it remained in a dia-

lectical relationship with another, equally transnational and yet politi-
cally more forceful, aesthetic form. I shall refer to this style as classicism
or antiquarianism, for it identified ancient Rome and the Renaissance
as sites and moments of glorious political and military history, splendid
art, and architectural treasures. Many roads led to Rome. While early to
mid-nineteenth-century Italian intellectuals were busy translating the
ethnocentric ideal of a timeless Italian civilization into a political entity,
for more than a century Roman antiquity had been the political and
symbolic *lingua franca* of "new-emerging nations" which, as Benedict An-
derson aptly noted, "imagined themselves antique."[1] Classical Italy was
thus an international aesthetic and political currency which held great
exchange value among the most prominent nations of the day. The study
of ancient history and the classics informed their educational ethos.[2] In
this instance, the British and the American experiences are of particu-
lar significance both in and of themselves and for the Anglo-American
framework of this study.[3]

As the largest world empire and having described itself as Augustan
since the eighteenth century, Britain thought of itself as the only true heir
of ancient Rome. Whether for political or literary purposes, the British
tendency to reference the ancient past took the form of revivification. In
the preface to the immensely successful novel *The Last Days of Pompeii*
(1834), which early Italian cinema repeatedly adapted, statesman and nov-
elist Sir Edward Bulwer-Lytton wrote explicitly about the "art to revive."
He underscored his "keen desire to people once more those deserted
streets, to repair those graceful ruins, to reanimate the bones which were
yet spared to his survey; to traverse the gulf of eighteen centuries, and to
wake to a second existence—the City of the Dead!"[4] Not every nation
could perform this miracle of Lazarus. Victorian Britain's revitalization of
the Mediterranean South was also part of a larger material, cultural, and
racially charged appropriation enacted amidst a fascination with deca-
dence, ruins, and death.[5] The British fondness for the picturesque mode
in painting, landscaping, and aesthetic theory was the consequential flip
side of Britain's own teleological self-appointment as interpreter and re-
storer of Roman imperial excellence. In the name of such self-ascription,
Britain's territorial conquests were dubbed an *Imperium Britannicum*.

Toward the end of the century, the United States assumed the man-
tle of Old World empire through a "transfer of rule" (*translatio imperii*),

as emphasis shifted from westward expansion toward overseas colonies, most effectively and symbolically through the Spanish-American War (1898), Theodore Roosevelt's presidency, and a vast domestic cultural halo (comprising such things as World's Fairs and Buffalo Bill's Wild West Shows).[6] Meanwhile paintings, prints, and literary texts were not just illustrating George Berkeley's famous line "Westward the course of empire takes its way" (1752) with contemporary images and narratives of territorial conquests. They were also transfiguring it through the historical epic format that granted imperial cachet under the guise of a celebratory and religious universalism. Most notable examples were *Ben Hur: A Tale of the Christ* (1880), written by the American statesman and novelist Lew Wallace and adapted for the screen as early as 1907, and D. W. Griffith's *Intolerance* (1916), which, in seeking artistic and cultural self-legitimization, emulated the set designs of Italian epics and even hired some of their gifted technicians.[7] As chapters 3 and 4 will show, the impressive success of the picturesque aesthetic in the U.S. was inextricably linked to a Gibbonian fascination with "the course of empire." This expression refers to Thomas Cole's famous series of paintings, which, produced between 1834 and 1836, warned about the heights of imperial splendor and the lows of its ensuing decline. The British-born Cole was the founder and leader of the Hudson River school that, in its concern for realistic portrayal of American landscape and wilderness, was instrumental in turning the picturesque into "the first American aesthetic."[8]

Back in Italy, the association of antiquarian erudition and nationalism still inspired the political rhetoric and iconography that had accompanied the movement toward national unification and become "the dominant theme for the Italian élites' process of self-representation."[9] After 1861, as these educated classes filled the ranks of the new state's military, bureaucratic, cultural, and political leadership, the culture of the state gained a sanctioned officialdom. Their privileged involvement in the new media of photography and film led to the promotion of a national visual poetics that both romanticized and naturalized, for Italian and foreign consumers, the undying excellence of Italy's historical, cultural, and artistic civilization.[10] In cinematic terms, the most obvious outcome of this process was the emergence of the historical film genre, which found in Italy its most artistically ambitious producers. The ancient history of Rome and the recent events of the Risorgimento were

adopted by Italy's aristocratic producers to articulate and communicate ideas of national and racial identity. At a time when Rome was becoming the favorite synecdoche of Italian nationalist culture and at a time, too, of international fascination with Roman antiquity, *Romanitas* was an irresistible visual and dramaturgic opportunity. It was not by chance that the main political thinker of the Risorgimento, Giuseppe Mazzini, had envisioned national unification as the coming of a "Third Rome"—as, incidentally, did Mussolini a few decades later.

While the culture of the new state looked to the past for political and international sanction, the present-day realities of a Southern Italian socioeconomic difference inspired large-scale anthropological theorizations of a dramatic internal dissonance. Europe, it was all too often concluded, ended somewhere to the south of Rome. By replicating and furthering the rhetoric of international travel literature and picturesque imagery, Italian national culture looked at the Southern regions with a mixture of distress and fascination. Aware of the national and international appeal of narratives and images of Southern Italian backwardness and primitivism, local writers, playwrights, artists, musicians, and filmmakers turned social and anthropological prejudices into a compelling aesthetic resource. The Neapolitan and Sicilian publishing, theatre, music, and film businesses skillfully adopted and reworked (through ironic and often subversive appropriations) the same picturesque poetics of passionate love stories, betrayal, and brigandism to formulate a distinct poetics of sensationalist realism. It was as if Southern Italians too had signed up for a Grand Tour of Italy's volcanoes. I will refer to this aesthetic mode as Southernism. Attuned to the cosmopolitan and intermedial fascination with the picturesque, a Southernist aesthetic traveled, like its dialectically opposed *Romanitas,* across geographical borders and media forms. As we shall see in chapter 7, it eventually found a most fertile terrain of re-actualization in the small-time vaudeville houses and movie theatres of the Lower East Side, where it matched American nativist prejudices with performances of vernacular authenticity.

PHOTOGRAPHING THE *BAEDEKER*

In the mid-nineteenth century, processes of democratization and institutionalization turned the elitist Grand Tour into a more socially inclusive

form of tourism. Travelers were no longer solely noble men and women wishing to further their education and erudition, complete a pilgrimage to Rome, or spend the winter in a mild climate. They also included curious and prosperous members of the bourgeoisie who avidly sought reputable leisure pursuits and status and found more and better means of transportation (e.g., railways) to reach their destinations.

Tourism required organizing institutions. The publication of John Murray's and Karl Baedeker's detailed travel handbooks, beginning respectively in 1836 and 1839, and the organized tours arranged by Thomas Cook since 1841 indexed a capitalistic organization of mass travel, at once highly facilitated and bureaucraticized.[11] The popular new guides' efficient laying out of "beaten tracks" meant the standardization of both "direct" experiences and subsequent reports.[12] Tourism welcomed Italy's national unification as its aesthetic destiny, for it enhanced the codification (and fetishizing) of views of its landscape and populations. Comparable beaten tracks were also noticeable in the visual continuities between old painterly traditions, new mass-produced prints and, later, daguerreotypes, photographic repertoires, and tourist postcards, which added an evidentiary surplus of visual accuracy and ethnographic realism.[13]

The aesthetic of the Grand Tour provided the common international currency that largely defined photographic representations' subject matter, style, and mass marketability. The relationships between Italian and foreign photographers reproduced the web of collaborations and competition that in the previous centuries had characterized the production of and commerce in artworks about Italy.[14] Such a transnational network of commercial and artistic interests was instrumental to the success of Italy's most prominent and influential atelier, the Fratelli Alinari of the Florentine brothers Leopoldo and Giuseppe Alinari. For decades, the cosmopolitan reputation of the Alinari firm as "Italians' visual dictionary" rested on the superior quality of their reproductions of Italy's historical monuments, urban views, and artworks.[15] Cultural and art historians have recently begun to recognize that the Alinaris' aesthetic and ideological contribution was indebted to seventeenth- and eighteenth-century painterly traditions and subsequent graphic reproductions, including picturesque ones.[16]

The Alinaris were innovators who transformed traditions from within. They renewed and furthered the rich painterly practices of both

architectural view painting and *paysage classique,* although they clearly favored the former.[17] While scouting Northern Italian cities with the aid of foreign tourist handbooks, they engaged with the contemporary European use of photography to document iconic sites of European civilization in the manner of the *Excursions daguerriennes* (1840–43), a collection of over a hundred images of Grand Tour destinations. They also studied John Ruskin's daguerreotypes and the work of the international artists who, as members of the "Roman School of photography," had since the 1840s and 1850s codified the photographic reproduction of known painterly views—from the Florentine panorama and monuments to Rome's Arch of Titus, Castle of St. Angelo, and Forum.[18] In so doing, the Alinaris gradually reproduced the nation-building and nation-preserving task of the *Mission héliographique* of 1851, a most influential (and jingoistic) patrimonial survey sponsored by the French Commission des monuments historique.[19]

The Alinaris' series operated according to complex and highly formatted narratives, halfway between those of a tourist guidebook and an art history manual. Their catalogs usually began with panoramic views of a city or landscape shot from a distance, followed by multishot renderings of the most important monuments of the area, and concluded with the most remarkable municipal artworks. Through their renowned use of glass-plate negatives and albumen prints, which soon took on connotations of historical nostalgia, the Alinaris contributed to the codification of a timeless urban and natural iconography. Their work sought to capture the endurance of Italian civilization just as public works projects were in the midst of demolishing medieval walls and shabby residential districts to make space for larger avenues and railway infrastructure. More consistently than other photographic ateliers, the Alinaris' photographic albums of Italian landmarks, mostly located in Tuscany, Venice, and Rome, informed the growth of archaeology and art history as scientific disciplines and standardized habits of viewing, reproducing, and remembering images of Italian art, cities, and scenery. For decades most images of Italian works appearing in scholarly monographs, art periodicals, or illustrated textbooks, or even in the guidebooks of the Touring Club, were likely to be Alinari reproductions.[20] The most profitable genre of early Italian cinema, the historical film, whether set in ancient Rome or the Renaissance, was deeply indebted to the same encyclopedia of the

2.1. *Colosseum, Meta Sudans, and, on the Right, the Arch of Constantine,* original albumen print, 1890. Used by permission of the Alinari Archives (Florence, Italy).

nation's architectural patrimony that the Alinari were selling at home and abroad according to the unconcealed principle that there was "no place like Rome."[21]

One of the most recognizable icons that preceded, was included among, and exceeded the Alinari reproductions was the Colosseum. Celebrated renderings of this iconic Roman monument in ruins figured in Jan Gossart's Renaissance drawings, Piranesi's eighteenth-century etchings (fig. 1.3), and Sigismond Himely's nineteenth-century aquatints. The photographers variously affiliated with the Roman school of photography were quite familiar with these painterly models and their accompanying viewing perspective. Within a short period of time, several photographers manufactured very similar images of the Colosseum. They included James Anderson (1855), Robert Macpherson (1855), Giorgio Sommer (ca. 1857–62), Gioacchino Altobelli (1866), and

the Alinari brothers (ca. 1890; fig. 2.1). Similarly, ambitious producers and filmmakers who specialized in Italian historical epics often chose the famous Circus Maximus (or, actually, its reconstructed interior arena) for scenes of duels and triumphs, as in the 1913 blockbuster epics *Quo Vadis?* and *Spartacus.*[22] Painter-director Enrico Guazzoni, director of *Quo Vadis?*, even stopped the continuity of an action scene to inter-polate a tableau of the victorious gladiator stepping over his pleading adversary (fig. 7.4). The scene was directly drawn from another popular painterly reference—Jean-Léon Gérôme's *Pollice Verso* (1872)—which at the time was being circulated widely in prints, illustrations, and post-ers of sword-and-sandals spectacles.[23] Never mere formal practices, these cosmopolitan and intermedial references evoked the cultural and political domain of *Romanitas,* sustained the historical realism of the cinematic representations, and inspired a sense that "Roman civiliza-tion" was being renewed—either literally, in Italy, or figuratively, in the West.

If the style of Romanitas and historical epics relied on the embalm-ing of time, the rendering of its inexorable passing defined the pictur-esque mode. Picturesque photographs of the South of Italy replicated the geographically dependent formal and ideological variations of view paintings. The further south one traveled, the more hegemonic the pic-turesque style became, to the point that the Alinaris had to abandon their splendidly antiquarian style and adopt the cosmopolitan photographic paradigm of the picturesque.[24] The photographic commodification of the South of Italy was, in fact, the product of the aesthetic commonality between the artistic and cultural élites of Naples, Catania, and Palermo and the foreign professionals who had resided in the same centers since shortly before the national unification of 1861. Differences in background did not keep them from sharing a fascination with the picturesque. When photography first appeared in Naples in the mid- to late 1840s, the earliest and most elitist periodicals dealing with the medium had such revealing titles as *Omnibus pittoresco* (Picturesque Compilation), *Poliorama pittoresco* (Picturesque Polyorama), and even *Salvator Rosa.*[25] In the 1850s and 1860s, when the picturesque constituted the dominant frame of visual reference, photographers and merchants, whether local or foreign-born, were selling scores of portraits of captured brigands and views of Vesuvius, Pompeii, and the Neapolitan bay.[26]

The inception of photography did not imply the obsolescence of painterly forms. On the contrary, the two visual practices exchanged aesthetic styles, themes, and audiences, while being in constant dialogue with national and international influences. By the 1860s photography in Naples had become a poetic and commercial reference for the city's emerging painters, who employed the new medium to enhance their paintings' truth effects and to make and sell copies of their works. In turn, their best-selling genres of landscape and street views affected photography's own compositions and subjects. Notable for its mediated absorption of French realism and the exoticism of Corot, Courbet, and Gérôme was the Portici school, a local group of painters of national renown who were versed in naturalizing and exoticizing *plein air* views of plebeian hardship, delinquency, and sensuality, as well as of natural adversity (e.g., local effects of Vesuvius's eruptions or earthquakes).[27] They did so in a dialectical relationship with scores of graphic artists and photographers, from Naples and elsewhere, including the Alinari brothers, with whom they authored and broadcast a mode of looking at, imagining, and promoting Southern landscapes and figures.[28]

In poetic partnership with Italian painters, a legion of foreign photographers based in Naples and Sicily were particularly influential in the realist articulation of the Southern Italian picturesque. Armed with an artistic background, many had come to Naples to cultivate interests in archaeology or painting, as was the case with Claude Victoire Grillet and Gustave Eugène Chaffouirier. Soon, however, without losing artistic sensibility, their work slanted toward tourism or photojournalism, as was the case, respectively, with Giorgio Conrad from Switzerland and Alphonse Bernoud from France.[29] The most successful and influential among them was Giorgio Sommer (1834–1914), a prolific German photographer who had been active in Naples since the late 1850s. Sommer was gifted with exceptional business skills and was very familiar with the works of Goethe and Burckhardt.[30] His photographs included characteristic landscape views (the Neapolitan bay, the ancient ruins of Pompeii, and Sicily's archaeological sites), images of the repression of brigands, *presepi* or sketches of local customs, and reproductions of famous paintings and sculptures. Among his images of the erupting Vesuvius, made from the 1860s to the 1880s, a series of photographs shot on 26 April 1872 at half-hour intervals became legendary and sold widely in commercial and scientific markets.

2.2. Giorgio Sommer, *Panorama with Pine*, ca. 1867–73. Courtesy of the Dietmar Siegert Collection (Munich, Germany).

What played a role in Sommer's capacity to further crystallize certain aspects of the Neapolitan physical environment into visual *topoi* was, as Miraglia has noted, "his double role as bourgeois and foreigner," which enabled him "to distill to its maximum extent the two opposite eighteenth-century tendencies of picturesque and documentary view."[31] His photographs of Naples, which were taken from the heights of the Vomero hills, recalled the rich Italian tradition of topographical view painting. On the other hand, his stereotypical panoramas of the Neapolitan bay with the maritime pine in the foreground (fig. 2.2) overtly repeated the picturesque style and framing seen in drawings, engravings, and *gouaches* circulating since the publication of Sir William Hamilton's lavishly illustrated treatise about volcanoes, *Campi Phlegræi* (1776–79).[32] His mastering of such visual vocabulary enabled him to publish his works in national and international periodicals (including the *Philadelphia Photographer*), lavishly illustrated volumes of art history, numerous editions of the Baedeker guidebook and other tourist

2.3. Thomas Cole, *Mount Etna from Taormina,* oil on canvas, 1843. Used by permission of the Wadsworth Atheneum Museum of Art (Hartford, Connecticut).

guides, and thousands of postcards. Undoubtedly the technically gifted Sommer was a master of commercial networking and self-promotion. His success, however, also reveals the appeal of a hegemonic visual paradigm of Naples and Southern Italy in general that seamlessly matched tourist stereotypes with the interconnected local and international cultural industries of visual reproduction—even before the introduction of photoengraving.

The situation in Sicily was very much comparable. In the 1840s and 1850s, English, French, and German makers of calotypes and stereoscopic images, including Calvert Jones, George Bridge, Eugène Piot, and Jakob August Lorent, established their photographic ateliers in Palermo, Catania, and Messina. In the 1860s, the military campaigns led by the already famous Garibaldi brought to Sicily some of the most important personalities of the world of photography: Eugène Sevaistre (who captured the first-ever war images), Gustave Le Gray (who was traveling with Alexandre Dumas, *père*), Maxime Du Camp, Chaffouirier, and the ubiquitous Sommer.[33] Also notable were the contributions of a number of Sicilian photographers, from Giovanni Crupi and Tommaso

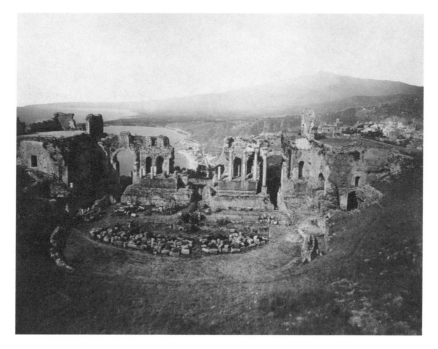

2.4. Giorgio Sommer, *The Greek Theatre in Taormina, Sicily, Italy,* albumen print, ca. 1875. Adoc-photos / Art Resource (New York).

Leone to the more famous Giuseppe Incorpora, whose landscape views and regional ethnography included images of Arab architecture, Greek temples, and picturesque views of Etna, the Sicilian coastline, and local populations.[34]

Evident in these representations are recurring ideas about the overwhelming force of nature, past historical excellence, and arrested anthropological development. Equally evident is their exact repetition of the viewpoint, perspective, and composition of a number of picturesque paintings and engravings of celebrated sites and sights. Painters Jean-Pierre-Louis-Laurent Hoüel, Franz Hegui, and Thomas Cole depicted the same vista of Mount Etna from the Greek Theater in 1776–79, 1820, and 1843 (fig. 2.3) respectively. Photographers Giorgio Sommer and Giovanni Crupi captured the same scenery and perspective in the years between 1873 and 1881 (fig. 2.4) and in 1890.[35] Drawings of the Cyclopes appeared in Saint-Non's *Voyage pittoresque* (1785; fig. 1.7) and Hoüel's

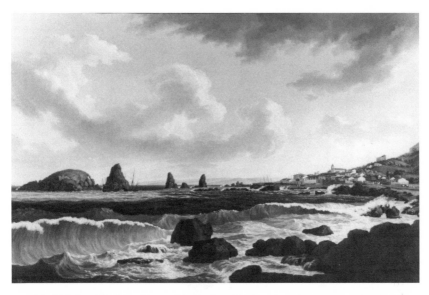

2.5. Jakob Philipp Hackert, *Views of the Rocks of Aci Trezza*, oil on canvas, 1793.
Courtesy of Soprintendenza per i Beni Architettonici ed il Paesaggio, Palazzo Reale
(Caserta, Italy), by kind concession of the Ministero per i Beni e le Attività Culturali
(Rome, Italy).

Voyage pittoresque des isles de Sicilie, de Malte et de Lipari (1782–87). In
1793 Jakob Philipp Hackert devoted a painting to the famous site (fig.
2.5), which the 1887 *Baedeker's Southern Italy* described as "most pictur-
esque."[36] Captured in the *novelle* of Catanese writer Giovanni Verga and
in his masterpiece *I Malavoglia* (1881; *The House by the Medlar Tree*), the
renowned rocks appeared in the 1880s and 1890s works of photographers
Vittorio Sella, Luigi Martinez, and Giuseppe Incorpora. That many Ital-
ian photographers shared the styles and perspectives employed by most
foreign image-makers downplays the relevance of national belonging. It
reveals instead the significance of a shared social status and a cultural
capital that crystallized the picturesque imagery of Southern Italy onto
a few *loci classici*.[37]

What was true for landscape views was also true for portraits and so-
cial scenes. Traditionally, the hegemonic Alinari production of commer-
cial portraits, generally made in a studio, privileged exceptional figures:
musicians, actors and actresses, intellectuals, and a few political figures of
high national interest (e.g., Garibaldi, Mazzini, the king and his family).

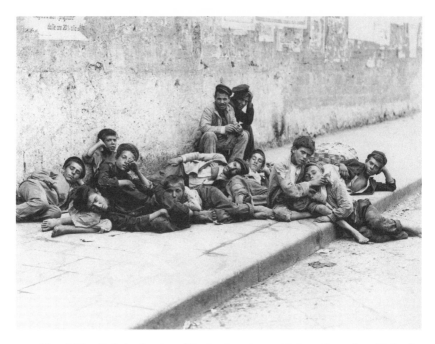

2.6. Alinari, *Napoli: Dolce far niente* (*Naples: Sweet Doing Nothing; Neapolitan Urchins*), modern print from original negative plate, ca. 1895. Used by permission of the Alinari Archives (Florence, Italy).

When they began producing instantaneous tableaux of life and customs among the Southern lower classes in the 1890s, they adopted different visual protocols. Since the 1860s and 1870s, Sommer and Bernoud had translated the popular pictorial tradition of Southern customs (*presepe*) and plebeian street scenes into widely circulating and imitated photographic commodities.[38] The key to their success was their style. Sommer's depictions of urchins and *lazzaroni* in exotic poses of atavistic primitivism "exalt[ed] to a highest degree the picturesque taste," which, as Miraglia has noted, "found in photography and in the context of a growing mass tourism its definitive expressive triumph."[39] The Alinari brothers readily adopted this partly touristic and partly ethnographic model for their famous *Napoli: Dolce far niente* (*Naples: Sweet Doing Nothing; Neapolitan Urchins*), ca. 1896 (fig. 2.6). Its visual and ideological similarity with the work of Jacob Riis, as we shall see in chapter 4, is apparent.

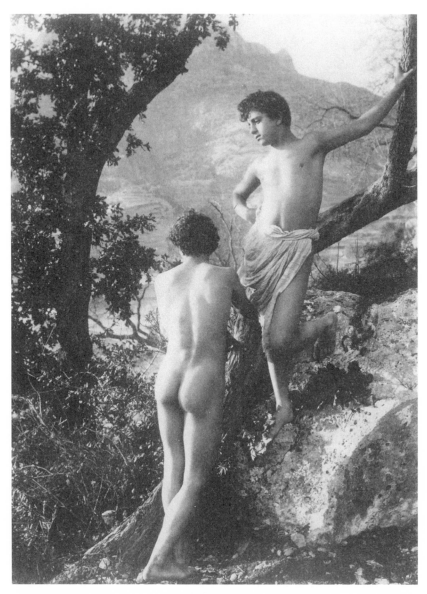

2.7. Wilhelm von Gloeden, *Coppia di giovani nudi di fronte e di spalle, n. 1189 (Pair of Naked Youths, no. 1189;* or *Two Boys)*, salt print, 1902. Used by permission of Erich Lessing / Art Resource (New York).

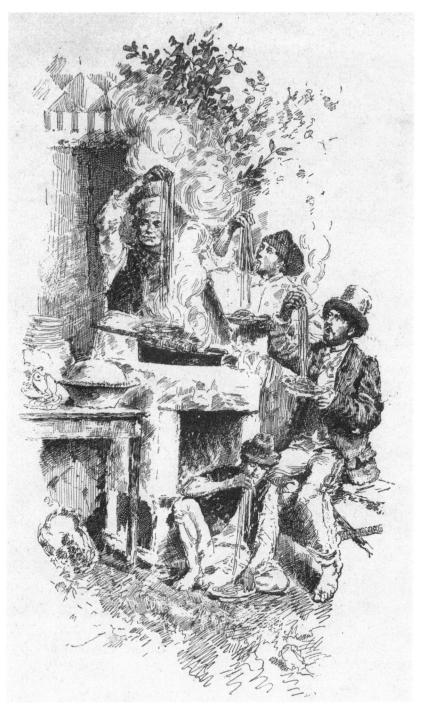

2.8. Raffaele Armenise, *I mangiatori di maccaroni* (*Macaroni Eaters*), lithograph, 1880–85, from Carlo del Balzo, *Napoli e i Napoletani: Opera illustrata da Armenise, Dalbono e Matania* (Milan: Treves, 1885; reprint, Rome: Edizioni dell'Ateneo, 1972), 80.

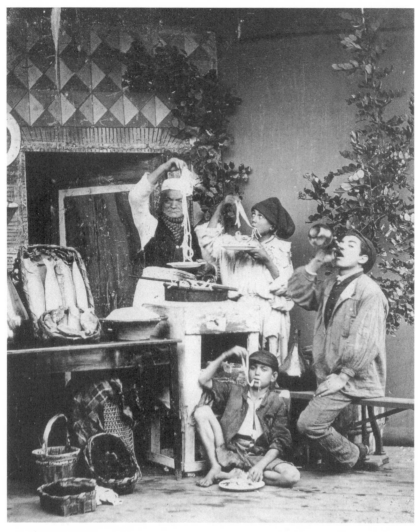

2.9. Giorgio Sommer, *Costume di Napoli: Mangiatori di maccheroni* (*Neapolitan Custom: Macaroni Eaters*), albumen print, 1860–70. Courtesy of the Dietmar Siegert Collection (Munich, Germany).

The intermedial pervasiveness of the picturesque form, whether applied to landscapes or social groups, challenges the teleological criticism associated with the inception of photography. On the one hand, photographs reproduced older pictorial subjects to incorporate a variety of clichéd painterly motifs and tableaux, and amounted to what Dean MacCannell has called, with reference to tourism, an "ethnography of

2.10. *Eating Macaroni in the Streets of Naples* (Edison, 1903). Courtesy of the Library of Congress, Motion Picture, Broadcasting, and Recorded Sound Division (Washington, D.C.).

modernity."[40] Wilhelm von Gloeden's photographs of young lads from Taormina, dressed up as ephebic figures to sustain a "homoerotically arcadian imagery," exemplified this style (fig. 2.7).[41] Yet the opposite also occurred. Trendy collections of engravings and lithographs, such as Carlo Del Balzo's *Napoli e i napoletani* (1885), reproduced earlier, popular photographs of ethnographic scenes. Working in the 1880s for Del Balzo, the artist Raffaele Armenise drew the celebrated image of "macaroni eaters" by copying Sommer's famous studio photograph, made between 1860 and 1870 (figs. 2.8 and 2.9).[42] Participating in what Martin Meisel has described as the century's pictorial dramaturgy, in which the narrative "unit is intransitive," comparable to "an achieved moment of stasis," the tableau clearly had a cosmopolitan circulation.[43] It also belonged to the American archive of images about Neapolitans: in Edison's *Eating Macaroni in the Streets of Naples* (1902) the cameraman's assistants conspicuously choreograph the local crowd into performing the famous folkloric gesture as if it were a spontaneous and communal routine (fig. 2.10).[44]

The 1890s transition from studio photographs to street scenes, made possible by the faster exposure time of silver bromide gelatin, added a further dimension of realism. *Plein air* views of local life shot on location resonated with the realist and socially engaged poetics that pervaded the wider contexts of journalism, literature, theatre, and popular culture and insisted on a novel proximity to the lives of the destitute classes. Abandoning the simple and joyful spontaneity of their first, neatly posed and well-lit studio subjects, Italian or Italianized bourgeois photographers entered the city's streets and dark alleys to capture authentic settings and scenes of misery. Their still carefully choreographed subjects, known as *dal vero,* walked a fine line between disturbing reportage of widespread wretchedness and ethnographic voyeurism. Even the Alinaris' 1890s urban views of Southern locations abandoned any emphasis on architectural significance to focus on the realistic display of local, plebeian life. Together with civic concerns, the same images relied on a longing for archaic and folkloric customs—an antimodernist nostalgia—made particularly compelling when paired with the many projects of urban renewal and sanitation that were destroying old Neapolitan neighborhoods. "Only on the brink of destruction," as Linda Nochlin has fittingly observed, "are customs, costumes and religious rituals of the dominated finally *seen* as picturesque."[45] Comparable scenes were being uncovered elsewhere. In 1877, John Thompson had published his *Street Life of London,* a landmark photographic exposé of the conditions of the poor, which replicated the Dickensian subjects of magic lantern shows.[46] Thompson's volume exerted a deep influence on the American social reportage of photographers Lewis Hine and Jacob Riis and, in turn, on American cinema's penchant for tenement melodramas.

Arguably the most emblematic icon for the representation of Southern Italy was the image of the fuming volcano, whether Vesuvius or Mount Etna. In Naples, Calabria, and Northeastern Sicily, telluric and volcanic activities had never been exceptional events: natural scientists, travelers, and artists had recorded and represented them for at least three centuries. At the turn of the twentieth century, however, the occurrence of several calamities, which included the 1908 earthquake in Messina and the exceptionally intense eruptions of Vesuvius (1906) and Mount Etna (1909), in addition to the enhanced possibilities of photographic illustration and cinematic reproduction, turned Southern Italy into a

favorite media subject. Photographers and filmmakers from all over the globe hurried to the scene and relayed worldwide the all-too-familiar image of the South as a charming but unredeemable land of misery and desolation. Even before their arrival, however, news organizations had at their disposal a rich archive of ready-made images.

For instance, the earthquake that on the dawn of 28 December 1908 struck Messina and part of Southern Calabria was considered the Western world's deadliest seismic event, with a death toll of about a hundred thousand. Evoking familiar visual precedents of earlier or even ancient disasters in the same area, the event became a national and international news sensation.[47] When two days later the *New York Times* published a front-page article on the disaster, it illustrated it with a stereograph of a fuming Mount Etna that one of America's major stereo view firms, Underwood & Underwood, had made three years earlier.[48] Meanwhile, all the major Italian film companies (Ambrosio, Itala, Cines, Saffi-Comerio, and the Milanese Croce & Co.), in addition to several American ones, including Vitagraph, Kleine-Gaumont, and Lubin, sent operators on location to shoot news footage.[49] Their films circulated widely. When Mount Etna erupted again in September 1909, the "catastrophic film" had become a successful genre, concocting a form of "pathetic realism" (from pathos) that was not limited to films *dal vero,* but that included such tear-jerking melodramas of loss and romantic rescue as *Dalla pietà all'amore* (Pity and Love, Saffi-Comerio, 1909) and *L'orfanella di Messina* (The Orphan of Messina, Ambrosio, 1909).[50] Incorporating newsreel footage of the eruptions, their success outside Sicily, in Italy, Europe, and the U.S., confirmed the idea of an Italian region that remained isolated, underdeveloped, and somewhat ill-fated, and for that reason provided an appropriate setting for realistic melodramas of pathos and much-needed redemption.[51]

The American coverage of the disaster of 1908 is also interesting for the kind of cultural referencing it immediately indulged in. Less than a week after the catastrophe of Messina, the *New York Times* published a very self-conscious one-page piece that reflected on the parallels between the recent Sicilian disaster and the mythical dangers that Ulysses faced during his journey home through Sicily when he overcame the menace of the sirens, Scylla and Charybdis, and the Cyclops Polyphemus (fig. 2.11). Titled "Classical Allusions to Stricken Italy," the article resembled an eighteenth-century diary entry and abounded with correlations be-

2.11. *New York Times Sunday Magazine*, 3 January 1909, SM2.

tween locations' names and Homeric events. It had, though, something that was absent from a Goethean travel book: it was illustrated with photographs. One of them, located on the top left corner and devoted to the bleak remnants of the Temple of Castor and Pollux in Agrigento, is familiar. It reproduces, albeit without acknowledgment, the exact shooting angle and proportion of a famous and most picturesque Sommer photograph, taken in 1886, that had become widely known.[52] For instance, for its 1913 company logo, the Catanese film company Etna Film placed the same image of the temple against the background of Mount Etna—a geographical impossibility.[53] Thus the same intermedial imagery framed photographic documentations, newspaper illustrations, and film marketing in a cosmopolitan circle of visual and literary citations, whether explicit or not.

The worldwide popularity of volcanoes, whether as subjects of recent news or as established tourist attractions, in fact, made them alluring signature features for ambitious historical epics. The eruptions of Vesuvius

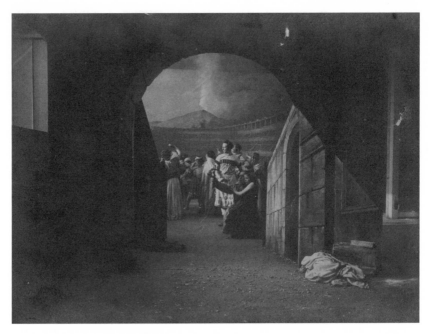

2.12. The eruption of Vesuvius in *The Last Days of Pompeii* (Ambrosio, 1908). Used by permission of the Museo Nazionale del Cinema (Turin, Italy).

and Mount Etna in, respectively, *The Last Days of Pompeii* (Ambrosio, 1908 and 1913) and *Cabiria* (Itala Film, 1914) were such crucial visual and narrative moments that their artful production monopolized the films' publicity and critical reception. These spectacular eruptions performed their exoticism according to both historical and geographic scripts. As notable emblems of a revered antiquity, they conveyed a universal notion of pastness and decadence that impinged upon the menace of an undomesticated nature—a hazard largely unknown to modern Western nations. As natural phenomena recognizably located in the South of Italy, volcanoes were geographic markers of a picturesque and even explosive Southernness that the volume of *actualités* and fiction films centered on these tragic fatalities, particularly the historical epics beginning with *The Last Days of Pompeii* (1908), further augmented (fig. 2.12). This geopolitically loaded visual currency carried, as we shall see in chapter 7, a remarkable ideological significance in America's hegemonic and diasporic culture, for it affected how Italian communities living in the U.S. articulated and experienced their Southernness.

SOUTHERNISM

What barbarism! Some Italy! This is Affrica [*sic*]: the Bedouins are the flower of civilized virtues compared to these peasants.

LETTER FROM THE PIEDMONT ENVOY IN THE
SOUTH TO COUNT CAVOUR, 27 OCTOBER 1860

So far we have discussed how the transnational paradigm of the picturesque affected several media representations of Southern Italian landscapes and populations, and how the same paradigm included the contributions of a number of Italian image-makers. Yet how did Italian culture as a whole react to, and make use of, this visual and ideological archive of charming backwardness and racial dissonance? This is a relevant question in and of itself, pertaining to the ways in which a nation processes widely negative perceptions of a large portion of its territory. But it is also relevant because Italy's anthropology and aesthetics influenced in turn the powerful transnational paradigm of the Southern Italian picturesque that both hegemonic Anglo-Saxon constituencies and diasporic Italian American ones embraced as a visual and literary lexicon of racial difference.

The way in which newly unified Italy processed the "discovery of the South" (but also its reinvention) was painfully educational. For a political and cultural regime that, after achieving territorial unification, wished to see the rest of Europe as its peers, the existence of a problematic "internal other" constituted a major challenge. Although a complete removal of the troublesome South was impracticable, a convenient solution was disavowal. From as early as 1860, a series of political, socioeconomic, and ethnographic accounts referred to the new Italian nation through a highly ideologized and reifying dualism: North versus South. The North embodied the normative realization of what Italy had to become, with efficient administration, economic development, and a modern citizenry. Regarded as backward and primitive, the South instead represented the new nation's major disappointment, and thus its radical alterity. Although the reality on the ground was much more complicated than what these reifications indicate, the ideology of the "objective" dichotomy of North vs. South remained outstandingly resilient.[54] This

stark dichotomy structured many reports that emphasized the difficulties of implementing administrative or economic policies in the former Kingdom or protested against them as impositions. Together with later full-fledged analyses, these reports were at the origin of the tradition of *meridionalismo* (from *Meridione,* or Southern Italy), the set of allegedly scientific discourses on, and policymaking decisions about, Southern difference.[55]

Meridionalismo had different facets. Its hegemonic stance postulated the dualism of civilized North versus feudal South as the cause of differentiated policies, particularly economic ones—agrarian development in the South and industrial progress in the North. In its less antagonistic formulation, *meridionalismo* saw the same dualism as an effect of an authoritarian national annexation, a royal conquest, which had generated political corruption and inefficiency and whose disastrous economic and tax policies had ultimately caused the mass migrations of the 1880s and 1890s. Over time, mainstream *meridionalismo* turned from a form of scientific inquiry into a broadly conceived social and cultural assessment. As such, it dramatically expanded its discursive platitude. The "Southern question," to use Gramsci's famous expression, became much more than an estimation of the South's distance from European-like models of industrial and economic development.[56] Frustration at the South's perceived economic immobility and sociocultural dissonance inspired racialized judgments of Southern psychology and anthropology. Allegedly, the South could not improve itself or its economy (or allow the North to do so) because it was a land of "unredeemable subjects," inherently inferior and largely ruled by their own superstitions, emotions, and ignorance. Social Darwinism's racial explanation of Southern misery obscured the crucial fact that, as Gramsci put it, Italy's "unity had not been created on a basis of equality."[57]

The discursive framework of anthropology contributed to a systematic and influential inclusion of racial difference in Italian social sciences and humanities, and originated what I earlier referred to as Southernism. As a multidisciplinary expansion of the policy-driven approach of *meridionalismo,* Southernism identifies a cluster of essentialist value judgments dialogically juxtaposing Southern Italian landscapes and populations against ideas of modern nationhood and citizenship. It operates through an overlapping combination of anthropological, aesthetic, and touris-

tic assessments. Although centuries of travel reports and related visual and narrative characterizations, most notably the picturesque mode, informed this "imaginative geography" of Italy's South, in a narrower and more cogent sense Southernism is formulated discursively within the new political and cultural scene of the Italian state.

Because of its links to the Gramscian "Southern question," Southernism could be profitably compared to Said's Orientalism.[58] What enables their methodological connection is the linkage between geography and culture—which Said acknowledged, building on the work of Gramsci. Yet there are two important differences. First, while Orientalism examines how the West viewed and constructed the Orient as an *external* other, Southernism examines how Italy (and thus the West) viewed and constructed the South as an *internal* Other.[59] Despite charges of a colonial annexation,[60] the South emerged as a liminal space at the borders of Italy's hegemonic identity representations; a despised alter ego with a different racial make-up, religious customs, and emotional regimes, yet still within the nation's cultural geography.[61] Second, while Said's Orientalism does not encompass how the "Orient" reacted to its exoticizing objectification, my understanding of Southernism includes the process by which Southern Italian culture elaborated racist prejudices within its literary, theatrical, and visual productions, both in Italy and among immigrant communities. The name of the receptive process that I set out to describe, briefly here and in more detail in chapter 7, is "mimesis." As a highly complex and dialectical cultural dynamic, mimesis entailed imitative mechanisms of consensus, acceptance, and internalization, but also mocking and subversive mimicry that, as a reaction against hostile Southernist prejudices, pervaded both higher and popular dimensions of Southern culture. Southernist mimesis enhanced reciprocal communication between North and South, bridged the chasm between highbrow and lowbrow realms of cultural production and reception, and transfigured hostile pronouncements of racial dissonance into political and aesthetic practices of identity.[62]

Southernism encompassed a variety of intermedial arrangements and poetic forms, but its most recurring outcome was a quasi-ethnographic, and thus realistic, depiction of life among Southern Italian common people, whether filtered through literary naturalism (or *verismo*, as it was known in Italy), *dal vero* painting, or still or moving pictures. Informed

by the literary, stage, and musical productions stemming from the established (yet also consolidating) centers of vernacular culture of Naples and Sicily, Southernism was a national aesthetic language that operated on the basis of an alleged closeness to the destitute classes that granted it the semblance of anthropological authenticity. While merging aesthetics and anthropology, Southernist representations, particularly when playing the melodramatic chords of passion and excess, combined the long-standing visual delectation of the picturesque with contemporary theories of anthropological difference. Turn-of-the-twentieth-century Italian anthropology was, in this regard, quite influential. Not only did it reify Southern difference in racial terms, but, promptly translated into French, German, and English, it also traveled to the desks of American eugenicists and social Darwinists, who were eager to assimilate it into their own nativist rhetoric.

Italian anthropology is linked to the crucial figure of Verona-born physician and criminologist Cesare Lombroso (1835–1909), founder of the discipline of criminal anthropology and the original proponent of a theory of atavism—the recurrence in an organism of traits typical of an ancestral form.[63] By revamping the old tradition of phrenology and applying Darwin's monogenism to human societies, Lombroso explained social diversity as the result of inherited (and measurable) outer physical characteristics, which, more than any environmental factor, in his view defined individuals' social, psychological, and intellectual profiles. Despite having initially been oriented toward environmental influences, Lombroso believed that certain human groups, from criminals and anarchists to women, Jews, and Southern Italians, displayed outer signs of their primitive and inferior stage of evolutionary development.

On the pressing question of criminality in Southern Italy, Lombroso collapsed any difference between the political phenomenon of brigandism and the criminal one of the Mafia and the Camorra: for him they were both expressions of ancient barbaric tendencies, whose prevalence in the region was "fundamentally due to African and Oriental elements."[64] His racial determinism influenced the younger Sicilian anthropologists Alfredo Niceforo and Giuseppe Sergi, whose work also had wide circulation.[65] Niceforo and Sergi further reified Southerners' racial incompatibility with normative Europeans by recourse to either a gender or a phrenological argument. Niceforo described Neapolitans

as "a female people," comparable to "an hysterical woman." Sergi argued that Southern Italians' "cranio-facial skeletal characters" evidenced their being "Southern Euroafricans" and thus not only biologically different from Northern Italians ("Northern Euroafricans")—whom he considered their fellow Mediterraneans—but utterly incompatible with Northern Europeans, whom he designated as Aryans or Euroasians.[66] Together with Lombroso's influential prose, these "scientific" accounts naturalized stereotypical narratives about Southerners, insisting on Southerners' temperamental excesses, "Arabic delinquency," and general lack of the virtue of "self-government" (Niceforo used the English term).[67] These narratives, which antiracist writer and politician Napoleone Colajanni described as "anthropological *novels*" and Gramsci as "Southernist *fictional literature*," informed articles, sketches, stories, novels, books of impressions, and memoirs.[68] In particular, they played a crucial role in complementing the visualization of Southern types that Italian anthropologists were endeavoring to fix on photographic paper.

Although Lombroso never took a single picture for his archive, he organized his massive photographic collection according to rubrics and taxonomies (juridical, psychiatric, medical, racial, and social) in order to visualize not just individuals, but also typologies of atavistic abnormality and deviance. Organizing them according to comparisons with skulls and Lavater-inspired physiognomies, Lombroso collected images of Sardinian anthropological types, chiefs of Camorra bands, and Southern brigands in a special "album of criminals" (*album dei delinquenti*) (fig. 2.13). Yet his attempt to reconcile anatomical morphology with moral and racial semiotics was much less conclusive and persuasive than the verbal characterizations that the social and psychological sciences provided in their profiles of typical criminal personalities and behavior. Because of its indexicality—not in spite of it—photography created more problems than it solved.

Lombroso's work participated in a widespread effort to grant scientific effectiveness to the photographic medium. The problem was that, with their uneven particularities, photographic portraits in general were both excessive and deficient in their supply of visual information.[69] Photographs, as both police record-keepers and eugenicists were realizing, required a narrative integration to overcome what Talbot famously re-

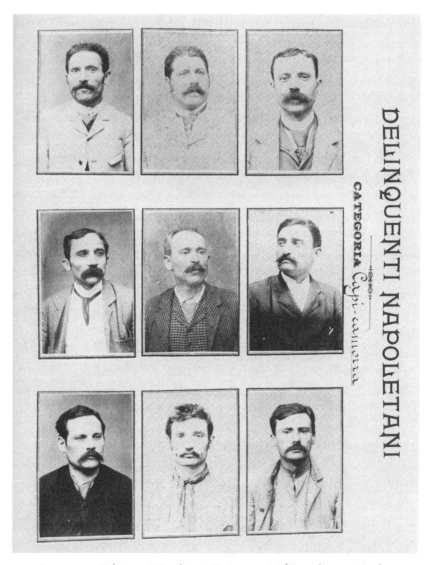

2.13. Anonymous, *Delinquenti Napoletani: Capi camorristi* (Neapolitan criminals: Camorra bosses), albumen print, undated. Used by permission of the Museum of Criminal Anthropology "C. Lombroso" (Turin, Italy).

ferred to as their "mute testimony."[70] This was the challenge faced by Francis Galton's ambitious, yet ultimately unsuccessful, method of eugenic taxonomy known as the "composite portrait" and by American racial photography in general.[71] Engaged in physiognomy's old obsession with drawing and comparing typologies, photography's own taxonomic

endeavors were actually impaired by the medium's "extremely individu-
alizing process," as Tom Gunning put it. "No one photograph could fin-
ger the guilty part," Gunning concluded, with reference to the work of
Alan Sekula; "the act of recognition relies on comparison . . . within a [sic]
vast photographic archives, cross indexed by system of classification."[72]
The solution was the realization that a system of self-evident classifica-
tion did not have to be solely visual.

Metric photography could be of better use when integrated with
sociological and ecological accounts—that is, with eloquent Southernist
descriptions. Lombroso himself had contributed to this convergence of
scientific and literary typecasting through his lively prose, which seam-
lessly intertwined ethnographic research with literary types drawn from
famous novels and popular proverbs. His studies had become bestsellers
in Italy and abroad. If anthropology and social sciences learned from the
literary and visual habitus of characterization to draw coherent "racial
types," "scientific" notions about characters' racial inheritability became
features of literary, theatrical, and visual profiles. At the turn of the cen-
tury, Italian literature abounded with the morbid figures of the crimi-
nal, the immoral woman, and the artistic genius. It also often featured
intriguing alienists busy dealing with deviancy, neuroses, and maladies
that ultimately composed, in the words of Lombroso's chief cultural bi-
ographer, "a picturesque gallery of quasi-folklorist exempla that do not
lack references to ethnographic literature," to the point that a contem-
porary French critic described the Italian literature of 1897 as "scientific,
Nietzscheian, pre-Raphaelite, and criminological."[73] Even more effec-
tive in its epistemological synthesis of anthropology and aesthetics was
the Southern Italian intermedial poetics of ethnographic realism and
heightened melodrama, featuring Southern Italian characters who, as
in Emile Zola's fatalistic narratives, were afflicted by forms of personal
or racial degeneration.[74]

BRIGANDS, BANDITS, AND MAFIOSI

A most emblematic figure at the intersection of Southernist narratives
and historical events was that of the *brigante* (brigand), a figure par-
tially linked to the Italian state's ruinous administration of the South
and partially predating the formation of the state. Despite earlier prom-

ises of communal land allotment, the new Italian state did not initiate any serious reform, but increased the fiscal pressures on peasants and commoners to new extremes.[75] In the 1860s, the worsening of Southern populations' living conditions led to violent protests and insurgencies against what Southerners viewed as another illegitimate, yet unbearably oppressive, occupation. The counterresponse of the new Italian government was extraordinarily violent. The state executed hundreds of rebellious peasants, who had also occupied communal, unexploited land, and declared war on the guerilla rebels known as *briganti,* who were attacking its soldiers, sabotaging its symbols of power, and disrupting inland commerce and transportation.[76] The next two decades saw mass migration from the South.

If the scale of the repressions was unprecedented, the figure of the defiant criminal hiding in the mountains was not. Here historical and geographic distinctions between *banditi* and *briganti* are required, although absolute differentiations are impossible. As common criminals, literally banished from their community (as the word indicates), *banditi* had populated Italy's roads and countryside for centuries. To the foreign visitor, *banditi* or *banditti* were romantic cultural icons. Featured since the seventeenth century in Western paintings of Italian landscapes—particularly in the atmospheric works of the "mischievous" Salvatore Rosa—*banditi* became leading characters in the literature of celebrated authors (e.g., Ann Radcliffe, Stendhal, Lord Byron) and famous travelers (e.g., Washington Irving and Norman Douglas).[77] *Briganti,* instead, were a more recent phenomenon and their actions had in general a more political significance. They owed the popularity of their name to the French regime that for a few years (1806–15) ruled the Southern Kingdom and that intended to delegitimize the pro-Bourbon actions of local bands of antigovernment lawbreakers. In the context of popular and collective revolts against oppressive economic measures, local populations welcomed brigands' crimes against soldiers and institutions as participating in the same fight.[78] The state's official culture did not recognize the desperate protest in such popular support for *briganti,* but instead condemned it as an expression of a Southern atavistic inclination toward violence and disorder.

Involving about a quarter of a million soldiers and policemen (*carabinieri*), two-fifths of the national military force, the state's all-out war

2.14. Unknown, posing *Brigantessa*, albumen print. Used by permission of the Comune di Roma, Archivio Fotografico Comunale (Rome, Italy).

against the antipatriotic *briganti* produced horrific results. Almost ten thousand Southern men and women died, while twenty thousand were exiled or imprisoned. The national media coverage of the war against the *briganti* was exceptionally callous and racist. Violent tales and cruel images of brigands gunned down or imprisoned flooded newspapers and magazines. Authentic photographic records, however, were also in-

sufficient for visualizing the brigand type. Actual portraits of captured or killed brigands standing against a prison wall could be easily alternated with images of male and female models dressed up for the part and posing in darkened studios or against picturesque backdrops (fig. 2.14). The nation's hegemonic public discourse relied only partially on the convergence between photographic exactitude and anthropological taxonomies to identify brigands as "barbarous criminals" of a backward and brutal nature.[79] When Biagio Miraglia, director of the Neapolitan Criminal Mental Hospital, published a phrenological report on a famous gang of brigands, his graphic rendering relied both on a widely circulating photograph of the gang and on available caricatures and narrative sketches. Superimposed on established anthropological types, the jarring physiognomic traits of one bearded brigand sustained the stereotype of a swarthy, primitive, and rebellious humanity, not limited to Southern criminals but extended to Southern populations in general.[80]

Southern populations, indeed, often hailed rebels as local heroes fighting against the repressive authority of the Piedmontese Kingdom, as was the case with the popular Calabrian brigand Musolino. Their fascination with *briganti* hinged on a notion of social disobedience and romantic uprising, famously captured in Eric Hobsbawm's classic *Primitive Rebels*, which inspired popular oppositional literature (both serious and popular), vernacular songs, and stage plays.[81] Like other scientific "problems" of Italy's South, the *brigantaggio* was also the subject of a series of scholarly inquiries, generally aimed at revealing the phenomenon's socioeconomic genealogy, but also engaged in rebuffing its frequent racializing explanations.[82]

Briganti and *banditi* ought not to be confused with *mafiosi*. Largely composed of rebellious peasants, *banditi* and *briganti* lived and thrived while hiding from authorities in the mountains and the countryside of continental Southern Italy. The Mafia, to use its Sicilian name, was a different social and criminal phenomenon—although absolute distinctions are unworkable. The term "Mafia" identified a number of criminal organizations that, in general, existed and operated through secret, yet colluding relationships with the official regime, not against it. In Sicily, Mafia organizations originated both within and outside the Palermo provinces; in Naples similar organizations were known as Camorra, in Calabria as 'Ndrangheta, and in Apulia as Sacra Corona Unita. Their

members could be peasants and farmers, but often belonged to higher social classes and had economic, cultural, and political access to local institutions. In situations of social unrest, Mafia associations mediated between, on the one side, governments and institutions, and, on the other, bandits, brigands, and rebellious local populations. This mediation consisted of providing "protection" and "patronage" for all—at a price. Depending on the location and circumstances, these relationships could easily reverse, with the Mafia either helping bandits and brigands evade capture or helping authorities to capture them.[83]

As a result of racial prejudices and because one of the most imaginative hypotheses concerning the origin of the word "mafia" traces it to Arabic, nineteenth-century accounts commonly spoke of the Mafia as an atavistic, centuries-old phenomenon.[84] The reality was quite different. The emergence of the Mafia was inherently linked to economic dynamics that originated in the previous century, when Sicilian lemons had become a high-quality export crop. In the early 1800s, from the ports of Messina, but particularly Palermo, hundreds of thousands of cases of lemons and oranges were reaching London and, after the 1830s, New York and New Orleans.[85] Citrus fruit gardens required large investments to prepare the land, terrace it, and protect it against thieves and the elements. "It was this combination of vulnerability and high profit," as John Dickie noted, "that created the perfect environment for the Mafia's protection rackets."[86] Based in Palermo, the Sicilian center of trade, commerce, and politics, the Mafia was thus originally involved in the business of protection and extortion around a modern commercial enterprise that had a major Atlantic reach. The post-1880s Sicilian migrations to New Orleans and New York enabled it to make international strategic connections and, eventually, contributed to its popularity in American culture.[87] In Italy, of course, the Mafia was already well known.

Despite its modern economic genealogy, the Mafia's notoriety was not due merely to its profitable expansion. In the early 1860s, the term *mafia* had acquired a large narrative and ideological currency in Italian culture thanks to an enormously successful two-part drama, *I mafiusi di la Vicaria* (The Beautiful People of Vicaria). Written by Giuseppe Rizzotto and Gaspare Mosca and staged for the first time in 1863 in Palermo, *I mafiusi* was set in 1854 in one of that city's prisons, the Vicaria, and it exposed the jargon, the violent actions, and the sinister culture

of local criminal gangs. Although the word *mafia* was never actually used in dialogue, the play added a criminal connotation to the term *mafiusu,* which in western Sicilian meant, more neutrally, "beautiful" and "trendy." Hailed now as "the start of modern Sicilian theatre," the Rizzotto-Mosca play was quickly staged all over Sicily and the South, and in Rome, Milan, and Turin. It appealed to regional and national audiences alike, all intrigued by the voyeuristic opportunity to gain access to the secret ways of the Mafia.[88] For decades, it remained a regular and eagerly anticipated production on both sides of the Atlantic, being performed several times a year for Southern Italian immigrants in New York and in South America.

The success of the play contributed to, and resonated with, popular assumptions about the Mafia, which stressed its primeval sectarianism, congenital secrecy, and primitive violence and which equated Sicilian crime with conditions of abject destitution. Contributing to this inaccurate perception were the press coverage of killings and public trials and both sensationalist and realist literature.[89] These views were so pervasive that they affected even the Italian government's social and economic policies in the South—despite the different conclusions of the inquiries it itself sponsored.[90]

Within the growing tourist-anthropological paradigm of Sicily as a land (and a people) existing outside history and civilization, literary and filmic narratives about the Mafia generally ignored the complicity of national and regional institutions with the Mafia's modern business dealings and their unmentionable complicity in the quashing of Southern rebellions. More convenient, instead, was the semantic and ideological slippage that equated and conflated the images of the Mafioso with that of the Southern brigand or *bandito,* already invested with connotations of atavistic violence. The numerous images of primitive and destitute brigands in Italian visual and literary culture far outweighed corresponding images of Mafiosi as successful businessmen or "entrepreneurs of violence," as Franchetti and Sonnino defined them. As icons of a general Southern backwardness and archaic brutality resisting the workings of the modern Italian state, *briganti* and *banditti* symbolized the South's dark resistance. They had to be defeated militarily, extirpated socially, studied as anthropological anachronisms, and exploited in racist and sensationalist narratives.[91] Unlike American cinema, which was fasci-

nated by the subject, Italian cinema devoted relatively few productions to Mafia or Camorra narratives. Although the pioneering Neapolitan filmmaker and producer Roberto Troncone began his career with the fiction film *La camorra* (1905), the topic of organized crime never became a hegemonic subject of silent Italian films—although it informed much sensationalist literature. The eruptions of either actual volcanoes or temperamental Neapolitan or Sicilian characters were much more attractive. The latter were linked to a Southern Italian dramatic tradition of instinctive, at times violent, but often romantic and picturesque characters that, for different reasons, local and national audiences alike found both familiar and captivating.

"ANTHROPOLOGICAL NOVELS" BETWEEN MIMESIS AND PRIMITIVISM

Beginning in the second half of the nineteenth century, such different Southern writers as Giovanni Verga, Luigi Capuana, Nino Martoglio, Luigi Pirandello, Salvatore Di Giacomo, Roberto Bracco, and Francesco Mastriani achieved national and international recognition for their literary, theatrical, and cinematic dramatizations by often relying on a combination of plebeian realism, picturesque landscapes, and Southernist primitivism. Their self-conscious melodramatization of the "Southern question" resulted in a regional poetics radically different from the antiquarian ideals of Italy's official culture, which relied on a classic poetic *gravitas* and the nation's glorious past history. Yet the emerging Southern *koinè*, or regional character, engaged in an intense dialogue with the nation's mainstream officialdom as it sustained spirited aesthetic discussions about the national significance of local vernaculars and primitive folklore.

In the country of "a thousand dialects," one crucial terrain of such poetic invention was language. The formation of the state and the national normativization of literary Tuscan did not erase Italy's linguistic polycentrism or reduce its widespread illiteracy. Instead, it made all dialects, including those that had a literary history, into spoken regional idioms.[92] The national normativization of literary Tuscan changed "the social and geographical diversity of the dialect," language historian Hermann Haller argued, as it "provided an innovative source for ex-

pressionism, vigorous irreverence, and transgression" by emphasizing dialect traditions as lyrical and comedic vehicles for grotesque realism, social protest, and licentious satires.[93] This perceptual change ran parallel to a paternalistic and archaeological attitude toward the culture of the common people that resulted, for instance, in the new disciplines of dialectology and folklore studies. The issue of a specific Neapolitan, Sicilian, or Calabrese identity was constantly associated with questions of language, poetic form, and social address: dialect versus Italian; sentimental melodrama versus historical drama; lowbrow versus highbrow culture. In these processes of vernacular self-positioning, Southern writers and intellectuals played a crucial role. Although by training or interest many of them were philologists, linguistic ethnographers, and even folklorists, they exerted a wide and public influence as editors, reporters, columnists, and *feuilletonists* for daily newspapers and periodicals. In late nineteenth-century Italy, in fact, the press crucially contributed to popularizing a more colloquial Italian prose that, rich in vernacular expressions, gave unprecedented space to the lives of the city's *lumpenproletariat.* The ensuing prominence of the lower classes as the subjects of discourse and dramaturgic address promoted debates and practices advancing nationally understood standards of vernacular expression for a wider, interclass range of audiences.[94]

In this context, Sicilian playwright and literary critic Luigi Capuana was instrumental in positioning Sicilian vernacular theatre within the broader realm of the Italian stage scene, at home and abroad. In the latter part of the century Capuana both wrote and theorized about what he thought to be essential for Sicilian writers and Italian readers: dialect literature. He translated two of his own plays into Sicilian, *Giacinta* (Giacinta, 1888) and *Malìa* (Witchery, 1891), which in their original Italian versions had not done well on stage. Their dialect versions, performed respectively in 1892 and 1902, were a huge success, particularly the latter, played by then emerging stage stars Giovanni Grasso and Marinella Bragaglia.[95] The story of a Sicilian woman who is madly in love with her sister's husband and who is believed to be a victim of witchcraft, *Malìa* relied on familiar anthropological motifs: Southern superstition, female sensuality and hysteria, and Sicilian vendetta. Plot and themes aside, how could the story be appreciated outside Sicily? What enabled the play's nationwide success was the adoption of a widely comprehensible,

Italianized Sicilian dialect. Through a self-conscious mimesis of melo-dramatic dialogues performed in an accessible vernacular, *Malìa* became a Southernist cornerstone of Sicilian and, eventually, Italian American realist theatre. Its success enhanced the appreciation of earlier works that featured comparable linguistic operations, from Gaspare Mosca and Giuseppe Rizzotto's aforementioned *I mafiusi di la Vicaria* (The Beauti-ful People of Vicaria, 1863), Giuseppe Giusti Sinopoli's *La zolfara* (The Sulfur Mine, 1894), and Giovanni Verga's *La cavalleria rusticana* (Rustic Chivalry, 1880). As we shall see in chapter 7, these texts were to become masterworks of Southern Italian diasporic culture, repeatedly staged in dialect in the vernacular theatrical venues of America's Italian quarters by professional and amateur stage companies alike.

A comparably Southernist strategy determined the success of Gio-vanni Verga, Capuana's more famous fellow Catanese and the major exponent of Italian literary naturalism (*verismo*). In the early 1870s Verga achieved national notoriety while living in Milan, where he befriended several of Italy's most important publishers and critics and realized the national horizon of expectations associated with Sicilian narratives. From Milan, as Nelson Moe succinctly put it, he "approache[d] the ru-ral Sicily of his great realist works by way of the picturesque."[96] Through original linguistic solutions which were open to vernacular syntax and expressions, he set his stories in the picturesque landscape of and around Aci Trezza, near Mount Etna; cast peasants, shepherds, fishermen, and sulfur-mine workers as leading characters; and placed them in narratives of dire poverty, excessive passion, and tragic fatality.

Although publicly reticent about, and privately disapproving of, the film medium, both Verga and Capuana endorsed the artistic representa-tion of regional differences in moving pictures. Their film collaborations and adaptations were generally disappointing, however, because the two writers did not take a direct role in their production. Much more success-ful was the film career of another Catanese intellectual, the playwright, writer, and linguistic ethnographer Nino Martoglio, who as a theatre impresario and film director was instrumental in launching the stage and film career of a former puppeteer from Catania's popular quarters, Giovanni Grasso.[97] Grasso was a very successful Southernist performer, who aroused racist prejudice with his stage adoption of the jargon and the knife of the Mafioso and with his antimodernist primitivism. In his

voice, presence, and gestures audiences saw "the customs of those Southern regions where the powerful force of modern civilization has still not penetrated as it did in ours," as a contemporary Milanese reviewer put it; "in their midst a great deal of passion still throbs, feelings are expressed in an entirely wild manner, certainly a freer one."[98] He toured Italy in 1904, and Europe and South America in 1907 (only in 1921 did he first visit the U.S.), and his performances of "Southern excess" became legendary. In the 1950s, Gordon Craig recounted having seen him perform at the Moscow Art Theatre, where usually "the brains of the spectator . . . rattled a sort of dry bullet-like volley of applause at any performance of any play." But at the end of Grasso's performance, the famous British stage director and designer noted, "the audience in that theatre rose to its feet electrified and out of itself."[99]

Martoglio was quite aware of Grasso's reputation as "the moral and aesthetic interpreter of the Sicilian race," as one critic wrote, when he cast him for the feature film *Sperduti nel buio* [Lost in darkness, Morgana Film, 1914] together with fellow Sicilian stage actress Nina Balestrieri.[100] Released in 1914 and unfortunately lost since World War II, the film was an adaptation of the eponymous Neapolitan drama (1910) written by journalist, playwright, and songwriter Roberto Bracco. It represented a Southernist, multiregional synthesis of Sicilian performances and Neapolitan narrative and setting.[101] The film tells the story of the moving friendship between Nunzio, a blind man who plays the violin in a café in the city's slums, and Paolina, the little girl he protects from the perversions of the Camorra and who is both the illegitimate daughter of a ravenous and selfish aristocrat and none other than Nunzio's half-sister. As they had in previous films, critics recognized the unambiguous association in *Sperduti* between Naples's plebeian setting and the characters' primitive passions.[102] Some appreciated Grasso's humanistic realism against this Southernist background; others found it excessive.

Sperduti nel buio's cinematic realism and emotional intensity elicited an enthusiastic cross-class response. Significantly, the film narrowed the gap between the intellectual "vanguards" of Southern playwrights and writers and the cultural "rearguard" of local common audiences. This did not imply an absolute convergence of cultural preferences. Northern and Roman reviewers criticized the graphic realism of Grasso's characteriza-

2.15. Nunzio and Paolina against the view of the volcano in *Sperduti nel buio* (Lost in darkness, Morgana Film, 1914). Used by permission of the Cineteca Nazionale (Rome, Italy).

tion and acting style as excessive and inappropriate for their audience's psychology and taste (a "realism that in our arenas is an excess").[103] The critic known as Keraban instead emphasized the modernity of Martoglio's newly achieved balance: "While he holds a great deal of that violent color of Sicilian tradition in his art, [Martoglio] shows himself to be gifted with a very modern sensibility."[104]

The novelty of the film lay precisely in its doubling of expressive strategies and cultural address. It satisfied the authors' ambition of artistic quality (realism, folkloric authenticity, antisensationalist *dénouement*), but it also resonated with popular audiences' taste for melodramatic intensity and clear-cut moral confrontations, evident in the vivid contrast between the corruption of Neapolitan aristocrats and Mafiosi and the integrity of the city's humble inhabitants. Because of this, *Sperduti nel buio* allowed a complete, and even surprising, communicative

circle, touching both lower and higher cultural levels. And it did so on the basis of a Southernist poetic synthesis combining Neapolitanness— present in the story and the picturesque scenery (fig. 2.15)—and Sicilian- ness—evident in the actors' fame, their performances, and the direction. Against the predestined background of Vesuvius, where Nunzio and Paolina find a temporary refuge, the film connected social populism with artistic maturity. The vulgar crowd that kicked and screamed to get a seat at Naples's central Salone Margherita, where the film was first publicly screened, clearly enjoyed the (melo)dramatization of their own milieu and of their own condition. The realism of setting and costumes was remarkable not just because they *looked* authentic, but because, once projected on the screen and accompanied by the popular vernacular tunes that exhibitors preferred, they offered an aesthetic transfigura- tion of, and thus gave a higher significance to, people's lives. Indebted to the familiar picturesque association of volcanic views with plebeian temperaments, *Sperduti nel buio* performed a Southernist mimesis for both local and national audiences.

Even more than "Sicilian cinema," the cultural universe of Neapoli- tan film production and reception was capable of transfiguring, much more consistently, metropolitan situations of economic deprivation and social marginality into narratives of intense humanistic and moral breadth. At work in these films was the rich dramatic culture of the for- mer capital, its extraordinary encyclopedia of vernacular melodramas and comedies, authored by the established playwrights Ferdinando Russo, Libero Bovio, Edoardo Scarpetta, Francesco Mastriani, and Sal- vatore Di Giacomo and performed by such towering dialect figures as Edoardo Scarpetta. Neapolitan theatre differed from that of Sicily in that it relied on a uniquely popular music culture associated with the yearly Neapolitan singing contest of Piedigrotta. Since the 1880s, Piedigrotta had produced singing talents, "timeless" songs, and a unique musical taste among the listeners of many classes who regularly attended the *cafés-chantants* not just of the city, but of the nation as a whole.[105]

Emerging in France in the last decades of the nineteenth century, *cafés- chantants* or *cafés-concerts* were urban meeting places where food was served to the accompaniment of songs, dances, and comedic sketches. In early twentieth-century Italy, *cafés-chantants* became full-fledged the- atrical venues, known for their rich, variety-format attractions, which

tended to discard traditional psychological dramas and morality tales in favor of dialect melodramas and sentimental songs. Neapolitan *cafés-chantants* presented distinct features thanks to the so-called *sceneggiate,* the stage dramatizations of famous vernacular songs, which eventually also included cinematic adaptations exhibited in the same locales. The scene from *The Godfather Part II* described in the introduction belongs exactly to this cultural practice. The combination of *sceneggiate* and *cafés-concerts,* which in the 1910s began exhibiting films and became known as *cinema-concerts,* unmistakably defined Neapolitan cinema's Southernist poetics. Often shooting *en plein air,* local film companies specialized in convoluted plots of sentimental excess, doomed romance, and vendetta, which regularly highlighted local picturesque settings, whether urban or natural.[106] Some of the most famous adaptations of popular Neapolitan songs were *La figlia del Vesuvio* [The daughter of Vesuvius, Dora Film, 1912], *A Marechiaro ce sta 'na fenesta* [At Marechiaro there is a window, Dora Film, 1913], and *Fenesta che lucive!* [Lighted window, Partenope Film, 1914].[107] The ideal Neapolitan companion to *Sperduti nel buio,* however, was *Assunta Spina* (Caesar Film, 1915), a melodrama that Gustavo Serena and Neapolitan diva Francesca Bertini adapted from Salvatore Di Giacomo's eponymous novella (1888) and that was first staged in 1909.

Assunta Spina is a noirish intrigue whose eponymous heroine is an attractive seamstress who is slashed in the face by her jealous fiancé, Michele. What enhanced the realism of the film was the deployment of two significant expressive screen figures, the crowds and the cityscape. More than just background extras or setting, the crowds and cityscape emplaced the main characters, their narrative, and the film's spectators. Through a number of visual strategies, the film reproduced the peculiar feeling of Naples's plebeian neighborhoods, where private and public life continuously intersected in the setting of narrow alleys (*vicoli*), thus revealing the profound exchanges between the city's physical and social landscapes. Bertini's acting style is dialogic, constantly engaging in gestural conversations with both the local crowds and the scenery. Through these conversations, the film constructs a position of spectatorial involvement, of emplacement, which turns the conventionally picturesque settings that surround her figure into vectors of Southernist experiences. It is not that, through the film, audi-

ences in Milan, Palermo, or even Naples simply "went to Naples." The melodramatization of the familiar picturesque scenery made local and non-local audiences alike feel part of the city and in close contact with its emotional residents.

The very first moment of the film introduces Assunta, in a medium shot, proudly standing with her back turned to the picturesque waterfront, with the sea visible behind her. Rather than appearing as a static figure, she twists slowly at the waist, as if addressing the camera and posing for the spectator. The image has no narrative relevance *per se:* it is almost a pure homage to Bertini's star persona, but it is also an eloquent emplacing tableau. Assunta's physical presence and personality are grounded in the locality of Naples's most recognizable topography, the waterfront. Her story is thus never personal.

Likewise, the violence she endures is intrinsically public. The *sfregio* is not a cut made on a hidden or private part of the body: like a scarlet letter, it is socially lethal for its victim because it will affect her relationship with the whole community. Michele intended it to be a public sign of infamy and an evident mark of fault. Even if Assunta could forget it, no one who looks at her will, including the Neapolitan audience.

The film's spectator is never made to exit the scene. In various ways, the film manages to emplace its viewers through collective and vicarious figures. The solicited spectatorial stance is that of a metonymical exchange, an intimate conversation, between on- and off-screen crowds. By acknowledging and addressing friends, acquaintances, and strangers, Assunta's dialogic postures create an inviting bridge for the extratextual crowd of both Southern and Northern Italian spectators. Her character invites identification not just with herself, but also with the public settings in which every action occurs, which are constantly enhanced by the open doors, the half-uncovered windows, the open-air parties, and the large courtyards in which her drama unfolds.

Intrinsically connected to the character of the crowd, the Neapolitan landscape is the other crucial element that enables forms of spatially defined, or "landscaped," spectatorial participation. Relying on the familiar pictorial and photographic forms of the panoramic city view and the filmed *actualités,* the dramatization of *Assunta Spina* elevates the landscape's expressivity to make it a major conduit for the audience's involvement. Concessions to the picturesque mode are frequent. The

archetypal view of the Neapolitan Gulf frames the film's opening image and in various forms reappears as Assunta and Michele tenderly embrace on a public terrace, during their boat outing in the sunset, or as they walk along the shore. Finally, the celebration of Assunta's saint's day takes place at Marechiaro, a Neapolitan locality famous for its beauty and panoramic viewpoints. The landscape appears then as Assunta's own spatial contour; it closely surrounds her, much like the white shawl that in the film's first half she so often arranges around her shoulders. The film's setting is a metonymic correlative of her life, housing what Bruno calls her "corporeal geography."[108] Although in the second part, the familiar images of the waterfront disappear, the film's spectators never leave the familiar cityscape. When the melodrama acquires the bleaker connotations of a tragedy, darker views of Neapolitan marketplaces and urban alleys become more frequent. Assunta's white shawl disappears, replaced by a black one and a black dress. In the film's second part, in fact, it is the crowd that becomes the setting, enveloping atmosphere, and "corporeal landscape." It is a plebeian crowd, operating as mirror of, and catalyst for, the film audience's intense participation as close witnesses and neighbors, not as contemplative spectators. One may refer to a metonymical rather than metaphorical mode of spectatorship, because the relationship between audiences and on-screen events is based on spatial contiguity rather than on an imagined association.

Confirming the film's construction of spectatorial position, *Assunta Spina* was a huge success. Neapolitan audiences flooded the popular movie theatres where the film was first screened. There were rumors that the film's box office receipts were unprecedented. Critics expressed a more nuanced response. Most of them remembered the stage production, whose dramatic intensity they considered unparalleled. The film version, as a few perspicacious critics noted with disappointment, lingered on the picturesque setting rather than efficiently furthering the story's dramatic contrasts. Yet the same critics also acknowledged that the filmmakers had "a deep knowledge of . . . the places where the drama unfolds," by which they meant not knowledge of Neapolitan topography, but command of the city's pictorial aura ("an understanding of effects and contrasts"), which granted the production "truth, and with truth, art."[109]

The film's pictorial referencing was thus hailed as both realistic and artistic, and, as such, as transcending local contingencies. The passage from locally specific to artistic and universal is a significant aesthetic conversion: it also created long-lasting critical blind spots. References to universal notions of human truth and moral intensity undermined the film production's rootedness in distinct places, aesthetic traditions, and aesthetic responses. In 1924, a Turinese reviewer still noted, "The work, which seems to have aims and motifs that are simply local, rises to a universality that relies on premises of ethics and aesthetics."[110] The stress on the realism of the mise-en-scène, which was consistently praised for its universal human value and artistic merit, erased the film's powerful Neapolitan (and Southern Italian, in general) emplacement. The disavowal of Bertini's creative contribution paralleled the disavowal of her biographical and performative Neapolitanness. She was viewed as the Italian diva *par excellence,* as an interpreter who possessed national, and not regional, value. A few decades later, neorealist film critics and practitioners would make the same move.[111] Marxist critic Umberto Barbaro saw *Assunta Spina* and *Sperduti nel buio* as forerunners of Italian neorealism, thus translating the films' "Southern Romanticism," to use his own expression, into the emblem of a national, and not regional, aesthetics.[112]

For Neapolitan audiences and, *ab extenso,* for other Southern territories, as the critic Keraban and others reveal, the film's realism had a different meaning. It was not an impersonal, objective, eyewitness view of another world, confronted from a distance and possibly regarded in high artistic terms. It was not even a form of aesthetic contemplation or delectation, such as often marked the generally aristocratic consumer of picturesque representations. A Neapolitan *popolana* (woman of the people) caught in a story of passion, violence, and official justice and repression, occurring in the familiar settings of seashores, courtyards, *vicoli,* and *piazze,* could not be experienced as a travelogue or a human drama to be observed with detachment. Instead, Southern spectators' rapport with the film arguably relied more on tropes of sameness and contiguity. Evidence from contemporary exhibition patterns and Southern participatory practices suggests that the film co-opted the audience on an aural level as well. Apart from the likely presence of a popular musical accompaniment, the loud context of film exhibitions—emergent in

the case of *Sperduti nel buio*—made the boisterousness of the crowds on screen both interpellate and resonate with the equally animated involvement of movie theatre audiences. The experience of actual spectators arguably challenged the ocular hegemony of naturalism's observational style and of silent cinema's photographic indexicality by enabling a mimetic symbiosis with the film's audiovisual texture. Arguably, Southern audiences experienced a relation of spatial and emotional proximity to the characters, crowd, and landscape on screen, indeed a "metonymical *communitas*" that was recognized as part of a larger sense of self. Adopting the participatory pattern of the Neapolitan *café-chantant,* which was centered on a relationship of contiguity between audiences and performers and enhanced by popular musical accompaniment, local audiences displayed forms of collective involvement that ran counter to mainstream modes of spectatorship. Unsympathetic Northern Italian critics found Southern audiences' emotive response all too boisterous, reprehensible, and primitive. But in Naples, in Southern Italy in general, and in America's Little Italies, the same experience fostered a sense of communal and self-conscious rootedness. What the screen and the movie theatre's contagious and "primitive" experience revealed was a melodramatic transfiguration of Assunta's love life into a larger and more resourceful communitarian experience that produced self-recognition and self-celebration and imbricated spectators with the modern pressures of identity configuration. Contemporary to such experiences was the migration *en masse* of Southern Italians to the United States. The tensions of cultural self-awareness and self-fashioning continued across the Atlantic Ocean. Within American racial culture the impetus for geocultural mimesis and (self-)emplacement would contribute to the emergence of a Southern Italian diasporic culture.

In this chapter I have discussed how photographers and filmmakers, whether Italian or foreign, represented Southern Italian landscapes and characters according to established picturesque formats of aesthetic, touristic, and ethnographic delectation. In brief, photographic media naturalized picturesque forms and ideologies. The process was functional not just to Southern Italians' racial ascriptions, but also to their own self-positioning. Whether produced in Naples or Sicily, a number of literary, stage, musical, and cinematic works arranged the representation of volcanoes, dark alleys, ruthless brigands, and jealous lovers into

deterministic, yet poignant, visual narratives. I call this poetic strategy Southernist because of its capacity to turn familiar racial prejudices into visual and dramaturgic resources for plays, songs, and films. Indebted to the recognizable picturesque associations of landscape and characters, these works achieved artistic recognition and wide circulation, both in Italy and abroad. The story of how the picturesque traversed the Atlantic Ocean, and how it informed the racial culture that both preceded and framed Southern Italians' American experience, is told in the next chapters.

Picture-Perfect America

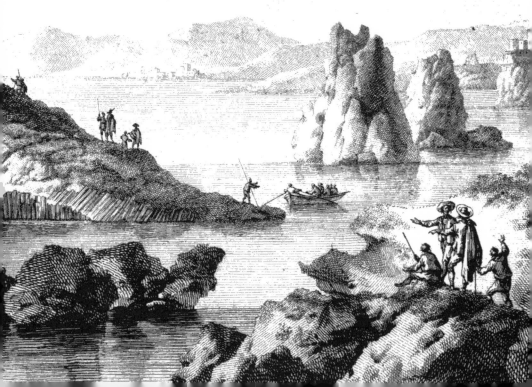

Picturesque Views and American Natural Landscapes

The painter of American scenery has, indeed, privileges
superior to any other. All nature here is new to Art.

THOMAS COLE, 1835

As to your great Vesuvius, we have a Niagara
that would put it out in half a minute.

FICTIONAL DIALOGUE BETWEEN
AN AMERICAN AND A EUROPEAN BOY,
THE SCHOOL READER: THIRD BOOK, 1853

This picturesque, a real, definite commodity of genuine
commercial importance, goes with many another moving
picture film across the seas.

MOTOGRAPHY, 1911

By the time Italians began their mass migration to the U.S. in the 1880s,
American artists and writers had for decades been intimately familiar
with real and imagined representations of Italian landscapes. They had
viewed, studied, and absorbed the style of picturesque paintings and
prints during their journeys to Europe, at private and public exhibitions
at home, or through art reproductions.[1] More creatively, they had ad-
opted the picturesque tradition to aestheticize the American natural,

urban, and social landscapes and codify their representations, despite persistent claims of (and ambitions for) American artistic distinctiveness. In this chapter, I show how the formal and ideological framework of the picturesque contributed to defining, in highly racialized terms, the New World balance between delectation and containment of unspoiled natural scenery and characters. Around this balance American painterly, print, photographic, and film culture constructed a range of narratives of national distinction and racial difference by setting them in the open spaces of the Northeast, the Rocky Mountains, and the vast prairies of the West, or, as I show in the next chapter, in the urban alleys of New York City, to which Italians migrated *en masse.*

In light of the powerful ideological significance of the picturesque, familiar aesthetic distinctions between, for instance, survey and artistic photography, or non-fiction and fiction film productions, may lose their strict categorical cogency. Specifically, travelogues, ethnographic films, Western and Indian dramas, and Civil War films all made ample use of picturesque conventions to correlate ideas of a predestined national place with notions of racial difference and worth. By sharing the ideological assumption that the American landscape was an unclaimed *terra incognita,* nineteenth-century depictions of it turned the impetus toward territorial exploration and appropriation into a hegemonic and patriotic practice. A whole range of painterly, printed, photographic, and film productions, as well as novels, tourist books, and landscape design manuals, cogently sustained the highly romanticized notion of an American environmental distinctiveness. Images and narratives of a predestined place in geography and history characterized the racial identity and worth of those who, under different credentials, inhabited America's natural and urban landscapes, from indigenous populations, Bible-reading pioneers, and tourists to middle-class residents and immigrants. Of nationwide relevance, this massive artistic and cultural appropriation of the landscape originated in the urbane and cosmopolitan circles of the East. Still, while sensitive to established European formulations of landscapes as national environments, such a multimedia production creatively reworked familiar picturesque morphologies for the boundless spaces of the West.

At various times in nineteenth-century America, intense journalistic, literary, and visual coverage adopted the picturesque style mainly for three different settings: the easily reachable localities of the Northeast,

particularly the Hudson River valley; the frontier territories located west of the Mississippi; and New York City. Although, as Roderick Nash famously put it, "wilderness was the basic ingredient of American civilization," an even more defining American effect was the domestication of untamed lands and populations and their transformation into what Leo Marx identified as the "pastoral ideal."[2]

In the nineteenth century, America's leisure time industries first turned Northeastern mountains, lakes, and valleys into fashionable tourist destinations that bore familiar connotations of Arcadia and gentility. The wild and boundless forests of the West required a more arduous effort of physical conquest and aesthetic domestication. Within recurring comparisons to Europe, the appreciation and management of the wilderness of the New World informed narratives of national distinction. While a massive material and industrial process of settlement was radically altering the once pristine Western lands, in fact, a whole production of paintings, engravings, photographs, and films masked the expansion as a romantic, environmentally friendly, and nation-building mission. Equally painstaking was the elision of the human cost of the westward expansion. Indians had to become specimens of an era now past, docile and distant spectators of fast-moving trains, or vicious, primitive, but ultimately doomed rebels against the course of progress. Finally, and perhaps most surprisingly, the picturesque was deployed for representations of New York City, which, as the nation's principal immigrant port and frenzied publishing and filmmaking center, was to many observers the least American place in America. In the nation's largest metropolis, picturesque attributions were reserved for the very modern landscape of urban immigrant ghettoes, where a human form of semiprimordial nature called for both improvement and contemplation.

Pastoralism and picturesque domestications did not affect just the representation of landscapes and populations: the burgeoning discourses of landscape gardening and environmental culture also impacted actual settings and scenes. The effect was obvious in the creation of country homes (and in the very idea of country residences), but even more so in the establishment of national parks—permanent enclaves of wilderness located in the West and even in New York. In these Edenic manifestations of the promised land, the presence of Native Americans or immigrants was either forcefully excluded or imagined as radically disciplined.

Overall, the picturesque aestheticized America's natural and urban environments into anaesthetized, national sights. It did so by advancing a contemplative, imaginative, and touristic mode of consumption that concealed power-laden, exploitative, and merely utilitarian relationships and that enhanced the Americanization of these settings and the aestheticization of Native and immigrant populations into ethnographic spectacles. As the most powerful and pervasive mass medium of its time, cinema contributed to the "landscaping of America" through a constellation of genres and styles, from the travelogue to the Western drama, that maintained intense material and symbolic relationships with the American natural scenery.

EASTERN SCHOOLS: FROM ART TO PARKS

In the early part of the nineteenth century, authors and naturalist philosophers Ralph Waldo Emerson and Henry David Thoreau articulated a view of the American landscape as an all-encompassing spiritual entity, a raw, often sublime natural environment that was devoid of historical, man-made traces. "Nature couldn't do without God," as Barbara Novak has aptly recapped this process, "and God apparently couldn't do without nature."[3] Similarly, accounts of travel to distant Western locations, from Washington Irving's *A Tour on the Prairies* (1835) and Charles Fenno Hoffman's *Winter in the West* (1835) to Francis Parkman's *The Oregon Trail* (1849), narrativized journeys of personal physical and spiritual restoration in the midst of unspoiled natural environments and, in the process, tested ideas about American character and destiny. Yet the Americanness of the U.S. landscape, far from being an absolute given, was always the result of a gesture of cultural comparison, with Europe and with its own once primitive yet rapidly changing state.[4] These changes, of course, began on the East in the early decades of the nineteenth century.

Since the mid-1820s, steamboat and, later, train routes had made it reasonably safe for Easterners to travel to several locations along the Hudson River valley. By projecting picturesque attributes onto these sites, travel guides and illustrated periodicals, from the *New York Mirror* and the *New York Review* to *Atheneum Magazine*, made them into America's beaten paths. This is a story with several crucial enablers. Journalist, poet, novelist, and traveler Nathaniel Parker Willis (1806–67), founder

in 1829 of the *American Monthly Magazine,* helped to codify sightseeing journeys along the Hudson and to Saratoga Springs into a trendy touristic experience, amidst ruins left by Native Americans and Dutch *patrons* (landholders). A number of American cosmopolitan artists and writers felt challenged (although never defeated) in their attempt to project the artistic conventions of the picturesque—ruins, deserted abbeys, storied associations—onto the vast American landscapes just as the clearance of trees for the railroads and the passage of steamships were fast changing the scenery. "All nature here is new to art," insisted Thomas Cole (1801–48), the English-born painter and cosmopolitan pioneer of the Hudson River school, in 1835.[5] His idealization of the once pristine American landscape through canvases of dramatic vistas with atmospheric lighting and striking waterfalls (Salvator Rosa) or of Arcadian views of pastoral quietness (Claude Lorrain) enabled the new nation to see and appreciate "a recognizable image of itself in art."[6] In the same period, several writers shared Willis's and Cole's aestheticizing efforts, including James Fenimore Cooper, who was a former topographic artist, Cole's New York neighbor, and a longtime European resident.[7] In *The Last of the Mohicans* (1826) and other works, Cooper adopted the picturesque conventions of Lorrain, Poussin, and Rosa and employed ruins ("graves of dead Mohawks"), waterfalls, table rocks, and precipices to memorialize the American natural and social landscape within a heightened "awareness of the visual and dramatic possibilities of the American frontier setting."[8]

What prompted and sustained the visual coverage of the West, instead, was a more complex convergence of military, economic, and cultural motifs. Pride in the newly achieved unity of the nation, the completion of the railroad route to the Pacific, and the development of print media trained millions of Americans to associate news and stories from the West with widely circulating and affordable visual reproductions. *Frank Leslie's Illustrated Newspaper* and *Harper's Weekly* were crucial to the diffusion of picturesque depictions, but it was the serial publication of an illustrated section of the New York–based *Appleton's Journal,* named *Picturesque America* and founded in the 1870s, that had the most pervasive cultural and commercial impact. The popular section sold millions of subscriptions for *Appleton's Journal.* Between 1872 and 1874, the publisher, D. Appleton, assembled all the issues of *Picturesque America* into lavishly illustrated volumes which, again, sold by the millions (fig.

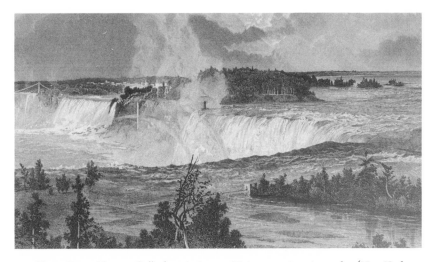

3.1. Henry Fenn, *Niagara Falls,* frontispiece to *Picturesque America,* vol. 2 (New York: D. Appleton, 1874). Used by permission of the University of Michigan, Special Collections Library (Ann Arbor).

3.1).[9] The American equivalent of Saint-Non's *Voyage pittoresque, Picturesque America,* as Sue Rainey has eloquently put it, "participated in the accelerating democratization of picturesque touring from an upper-class pastime rooted in art and literature to a way for middle-class tourists to take possession of the landscape."[10] Along this trajectory, as I will show later in this chapter, only cinema enabled a further expansion of the consumption of picturesque imagery to mass audiences.

The picturesque domestication of the wilderness also implied a power-laden management of the depiction of racial differences. The written texts accompanying the illustrations of Native Americans in *Picturesque America* often refer to them as "children of Nature" and romanticize them as a component of a natural domain that progress will inevitably, albeit sadly, erase. Likewise, the dramatic violence of land expropriation, conflict, and cultural invasion was utterly elided in these depictions. For the more rarely drawn African Americans, similar romantic sketches of childlike serenity ("the negro laughs, as the birds sing, by instinct") downplayed cogent questions about postslavery hardship, social strife, and coexistence with white America.[11] As a compositional style devised to contain exotic wilds, exported picturesque representations fed the appeasing and conciliatory myth of westward expansion as a necessary

and inevitable settlement. In the paintings of Thomas Moran, Albert Bierstadt, and Asher B. Durand, among others, images of blissful fertility and prosperity, together with representations of courageous fur trappers, cattle herders, and farmers, masked the profound military, social, and economic effects of what was unquestionably a massive colonial enterprise. Like the topical lithographs of Currier & Ives, the productions of these artists hardly ever portrayed the cruelties of the Mexican war, the forced displacement or massacre of Indian tribes, or the ruthless exploitation schemes of the Eastern business and political communities. From the perspective of their New York studios, landscape painters and lithographers de-dramatized and eulogized the expansionistic impulse and turned the colossal economic mobilization of resources and men necessary to "conquer the West" into a nationalist anthem. Depictions of Wyoming, the Colorado River, and the Grand Canyon contributed to the invention of "[Western] subjects as both Edenic wonders and emblems of national pride." Glorious images of trains passing through boundless prairies, efficient deforestation, and new towns gave the impression that "an empire could be built that did not destroy nature or the social fabric already under stress from expansionistic activities."[12] The most emblematic picturing of the West, in fact, relied on a strict codependency of wilderness and civilization. Native Americans better served the notion of America's distinctiveness as promised (pastoral) land by remaining well in sight. Defeated in battles, in federal courts, and by modern progress in general, Native Americans nonetheless maintained a striking aesthetic relevance, fostering nostalgia for their noble primitiveness and inevitable obsolescence. It was through this merciless representation of the course of civilization that nineteenth-century America activated the Grand Tour's domesticating conventions, which ultimately shaped the romantic visual and racial forms of the Western genre in literature, public reenactments, and the visual arts.[13]

As had already occurred in England, increasing appreciation of nature in the U.S. and the urge to preserve its wilderness produced an isomorphism between the representations of natural landscapes and their actual design. Gardens and physical landscapes in general were nothing other than "three-dimensional landscape paintings, replacing oils on canvas by leaf and stone."[14] Emblematic of this linkage between picturesque representations and environmental culture was George Catlin,

known as a master painter of Native Americans. In 1832 he called for the creation of "a *nation's Park* containing man and beast, in all the wild[ness] and freshness of their nature's beauty!"[15] In his plea, Catlin was not alone. The Western landscapes of painter Thomas Moran were instrumental in promoting the creation in 1872 of Yellowstone National Park, the first one of its kind in America.[16] Likewise, in the late 1840s, Andrew Jackson Downing, America's first landscape designer and a prominent advocate of country homes, introduced the notion of implementing the pastoral ideal in the midst of America's most urban environment, New York City. In 1858, landscape designer Frederick Law Olmsted and architect Calvert Vaux drew up plans and realized Downing's project of a pastoral retreat by applying painterly compositional conventions that created scenic effects out of managed wilderness and country views.[17] The result was Central Park, completed in 1873. As millions of newcomers poured into the city, the park grew to be, more by design than by practice, an institution of racial and civic Americanization. The city's socially and environmentally progressive élites saw this rural and pastoral enclave as an emblem of "the love of country life, the enjoyment of nature, and the taste for rural beauty," which, as Downing wrote in 1853, "we also inherit from our Anglo-Saxon forefathers."[18] Like the park's wealthy and cosmopolitan advocates, Olmsted had not only democratic aspirations for its civic use, but also rather genteel views of proper public behavior. As a mid-nineteenth-century cultured man, he shared Downing's belief that "when smiling lawns and tasteful cottages begin to embellish a country, we know that order and culture are established."[19]

Ultimately, the reality of such an enormous picturesque rural retreat in the middle of America's largest and most racially diverse metropolis daringly embodied the pastoral ideal's grand mission of cultural education and recreation. It was an ambition shared by unlikely allies, the Progressive-era reformers and the populist and manipulative political machine of Tammany Hall, all equally distressed by immigrants' appalling and vice-inducing living conditions.[20] A broader cultural convergence trumped their contingent political differences. The park's well-defined walking paths and recreational activities powerfully embodied an aestheticized idea of nature that embraced the democratic notion of universal public access. In reality, however, the ideal of a natural realm for the disadvantaged was based on operations of racial pruning: it did not

apply to those who indisputably fell outside the domain of whiteness—as I will discuss in chapter 5. For "people of color," even a domesticated inclusion was never a possibility. The wilderness ideal that, in an endeavor to preserve pristine natural landscapes, had led to the creation of the Yellowstone, Glacier, and Yosemite National Parks had also forcefully denied visibility to Native Americans, who, as "savages of nature," were condemned to either a noble vanishing or an inglorious displacement.[21] White Europeans, instead, enjoyed varied and better forms of inclusion in the parks and gardens, and on the movie screens, of America.

A whole range of photographic media enhanced and objectified these inequitable practices. Landscape and ethnographic photography, travelogues and ethnographic films, as well as Western films and tenement dramas, aestheticized natural and urban environments according to similarly biased painterly forms. They also aestheticized what was considered "natural" about the racially othered characters inhabiting them and, in the process, naturalized such representations as at once truthful and appealing. Concomitant with survey and scientific expeditions, in fact, the inception of landscape and social photography blended established painterly modes of national and racial ascendancy with rationales of unprejudiced accuracy and touristic attractiveness.[22] "The expeditionary photographers may not have thought of themselves as artists," as Miles Orvell has noted, ". . . but even when seemingly most literal, the nineteenth-century professional was striving for rhetorical effect."[23] Their aesthetic memory and political patronage—by Congress and public opinion—made geologists and surveyors sensitive to photography as both uniquely accurate in its visual depictions and eloquent in its visual appeal.[24]

LANDSCAPE PHOTOGRAPHY AND LANDSCAPE CINEMA

The Hopis, Havasupais, Apaches and Navajos are more picturesque than the Swiss, Irish, Serbian or Russian peasants.

GEORGE WHARTON JAMES, LECTURER,
JOURNALIST, AND PHOTOGRAPHER, 1915

Mostly practiced in the trans-Mississippi West, American landscape photography was "a child of the Pacific . . . although its seeds were rooted

in the eastern states and in Europe."[25] A pastoral manner of landscape photography admittedly indebted to the picturesque aesthetic had, in fact, emerged in Britain and France in the 1850s and, with the development of the glass-plate process, had spread identical prints of far-away lands and populations around the world. Their success prompted the fashion of outdoor photography, initially practiced in the American Northeast and greatly facilitated by the stereo camera's easy portability and unique illusion of depth. Frederick Langenheim's famous 1850s stereographs of Niagara Falls, with their heightened sense of space, served to establish the circulation of photographic views of picturesque and pastoral landscapes as a commercial venture, widely practiced in Boston, Philadelphia, and New York.

The pressing question is whether the West's presentation of new landscape motifs implied completely new aesthetic approaches. Eastern landscape artists, such as Frederic Edwin Church and Albert Bierstadt, were among the first painters to explore Western landscapes, for both artistic and documentary purposes.[26] "By the 1850s," as critic Eugene Ostroff shows, "painters and illustrators were accepted as important adjuncts to western explorations."[27] The exchanges between daguerreotypes (and, later, photographs) and artistic renderings were extremely intense. Painters and engravers saw photography as a useful aid to their personal and documentary work—as Bierstadt did during a survey of wagon routes to the Rockies in 1859. Expedition photographers displayed a painterly sensibility for both aesthetic and commercial reasons. Initially, the American public understood the value of photography for Western exploration from the engraved illustrations of Western mountains and valleys, based on photographs, that, for instance, *Harper's New Monthly Magazine* was publishing. Appreciating this media convergence, the government- and business-sponsored topographic surveys employed both draughtsmen and photographers. Just as in the East landscape photographers imitated the earlier work of painters, in the West the collaboration of painters and photographers advanced a landscape visual culture that, despite the newness of the environment and the external advocacy of scientific expeditions or transportation surveys, continued to display an appreciation of nature as "a work of art." For photography critics, Carleton E. Watkins's "landscape photographs were the earliest and most important examples of photography paralleling painting in the West."[28] Known for

his mammoth-plate panoramic views of Western scenery, in fact Watkins, together with Charles Leander Weed, Nathan M. Klain, Timothy H. O'Sullivan, and Eadweard Muybridge, helped to establish and sustain the close relationship between American landscape aesthetics and the West Coast, particularly San Francisco and the much-photographed scenery of Yosemite.

Between the early 1860s and the mid-1880s, photographers of the West found themselves at a profitable juncture. By echoing the picturesque style of relocation and touristic advertisements that railroad companies were placing in Eastern periodicals for promotional and fundraising purposes, their work combined recognizable aesthetic arrangements with unprecedented commercial and cultural appeal.[29] In the late 1870s even a Western photographer like Watkins produced cabinet-size images that "emphasized foreground areas in an effort to force perspective," while his cropped round and oval prints continued the picturesque tradition of the Claude glass (fig. 3.2).[30] The British-born Muybridge, a "mannered romanticist" with a shrewd business sense, also took part in the widespread upgrading of landscape photography to a major publishing and stereographic trade—to the point that he copyrighted all his 1872 Yosemite plates. The second generation of landscape photographers, operating into the 1880s, catered even more to a tourism industry that, in conjunction with ethnographic photography, married issues of aesthetic and anthropological relevance to the national ideology of the American frontier—the ultimate fabric of the Western film genre.[31] Survey photography, for instance, went hand in hand with cartographic endeavors, and in the process sustained a familiar racial discourse of repossession as locations and geographical features bearing Indian or, in California, Spanish names were rechristened to commemorate famous American characters and architectural monuments. In several of these visual productions, Native American names and figures became conspicuously absent.[32]

Throughout the second half of the nineteenth century, the pictorialization of the American landscape constituted a vast intermedial phenomenon of influential formal and ideological significance. As settings of travel narratives, scientific expeditions, and railway journeys, images of Eastern and Western landscapes pervaded many visual forms: magic lanterns, panoramas, chromolithographs, stereoscopic views, photographic slides, illustrated books, postcards, and moving pictures. Rather than

3.2. Carleton E. Watkins, *View on the Merced,* albumen silver print, 1878. Used by permission of the Bancroft Library, William Keith Collection, University of California, Berkeley.

distinguishing among these media by the mechanism and material of their technology and in so doing promote implicit teleological rankings, it may be more productive to recognize that, as the era of exploration was ending, they variously participated in a common, nationally charged aesthetic ethnogenesis that was formally indebted to the tourist paradigm of the picturesque. In the context of other circulating images from the outposts and colonies of Europe, Asia, Africa, and America, these media representations translated the newly domesticated American landscape into an easily recognizable national icon.[33]

As with painting and photography, the representation of both distant and neighboring landscapes was a central subject of both early American

cinema and early cinema in America. This is not an academic distinction. In the U.S. as elsewhere, in fact, the films that were exhibited both came from and depicted an extraordinarily wide range of countries. Richard Abel and Charles Musser have argued that this transnational perspective, which Musser calls "cosmopolitan internationalism," compelled the American film industry to develop productions of clear national significance.[34] For instance, the worldwide (though brief) success of the Lumières' cinematograph after 1895 allowed the circulation of unprecedented sights of world capitals and touristic wonders, but it also showcased a penchant for French military parades and state officialdom which in turn stimulated nationalistic responses. At the first American commercial projection of motion pictures, held in New York City on 23 April 1896, one of the six films exhibited was *The Monroe Doctrine,* "a political cartoon on film, one that asserted U.S. dominance in the western hemisphere, mobilizing and uniting the audience through its jingoistic assertion."[35] In the 1890s, the alliance of American film companies and American-financed transportation companies spurred the production of films about domestic and international locations in which the U.S. had either a strategic or a business interest. These included Niagara Falls, the Rio Grande, the Rockies, the Southwest, but also Mexico, China, Japan, and Hawaii.[36] In the continental U.S., railroad companies sponsored tours and travel lectures by contracting landscape artists, photographers, and filmmakers to produce photos, posters, postcards, and film panoramas of the tourist destinations of both East and West.[37] This visual panoply sold railroad tickets, tourism, and cinema itself. It also turned the American landscape into a cultural and commercial commodity, familiarly configured according to visual morphologies developed in prephotographic times.

In the spring of 1895, the very first public projection of moving pictures in the U.S., set up by the Edison kinetoscope team of the Latham brothers, included cinematic renderings of the flickering foam of the Atlantic Ocean and of Niagara Falls—two established artistic subjects of paintings and panoramas that early cinema readily adopted.[38] The Great American Picture tradition, as Iris Cahn has noted, "helped to establish an iconography for early American cinema whose subjects would be linked to the adventure of railroad, tourism, and later, to the rugged backdrop of a mythic West."[39] Particularly at the turn of the last century,

the panoramic views of Niagara Falls were a "Mecca of all motion picture cameramen," attracting both American and French filmmakers.[40] In a nationalist competition with comparable European landscapes, the sublime Niagara Falls was both a cosmopolitan attraction and one invested with national pride. Katherine Manthorne has eloquently traced a visual genealogy of comparable viewing perspective which links the paintings of Frederic Edwin Church (1857), Henry Fenn (1874; fig. 3.1), and William Morris Hunt (1878) with Lumière's *Niagara, Horseshoe Falls* and Edison's *America Falls from Above, American Side* (fig. 3.3), both from 1896.[41] Unlike earlier paintings, which mainly fostered a sense of the sublime before the swirling waterfalls, the filmed travelogues and the later fiction films about the awe-inspiring falls showed instances of human and technological domestication, visible in the framing of telegraph poles and railroad fences and in the figures of professional observers—photographers and tourists.[42] The modern novelty of the film's technological means of expression went hand in hand with the familiar strategy of picturesque aesthetic domestication. As a major medium of tourist imagery, cinema participated in the manufacturing and marketing of America as "'nature's nation,'" as Marguerite Shaffer put it, "defining a shared history and tradition that manifested an indigenous national identity sanctioned by God and inscribed across the natural landscape." Yet, rather than being extraneous to nature, the cinematic display of technology, both as a semiotic presence and as the medium of its expression, enabled the picturesque containment and commodification of the natural realm. Niagara Falls could not remain the subject of a sublime, "Burkean" fascination. The picturesque framework of vicarious tourism captured the Falls within a form of virtuous consumption that, as a "ritual of American citizenship," developed a balance between the representations of a stunning natural sight and the coarser realities of their material production and circulation.[43]

As a subject and a form of entertainment, the exhibition of views of national or exotic natural landscapes preceded the inception of moving pictures in the form of a rather elitist, yet widely admired and influential phenomenon: the illustrated lecture. From the 1870s on, public lectures were one of the most effective American modes for the wide circulation of travel images and, later, a major context for the exhibition of "landscape films." Illustrated first with painted and then with photographic

3.3. *American Falls from Above, American Side* (Edison, 1896). Courtesy of the Library of Congress, Motion Picture, Broadcasting, and Recorded Sound Division, Hendricks Collection (Washington, D.C.).

slides, this genre of entertainment was indebted to the long-standing European tradition of magic lantern shows that had codified sites of visual and narrative interest, ranging from the Vesuvius eruptions to Niagara Falls.[44] Performed on the Lyceum and Chautauqua circuits, illustrated lectures were full-fledged cosmopolitan narratives with a genteel appeal, and their patriotic celebration of Western scenery increased remarkably toward the turn of the century. A polished master like John L. Stoddard generally preferred European high-culture sites and subjects, from literary London to Versailles, as well as familiar world tour destinations, from the Holy Land to Constantinople and China. Yet during the 1896–97 season (his last), Stoddard also lectured on Yellowstone Park at the request of the U.S. Congress, which wanted to promote the park. Similarly, in 1897, Stoddard's widely recognized successor, E. Burton Holmes, began making his own moving pictures while visiting Rome,

Sicily, Naples, and Venice. In 1904 Holmes started referring to these films as "travelogues."

Holmes's travelogues, which he shot all over the world, brought him immense fame and further codified a production and exhibition genre even for those Americans who had never seen one of his shows. His travel films and lectures, inspired by his famous motto "To travel is to possess the world," followed established patterns of tourist appeal and ethnographic curiosity, which he superimposed onto nations and populations all over the world. "A typical show," as Genoa Caldwell has explained, "ended in the projection of brief action scenes of the Omaha fire brigade, followed by a police parade in Chicago and Neapolitans consuming spaghetti, each reel running twenty-five seconds."[45] Holmes's American coverage resembled a patriotic pageant: it included images from the Grand Canyon, Yosemite and Yellowstone National Parks, and a few Indian reservations in Arizona. In these choices he was not alone. Other high-class lecturers, including Edward Burton McDowell, Frederick Monsen, and, particularly, Lyman H. Howe, had films with a strong national appeal in their repertoire.[46] In the early 1900s and 1910s, Howe exhibited films about the Grand Canyon; Yellowstone, Glacier, and Yosemite Parks; and Niagara Falls, and, like the influential Lumière films produced more than a decade earlier, he presented various portraits of American military might. Also in his repertoire was a highly patriotic 1905 film about President Roosevelt's visit to Wilkes-Barre, Pennsylvania.[47]

In turn-of-the-twentieth-century America, travelogues were an influential form of entertainment. Their depictions of national landscapes and populations were visible everywhere, whether exhibited as stand-alone attractions in variety-format shows, projected in special movie theatres designed to look like railroad cars (e.g., the Hale's Tours of 1905–1906), or alternated with fiction productions in the film programs of the storefront movie theatres called nickelodeons, which mushroomed in American cities after 1906.[48] With the increase in demand for fiction or story films after 1904–1905 and the emergence of feature films in the early 1910s, the frequency of travelogues' production and exhibition decreased. This, however, did not reduce their cultural value as familiar shorthand for educational exoticisms, middlebrow gentility, and implicit racial and jingoist ascendancy. Jennifer Lynn Peterson has thoroughly researched their production from the beginning of the cen-

tury to the late 1910s, discovering that "the western United States was one of the most frequent locations for travel films."[49] As preferred settings, national parks and Indian reservations operated as synecdoches not just of the West, but of America as a whole. Their repeated representation turned the West into "the land of scenic nationalism," where the primitive wilderness had been conquered and turned into tourist resorts or attractive places for immigrants to settle. Paralleling history, travelogues both celebrated and carried out the racial and national occupation of the land, which was often reduced to a mere background. In the one-shot films *Tourist Train Leaving Livingston, Mont.* (Edison, 1897) and *Tourists Arriving at Wawona Hotel* (AM&B, 1902), tourists were much more prominently displayed and relevant than the famous natural scenery of Yellowstone and Yosemite.[50] Native Americans, of course, had long since left the premises.

In a continuum of exotic and nationalistic image-making, cinematic representations could vividly mediate the travel experience because, as Peterson argues, "nineteenth-century pictorial conventions such as the picturesque were reconfigured in more popular and commercial terms."[51] The influence of the picturesque on the travelogue was evident not only in its subject matter, framing, and composition, but also "in its treatment of race and in its class implications, and in the larger sense of the kind of global imaginary the travelogue fosters."[52] As a result, the familiarity of structuring pictorial conventions served a strong nationalistic impetus: the scenic West was a national aesthetic currency as well as a patriotic commodity. If Colorado and California were often described, respectively, as the Switzerland and Italy of America, the photographer and popular author George Wharton James went a step further. In his 1915 guidebook to the American Southwest he wrote that "the Hopis, Havasupais, Apaches and Navajos are more picturesque than the Swiss, Irish, Serbian or Russian peasants."[53] The terms of comparison are significant. Rather than being a distant and quaint aesthetic category, the picturesque granted to the New World the primacy of wilderness while also shaping a fantasy of reassuring containment, as in *Picturesque Yosemite* (AM&B, 1902) and *Picturesque Colorado* (RMP, 1911; fig. 3.4). The nostalgia-eliciting contrast between the presence of modern tourists and the once spectacularly uninhabited and hostile environment confirmed Linda Nochlin's assessment that the picturesque "mask[ed] conflict with

3.4. Reassuring views of the Far West: tourists posing before famously hanging rocks: *Picturesque Colorado* (Rex Motion Picture Co., 1911). Courtesy of the Library of Congress, Motion Picture, Broadcasting, and Recorded Sound Division, Hendricks Collection (Washington, D.C.).

the appearance of tranquility."[54] Quite aptly, Musser has interpreted travel films as a "cinema of reassurance."[55]

The aesthetic practice of turning the territories of the West into a series of sights or memorable views encompassed powerful and inter-twined economic, political, and semiotic processes. It provided imme-diately identifiable icons for the promotion of tourist trips ("See America First!" was a famous slogan and the title of a guide series), railway jour-neys, and territorial relocations. It also visualized and codified contem-porary narratives of national self-mythologizing and self-knowledge, including their racial rankings and depictions.[56] Crucially, when adopt-ing the indexicality of photographic and cinematic signs, this repository of familiar views of American landscapes masked their pictorial codes

for documentary authenticity. As Peterson noted, "travel films [were] marketed as actuality," while the "national myth [became] naturalized as truth."[57] The reification of travelogues' picturesque form hid their stylized domestication of wilderness, including all the violence perpetuated on the landscape and its native inhabitants. They accomplished this domestication by turning the wilderness into admirable "roughness" and "variety," while transforming such a taming operation into a natural destiny. The familiar distinction between fiction and non-fiction productions hinges on the masking of the pervasive politics and aesthetics of the picturesque. Picturesque forms, in fact, were inscribed in both fiction and non-fiction productions as indicating "authenticity" of setting and representations. The vast, multimedia naturalization of the picturesque form made it disappear as a pictorial code. Travel and Western films were particularly indebted to this naturalization of convention and to its massive reiteration; that is, to its extensive replication and sedimentation in painterly, printed, and photographic media.[58]

Indeed, at the turn of the twentieth century travel films, just like ethnographic *actualités,* were not at all a radical alternative to what we may think of today as the hegemony of fictional narratives (which had not yet materialized). Instead, they were powerful emplotting productions whose expository and naturalizing authenticity spilled over to other filmmaking practices while conveying influential notions of racial supremacy. Kristen Whissel has lucidly shown how such live historical reenactments as William F. Cody's "Buffalo Bill's Wild West" (as well as their cinematic by-products, the battle reenactment films) were not radically different from, and not at all inferior to, either documentary *actualités* or ambitious fiction films. They constituted "not recreations but reductions of complex events into 'typical scenes.'" As such, the tableaux of the reenactments brought the pictorial ideals of the "Drama of Civilization," as it played out in the "Wild West" reenactments, to the doors of the East.[59] As a presence of living pictures and a visual totality, the "Wild West" shows transported the (Eastern) American spectator to one of the most powerful geopolitical sites of the new nation—the vanishing, or already vanished, Western frontier.[60] Turn-of-the-century events, however, were also affording visibility to other frontier narratives. Like Wild West shows, filmic reenactments of the Spanish-American and Philippine-American Wars, including such 1899 Edison productions as

U.S. Troops and Red Cross in the Trenches before Caloocan and *Filipinos Retreat from Trenches,* shared a formal, thematic, and ideological "sense of historical continuity between the new, overseas imperialism and its earlier continental phase."[61] The placement of the American spectator in the imperial landscape of the West, including its metaphoric outposts in the Caribbean Sea or the Pacific Ocean, showcased racializing characterizations of "strenuous" and imperial masculinity, featured for instance in *Roosevelt's Rough Riders* (AM&B, 1898) and in several Edison war *actualités,* laced with discriminatory racial pride.[62] In 1899, a reviewer for the New York weekly *Criterion* wrote about the Cody show that the Wild West's "spectacle of struggle and slaughter" awakens the "hidden savage," "stirs the thinnest blood and brightens the dullest eye in the civilized Anglo-Saxon."[63]

In Western films, the self-mythologizing representations of the country's picturesque landscapes developed concurrently with the occupation of the land and the related visualizations of racial difference. In the American images of the West, natural wilderness and Native Americans functioned as each other's objective correlatives within emerging nationalizing and anthropomorphizing iconographies that persistently conflated narratives of place and race. The notion that the Anglo-Saxons were bringing railways and civilization to tame and modernize the wilderness of the West could veil and silence the genocidal destruction of Native Americans, who were then landscaped into a destined doom. A 1909 article on cinema and the railway that appeared in *The Nickelodeon* put it quite succinctly: "From his picturesquely dirty teepee, the modern redman, still primitive, looks solemnly upon the speeding emblem of progress."[64] The homology between landscape and people functioned on the basis of their shared existence as iconic objects of picturesque attraction, as in the panning shots linking natives' dancing and the surrounding cliffs in *Picturesque Colorado* (1911), which simply "reverses," without challenging or disrupting, "the common ethnographic film-editing trajectory from wide shots of a landscape to physiognomical close-ups of its inhabitants."[65] The same homology was at play in the convergence of geography and ethnography. This was made possible, as Fatimah Tobing Rony has aptly observed, by "the idea that one could map human groups just as one maps mountains and rivers." Within the binary vocabulary correlating the opposition "here" and "there"

with "us" and "them," the logistical and aesthetic management of wild landscapes and populations went hand in hand, to the point that "by the late nineteenth century, the word 'ethnographic' had taken on the connotation of 'exotic' and 'picturesque.'"[66] As much research has revealed, a similar convergence of touristic and anthropological modes pervaded the ethnographic photography at turn-of-the-century World's Fairs and exhibitions.[67]

Through landscape paintings, prints, and newspaper and book illustrations, as well as photographs and films, a vast aesthetic, commercial, and scientific mobilization of image-makers dealt with Native Americans as aesthetic appendages, geopolitical pawns for American nationalism, and a conveniently vanishing race. Although not all productions were equivalent, they variously showcased both an aestheticization of the exotic and a popularization of an ethnographic sensibility. Notwithstanding their ambition of ethnographic accuracy, the anthropologist Franz Boas and the photographer-filmmaker Edward Sheriff Curtis could not escape the aesthetic influence of the picturesque. Boas considered "picturesque" those ethnographic representations of authentic primitive customs that were "attractive to the public" and that the ethnographer had kept from vanishing "from a pictorial point of view."[68] Similarly, in his photographs and his film *In the Land of the Head Hunters* (Seattle Film Co., 1914), Curtis's "taxidermic cinema" of America's vanishing races made ample use of a "pictorialist photographic style" of "soft focus, carefully staged mise-en-scène, lighting effects, and sepia toning."[69] In 1915, in the first full-fledged book of film history, Vachel Lindsay admirably noted that Curtis's "ethnological collection of photographs of our American Indians . . . shows the Indian as a figure in bronze."[70] For Boas and Curtis, the picturesque was an effective strategy of constructing, through stylized arrangements, historical records of vanishing races while eliding the presence of the ethnographic observer.

At the same time, an overt ethnographic imagery provided a sense of accuracy and realism to commercial productions. Between the mid-1890s and the early 1900s, Edison, Pathé, Kalem, and Biograph produced popular *actualités* featuring two iconic scenes of Indianness, the ritualistic snake dance and the war council. Several feature films released between 1907 and 1914 resorted to the same ethnographic tableaux.[71] This repeated exposure, as Alison Griffiths argues, trained "nickelodeon

audiences to don the epistemological garb of the anthropologist" and induced filmmakers to incorporate in their films highly codified and recognizable "ethnographic moments."[72] In one of the most successful genres of American fiction production, the Western film, ethnographic displays and racialized narratives were inherently correlated with the representation of natural scenery and its widely publicized topography.

PICTURING THE WEST

The whole scene formed a striking picture, whose frame was composed of the dark and tall border of pines.

JAMES FENIMORE COOPER, *THE LAST OF THE MOHICANS*, 1826

Until 1910, the West was not Westerns' obligatory setting. Several New York–based companies did their outdoor shooting in the more convenient locales of the tri-state area (New York, New Jersey, and Connecticut). The film industry eventually moved west (and south), and ultimately to Southern California, for a host of familiar reasons, including not only better weather conditions but also a greater variety and authenticity of locations. Scott Simmon, Richard Abel, and Andrew Brodie Smith are the scholars who have been most sensitive to the question of the Western film landscape—as production site, narrative setting, and ideological vector. In his *The Invention of the Western Film*, Simmon has identified an early set of Western films, dating from 1908 to 1910, which he has termed "Eastern Westerns," whose landscapes are "lush, woodsy, and wet: filled with lakes, streams, and canoes, of chases through the underbrush, of hand-to-hand fights through forest clearings" and which feature "a 'noble redskin' as guide or savior to the white hero."[73] This familiarly picturesque setting was Western films' initial favorite setting. Two emerging Chicago-based companies, Selig and Essanay, made Westerns in Colorado in the first decade of the century following the same Eastern visual paradigm. Their films were set, as Smith has noted, "in lush, green mountain valleys filled with lakes and rivers."[74] Essanay's own advertisement for *An Indian's Gratitude* (1908) promised, in a tone reminiscent of Thomas Cole, "scenery that the world's artists gaze at in amazement without hope of duplicating . . . [and] that tourists from the old world come thousands of miles to see."[75] Only after 1911, Simmon argues, with the inception of the

"Far-Western," "do we begin to find the wide vistas, rolling grasslands, arid deserts, and those savage Great Plains Indian wars that now appear so fundamental to the genre."[76] These settings were crucial in the effort to differentiate the output of the American film industry from its European rivals. Abel and Smith have shown how the companies that initially used the West to make Western films—Selig first, followed by Essanay and the New York Motion Picture Company—pioneered and greatly emphasized the recognizability of Western locations' distinct Americanness both in their narrative selections and in their advertising strategies. Selig and Essanay, as Smith has written, "set the standard in terms of location shooting in the West and forced other manufacturers to follow their lead. Most important, the firms anticipated the future of the western."[77] Describing *The Cattle Rustlers* (Selig, 1908), Abel has eloquently commented on its use of landscape features of striking scenic appeal. The film, he observes, "includes an *actualité* sequence of rounding up and branding cattle in a mountain valley, repeated scenes of the rustlers' camp beside a swiftly flowing stream, and a climactic shoot-out at a log cabin, isolated on a treeless hilltop and backed by high, distant mountains."[78] At stake was the cultural and commercial development of the Western film genre as the quintessential "American subject" against the foreign competition of such a giant French company as Pathé. Only American companies—as newspaper ads and editorials suggested— knew how to capture such scenes. A *Moving Picture World* ad for Selig's *Western Justice* (1907), for instance, insisted that its "story deserve[d] to be [set] in the wildest and most beautiful scenery of the Western Country."[79] It was not just a matter of a marketing distinction. Under what nativist and supremacist ideologies perceived as the threat of European immigration, Western films appeared to the same trade periodical as "distinctly American in characterization, scenery, and surroundings," and capable of displaying "themes 'racy of the soil.'"[80]

As a genre, Western films trod a double track of ideological and iconographic postures by emphasizing either a conciliatory atonement or a stark confrontation with Native American figures. On the one hand, whites cultivated a sense of nostalgia and regret for the plenitude of the premodern, uncontaminated landscape that Native Americans had allegedly always enjoyed and that, in point of fact, the Westward expansion was spectacularly destroying. On the other hand, pervasive ideas

of inevitable racial progress characterized Indians as a "vanishing race" condemned to witness from afar the predestined conquest of their land. In the actual and symbolic real estate of the genre, location mattered.

The universe of fiction productions set in the West, but most often shot in the East, between 1907 and 1910 comprised what the trade press referred to as "Indian and Western subjects." These films featured "Indian rites" and "Indian pastimes and costumes" and, as Abel notes, "were promoted as 'realistic' spectacles, meant to educate as well as entertain, much like the 'ethnographic displays' or *tableaux vivants* mounted in museums and world's fairs."[81] Even more than the dime novels which, much appreciated by American youngsters, displayed significant interest in the relationships between whites and natives, most Eastern Westerns' focus on Indian characters, settings, and customs conveniently projected onto Native Americans a "natural" inclination toward heroism and self-sacrifice. D. W. Griffith's Eastern Westerns confirm this narrative and ideological direction. His Western productions are uniquely available for study, and as a whole they powerfully exemplify the correlation between production sites and poetic stance.

Griffith's Eastern Westerns made ample use of such picturesque settings as lakes, rivers, and darker woodlands and of picturesque framing practices. Writing about what Griffith shared with other filmmakers of the same genre, Simmon noted that Eastern Westerns "typically sought in the forest landscape small clearings, natural theatrical spaces open to the light and usually framed on the sides by overhanging trees, a Claude Lorrain convention that had been widely adopted into American landscape."[82] By adopting the picturesque aesthetic of the painting tradition of the Hudson River valley, Griffith's early Western films insisted on a reconciled and domesticated relationship with the racial difference of the Native Americans. The many tableau-like shots of forest clearings placed and aestheticized the Indian characters in a harmonic relationship with their pristine, yet familiarly choreographed landscape. In one of Griffith's most celebrated Indian dramas, *The Mended Lute* (1909), ethnographic accuracy went hand in hand with a familiar sense of landscape pictorialism. Aiming at "a heightened pictorial sense of landscape," as Gunning has argued, D. W. Griffith and his cinematographer Georg William "Billy" Bitzer chose to shoot the film not outside the Biograph studios in Fort Lee, New Jersey, as they had been doing up to that point,

but in Cuddebackville, in the Orange Mountain region of New York State, about ninety miles north of Manhattan. There, Gunning continues, the "white threads of a mountain cascade [presented] a picturesque background" providing "lyrical emotional resonance."[83] What the film ultimately embodies is the striking convergence of a tourist setting, resonating with a Europhilic artistic memory, and a Western drama featuring indigenous populations depicted in timeless and admirable agreement with their charming landscape.

Things changed at the end of the first decade of the twentieth century when Griffith, and the American film industry at large, began moving westward, and the lush Eastern forests gave way to the dangerous and barren horizons of arid regions. Between 1909 and 1913 Griffith traveled every winter to California, where he shot his most famous Western pictures, including *The Last Drop of Water* (1911), *The Massacre* (1912), and *The Battle at Elderbush Gulch* (1913). These films differed strikingly from his earlier Eastern Westerns in setting and, consequently, in spirit: the new landscapes of wider and whiter spaces, crowded with wolves and bears (and unforgiving Indians disguised as wolves, as in *The Massacre*), functioned as vectors of hostile racial narratives. As Simmon put it, "Griffith was accustomed to working in a European tradition, inherited via Thomas Cole and the Hudson River painters, in which transcendental beauty was evoked by forested lakes and rivers."[84] The new settings constituted a major formal and ideological challenge for him, as they had been for painters (e.g., Albert Bierstadt, Thomas Moran, and Frederic Remington) and photographers (e.g., William Henry Jackson, Timothy O'Sullivan, William Bell, E. O. Beaman, and John K. Hillers).[85] Like them, he attempted to bring Eastern visual forms to the West. He looked for trees, bushes, and towering rocks to add variety to the mise-en-scène. He made use of so-called "prospect shots" obtained by raising the viewpoint so as to reduce the emptiness of the horizon. He systematically adopted the iris shot, to the point that Karl Brown, Bitzer's assistant cameraman, later recounted that "Griffith never called 'Camera' or 'Cut' as was customary with other directors, but always 'Fade in' and 'Fade out.'"[86] What Simmon cogently argues is that the move to the West dramatically changed Griffith's Western films (and the genre in general). From the standpoint of Native Americans, it was a change for the worse. Set in inhospitable surroundings that were absent in the East,

the resulting narratives displayed a heightened level of racial antagonism and violence which, later on, condemned Native populations to invisibility. This change, which in 1911 was widely registered as a novelty, had no equivalent in the literature of James Fenimore Cooper, which had taught Americans about the nobility of the vanishing Natives. Instead it was aligned with historical events and cultural practices that implied a fiercer racial antagonism and the challenges of its cinematic representation. These events included the Plains Wars of the 1850–80 period, when Native Americans were massacred *en masse;* the ritualistic live pageants of Custer's "Last Stand" that William F. "Buffalo Bill" Cody had staged with incredible success between 1887 and 1905; and Theodore Roosevelt's nativist slogans of "strenuous life" and defense of "blood heritage."[87]

The move to the West challenged the principle that a story's setting is a mere function of its plot line. As Simmon has noted, "eastern landscape asked for one sort of story while western landscape demanded quite another."[88] In the Far-Western, higher prospects, longer shots of vast and treeless spaces, and the closer views of characters that were made to fill the emptier frames othered Native Americans as hostile and barbarian primitives whose racial difference translated into direct menace. The sympathetic and peacemaking narratives of Indians' Eastern exoticism had to find a different way to inhabit the empty spaces of the West, which all too often lent themselves to being filled with racial battles.[89] For the better future of the quintessential American film, both the trade press and the industry were envisioning conciliatory poetics against the heightened racial antagonism of several sensationalist one-reelers. There were a number of options. Western films could legitimize their exhibition of violence against non-white characters. Selig, for instance, made "Indian military" Westerns in Oklahoma and California, including *Pet of the Big Horn Ranch* (1909), with plots of clear-cut moral contrast in which violence was "a fundamental part of nation building and . . . a reflection of whites' pioneering spirit."[90] Another, more cautious option was to avoid any risk of controversy. While it was shooting films in California and Colorado, Essanay's "West" became increasingly empty of racialized figures and narratives. After the negative reactions to *An Indian's Sacrifice* (1910) and *The Mexican Faith* (1910), which featured its leading Western actor and director, Gilbert M. Anderson, in non-white roles, Essanay mostly abandoned the divisive, racially charged conflicts between Indi-

ans and settlers. After setting for the "good rough Western scenery" of the Northern California town of Niles, the company launched the incredibly successful Broncho Billy one-reelers, starring Anderson as the titular cowboy hero. Broncho Billy's outstanding middle-class appeal consisted in his eschewing "Indian fighting, westward migration, or other activities associated with empire building on the frontier."[91] The uncontroversial white masculine hero was a winning formula that the former Shakespearean stage actor William S. Hart used in the mid-1910s for his remarkably popular and stoic film character. In such ambitious multireelers as *The Bargain* (NYMPC, 1914) and *The Aryan* (Triangle, 1916), Hart's character combined the Victorian values of self-restraint, self-sacrifice, and respectability with the new "Western" values of aggressiveness and strength and a Remington-like praise of white masculinity.

Finally, there was another option. If Native Americans and Mexicans were destined to lose their battle with civilization, their narrative trajectory had to acquire romantic tones. The treatment of the landscape could play a vital role in achieving this goal. In this instance, Griffith's *Ramona* (1910) is an emblematic text. Adapted from the popular Helen Hunt Jackson novel (1884), *Ramona* is the story of doomed love between the title character (who in the film is Spanish, but in the novel is Mexican) and Alessandro the Indian, who, for daring to court her, loses not only his home but, most dramatically, his land. The young couple is condemned first to a humble life, but soon to destitution and homelessness as a result of what an intertitle suggests is "whites' persecution." Even more effectively than the numerous stage adaptations, the film strikingly sabotages the familiar Eastern Westerns' motif of a harmonious bond between Native Americans and their natural setting. Both visually and narratively. Ramona and Alessandro experience a sudden and tragic alienation from their land. Positioned in foregrounds of arid mountaintops, their bodies contrast absolutely with the distant and barren background. No middle ground, trees, bushes, or other signposts mitigate their visual and narrative divorce from what was once their environment. By stylizing such disjunction as nostalgia for a lost plenitude, the film fueled, and participated in, an emerging *Ramona*-obsessed tourist and iconographic industry that fetishized the topographical location of the novel—Camulos, Ventura County, California. As Chon Noriega has argued, moving pictures' new and sought-after respectable male audience focused on the

innocent charm of Mary Pickford, who played Ramona, to fill the wide empty spaces of the unjustly confiscated land and thus to aestheticize the tragic destiny attached to her racial difference.[92]

Ramona is also emblematic of a process of narrative expansion and ideological compromise that characterized the Western genre in the early 1910s. Given the decreased critical and commercial popularity of action-packed Western one-reelers, American companies aspired to give the genre a cultural cachet (and length) comparable to that of the multireel historical epics manufactured in Europe. The politics of the landscape were central to the genre's acquisition of importance and recognition, at home and abroad. As Abel recounts, when an enthusiastic press compared Bison-101's 1912 *War on the Plains* and *Battle of the Red Men* to imported Italian epics, the Western genre had succeeded in shucking its dominant association with low-priced juvenile entertainment. It had become "a serious historical subject."[93]

In this very period, in fact, Kay-Bee distributed what was arguably the most ambitious Western film of its time, the three-reeler *The Invaders* (NYMPC, 1912). Produced by Thomas Ince and directed by Francis Ford, the film was shot in the scenic splendor of Santa Ynez, north of Santa Monica, an area of about 18,000 acres, bordered by a canyon and the ocean, which allowed for a unique range of landscapes, settings, and views. *The Invaders* literally narrativized the white man's questionable, yet predestined, takeover of wild natural lands and their indigenous populations. A group of surveyors for the transcontinental railroad arrogantly trespasses on the Indians' land, which a peace treaty is supposed to protect. Through his camera's viewfinder, one of the surveyors catches sight of Sky Star, the Indian chief's daughter, emerging from the unspoiled and unpopulated natural landscape. Mesmerized, he starts courting her. Her Indian suitor, however, has witnessed their tender encounter. The white men's invasion of the land and the seduction of the young princess trigger a fierce reaction. The local tribe attacks and kills the surveyors and besieges the nearby Army fort. Only a last-minute rescue saves the stronghold, where the pacifying Pocahontas-like Sky Star has found refuge, and the defeated Indians are forced to ride away toward a receding wilderness.[94] Ambiguous in its sympathy for Native Americans, this epic production gave impressive narrative and visual significance to the environment: the "landscape is the reality that *The*

3.5. Sky Star (Anna Little) canoeing in a pastoral world: *The Invaders* (New York Motion Picture Co., 1912). Courtesy of the Library of Congress, Motion Picture, Broadcasting, and Recorded Sound Division (Washington, D.C.).

Invaders has over Buffalo Bill's shows," as Simmon aptly put it.[95] It is a reality that reveals a reactivation of Eastern visual and ideological strategies and their deployment in the Far West.

At first, Sky Star wanders through a pastoral environment of wild-flowers, woodlands, and a small lake that Ince had artificially excavated at Santa Ynez (fig. 3.5), realizing that, as landscape historian John Stilgoe puts it, "a landscape happens not by chance, but by contrivance, by premeditation, by design."[96] After this initial "Eastern" scene of Arcadian peace, the film changes register. If "the eastern land itself had been able to provide an enveloping focus under the aesthetics of eastern painters," as Simmon argues, the West "brought a disquiet alleviated only when [its] bright and wide landscapes [we]re set up as empty spaces that must be filled by racial battles."[97] By filling the screen with battle scenes and the last-minute arrival of the cavalry that literally drives the Indians offscreen and off-site (another Western feature of these narratives),

The Invaders can have it both ways, as the ambiguity of its title reveals. It can dramatize and visualize the white occupation of the land while proffering an anthropologically informed sympathy for the violent, yet ultimately vanishing Indians. Through "the best photography as applied to still life, with far greater emotional effects," as an appreciative *Moving Picture World* review put it, the pictorially landscaped and partially redesigned West can ultimately become the most fitting setting for biased nationalist narratives of racial progress and reconciliation of outstanding national and international impact.[98]

Given the outstanding popularity of the picturesque form as pleasurable rendering of roughness, contrast, and variety, its extension to Western scenes was widely recognized as fundamental to the success of the genre. By 1911, several reports confirmed that "scenes of cowboys and Indians" were extremely well-liked at home and abroad as recognizable "American images" because they resonated with an equally popular pictorial tradition. "There is one American article of export out of which fortunes are being coined in every corner of the world," boasted *Motography* in August 1911. "This is the picturesque—what is bizarre, exciting and unusual in American life, chiefly scenes of cowboys and Indians. . . . Exporting the picturesque has thus become a money maker."[99] The very use of the term signals the adoption of a visual convention that exuded authenticity not through an unmediated representation of the landscape, but through optical and choreographic arrangements—"scenes"—resulting in aesthetic delectation of rough and arresting sights.

In accordance with an often explicit homology between racialized landscapes and characters, a comparably productive practice was apparent in performers' racial masquerading. In most of these films, white actors and actresses play the most prominent Native American characters, using heavy makeup and a range of well-codified emphatic gestures and tableau-like postures. This dismayed numerous reviewers, who, in the logic of salvage ethnography, complained about the failure to cast Native Americans "while we still have the real Indians with us."[100] Based on the notion that Native Americans could not act with the same range of dramatic expressions as whites, the practice of racial cross-casting had both ideological and formal implications. Particularly for the roles of Indian characters who adopt Anglo-Saxon customs, the failure to cast authentic Native Americans revealed striking assumptions about

the limits to which they could be assimilated into white America. As we shall see in chapter 5, in the 1910s the same was true of European immigrants who, as "foreign savages" or an "alien mob," were often compared to America's Native populations.[101] In this logic, what activated the performers' mimetic codes of dramatic and even ethnographic authenticity was, paradoxically, their unambiguous physiognomic alterity from the represented subjects—a popular performative fiction shared by minstrelsy.[102] White actors' effective Indianness, in other words, was predicated upon their visible non-Indianness, just as the staged blackness of minstrel performers was predicated upon their known whiteness. Racial form and ideology met in the stylized picturesque "dressing up" of the Indian characters and their landscape. "Communities are to be distinguished," as Benedict Anderson put it, "not by their falsity/genuineness, but by the style in which they are imagined"—and represented, one might add.[103] Only the ploy of redface could turn such subjects into the safest and most commodifiable images of Anglo-Saxon society's rule over Native otherness. Ultimately, the tourist aestheticization of the once pristine American landscape and the romantic landscaping of its Native inhabitants helped ease questions of racial culpability. As Sara Suleri has written regarding English representations of India, the picturesque can "transfix a dynamic cultural confrontation into a still life, converting a pictorial imperative into a gesture of self-protection."[104] The flood of images of the American landscape was a shielding gesture that quite effectively protected image-makers and image-viewers alike from awareness of the territorial destruction and the racial warfare of the Western expansion. And this self-protective gesture was not unique to the Western genre.

GRIFFITH'S GARDENS

Even when not explicitly including individuals of different racial background, stylized landscape views could still convey notions of racial and national identity. Although a hypothesis about the links between race and the representations of natural landscapes ought to be tested on a large sample of American films, an examination of Griffith's "pastoral" and Civil War films provides an instructive lesson on the cinematic currency of the picturesque. As the most prominent American figure of early

narrative cinema, Griffith repeatedly showed a pictorial sensibility for the use of picturesque effects to turn outdoor natural scenes into coherently meaningful landscapes that conveyed ideals of (white) Americanness.

From the beginning of his filmmaking career, Griffith used the recognizable picturesque style to frame and choreograph images of hills, streams, river valleys, forests, and fields in order to evoke a pastoral ideal. This style is visible in his first film, *The Adventures of Dollie* (AM&B, 1908). As cinematographer Billy Bitzer later recounted, Griffith envisioned setting the film "on the lawn of a country residence" near a "picturesque stream."[105] Dressed up in white clothes, the film's ideal American family of father, mother, and child enjoy a harmonious relationship with the idyllic nature surrounding their country home, until a drifting and thus "homeless" gypsy kidnaps little Dollie. The accidental journey of the water cask in which Dollie has been hidden acquires visual and ideological significance. Fallen from the gypsy's wagon and swept over rapids and waterfalls, the cask in the end reaches the quiet cove of the first scene, where it is recovered before the anticipated family reunion. Arcadia has been restored. This popular film's visual and narrative closure clearly resonated with the American pastoral myth at a time when mass internal migrations were injecting country folks and a nostalgia for rurality into urban life. The same nostalgic imagery infused a number of Griffith's modern dramas. It pervaded *The Message* (1909), which Gunning defines as "one of the first pastorals of the cinema." And it inspired the slow and lingering shots of picturesque exteriors at the beginning and the end of the drama of neighborliness *The Country Doctor* (1909), which Griffith "shot in Connecticut, the cradle ground for the American conception of the pastoral landscape."[106]

Like painters and photographers of the American landscape, Griffith's "pastoral dramas" (the phrase used in the *Biograph Bulletins,* the company's press releases) established harmonious relationships between a natural vastness of open, pristine, and uninhabited spaces, virtually absent in Europe, and the closure of a domestic site protected by rivers, pathways, and low walls. "Griffith's way of describing nature for much of his Biograph period," as Jean Mottet eloquently puts it in a rare study of landscape representation in Griffith's cinema, includes a house "perched on the side of a hill, a lake in the distance, a country road edged by a low wall, some trees and sheep in a rolling meadow: all of the signs

of a countryside haven are brought together."[107] The recurring agrarian and visual trope of the homestead epitomized various possible relationships with the natural realm. If the porch signified friendly and confident openness, the picket fence—a defining signature of Griffith's country homes—conveyed a sense of separation and protection from the outside world. In either case, the association of "nature" with "home" spoke of a virtuous, even watchful domestication. Deployed in the paintings of Thomas Cole and the poetry of Walt Whitman, the image of the homestead represented an American *genius loci* of intertwined cultural and political relevance. It could inspire a populist rhetoric, appropriated by social programs that idealized the rural, because it juxtaposed an all-American moral rectitude to the city, the *locus classicus* of moral corruption and menacing diversity.[108] As Mottet summarizes it, Griffith's cinematic "use of bucolic images became tied up with a quest of identity" and, early in the twentieth century, became associated with "how a nation provides for itself new images, new concepts at the moment of a grand new beginning."[109]

As we have seen in the case of Western films, the move to the open horizons of the West did not necessarily prevent Griffith from relying on pictorial compositions to convey notions of national identity and racial difference. Choice of location was undoubtedly a factor, as it was in one of his most expressive sea films, *The Sands of Dee* (1912), whose Santa Monica "beach, sea-worn rocks, and cliffs," as Gunning noted, "provide[d] Bitzer with his most picturesque landscapes."[110] In other cases, even while living in the West, Griffith may have relied on stockpiles of shots of the Hudson River, one of America's most emblematically picturesque views. Bitzer referred to "Hudson River shots" in his autobiography in recounting his accidental discovery of the technique of double exposure: after he processed images shot in Manhattan, the footage revealed "a Hudson River steamer . . . plowing up Broadway."[111] It was in the genre of Civil War films, however, that Griffith operated on cultural and political grounds that were quite conducive to the conciliatory ideology of the picturesque. I am referring to that broad cultural palimpsest that included Civil War stage reenactments and their impressive visual paratext of prints, lithographs, and photographs; an emerging historiography that hailed the Civil War as a unifying American moment, marred by terrible, yet shared, sacrifices; and the related

myth of the "Lost Cause," which spurred the nostalgic myth of the Old South as an idyllic universe of gentlemanly plantation owners and contented slaves.[112] The familiar juxtaposition of the modern, industrialized, and urbanized North and the premodern, bucolic, and genteel South invested the latter with the nostalgic aura of a vanishing way of life, of pastoral scenes and racial harmony. An emphasis on the Civil War films' "usable scenes" may complement Richard Abel's notion of these productions' "usable past."[113]

Unlike the Civil War films made before 1910, which displayed a Northern bias, in the years leading up to the commemorations of the "Golden Jubilee" (1911–15) American films began privileging stories of Confederate heroes and heroines in a spirit of general solidarity and non-partisanship.[114] These films, like the stage melodramas they often adapted, undoubtedly contributed to a climate of reconciliation, but in the nativist context of the early twentieth century, they also fortified a nationalistic Anglo-Saxonist alliance between Northern and Southern whites. "No Grecian phalanx or Roman legion ever knew truer manhood than ... when Anglo-Saxon met Anglo-Saxon," wrote Francis Trevelyn Miller, editor of the ten-volume *Photographic History of the Civil War* (1911)—which incidentally devoted almost no space to black heroes.[115] Griffith's Civil War films participated in this celebration of a racial kinship between white Northern and Southern families. His films often resorted to the trope of paired households, divided families, or love affairs across the Mason-Dixon Line, a narrative solution deployed also in *The Birth of a Nation* (1915) and which, as David Mayer notes, was part of "widely-known and generally-accepted theatrical conventions."[116]

Several of Griffith's thirteen films on the topic begin with farewell scenes, as young soldiers on both sides part from their homes and families. In these works Griffith's use of highly pictorialized landscapes conveys the notion of a tragically contested, yet shared, homeland. In the revealingly titled *In the Border States* (1910), for instance, the most picturesque image is the view of a river from high ground, very similar to stock images of the Hudson River and inclusive of the requisite tree branches framing the sight (fig. 3.6). Its foreground space, we learn quickly, is a soon-to-be-attacked guard post. *The Informer* (1912) features a similarly picturesque and disputed place. These guard posts are coveted strategic sites that juxtapose a logic of military antagonism with one of aesthetic

3.6. The view from a hilltop makes it a coveted guard post in *In the Border States* (Biograph, 1910). Courtesy of the Library of Congress, Motion Picture, Broadcasting, and Recorded Sound Division (Washington, D.C.).

delectation. In the two films members of both armies vie for, and briefly exchange, tactical and visual control over spaces whose pictorial expressiveness refuses exclusive ownership. Similarly, in *The Fugitive* (1910) the most picturesque scenery is a shared hillside view of a river. At first it serves as the setting in which John, a Confederate soldier, bids farewell to his family before going to the front. Within a few scenes he is killed by a Unionist, another young soldier also named John, who escapes retaliation and enters the same picturesque scenery while seeking protection from the mother of the boy he has just slain. The soldier's mother, before and after knowing of her son's death and the fugitive's identity, grants safety to the latter after thinking, as a significant intertitle reads, "of another mother awaiting a son's return." The war destroys sacred bonds that on both fronts, the film clearly suggests, should remain intact. The two crucial settings of the home and the picturesque view of the "Motherland" represent what soldiers, parents, and lovers of all parties share,

visually and ideologically. Although the Mason-Dixon Line was nowhere near the Hudson River, the pictorial form that Griffith deploys is recognizably similar to the visual paradigm of the Hudson River school and its iconographic tradition. Like the numerous scenes of domestic bliss, the "pleasing prospects" of a river conducting the eye toward the horizon or of hills graciously sloping down to the vale called attention to a natural beauty and a communal humanity that, in the visual poetics of the film, withstands the tragic divisions of the war.

Film scholars have often recognized Griffith's profound pictorial sensibility in his 1915 *The Birth of a Nation*. The proclivities of authorial film criticism have all too often emphasized the director's outstanding visual talent. Griffith was not, however, solely responsible for the pictorial design of the film. Karl Brown recounts how on the set of *The Birth* there were about a dozen copies of the newly (and inexpensively) reprinted *Battles and Leaders of the Civil War* (1912), the illustrated exposé of the Civil War first published in four pricy volumes between 1884 and 1888. In Brown's words, *Battles and Leaders* became "the bible of our construction crew," being used to guarantee the accuracy of costumes, make-up, and mise-en-scène.[117] The film's recourse to a familiar iconographic tradition was arguably crucial to a few important narrative settings: the two families' residences, the courtship scenes, the battleground, and the isolated besieged cabin.

By privileging a Southern ideological and topographic perspective, like many Civil War films of the period, *The Birth* made little effort to convey the spatial contours or the outward appearance of the Stonemans' Northern residence. The Camerons' South Carolina house is much more richly visualized, inside and outside, and effectively contextualized on the main street of the town of Piedmont. Most importantly, it looked familiar. "There was no question as to what the town should look like or how it should be dressed," wrote Brown about the construction of this set in a lot at the corner of Sunset and Hollywood Boulevard, "I doubt if there was a man on that work crew who hadn't been out with a 'Tom' show, as the *Uncle Tom's Cabin* shows were called."[118] Its instantly recognizable picket fence separates the "sacred realm" of the Colonel's white family and the pastoral bliss of the Southern residence from the outside forces that threaten that idyllic concord between white owners and black slaves, while still juxtaposing one to the other. After the calm,

the storm. The disruption of the Southern arcadia is visualized as inva-sions of the neighborhood and the home, made by generic black soldiers, the renegade Gus, and the mulatto politician Silas Lynch.[119]

The visual palimpsest of the Civil War epic also included references to the "real-life" (yet often choreographed) photographic coverage usu-ally associated with Mathew Brady, which circulated widely through album cards, mounted prints, and stereographs.[120] A sense of theatri-cality, indebted to the heroic postures of painting and stage traditions, pervaded the mundane appearance of average soldiers and, last but not least, the natural scenery surrounding the views of battles and troop movements. If Griffith relied on Horace Porter's *Campaigning with Grant* (1897) to guide the make-up and costuming of famous leaders, his repre-sentations of armies in motion, battlefields, and natural scenery were in-debted to a host of commemorative illustrated war albums, lithographs, and drawings of various kinds, most notably Paul Fleury Mottelay's *The Soldier in Our Civil War* (1884–85) and Alfred H. Guernsey and Henry M. Alden's *Harper's Pictorial History of the Civil War* (1886).[121] Brown was aware of the pictorial and photographic appeal of the site chosen for the battleground, the old Universal Field, located along the north-ern slope of Cahuenga Mountain. His description of the place, soon known as Griffith Ranch, reads like a manual of picturesque framing and landscaping choreography. It underscores the similarities between a tradition of iconographic representation of battle scenes and the film's actual shooting location.

> The battleground-to-be was ideal for the purpose photographically. A sort of ridge to high ground curved around the rim of a gently descending slope of clear ground that ran down to where the dry-as-dust riverbed of the Los Angeles River lay baking in the sun. There were little clumps of trees clustered on both sides of this open area, with small hills rounding up here and there in the background to provide splendid locations for artillery-men to rake the field with grape and canister, the two favorite close-range charges of the Civil War cannoneers.[122]

When compared to how American cinema was to represent the tragic events of World War I, the extent to which Griffith's visual approach to the Civil War belonged to a long-standing tradition of romanticized de-piction is even more evident. "A modern war is neither romantic nor pic-turesque," Griffith himself noted in a 1918 interview. "Everyone is hidden

3.7. Landscape of Southern heroism: Ben's decisive epiphany in *The Birth of a Nation* (David W. Griffith Corp., 1915). Courtesy of the Library of Congress, Motion Picture, Broadcasting, and Recorded Sound Division (Washington, D.C.).

away in ditches. As you look out across No Man's Land there is literally nothing that meets the eye but an aching desolation of nothingness."[123] By contrast, his cinematic treatment of the most salient moments of the narrative, made particularly effective through the resourceful use of high-angle long shots, relies on familiar picturesque views that exude a sense of reassurance and inspiration. A tactical advance by Confederate soldiers, reminiscent of General Sherman's army, occurs through picturesque Southern scenery according to a tradition of comparable representations that had been appearing for decades in *Harper's Weekly*. Similarly suggestive is the setting of Ben Cameron's historic epiphany. His conception of the Klan occurs in the pastoral setting of a bushy hilltop facing the river below (fig. 3.7).

Toward the end of *The Birth*, the highly dramatized narrative and visual solution of the isolated log cabin reiterates a solicitation of racial solidarity. As an emblem of virtuous American rural life, the cabin had a long history in American political and visual culture, from its as-

sociation with President William Henry Harrison's "Log Cabin Campaign" of 1840 to Thomas Cole's *The Hunter's Return* (1845), Whitman's "Broadaxe Poem" (1856), and the multimedia iconography of Harriet Beecher Stowe's novel *Uncle Tom's Cabin* and Griffith's own *The Battle at Elderbush Gulch,* shot two years earlier. Highlighted by recurring iris shots, the aesthetically precious image of the cabin embodies the common land shared by Northerners and Southerners that must be defended against the black threat. It is a site where "former enemies of North and South," as one intertitle put it, "reunited again in common defense of their Aryan birthright."[124] Lastly, the film's courtship scenes feature only white characters, chiefly Ben and Elsie, strolling through the soft hills, lush meadows, and lazy shores of the South. The final tableau of the two principal lovers "seated on a high bluff overlooking the ocean, with the sunset sending a broad path of light down upon the waters below," seals the film's bond between alluring natural landscape and the white race.[125] Film criticism registered this alliance quite early. Writing in 1915 about Ben Cameron's efforts to rescue his family, Piedmont's victimized whites, and, by synecdoche, the South, the film poet and critic Vachel Lindsay described the heroic scenes of last-minute rescue as a "white Anglo Saxon Niagara."[126] The Klan's leader enters the scene not as an individual, but with the force of one of the most quintessentially American icons, a cleansing natural wonder that, in the ideology of the film, washes the homeland clean of unaesthetic figures.

The national and racial signification of Griffith's visual topology, and that of American cinema generally, would not be complete if it were limited to pastoral settings and natural landscapes. In the second part of the nineteenth century, one of the most recognizably American sites was New York City, the destination of millions of immigrants and the center of the nation's publishing, image-making, and filmmaking industries. After enveloping the Hudson River and the Wild West, the picturesque mode returned to a place that it had actually never left. In America's major urban center, the picturesque projected its formal and ideological cast onto a metropolitan environment of striking racial diversity, in need of conciliatory visions, and crowded with Southern Italians—the picturesque's original subjects.

FOUR

Picturesque New York

I saw one not-to-be-forgotten little picture: it was a woman . . .
with a beautiful child upon her arm, and her dark, coarse shawl
drawn over her own head and the child's, and around him,
achieving one of those mysteriously simple and artistic effects
that semi-barbarians, and they only, seem able to master.

VIOLA ROSEBORO, "THE ITALIANS OF NEW YORK," 1888

As the steamer moves up the bay on the left the Great Goddess
greets you, a composition in colour and form, with the city beyond,
finer than any in any world that ever existed, finer than Claude ever
imagined, or Turner ever dreamed. Why did not Whistler see it?
Piling up higher and higher right before you is New York; and what
does it remind you of? San Gimignano of the Beautiful Towers away
off in Tuscany, only here are not eleven, but eleven times eleven.

ILLUSTRATOR JOSEPH PENNELL, 1912

By 1820, New York, with a little more than one hundred thousand people,
was America's largest city. Its dense urban character, however, could not
dislodge the new nation's defining association with pristine landscapes
of immense prairies, lush forests, and majestic, rocky mountains. Half
a century later, things had changed. After the 1825 opening of the Erie
Canal linking the Hudson River with Buffalo and the Midwestern wheat
centers, New York City went on to become a nexus of both national and

international commerce. In the subsequent decades, the city multiplied its logistical, financial, and economic importance and experienced geographic and demographic expansion on an unprecedented scale. Over the course of the second half of the nineteenth century, New York came to personify both the most dynamic manifestations and the most detrimental excesses of capitalist modernity.[1]

As converging social and economic forces propelled skyscrapers upward, mass circulation and mobility demanded the extension of complex railway systems and the completion of impressive interborough subway lines. Meanwhile, plebeian multitudes of poor American workers and foreigners of different races, religions, and cultures crammed the lower, darker, "pathological" parts of the city—the dreary quarters of shady alleys, filthy boarding houses, opium dens, and all-night dives of the Five Points, the Lower East Side in general, Hell's Kitchen, and East Harlem. In droves the old genteel and the new wealthy classes relocated to mid-Manhattan and uptown.

Newspapers, magazines, and novels, which relied on sensationalist descriptions and statistics, identified the "invading" multitudes of immigrants from Europe and Asia as the cause of American cities' social disorder. Politicians' speeches, newspaper editorials, and cartoons expressed fierce opposition to the unrestricted arrival of strangers across once forbidding oceans. This stance was not surprising. Between 1880 and 1915, more than 14 million Southern and Eastern Europeans arrived in the U.S. From 1850 to World War I approximately a million Asians (Japanese, Chinese, Koreans, Filipinos, and Indians) landed on the West Coast despite numerous restrictions, while, through the imposition of a border, more than a million Mexicans found themselves "immigrants" in a new country. Furthermore, since the early 1910s, thousands of African American former slaves—approximately half a million after 1916—had begun moving northward to urban environments.[2] By 1900, at least 60 percent of the residents of the nation's twelve largest urban centers were either foreign-born or of foreign parentage. In New York City these "urban hordes" approached 80 percent of the population.[3]

To many, however, the disturbing novelty of these immigrants was not just their numbers. Those who came from Europe after 1890, particularly Italian Catholics and Eastern European Jews, were visibly more diverse and "alien" in dress, customs, and religion than earlier immigrants.

Southern and Eastern European immigrants were regularly viewed as imbued with inherited and thus unchanging linguistic, cultural, and devotional characteristics. Since racial discrimination was not just color-coded, such features were often criticized as un-American and explained according to the racial taxonomies and hierarchies developed by the increasingly popular tenets of social Darwinism and eugenics. At the same time, immigrants' deplorable living conditions, stemming from labor exploitation and prohibitive rents, became the subject of a range of urban "ethnographic" discourses interspersed through America's high-brow and popular racial culture. Urban life and racial characters were favorite subjects of mainstream (and sensationalist) journalism, reform-ers' writings, pioneering social and pictorialist photography (Jacob Riis, Lewis Hine, and Alfred Stieglitz), the Ashcan school of painting, the new "realist" literature of William Dean Howells, Theodore Dreiser, and Henry James, and the so-called tenement melodramas of Abraham Ca-han, Fanny Hurst, and Israel Zangwill, as well as of countless vaudeville scenarios.

This chapter discusses how, in turn-of-the-twentieth-century New York, the currency of the picturesque emerged as a significant aesthetic and political mediator. In paintings, photographs, and films (though not necessarily in that order), the picturesque soothed the epochal anxiet-ies associated with the city's modern architectural environment and its startlingly diverse social landscape through nostalgic and familiarly ar-ranged views of nature. "Nature" here refers to a variety of objects and figures, from atmospheric conditions (e.g., snow, winter fog, the darkness of night) to immigrants' primitive and thus precivilized and "natural" living conditions. Once the picturesque entered the usually dystopian palette of reformers, social workers, and urban reporters, the result was a stylized domestication of the modernity of the city's stunning ver-tical growth and street-level unruliness. The picturesque contributed to rhetorically turning New York from a site of grim urban problems into one of uniquely attractive views. The same gesture of "picturing the city" pervaded social and artistic photography, painterly schools and taste, newsreels, and urban travelogues, as well as novels and vaude-ville theatre. This pictorial mediation popularized a way of looking at, writing about, and commercializing the city through a combination of ethnographic and aesthetic appeal that connoted artistry, authenticity,

and realism. Southern Italian immigrants often found themselves at the center of this newly articulated urban picturesque.

BABEL'S PICTURESQUE, OR "THE GREAT HARMONIZER"

New York City was not new to tales of urban decadence. Since the mid-nineteenth century, a literary genre centered on warnings about the moral and civic dangers of mass urbanism had blamed out-of-control urban overpopulation for turning the city into a disturbing *terra incognita*. Combining moral uplift with the familiar tradition of travel writing, in the 1840s and 1850s this popular and profitable genre informed newspapers' exposés, reports by popular magazines (e.g., the *New York Tribune* and the *Niles Weekly Register*), and both pulp and serious novels, by writers ranging from Ned Buntline to Herman Melville.[4] Targeted readers were not only country folks, who might have never visited a large city, but also middle-class urban citizens who would not dare to venture into the teeming lanes and alleys of the lower-class neighborhoods. By the end of the century, America's cultural imagery had repeatedly referred to New York City through the biblical images of Babel and Babylon, thus turning the nation's largest metropolis into the captivating, wicked city *par excellence*. Even taking inspiration from Dante's masterwork, the authors of a richly illustrated exposé of New York ghettoes, *Darkness and Daylight; or, Lights and Shadows of New York Life* (1892), equated the widespread wretchedness of immigrants' "cursed souls" with an urban *Inferno*: "This underworld would appall even Dante," they wrote.[5] The literary metaphor turned literal when it became known that numerous immigrant criminals freely plagued the urban sewers, one of the city's most vital, yet least visible infrastructures.

Hailing themselves as pillars of the American social order, apprehensive moral crusaders and reformers translated these literary and journalistic exposés through the scripts of the new social sciences. Combining data reporting with such plain graphic representations as "nationality maps," which showed the origins of the inhabitants of each district, reformers broadcast a depressing view of New York "as solely the site of urban problems."[6] They blamed either the immigrants themselves, or the environment in which they happened to live, for the city's much-publicized problems. Over time these two explanations deeply affected

American media's racialized dramaturgy. If the first augmented narrative determinism, the second allowed for a range of tales of immigrants' adaptation and adjustment to America's physical, social, and moral environment.

Generally Protestant, reformers intended to identify and sanitize, both medically and morally, the disturbing diversity of the increasingly numerous Catholics and Jews. Some of them viewed the immigrants' miserable living conditions as the result of such religiously coded vices as "self-indulgence," "idleness," and "filth." Several New York organizations aiming at social betterment, such as the Society for the Prevention of Cruelty to Children and the Charity Organization Society, operated under the assumption that, in large part, the roots of poverty lay in "the characters of the poor themselves."[7] In order to instill habits conducive to higher moral standards, they aimed to scientifically diagnose and document each individual's temperament and character.[8]

Less patronizing settlement workers, on the other hand, while still maintaining that poverty, crime, and child abuse had to be documented, were more concerned with the moral and industrial environment surrounding immigrants, rather than with their inner "moral fiber."[9] Part of a larger moral reformism that emerged during the 1890s in New York, Chicago, and other American cities and not necessarily linked to religious organizations, the campaigns of these enlightened social workers had familiar moral goals, but also larger and quite tangible political aims. They not only denounced organized gambling, blatant brothels, and saloons, but also promoted wage-and-hour legislation, child-labor laws, and factory safety regulations. Their most radical remonstrations were directed at cities' political leadership. Tammany Hall and other political machines were held responsible for widespread corruption and civic dissolution, especially police connivance with prostitution, gambling, and liquor-law violations.

While considering the material conditions in which immigrants were forced to live as an effect and not a cause of their poverty, these less deterministic reformers worked to create an alternative, healthier urban environment, with parks, playgrounds, gyms, swimming pools, and public baths. In the words of an 1895 New York State Tenement House Committee, these venues were meant to have a "favorable effect ... upon character; tending to self-respect and decency of life."[10] Soon, the

power of the environment to shape immigrants' lives was scientifically recognized, mainly through the work of sociologists, criminologists, and cultural anthropologists. Variously aiming at issues of social control, urban order, and racial knowledge, Franz Boas (himself a Jewish immigrant) and, later, Robert E. Park disputed standard contentions of racial or biological determinism, attributing group differences primarily to the dynamics of cultural adaptation in that privileged "laboratory" that was the city.[11] The "human ecology," a concept introduced by Park, became an important framework for the study of social pathologies, including group conflict, overpopulation, and community deviance. For instance, in the mid-1910s, the antiprostitution movement spoke more of social hygiene than social purity, and referred to the problem as one of public health rather than blaming individuals' (inherited) moral defects. This environmentalist emphasis also informed a number of popular forms of dramatic representation, both literary and cinematic.[12] Without utterly relinquishing the power of individuals' racial difference (often coded as civic and moral dissonance), human ecology allowed for sympathetic narratives addressing immigrants' efforts to adapt to their difficult environment. American cinema witnessed this change from the early 1910s. As I discuss in chapters 5 and 6, films depicting Italian immigrants as victims of criminal exploitation and deceit were often indebted to this second reformist stance, which hardly ever referenced America's non-white populations.

Tourist operators, real estate developers, and business groups also established an influential constituency that had a vested interest in broadcasting positive and appealing images of the city. They endeavored to represent its diversity and its difference from the rest of America, but also its quintessential American character. Beginning in the 1880s and 1890s, these boosters of the image of New York, as cultural historian Angela Blake has called them, aimed at depicting the city as an attractive place for its commercial and cultural liveliness and its novel visual appeal. Rather than promoting a "topography of social problems located in isolated urban pockets," boosters stressed the city's "topography of 'sights,'" which included new buildings, museums, shopping districts, and Central Park.[13] By emphasizing fluidity and mobility in contrast to barriers and stark divisions, they associated a new, reassuring knowability of the city with a regime of views from above. Like the architectural view paintings

of the seventeenth century and the panoramas and dioramas of the eighteenth and nineteenth centuries, which highlighted and exalted cities' most relevant political and architectural symbols, panoramic views from atop the 309-foot-tall New York World Building, the Singer Building, or the Metropolitan Life Tower, reproduced on canvas, paper, or film, emphasized the modern city's dynamic media and business enterprises. As the outpost of American architectural modernism, New York became known for its uniquely monumental skyscrapers. Its drawn, engraved, or photographed "views from above" advanced a form of visual pleasure which, by linking commercial dynamism with aesthetic grandeur, freed the emerging class of urban tourists "from the finger-wagging of the reformers and their demands for civic responsibility."[14]

Viewed through the lens of a touristic paradigm, even the immigrants' living quarters became tourist destinations, and their racial and cultural diversity developed into an attraction. In the 1890s, tourist guidebooks stopped describing certain sections of the city, such as the Lower East Side, as exclusively sites of danger and immorality. This, of course, did not mean that interest in those pockets of Manhattan had diminished, but only that they had become colorful sites of middle-class tourist and ethnographic interest. "In no place on this continent," boasted the guide *Hints for Strangers, Shoppers, and Sight See-ers in the Metropolis* (1891), "can a visitor view such a kaleidoscopic scene as is continually presented by the crowds upon our streets."[15] The transformation of the city into an alluring site of exhibition standardized routes and stops along Fifth Avenue or Broadway, while guided tours took tourists safely to Chinatown and "the Ghetto." Through postcards, stereographic views, and photographic albums, American tourism patterned a respectable sightseeing experience of the Lower East Side that would anticipate, inform, and later parallel film spectators' voyeuristic access to immigrants' miserable quarters and lives. This process was defined by the familiar and transnational aesthetic of the picturesque, which in New York acquired conspicuously American features.

Unlike the "darkness and daylight" rhetoric common in mid-nineteenth-century descriptions of the city, which relied on dramatic social and moral contrasts, turn-of-the-century New York culture promoted ideas of cosmopolitan patriotism. Following the victory against Spain, which had sanctioned America's imperial ambitions overseas, attempts

were made to recast the country's most diverse and modern metropolitan center as an "American" place. That meant focusing on the city's two defining features—its earthbound low-end tenements and its sky-scraping high-rise buildings—and on their aesthetic and ideological relationship. If mass migrations and immigrant quarters were readily recognized as emblems of America's multinational fabric, what identified the city's skyline as "American" was a uniquely architectural structure, the high office building. Rather than merely indexing pure verticality, the high office building represented a uniquely American combination of economic utility and aesthetic appeal—as attested by the widely admired Beaux Arts style of several banks that tourist guides featured as architectural attractions.[16] The aestheticization of the city's skyline ended up recalling familiar Old World practices. The renowned illustrator Joseph Pennell (1858–1926), who worked for *Scribner's Monthly* and *Century* and illustrated the Italian journeys of William Dean Howells, Maurice Hewlett, and Henry James, repeatedly compared New York City to Italian cities.[17] To him, the modern primacy of the former was unchallenged, although it was proclaimed by comparing it with any representative of the latter group. Viewed from the bay, the American metropolis appeared to Pennell to display a "colour by day more shimmering than Venice," and, even when compared to renowned Tuscan centers, New York was superior, a "gold, glittering city." The American metropolis embodied a new and better "postcard from Italy": "New York is a San Gimignano glorified."[18]

What further turned the metropolis's cityscape into an American emblem was its powerful association with scenery that had already become the ultimate natural (not urban) representation of American identity. As Angela Blake writes, "In the early years of the twentieth century, efforts to incorporate the seemingly unnatural and incomprehensible environments of the Far West and Manhattan into a nationalist iconography brought together these two otherwise dissimilar landscapes."[19] In the context of the ongoing rivalry with the European landscape aesthetic, the ascription of Western-style rocky features to New York skyscrapers—Pennell had described them as "mountains of buildings" and "mighty cliffs," and the spaces between them as "canyons"[20]—naturalized both the appearance and the American character of the city's modern vertical skyline. Because skyscrapers were built without a municipal plan, emerging more or less "spontaneously" according to real

estate costs, building utility, and patrons' wealth, they materialized so "naturally," erratically, or irregularly that a contributor to *The Craftsman*, the mouthpiece of the American arts and crafts movement, found them "picturesque."[21] Not only could New York claim to embody an urban version of the American picturesque, but the city's own Americanization modernized the definition of America. As Blake eloquently concludes, "both skyscrapers and mountains were necessary to the development of an American New York."[22]

New York–based American cinema devoted a number of films to the city's emblematically American monuments, spectacular squares, and hectic traffic. In the late 1890s, Edison alone made several such films, including *Herald Square* (1896), *Statue of Liberty* (1898), and *New Brooklyn to New York via Brooklyn Bridge* (1899).[23] The attraction of the city's skyline and street life was both international and long-lasting. In 1896, Lumière made *New York, Broadway at Union Square* (1896), while in 1902–1903 the American Mutoscope & Biograph Company was still making such urban travelogues as *Broadway and Union Square, New York* and *Scene on Lower Broadway*.[24] Of all the city's architectural attractions, a favorite subject was the Fuller Building, widely known as the Flatiron Building. One of the tallest buildings in New York City upon its completion in 1902, it appeared in countless illustrations, including Pennell's etchings, artistic photographs by the likes of Stieglitz (1903, fig. 4.1), Edward J. Steichen (1904), and Alvin Langdon Coburn (1906 and 1911), and urban travelogues, including American Mutoscope & Biograph's *At the Foot of the Flatiron* (1903) and *Panorama of the Flat Iron Building* (1903, fig. 4.2).[25] The stylistic recurrences involved in several representations of this building are revealing. The depictions of the Flatiron Building—amidst winter fog, through tree branches, or on windy days—reveal the protocol of the picturesque mode at work: the compositional agreement of variety and contrast. What are such variety and contrasts about? They display the insertion of natural elements into most urban scenery—Stieglitz's fondness for horses is famous—the disparity between the city's utilitarian grid of avenues and streets and the

4.1. (*opposite*) Alfred Stieglitz, *The Flatiron Building*, gravure on vellum, 12⅞ × 6⅝″, 1903. Plate 1 from *Camera Work*, no. 4 (October 1903). © 2008 Georgia O'Keeffe Museum/ Artists Rights Society (ARS), New York. Digital Image © The Museum of Modern Art/ Licensed by SCALA/Art Resource, New York.

4.2. *Panorama of the Flat Iron Building* (American Mutoscope & Biograph, 1903). Courtesy of the Library of Congress, Paper Print Collection (Washington, D.C.).

dark alleys of its immigrant quarters, and the striking contrast between the frenzied vertical development of new office buildings and the restive composure of old and elegant brownstones—as in Stieglitz's *Old and New New York* (1910). Writers, illustrators, and photographers often referred to these living contradictions as the alluring chasm between "New New York" and "Old New York."

Whether evoked in the impressionistic style of paintings, etchings, and films or invoked in critics' writing, one aesthetic trope was repeatedly made explicit: picturesqueness. The concept was both aesthetically and ideologically useful: not only did it stress the modernity of the New World metropolis in opposition to classical notions of urban beauty and splendor, but it also injected a familiar aesthetic quality into modern metropolitan settings. In his *The New New York* (1909), richly illustrated by Pennell, the art critic and historian John C. Van Dyke was adamant: "Those who have erected the new city, as need has dictated, have builded better than they knew. They have given us, not the classic, but the picturesque—a later and perhaps a more interesting development."[26] At the

same time, in his 1900 essay "Plea for the Picturesqueness of New York," critic and poet Carl Sadakichi Hartmann stressed New York's proximity to stereotypically picturesque views. Looking northward from the Highbridge Reservoir, the King of Bohemians, as Hartmann was known, noted, "The wide Harlem River sluggishly flowing through a valley over which two aqueducts span their numerous arches—reminds one involuntarily of a landscape of Claude Lorraine."[27]

The critics and artists who made wide use of the notion of picturesqueness in describing New York City seemed to agree on its century-old meaning. In an 1892 *Century* essay titled "Picturesque New York," art critic and pioneering advocate for landscape architecture Mariana Griswold Van Rensselaer declared, "The essence of picturesqueness is variety; and the charm of variety is more easily appreciated than the charm of simple and pure perfection."[28] Twenty years later, Van Dyke similarly contended that New York's "variety is startling, disturbing, even shocking at times. It is a city quite by itself, a city of contrasts."[29] Yet what did this variety consist of? On the one hand, the word referred to how heterogeneous and multidimensional the city appeared when viewed from afar, at night, or in misty weather conditions. "The most picturesque of all the sights that New York offers," Van Rensselaer insisted, is "when seen at night from a boat on the water. The abrupt, extraordinary contrasts of its sky-line are then subdued to a gigantic mystery."[30] In this aestheticization of the city, crowded with familiar props ("the bridge always playing its part"), writers, photographers, painters, and filmmakers hailed the atmospheric conditions as an ideal painterly catalyst. A common thread links *The Blizzard* (AM&B, 1899) with the photographs of the Flatiron Building and with numerous paintings by Ashcan artists, most prominently Childe Hassam, John Sloan, Robert Henry, and George Bellows.[31] It is the principle, voiced by John Corbin in a 1903 issue of *Scribner's Magazine*, that "the flurries of snowflakes [make] the commonest city sights loom vague and mysterious."[32] It is the principle, in other words, of pictorial suggestiveness that holds true even when the image-making medium is celebrated for the neatness and truthfulness of its indexical reproductions.

Another kind of variety contributed to the city's suggestive picturesqueness. If one moved away from the open spaces of squares and large avenues to the narrow and crowded alleys of the immigrant quarters,

CHEAP CLOTHING—THE SLAVES OF THE "SWEATERS."—DRAWN BY W. A. ROGERS.—[SEE PAGE 335.]

4.3. W. A. Rogers, "The Slaves of the 'Sweaters,'" *Harper's Weekly* 34, no. 1740 (26 April 1890): 333, wood engraving, with a Flatiron-like building in the background.

a social scenery of superb national and racial variety opened up. "We cannot appreciate the picturesqueness which New York wears to both mind and eye," Van Rensselaer noted in 1892, "unless we go immediately from the stately commercialism of its down-town streets to the adjacent tenement-house districts."[33] Many tourist boosters, metropolitan businesses, and city journalists could not avoid considering this contrast. Whether published in monthlies of general interest or in photography periodicals, a number of essays stressed the appeal of immigrants' presence and lives in pure pictorial forms. Writing about the city's human variety, Van Dyke made reference to a familiar image when describing the restless mass of immigrants as showing "as little repose in its streets as in the lava stream of a volcano."[34]

The fact that turn-of-the-century New York was the only place in America where the vast majority of the population were either immigrants or the children of immigrants could in and of itself defy all efforts to turn the city into a beacon of Americanism. A different perspective was required, one that could hail such extraordinary diversity as itself a marker of Americanism—against the dystopian perspective of some reformists' rhetoric. The pictorial aestheticization and containment of the city's social diversity provided such a new *Gestalt*. It tamed and absorbed the city's chaotic variety of races and national customs into a sign of the New World's cosmopolitanism, which turned New York into the country's most modern face and, in the process, urbanized the face of America.

Since the mid- to late nineteenth century, New York–based media had endeavored to document the terrible living conditions of the city's immigrants. The daily and periodical press, from Pulitzer's *World* to *Frank Leslie's Illustrated Newspaper,* published engraved reproductions of drawings and cartoons which, along with the popular prints of Currier & Ives, regularly othered the city's unhappier denizens. Toward the end of the century, however, these publications provided less distancing forms of coverage.[35] Following the influential and Dickensian example of John Thomson and Adolphe Smith's *Street Life in London* (1877), the first study of urban poverty that combined text with photographs and a stylized paradigm of urban realism, the American press showed another form of paternalistic attention to the poor. In this period, illustrator William Allen Rogers (1854–1931), with his artistically conceived drawings

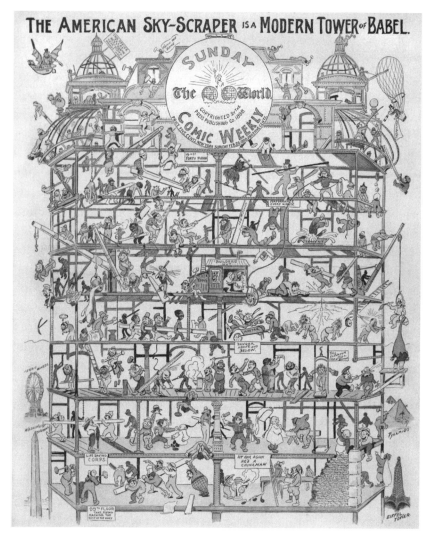

4.4. "The American Sky-Scraper Is a Modern Tower of Babel," *World,* 20 February 1898. Cover of the comic weekly section; art by Dan McCarthy. Used by permission of the Rare Book, Manuscript, and Special Collections Library, Duke University (Durham, N.C).

of the daily plight of the destitute immigrants, often caught against the backdrop of imposing tenement buildings (fig. 4.3), became "*Harper's* specialist on the picturesqueness of poverty."[36]

Perhaps the most effective and literal assimilation of skyscrapers and immigrants in the promotion of the city's "American" diversity was an extraordinary cartoon, titled "The American Sky-Scraper Is a Mod-

ern Tower of Babel," which the illustrator Dan McCarthy published in 1898 in the Sunday edition of Pulitzer's *World* (fig. 4.4). In a spectacle of witty *mise-en-abyme*, the cartoon celebrated and lampooned both the verticality of New York's skyscrapers—the World Building was one of New York's tallest and most famous structures—and the city's cultural, racial, and physiognomic heterogeneity. McCarthy exaggerated the already impressive size of the building to make it dwarf even the Egyptian pyramids, the Washington Monument, and the Eiffel Tower. Yet he also looked at the skyscraper as a "slapstick game of Chutes and Ladders" and, through an imaginative physiognomic rendering of every racial group (and a number of racist inscriptions), turned the architectural structure into a Tower of Babel where every possible accident becomes a jesting and picturesque tableau.[37]

By the late nineteenth century, the association of poverty with visual enchantment was familiar. "I have seen Mulberry Bend on an October day," Van Rensselaer wrote, "when it was just as full of Italians, lounging, eating, working, gossiping out of doors, with faces as beautifully brown and ruddy, teeth as white, smiles as quick, speech as voluble, jewelry as profuse, and garments as party-colored, as though they were at home in their Naples; and the New York sun gilded them as radiantly as though it had been the sun of Naples." On the same page she is even more explicit in her aestheticization of destitution and has no trouble claiming that "loathsome abodes of filth and horror . . . gratify the eye that seeks pictorial pleasure."[38] Hartmann was even more daring. After describing the "Hebrew quarter" as "undoubtedly the most *picturesque* part of New York City, i.e., the one which lends itself most easily to artistic interpretation," he clarified his account. The quarter's "very dinginess and squalor render it interesting. For filth—as disagreeable as it is in actual contact—is *the great harmonizer* in the pictorial arts, the wizard who can render every scene and object—even the humblest one—picturesque."[39] That immigrants' destitution and urban squalor was described in purely aesthetic terms—"the *great harmonizer*"—is significant for a number of reasons. It surely reveals a conservative political stance: social inequalities are reduced to decorative elements and thus expunged from any politics of social change. By making them into a scene, they are instantly reconciled or, better, "harmonized." On the eve of the American embrace of artistic modernism, the same statement is

also significant in purely aesthetic terms: the power of the picturesque domestication of urban poverty is understood in the formal terms of color and texture. "Even the ordinary garbage dump, with its heaps of shining tin cans," Hartmann added, "contains such a wealth of subtle values and warm color notes and such varieties of texture that it should send, not only painters, but every person in search of the picturesque into ecstasies."[40]

In the face of the challenges of representing the threatening modernity of the city, the picturesque presented reassuring associations with nature and the past. This holds great significance for a discussion of racial representation. As Douglas Tallack significantly put it, even without mentioning race, "if nature again mobilizes the picturesque by effecting a backward link and compositionally organizing the picture, nature is not necessarily about to disappear."[41] Tree branches, harsh weather conditions, and nightly mist introduced nature (and variety) to the urban environment. The premodern, and thus allegedly slightly uncivilized, Old World immigrants introduced social and racial variety.

Thus at the turn of the twentieth century the picturesque operated as an aesthetic and ideological mediator. It mediated the transition from Old to New New York by domesticating both. It fostered a cogent aestheticization of the Old World's racial variety crowding the city's low quarters. As historian Peter Conrad has put it, "picturesqueness tolerates the city's social inequalities as a decorative enhancement."[42] It also contained the city's hyperutilitarian and alienating capitalist and urban development by projecting onto its vertical symbols familiar aesthetic models, whether drawing them from Europe or the Far West. In the process, the picturesque enabled photography to overcome the allegation of being a mere mechanical instrument of reproduction and aspire to artistic status—a move that later affected both commercial and avant-garde filmmaking practices. The career of photographer Alfred Stieglitz, the iconic American promoter of photography as art, best embodied these multiple mediations.

A frequent Grand Tourist and a friend of Zola, Stieglitz concentrated in his earliest photographs on the picturesque landscapes and peasants of Venice, Holland, and Germany.[43] In an 1896 editorial in the New York–based *Photographic Times*, Stieglitz described his experience "among the street urchins and peasant folk of Venice." "Nothing charms

4.5. Alfred Stieglitz, *Winter, Fifth Avenue*, 1893. © 2008 Georgia O'Keeffe Museum/ Artists Rights Society (ARS), New York. Photo Credit: Digital Image ©The Museum of Modern Art/Licensed by SCALA/Art Resource, New York.

me so much," he submitted, "as walking among the lower classes, studying them carefully and making mental notes."[44] A year after one of his trips he published a luxury portfolio of twelve photogravures printed on paper. Titled *Picturesque Bits of New York and Other Studies* (1897), the

collection captured the movement of the picturesque from its traditional European settings to urban America: it contrasted images of the Dutch seashore and Venetian canals with the famous and influential *Winter, Fifth Avenue* (1893, fig. 4.5) which, as fellow photographer J. Nilsen Laurvik maintained, "blazed the way for a whole school of painters who set themselves the task of depicting the streets and life of New York."[45] The publication inaugurated a wave of volumes collecting high-quality intaglio prints of photographs of New York whose titles were all forms of *Picturesque New York*.[46] "The picturesque offered Stieglitz," as photography historian Douglas Tallack best put it, "the possibility of retaining aura in a medium that came to typify its loss through the reproducibility of the image."[47]

Inspired by an established pictorial tradition, Stieglitz publicly distanced himself from amateur practitioners' aesthetics in the name of the artistically ambitious project of "pictorialist photography." After forming ties with the British photographer Peter Henry Emerson, known for his exquisite atmospheric effects and stylized natural landscapes, Stieglitz surrounded himself with painter-photographers such as Edward Steichen. He then founded an enterprising art gallery, known as "271" from its Fifth Avenue address, and an influential journal, *Camera Work*, which he edited from 1902 to 1917 and which treated photographs as objects with intrinsic semantic autonomy and as precious works of art and craftsmanship. Both in his gallery and on the cover of his magazine, he gave unprecedented space to Europe's modernist and avant-garde artists (e.g., Picasso, Matisse, Rodin, and Cézanne), who inevitably influenced his work. Eventually, the picturesque, which brought artistic considerations to subjects not usually associated with art, "could not cope with the direction of, and form taken by, change in New York City from the 1910s onwards, on the one hand, and degrees of fragmentation within abstract modernism on the other."[48]

Still, "the picturesque provided a means for visualizing change in the years before abstraction, offering ways of seeing the emerging modern city was that New York."[49] Describing in 1942 one of his widely admired photographs, titled *The Steerage* (1907), which showed immigrants aboard a ship returning to Europe, Stieglitz did not refer to the memorialization of the immigrant experience, in the ways a social photographer would have done. Instead, he spoke of Cubist pure formal elements. "You

may call this a crowd of immigrants," he wrote. "To me it is a study in mathematical lines, in balance, in a pattern of light and shade."[50] What might once have been mistaken for a picturesque depiction of plebeian migrants had become the subject, as Alan Sekula later put it, of a "pure symbolist autobiography."[51] Devoid of its iconic meaning, the photograph has become abstract art—a degree of aesthetic investment that Paul Strand's *Manhatta* (1921) realized, but which did not characterize mainstream American film productions.[52]

The sophisticated artistic and critical contributions of Stieglitz and the aforementioned critics showed how pervasive the picturesque had become in American highbrow culture. In the 1890s, just before the inception of America cinema, two important figures, Jacob A. Riis and William Dean Howells, propelled the notion of the picturesque into the mainstream of American visual and literary culture. By looking at and writing about New York ghettoes as a foreign country populated by exotic subjects, Riis and Howells endeavored to soothe the perception of immigrants as frightening foreigners. Their articulation of an "urban picturesque" turned the oft-cited shocks of modernity into minor jolts, expected surprises filtered through a reassuring touristic paradigm that veiled immigrants' destitution and supposed racial inadequacy, making them into a pleasurable exoticism that aestheticized and depoliticized their lives. As an aesthetic and sociological currency, the "urban picturesque" helped make sense of and manage the diversity of urban immigrants and, in Carrie Tirado Bramen's words, "helped to equate ethnic variety and urbanism with modern Americanism."[53]

POPULAR PICTURESQUE DRAMATURGY

Half the people in 'the Bend' are christened Pasquale.... When the police do not know the name of an escaped murderer, they guess at Pasquale and send the name out on alarm; in nine cases out of ten it fits.

JACOB RIIS, *HOW THE OTHER HALF LIVES,* 1890

[The city] affords [the poor] for nothing the spectacle of the human drama, with themselves for actors.

WILLIAM DEAN HOWELLS, "NEW YORK STREETS," 1894

At the crossroads of social work, literature, and visual media stood the key figure of Jacob Riis (1849–1914), a Danish Protestant immigrant who worked first as a police reporter, then a social worker, and, most famously, a writer, lecturer, and photographer. His illustrated collection of narrative sketches of the New York ghettoes, titled *How the Other Half Lives* (1890), catapulted him to fame with its pioneering combination of ethnographic journalism, reformist moralism, and gripping photographs.[54] Organized in chapters devoted to individual "racial" groups— Italians, Chinese, Jews, Bohemians, and Blacks—the book's ideological shorthand capitalized on, and further promoted, the reification of racial differences into national types. Today Riis is mainly known as one of the earliest social photographers, who made the most of the discovery of flashlight photography, but at the turn of the twentieth century his fame rested on his merits as a "slum writer" and lantern-slide lecturer.[55] As one of the most famous housing reformers of his era, Riis was an energetic and moralistic mix of jingoist and evangelist, pietist and social scientist. The ethnographic aesthetic of his prose, lantern-slide presentations, and photographs also expressed a combination of strictness and understanding. Sympathetic to the coercive policies of preaching politicians like Roosevelt (who was his mentor), Riis reiterated rigidly coded depictions of racial characters and types. Yet, while working to elevate individuals' ethical character and behavior, he was also a major exponent of environmental reformism. As chair of the Small Parks Advisory Committee of New York, Riis strove to establish parks, playgrounds, and bathhouses in the vice-ridden ghettoes of New York to grant a chance for self-improvement to children whose behavior he did not consider due to any personal moral defect—although a certain racial determinism did permeate his work.

This pervasive double track of caring sympathy and moralism informed Riis's wavering attitude toward Italians. The Danish American author, who had learned English from the novels of Charles Dickens and James Fenimore Cooper, sympathized with the thousands of Italian immigrants for their pitiful living conditions in the Bend and showed a consistent appreciation for their renowned familial dedication. Still, like an American tourist back from Europe, he described them as "certainly a picturesque, if not very tidy, element" and marveled at their "Mediterranean exuberance."[56] His exoticizing distance informed a number of

4.6. Jacob Riis, *The Mott St. Boys "Keep off the Grass" Sign,* ca. 1890. Used by permission of the Museum of the City of New York, The Jacob A. Riis Collection (Riis 125).

negative and racializing portrayals. Riis saw Italians as clannish, fatalistic, often emotionally unrestrained, and, unlike their Jewish neighbors, disturbingly reluctant to embrace the sacred American ethos of upward social drive and abandon their poverty. His distrust of their willingness to assimilate was particularly augmented by his sharing of the increasingly widespread, unmistakably nativist distinction between Italy's Northerners and Southerners.[57] Rehashing the anti-South prejudices developed since the 1860s and 1870s by Italian anthropologists, economists, and cultural commentators, Riis distinguished between hard-working Northern Italians and swarthy Southern peasants, "avowedly the worst of the Italian immigration," who "wash less, and also plot less against the peace of mankind, than they do in the north."[58] Adopting widespread prejudices about Southern Italians' atavistic criminality, Riis also referred to Neapolitans and Sicilians as ruthless brigands or members of Camorra or Mafia organizations, engaged in daily violence against and blackmail of honest but vulnerable countrymen. His celebrated photograph, *Bandit's Roost,*[59]

½ *Mulberry Street*—shot on a stereographic negative in the company of amateur photographers Richard Hoe Lawrence and Henry G. Piffard in a narrow, filthy alley in Mulberry Bend—captured the dark, dangerous, but fascinating quarters most Americans would never have dared venture into. It also posited local bandits as specimens of a highly aestheticized ethnography made popular by books, lantern-slide shows, and magazine illustrations. As Yochelson emphasizes, "produced by the millions in the nineteenth century, stereographs, often of tourist sites, were a popular form of parlor entertainment."[59] Likewise, the most sensationalist and morally pressing form of slum exposé involved children. In the very same period, Riis's visual and literary attention to minors (and childlike adults) maintained racially coded characterizations while adopting a tone of sentimental pathos and condescending pity (fig. 4.6).

The actual medium of Riis's ideological interventions inherently shaped his message. Not only did his photographs expose the wretched hardship of immigrant ghettoes, but his literary and journalistic characterizations drew distant middle-class readers closer to individual immigrant figures. "Half of the world does not know how the other half lives," the introduction to his bestseller forewarned. Besides repeatedly employing racial and national typing (of Italians, Chinese, Jews, Bohemians, and "Negroes"), Riis chose individuals—young drifters, street food vendors, and rag-pickers—and naturalized their daily customs as racial traits before turning these characters into unfortunate individuals who merited sympathy. While characterizing Italians as part of the non-Anglo-Saxon "other half," he granted them redeeming features, thus effectively translating racial theories into literary characterizations of vice and salvation. As a reviewer for the *Indianapolis News* put it at the time, "[he] knew how to put scientific and sociological truths in such a way as to make one think he was reading romance."[60]

Despite his claims of realism, Riis knowingly manipulated his photographic images by exaggerating the effects of the flash, arranging the dirt and chaos of the domestic interiors, and using "jagged-edge" framing to convey a sense of instantaneous reporting. Still, he admitted that he aimed to produce an experience of voyeuristic slumming, a form of armchair tourism. "The beauty of looking into these places without actually being present there," he recounted in an 1888 interview, "is that the excursionist is spared the vulgar sounds and hideous scents and repulsive

4.7. Lewis W. Hine, *Fresh Air for the Baby, Italian Quarter, New York City, 1910*, gelatin silver print, black and white, 21 × 26 cm, 1910. Used by permission of the Photography Collection, Miriam and Ira D. Wallach Division of Art, Prints and Photographs, The New York Public Library, Astor, Lenox and Tilden Foundations.

exhibitions attendant upon such a personal examination."[61] Keith Gandal neatly summarized the appeal of Riis's exoticization of poverty in now-familiar terms: "What is bad for Protestant virtue—filth and crowds, is good for viewing pleasure."[62]

Riis's first snapshots of the New York slums struck a fine balance between a concerned responsiveness to immigrants' racial and cultural difference and contemplation of their quaint folkways. As such they appear to continue the picturesque exoticizations of urchins, *lazzaroni,* and wearying destitution that Giorgio Sommer and the Alinari firm were producing in Italy at the time, often arranged in proto-ethnographic frontal poses of atavistic idleness or superstition (fig. 2.6). Riis's pioneering social photography influenced the work of other, more skilled practitioners, including the Wisconsin-born Lewis W. Hine (1874–1940). A staff photographer since 1908 for the National Child Labor Committee and for the magazine *Charities and Commons* (later called *Survey*), Hine focused his work on newly arrived immigrants in New York and on child laborers throughout the country. Conceived within the framework

of social work advocacy, his images nonetheless exhibited remarkable aesthetic qualities, as is evident from the heartbreaking and stylistically defiant photo-study *Fresh Air for the Baby, Italian Quarter, New York City, 1910* (1910, fig. 4.7). The image of an Italian infant sleeping on a sidewalk of the Bend, outside a sweltering and unventilated tenement and under the close supervision of the baby's tired grandfather (or grandfather figure), embodies the conventional trope of the intense family bond among Italians. The handwritten inscription "Beans Soup" positioned between the two figures conjures up themes of hunger and hardship. Yet, in the carefully framed photograph, destitution is much more than an issue for social workers. An Italian advertisement for the famous Verdi opera *La Traviata,* located on the top left corner of a diagonal line that includes the old man and the infant, aestheticizes the image into a melodramatic social sketch that Hine either intentionally arranged or could not resist capturing.[63]

Riis's photographic expositions were unprecedented, although his overall approach was not entirely original. Toward the end of the nineteenth century, racial characterizations of the urban poor as a different breed of people—socioeconomically, morally, and racially—acquired a vast dramaturgic currency. Once the target only of police reporters, reformers, health officials, and sensationalist dime novelists, the immigrant slum was becoming a favorite setting for photojournalism, popular theatre, and even highbrow literature.[64] As an American master of letters, popular novelist, and influential literary and theatre critic, William Dean Howells deserves special attention.[65] Like Riis, Howells oscillated between stark racially othering representations and sentimental depictions of immigrants and African Americans. In the "cosmopolitan Babel" that was New York, Isabel and Basil March, the protagonists of Howells's *A Hazard of New Fortunes* (1890), are both attracted to and repulsed by the strange panorama of exotic physiognomic and linguistic registers, the city's unique "variety of people," which the author found "unfailingly entertaining."[66] The two characters recognize with curiosity "Italian faces, French faces, and Spanish faces" and compare the poverty of New York's Little Italy with the "familiar picturesque raggedness of southern Europe," wondering if such spectacles "somehow existed for their appreciation"—a preoccupation that Howells himself publicly shared.[67] An exponent of the culture of the Grand Tour since his travels in Italy in

the 1860s, which he documented in his *Italian Journeys* (1867), Howells was careful to distinguish between Northerners and Southerners: he often referred to the latter simply as "Neapolitans" and had Basil describe them as defined by "immemorial brigandage and enforced complicity with rapine."[68] Their radical, unbridgeable difference was for Howells evident in their faces and language: after hearing Neapolitans' "unintelligible dialect," Basil wonders "what notions these poor animals formed of a free republic from their experience of life under its conditions."[69] Writing about the Jewish "tenement literature" of Fanny Wurst, Israel Zangwill, Morris Rosenfeld, and Abraham Cahan, which Howells publicly sponsored and admired, the author of *A Hazard of New Fortunes* advanced starkly conflicting judgments. In 1898, he described the representation of the poverty and squalor of the city's ghetto as "so entirely of our time and place, and so foreign to our race and civilization." Three years later, he argued that the realism of these literary depictions held a universal dimension of humor, pathos, and human emotions that represented "that unity of tradition which as yet is of such integrity with us that no word of national import needs translation, in all the length and breadth of the Union, from the original accent in which it was uttered."[70]

Ultimately for Howells, the reality of racial difference and the ideal of a shared humanity could line up only if artistic expression could retain the specifics of racial origin while aiming at some form of higher, albeit never complete or universal, transfiguration. "If we come to look at a man in his relation to aesthetics," he maintained in 1910, "we perceive a certain inalienable propriety in his being of this origin rather than that."[71] Whether a behavioral or linguistic accommodation to Anglo-Saxon America was achieved or not, Howells, like many of his contemporaries, continued to posit that an author's means of literary expression were inextricably tied to his racial heritage. In the arts, he maintained, full assimilation was not just impossible to render, but should not even be attempted: diversity of accents and characters constituted a major stylistic and dramatic resource and a magnificent mystery—"a thing composite and strange beyond our present knowledge."[72] Against the sentimental calls of Zangwill's "melting pot," Howells and a large part of American visual and literary culture preferred the very American spectacle of the "unmeltable ethnics," to use the title of Michael Novak's classic study.[73]

Following the lead of Howells's 1890 novel, several of the most promi-
nent American novelists of the time, including Frank Norris, Stephen
Crane, Edward Steiner, Theodore Dreiser, Henry James, and Mark Twain,
participated in the "touristic" discovery and realistic rendering of urban
social squalor, which quickly became widespread. Venturing, at least
vicariously, to where "the other half" lived and minutely rendering the
slums provided writers and readers alike with the opportunity to both
explore and contain the disquieting otherness of nearby immigrants.[74]
Realism, as Amy Kaplan has put it, became "a strategy for imagining and
managing the threats of social change."[75]

Similarly, toward the end of the nineteenth century, the language of
American theatre as a whole acquired a rewarding independence from
the comedies and serious melodramas of European origin and taste. Since
the mid-nineteenth century, minstrelsy—and later racial burlesque and
vaudeville—had popularized stereotypes and characterizations stem-
ming from the racial antagonism that pervaded many American regions
and cities, particularly New York. Representations and modes of address,
however, were by no means limited to specific and isolated racial groups:
Yiddish routines for Jewish audiences, German caricatures for German
spectators, Irish burlesquing for Irish patrons, and "wops" and "dagoes"
for Italian theatregoers.[76] For obvious commercial, cultural, and linguis-
tic reasons, vaudevillians preferred mass and multiclass audiences over
segmented ones and favored shows that included a whole range of racial
impersonations. As a result, a "national interracial currency" of heav-
ily stereotyped picturesque characters was circulating in a number of
burlesque and vaudeville venues in New York and across the nation's
comedy circuits. As in minstrelsy, the staged characterizations did not re-
quire their performers to be members of the race they were portraying.[77]
These characterizations included beer-guzzling Germans; dim-witted yet
amusing African Americans; gesticulating, pimply, and sallow-cheeked
Jews; pigtailed Chinamen; inebriated Irish Pats and Bridgets; and emo-
tional Italian would-be opera singers and Mafiosi. An array of cheap
songbooks and joke collections were published in the late 1800s, by the
likes of I. & M. Ottenheimer (Baltimore) and the Wehman Bros. (New
York). In these irreverent manuals, the character of the "Eyetalian wid big
whiskers" speaks an almost incomprehensible vernacular, is both naïve
and cunning, and is always quick with insults and his stiletto.[78] Film his-

torians have often asserted the deep relationships between early cinema and the racial scripts of vaudeville shows, although a systematic overview of such relationships does not yet exist.[79] It is possible to argue, however, that because of cinema's porous intermediality, films often blurred the line between vaudeville entertainment and ethnographic rendering. As Musser writes, "performers who might be classified as 'ethnographic' when viewed from one perspective might be considered vaudevillians from another."[80] Performing in either short comedic films or longer dramas, as we shall see in the next chapter, former vaudeville actors and actresses reproduced familiar stage stereotypes about Italians, including their "naturally" violent inclination and picturesque customs.

The aesthetic of the picturesque, as Carrie Tirado Bramen most eloquently noted, "provided a much-needed vocabulary for middle-class inhabitants of the city. It offered a discourse of color and variety with which urban dwellers could visually transform the rubbish, congestion, and misery of the city into a source of rough and rugged pleasure."[81] As an ideologized aesthetic form, the urban picturesque "operated within a larger narrative of Americanization, defined not in terms of assimilation, but along the lines of Randolph Bourne's ideal of 'Trans-national America.'" Arguing against the melting-pot, Bourne had developed a model of national incorporation of "unity-in-discreteness," according to which "immigrants should retain their 'foreign savor,' which would distinguish modern America from the supposedly homogeneous nationalities of Europe."[82] Bramen has skillfully linked New York's topography of diversity with the aesthetics of the picturesque on the basis of a common visual morphology. Through walking tours, visual or journalistic reports, and later filmed travelogues shot in immigrant neighborhoods, one could experience the city's impressive brusqueness, diversity, and heterogeneity. These most picturesque qualities recalled the identical attributions of "roughness," "irregularity," and "variety" that at the end of the eighteenth century Reverend Gilpin had singled out while differentiating the "Picturesque" from the tidiness and elegance of the "Beautiful" and the impressive vastness and mystery of the "Sublime."[83] Still, and quite significantly, not all races could aspire to become picturesque subjects of delectation.

When American writer and *McClure's Magazine* fiction editor Viola Roseboro wrote in 1888 that "'picturesque' and 'charming' and 'artistic'

are words apt to be badly overworked in writing about the Italians," she was clearly referring to a sediment of associations linking certain European groups with a specific form of aestheticization.[84] The picturesque operated not as a racially democratic aesthetic trope, but as a discriminating one that privileged those social groups that counted as white. "When interpreted by the sympathetic artist," argued leftist journalist and author Hutchins Hapgood, the Jewish ghetto was "deeply picturesque."[85] By contrast, Chinese immigrants to the city were rarely described as picturesque, and African Americans never. Comparing Chinatown to the Bend, the Italian quarter, Riis was quite explicit: "Chinatown as a spectacle is disappointing. Next-door neighbor to the Bend, it has little of its outdoor stir of life, none of its gaily-colored rags or picturesque filth and poverty. Mott Street is clean to distraction." While Riis welcomed the fact that "when the sun shines the entire population [of the Bend] seeks the street" and becomes subject to his touristic and ethnographic curiosity, he maintained that the Chinese immigrant displayed a secretive demeanor: he "shuns the light, less because there is anything to conceal than because that is the way of the man.... Stealth and secretiveness are as much part of the Chinaman in New York as the catlike tread of his felt shoes."[86]

As a form of aesthetic incorporation, the picturesque consistently excluded non-white populations. Like the right to vote, to acquire property, and to freely choose one's spouse, the right to become characters or faces of the picturesque was reserved to whites. But not to all white races, either: Anglo-Saxons, because of their hegemonic standing among whites and their cultural profile, were seldom described as picturesque. It was as if in the name of the picturesque a line was drawn between America's white Anglo-Saxon constituency and the former slaves, on the one side, and European immigrants, on the other. A full-color, two-page cartoon that appeared in the comic weekly *Judge* in March 1889, a time of harsh debates on immigration restrictions, depicts exactly such a line (fig. 4.8). In the cartoon, Uncle Sam solicits President Harrison's approval of a nativist policy excluding the multitudes of different, and rather colorful, white immigrants.[87] The projection of nationalistic connotations onto an aesthetic category once solely employed for the description of natural landscapes ended up charging the picturesque with discriminating attributes of privileged racial status. Being "colorful" implied not being "colored."

4.8. "President Harrison recommends restrictions of immigration. Uncle Sam—'If we must draw the line, let us draw it at these immigrants!'" *Judge* 15, no. 389 (March 1889): 708–709.

As films extended their length beyond the one-shot format and incorporated the urban landscape as the background of more complex narratives, the picturesque shifted its semantic grip from inanimate views to racial characters. If in the mid-nineteenth century New York was a *terra incognita*, by the turn of the twentieth century it had become a theatre of types. The American picturesque tamed and contained the sublime unknowability of the city and the incommensurability of racial difference by incorporating the foreignness of its resident aliens into amusing national narratives. One may legitimately ask not only how the pictorial imagery fared with film images, but also how it fared with the frenzied movements of city life, what Georg Simmel referred to as the "rapid crowding of changing images, the sharp discontinuity in the grasp of a single glance, and the unexpectedness of onrushing impressions."[88] By the time American companies started making films in the city, they were not simply exiting the studios and encountering the spontaneous life of the street. Instead, they were meeting an environment saturated with a memory of visual representations: as Mottet has put it, "The filmic text is here a rewriting of other representations (photographic, literary, etc.)."[89]

Without conveying the so-called "shocks" of modernity, the aesthetic deployment of picturesque representations in literature and the visual arts produced experiences of mild recasting that familiarized the disquieting poverty and diversity of the city within reassuring and entertaining urban plots. The picturesque operated on many levels. It impelled a sociological and ethnographic organization of the immigrant masses into recognizable types. It naturalized the destitution of their living conditions into well-contained urban and social scenery, whose aesthetic and ideological appeal highlighted their exotic diversity and elided their potential for civic and political rebellion. Within the larger process of the vicarious experience provided by newspapers, novels, and visual media, which were meant to bring consumers closer to distant realities and events, the spectacle of the poor and foreign immigrants solicited both intimacy and estrangement, but in the end remained just that: a spectacle. "To read about the strange habits of the poor, to view the poor, the immigrant, the tough in photographs," as Gandal best put it, "is also to develop a particular relationship to them. One becomes not only or necessarily brother to the poor or moral reformer of the poor or potential victim of the poor; one also becomes a spectator of the poor."[90]

Some of the most recurring and significant filmed spectacles of the poor concerned Southern Italians, who by now had a long history of connection with the picturesque. The remainder of part 2 will look closely at Italian immigrants both as characters in films and as spectators of them. It will do so in the context of how popular racial ideologies variously characterized immigrants and racialized populations in general in narratives of alienation or attempted adaptation, but never of full assimilation. The *raison d'état* of the American aesthetic regime would not allow it.

FIVE

Black Hands, White Faces

In Italy, people who quarrel cheat the spectator.

MARK TWAIN, 1880

Adventures whose tragedy is relieved by picturesqueness.

"ROMANCE OF BRIGANDAGE," *NEW YORK TIMES*, 1892

One does not wonder that the Sicilian will stab his
best friend in a sudden quarrel over a game of cards.

SOCIOLOGIST EDWARD ALSWORTH ROSS, 1914

American cinema emerged in racially inflected circumstances. Early
filmmaking developed at a historical juncture and in a geographical
setting—New York City—profoundly marked by European mass mi-
grations. This critical concurrence informed the racialness of American
moving pictures in ways that both furthered and complicated the coun-
try's preexisting racial culture. As Matthew Frye Jacobson has shown,
the arrival of European immigrants in general since the mid-1800s had
problematized the inclusivity of the 1790 naturalization law (which as-
sumed the notion of a "free white person") by fracturing the monolithic
notion of whiteness into "a hierarchical ordering of distinct white *races*."[1]
Compared to the arrival of Irish, German, and Scandinavian popula-

tions, however, the waves of mass Southern and Eastern European immigration after the 1880s brought an even more alien variety of races, nationalities, languages, and customs to Anglo-Saxon America. The new immigrants represented a source of fascination and exoticism, but the sheer degree of their diversity radically challenged familiar associations of racial difference with skin color (or with "simianized" Irish Catholics). Southern and Eastern European newcomers posed pressing representational challenges to the visual and narrative media of the time. How to convey immigrant characters' distinct racial identity in the absence of obvious color markers? How to determine what sorts of stories or racial destinies these characters could be involved in? And, for the nascent medium of moving pictures, how to represent characters that could justifiably stand for larger racial groups when photographic reproductions were so realistically individualizing?

Illustrated periodicals and literary, theatrical, and cinematic representations responded to this challenge by relying on a familiar shorthand of racial and national characters, the "racial type." Endorsed by social Darwinism, racial types were established by both popular and scientific taxonomies. But they were not all created equal. Despite immigrants' various national and geographic origins, American popular culture depicted only a rather narrow assortment of "types." What determined this cultural selection was the availability of visual and dramaturgic precedents; that is, the existing "economy of typecasting." More than Hungarians, Danes, Greeks, Armenians, Syrians, or Slavs, Italians enjoyed special cinematic attention because of a long-standing, enduring, and intermedial tradition of antiquarian and picturesque representations of Italy, its history, and its populations. New York, in this sense, was not a marginal stage. It was right at the center of the transatlantic "web of economic transactions, communications and movements of goods, money and people" that for Eric Hobsbawm defined Western modernity.[2] In these social, material, and aesthetic exchanges, racial types functioned as a currency that enabled representations to be recognized, to circulate, and to entertain. In addition, within highly regarded and hegemonic ideologies of adaptation, the representation of certain racial types could loosen their deterministic rigidity in order to accommodate possibilities of civic and moral "improvement." Configured in a religious imagery of sin and redemption, the notion of "racial character" offered selected

racial types the possibility of transcending the strict association between racial identity and moral condition. Italians enjoyed this privilege not only on the basis of their white racial standing, but also by virtue of a long-standing repository of familiar and reassuring narratives. While their lives and neighborhoods were associated with the threatening presence of criminal organizations, many Italian film characters were often granted the crucial opportunity to play the Mafia's victims or foes. This resilience opened narrative and characterizing possibilities for years to come.

RACIALNESS AND TYPING

Up to the mid-1910s, New York City was the center of the American film industry. Films were shot in the city's streets and studios, and often in nearby New Jersey. The very first sites of exhibition and commercialization were the movie theatres of Union Square, the Bowery, Third Avenue, and 125th Street. New York was the place where early American cinema began to depict immigrant narratives, whether dramatic or comedic, exposing and recreating stories of European racial characters for local audiences composed largely of Old World immigrants and their descendants. A remarkable proportion of producers, distributors, and exhibitors, and an even larger proportion of early film audiences, were first- or second-generation immigrants. Many actors and actresses, as well as a few directors and film scenarists, had worked on Broadway or were familiar with the city's vaudeville scene, its numerous foreign theatre traditions, and the established codes of racial impersonation typical of both venues. Racialness arguably defined American cinema more than it did any other Western film culture.[3]

Caught between the need to address its immigrant constituents and its hopes of cultural respectability and commercial viability within the dominant, Anglo-Saxon society, early American cinema was compelled to tell stories about both old and new Americans. In their receptivity to contemporary scientific and popular rhetoric of racial antagonism, American film producers often resorted to racially inflected plots about city life, crime, white slavery, and, as we have seen in chapter 3, battles between frontiersmen and Native Americans. Whatever their genre, films were compelled to assert the moral and cultural superiority of

Anglo-Saxon culture and lifestyle through more or less overt displays of a racialized nationalism.

Over the decades, D. W. Griffith's negrophobic *The Birth of a Nation* (1915) has achieved a unique (and apt) prominence in the historiography of early cinema: the highest-grossing silent American film was also the most controversial one. Its release caused an unprecedented range of debates on censorship and racial representation and prompted the emergence of antagonistic filmmaking and critical practices among African Americans.[4] *The Birth* epitomized a cinematic tradition that had regularly used—and would continue to use—race-as-color to depict African Americans, as well as Asians, Latinos, and Native Americans, as subjects racially extraneous to the realm of American polity and thus constitutionally unfit to assimilate into white American society.[5] As emblematic as *The Birth* is for a discussion of race in American cinema, however, its reliance on the dyadic framework of the "color line" does not make it exhaustive. Its "biracial" politics, to use a term that first appeared within the new "race-consciousness" of the mid-1910s and was premised on the juxtaposition of black and white, overlooks non-color-coded forms of racial discrimination.[6] A whole range of racial signifiers, in fact, were used to mark the distinctiveness of European immigrants and Italians, in particular, within the complex and varying connotations of urban views of race at the opening of the twentieth century.

Here our discussion may profitably engage with contemporary historiographical debates on whiteness and with recent research on illustrated periodicals' pictorial culture in order to gain a better understanding of racial differences in American social and cultural life. A number of scholars writing on the question of Europeans' whiteness in late nineteenth- and early twentieth-century America, from the groundbreaking David Roediger to Matthew Frye Jacobson, Noel Ignatiev, and Karen Brodkin, have pointed out how the racialized immigrants from Southern and Eastern Europe "learned the ropes" of America's binary color system. Although often presumed and vehemently claimed, the whiteness of these immigrants was not a given. Instead, it was "probationary" (Jacobson) or "conditional" (Brodkin), and ultimately it represented the goal of a difficult, certainly opportunistic, but often imperfect process.[7] Because of this unsteadiness, Roediger and other scholars have described European immigrants as "inbetween people," namely, "'in-

between' hard racism and full inclusion—neither securely white nor nonwhite."[8] Although Thomas Guglielmo describes Italians as incontestably "white on arrival," the contention that immigrants' experience in America was a dynamic process of racialization calls attention to the historical processes of acceptance and rejection that a rigid "structure of race," based on preset color attributions, may not sufficiently convey.[9] On the one hand, it is crucial to stress that European immigrants did not experience forms of racial discrimination comparable with the violent and unbending exclusion endured by Latinos and by Native, Asian, and African Americans. Because they shared the political, economic, and social perks of whiteness in courts of law, the workplace, and everyday life—even if sometimes only provisionally or probationally—Irish, Jewish, Italian, and Slavic populations were not denied adaptation and assimilation in principle. This benefit of the doubt was utterly unknown to "people of color." On the other hand, it is also important to avoid reifying the distinction between color and race. The risk is that we may overlook both the historicity of race's physical and biological ascriptions—which included skull shape, physiognomic traits, and hair type, as well as color—and the different roles that such ascriptions played in allowing or denying narratives of adaptation.[10] "The unresolved issue here," as Peter Kolchin has lucidly noted, "is the extent to which Americans conceived of *whiteness* (rather than other criteria such as religion, culture, ethnicity, and class) as the main ingredient separating the civilized from the uncivilized."[11] In other words, to reduce the notion of whiteness to a single, one-dimensional realm of advantage fails to account for the spectrum of its own internal, highly racialized taxonomies, which early American cinema often narrativized and displayed for both civic and entertainment purposes.[12] Writing the history of the thirteen million "new immigrants" coming from Southern, Eastern, and Central Europe between 1886 and 1925 requires that we avoid what Roediger calls the "easy assumption that [they] were simply white and that their stories were always ones of assimilation (or not) into American rather than specifically white American ways." Instead, he argues, it is paramount to recognize the "*messiness* to the plot of how new immigrants became white" and how their living and transcending of a condition of racial inferiority impacted, through "uneven, many-sided, harrowing processes," every aspect of their lives.[13]

Early film historiography may learn a great deal by understanding the plasticity of the turn-of-the-century notion of race in contrast to the rigidity of color ascriptions. Specifically, historians of race offer two most constructive insights. The first is the acknowledgment that race operated on all sides of the color line, which means that whiteness itself was fraught with striking racial variation.[14] The second is that the crude biologism of the turn-of-the-century notion of race was a discriminating protocol that encompassed (and never separated) physical features (hair type, complexion, physiognomy, etc.) and cultural and moral ones. In many respects, racial differences coincided with national differences. "In 1890," as George W. Stocking has lucidly shown, "the idea of race was in many ways and for many people not very different from what we would call today national character." "If [race]," Stocking has added, describing a viewpoint shared by politicians, scientists, journalists, writers, and the men of the street, "was a *determinant* of national cultural experience, it was at the same time an outgrowth of previous national and cultural tradition."[15] As a result, not only did Slavic, Jewish, Greek, and Italian immigrants radically differ from the Anglo-Saxon core of American society, but they also differed from one another in both physical and cultural traits.[16] How, then, could one differentiate among immigrants?

Moving pictures shared with other areas of American cultural life the need for a method of semiotic discernment. In New York, as in America's other large and diverse municipalities, recognizing who or what the foreigners were, knowing the borders of their neighborhoods, and understanding how to (or how not to) interact with them was increasingly necessary. Just as street orientation requires signposts, so too did social semiotics require new manuals to distinguish among the "faces in the crowds," as Edgar Allan Poe and Herman Melville, a few criminologists, and countless journalists and social workers had already realized in the last decades of the 1800s.[17]

In both popular culture and scientific circles, the notion of racial type came to the rescue as a solvent of general, even contradictory traits. Racial typing had always been in terms of heads and faces. Racial and facial politics, in fact, had been intertwined for over a century in Western culture, since the physiognomic treatises of Johann Caspar Lavater, the racial rankings of Johann F. Blumenbach, and the anthropometric research of Franz Joseph Gall, the founder of phrenology. In the nineteenth century

phrenology gained remarkable popularity in England and the U.S. and, as a volumetrics of the skull, enhanced an unprecedented medicalization of the mind and a materialist reduction of human differences. Because of this it exerted an influence in an impressive array of scientific, political, and even aesthetic contexts.[18] English phrenology did not invent brand new typologies for non-English populations. "Old national stereotypes which Englishmen enjoyed making of their Continental neighbors," as David de Giustino has noted, "were . . . absorbed into phrenology and given deeper meaning."[19] In mid-nineteenth-century America, phrenology informed Samuel George Morton's lavishly illustrated and scientifically ambitious *Crania Americana* (1839), which correlated the cranial measurements of Indians of North and South America with low intellect and incivility. On the other hand, and thanks to the entrepreneurship of the Fowler brothers, phrenology also became a mass cultural phenomenon. Through a museum, the Phrenological Cabinet, which competed with Barnum's spectacular attractions in popularity, and a lucrative mail-order business selling hundreds of thousands of books and pamphlets, phrenology became an accepted and familiar practical science of self-study and self-improvement and a unique gauge of individuals' inherited and improvable qualities.[20] The science of skulls and heads inevitably intersected with the illustrative tradition of physiognomy according to the principle that, as the Fowlers put it, "all the phrenological organs have likewise their facial poles."[21] The emphasis on cranial shape and facial traits found an even more popular visual codification—especially in terms of racial, and not just social, typecasting—in the New York–based illustrated periodicals and newspapers, from *Scribner's Monthly* and *Harper's Weekly* to *Frank Leslie's Illustrated Newspaper.*[22]

As America's publishing and, later, filmmaking center, and as the nation's most diverse metropolis and emblematic ethnographic field, New York City was at the critical intersection of nationwide commercial practices and type-centered visuals and narratives. In his groundbreaking work on mid- to late nineteenth-century pictorial reporting, Joshua Brown has shown that "the practice of typing helped Americans master social and political differences in an increasingly heterogeneous, disorderly, and perplexing nineteenth-century reality marked by commercial competition between regions, emerging industrial conflict, and the chaotic expansion of the body politic." Although the illustrated

press was initially subordinate to the typecasting operations of plebeian theatrical and literary productions (e.g., woodcut illustrations of comic almanacs or lithographs of actors portraying celebrated characters), its "advent . . . in the 1850s prolonged the practice of social typing through the nineteenth century." Ultimately, Brown argues, "the codes and conventions of American illustrated journalism . . . were predicated on teaching greater 'philosophical generalizations,' most particularly by conveying the true character of people and events through typification and physiognomy."[23] This was particularly evident in typing caricatures. Indebted to comic and melodramatic theatre, social and racial caricatures found one of their earliest venues in such comic magazines as *Yankee Notions* (1852–75), exploded in the pages of *Harper's Weekly* by the hand of German-born Thomas Nast, and, after the 1870s, filled such chromolithographic weeklies as *Judge* and *Puck*.[24]

Initially, the most common types of American pictorial culture included the calculating "Brother Jonathan" of New England, the independent Western frontiersman (soon to become the cowboy), the rude Southern "cracker," the urban plebeian "Mose," and the childish plantation slave.[25] In general, before the 1870s, physiognomy was used as an easily readable marker of disorder, mayhem, and social distance. Normally, this would "not work in representing situations in which readers might, in effect, recognize themselves as participants and victims," particularly during difficult and divisive times of labor strife, strikes, and protest.[26] To convey the justifications of all sides, some illustrated periodicals had to downplay the physiognomic typification of their cartoons, making them less caricatural and more realistic renderings. "This call for the real," as Brown put it in a statement that resonates with the method of this study, "may have had less to do with the much-vaunted hegemony of photographic practice than with the conflicting demands of a broad and increasingly diverse readership."[27]

When the new pictorial and reproductive technique of the halftone emerged, in fact, physiognomic typing did not go away. As a long-lasting semiotic code with an established commercial and ideological tradition, physiognomy simply changed targets. If through the 1870s the representation of urban poverty had shown the "inflection" of Irish physiognomies, notably through Thomas Nast's simianized representations for *Harper's Weekly,* the social and labor tensions of the 1880s, from Charles

Guiteau's assassination of President Garfield in 1881 to the 1886 bombing in Chicago's Haymarket Square, promoted a transfer of pictorial conventions. Violence in American society seemed to have foreign, and thus menacing, facial traits. By the 1880s, Southern Italians and Eastern European Jews, who had their own repository of unsettling pictorial traits, succeeded the Irish as the most common types. Because the new immigrants were not readers of the illustrated periodicals, the resurgence of pictorial typing appeared to resonate with the larger ideological (not just aesthetic) turn toward realism, not despite but because of physiognomy's selective application. Caricatures could realistically convey that certain characters associated with pauperism and brutality deserved civic exclusion by inscribing their character flaws in utterly alien, unassimilable physiognomies.[28] In 1888, *Frank Leslie's* began publication of a series of engravings titled "Italian Immigration and Its Evils" which associated Italians' hirsute physiognomies with criminal and abusive practices typical of "the most squalid districts of swarming Naples."[29] For years, the arresting contours of these typing physiognomies, allegedly truthful in their representation of Italians' "strikingly brigandish" features, conveyed a deterministic commentary on immigrants' degeneracy, understood as their unwillingness to assimilate or, worse, their inability to change.[30] In illustrations that featured Italians as victims, rather than perpetrators, of violent actions, this visual pattern was also well in place—as was the inevitable stiletto.

Typecasting was also the working protocol of eugenics, an influential branch of social Darwinism. Developed in England since the 1880s by Francis Galton, Darwin's cousin, it became extremely popular in early twentieth-century America. As a mathematical treatment of heredity, eugenics identified and classified taxonomies of racial stock, correlated them with "inherent" national qualities and with scales of human development and worth, and endeavored to improve the human races through separation or "racial hygiene." In the 1920s, in association with the political ideology of nativism, eugenics provided the scientific basis for policies of immigration restriction.[31] Structured around a presumed Anglo-American distinctiveness and accounting for both outer physical traits and so-called "racial temperaments," eugenics participated in the articulation of an impressive range of racial typologies.[32] Eugenics did not codify racial types, since "the Jew," "the Italian," and "the Greek"

were already a currency of great popular and ideological value. But it sanctioned their scientific applicability as analytical protocols in the social sciences (e.g., criminology, anthropology, and sociology), often in combination with experimental photographic practices (e.g., Galton's "composite portraits") and their realistic appeal in high- and lowbrow literary, journalistic, and visual narratives, including illustrated periodicals and moving pictures.[33]

Early cinema learned a great deal from the newly legitimized typing protocols of pictorial reporting, as it did from vaudeville theatre, which I discussed in chapter 4. A present-day reading of media differences among these popular forms of amusement may underestimate what they all shared: race-centered entertainment routines and a semiotic fondness for physiognomy.[34] Since the beginning, cinematic staging of "character sketches" or of famous individuals' gestures, such as the sensational close views of the kisses in *The John C. Rice–May Irwin Kiss* (Edison, 1896), enabled unprecedentedly close views of celebrated painterly, lithographic, and stage representations.[35] Within a few years, productions of closely framed faces, known as "facial expression films," exhibited deformed and grotesque expressions for humorous purposes, as in Edison's *Facial Expressions* (1902) and *Goo-goo Eyes* (1903).[36] As we shall see later in this and the next chapter, facial traits constituted remarkable dramaturgic resources for films addressing narratives of racial difference—whether color-coded or not. Yet, since the early 1910s, when anthropological and sociological ideas about environmental effects began to raise questions about the deterministic power of heredity—although only about its power over white subjects—the fatalistic shorthand of physiognomic typing could not remain the dominant characterizing strategy of racial difference, particularly as cinema was beginning to tell significant stories of immigrants' adaptation and assimilation. Factors germane to cinema's own development furthered the process. In its continuous effort to attract immigrant audiences and make moviegoing a respectable cultural experience—comparable to attending the opera or legitimate theatre—early cinema strove to abandon the demeaning sensationalism of racial prejudice, which had been particularly acute in slapstick comedy. Two interesting interventions written by the future head of Universal Studios' scenario department, William Lord Wright, published in the *New York Dramatic Mirror* in the spring and fall of 1915, are cases in point.

Following the public outcries of a growing number of antidefamation associations, the two articles made clear that the comedic mocking of racial differences was culturally and commercially ill-advised. "Racial characteristics should not be treated," one article warned, with particular emphasis on slapstick comedy. "The green-whiskered Irishman, blundering Dutchman, and gesticulating Frenchman and other exaggerated types should not be employed in film comedy. Many of the caricatures are offensive to persons of the same nationality."[37] Although "the screen followed in the footsteps of the stage and the ridiculing of racial characteristics became the mode," admitted the other piece a few months later, a flood of public and organized protests "makes it well for the photoplay authors to remember that racial ridicule will not aid in the marketing of comedies."[38]

By the mid-1910, cinema was radically changing in other respects as well. In fierce competition with Europe's feature-length productions, American filmmakers had begun producing multiple-reel films.[39] Longer narratives allowed more complex psychological characterization of film characters, including racialized protagonists. What had been schematic and often quite unfavorable configurations of white immigrant types could now have depth and flexibility. The notions of characters' depth and plasticity are critical in a study of race and characterization because they are predicated on two crucial conditions: the admissibility of identity markers that are not reducible to physical features and the possibility that a racial character may change. Cathy Boeckmann has recognized and described the first condition through the trope of the racial character, which, as we shall see, is also at the basis of the second one.[40]

Encompassing both outer physical features and invisible ones, and often implicitly formulated at the intersection of science, politics, and literature, the notion of racial character derived its conceptual contours from the notion of personal moral character, which identified individuals' ethical nature within the profoundly religious culture of nineteenth-century America. Through the intensification of the racial question in American political and public culture throughout the second half of the nineteenth century, the trope of individual character acquired a broader, racial currency. Notwithstanding the fact that the popularization of photography had given racial thinking an epistemic inclination toward definite visual detection, recognizing European newcomers' dis-

tinct racial identity, by signs ranging from physical appearance to ethical and cultural customs, was particularly urgent and difficult in the city's racially complex context.[41] Hence, as Cathy Boeckmann writes, racial identity had to be formulated in ways that bypassed the ambiguities and typecasting temptations of mere visual inspection. As a result, she writes, "the need to locate the essence of racial difference fell upon the concept of inherited racial character—a racial essence that is connected to the features of race but which can also be extricated from them." Nineteenth-century racial culture allowed the relationship between physical signs, racial identity, and racial character to be highly flexible, to the point that "the concept of character defined a racial essence that was not visible."[42] Increasingly used within scientific, literary, and popular discourses, the notion of character thus implied, in a true neo-Lamarckian manner, that an individual's life summarized and expressed the features of his or her race because individuals inherited not just biological make-up and physical traits, but also the less visible but equally permanent characteristics of social and moral customs. While still emerging within the resilient framework of heredity rather than environmental determinism, the notion of racial character served the purpose of identifying the racial distinctiveness of "othered" white populations in terms of their behavioral and moral adaptability—that is, in terms of their ability to become American. Ultimately, the trope of the racial character identified a complex and much more flexible narrative about a racial type. The stories associated with a given racial type could allow (and welcome) its change, or rule it impossible.

Evidently, change in and of itself is not at issue here. Within the contemporary nativist and Anglo-Saxonist framework, change for immigrants meant "Americanization"; that is, improvement, or the acquisition of a set of moral and economic views that defined the American way of life. Several cultural constituencies needed and thus embraced the notion that immigrants' behavior could change. Social reformism postulated it to justify its own existence and programs. Chasing similar goals of social uplift, moving pictures, too, required change as improvement as a dramatic resource for narratives of moral or civic conversion. In real life, as in fiction, immigrants could change their lifestyle, but could alter their physical features and appearance only superficially—although for their descendants it was a different matter, as Franz Boas's famous re-

search on second-generation immigrants contended.[43] Still, immigrants' potential to adapt depended on the cultural and visual assumptions that American culture made about their past and present civilization, literacy, and "temperament," or attitude toward Americanism.

The notion of change as improvement was inscribed in the very definitions of both the picturesque and eugenics, understood respectively as the aesthetic enhancement of actual or painterly landscapes and as race betterment. In both cases, improvement was also inherently linked to questions of national distinction. If park design and development were initially an aristocratic preoccupation, the extension of concern for the look of the land involved what cultural geographer Stephen Daniels has described, in the British context, as "the patriotism of landscape improvement."[44] Similarly, eugenics, which Galton defined as "the study of all the agencies under social control which may improve or impair the inborn qualities of future generations of man,"[45] made efforts that may have been cosmopolitan in scope, but which were intensely jingoistic in purpose. Far from being just a theory of deterministic racial birthright, it considered the environment as a catalyst of racial betterment. Because of this, eugenics inspired discriminatory narratives of progress by postulating that, within controlled and well-managed environments, certain races could develop for the better, while others could not.[46]

The variety of foreign film characters on American screens did not proportionally match the diversity of recent immigration: many large groups, including Slavs, Greeks, Poles, and Arabs, did not gain wide visibility on screen. By and large, Southern and Eastern European characters were outnumbered on screen by Native Americans, African Americans, and Southwestern Latinos. Jews were much more often involved in the various facets of the film business than they were portrayed on screen. Still, their characterizations were frequent and remarkable in variety, ranging from the scheming merchant and the stern patriarch to the prodigal pawnbroker and the rose of the ghetto.[47] Prejudice and sympathy often alternated in their depictions, yet, unlike Italians, Jews in Europe were not associated with picturesque settings or scenes. These familiar aesthetic references surfaced only in the representations of their life in America.

Anti-Semitic caricatures were common in comedies, such as *Cohen's Advertising Scheme* (Edison, 1904) and the animated work *Cohen and*

Coon (Vitagraph, 1906), which adapted familiar slapstick and vaudeville routines.[48] The so-called "pogrom films," including for instance *The Hebrew Fugitive* (Lubin, 1908) and *In the Czar's Name* (Yankee, 1910), told stories of anti-Semitism in Russia and in Eastern Europe, but tended to feature sympathetic and often self-sacrificing protagonists. The largest dramatic subgenre, the "ghetto film," was devoted to stories of hardship, discrimination, and heroic generosity, set in the widely aestheticized immigrant quarters of New York City. These films included, among others, Lubin's 1908 *The Yiddish Boy* and *The House Next Door,* as well as Biograph's *Old Isaacs, The Pawnbroker* and *Romance of a Jewess,* which Griffith wrote and directed in 1908. Unlike other immigrant groups, Jewish actors were often cast to play screen characters belonging to their own racial group—a feature that gave on- and off-screen realistic significance to their narratives of acculturation, intermarriage, and adaptation.[49] In the early 1910s, Griffith most notably contributed to the realism of ghetto films with *A Child of the Ghetto* (Biograph, 1910) and the heartbreaking *The Lily of the Tenements* (Biograph, 1911). The first part of *A Child of the Ghetto,* shot on location along Rivington Street, resonated with familiar images of the Lower East Side photographed by Riis and others, circulating in paintings, prints, and countless postcards, and filmed a few years earlier in such urban travelogues as *New York City "Ghetto" Fish Market* (Edison, 1903). It echoed the well-known visual repertoire of Lower East Side sidewalks, composed of the proverbial tenements, advertisements in Yiddish, plebeian youngsters, exotically dressed passers-by, and carefully guarded street carts.[50] In the film, life in the ghetto signifies vice, destitution, and merciless exploitation. Only the pastoral landscape of the nearby countryside enables the protagonists' moral regeneration. A year later, *The Lily of the Tenements,* devoted to the plight of a Jewish seamstress, was the last Griffith film inspired by a Dickensian denunciation of social inequality and injustice that had informed American paintings, poems, and novels since the mid-nineteenth century. Eventually, the immigrants' ghetto became for Griffith (and in early American films in general) less the site and symbol of a cinema of social concern and more the setting of criminal and sentimental dramas of both realistic and sensationalist appeal. This could be achieved by either leaving the racial identity of the criminals rather undetermined, as in the classic, Riis-inspired *The Musketeers of Pig Alley* (Biograph, 1912) (which, shot on

East Twelfth Street and with such intertitles as "New York's Other Side," was still no temperance lecture),[51] or by relying on well-known and racially specific narratives. Centered on the activities and punishment of a Jewish criminal organization, Kalem's *A Female Fagin* (1913) was an East Side drama which capitalized on the widely covered 1912 murder case of the notorious gambler Herman Rosenthal. Stories like this one, however, were infrequent. Although in 1908 the New York City police commissioner had famously claimed that "with a million Hebrews, mostly Russians, in the city . . . , perhaps half of the criminals should be of that race," a crime film genre principally associated with Jewish immigrants did not materialize.[52] It was not that Jewish criminality declined while Italian delinquency rose. It was, rather, a matter of narrative precedents which, together with the important factor of the background of several film producers, discouraged any regular association of Jewish immigrants with crime. The variety of Jewish characterizations, in fact, derived from burlesque and melodramatic stage traditions that favored the suffering outsider and the victim rather than the criminal. In the case of overtly sympathetic characters, whose numbers increased considerably from the mid-1910s—the "ghetto films" continued throughout the 1920s—they also resonated with a contemporary production of fiction and memoirs on diaspora, relocation, and generational conflict authored, for instance, by Abraham Cahan and Edward A. Steiner.[53] Utterly absent was a tradition of Jewish *banditi*, or *banditti*, as European and American painters used to call one of their favorite subjects.

Italian film characters, in fact, belonged to a different aesthetic universe. Italian Americans did not hold leading roles in the industry, and not until the 1930s did Italian American writers begin publishing in English. Italian immigrants' exceptionally numerous novels, poems, and plays were available only in Italian or in literary vernacular until the late 1920s.[54] Yet Italians were conspicuous on American screens. Their characterizations displayed a remarkable consistency and variety by virtue of America's rich visual and narrative repository of representations related to both Southern Italians' rather destitute present and Italy's celebrated ancient past.[55] Because of their standing in America's racial culture and because of their association with the tradition of "agreeable pictures," to use Gilpin's famous definition of the picturesque mode, Italian film characters enjoyed a multiplicity of "agreeable" characterizations that

nonetheless always fell short of complete assimilation. This was not be-cause their positive characterizations as hardworking family men and women or naïve newcomers were obscured and spoiled by the recur-ring presence of negative characters, which included the shady criminal and the impossibly jealous lover. It was instead because the two moral positions, no matter how different they seemed, resulted from the same picturesque fall from grace that the images and stereotypes of the Grand Tour had been broadcasting in American cultural imagery for decades.[56] In other words, the very phenomenon of migration, largely motivated by economic hardship, was itself part of a narrative of social and anthropo-logical decline that widespread destitution and criminality embodied to a remarkably sensationalist degree.

Thus it was not despite, but because of, its romanticized Eurocen-trism that American culture promoted a separation between Italy's widely admired artistic and cultural heritage and the recent newcomers from Sicily, Naples, and neighboring regions. Different kinds of source material reveal the pervasiveness of this chasm, which critic Richard H. Brodhead has described as the conflicting coexistence of a "touristic-aes-thetic Italy" with an "alien-intruder Italy."[57] As early as 1834, a poem in a popular textbook read, "Where the old Romans deathless acts displayed / Their base degenerated progeny upbraid."[58] In his 1907 essays titled "The American Scene," Henry James juxtaposed New York Italians to an ideal and familiarly worded notion of Italian social characters. "What has become," he wondered, "of that element of the *agreeable* address in *them* which has, from far back, so enhanced for the stranger the interest and pleasure of a visit to their beautiful country?"[59] Even more antagonisti-cally, in his popular 1916 work *The Passing of the Great Race,* eugenicist Madison Grant found it quite difficult to understand "to what extent the Mediterranean race entered into the blood and civilization of Rome." His conclusion was that "the traditions of the Eternal City, its love of organization, of law and military efficiency, as well as the Roman ideals of family life, loyalty and truth, point clearly to a northern rather than to a Mediterranean origin."[60] To refer again to Brodhead's distinctions, Jacob Riis too adopted for Italian immigrants the idea of "Low Domestic Barbarism," made particularly virulent by comparison to Italy's past and genteel "High Cosmopolitan Civilization."[61] Back in Italy, he noted, "in the frame-work of Mediterranean exuberance, [Italians] are the delight

of the artist, but in a matter-of-fact American community [they] become its danger and reproach."[62] As we have seen, Riis's own writing and photographs contradicted this rhetorical polarization: in New York, Italians continued to be aesthetically appreciated.

GLADIATORS, CRIMINALS, AND BLACK HAND STORIES OF REDEMPTION

Ever traveled abroad?
Sure. I was in Italy once. Some bandits captured
me, and bound and gagged me.
What were they, comic opera bandits?
Nope, no comic opera about them. The gags they used were all new.

"OUR SUMMER BOARDER," VAUDEVILLE SKETCH, 1915

It does not take an Italian long to save money and contribute
his mite to the Government. He works hard, has simple
pleasures, loves the things that are beautiful, and sends his
children to the public schools. He is worth enlightening.

DETECTIVE JOSEPH PETROSINO,
NEW YORK TIMES, DECEMBER 1906

The American fascination with classic Italian humanism and Italy's timeless civilization did not just inform the taste for imperial splendor and civic grandeur in the high cultural circles of politics, academic education, literature, theatre, and the *beaux arts.* It also circulated in the lower realms of popular entertainment. P. T. Barnum operated the world's first three-ring circus from the Great Roman Hippodrome, which opened in New York in the mid-1870s (and was later renamed Madison Square Garden). Since the 1880s, the success of chariot races, living-statues tableaux of mythological figures, toga plays—spectacular melodramas pitting early Christians against Roman oppressors—and lavishly staged pantomime productions had attested to the widespread and cross-class popularity of spectacles of antique cruelty, excess, and decadence.[63] One such staged production, Imre Kiralfy's *Nero; or, The Destruction of Rome* (1890), which quickly became part of Barnum & Bailey's Greatest Show on Earth, anticipated the multireferential wealth of historical films,

5.1. Cover image of a souvenir booklet by Imre Kiralfy, *Nero; or, The Destruction of Rome* (Buffalo, N.Y.: Courier, 1890). Used by permission of the Illinois State University's Special Collections, Milner Library (Normal, Ill.).

whose plots were drawn from popular toga plays or literary classics like Bulwer-Lytton's *Last Days of Pompeii* and Lew Wallace's *Ben Hur,* and whose visuals were copied wholesale from the widely reproduced Roman arena paintings of Jean-Leon Gérôme (figs. 5.1, 7.4).[64] Not too far distant from New York City, at Manhattan Beach, thousands of summer spectators could witness the spectacular nightly routines of James Pain's pyrodrama *The Last Days of Pompeii.* At adjacent Coney Island, daily and nightly visitors could also enjoy the E. C. Boyce cyclorama show, the apocalyptic, yet mechanically operated downpour of lava and ashes destroying Pompeii, all while standing inside a classical Greek temple known as the Destruction of Pompeii building, which Charles Shean had decorated with a fresco of Vesuvius and the Bay of Naples.[65]

Aware of this pervasive cosmopolitan inclination, between 1906 and 1916 early Italian film companies produced dozens of historical dramas for the U.S., the world's largest market. Designed to satisfy the genteel and antiquarian taste of the American middle class, such lavish historical epics as *The Last Days of Pompeii* (Ambrosio, 1908 and 1913), *Nero; or, The Burning of Rome* (Ambrosio, 1909), *The Fall of Troy* (Itala Film, 1911) and *Quo Vadis?* (Cines, 1913) became both strong commercial competition for American cinema and influential aesthetic exemplars.[66] George Kleine, a former Chicago optician and a member of the Edison trust, capitalized for years on their distribution. He became directly involved in the production of some, the most notable being the historical colossal *Quo Vadis?*, and he even established a firm, the Photodrama Company, outside Turin. Kleine quickly foresaw the business potential of marketing the past to America's higher classes. In 1914, he even planned the construction of a special movie theatre, the Photo Drama Theatre Deluxe, at 226 West 42nd Street, in the city's theatre district and about three blocks from the Astor Theatre, where *Quo Vadis?* had premiered in the spring of 1913 to enthusiastic audiences. Had the war not compromised the activities of the Italian film industry (and the rest of Europe's), the theatre would have exhibited all the major Italian productions listed in the banner exhibited during its construction.[67]

Southern Italian immigrants arrived at Ellis Island with a different, yet not unrelated set of narratives. Their racial typecasting, predicated upon their alleged incongruous physicality, as well as their violent hyperemotionality, signified the tenuous state of a problematic adaptation.

TYPES OF SICILIAN BRIGANDS.

5.2. "Types of Sicilian Brigands," *Harper's Weekly* 19, no. 959 (15 May 1875): 411.

A frequently recurring means of racial underscoring was the law, with its sets of policies and regulations defining a social contract that Italians were depicted as naturally breaching. At times benevolently rendered in folkloric and picturesque terms, this "racial dissonance" signified the unlikelihood of their full equivalency with native white characters.

The phenomenon of brigandage was frequently associated with Southern Italians. Since the 1870s the American press had exposed its readers to "factual information" about Southern criminality: the difference between the Neapolitan Camorra and the Sicilian Mafia and the fact that they "are associations which one cannot imagine existing in Piedmont or Tuscany."[68] *Harper's Weekly* also provided visual documentation of the "typical" facial traits of Sicilian brigands, as shown in the physiognomic table of fig. 5.2. At the same time, the coverage of Southern Italian brigandage was often intertwined with romantic narratives and familiar aesthetic effects worthy of a Salvator Rosa painting. Contributing to this idealization was the bestselling memoir *English Travelers and Italian Brigands: A Narrative of Capture and Captivity* (1866), written by an Englishman who had been kidnapped by a Sicilian band of brigands and who kept a diary of keen and sympathetic observations of their adventurous and defiant lives. Itself an expression of an older fascination with Rosa-like bandits, the memoir inspired a whole host of romantic references to brigandism which appeared in the following years in the city's daily and periodical press.[69] Perhaps paradigmatically, in 1892 the *New York Times* reprinted a letter written by Ouida (the pen name of Louise de la Ramée) for the London *Times*. The author first admitted that Sicilian brigandage was "horribly brutal and hideous in its deeds," but also aestheticized the phenomenon as a stylized stage melodrama that "still takes a picturesque, operatic aspect in its *décor du scène.*" As the letter's subtitle put it in an eloquent formula, the deeds of brigandage constituted "adventures whose tragedy is relieved by picturesqueness."[70]

Beginning in the mid-1870s, accounts of criminal life in Italy began to alternate with reports on the arrival of Southern Italian brigands in New York, where, the *New York Times* sarcastically noted, "a band of brigands would find the rookeries of Mulberry Street more comfortable than the Calabrian forests, and much safer."[71] It was a different community from what it had been just a few years earlier, the *Times* protested in 1875, when the "Italian colony was made up almost exclusively of industrious and honest people from Genoa and the towns of the Ligurian coast, with a few emigrants from Piedmont and an occasional Livornese." The new immigrants were Southerners, who, the paper contended, "have been reared with the belief that brigandage is a manly occupation, and that assassination is the natural sequence of the most trivial quarrel." Con-

cluding with an explicitly deterministic tone, the article argued that "it [is], perhaps, hopeless to think of civilizing them, or of keeping them in order, except by the arm of the law"[72]—it was as hopeless as appeasing what another article termed the "social volcanoes in Europe."[73]

Particularly striking was the allegation of Southern Italians' "normal" affiliation with criminal organizations, usually identified as Black Hand societies. It was a contention supported by attributions of an innate violent propensity, which translated into racial unsuitability and "unfitness" for citizenship. Despite some intellectual reservations, the leading American sociologist Edward Alsworth Ross adopted the viewpoints of Italian criminal anthropologists Lombroso and Niceforo, who had argued that Southerners' barbaric, degenerate, and highly delinquent living habits were a direct effect of their visibly degraded race. Under the spell of fashionable phrenology, Ross argued that the evidence that "such people lack the power to take rational care of themselves" was the "distressing frequency of low foreheads, open mouths, weak chins, poor features, skew faces, small or knobby crania, and backless heads."[74]

The ensuing equation of Italians with unrepentant, ruthless, and Mafia-type criminals, at first limited to the urban press of New York and Chicago, spread nationwide in the fall of 1890, when the police chief of New Orleans, David G. Hennessy, who had been investigating local criminal activity involving Italian immigrants, was shot dead. His alleged dying statement that "the dagoes" had done it prompted the arrest of numerous innocent Sicilians, part of a colony of Italian islanders who had lived in New Orleans for decades. Nine of them were tried, but were found not guilty for lack of evidence. Immediately after the verdict, local politicians and businessmen assembled a mob of five to twenty thousand outraged citizens. The vigilante horde attacked the prison where the defendants were still held and lynched them. The Italian government vehemently protested and even threatened military action, while several American and foreign newspapers reacted with dismay to the news of the barbaric act. The national media coverage of the New Orleans events did not simply popularize the term and spread the concept of "the Mafia" as a specifically Sicilian phenomenon. It also provided a moral narrative: every Southern Italian criminal act was described as linked to an underground society of cold-blooded thugs coming from the Old World and threatening American institutions.[75] Although a few articles in the

mainstream media questioned the legitimacy of allegations of Italians' racial inferiority and natural proclivity for violence and criminality, they could not compete with the eugenicist "popular wisdom" that claimed that Southern Italians were racially, and thus inherently, incapable of citizenship.[76]

In the following years, criminal gangs calling themselves "La Società Camorrista," "La Mala Vita," and "Mafia" intensified their activity by kidnapping and blackmailing members of the Italian American professional and business class. Although such criminal acts took place throughout the country, they continued to hold intense interest in the New York area until the spring of 1903, when a gruesome crime was committed in the Italian section of the Lower East Side. It quickly came to be known as the "Barrel Murder" case, for the beheaded body found in a barrel in an empty lot between East 11th Street and Avenue D. The press followed the case closely: it was soon uncovered that the murdered man had "threatened to expose the secrets of the Mafia band of counterfeiters and blackmailers."[77] News of Italian crimes, whether linked to the case or not, multiplied exponentially. That September, a journalist for the *New York Herald* named one Italian gang "The Black Hand" (*La mano nera*), recognized its link to the "Mafia society," and explained its workings. A letter, embellished with threatening drawings of skulls, crossbones, daggers, and black hands, was usually sent to an Italian immigrant of some means. In broken English or poor Italian, the letter would threaten the kidnapping of a loved one, the bombing of property, or the murder of a family member, unless a large payoff was made.[78] Despite regular warnings that the ominous emblem was in reality a swindle that cloaked many crimes, to paraphrase the title of a cautionary *New York Times* article that appeared in late September 1903, the sensationalist coverage gave Italian criminality in New York a contagious publicity.[79] Several gangs, including non-Italian ones, used this cover because the name "Black Hand" sounded "high-sounding and terror-inspiring," as Italian community leader and writer Gaetano D'Amato acknowledged.[80] Between 1903 and 1908 newspaper headlines used it freely in reports of crimes committed by Italians, where it replaced earlier mentions of the Mafia and Camorra. The murders, bombings, and kidnappings allegedly committed by the Black Hand were confined to the Italian American quarters, which made the news reports a cross between detective investigation and eth-

5.3. "A School of Italian Art (Not Appreciated in the U.S.)," *Life*, 1 April 1909, 445.

nographic fieldwork.[81] By 1908, the Black Hand had become more than a common expression: it was a popular myth, a media obsession, and an easy confirmation of broad racial typecasting narratives about Southern Italians.[82] The "barrel murder" still held a paradigmatic appeal. In the spring of 1914, the *Chicago Record-Herald* ran a series of articles in its

Sunday special feature section, titled "Inner Secrets of the Black Hand Revealed," in which William J. Flynn, then chief of the Department of the East of the U.S. Secret Service, explained how he "solved the mystery of the Barrel Murder."[83]

Newspaper headlines and cartoons capitalized on the phenomenon. They often treated it with a combination of criminal justice and ethnographic methods by exposing the so-called "inner workings of the Mafia," while also often promoting its fictional, sensationalist, and even aesthetic connotations. A cartoon published in *Life* in 1909 explicitly paired Italians' criminality with an Italian pictorial style before declaring America's disapproval of the latter (fig. 5.3). Cinema followed a similar path.

Duplicating the yellow press's sensationalist reports of saloon gambling, prostitution, and terrible brutalities in Little Italy and satisfying a growing ethnographic interest in Italians' life in New York, early American cinema magnified (and fictionalized) what many imagined about the darker, more frightening circuits of the American metropolis. The conventional association of the gangster film genre with 1920s Prohibition or even with the genre's forerunner, D. W. Griffith's highly praised *The Musketeers of Pig Alley* (Biograph, 1912), needs to be revisited. As early as the mid-1900s, in fact, cinema had already cast Italian characters (as well as Chinese and Jewish ones, but to a far lesser extent) in narratives that captured widespread anxieties about the criminal outgrowth of seedy urban ghettoes and immigrants' hopeless misery existing a few blocks away from (or under) ordinary city life.[84]

The notion of cinema as a "visual newspaper" is particularly apt for what can be considered the prototype of the "Mafia genre," *The Black Hand*.[85] Produced in 1906 by American Mutoscope & Biograph, the film informed its spectators in its subtitle that it was the "true story of a recent occurrence in the Italian quarter of New York."[86] A month and a half before the film's release on 29 March 1906, in fact, the city press had reported that Pietro Miano, a butcher at 211 Bleecker Street, had informed the police that he was being blackmailed: he had to pay fifteen thousand dollars to avoid having his shop blown up. In charge of the investigation was then–detective sergeant Joseph Petrosino, an Italian-born officer whose successful crimefighting had made headlines since the spring of 1903 and who, since the fall of 1904, had directed an "Italian branch

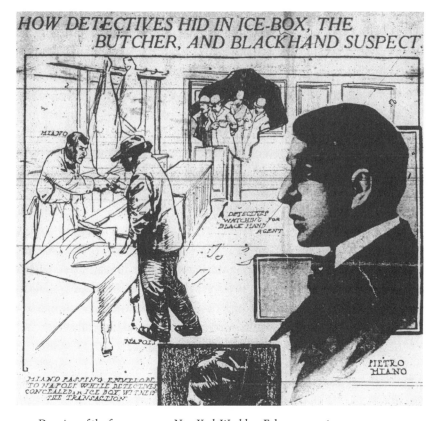

5.4. Drawing of the freezer scene, *New York World*, 17 February 1906, 3.

of the police service" established by the police commissioner, William McAdoo, "to wipe out 'Black Hand' outrages."[87] What made the Miano affair stand out were the singular circumstances of the Black Handers' arrest. The *New York Times* reported that in order to capture the criminals "Petrosino decided that the icebox was the best place for his men to hide in and ordered them into it." From dawn to evening, the paper reported, the detectives stayed there, trying all sorts of ways to remain warm; they alternated sitting and standing and, in a revelation that the film version could not help using, "occasionally they danced a little." Eventually a Black Hander, one Gioacchino Napoli, showed up and was swiftly arrested.[88] The detectives' ingenious tactic of hiding in the icebox proved to be a temptation too difficult for the editors of the *New York World* to resist, and they published a half-page cartoon revealing how the policemen witnessed the transaction between the butcher and the Black

Hander (fig. 5.4). *The Black Hand*'s director, Wallace McCutcheon, Jr., and Griffith's future cinematographer, G. W. "Billy" Bitzer, repeated the scene by making use of what appears to be a giant, windowed freezer, and staging the detectives' warming-up dance.[89]

Shot a month after the arrest, on 15 and 16 March, at and around the Biograph studios on 14th Street, the film exposed, in its narrative and visuals, the stark divide between honest Italian citizens—a category newspapers and the commissioner often insisted existed—and merciless Italian criminals through a combination of realistic rendering and unambiguous moral and racial legibility. In this "true story of a recent occurrence," an honest Italian butcher, Mr. Angelo, receives a letter written in broken English from two Italian Mafiosi, who threaten to kidnap his daughter, Maria, unless he pays them one thousand dollars. In contrast with several newspaper reports on Italians' distrust of law enforcement, Mr. Angelo immediately calls the police.[90] Meanwhile, the gang kidnaps little Maria in what appears to be an authentic outside shot of a nearby avenue. The police react cleverly. Two detectives hide in the walk-in refrigerated cabinet of Mr. Angelo's shop, and when a gangster comes in to retrieve the ransom, the wife opens the cabinet door and the two officers arrest him. Immediately afterward, Maria is rescued, the gangsters are all rounded up, and the family is happily reunited.

Despite its short length, *The Black Hand* allows significant insights. The Italianness of the gangsters is made visible through negative and stereotypical codings, beginning with their rather scruffy physical appearance (which was shot at a closer range than usual for the time). From the very first scene ("The writing of the letter"), the two Black Handers are not easily distinguishable from each other: they represent the same type (fig. 5.5). Played by the Italian American Robert Vignola (on the left in the figure) and Anthony O'Sullivan (on the right), the two young actors perform against a grey painted backdrop, with only a few props. Yet the contours of both faces are carefully marked by a dark hat on top, a scarf around the neck, and a heavy moustache at the center. They both wear dark vests over their light-colored shirts. Further, their behavior indicates habitual drunkenness—signified by a large wine bottle on their table and by their repeated drinking—in addition to their gestural and thus emotional excesses.[91] During Maria's imprisonment, one of the gangsters (Vignola) reacts with brutal ferocity to her escape attempt,

5.5. Medium shot of two rough, heavily mustached Italian kidnappers holding the ransom letter, right, from *The Black Hand* (American Mutoscope & Biograph, 1906). Courtesy of the Library of Congress, Motion Picture, Broadcasting, and Recorded Sound Division (Washington, D.C.).

and would hit her violently if his accomplices didn't stop him. This is a gang of primitive and ignorant criminals. The blackmailing letter the Mafiosi write is shoddily composed and contains misspellings. Literacy is an important cinematic signifier, which, as we shall see, discriminates between good and bad Italians. Indeed, the Immigration Commission was using literacy rates to recommend immigration restrictions to the American Congress.[92]

If the two Black Handers are unmistakably alien, utterly invisible is the Italianness of the patriarch (significantly named Mr. Angelo and not Signor Angelo), his family, and even the detectives—who, in the events that inspired the film, were Italian Americans. Well-groomed and wearing an immaculate white shirt, Mr. Angelo sports either a neat shop-owner's apron or the dark attire of a businessman. His heavyset body also speaks of wellbeing and prosperity, an impression promoted by his working in a well-stocked shop with faultlessly written labels naming and pricing his products (ham, veal, lamb, eggs, and butter). In the

recently restored version, Mr. Angelo is shown dealing with one of his customers, a rather picky or undecided one, in a very respectful and professional manner. There are no traces of temperamental self-indulgence or emotive excess in his bearing: he has become a modern, all-American figure. More conventional is his wife's appearance, though she is dressed in very light colors and appears to fully support his decision to go to the police. As an exemplary family, Mr. Angelo, his wife, and even Maria do not show any outward racial traits. They appear to be assimilated and Americanized immigrants, hardworking, honest, and fully confident in the American justice system. Like her parents, Maria appears to be wholly at ease with the English language: her liberation depends on written instructions secretly passed to her by the police and perfectly executed by the little girl. In this the film showcases a nativist refrain that literacy revealed immigrants' true character: unassimilated Italian criminals are often illiterate, whereas honest immigrants' command of the English language brings to light both their willingness to assimilate and their moral integrity.

The film employs other codes and props, related to ideas of gender and setting, to convey the realism of its racial representation. The presence of a woman in the gang resonates with criminologists' contemporary notion of a homology between Southern Italian criminality and femininity. Lombroso had famously theorized on women's and Southerners' stark atavism, which he said often resulted in superstition, irritability, and savagery. The American press had often capitalized on this sensationalist insight into the Mafia's workings.[93] Dressed poorly and wearing long, shiny, dangling earrings, the one female Black Hander of the film mistreats Maria with a stunning ferocity that drastically contrasts with Victorian expectations of gendered compassion and grace, but not with circulating prejudices about Italian women. "Women have often played an important part in the world of brigands," *Harper's Weekly* stated as early as 1881.[94] As for location, the film employs two outside shots, presumably filmed not far away from the Biograph studios at 11 East 14th Street, at places advertised by the *Biograph Bulletin* as authentic Italian sites. The first one is a prolonged view of a major and busy New York avenue, partially covered with snow. The combination of urban setting and snow may be associated with Stieglitz's *Winter, Fifth Avenue* (1893) and its several print and painterly reproductions, except that the film shot

displays dense commercial car traffic and curious and well-dressed pedestrians (fig. 5.6). In addition to the initially hardly visible Black Hander and Maria, the shot reveals a number of interesting figures, including several businessmen, respectable women, and well-dressed youngsters. One African American passes by the camera, and a policeman crosses the shot while roughly accompanying a disheveled suspect. Seeing the kidnapping, a few eyewitnesses appear to be dashing to Maria's rescue, while another alerts the nearby police. Although their efforts seem a bit staged, the *Biograph Bulletin* proudly noted that "the kidnapping scene was done with such realism that our actors had no little trouble in getting away from policemen and detectives who persisted in regarding it as the real thing."[95] Immediately following this one, the second urban shot is set along a street, not an avenue. It is a darker view of a more modest location, where neither the street nor the sidewalk have been completely cleared of snow. None of the individuals or types who crowded the avenue are present. A lonely boy rides his horse below a huge sign advertising a local brewery, and construction workers are visible nearby. Opposite, on the left side, is the roughly written commercial sign "Junk Shop," which, as we quickly learn, marks the entrance to the Black Handers' headquarters. The contrast between the two shots conveys the opposition between the respectable, commercially thriving "American" environment where Maria usually wanders and the ghetto-like scenery surrounding the Italian criminals' lair, much more invested with an aura of documentary and plebeian realism. It is likely that the New York audiences of the time recognized and appreciated the striking semiotic and ideological contrast of these two locations, which provides an objective correlative to the moral distinction between virtuous and vicious Italians.

If streets and avenues are invested with different moral and racial connotations, the detectives are made to look indisputably American. Introduced by an intertitle that both documents and editorializes the plans of the police ("Levying the blackmail. A clever arrest. Actually as made by the New York detectives"), two policemen decide to use the freezer as a hiding place while waiting for a Black Hander to show up. They use such emphatic gestures to indicate the cold of the freezer that, comically, they almost appear to be dancing. When the Mafioso shows up, appearing more like a Western bandit than a Sicilian brigand, they are ready for him. Mr. Angelo hands him piles of dollar bills that he

5.6. Street scene from *The Black Hand* (American Mutoscope & Biograph, 1906): the large thoroughfare where the kidnapping takes place. Courtesy of the Library of Congress, Motion Picture, Broadcasting, and Recorded Sound Division (Washington, D.C.).

has taken from a safe. Meanwhile Mrs. Angelo has skillfully opened up the door of the freezer without being seen: quickly the two detectives emerge from hiding and make their arrest. As the policemen and the Mafioso exit the scene to the left, Mr. and Mrs. Angelo are seen relieved at the outcome and tenderly hugging, while the money, which the Black Hander dropped on the floor as he was being arrested, is left untouched and uncared for. Italians' widely admired valuing of family unity above all receives a short but precious homage. Shortly after, possibly thanks to the collaboration of the arrested Mafioso, three policemen in uniform arrive at the hideout, and with the help of Maria, who follows their instructions to the letter, they arrest the Sicilian criminals.[96]

The principle of splitting the Italian community into two morally different groups was even further promoted by news of the Italian squad's success against the Black Hand and by the public pronouncements of the squad's chief, Sergeant (and later Lieutenant) Joseph Petrosino, whom

5.7. Lieutenant Joseph Petrosino, uncredited and undated photograph, from Arrigo Petacco, *Joe Petrosino* (Milan: Mondadori, 1972).

the press liked to profile even physiognomically as a trustworthy and determined individual (fig. 5.7).[97] A superb detective and perfectly bilingual, having migrated from Calabria to the United States when he was thirteen, Petrosino was much more than an inspiring historical figure in the civic and racial culture of turn-of-the-twentieth-century New York. He became the Italian face of American law enforcement, or its "butcher's face" and "mastiff," in the physiognomic description of Italian

journalist Luigi Barzini.[98] By setting the moral compass for Italian film characters, he enabled spectators to identify with characters who did not have to completely shed their markers of racial and cultural difference (although they could).[99]

Petrosino was personally close to Theodore Roosevelt and had friends on the city's papers, so his words spoke as loudly as his actions. Possibly to dislodge the conventional identification of Italians with criminals (and put pressure on Italian customs officials), Petrosino advanced a sociological theory of Italian criminality that revealed a racially charged trajectory of Italians' adaptation. He juxtaposed a past of criminal customs with the idea of a modern and virtuous American citizenry, which, he argued, Italians were quite capable of embracing. On 15 October 1905, he told the New York Times that the infamous eight-year-old "blackmailing business," as he called it, was conducted by "descendents of generations of brigands from Reggio Calabria and from the Palermo Province of Sicily [who] were brigands before they came to America."[100] One year later, in an interview in the same paper titled "Petrosini [sic], Detective and Sociologist," Petrosino divided Italians into two groups, identifying two possible racial characters: one, a violent and "rustic brigandage" composed of individuals who "are generally from Sicily and Southern Italy" and whose presence in New York culturally and even aesthetically contrasts with "the streets of one of the greatest and most civilized cities of the world." Opposed to them is a second group of "white-faced but swearing" men who, according to the Italian lieutenant, unfortunately still ignore "the greatest of all blessings this country affords, equal rights," but who have the ability to change. Ultimately, in a logic that defied racial determinism and favored successful adaptation on the basis of a moral, and thus racial, inbetweenness and civic enfranchisement, Petrosino maintained that what "can bring about the end of the Black Hand, is enlightenment." Advocating education more than policing, Petrosino also argued for the presence of "a missionary more than a detective in the Italian quarters of New York," someone who could persuade the Italian American citizen "that every line of the law of the city, State and Nation is as much for him as for the native born of the American whose ancestors fought to establish the Republic." Petrosino's solution was a slogan of civic promotion as much as a motto for future filmic narratives: "the Italian has a natural love for liberty. . . . He is worth enlightening."[101]

Meanwhile, stories of "Italians chasing Italians" had an obvious racial appeal. Despite the dramatic juxtaposition of honest and criminal Italians, at play was also the assumption of Italians' unshakeable racial and cultural communality: the virtuous could defeat or appease the Mafia, because they were almost genetically in tune with its customs and methods. In January 1909, Kalem released the one-reeler *The Detectives of the Italian Bureau,* a racial thriller that operated on the premise that only "courageous and honest men of Italian birth" had the ability and the cultural skills to catch Italian criminals.[102] Less than two months later, Petrosino went to Sicily to further his investigations into the connections between Italian and Italian American Mafias, which he rightly suspected to be rather flimsy, since Italian criminality in New York had not yet become an organized syndicate. His transatlantic investigation was supposed to be secret. Just days before his departure, however, the *New York Herald* published the story of his Sicilian visit. On 12 March 1909, Petrosino was killed in the central Piazza Marina of Palermo under mysterious circumstances by what, years later, was revealed to be the arrangement of a local Mafia chief. He had not suspected that a meeting with an informant was instead a deadly trap. In the newly interconnected context of transatlantic news agencies, his arrival in Palermo was no secret.

When his funeral was held in Manhattan on 12 April 1909, about two hundred thousand people attended.[103] The man who had embodied a moral bridge between Italians and the New World had been defeated by the old one. While he was held up as an American hero, his assassination increased the American public's hostility toward Italians and its suspicion that they could not change. For many, his murder proved not only that "the dreaded society did exist, that it was responsible for many if not all unsolved crimes in American cities," but also that "in a leap beyond logic . . . all Italian Americans were to blame."[104] The event, in other words, furthered the dualism between the moral uprightness of assimilation and the wickedness associated with its refusal, which Americans saw as Italians' unfortunate and ungrateful tendency.[105] Yet the very dualism and the racial epistemology of a figure like Petrosino was predicated on a possibility of redemption that his individual death did not and could not obliterate.

Not only did Petrosino's assassination fail to stop the production of films centered on the figure of the tireless Italian sleuth, but it actually

spurred the production of films meant to expose the redeeming clash between brilliant and heroic investigators and cruel and vicious Mafiosi. Most importantly, the stories inspired by his life relied on a transatlantic narrative framework that had defined and would define films about European immigrants, and particularly Jewish and Italian characters, for years to come, just as it configured the stage backdrop discussed at the beginning of this study. In these narratives, as we shall see, the relationship between the two coasts is never an equal one. His murder had revealed (and exaggerated) the international dimension of Southern Italian criminality, but, since the crime had been committed in Sicily and not in New York, his tragedy left the impression that Old World criminality maintained traits of cruelty and ruthlessness unknown in America. Still, the fictional deeds of a young detective of Italian or, even better, Italian American background were the subject of film productions that either offered happy endings or concluded, in rather melodramatic ways, with the tragic assassination of the protagonist. In either case, moving pictures promoted *exempla* of criminal justice, moral rectitude, and, in the process, virtuous racial amendment.[106]

The first of such productions was *Foiling the Camorra,* released early in 1911 by the Yankee Film Company. Despite its reference to the Neapolitan criminal organization, the film featured a violent and shrewd Sicilian boss who escaped from Italy and found refuge in New York. Only a "young police lieutenant" named Victor Petroso, whom *Motion Picture News* called "the fearless 'Italian Sherlock Holmes,'" could "run down the boldest and most merciless band of kidnappers ever recorded in the annals of the Black Hand."[107] One year later, *The Adventures of Lieutenant Petrosino,* directed by the Odessa-born Sidney M. Goldin (a Jew who usually directed comedy), displayed the same mixture of hagiographic and sensationalist realism.[108] Produced by Feature Photoplay "with the 'special permission' of Madame Petrosino," the film showcased the ingenious methods that Petrosino, the "famous Italian-American detective," employed in New York and Palermo. The film exhibited "blood-curdling scenes" and ultimately revealed, in an ethnographic manner, "the workings of that mysterious band of the underworld."[109]

At the film's opening, Italian gangsters are basically running the city. When a policeman approaches a group of them sitting idle near the East River, they attack him, unafraid of the approaching back-up. That's

when the chief of police posts Petrosino, a proud dark-haired sergeant, to the Italian quarter. Confronting the same group of hoodlums in the same location, Petrosino does not play defense, but offense. He initiates a fight and, alone, defeats them all. He also cleanses the community of other forms of violence. In one scene he saves a little girl, Angelina, from the disturbing violence of her Italian father, a rag-picker. At the end of his busy days, he is often shown dining in the comfort of his bourgeois home while his wife listens affectionately to his recounting of his deeds.

But despite his early success, the Mafia regroups. In a shot that resembles many illustrations published in the Sunday edition of the *World,* several members of the criminal organizations are shown meeting in a dark basement, surrounded by black pirate flags, wearing colorful bandanas and communicating with bizarre hand signs. As in *The Black Hand,* the Italian criminals are after the money of a successful fellow Italian, in this case Antonio Lorenzo (named Frank in the Dutch print), owner of a classic Italian business, a bank which functions also as a travel agency and remittance office. Good-looking and of high social status, Mr. Lorenzo also has civic and moral virtue: after receiving the black-mailing letter he immediately notifies the police, although he decides not to inform his family about the threat. That very evening, however, he is murdered in the reading room of his brownstone. On the trail of the murderer, Petrosino masquerades as a low-life, by adopting a moustache, a hat, and a lot of attitude. He follows one of the brigands to his miserable shed, which is surrounded by rags, trash, and dirt. Inside, the bandit first beats his daughter under an image of Jesus, in a visual composition that encapsulates and aestheticizes the moral hypocrisy of the coarse Southern Italian malefactor. Then, as Petrosino sneaks into the hut (fig. 5.8), the bandit lights up his pipe with a gesture and in a setting that recalls a famous Jacob Riis photograph of an Italian rag-picker (*An Italian Home under a Dump,* 1892). Just as Petrosino is about to arrest the man, his fellow brigands intervene and knock the sergeant down. They quickly plot to throw him in the river, but the brigand's daughter, who has already prevented her father from knifing Petrosino, runs to alert a passing policeman, Giuseppe, of the murderous plan. Giuseppe hastily follows the gang. He is able to stop them just in time, but, surrounded by four brigands, he is nearly overwhelmed by them. Suspenseful parallel editing, however, shows his fellow policemen speedily riding their

5.8. Dressed as a thug, Petrosino enters the hut of one of the brigands in *The Adventures of Lieutenant Petrosino* (Feature Photoplay Co., 1912). Courtesy of the Netherlands Film Museum (Amsterdam).

motorcycles to his and Petrosino's rescue. All the ruffians on the scene are arrested and Petrosino is saved.

Undeterred by his near death, Petrosino is determined to eradicate the entire gang by personally infiltrating it. Impersonating a brigand with disheveled clothes and a large moustache, he learns their language and gestures and befriends the ruffians in their favorite saloon. Eventually he leads his fellow detectives to the Black Handers' lair and secures a massive arrest. Shortly afterward, however, some of the gangsters flee from prison and, artfully camouflaged as a loving old couple, escape to Italy. Petrosino decides to follow them, alone. As he disguises himself as a "typical" Italian bourgeois man, again by adding facial hair, his wife embraces him repeatedly and cries, anticipating the film's final, painful scenes. The Sicilian Mafia (which the film's Dutch intertitles mistakenly refer to as the Camorra) has been alerted to his arrival. Unlike in New

York, in Palermo all the Mafiosi seem to be members of the upper classes, as if on the Southern island there is no distinction between criminal and respectable society. To start his investigation, Petrosino visits a trendy café, where he is immediately recognized. Shortly he is hunted down and killed. Without any exterior shots of Italy, we are simply alerted that "tragic news" and his dead body are reaching New York. The crime story becomes, in the final moments, a tear-jerker. Lingering frontal shots of the coffin, which is surrounded by Petrosino's wife, his fellow policemen, and a priest, anticipate the final scenes of the lonely widow on what appears to be a typical day of mourning: a visit to the cemetery and long crying at home in front of the image of the long-gone husband-hero.

Although Petrosino's murder had occurred three years earlier, most spectators were aware of his brave but tragic mission, thanks to newspaper coverage, film adaptations, and popular memory. The film never contradicts the audience's memory of his appearance with close-ups of the actor playing him, but instead tries to place the known story within other familiar national narratives to strengthen its recognizably American heroism. If the behavior of the wicked rag-picker's daughter clearly pairs her with Pocahontas, the policemen's last-minute rescue resembles the Western cavalry's comparably laudable deeds. The death of Petrosino then acquires the semblance and the meaning of a noble sacrifice, which, in the racial logic of these films, draws up a model of adaptation. Like several early American films about Italians, *The Adventures of Lieutenant Petrosino* manages to oppose two morally incompatible, but superficially fluid and interchangeable, models of Italianness. Petrosino may easily dress up as a shady Sicilian Mafioso, but the masquerade will not corrupt his moral character. Visible evidence of the hero's inner morality includes his professional achievements, his financial prosperity, and, last but not least, his domestic bliss. There are no scenes of jealousy or excess in his home. Petrosino is quite violent on the job, but a loving husband at home. His theatrical gesticulations and unbridled passion for abundant food are all that remains of his Italianness, domesticated and landscaped by the middle-class décor of his American house. He is a model of the successfully adapted (yet never completely assimilated) Italian immigrant, whose violent death augments his inspiring biography in the way immigrants allegedly best understood—through the emotional cogency and moral clarity of the melodrama.

Three years later, *The Last of the Mafia* (Neutral Film, 1915) went a step further as it told a fictional story of vengeance for Petrosino's murder. A famous Italian detective comes to America on an official mission to track down Sicilian Mafiosi. While investigating kidnappings and violence, he is killed in an ambush. Detective Lieutenant Cavanaugh, of Italian parentage but bearing an English name that indicates an American upbringing, heroically intervenes. He arrests the guilty parties and makes sure they are all extradited to Italy.[110] In *The Last of the Mafia*, it is clear from the outset—even the title indicates—that the narrative will produce a pro-American resolution to the conflict between Old and New Worlds. In the film's fictional universe, a newly acquired sense of entitlement to justice—Petrosino's lesson—enables immigrants to resist criminal threats and, in the end, to prevail over them. The "good" Italian Americans, whether citizens or detectives, ultimately disrupt and defy the criminals' plans. The ideological overtones of such a story line—as *Moving Picture World* commented—turned the film into "a popular offering."[111] Inspired by events selectively reported by the press, popular stories of mob delinquency within the Italian community abounded from the late 1900s to the mid-1910s.[112] By the early 1910s, the narrative and commercial appeal of the Italian criminality of New York was established not just for American cinema, but also for the powerful and competitive French industry, which produced a few Black Hand films for the American and international markets.[113]

As was already clear in *The Black Hand*, the visibility of honest Italian immigrant characters who hold respectable social positions and do not bear obvious physical signs of Italianness identified an advanced and well-rewarded process of moral and civic assimilation. Although few of them are extant, several films focusing on Italian immigrants and crime are not mute about their narrative and ideological epistemology. Analysis of their plots and reviews reveals that, despite growing up in social and urban landscapes marred by vice and criminality, for Italians assimilation was depicted as a challenging, but not impossible, process of moral domestication and adjustment that eventually transformed their class status and even their appearance.[114] The narrative and ideology of this paradigmatic portion of American cinema emphasized Italians' vast racial and cultural diversity, particularly in their levels of innate violence, strength of passions, and modernity (or lack thereof),

and tended to stage either a merciless confrontation between Italians of opposite moral character or a redeeming transformation—a conversion of sorts. In the end, characters who share the principles of mainstream American ethics are both socially and economically rewarded. If they do not, their racialization is further underscored in dramatic and, less often, comedic ways.[115]

The emphasis on non-criminal, yet colorful or even just different, habits called attention to traits that Anglo-American culture admired or, at least, did not utterly fear in Italians, including endurance, devotion to the family, romantic passion, and even jealousy.[116] What remained constant, however, was the presence of violence in the form of criminal brutality or terrible accidents. In *The Criminals* (Mecca, 1913), for instance, the police wrongly arrest an honest father whose only child has been killed by the Mafia. Combining the popular crime plot with the notion of Italians' strong, even obsessive, family attachment, the film's heartbreaking plot line anticipates later works depicting Italians suffering awful injustices. Prepared by several films insisting on Italians' sympathetic qualities—their musical talent, romantic passion, and love of home—the work of George Beban, as we shall see, walked a sentimental but rewarding line between uplifting plots of adaptation and entertaining accounts of racial difference.

SIX

White Hearts

A very important part of most screen characterizations
... is the quality of *picturesqueness.*

"ITALIANS' DELINEATOR" GEORGE BEBAN, 1921

BLOOD AND THE PERFORMANCE OF SENTIMENT

Although allegations of a natural criminal inclination remained readily available, early American cinema found other ways to stress Italians' racial and cultural diversity, through both storytelling and characterization.[1] Recurring motifs attached to Italian characters were the racializing themes of passionate, yet impulsive love, the irrepressible need for revenge, and a generally violent emotional regime. By exploiting rather than avoiding negative racial stereotypes, however, films about Italians in America consistently made space for positive characterizations as well. Often the storyline divided immigrant characters into two clear, morally defined groups: violent criminal figures versus honest Italians. It also could rely on misunderstandings and subterfuges to contrast characters' apparent deviousness with their actual moral purity. Or it might create a space of genuine moral vacillation within a single character's conscience—usually ending with an act of self-sacrifice indicating a final moral redemption. The cinema of actor and director George Beban, whom many newspapers branded the "best delineator of Italian charac-

ters," captured and furthered all these narrative possibilities in feature-length productions of striking critical and commercial success.[2]

Let us begin with the theme of Italians as Latin lovers. Early American films gave an ideological charge to this allegedly natural disposition by linking the display of untamed passion and sensual excess with romantic inconsistency. "There is no easier victim of Cupid's darts than the Italian," read the initial lines of the *Biograph Bulletin* on Griffith's *The Italian Barber* (1910), anticipating a long list of romances.[3] The film's title character falls in love with, and marries, the local newsgirl in a fortnight. Yet when her sister appears, he is instantly and impetuously drawn to her. The young wife, meanwhile, falls in love with her sister's fiancé in a game of sentimental switches that exemplarily associates Italians' ardent affection with fickleness and infidelity. Similarly, other Griffith films, from *In Little Italy* (1909), *The Cord of Life* (1909), and *At the Altar* (1909) to *The Italian Blood* (1911), emphasize such characterological stereotypes as pathological jealousy, impetuous anger, and "Sicilian tenacity." *In Little Italy* is the story of Tony, a ferociously jealous suitor, who, rejected by Marie, plans to kill Victor, the man she intends to marry. Only the police's timely intervention defeats his "indefatigability of purpose," which, according to the *Biograph Bulletin,* constituted "one of the most dominant traits in the Sicilian's culture."[4] Playing the Sicilian character of Victor, Henry B. Walthall, a former stage actor and a Griffith favorite (he played the Little Colonel in *The Birth of a Nation*), gave a histrionic performance that strikingly contrasted with his restrained portrayals of positive American characters.[5] This depiction of Sicilianness was common at Biograph, often linked to intense but failed courtship. It surfaced in the figure of the villainous Antonine, the "facinorous Sicilian profligate" of *The Cord of Life,* and in the vengeful Sicilian Grigo of *At the Altar,* who plots horrible deeds against the gifted musician who has won the heart of his beloved. In these films, Sicilianness (or Southernness generally) and Italianness are not necessarily contrasted. As characters' Southern origins are often presumed, so are their conventional inclinations. *The Italian Blood* tells the story of an Italian wife of "Southern blood" who tries to revive her husband's love through the dangerous artifices of jealousy. The plan backfires. The husband is driven into a frenzy and comes to his senses just as he is about to kill his own children. The very title of the film racializes the

storyline: the way in which characters act and interact is "explained" by their peculiar biological make-up.[6]

In other instances, Italians' alleged short temper and inclination toward vendetta were narratively justified, with varying degrees of ambiguity, by dreadful adversities affecting their intense familial bonds. In *The Wop* (IMP, 1913), a widowed father named Luigi, after being unfairly jailed, "breaks down and wild with rage, curses the judge and . . . is possessed of but one idea—to kill the child of the man." Eventually, only the sight of his own daughter, who has in the meantime been adopted by the judge, halts his fury.[7] Similarly, in *The Circle of Fate* (Kay-Bee, 1914), "an Italian girl is inveigled into coming to America and is then abandoned. Her father meets the man later and throws him in the mouth of Mount Vesuvius." Given the circumstances justifying such a violent reaction, *Motion Picture News* had no doubt: "A story with a moral that will not fail to make its appeal to everyone."[8]

Over time, the repeated display of Italians' allegedly defining traits, no matter what their moral value, called attention to the cinematic strategies that best conveyed those traits. One of the most effective ways to render Italian characters' violent inclinations and intense emotional outbursts was an exaggerated acting style that echoed the "emotional temperament of the Latin race."[9] As Kristin Thompson has noted with regard to *The Cord of Life* (1909), Griffith's Sicilian protagonist spends a lot of screen time shaking his fists, brandishing his knife, and thus repeatedly "signal[ing] his psychological motivation for his actions—revenge."[10] Similarly, Steven Higgins has argued that the scene in Griffith's *The Lure of the Gown* (1909) in which a discarded lover wins her fiancé back by reawakening his jealousy "is filled with lots of passionate gesticulation and physicality, so common in portrayals of Italian communities in American cinema."[11] Within the popular melodramatic genre, the difference between operatic stock figures and psychologized individuals marked a significant separation, one charged with racialized connotations.[12] It marked a divergence between clear-cut narratives, whose characters' behavior was reactive, instinctual, or perfunctory, and psychological storylines emphasizing characters' inner turmoil and motivation. Although the repetition of sentimental whirlwinds and emotional excess granted realism to racial impersonations, the development of longer, feature-length "tenement dramas," in film and, even earlier, on stage, al-

lowed for more complex melodramatizations of Italian characters and, consequently, for more complex emotional responses from audiences. There were plenty of influential examples in the city's theatrical culture. A wealth of talented Italian actors and melodramatic performers lived and worked in New York. They included famous opera singers such as Enrico Caruso and Luisa Tetrazzini,[13] as well as stage actors Adele Ristori and Ermete Novelli. Since the 1890s, New York had also been home to a host of talented Neapolitan and Sicilian stage companies.[14] Whether performed in Italian or in dialect, their melodramatic narratives featured highly sentimental plots of jealousy and revenge, as well as tear-jerking stories of sudden misfortune, deprivation, kidnapping, and personal wretchedness that reviewers, most notably John Corbin and Carl Van Vechten, constantly praised for their pathos and universal humanity.[15]

Since acting style was thought of as revealing a character's national and racial identity, it was often employed to surprise fictional characters and real spectators alike. The narrative motif of *méconnaissance,* or misrecognition, in which fictional circumstances and typical demeanor misrepresent a character's true moral nature, was common. In most cases, the uncovering of an authentic identity is a positive fact: it reveals a moral rectitude, a nobility, or even an American biography beneath a stereotypically plebeian Italian character. In *The Organ Grinder's Ward* (Reliance, 1912), as *Motion Picture News* summarized it, "Pietro, an Italian nobleman, has adopted the organ grinder's disguise in order to find a villainous Italian Count who has ruined his home."[16] In *The Sign* (Essanay, 1913), an honest and thrifty Italian laborer named Pietro is mistaken for a member of the Black Hand because, in writing to his bank, he accidentally turned over an ink-well and smudged a handprint on the letter.[17] In *A Child of Mystery* (Universal, 1916), an Italian girl, Carlotta, is a constant victim of Black Hand leaders until an honest judge, a clear synecdoche for the American legal system at large, recognizes her as his long-lost granddaughter. Soon afterward, the Mafiosi are punished.[18]

Along the same lines, Sidney Olcott's feature-length *Poor Little Peppina* (Famous Players–Mary Pickford Co., 1916)—a seven-reeler now unfortunately available only in an abridged four-reel version—stages a double disguise. None other than Mary Pickford, in her longest film to date, plays Lois Torrens, the daughter of an American judge in Italy, who is a "Yankee girl . . . posing as an Italian Boy."[19] After being kidnapped by

the Mafia at a very young age, she is renamed Peppina and raised among Italian peasants with a foster brother named Beppo, played by her real-life brother Jack Pickford. Finally she escapes to America, masquerading as a young boy. In New York, she is recognized by the Mafia and forced to recycle counterfeit money. After being caught by the American authorities, she tells the police her story and collaborates with them to help expose the underground operation. In the process she also reencounters her parents, who had resettled in their estate along the picturesque Hudson River, and finally marries her valiant (American) rescuer, a young assistant attorney. In her impersonation of an individual of a different race and of opposite gender and moral value, Peppina-Pickford plays with familiar and explicit conventions in front of film characters and audiences alike. The Toronto-born "America's sweetheart" gesticulates in a conventional Italian manner (fig. 6.1), plays (and tries to cheat at) bocce, and is as ready to wade into a fistfight as she is attached to her rituals of prayer (a "custom of the peasantry," as one character comments). To add authenticity to the Italian settings, a number of highly pictorial shots rely on a carefully arranged mise-en-scène of garlic braids and fireplaces, numerous iris shots, and chiaroscuro effects to emphasize the stereotypically humble and picturesque environment in which Peppina is forced to grow up. "The Italian atmosphere was cleverly caught through locations and set design," Kevin Brownlow has noted, describing the private estate in Peapack, New Jersey, where the shooting took place: "a hilltop estate overlooking a picturesque river, a deserted ruin where Peppina hides, the crowded streets of Naples."[20] The chief Mafioso and his lead companion are played by two icons of Italian American stage melodrama, Antonio Maiori and Cesare Gravina, duly acknowledged in the credits and reviews, which emphasized that "only Italians should be engaged to play the important Italian parts."[21] Peppina herself is unaware of her own true racial identity, although the audience never forgets it. Pickford's stardom, which garnered record-breaking turnout, made her disguise obvious: "as she wears a dark wig," the New York Times pointed out, "she makes a likely daughter of Italy."[22] Further, Peppina's skin is visibly lighter than Beppo's. Peppina's trip to America is a process of self-revelation marked by sacrifice and redemption. The film's most talked-about scene occurs when Beppo cuts her (fake) curls so that she can believably impersonate a boy and escape the Mafia. Audiences'

6.1. Iris shot of Mary Pickford performing a typical Italian gesture in *Poor Little Peppina* (Famous Players–Mary Pickford, 1916). Used by permission of the George Eastman House/Film Department (Rochester, N.Y.).

shock at the sight of her losing her much ballyhooed tresses is alleviated when, once she regains her American identity and family, she reappears with her familiar curls.[23]

The trope of redemptive self-sacrifice may have been narratively motivated, but in the common framework of the Atlantic journey to America, it was also attached to the "original sin" of Italianness—even when such nationality did not imply anything negative. This was the case in *The Violin Maker of Cremona* (Biograph, 1909), which displayed not just Italians' superlative, preindustrial craftsmanship and melodramatic cunning but also a final, redeeming episode of self-abnegation. In the film, which was shot entirely in studio, an exceptionally talented but crippled violin maker, Filippo, wins a contest for the hand of the woman he loves, but gives her up, for he knows her heart is given to someone else. Comparing the film to *Pippa Passes; or, The Song of Conscience*, a 1909 ad-

aptation (also by Griffith) of Robert Browning's eponymous poem, Scott Simmon notes that "Filippo's self-sacrifice suits Griffith's geographical hierarchy for Italy, where his ethical and racial values increase the closer one gets to the North."[24] Indeed, such logic was at play in more than just Griffith's work. Beban's Venetian protagonist in *The Italian* (NYMPC, 1915) flaunts the same geopolitical association of morality and locality. Overall, however, even when the geographical origin of an Italian character remained indeterminate, an artistic talent was, in and of itself, often a sign of moral decency and a catalyst of familiar, melodramatic aestheticizations. In *The Organ Grinder* (Kalem, 1909), a street musician helps a family find their kidnapped daughter.[25] *An Italian Gratitude* (Solax, 1911) tells the story of an American doctor who saves the life of a young Italian boy, the son of a family of musicians and street performers. When the doctor's little girl dies, "the Italians give up one of their two children."[26] In *The Immigrant's Violin* (IMP, 1912), the talented violinist Rosa, who was separated as a child from her parents at Ellis Island but found love and fame through a rich and generous American family, remains "true to the call of filial duty." When, many years later, she reencounters her long-lost immigrant parents, she does not reject them. Instead, by fully accepting her own unalterable origins, she reunites with them and embraces the "atmosphere and picturesqueness" that defines, for *Moving Picture World,* "the characteristic life of the poor Italian colony in New York City."[27] Similarly, the protagonist of *Tony the Tenor* (Pilot, 1913) is willing to forfeit his immensely promising talent and the possibility of an easy life in America because of his and his wife's incessant longing for "sunny Italy." And in *The Beautiful Lady* (Biograph, 1915), an Italian pottery vendor, whose craft illustrates "the innate poetry and love of the beautiful in even the lowest classes of the people of sunny Italy," falls in love with an American woman and sacrifices his own life when hers is threatened.[28]

The moral distinction between corrupt and virtuous Italianness, whether in multiple figures or within a single character, was a profitable narrative compromise. Embodying racial and thus moral difference in the figure of the Italian criminal, these films reaffirmed mainstream middle-class prejudices and granted cinema the high moral ground of documenting and denouncing real delinquency. Simultaneously, by exhibiting Italians' honesty, frequent victimization, and overall integ-

rity, they pleased the self-image of Italian and, generally, immigrant spectators, who constituted a remarkable portion of New York's film audiences.[29] Through all these different narrative options, the racialized topographies of New York City—early American cinema's master urban setting—enabled realistic visualizations of innocence and guilt, successful adaptation, and defiant (self-)exclusion. Films could depict these either by exhibiting the abandonment of past traditions and customs and the acquisition of new habits, or by focusing on Italians' tightly knit enclaves as evidence of cultural and civic isolation or national pride. In all these cases, adaptation did not translate into full assimilation. Markers of outward or temperamental difference often persisted, displaying an abiding and entertaining racial disjuncture within America's "white" society. As a few examples discussed earlier show, things changed considerably when films about racialized Italian characters successfully engaged spectators' emotional sympathy, not just their moral solidarity. More than any other performer, the American stage and film star George Beban enabled and crystallized American audiences' new compassion for Italian figures.

ROMANTIC RACIALISM AND GEORGE BEBAN'S "ITALIAN TYPES"

He rubbed some cold-cream thoughtfully across his brow
and into the swarthy grease-paint that turns this Scotch-
Irish-Austro-American into a "dago" of the deepest dye.

INTERVIEW WITH GEORGE BEBAN, *THE THEATRE*, AUGUST 1915

Did you ever interview a volcano—an ACTIVE volcano?

INTERVIEW WITH GEORGE BEBAN, 1919

At the turn of the twentieth century, minstrelsy, slave narratives, and (fictional) racial autobiographies, as Laura Browder has argued, made a case for racialized individuals' public aspirations to better rights and citizenship. While immigrants' narratives promoted emancipation, the genre of the immigrant autobiography, which emerged in a culture of widespread nativist sentiment in the 1910s and 1920s, offered first-person

testimonials for why immigrants deserved to be considered Americans or, at least, to be treated as if they were. Aesthetically, these literary and theatrical genres spoke to questions of authenticity when addressing issues of genuine racial difference and Americanness, but also of impersonation and performance when emphasizing the slipperiness of racial and national identities. In Browder's words, racial narratives "revise[d] the basis for a national sense of self."[30] This tension raises important questions for a discussion of racial characterizations and racial narratives. To what extent could the very American notion of self-invention apply to narratives about heavily racialized immigrants? Could immigrant characters operate within a space of consent, to use Werner Sollors's well-known distinction between natural determinism (blood) and cultural self-fashioning and self-improvement (law)?[31] Which ones could do so, and which ones could not? As performances that foregrounded, manipulated, and thus de-essentialized the stereotypical markers of racial identity, racial impersonations could "create a space for creative self-determination and agency."[32] Within a eugenic logic of racial rankings, however, self-improvement could generally lead only to individuals' moral and civic redemption, without erasing racial differences entirely. Still, the popularity of racial impersonations, as Browder has noted, made racial difference "consumable and allowed audiences to unwrap performances and use them in their personal self-definition of whiteness."[33] Contributing to a dialectic production of Americanness as civilized and superior, racial performances turned immigrants into protagonists of compelling narratives that aligned moral dilemmas with the pursuit of citizenship. On stage and in film, Italian characters—not yet Italian actors, though—were at the center of this process.

By the early 1910s, in fact, the stage and cinematic impersonation of the Italian racial type had been significantly humanized. In place of the stock characters who were represented as naturally deviant, prone to crime, or just unmanageable, a number of humbler and more sympathetic types made their appearance. The new poetic direction still racialized Italian characters, but, through plot lines of appalling discrimination and dreadful adversities, it roused audiences to poignant involvement. The combination of traditional ethnographic curiosity with more recent forms of sentimental closeness had an unquestionably broad marketability. Economic misery and dreadful misfortune,

especially within the dialectic of social integration as moral redemption, were both gripping and educational subjects capable of eliciting a strong emotional response from native and racialized audiences alike. To an industry that wanted to win its audiences' moral approval, the "humanity of the picture," as *Moving Picture World* described the appeal of the heartbreaking *The Immigrant's Violin* (IMP, 1912), was an essential opportunity.[34] Together with disavowing strict racial heredity to the advantage of environmental influences, in the early 1910s American films developed more racially tolerant formulations of American civic identity. This represented an aesthetic adjustment that matched the film industry's ever growing aspiration for the widest popular appeal. On the eve of World War I, even as nativist slogans like "100 per cent Americanism" aggressively called for national cohesion and loyalty, several films addressing immigrants' experience in America entertained cosmopolitan ideals of universal tolerance and harmony. Without alienating either its immigrant or middle-class audiences, in this period American cinema engaged in the "realistic" and universalist representation of racial and cultural diversities. By portraying immigrants as both picturesque and ill-fated, American films struck a fine, yet universalist balance between catering to familiar aesthetic responses and encouraging forms of emotional identification.[35]

Crucial to these processes was the Irish-Dalmatian figure of George Beban, whose stage and film career recapitulates the relationship between silent American cinema and race.[36] If in the mid-1900s Petrosino was the Italian face of the American justice system, in the mid-1910s Beban became the Italian face of American cinema. Although the vast majority of his films survive only in part or not at all, his acting style, directorial work, and even published lessons on racial characterizations demonstrate a lucid understanding of what was involved in constructing Italian characters and settings.

Born in San Francisco in 1873, George Beban began acting at the age of eight with the Reed and Emerson minstrel shows.[37] In the 1890s he made a name for himself in the vaudeville circuits as a comedian, and by 1908 he was regularly being cast in George M. Cohan vaudeville productions in New York, doing comedic routines as a French count.[38] Initially uninterested in moving pictures, he hoped to perform serious, dramatic stage roles and thus taper off his comedic ones. Surprised at the

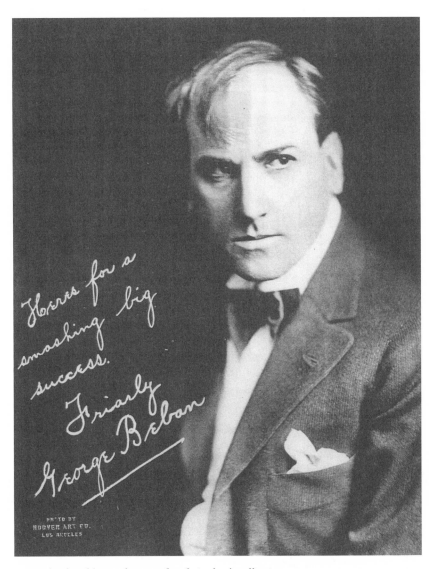

6.2. Beban's publicity photo, undated. Author's collection.

skepticism of his managers, as he recounted in 1911 in a self-celebratory autobiographical article, he persisted under the guidance of a simple principle: "pathos and comedy are very closely allied," since both "require the greatest skill and ability to depict."[39] Unable to find suitable material and persuade stage impresarios to take a chance on him, in 1909 he cowrote the playlet *The Sign of the Rose: A Play in One Act* with

a successful Broadway playwright, Charles Turner Dazey. It was the heartbreaking story of an honest Italian immigrant who experiences two calamities simultaneously: the loss of his daughter, run over by a speeding car, and an unjust criminal conviction. Shortly after writing the melodrama, Beban began starring in it on the city's vaudeville scene.[40] By late 1911, with the help of New York theatre agents Klaw and Erlanger, Beban had expanded the play into a four-act melodrama and taken it on tour through the U.S. and England. The success of *The Sign of the Rose* made him famous as a performer of Italian roles (fig. 6.2). "Mr. Beban's achievements in the matter of dialect, facial make-up and costume, re-markable as they are," noted an enthusiastic reviewer, "are yet small be-side his extraordinary conception of the spirit and temperament of the role."[41] Between 1914 and 1915, Beban agreed to star in the film adaptation of the play, produced and directed under the supervision of Thomas H. Ince for the New York Motion Picture Corporation. Unfortunately, none of the nine reels of the film are extant, although we can study it through its reviews. But before doing so, we must turn to the film that, released on January 1915, initiated Beban's successful career as a film actor in the roles of wronged Italians.[42]

In 1914, in fact, at Ince's pressing invitation, Beban took part in the Los Angeles filming of what today is his most famous extant film, *The Italian*.[43] Originally titled *The Dago,* written by Ince and C. Gardner Sullivan, directed by Reginald Barker, and distributed by Paramount, *The Italian* was a transatlantic tenement melodrama set in an imaginary Italy and in New York's Lower East Side.[44] Beban himself lobbied to change the original title to *The Italian,* apparently not out of cultural sensitivity but because he did not want to be the protagonist of a "common" film. Given the film's feature length and commercial ambitions, Beban desired to be associated with a "special feature," for which he deemed the more neutral national identification appropriate.[45]

The first part of the film takes place in a conventionally picturesque Italian setting. Silhouetted against the sun is an Italian monastery, sur-rounded by devout peasants. The film's Old Italy is a sunny, quaint place, where warm exchanges of affection among family members are custom-ary, as revealed in the introduction of the characters of Annette and her father, Trudo Ancello.[46] Old Italy is also a place where, as the church bells herald the afternoon prayer, monks and peasants respectfully halt

6.3. Beppo as a romantic Venetian gondolier, admired by tourists, in *The Italian* (New York Motion Picture Corp., 1915). Courtesy of Film Preservation Associates, Inc.

their work in unison according to an iconic practice made famous by Jean-François Millet's painting *Angelus* (1857–59). In this aestheticized Italy, Beban plays the role of Beppo Donnetti, a Venetian gondolier who sports a typical moustache and the timeless local costume (fig. 6.3). The first shot shows him not working, but happily playing his guitar on his gondola to win the admiration of foreign-looking tourists of shy manners, but amorous mood. None of their affection, however, matches his passion for Annette: he daydreams of her so intensely that at one point he falls into a canal, to the surrounding crowd's amusement. Shot in Venice, California, the fictional Italian Venice has an archaic and colorful side, evident in a *carabiniere*'s useless attempts to direct the street traffic of pigs, cows, donkeys, and sheep and in such communal rituals as joyful dancing and siestas. Gondolas, Italian flags, tourists, and even the stock figure of a street artist overdetermine the semiotics of the floating Italian city, visually and ideologically, statically and dynamically.

6.4. Beppo with Annette in Italy's picturesque countryside: *The Italian* (New York Motion Picture Corp., 1915). Courtesy of Film Preservation Associates, Inc.

The many low-angle tracking shots, with the camera mounted on the gondola, place the faces of Beppo and his romantic customers against the moving visual backdrop of the city's palaces and bridges. Finally, as our colorful but deferential gondolier Beppo steers two foreign lovers along the postcard-like canals, an intertitle carries a quotation that universalizes the romantic scene: "One touch of nature makes the whole world kin." Whether only a few or many spectators knew that the line was from Shakespeare's little-known *Troilus and Cressida,* or recognized it from one of the short stories that writer O. Henry published weekly in the *New York World* between 1903 and 1906, or simply considered it an old adage, most must have felt its resonance with a unanimous sentimentality.[47]

Amidst the monasteries, monks, and wall crosses, however, Old Italy displays its own archaic cruelty. The father's sense of obligation to an older and richer man who intends to wed Annette forces Beppo to make

6.5. The hilltop view of the sea, site of shared hopes and longing, featuring Annette longing for Beppo: *The Italian* (New York Motion Picture Corp., 1915). Courtesy of Film Preservation Associates, Inc.

a painful decision: he will emigrate to America to acquire the means to marry his beloved. There is no doubt that the couple's love will survive the prolonged separation. When they are alone with each other, they embrace passionately and kiss openly in the quiet of the picturesque countryside (fig. 6.4), showing none of the controlled affection of the foreign couples in Venice. Beppo and Annette's passion is as natural, romantic, and intense as the panoramic view of the sunset over the sea that participates in their embraces through silhouetting and contra-jour effects (fig. 6.5).[48] Beppo's departure displays the classic tropes of lovers' heartbreaking farewells: the drama of physical separation, the prolonged salute from the departing ship, and the ensuing melancholic homesickness. Still, his migration is chiefly motivated not by financial aspirations, but by love. Beppo and Annette's reciprocal affection is what defines them as sympathetic characters of sound moral value, a quality that is visually confirmed by the virtuous Annette's handing him a cross necklace just before he embarks for America.

On board the ship and through one of the many flashbacks book-marked by perfectly executed dissolves,[49] Beppo's thoughts of Annette are shown as poetically intertwined with the memory of the view from their favorite hilltop. In flashback they are usually shown together in a romantic, backlit silhouette, but what remains now is a solitary and longing Annette (fig. 6.5). By allowing its spectators access to Beppo's home- and lovesick imagination and by visually aligning their view with Annette's sublime vision of the sea that separates her from her lover, the film introduces them into the characters' emotional world. Viewers are optically and emotionally aligned with the two protago-nists, and are thus made to share their transatlantic desire for each other. It is a game of visual and symbolic reciprocity that abolishes oceanic distances. For instance, Beppo's admiring look at the Statue of Liberty, which visually and metaphorically opens America's arms to immigrants, matches the comparable gesture of Annette facing the sea with open arms.[50]

Landing in New York's Lower East Side, a harsh place ridden with criminals and vice, Beppo finds work as a bootblack. Flashbacks reveal that his thrift is constantly and solely motivated by his desire to bring Annette to America. When she finally arrives in New York, their initial inability to find each other surely resonated with the transatlantic anxiet-ies of many immigrants, many of whom may have been familiar with the popular *Traffic in Souls* (IMP, 1913), the landmark film on white slavery. Before Beppo actually encounters his beloved, however, a short scene emblematizes the film's racial politics. Beppo is buying flowers from a dark-skinned street vendor. She may be African or Native American. His manners are at first rather hurried and rude, eventually becoming condescending. He seems to give her more money than he had to and she laughs at it, in the fashion of the caricature and the vaudeville figure of the black Mammy. Set on the docks where European immigrants ar-rive, this brief scene reveals the racial position that, according to the filmmakers and Beban himself, Italians occupied in America. Whether descended from slaves or Indians, the street vendor did not arrive in America on a transatlantic commercial ocean liner. Slavery, extermina-tion, and forced relocation were closer to her experience than migration ever was or could be. Although Beppo's demeanor, costume, and lack of linguistic fluency constantly identify him as an alien, the way he treats

6.6. Beppo's encounter with the dark-skinned flower seller: *The Italian* (New York Motion Picture Corp., 1915). Courtesy of Film Preservation Associates, Inc.

her attests to a sense of distance and superiority that is shared by white immigrant America of the period. She is not at the docks to wait for relatives, but to sell flowers to the incoming Europeans, whose racial privileges she does not share (fig. 6.6).[51]

In order to achieve maximum pathos, Beban's melodramas, in this film as elsewhere, often alternated the narrative with comedic relief. The scene of his long-awaited encounter with Annette is a textbook display of exaggerated acting style. Beppo is so impetuous that he marries Annette right away, but in the hurry he forgets to buy the wedding rings. After a slapstick-like rush to a jewelry shop, the ceremony concludes amidst a community of convivial and rowdy friends surrounded by Italian flags. The birth of his child, Antonio, becomes another communal happening, a boisterous neighborhood celebration, and an opportunity for contagious histrionics. The flip side of these passionate dramatics is the delicacy and propriety he shows when approaching the room where Annette has just given birth to their son. The slow pace of his walk, the graceful taking off of his hat as he recognizes the Madonna-like pose (a

carefully choreographed iris shot) of Annette and little Antonio rest-
ing in bed together, and his accented comment that his son's sleeping
posture resembles his ("He is sleep just-a-like-a-me"), complete a visual
composition that lessens the otherness of his racial temperament in favor
of universal humanism.

Meanwhile, the representation of the New York setting, despite the
Californian shooting location, contributes to making Beppo a familiar
and humane immigrant figure. Although long shots of ghetto streets are
brief, limited to the scenes of Beppo running home after hearing news
of his son's birth or showing children following the ice wagon to refresh
themselves in the summer heat, they effectively evoke the New York
slums. Crowded with women, children, and peddlers, and displaying
Italian signs and strings of clothes hanging across the street, the Little
Italy of the film conveys the sense of a close-knit Italian community
(fig. 6.7). Like other exterior shots, particularly those showing the mod-
est street corner where Beppo cleans and polishes shoes for a living or
the courtyard of his modest tenement building, the scenes speak the
familiar language of poverty and social solidarity. Immigrant ghettoes
were not easy to find or recreate on the West Coast. William K. Everson
has noted that "the slum and ghetto areas where the bulk of the film . . .
takes place were actually shot in San Francisco, since Los Angeles' slums
looked a shade too prosperous to double for New York."[52] On the same
note, a 1917 *Photoplay* essay, ironically titled "The High Cost of Poverty"
and filled with references to, and illustrations from, Beban's films, re-
marked that while "the need for slums is an imperative one in the motion
picture industry," filming in Hollywood posed a serious problem: Los
Angeles "ha[d] no slums." If moving film production back to New York's
picturesque Lower East Side was not an option, America's classic immi-
grants' ghetto had to be recreated from scratch with "buildings, streets,
and all atmospheric appurtenances."[53] By many accounts, Beban's *The
Italian* successfully set a precedent. If the *New York Dramatic Mirror*
praised *The Italian* for its "realistic glimpses of slum life," Vachel Lindsay
elaborated on the film's effective realism by emphasizing the dramatic
contrast between Italians' "natural southern gayety" and "the drab East
Side."[54] It was a contrast that, in the narrative, eventually translated into
tragedy.

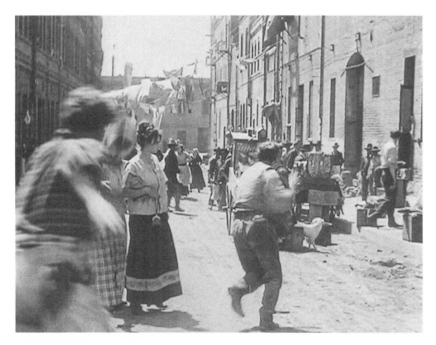

6.7. Upon hearing of his son's birth, Beppo runs home through the crowded Italian slum: *The Italian* (New York Motion Picture Corp., 1915). Courtesy of Film Preservation Associates, Inc.

One intolerably hot summer, in fact, little Antonio becomes sick and is on the verge of death because the family has no pasteurized milk—an obvious narrative concession to the familiar warnings of social workers about the unsanitary conditions, poor nutrition, and child mortality endemic among immigrants. Beppo could buy the milk, but a gang of local gangsters steals the last of his savings. Desperate, he begs everybody for help, including Mr. Corrigan, a heartless Tammany Hall politician with evident criminal ties who had previously received Beppo's vote during the local elections—a sure sign of Italians' enfranchisement—and who now does not recognize him, a trope repeatedly captured in Italian and American newspapers' sketches.[55] Feeling affronted by the excited demands of the immigrant, whom he considers just a "wop"—as one intertitle reveals[56]—Corrigan throws him out of his moving car and has him incarcerated. Meanwhile, dramatic parallel editing juxtaposes the infamous Corrigan, who is returning to his suburban mansion, with

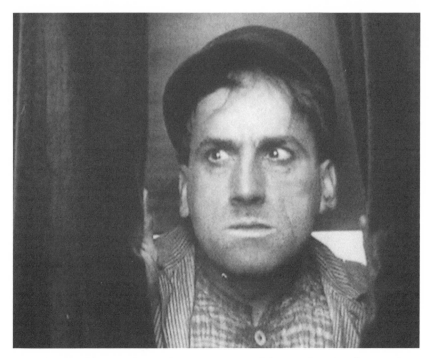

6.8. Close-up of the out-of-control Beppo in Corrigan's house: *The Italian* (New York Motion Picture Corp., 1915). Courtesy of Film Preservation Associates, Inc.

heartbreaking close-ups of the desperate Annette, who is waiting for Beppo to bring the much-needed milk for the baby. Eventually, lacking proper nutrition, Antonio dies. When Beppo returns home a week later, all his histrionics are gone. He is now a desperate and defeated man.

Remembering Corrigan's refusal to help him, Beppo decides to kill the boss's daughter, who has fallen terribly ill and for whom the least disturbance would be fatal. Disguised as a peddler, he enters the mansion and is determined to carry out his vendetta. His posture, carriage, and face are not normal: he has acquired beast-like features. Likewise, a visual regime of dramatic close-ups reveals a threatening physiognomy of primitive violence (fig. 6.8). He repents, slowly, only after noticing that Corrigan's daughter sleeps in the same baby-like pose as his own child. Recovering from the violent urge to avenge his son's death, Beppo decides not to kill the girl. The film then shows Beppo at his son's grave while the closing intertitle reads, "At the eternal bedside of his baby where hate, revenge and bitterness melt to nothing in the crucible of sor-

row." Despite his earlier mad looks, the humanity of his inner character has prevailed.

The story of an immigrant man toiling in a foreign land and struggling to bring his prospective wife to his side had been told many times, but never before in six reels. Ince's film was a notable and quickly celebrated example of "plot expansion" and, as a Paramount release, *The Italian* belonged to a "programme confessedly aimed at a more cultivated public than has been reached by that useful trinity, bathos, sentimentality and melodrama."[57] This is evident from the film's structure. *The Italian* starts (and ends) with a theatrically rendered framework that reveals the ideological positioning and the aesthetic debts of Beban's work. In the film's opening image, curtains open onto the library room of a private residence. Sporting an elegant evening robe, George Beban appears as himself, an upper-middle-class book lover, quietly sitting in his book-filled studio, reading a novel titled *The Italian*. At the film's end, the same scene reappears. This time Beban closes the book as stage curtains signal the end of the picture. The scene may be interpreted as a generic desire to pair cinema with higher-class entertainment traditions, such as theatre and literature. Yet Beban also intended to dissociate himself from the negative, highly stereotyped characterizations that one- and two-reelers had generally created of Italians (and immigrants in general) and that duplicated the racial typecasting of the vaudeville scene. Instead, he was explicitly signaling his engagement with the traditions of realist and sentimental literature and legitimate theatre which, best embodied by the countless theatrical representations of *Uncle Tom's Cabin* that Linda Williams has recently examined, staged complex forms of identification and desire that conveyed "racial sympathy" and a "melodramatic cross-racial recognition of virtue."[58] By echoing such respectable ideology, *The Italian* could aestheticize racialized characters and settings through sentimental touches of moral unanimity.[59]

This romantic universality has an Anglo-Saxon bent to it. On the one hand, Beppo's various misfortunes, particularly the loss of his child, are explicitly rendered as the result of the environment in which he lives, not as due to his own failures. On the other hand, however, the injustice and ill-treatment he has to endure are not narratively transformed into punishment of his abusers. The film denies him not only the right to express his rebellion and avenge himself, but also his right to justice.

After all, he remains an immigrant, not an American citizen. What the film exacts from its audience is not compassion for a peer, but a purely sentimental pity, which purposefully keeps the audience at a distance through a stoic and ultimately mortifying narrative conclusion. In its melodramatic combination of realism, pathos, and commiseration, *The Italian* carefully preserves a racialized legal and ideological distinction between Italian and American individuals.

From the available reviews, it appears that the most noteworthy elements of the film for audiences were the pathos of the narrative, the realism of the setting, and the poignancy of the performances. "Here we have," suggested the *New York Dramatic Mirror,* "a nice little plot giving free play to emotion and simple *pathos,* and we know that our audiences will respond." Writing about the performances of the two leads, the review continued, "they are realistic, there is no mistaking that, with all the sordid squalor of overheated, compressed poverty. . . . There is no fault to be found with the sincere emotional acting of George Beban and Clara Williams."[60] Likewise, *Motion Picture News* emphasized Beban's histrionic acting and the sentimentality of the film's storyline: "By facial expression and the natural gestures [he] is capable of depicting so many different phases [and] emotions. . . . The *pathos* as expressed on the face of Beppo [and] Annette (Clara Williams) is enough to move the audience to tears."[61]

Beban's reputation as a virtuoso actor, established on stage by his appearance in the long-running *Sign of the Rose,* significantly increased with the creative filming of the play. The film opened as *The Sign of the Rose* at Clune's Auditorium in Los Angeles (where *The Birth of a Nation* had just completed a nine-week run) on 12 April 1915 and was released in New York a month later, on 31 May 1915, under the title *The Alien.* At both premieres, the film was presented as a "combination of silent and spoken drama," because its denouement was a thirty-minute stage act, played by the film actors, with an impressive musical accompaniment that "ranged from popular songs of this and other days to the selections from well-known operas."[62] *Moving Picture World* emphatically saluted the event as "what may prove to be the most important development of the motion picture."[63]

At nine reels, the film (unfortunately now lost) was a racial melodrama of shocking adversity and cruelty, displaying the perverse out-

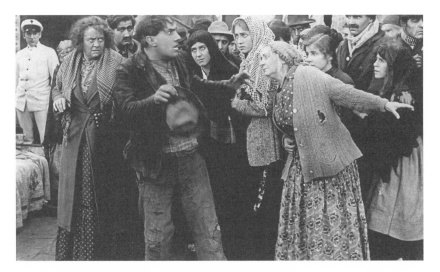

6.9. George Beban in *The Sign of the Rose* (a.k.a. *The Alien*, New York Motion Picture Corp., 1915), production still. Used by permission of the George Eastman House/Film Department (Rochester, N.Y.).

come of racial prejudices, and sentimentalizing along the way the miserable Italian protagonist. A financial dispute between two American brothers ends with one of them kidnapping the other's daughter and accidentally running over and killing Rosina, the only daughter of an Italian widower, Pietro. Distraught at her loss, Pietro is arrested as the kidnapper simply because he happens to be in the flower shop where the ransom was supposed to be paid, to a man identified by "the sign of the rose." Pietro threatens to kill the arresting detective and is released from suspicion only when news of the safe return of the kidnapped child reaches the shop. He refuses any compensation and sadly returns home without his beloved Rosina. As in *The Italian*, tragedy is the result of environmental and circumstantial factors, not personal moral failures or mistakes. *The Sign of the Rose*'s ideological address openly sympathizes with the Italian character's emotional outbursts, following his family tragedy and his unjust accusation. Yet, once more, the film narratively and visually racializes the protagonist, through the realism of costumes and setting, the "authenticity" of Beban's unrestrained acting performance, and, quite prominently, the lack of an equitable resolution. Once he is racialized, Pietro's legal standing falls to substandard levels: nobody is held accountable for the death of his daughter (fig. 6.9). The

audience's emotional response is reduced to inconsequential compassion. Pietro appears as an imperfect, deficient, and "pathetic figure": no full identification with him is possible.[64] Not only does the story deny him justice, but the film's social system also demands from him a childish and fatalistic submissiveness to the authority that failed to protect him. As the alternate title indicates, Pietro is and remains an "alien."[65]

Allegedly mimicking Italian stage performers and actual people, Beban emphasized racial mannerisms through a skillful, widely appreciated, and almost obsessive attention to props, settings, costumes, and facial expressions. But the entire film achieved a carefully thought out realism, further enhanced by crowd scenes featuring extras brought in from New York City and, in Ince's words, trained to look like "an excited, surging, crowding crowd."[66] Stephen Bush, the highest-ranked reviewer for *Moving Picture World,* remarked that both the stage and screen performances were superb in their realism.[67] The master "in the portrayal of racial type,"[68] Beban was taking full advantage of the medium. "Beban's facial emotion, magnified to intense proportions in the close-ups of the picture," noted *Photoplay,* "is infinitely more convincing than the patently false illumination, confined settings and more or less distant figures of the theatrical stage."[69]

PICTURESQUENESS

Beban was keenly aware of the effectiveness of his talent for Italian impersonations, to the point of conscious manipulation. He later reported that his yearning for authenticity led him once to visit the new Pennsylvania Station in New York City in order to buy the wardrobe "of the picturesque sons of Italy... 'as it stood' dirt and all," and use it as his stage costume.[70] What Beban was after, on stage and on screen, was not a mere act of imitation. His ethnographic approach to playing "the Italian" was functional to the construction of characters ("picturesque sons") that were to be recognized as "realistic" from both a racial and a performative standpoint. Thus, rather than an issue of individual replication, realism for him meant the fine-tuning of a cultural code that audiences could instantly identify and appreciate.

In 1921, now an acting instructor, he published a lecture in a booklet titled *Photoplay Characterization,* in which he explained his writing and

acting philosophy and linked it to the success of his character-driven cinema.[71] In order to gain the audience's sympathy for his characterizations, he wrote, the selection of the subject was crucial: "the very first step in the writing of a photoplay is the choice of a group of characters and the careful study of their traits in order that they be human and convincing." Familiarity with certain characters and narratives was paramount. Although "the photoplaywright has the entire population of the world from which to choose when he starts to people his story with characters," he insisted that "true characterization gives life and color to the somber background of age-old stories." Narrative traditions, however, are not enough. If the general traits of a character are a matter of racial origins and customs, Beban maintained, "a really good character should be both typical and individual." In order to recognize individuals as types and to read types as individuals, Beban recommended a quasi-ethnographic approach. "The character I portray," he noted, "is born of much observation and much contact with scores of Italians who are in some degree like him. I set out to study them, as individuals and as members of a type, I made countless notes upon them, I remembered and imitated their mannerisms, their habits of speech, their bearing, their clothing." The result is clear: "In the Italian I portray, I try not only to present a single individual Italian with *all* of the mannerisms and traits of that individual, but I also try to suggest all of the Italians I have ever known. The more individual I make my character the more typical he will be."[72]

Still, why did he focus on the Italian type? Beban's answer is significant, in that he seamlessly associates the familiar aesthetic of picturesque attractiveness with the representation of Italian characters. "Memorable characters have to possess the quality of *picturesqueness*," he wrote, before adding, "I like to play the Italian because his costume, his mannerisms, his gestures, and his unlikeness to the everyday people of the street make him stand out as a romantic and picturesque person." For Beban, picturesqueness thus allowed a curious, yet othered figure (often termed "picturesque" in its narrower meaning) to be dramatically appealing and to elicit an intense spectatorial involvement. This was possible because for him picturesqueness, rather than being the mere imitation of real-life individuals, consisted of a deliberate selection of traits connoting both domesticated familiarity and otherness.

Characters "should be like [the spectators] in fundamental emotions and desires," Beban argued, "but often they will be more picturesque and interesting if they are unlike in the superficial matters of appearance, costume, race, nationality, etc." He then concluded, "My Italian, at least I like to believe, is true to life in that he is emotionally akin to the members of the audience. But in the actual audience, there are very few Italians and perhaps none at all who resemble him outwardly in any way." Summing up his argument about picturesque characterizations, Beban formulated a very eloquent definition of what we earlier referred to as the racial character's dual, neoplatonic structure and its ideological expediency: "The likeness is an inner quality of the heart; the unlikeness or the dissimilarity is a matter of externals, which, none the less, add to his distinction and individuality."[73] Further, by describing his racialized film characters as picturesque, Beban identified cinema's profitable management of racial difference through familiar scripts, both formal and narrative, of emotional unanimity.

Thus to recognize the picturesque in Beban's cinema does not mean to look for images of ancient ruins in a Roman Campagna, Neapolitan bays, or erupting volcanoes—although one interviewer compared him to one! It means, instead, to identify the presence of a familiar aesthetic pattern: the taming of an explosive force that, although domesticated, will maintain residues of its striking natural otherness. If earlier films about Italians' alleged penchant for violence and emotionalism needed to juxtapose virtuous Italians to a few out-of-control ones, Beban embodied both parties. As we have seen in *The Italian*, the sensible, tactful, and poignant manners Beppo displays as he realizes the extent of his family tragedy replace his tumultuous and all-around energy and his passionate affection for Annette and their son. As Beppo chooses fatalistic resignation rather than pursuing his appalling revenge, the "volcano is conquered," to paraphrase the title of a sensationalist British newsreel, *Vesuvius Conquered!* (Fox Film Ltd., 1922), that a few years later demonstrated, once more, cinema's "daring conquest of Vesuvius" through thrilling and death-defying aerial cinematography.[74]

Beban and his critics appeared to be aware of earlier forms of image-making. In *His Sweetheart* (Oliver Morosco Company, 1917), he staged a prolonged silhouetted medium close-up of his character, Joe the Iceman, and his partner, Trina Capino, exchanging intense embraces at the film's

closing. In that "tender, quaint, pathetic photodrama" of unfair incarceration but happy resolution, the mere silhouetted outlines of Beban's expressions perfectly served the demands of expressiveness and clarity because they operated by physiognomic convention and tradition.[75] A year later, without mentioning the film explicitly but while explaining Beban's distinctive talent, a reviewer for *Motion Picture Classic* defined Beban as "a Roman Rotogravurist," referring to the intaglio printing process.[76] It was an apt description. Just like *Vesuvius Conquered!,* Beban's films captured and broadcast uniquely close views of his histrionics, which amounted to "volcanic actions" of a familiar and long-standing visual tradition.

Between 1915 and 1928, the year of his death in a riding accident, Beban played Italian characters in more than a dozen films, which he usually scripted and, in a few instances, directed. The large majority of these productions are now lost.[77] Available reviews and plot synopses reveal a striking consistency of characterization. He played an Italian grocer in *Pasquale* (OMP, 1916), an Italian iceman in *His Sweetheart* (OMP, 1917) and *The Greatest Love of All* (George Beban Productions, 1924), and characters named Guido Bartelli in *The Marcellini Millions* (OMP, 1917), Luigi Riccardo in *One More American* (Famous Players–Lasky Corp., 1918), Nicolo Rosetti in *Hearts of Men* (Hiram Abrams Production, 1919), Lupino Delchini in *One Man in a Million* (Sol Lesser Productions, 1921), Pietro Balletti in the remake of *The Sign of the Rose* (George Beban Productions, 1922), and Ricardo Bitelli in *The Loves of Ricardo* (George Beban Productions, 1926).[78] Although Beban's work is still relatively unknown and underappreciated, it is possible to argue that, while aiming for the greatest emotional consensus, his feature-length stories, which were dramatically and sentimentally enticing, marginalized earlier, unsympathetic representations of Italians as criminals and violent individuals—at least until the Depression. This was quite clear at the time. A *New York Dramatic Mirror* review of *His Sweetheart,* for instance, praised his constant ambition to produce more authentic versions of Italian heroes instead of "the individual with a long black moustache and a bandana handkerchief, armed with a stiletto."[79] The popular success of his performances, however, participated in larger aesthetic changes.

In the ten years between *The Black Hand* (1906) and *The Sign of the Rose* (1915), American cinema underwent significant aesthetic transfor-

mations, particularly in its narrative ambition and ideological address. From an initial sensationalist self-positioning as "visual newspapers," motion pictures developed a higher and more unanimous vocation. The so-called "universality" of the medium, which was highly praised for the unprecedented diversity of its masses of urban spectators, seemed to call for social inclusion and interracial kinship. Carrying out America's progressive mission of "civilization," American cinema aspired to the status of patriotic and humanistic pageantry.[80] This was not, however, an impulse toward racial equality in representations: films, including racial melodramas, remained committed to Anglo-American cultural and racial supremacy. The restaging of the myth of the West through the Western film genre in the 1910s generated nationalistic narratives that sought a wider ideological consensus by sentimentalizing the inevitable death of Native American chiefs or Pocahontas-like characters without challenging any self-righteous sense of racial entitlement. Similarly, George Beban's sympathetic narrativizations of immigrants' lives produced a shift from earlier representations of Italians as brutal and emotionally excessive types to humanized, yet still heavily racialized, individuals.[81]

His cinema, in fact, did not fully question contemporary Anglo-American prejudices about Italian racial traits. Instead, it capitalized on familiar racial attributions such as childlike emotional excess, aggressive tendencies, limited intellectual capacity, and intense family bonds. Beban's interest in displaying the melodramatic turmoil of Italian immigrants was often kept at the safe narrative and ideological distance provided by an American point of view—e.g., *The Italian*'s narrative frame—and within the respectable exhibitory boundaries of America's legitimate theatres. Relying on Italians' white racial status, Beban's racial urban melodramas stifled both nativist antagonism and newcomers' grievances by pasting "unanimous" ideals of universal brotherhood and solidarity onto stories of indigence, exploitation, and injustice. In so doing, his stories of victimization, fatalism, and ultimate emotional containment narrativized the belief that Italians could adapt to, without ever assimilating into, American society.[82] After reels of tear-jerking plots of melodramatic woe and tragic fatality, however, audiences felt too exhausted to demand social justice. Italian characters' instinctual and moral "difference" remained well in sight: full equality or redemption was not an option.

Still, as the "only character-star of the screen" who specialized in feature-length portrayals of non-American characters, Beban had both a significant impact on narratives of racial difference and the luck to find himself in favorable historical circumstances.[83] On the eve of World War I, when nativist slogans seemed to discourage attention to anything not American, Beban's films took advantage of the intense psychological characterizations of the American feature films of the 1910s and fostered an unprecedented intimacy and solidarity with racialized, non-American characters. And as the Great War increased American patriotism, the Great Migration of African Americans into Northern cities and the arrival of other peoples of African descent from the Caribbean supported the emergence of the New Negro Movement in a period also shaped by race riots, labor strife, and protests that engendered, in Guterl's words, "a national mass culture obsessed with the 'Negro' as the foremost social threat."[84] A racial polarization of black versus white, best epitomized by the unprecedented success in 1915 of *The Birth of a Nation,* made space for racial narratives that cast European immigrants in less antagonistic and more sympathetic roles. The growing interest in characters' psychological rendering, enabled by longer productions and more in-depth adaptations of literary and theatrical sources, allowed a wider circulation and commercialization of familiar racial differences for spectacular, emotional, and entertainment purposes.[85]

The second half of the 1910s saw, as well as Beban's continuing film-making efforts and recognition, the emergence of a hegemonic trend in Hollywood—the production of racial melodramas featuring new and foreign gender models, both male and female. A new, unprecedented spectrum of female protagonists were cast in passionate, highly sensualized, and quite controversial love stories set between the Old and the New Worlds. Written by a new and talented cohort of female screenwriters, including Sonya Levien, Anita Loos, Frances Marion, Jeanie Macpherson, and June Mathis, these stories featured such established all-American icons as Lillian Gish and Mary Pickford.[86] In many of these films, from *A Woman's Honor* (Fox, 1916) and *The Ordeal of Rosetta* (Select Pictures, 1918) to *Who Will Marry Me?* (Bluebird Photoplays, 1919) and *The Microbe* (Metro Film Corporation, 1919), New York City represented immigrants' sole and final destination. As the symbolic entry point into America's values, but also as a place of domesticated differences, New

York translated immigrants' risky decision to cross the Atlantic into an assured betterment. In the American metropolis, and not just in the immigrant quarters, social and family ties were much less oppressive than the ones experienced back in Italy. In these films' ideological efforts to attain Americans' sympathy, New York embodied a topography of unprecedented liberty and self-determination; it was the only environment that could grant racialized female Italian characters the possibility of reinventing their own lives—an opportunity usually denied back in Italy—and becoming, to quote the title of a 1918 Beban film, "one more American."

The maverick Beban's contribution to American film culture anticipated mainstream changes. On 4 December 1920, he published a one-page article in the *New York Dramatic Mirror* titled "100% Italian— In Plays," in which he envisaged the emergence of racialized stardom. Writing about popular non-American characters, he noted, "I feel that the time is fast approaching when the public and the picture star should get on a closer relationship."[87] Although he was still advertising his own work and his success as a portrayer of Italian characters, he unwittingly predicted the rise to fame of Rudolph Valentino, the gallant Latin lover, who, just four months later, would bring his racial difference to Hollywood stardom, the most publicly effective vehicle of racial intimacy. Born Rodolfo Guglielmi, Valentino migrated to America from the South of Italy in 1913. He rose to exceptional success in March and November of 1921 with *The Four Horsemen of the Apocalypse* (Metro Pictures) and *The Sheik* (Famous Players–Lasky Corp.), sixteen years after *The Black Hand* and six years after *The Italian* and *The Name of the Rose*. If Beban was successful in creating emotional solidarity with his racialized, yet utterly desexualized, immigrant characters, Valentino and the star machine around him succeeded in attaching him, as both an actor and a character, to the romantic and sensual stereotype of the Latin lover. Hollywood could do so by discouraging any straightforward association between the Italian-born star and Italian immigrants or any conventional narratives of migration. Fictional biographies described him as an Italian nobleman on the basis of the fact that his mother was French. In "real life" and on screen, Valentino thus did not exude the picturesque Italianness linked to the Lower East Side, but the older, yet equally aestheticized one of Don Juan and Casanova. Positioned between racial alterity and aesthetic

familiarity, he became an exotic object of sexual desire without arousing fears of miscegenation by exploiting a unique possibility of sensual intimacy that Beban had never enjoyed, though his stage and cinematic picturesqueness had helped to establish it. More generally, what Valentino benefited from was the space of a resilient yet malleable racial difference, for decades articulated as dissonant and picturesque—at worst deviant, and at best sentimental—but now turned sensually appealing and once more offered for public consumption.[88]

SEVEN

Performing Geography

If we really want to understand the effect the motion picture has
on the viewer, then we must first settle two things: 1) Which viewer?
2) What effect on the viewer are we talking about?

DZIGA VERTOV, "AT A KINOK CONFERENCE," *KINO-EYE*

You know, when I first came to La Merica I thought, what a foreign
place! It was so different from Sicily that I didn't know how I could
possibly remain. For several months I felt lonely and strange until a
friend of Tannu's took me to the theater.... There up on a huge white
wall was the most Sicilian thing I'd seen in La Merica: a cowboy movie!

TONY ARDIZZONE, *IN THE GARDEN OF PAPA SANTUZZU*, 1999

Chapter 2 sought to demonstrate that the widespread aesthetic currency
of the picturesque prompted Southern Italian culture to turn racial bi-
ases into effective visual and dramatic resources for both the production
and the experience of film. I called this process Southernism. In this
chapter, I discuss how the lively Italian American scene of vernacular
stage plays and comedies similarly positioned itself in ways that affected
Southern Italian immigrants' relationship with moving pictures—first
as spectators, and subsequently as filmmakers.

The relationship between early cinema and immigrants to the U.S.
has been one of the most lively areas of early film historiography. Con-

tributions to the study of early film spectatorship have often centered on New York City and have offered unprecedented evidence about the rise of moving pictures in the place of previous, largely impressionistic accounts.[1] They have shared, however, a few problematic methodological assumptions. In their analysis and prose, they have often disengaged moving pictures from other media, and when they have not done so, they have linked American film productions with other American entertainment at the expense of more complex scenarios that would include foreign films and other amusements. The older claim that American cinema was a powerful agent of Americanization for newly arrived immigrants has often remained as operative as it is unqualified. The reality on the ground was a bit more complex, since New York City was a commercial and cultural hub both for the international distribution of foreign films and for European immigrants' entertainment.

In New York, for instance, Italian Americans' experience of American films (and racial culture) was affected by other competing, yet interrelated, forms of entertainment, including Italian stage representations and films, of both historical and vernacular character. The process was similar to what happened in Italy, but also presented new layers. Since in multinational America national belonging was a precondition for identity and social mobility, Italian national affiliation became a crucially balancing, rather than antagonistic, term of reference for Neapolitan, Sicilian, and Calabrian immigrants. Traditionally identifying with their native village or its environs, Southern Italians learned in America the advantages of aligning themselves with broader geographies of identity—American, Italian, and regional. Mutual aid societies, the so-called "ethnic" press, the fame of celebrated opera singers, and Italian historical and war films taught Southern Italian immigrants to appreciate feeling Italian in ways they never experienced in their homeland. Similarly, countless stage melodramas and comedic sketches coalesced immigrants' sense of identity around well-established Neapolitan or Sicilian vernacular traditions. Moviegoing stirred up all these geopolitical alignments. Immigrants swung between pride in their locality and region, identification with their nation, and the prospect of Americanization. One memorable report listed the different, coexisting identities of a man from Sicily: "In America he will be an Italian to all members of other nationalities, a Sicilian to all Italians, and a Milocchese to all Sicilians.

In Sicily, he will be a Milocchese. In Milocca, he tends to remain a Pid-dizzuna [clan member] who has moved."[2] What all these constituencies shared was an aesthetic vocabulary that variously associated Southern Italians with picturesque backwardness, emotive excess, and violent passion, and that prompted the doubling of Southernist dynamics of cultural experience. For Southern Italian immigrants the picturesque became more than an aesthetic platform of Southernist identity or of mere nostalgia. Instead, it fueled a very modern diasporic culture that in many instances looked for the first time at traditional picturesque scenes of sea bays, fishermen, and volcanoes while embarking on a new life in America.

FILM HISTORY AND FOREIGN CONSTITUENCIES

[The moving picture] is probably the greatest single
force in shaping the American character.

AMERICAN REVIEW OF REVIEWS, 1910

In turn-of-the-century New York, the most publicly visible marker of modernity was the increasing number of people of all social and national backgrounds crowding streets and commercial venues. On weekday evenings and on weekends, they presented an unprecedented variety of racial cultures, national languages, and international entertainments. Phonograph and kinetoscope parlors, ethnic vaudeville houses and "ten-twenty-thirty" melodrama theatres, as well as amusement parks, ballparks, penny arcades, dance halls, and nickelodeons, were among the sites the city's teeming population visited on a regular basis. In 1909 alone, almost twenty million people visited Coney Island. By 1910, the seating capacity of New York's playhouses and movie theatres had reached almost two million. Reduced work hours and an increase in wages nourished a quest for leisure time that seemed to cross racial and class divisions. Public access, or "wideopenness," as a famous *New York Times* editorial had defined the new cultural landscape, was offering immigrants a unique resource of cultural enrichment and adaptation while affecting their self-conception and sense of belonging.[3]

For contemporary observers, moving pictures best embodied the "democratic" educational effect of American culture: moviegoing was

an unmistakable index of the mass co-optation of the working class and immigrants into the lifestyle of the modern metropolis. More generally, American movie theatres fostered the moral, social, and cultural communion of standardized mass entertainments and an Americanized mass society. Early chroniclers of cinema history hailed films as crucial vectors of immigrants' integration on the basis of a powerful assumption: the universality of moving pictures' appeal. Even Pacific Islanders and Eskimos, Lewis E. Palmer of the Charity Organization Society wrote in 1909, gather daily in "those dimly-lighted rooms where living comedy and tragedy flash across the screen," because cinema, he said, citing a now familiar Shakespearean line, helped "to make 'the whole world kin.'"[4]

Cinema's worldwide appeal, however, did not imply cultural unanimity. In 1908 John Collier, an investigator associated with the progressive People's Institute, called immigrant moviegoers "simple and impressionable folk that the nickelodeons reach and vitally impress every day."[5] The perception that immigrants were unequipped to resist films' suggestions went hand in hand with the notion that they had no cultural background with which to filter and resist filmic messages. An apparently benign, but in this sense deeply insidious, comment came from sociologist Mary Heaton Vorse, who, in her famous 1911 essay "Some Picture Show Audiences," recounted her experience of watching moviegoers in Tuscany. Attracted more to the spectators than to the films, she argued that "you must be poor and have in your life no books and no pictures and no means of travel or seeing beautiful places, and almost no amusements of any kind" to understand "what a moving-picture show really means, although you will probably not be able to put it into words." Her analysis of film audiences continued in New York, where once again she reported on immigrant spectators who, because of their low "intellectual capacity," were "permitted to drink deep of oblivion of all the trouble in the world," whereas American spectators, equipped with more developed "artistic sensibilities," found that it is "just so much more difficult . . . to find this total forgetfulness."[6]

If cinema could be so powerful for illiterate audiences, its effect on immigrants to America, many commentators argued, vastly surpassed that of any other vehicle of acculturation and assimilation.[7] After writing in his 1915 *The Art of Moving Pictures* that "the cave-men and women of

our slums seem to be the people most affected by this novelty," Vachel Lindsay, a poet turned film historian, referred to the American demo-cratic ideals of Emerson, Poe, and Whitman to describe cinema as a new language of "hieroglyphics" and, specifically, "American hieroglyphic."[8] In tune with the "national cosmopolitanism" of such modern American intellectuals as Randolph Bourne, William James, Ezra Pound, Morris R. Cohen, Horace M. Kallen, and Walter Lippmann, this view of motion pictures as democratic and equalizing became a truism.[9] One can find examples in the rhetoric of generations of film historians writing before and after World War II, including Terry Ramsaye, Benjamin B. Hamp-ton, Lewis Jacobs, and Paul Rotha.[10]

The more recent historiographical contributions, in a "democratic lineage" that encompassed Robert Sklar and Garth Jowett in the 1970s and Charles Musser and Ben Singer in the 1990s, have stressed the rel-evance of working-class film patronage in the exceptional social and communicative development of early cinema in America.[11] In light of parallel studies on working-class cultural and political agency, however, these scholars have stressed that films were sites of social conflict and that the "universal" appeal of moving pictures did not automatically im-ply a conflict-free mass broadening of middle-class values and sensibility. Other scholars, describing themselves as "revisionist historians," have thought differently. Russell Merritt, Douglas Gomery, and Robert C. Allen have set out to document what they view as the equally strong pres-ence of a bourgeois form of silent film patronage.[12] The debate became quite animated in the mid-1990s when, in an issue of *Cinema Journal*, Singer and Allen published a lively exchange on historical findings and methodology. Aside from comparisons of data on the number, location, and patronage of low-class movie theatres in New York City, at stake were divergences of opinion on the social dynamics of early film spectator-ship, including the significance of social and cultural conflict at the core of America's most notable mass medium.[13]

While displaying different methodological penchants, all these posi-tions reveal a converging blind spot, evident in the discounting of immi-grants' cultural universe. Those who argue that most film patrons were working class have fruitfully recognized the cultural and ideological tensions inscribed in film shows; they have also recognized, at least in general, the cultural differences among immigrant spectators. But they

have tended to subsume immigrants rather quickly into the category of working-class patrons.[14] By design, revisionist historians have not elected immigrants as their subject of study. Yet, more than any of them, Allen has made a useful methodological contribution by insisting on the intermedial relations between American cinema and American vaudeville. "The nickelodeon boom," he argues, "was but one aspect of a more general expansion in popularly-priced entertainment forms between 1905 and 1908," one that Allen says resulted in the creation of family-friendly and thus gentrified small-time vaudeville culture.[15] Despite his productive challenge to antivaudeville sentiment among film scholars, which has persisted since the early 1900s, and the teleological assumptions that have infused film historiography, Allen then utterly overlooks the relevance of immigrant entertainment venues.[16] His reading of the development of cinema's "exhibition scene" is based almost exclusively on an assumption of American entertainments or quickly Americanized audiences. Once more, the contours of immigrants' cultural constituencies remain invisible.

At least theoretically, Miriam Hansen has recognized the relevance of a web of immigrants' amusements, especially in large urban areas. Her theorization of immigrant moviegoers' "alternative public sphere" has allowed her to open up a speculative space of dissonance and autonomy against the institutionalization of American film spectatorship. In immigrant and working-class theatres, she argues, the so-called "variety format" enabled modalities of consumption that were characterized by such elements as local variability, immediacy, singularity, collectivity, and lively participation. "Going to the movies during the silent era," Hansen writes (quoting Richard Koszarski), "remained essentially a *theater experience*, not a film experience," by which she means that live music and audiences' loud reactions defined the meaning of the experience.[17] While speculatively groundbreaking, Hansen's theorization of a non-American film spectatorship ultimately treats it as an absence, an indeterminate and rather ineffectual cultural force.[18] The institutional disciplining of spectatorial experience is, for her, the final, inevitable destiny. Since immigrants "were barred from most institutions of the dominant public sphere" in 1907–17, cinema's "success destroyed . . . the whole spectrum of ethnic theatrical entertainments."[19] The specifics of immigrants' actual attachments to their own cultural and political life,

from religion and patriotism to vernacular theatre and popular culture, remain either unknown or mere anecdotes of "neighborhood flavor."[20]

Similarly, a number of impressive works on female moviegoing at the turn of the twentieth century have limited their focus to issues of commercial and narrative address, American women's spectatorship, or, when addressing immigrant women's cultural constituencies, English-language sources of evidence.[21] Although informed by advanced theoretical approaches, from Marxism and psychoanalysis to feminism, critical theory, and cultural studies, the historiography of early film spectatorship has largely remained U.S.-centric and monolingual with regard to films, vaudeville shows, and their audiences.[22]

Social historians have displayed a similar methodological monoglottism. Roy Rosenzweig, Elizabeth Ewen, and Kathy Peiss have resourcefully ventured into such historical territories as American working classes' and immigrants' factory work, family and community life, religion, dance halls, amusement parks, and entertainments.[23] They have approached these understudied fields, painting a much more complex picture of racial and gender interactions, yet, once again, they have done so on the sole basis of English sources of evidence and carriers of U.S.-centric perspectives. The specificity of immigrant historiography, which fruitfully employs foreign sources and cultural frameworks, has been hardly visible in their work. While language barriers may be understandable, they certainly do not justify film historians' claim that immigrants' film experience is impossible to uncover in the name of what has often been called "the riddle of direct evidence."

Some film historians working on film reception, including Roberta Pearson, William Uricchio, Janet Staiger, Lee Grieveson, and Miriam Hansen, have been quite careful not to define their work as an examination of "real people's responses" to specific films, preferring instead to focus on "conditions of reception," "class-bound discursive formations," and "reading positions." In New York, the argument goes, written evidence of the nature of spectatorship is limited by the illiteracy so common among Southern Italian immigrants. If Pearson and Uricchio have acknowledged that "we have practically no evidence as to how . . . audiences may have 'made sense' of the films,"[24] Staiger has cautioned that in her work she "will not be describing actual spectatorial responses."[25] In his research on "the emergence and proliferation of discourses about

audiences," Grieveson similarly warns that he "will not be discussing audiences themselves."[26] And Hansen guardedly writes that her discourse on immigrants' moviegoing "must remain speculative, since it is difficult to know how they saw and what significance moviegoing had in relation to their lives." Her methodological penchant is thus for an examination of a "horizon of reception."[27]

The recurring distinction between "hypothetical spectators" and "actual spectators" is predicated on the alleged absence of "direct evidence," which, many scholars contend, is impossible to come by, because illiterate immigrant audiences did not leave written traces. There are several problems with this contention. First, the impossibility of direct evidence is due not to immigrants' pervasive illiteracy, which did not prevent them from leaving an abundance of traces, but to the undocumentability of film viewing. Even if we had a few transcriptions of historical immigrants' actual film reception, they would make sense only within a larger interpretative perspective that ought to take into account the specifics of immigrants' native culture. Second, any historical explanation is in fact nothing more than a hypothetical construction based on the evidence found or made available. Different historiographical interpretations diverge not because some are mere hypotheses and others are not. They differ in the type of questions they pose and in the kind of historical evidence they seek out in order to answer those questions. What other forms of evidence are then possible?

The common postulation that cinema was inevitably and naturally liberated from any vassalage to preexisting forms of entertainment has run parallel with the constant disregard for the contextual relevance of not just foreign films, but also non-American forms of stage entertainment. The study of "media interactions" between vaudeville and films has left out the parallel amusement "synergies" occurring within New York immigrant communities.[28] By focusing on foreign constituencies such as Italian films and Italian national and vernacular theatre, I wish to expand the most commonly adopted historiographical perspectives on early cinema and immigration. First of all, the presence and endurance of the variety format as a widespread exhibition pattern ought to be stressed; it was not obliterated by the emergence of nickelodeons after 1905, but continued solidly for another decade and, in many cases, into the early 1920s. In 1907, a prominent charities administrator, Sherman C.

Kingsley, described the entertainments offered by nickelodeons as consisting of "moving pictures, instrumental music, clog dancing, jokes, and sometimes a play with more or less of a plot."[29] A year later, John Collier equated nickelodeons to "moving picture variety shows."[30] Immigrants' cultural institutions, which did not at all coincide with the mainstream culture of American Anglo-Saxon entertainments, played a pivotal role in defining immigrants' experiences of film. If the case of the Jewish popular culture of New York, particularly its Yiddish stage tradition, is rather obvious, the parallel presence, sometimes literally across the street or in the very same building, of an outstandingly rich tradition of Southern Italian vernacular theatre has not been so apparent.[31] Parallels are copious. As Nina Warnke has recently observed, at least "until the turn of the century, the Yiddish stage served as the central entertainment institution for Eastern European Jewish immigrants."[32] Although largely unpublished, Judith Thissen's work is crucial in highlighting the presence of Yiddish music halls and vaudeville houses, which, after the booming of the nickelodeons, began to include moving pictures in their variety programs of Jewish songs and sketches.[33] Similarly, the Italian *cafés-chantants* and music halls that often included films in their variety programs are also of great historiographical interest. Only in the context of Italian popular culture in America can the relationship between Italian immigrants and moving pictures be properly addressed.

THE SCENE OF FILM EXHIBITION:
ITALIAN NATIONAL AND VERNACULAR CULTURE

Constantly subject to the assimilating pressures of American institutions, Southern Italians' cultural stance in America was also constantly inflected by the double track of national and regional affiliation. Rarely antagonistic, this binary relationship animated a constant dialogue. Nationalism, military campaigns, and historical films fueled modern formulations of national identity. Parallel to them were modern exhibitions of vernacular identity, whose dialect idioms and picturesque references, on stage and in print, were redolent of unchanging backwardness. This dualism infused immigrants' material and imaginary life.

Southern Italians in New York City lived mainly in the so-called Mulberry Bend district in the Lower East Side and East Harlem. This

residential pattern reproduced Italian villages' close-knit life and dif-
fidence toward the outside world. Immigrants from small villages in
Apulia, Campania, and Sicily lived on the same block or even in the
same tenement building. The urgency of finding a job and mastering
an environment they did not understand led immigrants to rely on
the *padrone* system—an illegal arrangement in which a local boss de-
manded payoffs—or mutual-aid societies (*società di mutuo soccorso*), of-
ten led by high-flying professionals, bankers, and businessmen, known
as *prominenti*. Able to offer various kinds of help, mutual-aid societies
were initially open only to former inhabitants of the same province
or small town. Over time, however, these societies consolidated into
powerful regional and even national associations, involved in patriotic
pageants and benefits linked to the establishment of Columbus Day
(1892), fund raising for the victims of the 1905 Calabria earthquake or
for the erection of statues devoted to Dante, Garibaldi, and Ferrazzano
(the first explorer of the Hudson River), or simply celebrating the an-
niversary of Italy's unification. Instrumental in these consolidations
were the societies' presidents and the *prominenti*, whose public displays
of nationalism exercised a social and cultural influence over the entire
community.[34]

Similarly, on a scale between national and local affiliations were the
neighborhood parishes. Settling where Irish immigrants had moved
in a few decades before, Southern Italians found themselves not at all
welcomed by their fellow Catholics, mostly Irish, who abhorred their
unorthodox and "pagan" rituals. At the center of the "Italian problem"
were the *feste*, the lively public processions and celebrations of saints that,
from spring to fall, occupied and redefined the city's landscape with flags,
statues, banners, songs, and food stands.[35] Back in the South of Italy, *feste*
were connected to the saints' or Madonna's blessing of crops and protec-
tion from famine and disaster. In the American multinational urbanity,
as religion historian Robert Orsi puts it, "the entire *festa* recapitulated
the experience of immigration."[36] By displaying regional banners and
American-style electric lights, the Italian tricolor and the American flag,
the *feste* helped articulate an associational bond within the city's South-
ern Italian communities that transformed the original self-awareness of
each Italian village or region into a new national and racial awareness.
As Denise M. DiCarlo has shown, the *festa* of San Gennaro, originally

linked to the Neapolitan saint hailed as the protector against the erup-
tions of Mount Vesuvius, became in New York a multiregional affair.
Involving a number of parishes, it connected worship communities for-
merly unacquainted with the saint, but probably quite familiar with the
volcano.[37] In these complex mediations between regional patrimonies of
symbols, national affiliations, and anti-Italian racism, "the Italian clergy
thought of themselves as the guardians of Italian culture."[38] World War I
further augmented this unlikely bond between church and Italian state.
By then, Italian churches in the city were organizing pro-Italy benefit
evenings that featured opera arias, vernacular stage plays, popular songs,
and even Italian war films.[39]

Another major site of ideological tension and alliance between na-
tional and vernacular communities was the so-called "ethnic press"—
arguably the source of evidence most ignored by the historiography
of early film spectatorship. At the end of the 1910s, in New York alone,
there were twelve Italian American newspapers of varying circulations.[40]
The most popular one was the nationalist *Il progresso italo-americano*,
founded in 1880 by the *prominente* Carlo Barsotti and selling, by the late
1910s, between 90,000 and 100,000 copies. Another proudly patriotic pa-
per, *L'araldo italiano* (1889–1921), averaged a daily circulation of 35,000.[41]
There were also an impressive number of socialist and anarchist papers.
And then there was *La follia di New York* a unique literary and humorous
weekly founded in 1893. Edited on the model of the Neapolitan dialect
newspaper *La follìa, La follia di New York* became the most popular liter-
ary and theatrical publication in New York. While still a very patriotic
paper, ready to denounce the American press's racism, it was particularly
celebrated for its regional columns. Graced by humorous drawings of
characteristically Neapolitan, Sicilian, and Roman landscapes, these col-
umns began appearing in 1909 and were written in an Italianized version
of these areas' dialects (fig. 7.1).

Variously associated with the periodical press, a rich literary pro-
duction mediated international literary trends with immigrants' lives.
Most notable was the case of Beniamino Ciambelli, "the little Sue of
Little Italy" and the author of *feuilleton*-like tenement thrillers.[42] This
literary production, however, could not compete with the exceptional
fame of opera and stage dramas, as well as vernacular sketches and plays,
all regularly exhibited in the city's most prestigious venues or at neigh-

7.1. An example of vernacular columns: "Macchiette Napoletane" (Neapolitan sketches), "Scene Siciliane" (Sicilian scenes), and "Schizzi Romaneschi" (Roman sketches), from *La follia di New York,* 27 June 1909, 2.

borhood *cafés-chantants.* On stage, a transatlantic Italianness solicited recognition. If American culture was keen to racialize Italian stage and opera performers as "instinctive" talents, Italian American culture was equally ready to complicate the game of national and racial affiliations by projecting onto the same performers the familiar tension of national and Southernist affiliations.

Despite his tremendous fame, some critics felt that the Neapolitan tenor Enrico Caruso displayed a style that was "vulgar," "excessive," and "plebeian," and thus inappropriate to the integrity and the sacredness of opera.[43] Similarly emphasizing emotionality, Henry James hailed Tommaso Salvini's Shakespearean interpretations as examples "of pure feeling—of passion, with as little as possible of that intellectual iridescence which, in a piece of portraiture, is the sign of Shakespeare's hand."[44] As a whole, American critics believed that the unrestrained theatricality of Italian opera, stage performers, and audiences genuinely and naturally reproduced Italians' typical ethos. The vernacular melodramas staged along the Bowery prompted Italians to display, on- and off-stage, the "full gamut of human emotions," to quote the intrigued critic John Corbin.[45]

Since the 1890s, the Italian enclaves of New York had, in fact, housed an astonishing number of theatrical exhibitions of Italian and vernacular plays. Performed in locales slightly larger than the nickelodeons and variously called theatres, music halls, or *cafés-chantants,* these "dago shows," as Vorse called them, were organized in variety format and included popular songs, operatic arias, comic acts, circus-like performances, and, quite often, films.[46] Their offerings, addresses, and attendance in the high-density Italian neighborhoods of the Lower East Side and East Harlem gave these *cafés-chantants* a much more popular character than they

had had in Italy. On the "Bowery stage," as it was often called, countless small and amateur Southern Italian companies constantly performed the famous plays of Italy's most renowned writers, including all the major exponents of Southern poetics (Verga, Pirandello, Capuana, Di Giacomo, Bracco, Scarpetta, and Mastriani). These plays, whether performed in Italian or in dialect, comprised highly sentimental plots of love, jealousy, and revenge as well as tear-jerking stories of sudden misfortunes or widespread deprivation, child death and kidnapping, and personal misery and abuse. While Neapolitan melodramas were the favorite performances, two of the most popular plays were familiar Southernist staples of Catanese theatre: Mosca and Rizzotto's *I mafiusi di la Vicaria* (The Beautiful People of Vicaria, 1863) and Capuana's *Malìa* (Witchery, 1891). At least until the beginning of the twentieth century, Southern Italian vernacular theatre was busier and more popular in the United States than in the whole South of Italy.

The most revered exponents of such diasporic poetics were the Neapolitan Guglielmo Ricciardi, the master interpreter of Neapolitan comedic masks;[47] the Sicilian Antonio Maiori, who introduced Shakespeare to immigrants in his Southern Italian dialect productions;[48] and the Catanese Mimí Aguglia, who brought to America the Sicilian repertoire she had successfully performed with Giovanni Grasso.[49] Of a different scale, however, was the success of Neapolitan Eduardo Migliaccio, known as "Farfariello" (Little Butterfly), arguably the most famous performer of the Italian American stage scene.

If, in Italy, Neapolitan and Sicilian carousels acquired a Southernist accent, in New York City Southern Italian culture entertained more complex poetic relationships with the host American culture. This complexity resulted from the emergence of an Italian American performative language, centered on the juxtaposition of Italian, Southern dialects, American slang, and their various corruptions. The Southern Italian tradition of comic and dramatic improvisations, hyperrealistic sketches, and melodramatic plots came to address the hardships of immigrants' adjustments and, in the process, began to configure an Italian American diasporic culture of significant commercial value.[50] George Beban's melodramatic and histrionic portrayals, which Italian Americans widely admired, owed a great debt to the Bowery stage scene.[51] He regularly attended these shows, while American critics regularly interpreted

them as realistic renderings of Italians' wholly artless and "animalis-
tic" temperaments. In 1898, for instance, Corbin explained audiences'
outmoded and primitive reactions as resulting from "the instinctive
strength and delicacy of Italian affections[, which] may be more nearly
allied to the animal than a sympathetic observer suspects."[52] Two years
later, Greenwich Village cultural critic Hutchins Hapgood found that
the intense and excessive emotions of an Italian melodrama "were native
to the actors and characteristic of the play."[53] In 1917, the famous music
critic, novelist, and photographer Carl Van Vechten described Aguglia
as "one of the greatest living actresses," although without any theatrical
self-consciousness: "If you asked her about her method she would not
understand you."[54]

PATRIOTIC MOVIEGOING AT THE *CAFÉ-CHANTANT*

The arrival of moving pictures in the immigrant colony, amidst its exist-
ing web of leisure-time offerings, was hailed as an advent of modernity.
Systematically addressing the new medium after 1905–1906, the Italian
press repeatedly focused on cinema's technological novelty, including
the astounding prospect of sound films, and the irresistible development
of both filmmaking and moviegoing practices throughout the world.[55]
Cinema was regarded as a new attraction, one that the colony's most
common entertainment venues, *cafés-chantants,* could not afford to ig-
nore. What is clear in the coverage, however, was that films were not an
autonomous form of amusement. Rather, they constituted a new and
appealing offering within the well-established variety format of Italian
American small-time vaudeville houses.

What do we know about these locales? In his pioneering research,
Ben Singer has discovered the addresses and ownership of about thirty-
two Italian movie theatres scattered across Manhattan between 1907
and 1909.[56] While contemporary listings often do not make distinctions
between "common shows" (ordinary nickelodeons) and "concert mov-
ing pictures" (theatres that could house vaudeville acts, plays, and films),
the Italian American press turns out to be of some help in determining
the types of shows exhibited at many of these "movie theatres." From
available evidence, it seems that Italian-owned nickelodeons, storefront
theatres exclusively or primarily devoted to the exhibition of films, either

were not particularly common or did not receive much news coverage. Beginning in the spring of 1907, *La follia di New York* started publishing advertisements for a number of Italian venues, including the Excelsior Cinematografico (147 Mulberry Street), the Bleecker Street Theatre (157 Bleecker Street), the Teatro Cassese (196 Grand Street), the Cinematografo Caruso (124 West Houston Street), and the Cinematografo Sirignano (196 Grand Street).[57] Although the titles and genres of the films shown in these theatres are not specified (this would happen only later, and only in ads for major productions), all the ads insisted on the association of film exhibitions with vernacular attractions, especially Neapolitan singing duos and comedy acts. This pattern of intermedial exhibition was not restricted to Italian neighborhoods, however. In 1907 and 1908, two of the most typical vaudeville houses of New York, F. F. Proctor's Twenty-third Street Theatre and B. F. Keith's Union Square Theatre, were converted into successful movie theatres.[58] "The introduction of vaudeville acts into the nickelodeon program," as Allen writes, "was a transformation of the American motion picture exhibition scene." It signaled "the age of small-time vaudeville as the major form of motion picture exhibition."[59] What Allen does not specify, however, is that these settings exhibited an impressive range of foreign films.

Unlike most other immigrants, in fact, Italians in New York had a chance to watch hundreds of films made in their own country. Film historian Aldo Bernardini has shown that between 1906 and 1916 more than 1600 films were exported from Italy to the United States—an average of approximately three new films per week.[60] While many were marketed to, and thus first exhibited at, upscale movie theatres, eventually a few of them, particularly the most lavish productions, reached the exhibition venues of the Italian colony and found coverage in the Italian press. Beginning in 1907, American periodicals mentioned the exhibition of Italian travelogues and *actualités* about Italy's architectural landmarks or natural scenery. For instance, in early May of 1908 alone, *Moving Picture World* reviewed four such *actualités,* two produced by the British manufacturer Urban, *Country about Rome* and *Environs of Naples,* and two by Ambrosio, *Sicilia Illustrata* (Sicily Illustrated, 1907) and *Panorama di Venezia* (Panorama of Venice, 1906).[61] Although the Italian American press mainly focused on the grand historical epics and war films and rarely mentioned these "view films"—possibly because of their short

7.2. *Tuberculosis Poster—June 1908* (1908). Used by permission of the Museum of the City of New York, The Byron Collection (93.1.1.18292).

length and brief distribution—Italian immigrants' fondness for their homeland's celebrated scenery was not only well known, but may have been enhanced by the circulation of these *actualités*.[62] In June 1908, the Charity Organization Committee, working to prevent tuberculosis, devised a plan to warn Italian immigrants against behavior leading to the deadly scourge. They were to be given "antiplague posters." "A bright colored view of a part of a canal in Venice," reported the *New York Daily Tribune*, "is surrounded with advice, in English, and those who receive the posters are, of course, first attracted by the *colored bit of scenery representative of their native land*. Then they scan the printed matter." A young Italian, Miss Silenda, who had been cured of consumption, visited the Italian families of the Lower East Side and distributed hundreds of such posters (fig. 7.2). The initiative, conceived "in connection with the free open air stereopticon exhibition given by the Health Department," was "believed [to] have a marked effect in the course of time in reducing the mortality from tuberculosis."[63]

The commercialization of historical films began in America in 1908 as the result of a deliberate marketing strategy. Italian producers recognized that antique humanism, Shakespearian historical tragedies, and natural catastrophes set in Roman times were commercial opportunities of cosmopolitan appeal. Cines's advertisements in American trade periodicals proudly combined antiquity with patriotism. "We have delved into the classics and there found material for Comedy and Drama," one read. "And garbing our stories in the matchless splendor of Italian Art, we are going to give you a product which will be lauded from ocean to ocean."[64] After a few one-reelers about Shakespearean Italy, which were a convenient homage to both the English playwright and the Italian peninsula,[65] historical films' most common settings included ancient Rome and medieval Tuscany. Exhibited in prestigious Broadway venues and high-end movie theatres, *The Fall of Troy* (La caduta di Troia, Itala Film, 1911), *Dante's Inferno* (L'Inferno, Milano Films, 1911), *Quo Vadis?* (Cines, 1913), *The Last Days of Pompeii* (Ambrosio, 1908 and 1913), and *Cabiria* (Itala Film, 1914) exerted a major influence on American film productions. Their "beauty of form, magnificence of theme, epic grandeur, lofty morality and an appeal to the finest and deepest emotions," as *Moving Picture World* reported, shaped American cinema's aesthetic ambitions, civic and nationalist aspirations, and universalist mission.[66] Often imported and commercialized by George Kleine as a "Cycle of Film Classics," Italy's historical epics were cosmopolitan commodities. After they had exhausted their runs in the finest theatres of America, where tickets could sell for a dollar or even more, historical epics extended their commercial run to cities' ordinary movie houses, including the ones located near or within the Italian quarters.

Throughout their commercial trajectory from Broadway to the Lower East Side, the Italian American press constantly highlighted the Italianness of these productions and urged immigrants to see them. *Il progresso* wrote of Pasquali's *The Last Days of Pompeii* (1913) that "no Italian could miss this wonderful and victorious spectacle."[67] In the same period, ads in the newspaper were praising Italian productions of *Last Days* and *Quo Vadis?* with such slogans as "The greatest triumph of Italian film industry" and "Great Film Production Manufactured by Great Italian Artists." The patriotism of the film coverage was contagious: even *La follia di New York* contracted it. Writing about *Cabiria*, which

opened at the Knickerbocker Theatre (Broadway and 38th Street) on 1 June 1914, it wrote, "No Italian should miss going to the Knickerbocker to touch, or better, to witness the 'new miracle' of [Italian] national art and industry."[68]

In the colony, antiquity had both theatrical and iconographic precedents. The aesthetics of "historical realism" had found their way to New York through stage plays, most notably Pietro Cossa's historical tragedies and sensational biographical profiles—*Nero, Cleopatra, Messalina,* and *Giuliano L'Apostata*—a spectacular production of *Quo Vadis?* (1904), and an adaptation of Shakespeare's *Julius Caesar* (1905).[69] In 1907, even Sicilian playwright Giovanni De Rosalia acted in a vernacular profile of Nero, which he had translated into Roman dialect.[70] Furthermore, the "taste for antiquity" was a common iconographic style in the ad pages of Italian American papers. It was used with particular frequency in medicinal advertisements that graphically staged confrontations between health and sickness. In 1907, for instance, *La follia di New York* published a series of ads for the tonic Ferro-China Bascal which featured classic figures dressed in Greco-Roman tunics, representing the progress of science against physical afflictions. In one instance, however, ads for the same tonic offered a familiar, yet more ambivalent, tableau. It showed the conclusion of a duel between two gladiators, with the winner sporting the name of the tonic on his chest, in a Colosseum-like arena and in the presence of a large crowds and an imperial authority (fig. 7.3). The posture of the gladiators and the proportion of their figures precisely replicated Jean-Léon Gérôme's painting *Pollice Verso* (1872). This should not be at all surprising. Widely reproduced or, in Martin Meisel's words, "realized," in prints, illustrations, and posters of toga plays (fig. 5.1), the tableau had had and would continue to have a vast circulation both in Italy and in the U.S. Six years after the publication of the ad, the painter and film director Guazzoni made use of it in the 1913 international blockbuster *Quo Vadis?* (fig. 7.4).[71]

What does the tableau really represent, and what does this tell us about Italian immigrants as spectators of historical film epics? On the surface, the ad promoted an invigorating Italian drug, manufactured by an Italian pharmaceutical company (Basilea & Calandra), which it described as the "perpetual winner" in the battle against diseases associated with the American arena—high blood pressure, nervous weakness, and

7.3. *La follia di New York,* 17 November 1907, 7.

breakdowns. On a more symbolic level, the tableau embodies a parable of survival, pitting the virtuous but vulnerable immigrant against a hostile environment that cannot be ignored or escaped, but must be frontally challenged. Yet how can the Italian immigrant look at Rome as both an antagonistic arena and a prestigious site of origin? As David Mayer has shown, toga plays constitutionally embodied ambivalence in their displays of the conflicts undermining the hegemonies of modern capitalism and empire. Furthermore, in late nineteenth-century America, the phenomenon of immigration problematized the American empire's cohesive cultural and racial fabric. Yet toga plays made it "possible for the spectators to empathize or side with both agonists, to see themselves both as powerful winning Romans and as virtuous Christians... 'to have it both ways.'"[72] And this advertisement was not the only place they were used to do so. A year later, *La follia di New York* published a political cartoon that staged the familiar gladiatorial duel between a member of the Italian Chamber of Commerce in New York and a rival supported by the colony's *prominenti,* casting them as the new Caesars.[73] Once more, the tableau captured the audacity and self-determination of weak subjects

7.4. *Quo Vadis?* (Cines, 1913), postcard. Author's collection.

against powerful, yet never utterly othered establishments. The fact that Italians could use the iconography of antiquity (and its narratives) to imagine themselves as both historical insiders and winning outsiders may have helped establish their sense of cultural identity and place. What is certain, however, is that, since they clearly assumed that viewers would easily recognize and comprehend them, both the advertisement and the cartoon defy the common assumption that Italian historical films were an absolute novelty to the illiterate Southern Italian immigrants. In fact, several cultural practices centered on antiquity, from the stagings of Pietro Cossa's Roman tragedies to recognizable iconographic motifs, provided a circularity of visual references that informed and contextualized immigrants' patriotic reception of Italian historical films. In the same period and even beyond, a similar patriotic fervor was reserved for those Italian films depicting the nation's 1911 imperialistic war in Libya and its World War I military engagement.

Paradoxically, a great impetus came from the American press. In 1911, the *World* and the *New York Times* mounted a harsh campaign against the Italian invasion of Libya by accusing Italian soldiers (correctly) of acts of genocide. In support of their claims they often mentioned a controversial

7.5. Advertisement for an exhibition of *Italian-Turkish War* at the YMCA Hall (Brooklyn), *Il progresso italo-americano*, 4 January 1913, 4.

Vitagraph film, *Italian Atrocities in Tripoli*.[74] The Italian American press's response was immediate, well organized, and consisted of utter denial. *L'araldo* and other Italian newspapers organized a public rally on 12 November at Sulzer Park, where "tens of thousands of Italians" demonstrated against the film and the hostile press coverage.[75] *L'araldo* also mounted legal action against Vitagraph, forcing the American film company to withdraw the film from circulation in New York and other cities.[76]

The close correlation between nationalism and moviegoing did not stop there. The Italian American press regularly hailed with great enthu-

siasm the release of newsreels about the colonial war effort, encouraging Italians to patronize them *en masse*. Cines produced two different series on the subject, of fourteen and nine episodes respectively: *Guerra in Tripolitania* (Italian-Turkish War, 1911), released in the U.S. on 28 November 1911 (fig. 7.5), and *Corrispondenza cinematografica dal teatro della guerra italo-turca* (Scenes of the Italian-Turkish War, 1911), released on 6 June 1912.[77] Other, shorter productions on the topic were released in 1911 by Luca Comerio (Milan) and Ambrosio (Turin), both titled *La guerra italo-turca*. The regular exhibition of these films did something even more radical: it translated the idea of Italy into a series of images, according to a national aestheticization that carried intense racializing connotations. For both promotional and fundraising purposes (to benefit the families of the fallen soldiers), Cines's filmed "war episodes" inspired the commercialization of serially produced paintings, illustrated books, and even stereoscopic images, sold in bookstores or through newspapers.[78] Early in 1912, *L'araldo* promoted a fundraising "Italian concert" at Tammany Hall, advertising it in clear imperialistic tones as an opportunity "to join the fight of civilization against barbarism."[79]

In endorsing the 1913 rerelease of the first four episodes of *Guerra in Tripolitania,* exhibited as *La guerra italo-turca* (an Italian translation of the series's original English title), *Il progresso* proudly adopted the familiar promotional slogans of historical fictions. It emphasized the spectacular quality of the footage and its epic length ("three hours of spectacle"), the production's grandiosity ("800 live scenes of victorious battles"), and, of course, the triumphant outcome of the confrontation ("apotheosis of the army and navy").[80] As was done in many other ads, *Il progresso* solicited Italy's immigrants according to a classic call for the army: *"Italiani!"* ("Italians!").

The Italian American association of nationalism and moviegoing became particularly intense during World War I.[81] In August 1917, the entire ten-episode documentary series *Giornale della guerra d'Italia* (Regio Esercito–Sezione Cinematografica, 1917), also called *Al fronte d'Italia* and translated alternatively as *The Italian Battlefront* and *The Italian Front,* began its run at the prestigious 44th Street Theater, accompanied by a forty-piece symphonic orchestra.[82] American trade periodicals praised the film's displays of heroism.[83] *La follia di New York* and *Il progresso* did the same, but they also interpellated mention of Italians' financial

and ideological support of what they described as "our Italy."[84] The fact that moving pictures were a privileged and modern domain of Italian American patriotism, with reference both to Italy's colonial campaigns and to its participation in World War I, meant that cinema could compensate for racist prejudice. The very same *La follia* article that called for patriotic solidarity around *Al fronte d'Italia* insisted that the film's public exhibitions of heroism could finally counterbalance the American media's prejudices against and negative representations of Italians. In fact, the film showed to both Italians and Americans that Italians were capable of great deeds in their imperialistic efforts, despite their meager and shameful living conditions in New York.

> Isn't it a legitimate satisfaction to point out our glories ... and to oppose them to the miseries that we too often are forced to witness in our colonial life? And won't the admiration that a foreigner, willing or not, is forced to acknowledge to the glorious Italian soldier end up touching us indirectly?[85]

From Italian historical epics to the contentious filmed representations of the campaigns in Libya and of the Great War, the relationship between cinema and national identity became, for immigrants, increasingly intimate. Yet, although openly challenged, Italians' vernacular culture did not fade at all from the cultural resources mobilized by immigrants in their reception and experience of the new medium. Instead, it continued to remain a crucial cultural framework that journalists, performers, and immigrants alike employed to assess the profound changes that modernity brought to Italian Americans' lives.

PICTURESQUE NOSTALGIA AND DIASPORA

The relationship between Southern Italian vernacular culture and moving pictures was a dynamic one: it ranged from apparent incompatibility to creative appropriation. Numerous articles, short editorials, and even poems, mostly in tune with the vernacular culture of *La follia di New York,* opposed the social and cultural innovations brought by the new medium from a proactive Southernist perspective. Writing in dialect, either Neapolitan or Sicilian, famous columnists, stage actors, and playwrights depicted moving pictures as a series of multiple threats that were

shattering the South's "timeless" cultural identity, its literary and theatri-
cal vernacular expressions, and even its traditional gender relationships.
The multidimensional menace of film, however, was often complemented
by forms of appropriation. By identifying the film medium with dialect
names, the same literary and theatrical constituencies also demystified
its danger and praised the resilience of vernacular culture. In the 1920s
and 1930s, as we shall see, several actors and writers joined the moving
picture business and in a few rare, yet most significant, cases translated
their vernacular poetics into sound films. Let us begin with the initial,
dystopian stance.

On 14 February 1909, *La follia di New York* published a long poem
titled "Doppo nu suonno" (After a dream), written in Neapolitan by a
certain Armando Cenerazzo and dedicated to Eduardo Migliaccio, the
iconic star of Italian American theatre.[86] Rather than a simple dream,
the poem speaks of American cinema as a double nightmare, for the
pervasiveness of both its plots and its exhibitions. The protagonist, a
priest, recounts one of his dreams, which appears to unfold as an Italian
immigrant's perspective on American films. He dreams that he is a film
character whom a beefy policeman arrests and puts in jail for no appar-
ent reason, as if he were the brigand Musolino, without showing any
respect for his lifelong probity. Then he awakens to an even worse night-
mare, in which *move-piccie*—his vernacularized Anglicism for moving
pictures—reign unchallenged among the colony's leisure-time offerings.
Their pervasiveness is damaging. Films are forcing theatre performers to
change profession, while popular and untalented film authors consider
themselves equal to none other than renowned Neapolitan playwright
Roberto Bracco, author of the drama *Sperduti nel buio*. After denounc-
ing moving pictures for having "reduced Art to sausage meat," the pro-
tagonist concludes with a reference to a famous Sicilian natural disaster:
"Let's hope that a pandemonium will disrupt everything, like an earth-
quake, hopefully stronger than the one that struck Messina."

Another major voice in the colony, the Sicilian-born actor, play-
wright, journalist, and stage director Giovanni De Rosalia, voiced more
ambivalent thoughts about modern American life and amusements,
including cinema. A regular columnist and contributor to *La follia di
New York,* for which he wrote in Italianized Sicilian dialect, De Rosa-
lia created the half-wit comedic character Nofrio, a Sicilian caricature

(also known in vernacular Sicilian as Nofriu) modeled on Pulcinella, the classic Neapolitan character of Commedia dell'Arte and stock character in Neapolitan puppetry.[87] Speaking in a comprehensible Sicilian, Nofrio was a figure to whom many Southern Italians could relate in their challenging encounters with American modernity. Dressed in shabby clothes, checkered pants, and suspenders, Nofrio is the equivalent of Uncle Josh and the greenhorn in American and Yiddish culture, the naïve newcomer who misunderstands the novelties of modern life. Particularly famous was the sketch "Nofrio al telefono" (Nofrio on the phone), which displayed Nofrio's misunderstanding of the technology and his anxiety over whether Sicilian dialect could be spoken over an American phone line.[88] Committed to a poetics of "intense Sicilian vehemence, made of superstition, generous impetus, inextricable contradictions," in one critic's words, De Rosalia was addressing both Sicilians and non-Sicilians through a combination of ethnographic realism and self-exoticization.[89] Typical of Southernist representations, De Rosalia's Sicilianness had both the endogenous characteristic of self-expression and the extrinsic attribution of primitivism and nostalgia.

His success attests to the pervasiveness and success of this double positioning. De Rosalia repeatedly addressed the phenomenon of moving pictures. On 7 November 1909, in his column "Sicilian Scenes" ("Scene siciliane"), he first emphasized the similarity between cinema and Sicilian puppet theatre: "The Cinematograph is nothing else but a new form of Sicilian puppet show" (opria di li pupi). A few lines later, however, he identified cinema's novelty in terms of women's unique and uncontrollable passion for moviegoing—a passion they never exhibited for the pupi. For him, women's keenness is doubly misplaced: like Uncle Josh, they utterly misunderstand films' fictional nature, and their addiction is disreputable since it causes them to abandon any respect for their husbands. "My husband could have been dying," reads a line of dialogue he reports, "but I would not miss going to the movies." De Rosalia's conclusion is a manifesto of misogyny and conservatism: "Instead of going to the movie theatre where [women] don't learn anything that could be taught to children, they'd better stay at home cleaning up, knitting, washing dishes, and mending."[90] Cinema, in the end, appears to him and other commentators as a dramatic and most alluring novelty, dangerously capable of revolutionizing traditional habits and social rela-

tionships.[91] Dystopia, however, was not De Rosalia's only note. In a 1910 poem titled "Cinematografu," which meant both "moving theatre" and "film show," he first defined cinema as a school of vice (*scola di viziu*), but acknowledged that it allowed young daughters (*li figghi fimmini*) to return home from a movie show with an education (*ammaistrati*).[92] Usually "protected" from the outside world, Southern Italian women could find in moving pictures a relatively safe way to acquire social skills and practical knowledge.

Another crucial voice of the community was Alessandro Sisca, songwriter, playwright, and, with his brother Marziale, founding editor of *La follia di New York*.[93] A defender of the civil and cultural rights of the colony, Sisca was also famous for his public indictments of racist stereotypes of Southern Italians.[94] He was also quite vocal about moving pictures. In a patronizing approach much like De Rosalia's, Sisca identified the novelty of the new medium in its ability to spellbind the colony's most vulnerable subjects, "women, young men, and kids," seducing them into a vulgar absorption, an "indecent imbecility" (*sporca imbecillagine*). After listing the most common film genres, such as violent chases, "Black Hand" stories, bloody Western duels, and tasteless comedies, Sisca concluded that "moving pictures are a sort of 'Kindergarten' for the evil instincts, which they awaken, cuddle, and nourish with the light of the action."[95] Films could be this effective, he claimed, because of their cheapness and ubiquity within the numerous low-level and disreputable *cafés-chantants*. The success of these vulgar venues corrupted the general quality of authentic vernacular entertainments, which included such "giants" as Migliaccio's skits and Caruso's songs. It also threatened the viability of more deserving locales, Sisca added. A prospective city ordinance, announced in 1911 but adopted only in 1913, redefined motion picture theatres as locales without a stage and thus raised the license fees of all *cafés-chantants* that exhibited films (sixteen, according to his figures), including the ones offering serious vernacular entertainments. Sisca calculated that several Italian *cafés-chantants* were each about to lay off "an average of fifteen artists, counting dramatic actors and comedians, singers, *macchiettisti*."[96] In his dystopian view, Sisca's (and De Rosalia's) charge against women's addiction to moviegoing and his polemical distinction between authentic and ephemeral vernacular entertainments were inextricably linked.

The basis of this position was the acknowledgment that cinema was a catalyst for change. While the glamorous exhibitions of Italian historical epics and war films fostered modern, yet praiseworthy, patriotic feelings, the expansion of moviegoing in the colony was furthering more subversive changes. Within the performative contexts of the *cafés-chantants,* moving pictures had been subordinate to the male-controlled and -sanctioned sketches, plays, and melodramas. When that began to change, reactions ensued. *Cafés-chantants* had exhibited popular skits, including Migliaccio's female impersonations, that addressed radical changes in the definition of womanhood and gender relations. Off-stage, however, women's actual behavior was not so manageable, particularly at a time when the entire film industry was seeking female patronage in order to gain public respectability and middle-class approval.[97] For the male old guard, the existence of a female film audience seeking pleasure and patronizing moving pictures "feminized" the new medium, which was, in turn, charged with inducing passivity, cultural ephemerality, and even moral vice. It was a familiar and very modern move. The patriarchal resistance to commercial amusements was commonly verbalized as a juxtaposition of the intellectual value of literary or cultural modernism, primarily reserved for men, and the corruption of mass pleasures. In other words, the defense of traditional social legitimacy was structured as a conflict between men's artistic production and women's mass reception.[98] In America, within the Southern Italian colony, the configuration of mass society as female caused the dominant official discourse to revert to the most controllable element of the Italian American culture: its vernacular nostalgia. This, too, was an illusion, as later events would reveal.

In order to understand the *longue durée* of the relationship between cinema and Italian American culture, we need to step beyond the early film framework of this study. In the 1920s, for instance, Italian American vernacular culture was able to establish an appropriative, rather than a conflictual, relationship with moving pictures thanks to the American distribution of Neapolitan films. It was an isomorphic affinity. Since the late 1910s, Neapolitan cinema had relied on the popular intermedial formula of the filmed *sceneggiata,* which combined famous love songs and renowned stage melodramas of passion, betrayal, and revenge. During screenings both in the U.S. and in Italy, these films were exhibited with

vernacular intertitles, regularly dubbed by more or less well-known singers, and accompanied by small orchestras, all to the delight of local audiences. Films like *Reginella* [Little queen, Miramar, 1923] and *Pupatella* [Little doll, Miramar, 1923], which were adaptations of Libero Bovio's celebrated songs, became a model for commercial export by Neapolitan film companies. Historians of 1920s cinema in America have regularly neglected these films, because their circulation and advertisement tended to be limited to Italian venues.[99] Their exhibition in the theatrical venues of the Bowery complemented the rerelease of historical epics (*Cabiria* and *Quo Vadis?*) or the exhibition of new, comparable titles.[100]

For years, recording companies had commercialized in North and South America songs about immigrants, distant homelands, and faraway lovers and relatives, written and performed by famous Neapolitan singers, including E. A. Mario, Ernesto Murolo, and Ernesto Tagliaferri.[101] Borrowing from these companies both their marketing model and their content, in the 1920s film firms produced *sceneggiate* expressly for the diasporic Southern Italian communities of the Americas. Apparently they were never distributed with English titles. Among the most famous titles were *Core furastiero* [Foreign heart, 1924], *Te Lasso!* [I am leaving you!, 1925], and *Napule e Surriento* [Naples and Sorrento, 1929], all directed by Ubaldo Maria Del Colle and produced by Any Film. These films helped launch the American careers of scores of vernacular stars and idols, including Gennariello, Leda Gys, and Del Colle himself (the "virile and melancholy foreigner"), protagonists of "nostalgic, heartbreaking pictures, aimed at the use and consumption of distant, homesick compatriots."[102]

Particularly successful in the 1920s was Dora Films of America, the U.S. branch of Elvira Notari's Dora Films. Dora Films had a double strategy. On the one hand, it exported both its regular fiction productions, such as *'A Santanotte* (The Holy Night, 1922) and *Core 'e frate* (Brother's Heart, 1923), and a few films loosely designed for the American market.[103] On the other hand, as Giuliana Bruno has written, it "made films in New York or adapted Neapolitan footage into 'New York stories.'" These Neapolitan American productions, which catered to Southern Italians and other immigrants, included *New York Underworld after Dark, Wolves of New York, Italy in America,* and *Joe Petrosino,* a film about "the adventure of the famous Italian American detective."[104] The movies that

came from Naples to New York were praised as authentic cultural works in the Italian American press.[105] Southern Italian audiences turned attending them into an event of community life. Centered on passionate love, economic hardship, oppression, and survival, these dark melodramas made immigrants' fantasies and struggles visible. More decisively, through vernacular intertitles, collective singing, and loud exchanges, these films continued nourishing the sense of identity that small-time Italian vaudeville theatres and *cafés-concerts* had already been articulating for decades.

Through these films something of Naples, Sicily, or the South of Italy in general could be reencountered and regained. But if spectatorship was arguably the most common opportunity to do this, it was not the only one. A further indicator of Southern Italian immigrants' appropriation of the new medium is their commissioning of non-fiction films from Neapolitan film companies, though these commissions are hard to document. Dora Films alone made seven hundred half-reel documentaries, usually footage of villages' most representative monuments, family reunions, saints' processions, and surrounding landscapes, about which virtually nothing is known.[106] This phenomenon reveals that Southern Italian immigrants in America also became collective film authors, engaged in staging, through the new medium of film, the master visual and anthropological narratives of their native villages. Their embrace of a folkloric and picturesque view of themselves amounted to a vernacular self-mimesis, obtained by publicly embracing a Southernized view of simple lifestyle, primitive ethos, and religious backwardness. In the 1930s, this process reached its peak.

Unlike Eastern European Jews, Southern Italians did not have much success in the business of film production. Yet, in a few all-too-neglected instances, they found ways to produce sound films that, though amateur, took advantage of a vernacular culture that was deeply rooted in oral and musical expression. Casting icons of the local vernacular stage and singing scene, and even winners of beauty contests, these films (now mostly lost) included *Cosi' è la vita* [Thus is life, Thalia Amusement Corp., 1931], with stage and film actor Eduardo Cianelli; *La fanciulla di Pompei* [The young woman from Pompeii, Italian Star Film, 1932]; *Amore e morte* (Love and Death, Aurora Film Co., 1932), starring the icon of Sicilian American theatre, Rosario "Saro" Romeo; *Senza Mamma 'e nnamurato*

[Without mother and in love, Cinema Production Inc., 1932]; and *Vita napoletana* [Neapolitan life, Capri Film Co., 1932], starring Rosina De Stefano, the "Queen of Neapolitan song." Among the many Italian films shown at this time, including Hollywood multilinguals and imported Italian sound films such as *Napoli che canta* (When Naples Sings, Cines-Pittaluga, 1926), two recently discovered and restored films stand out: the short *L'attore cinematografico* (The Movie Actor, Roman Film Corp., 1932) and the feature *Santa Lucia Luntana* (Memories of Naples, Cinema Productions, 1931).

PICTURESQUE DIALOGUES

The discovery of these films allows us to better understand the linguistic complexity of Italians' diasporic culture and, in the process, the resilience of picturesque imagery in shaping nostalgic fantasies of homecoming. Just as in Italy, the privileged arena that housed in America the Southernist repositioning of Southern Italian culture was the verbal language of songs and stage dialogue. In many respects, this resulted from Italians' lack of access to or control of the means of image production. It was much easier to convey the heritage of the picturesque through live songs, theatrical dialogues, and even newspaper articles than through painted, photographed, or filmed views of Vesuvius and the Neapolitan Gulf. The same is true of De Rosalia's Nofrio, Caruso's Neapolitan songs, and Sisca's columns.

The two rediscovered films, however, show how film production, though unusual, could accommodate vernacular language through picturesque aesthetics.[107] *L'attore cinematografico* is a filmed one-man show featuring Edoardo Migliaccio (1880–1946), the most popular comedic character actor, or *transformiste*, of the colony. Known by his stage name of Farfariello, Migliaccio specialized in *macchiette coloniali* (colonial sketches), which translated the tradition of the Neapolitan comedy, or *macchietta*, for the new American environment.[108] Migliaccio's humorous poetics were adaptive: he performed up to a dozen routines in a half-hour set, changing costume for each, and this multiplicity, as Aleandri has argued, "demonstrated the bewilderment of the Italian immigrant in a foreign country."[109] His most famous impressions included the loud patriot, the prominent Italian, the iceman, the domineering wife, Enrico

Caruso, the Irish American, the opera diva, the gangster, the cop, and the *cafone*—the helpless new immigrant. By developing and popularizing a poetics of "colonial" self-knowledge and mimicry, his impersonations relied on class and gender parodies and a constant derision of both Little Italy's nationalism and American social customs.[110]

After almost three decades of stage fame, Farfariello embraced the cinematic medium, although—and quite conveniently, given the centrality of speech to his humor—only after its transition to sound. Directed by Bruno Valletty (or Valletti), the fifteen-minute *L'attore cinematografico* comprises a series of theatrical sketches that mock the colony's theatrical and cinematic world and, in so doing, expose the constructedness of social identities. Responding to a newspaper ad, the character of Farfariello auditions for a part in a film produced by Aurora Film. Initially, he shows up as himself and sings a few famous and enticing Neapolitan songs. The firm's manager, played by the famous Sicilian stage actor Raffaele Bongini, fails to recognize him and rejects him.[111] Defiant, Farfariello repeatedly returns for more auditions, each time impersonating another of his signature characters (fig. 7.6). He masquerades as a *sciantosa,* the Neapolitan cabaret singer adapted from the French *chanteuse,* and as a vulgar Mafioso or *rackettiere,* who boasts of successfully running a protection racket. Lastly, he appears as the nostalgic and patriotic *cafone,* the boorish peasant, who, even after thirty years in America, refuses to learn a word of English, expressing his preference for the Italian language by singing the Neapolitan song "'O sole mio," a hymn to the picturesque view of the Neapolitan sun and bay. Next is a repeat of one of Migliaccio's most celebrated skits, "'A lengua 'taliana (The Italian language)," which could only have been understood in America, not in Naples, because it frequently used Neapolitan-English expressions.[112] Only when "the king of impressionists" informs the film producer that he was the one portraying all those characters is he finally offered the job. At which point, shot in a very theatrical medium close-up, Farfariello directly addresses the film's spectators and repeats his signature slogan, "Aggiuffatt a 'merica!" (I made it in America!).[113]

The film's humor clearly relies on the changes of costume and makeup, but a central role is reserved for spoken language. Migliaccio wrote his own lyrics and monologues, and often even the music for his skits. In the film, as he had for decades on stage, Migliaccio speaks the creolized

Per la Prima Volta in Cinematografia
il Re dei Macchiettisti
Cav. E. Migliaccio
Farfariello
— IN —
Attore Cinematografico

Il Cav. E. Migliaccio
FARFARIELLO
Apparira in Persona
Nelle Sue Macchiette Coloniale

N. MORGILLO, ELOQUENT PRESS CORP.,

7.6. Illustrated advertisement for *L'attore cinematografico* (The Movie Actor, Roman Film Corp., 1932). Courtesy of the Center for Migration Studies (Staten Island, New York), Collection 015 (Farfariello Papers), box 1, Programs folder.

language of the colony—a combination of Italian, English, American slang, and various Southern vernaculars, mostly Neapolitan. On the one hand, Farfariello's linguistic hybrids and neologisms, which often reproduced immigrants' Neapolitan-English terms and pronunciation (e.g., *basciamento* for basement, *Broduè* for Broadway, *muvinpiccio* for moving picture), exposed the imperfect and self-derisory predicaments of immigrants' assimilation.[114] On the other hand, they also formulated immigrants' resistance to Americanization as an unwillingness to give up "the Italian language," although the idiom used to express such defiance was Neapolitan.

The unstated preference for the dialect form reveals the nostalgia and the newness involved in becoming Italian American. If Southernism is a strategic political and aesthetic recontextualization that repositions a local language and culture within a national context and that, in the process, amplifies localisms into broader regional expressions, Migliaccio's poetics points to a further extension, indeed a doubling, of the same dynamic. In his songs, the Neapolitan dialect is both a regional sound and the synecdoche of an Italian one, by virtue of a shared contrast with the American linguistic context. Further, the vernacular, allegedly timeless, has in fact undergone dramatic adulteration. The Neapolitan dialect dresses up as Italian to contrast with the English tongue, but in the process is both Italianized and Anglicized. The Neapolitan character played by Farfariello in the film, just like the Neapolitan narrator of "'A lengua 'taliana," communicates his disdain for the English language through vernacular songs and such Neapolitan-English expressions as *mi no laiche, dezze uaie*, literally "I don't like it, that's why." Migliaccio's humorous sketches thus expose a process of double and dialectic contextualization which unveils the impossibility of both total assimilation and enduring immutability. In other words, Migliaccio put into words and songs not only immigrants' anxieties and the pressures of their adaptation, which were related to new configurations of citizenry, gender models, and human interactions, but also their position suspended between official Italian and picturesque identities and unwillingly Americanized ones, and the slippage from one to the other. Farfariello's vernacular cynicism about patriotic rhetoric, both Italian and American, and his sardonic commentary on the ways of the Old and New Worlds combined a humanist denunciation of Italian society's cruelty and American

society's hypocrisy with a constant moral sympathy for the foibles of immigrants' experience. Because of this, he played a major role in the development of immigrants' Southernist double (or plural) consciousness, which was centered on their standing as a Southern Italian "dissonant" colony within the American context. In the *cafés-chantants* and music halls of New York's Little Italies, as well as on the film screen, Migliaccio provided Italy's picturesque immigrants with an opportunity to entertain a dialogue with themselves about their experience, a dialogue "cemented by a comic language, and sharing the alternative reality of the carnivalesque."[115] His grotesque and metalinguistic humor exceeded the domain of popular entertainment, since it could easily be experienced as a cultural performance of striking anthropological value. Migliaccio's caricatures created "an intuitive awareness about the performative nature of social identities," as Esther Romeyn eloquently puts it, "and of the semiotic system that forms the basis of structures of social distinction. . . . They deconstruct a culture's key categories of meaning, and invoke a deep sense of reflexivity."[116] It is this self-fashioning, and thus quite modern, repositioning that one needs to consider when discussing Italian immigrants' film spectatorship.

Yet self-consciousness did not imply radical cynicism or complete abandonment of the images and expressions that nourished and fortified a sense of community in the Italian American colony. Heartbreaking melodramas and satirical comedies were not opposite poetic forms, but different sides of the same Southernist habitus. Quite often, for instance, Migliaccio shared the stage with serious vernacular singers, including the famous Neapolitan soloist Carlo Renard, who, a year before, had acted in the nostalgic drama *Santa Lucia Luntana* (1931), which circulated among Italian American communities in both large cities and small towns.[117] Reviewed in the American press as *Memories of Naples,* and described in the Italian papers as a "Fonofilm sung and spoken in Neapolitan, Barese, and Sicilian," the film was a *sceneggiata* that adapted E. A. Mario's eponymous 1919 song, also known as "Partono i bastimenti."[118] Shot in New Jersey and produced by the Italian American Luisi Film Co., the film is a nostalgic drama set in Naples and New York. Directed in a very theatrical style by the untalented Harold Godsoe, it features the Sicilian Raffaele Bongini in the role of an aging Neapolitan widower, father of three, who migrated from Naples twenty years before. The names of his

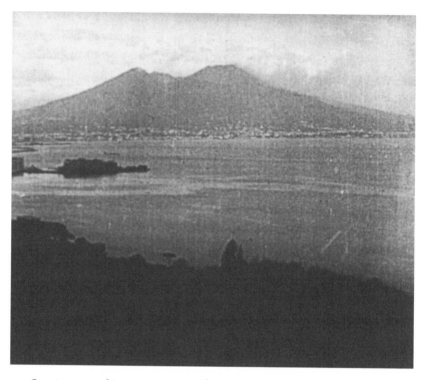

7.7. Opening scene of *Santa Lucia Luntana* (Memories of Naples, Cinema Productions, 1931): the Gulf of Naples and the smoking Vesuvius. Used by permission of the George Eastman House/Film Department (Rochester, N.Y.).

children, Elena (Italian) and Elsie and Mickey (English), epitomize different stances in the relationship between Italian and American culture. From the start, Elena's loyalty to the homeland is a sign of her personal authenticity and moral probity, whereas Elsie and Mickey are almost predestined to loss and corruption.

Santa Lucia Luntana has two beginnings. After a freeze-frame of the Gulf of Naples, over which the titles roll, jazz music introduces a series of avant-garde-ish matte and gyroscopic shots of New York. Then the melodic sound of the title song accompanies long shots of the classic view of Naples and the smoking Vesuvius (fig. 7.7). A series of oleographic postcard-like shots of the setting sun, busy fishermen, an incoming ocean liner, and a local square crowded with fruit and fish carts signal the return of the traditional picturesque. In the fictional universe of the film, Naples, at least in the beginning, is an imaginary place that the film visu-

alizes according to universally familiar postcard imagery. Whether this footage was shot on location or edited from the documentary material that abounded in New York, the iconic image of Vesuvius and the bay instantly reconnects a story of Italian immigrants in New York to their symbolic origin and activates the film's touching nostalgia. The question is whether and how one can really go back "home" to such a picturesque "primary scene."[119]

The film's story begins in the apartment of Don Ciccio, in the Italian quarter, on the occasion of the engagement of one of his daughters, Elsie, to an American man ominously named Mr. Gravesend. Shamelessly exchanging far too much physical affection, the couple is juxtaposed to the virtuous and restrained Elena, Don Ciccio's favorite daughter, and her Neapolitan boyfriend, Mario. A wholesome immigrant fellow played by Carlo Renard, Mario speaks only Neapolitan, wishes to marry Elena, and talks continually of returning to Naples. Enter Mickey, the only son. A gambler, eternally unemployed, and linked to criminal circles, Mickey shows no qualms about publicly insulting his father. He does so in English ("Shut up, old man!"), which is apparently the only language he speaks.

In addition to linguistic preferences, the film uses honest employment as an indicator of morality. Unsurprisingly, of all the family members, only Elsie and Mickey, who are constantly strapped for cash, lack an honest occupation. When Don Ciccio discovers that Mickey has tried to steal his life savings, his humiliation is so intense that he decides to join Elena and Mario and return to Naples to seek what he interestingly calls "a new life." Within hours they are ready to leave. With Elsie married and Mickey having vanished for one of his shady deals, Don Ciccio leaves behind only one thing: a portrait of his adored and long-deceased wife. He does so for his son, "if he comes back." As Don Ciccio, Elena, and Mario embark on a ship, surrounded by a very Southernist atmosphere of Italian flags and Neapolitan singing ("'O sole mio"), Mickey returns home only to find it surprisingly empty. After staring at his mother's portrait, he utters his first Italian word in the film, *mamma*. Then he starts whistling "'O sole mio" before dropping his father's money and sobbing in solitude.

Fast forward five years. Don Ciccio, his daughter, and his grandson live happily in a luxurious neoclassical home in Naples. One day, local

melodies audible in the background, they receive a letter from New York. For the first time, Mickey is returning to Naples, while one of his lavish remittances is preceding him. Once back, Mickey kneels down before his father in a very moving family tableau and asks, in Italian, for forgiveness of his past sins. When Don Ciccio asks him about the lavish remittances, Mickey repeats verbatim his father's proverbial expression, according to which the secret of success is simply hard work, determination, and sacrifice. As the family is finally reunited, physically and linguistically, in the place of its origin, Mario and his sister begin singing the title song, "Santa Lucia Luntana."

Built on much more than a mere geographic and ideological juxtaposition of New York and Naples, the film is a manifesto of diasporic poetics. In it (but not in the real Italy), Italian and the vernacular language are somewhat interchangeable. The discussions in America about returning to the beloved Naples, the family conversations in Naples, and Mickey's own confession are all in Italian. It is a linguistic strategy that recalls, by simple opposition, Migliaccio's skits: here it is the national language that is used to celebrate a local origin, as opposed to using Neapolitan to express national belonging. Equally important is that, although at first American culture and the English language appear to indicate moral corruption, they are not demonized as intrinsically negative. Mickey will *always* have an English, rather than an Italian, name, and yet that does not simply condemn him. Most importantly, the American experience significantly affects all characters according to a sort of Hegelian dialectic: opposition produces not only enriching synthesis, but also new starting points. It is, after all, the American experience that positions Naples, the place of origin, as both spatially and culturally far away (*luntana*), thus instituting the nostalgic mode of the film. It is also the American experience that urges and shapes the desire for an ever more comfortable life. The film is very vocal and precise about the astonishing amount of money that Mickey saves through honest, backbreaking work, and the correlation between fatigue and compensation is exposed as very American. The emotional and financial regime of the family, in other words, is linked to the American exile, which is the carrier of an intrinsically unstable and diasporic identity, but which is also financially rewarding. Not despite but because of intense homesickness, the original oceanic migration turns out to be an irreversible event. Since it is not

possible to ignore the American experience, it is impossible to return to Naples as if it were an original state of innocence. What remains is a nostalgic impulse that is by definition utopian, without a specific place as its final destination. The picturesque image of the Neapolitan bay and Vesuvius that opened the film was thus the image not of a real origin, but of an imaginary one, activated by a diasporic impetus that cannot easily be turned off. That is why, even once most family members are finally reunited back in Naples, they still cling to the old nostalgic motifs of "Santa Lucia Luntana."

What these films reveal is that cinema did not widen the gap between Italian immigrants' older, vernacular culture and identity and their modern settlement. Moving pictures were not always blatant agents of Americanization, as a long-held stance has contended. Southern Italian immigrants' exposure to Italian historical epics, American films about Italians, and Neapolitan films, and, most importantly, their spectatorial experience within the vernacular venues of *cafés-chantants* and theatres, modernized, rather than mortified, the sources and the expressive means of their Southernist identity. Informed by the literary, theatrical, and iconographic tradition of the picturesque, the encounter of Southernism and moving pictures contributed to a very modern process of self-definition and self-representation that we may describe as diasporic.

What *Santa Lucia Luntana* and Migliaccio's stage and film poetics tell us is that the collective and modern space of immigrants' film spectatorship was not experienced as in opposition to American culture and society, as well as Italian national symbols and identity. Filmed Neapolitanness (or Southernness in general) did not necessarily signify regional seclusion and localist autarchy. As a carrier of a distant but familiar popular culture, cinema allowed an active form of collective experience, which was itself a form of cultural authorship, expression, and performance. In America, these manifestations informed the dialogic stance of Southern Italians within the cultural hegemonies of both Americanness and Italianness. In the end, moviegoing and theatregoing enhanced an adaptation to pressing ascriptions of vernacular and national identity and leisure-time habits, rather than a mere assimilation into the American way of life.

The call of the picturesque did not fade once Mussolini, who was widely respected in U.S. politics and media, took office in 1922, enabling

forms of proud national compensation, rather than mere political and ideological conviction, in the multinational American crucible.[120] The radio broadcasts of Fascist songs and slogans in New York did not necessarily eradicate the popular broadcasts of Neapolitan songs, vernacular sketches and dramas, and other expressions of regional culture. As late as 1934, in the midst of what was still a U.S.-sanctioned enthrallment with Fascist nationalism, Duilio Marazzi, a distributor of Italian films in America, emphasized the stubborn preferences of Italian immigrants for stories of brigandage and dark, sentimental dramas. Discussing Italian cinema in America, Marazzi recounted his utter failure to understand the film preferences of Southern Italians living in New York.[121] While the Italian sound films he was distributing were unsuccessful, he said, huge lines of immigrants would wait, even in the rain, to watch a silent film about the famous Calabrese brigand Musolino. Marazzi does not mention the title of the film in question, although one could hypothesize that it was *Le geste del brigante Musolino* (The Life of Giuseppe Musolino, the Famous Italian Bandit, a.k.a. Musolino, the Famous Italian Bandit), a film apparently produced by an unknown company, Regina & Co., between 1924 and 1927, whose rerelease in a sound version in the early 1930s sparked deep controversy.[122] What he does mention, however, is the immigrants' enthusiasm for the film. Asked about the story of Musolino, an audience member replied to him in Neapolitan, "Musolino was not a brigand, he was a man who commanded respect, and if all men were to behave like he did, there would not be so many shameful adversities all over the world."[123]

The resilience of Southernist imagery also informed Southern Italians' affinity with other marginal and comparatively "primitive" subjects. In the late nineteenth century an anonymous Sicilian stage performer and puppeteer—possibly Angelo Grasso, Giovanni Grasso's father—projected the dissonance of his plebeian Sicilian dialect onto the American context and conjectured that "[American] Indians, being primitive, must speak dialect."[124] Many decades later, an Italian American novelist, Tony Ardizzone, known for his use of memoirs, family recollections, and historical sources, captured this extension of local identity in an extraordinarily apropos passage from his 1999 work *In the Garden of Papa Santuzzu*. Two Sicilian friends, immigrants to America, recount and elaborate on their first experience of film. After months of solitude and

nostalgia, one found himself watching "the most Sicilian thing . . . in *La Merica:* a cowboy movie!" The first man exclaims that the hills shown on screen are "just like the ones back in Girgenti, a forest where the outlaws could hide, and in the valley below fields pocked with rocks—hardly good for farming." The village square, too, he insists, is identical to the Sicilian ones he knew so well, "filled with poor people terrified of the crooked *gabbillotu* sheriff and his gang." At which point, he wonders, "But how come they don't speak Sicilian?"

> "Because of the *Americani*," my friend said with a nod. He was no greenhorn, fresh off the boat, like me. He was a fox, able to make sense of even the most foreign of things. "See," he whispered, "if they spoke with their Sicilian tongues, how could these *Americani* all around us understand?"[125]

Rather than creating an insurmountable chasm between Southern Italians and their vernacular identity, cinema actually nourished the latter, as one of Ardizzone's fictional characters would have it. The story of how the picturesque further crystallized in Italian American culture in the following decades, from the emblematic backdrop of *The Godfather Part II* to wall decorations of the Vesuvius restaurant in *The Sopranos*, could be the subject of another book. What remains to be understood, particularly from a methodological standpoint, is how a racially charged painterly style informed the vocabulary of still and moving photographic media. Perhaps the classic argument insisting on the radical semiotic novelty of photography and moving pictures, because of their unprecedented capacity to entertain an indexical relationship with the outside world, needs to be reassessed. In the conclusions of this study I shall begin to open up this avenue of discussion.

AFTERWORD

"A Mirror with a Memory"

Any viable history of photography has to be part of a history of picturemaking, and any viable history of picturemaking must include photography.

CARL CHIARENZA, 1979

The photograph has completed the triumph, by making a sheet of paper reflect images like a mirror and hold them as a picture . . . a mirror with a memory.

OLIVER WENDELL HOLMES, 1859

In *Italy in Early American Cinema* I have advanced a three-part argument. First, I have underscored the racial significance of picturesque representations, despite their original association with distant landscapes and not with people. Second, I have demonstrated how, despite its origin as a painterly style, the picturesque aesthetic preserved and expanded its racial import across a variety of visual media, from printed illustrations to motion pictures. Third, I have shown how, despite its original European, and specifically Southern Italian, imprint, the picturesque traveled across the Atlantic and offered American cinema a familiar design with which to sort through, domesticate, and romanticize the American natural and social wilderness generally and the puzzling diversity of New York City in particular. In brief, notwithstanding its wide range of evi-

dentiary sources, *Italy in Early American Cinema* argues that the power-laden aesthetics of the picturesque crossed historical periods and geographic distances, moved from the canvas to the photographic plate and the movie screen, and, consequently, served as a long-lasting resource for both racial allegations and identity formations. More work ought certainly to be done in this direction to verify, articulate, and broaden the validity of this racially based intermedial hypothesis. For instance, one could examine broader samples of films, photographs, and other visual materials, particularly with regard to racial groups I have not systematically discussed, such as Slavs, Latinos, Asians, and African Americans. One could also pair picturesque characterizations with another major vector of racial identification: physiognomy. If picturesque representations, in fact, kept figures in the middle ground or background, physiognomy brought them most forcibly to the foreground, into an extreme and most expressive "close-up." Since the seventeenth century physiognomic illustrations and classifications, as a combination of artistic and scientific practices, had provided racially charged templates of typological characterization for artists and writers, as well as for viewers and readers. Their influence on photographic portraiture is well known. Less discussed is their relevance to acting styles in cinematic representations.[1]

Here, however, I would like to advance some methodological reflections stemming from this study. The fact that the picturesque did not wane with the inception of still or motion photography is significant because it challenges the conventional assumption that photography's mechanical reproducibility and indexical relationship with the outside world were unique. How could a stylized pictorial style, deployed to draw racial meaning out of exotic sites, affect a medium whose mechanically reproduced representations are isomorphic to the reality they capture? The fact that such intermedial influence actually occurred urges a reconsideration of the way we approach photographic (and cinematic) reproductions. My interest here is not in discussing the ontology or the phenomenological nature of the still and moving image in general. Noël Carroll has proficiently attended to this task by deconstructing and challenging all the major arguments supporting films' medium-specificity.[2] Instead, I wish to examine the critical significance for racial representations of the aesthetic and ideological investments associated with photographic indexicality and reproducibility, which are often used to

identify the modernity of photographic reproduction. While the associa-tion of photographic reproduction with modernity has been quite heu-ristic for early cinema studies, its critical force has relied on problematic assumptions.[3]

VIEWFINDERS AND BLIND SPOTS

The Italian city, ancient or modern, is prodigiously photogenic.

ANDRÉ BAZIN, 1948

A whole history remains to be written of *spaces*—which would at the same time be the history of *powers* . . . from the great strategies of geopolitics to the little tactics of the habitat.

MICHEL FOUCAULT, 1977

A main thrust of the Benjaminian "modernist" argument is its emphasis on the photographic media's mechanical reproducibility, in contrast to the auratic ontology of original artistic works and experiences. As Wal-ter Benjamin himself admitted, however, reproducibility did not begin with photography and cinema. "In principle," he wrote at the begin-ning of his most famous essay, "a work of art has always been reproduc-ible."[4] Reproducibility, in fact, started centuries before photography with printed pictures, pictorial images that, reproduced by various methods (woodcuts, relief metal cuts, engraved and etched copper plates, and lithography), could be multiplied, since, in Antony Griffiths's words, "an essential feature of prints is their multiplication."[5] Still, Benjamin insisted that although "lithography enabled graphic art to illustrate ev-eryday life, and it began to keep pace with printing," photography was a different process altogether. "For the first time in *the process of pictorial reproduction*," he argued, "photography freed the hand of the most im-portant artistic functions which henceforth devolved only upon the eye looking into a lens."[6] The familiarity of this claim should not prevent us from fruitfully questioning whether pictorial and photographic means of reproduction are to be associated with utterly different practices of visual representation and consumption. Beyond issues of artistry, in fact, the massive historical effects of visual reproduction (of which cinema could

be hailed as one, extraordinarily popular, manifestation) call for an appreciation of long-term continuities.

In his classic *Prints and Visual Communication* (1953), art scholar William Ivins has looked with great lucidity at the history of image-making (including both photography and motion pictures) as a series of practices "by which exactly repeatable pictorial statements can be made about anything."[7] His still powerful argument stresses that looking at printed pictures means looking less at artistic merit or semiotic make-up, and more at the communication of visual information and ideas:

> Until a century ago, prints made in the old techniques filled all the functions that are now filled by our line cuts and halftones, by our photographs and blueprints, by our various color processes, and by our political cartoons and pictorial advertisements. If we define prints from the functional point of view so indicated, rather than by any restriction of process or aesthetic value, it becomes obvious that without prints we should have very few of our modern sciences, technologies, archaeologies, or ethnologies—for all of these are dependent, first or last, upon information conveyed by exactly repeatable visual or pictorial statements.[8]

By reproducing pictorial statements with a high degree of exactitude, these practices created unique opportunities to illustrate and popularize: they circumvented the need for direct acquaintance and enhanced scientific, technological, artistic, and general knowledge in fields as wide-ranging as botany and manufacturing, art history and anthropology. Decades before photography and motion pictures, the practice of image reproduction instituted complex intermediary processes and implied a division of labor that complemented or replaced individual artistic creation, and soon became commercially available to the growing markets and audiences linked to art connoisseurship, tourism, and popular entertainment.

The lasting formal and ideological legacy of picturesque representations among pictorial and photographic media may prompt us to think of cinema not just as an exceptional medium, gifted with a unique capacity to reproduce movement photographically, but also as a *particular form of printed image*, obtained through a photo-mechanical process of reproduction.[9] What *Italy in Early American Cinema* seeks to avoid is both the familiar emphasis on the allegedly radical discontinuities created by motion pictures' inception and the equally problematic notion

of a sanitized and uneventful continuity between the film medium (or media) and other visual domains of experience, either preceding or simultaneous with its appearance. While still relying on the conventional expression "early cinema," this study has sought to identify a continuity of aesthetic forms, geopolitically and racially charged, by looking at how Western representational media, preceding and contemporary with the inception of motion pictures, have first formalized the representation of Italian landscapes as distinct places, and then turned such specific representations into general, "natural," and entertaining sights of geographic and racial difference. Rather than arguing that a cinematic mode of representation originated earlier than has been thought, I have sought to stress the influential mechanisms and the continuity of older and highly politicized modalities of racial characterization and narrativization that motion pictures both absorbed and reworked. This, of course, raises a fundamental methodological question. How could films employ such prephotographic visual codes if what defines motion pictures' alleged expressive novelty is their photographic indexicality?

The modernist emphasis on cinema's formal distinction from earlier forms of representation rests upon the notion of photographic reproductions' unprecedented mimetic correspondence to their material referent. Generally, the newness of photographic indexicality has been articulated as a degree zero of semiosis that expunges any diachronic influence. The inclination to distinguish cinema from other media on the basis of technological form has turned the representation of racial difference into an accidental phenomenon. Certainly, scholars of early cinema have always considered racial representations significant. Yet they have generally approached such representations as contingent, rather than constituent of the very form of cinematic representation. Racial representations, the argument implicitly goes, do not fundamentally contribute to the morphological alignment of early cinema with modernity. In *Italy in Early American Cinema* I have sought to demonstrate that early motion pictures maintained lasting relationships with preexisting visual forms. These relationships existed in alignment with a continuity of ideologies of national and racial difference that the novelty of the photographic form, both still and moving, did not obliterate.

The indexicality claim has a long history. When photography entered the Western cultural scene, as is well known, the negative and positive

reactions to it were widespread and intense. Arguably Baudelaire voiced the most famous response to photography, which he described as an artificial, mechanized, and alienating process of image reproduction—in sum, "art's most mortal enemy."[10] By contrast, photographers like Nadar campaigned for the medium's artistic merits and multiple uses. Likewise, scientists generally found photography "equally useful in all the sciences of observation, where visible forms are to be represented."[11] Despite their differences of approach and judgment, these positions agreed that photography maintained a very close relationship with the material world it depicted—one of unprecedented resemblance. That no human hand seemed to play a role in the process of image reproduction was interpreted as a sign of the image's objective and thus accurate rendering of the exterior world. Even such "purist" movements as "straight" photography accepted the notion of photography's iconic truthfulness in their effort to grant the new medium full status as art.[12]

Twentieth-century visual theorists have variously endorsed this fundamental claim by negatively and teleologically juxtaposing photography and films to earlier media of visual representation.[13] "As compared to paintings," wrote Walter Benjamin in 1937, "filmed behavior lends itself more readily to analysis because of its incomparably more precise statements of the situation." Seven years later, in a rhetorical turn of phrase, André Bazin even claimed that "the photographic image is the object itself." In 1947, in the definitive version of an essay that first appeared in 1934, Erwin Panofsky held a similar position: "the medium of the movies is physical reality as such."[14] Throughout the 1960s and 1970s, both older and younger generations of film scholars never fundamentally challenged the core of this argument. In 1960, Siegfried Kracauer advanced a position already voiced in the 1920s by positing that film is "an extension of photography: and as such shares with this medium a marked affinity with the visible world around us." In 1968, the founding father of film semiotics, Christian Metz, famously defined cinema as "the 'phenomenological' art *par excellence.*" In the same period, Stanley Cavell insisted that "photography overcame subjectivity in a way undreamed of by painting . . . by *automatism,* by removing the human agent from the task of reproduction," with the result that photography is "*of* the world" whereas painting "*is* a world." Similarly, in the first issue of *Critical Inquiry* (1974), Rudolph Arnheim repeated the arguments put forward in

his 1932 classic, *Film as Art,* by attributing to photographs an "authenticity from which painting is barred by birth." In his book-length essay *Camera Lucida* (1980), Roland Barthes seemingly applied the Bazinian argument to photography by stressing its "evidential force" and arguing that its "power of authentication exceeds [its] power of representation."[15]

The question is not one of methodological naïveté, but of balance. I concur with Miriam Hansen's historical contextualization of Kracauer's "photographic approach" to films, which, she argues, did not imply "a transparent, iconically motivated relation between sign and referent."[16] What remains cogent, however, to return to Barthes' expression, is the "evidential force" that photographic reproductions have historically secured. Over time the "transparency fallacy" (or its temptation, however justified) has prompted both a general acceptance of still and moving pictures' realistic charge and, by reaction, the detection of their poetic constructedness.[17] Both this realistic investment and the related emphasis on images' non-transparent qualities have ended up naturalizing racial differences, whether for aesthetic, scientific, or political purposes. They have also exerted a profound methodological influence on how the historiography of early cinema has dealt with race in addressing cinema's technological inception, its relationship with other media, and the historical circumstances of its emergence.

The positions insisting on early cinema's photographic referencing and seeing it as the ultimate expression of modernity show a common epistemological penchant: a repeated (and quite heuristic, admittedly) use of the tropes of time and history at the expense of space and geography.[18] Specifically, what links the representational framework and the privileging of temporal tropes is the implicit argument that photographic objectivity holds a "singular, existential import," as Noël Carroll puts it, "because it is produced from *something that existed* which caused it to be." "Photography," as Bazin famously stated, "embalms time[, and] viewed in this perspective, the cinema is objectivity in time."[19] This emphasis on temporality has a long history, especially in the German cultural criticism that is so central to current formulations of modernity. Kracauer and Benjamin were particularly sensitive to the simultaneous emergence of photographic technology and historicist thinking. While engaged in a polemical dialogue with the work of Wilhelm Dilthey in 1927, Kracauer wrote that if "photography presents a spatial continuum[,] historicism

seeks to provide the temporal continuum. . . . Historicism is concerned with the photography of time."[20] Later, in the posthumously published *History: The Last Things before the Last* (1969), he envisioned a powerful equivalence between cinema and the writing of history by advancing for films a role (*telos*) modeled on a distinct historiographical method. Suspicious of large, synoptic overviews and of the conceptual tenability of a single notion of chronology, Kracauer spoke of a microhistorical approach that, like a series of penetrating close-ups ("time atoms"), could render the world painstakingly and objectively.[21]

On a broader level, the stress on temporality reveals a general disavowal of spatial and geopolitical considerations shared by both German philosophy and its criticism. Recent illuminating critiques of modern German thought (e.g., that of Hegel, Marx, Nietzsche, Freud, Heidegger, and Adorno), while emphasizing its influence on postcolonial studies, have noted that "postcolonial theories have not subjected their German theoretical antecedents to the same sorts of criticism directed at most European cultural texts."[22] To many scholars, an examination of Germany's colonial past (1884 to World War I) and its effects on the nation's political and philosophical culture has seemed less cogent than an inquiry into the totalitarian culture that led to Nazism. The result has been remarkable. Several appalling racial theories that the German state embraced after 1933 had in fact emerged in Germany (and Europe in general, as well as the U.S.) between the late nineteenth century and the early twentieth century. The effect of imperialism and colonialism on Western philosophical thought is not elided only in the German case. The widespread adoption of slavery as a metaphor for feudal and legal tyranny among earlier, classical Western political writers and figures (including Locke, Montesquieu, Rousseau, and Thomas Jefferson) rarely addressed the imbrications between their countries' economic progress, domestically and abroad, and the real-life enslavement of colonized and yet highly romanticized non-Western peoples.[23] Yet the rhetorical appropriation of slavery and imperialism and their abstractions into philosophical themes at the expense of their historical consideration has been particularly influential in German thought. In a brilliantly polemical essay, Susan Buck-Morss has illustrated the contours of this widespread intellectual removal by arguing that Hegel's theorization of the dialectics of lordship and bondage was inherently linked to the widespread news

of the successful slave revolt in Haiti.[24] Not many years before, in a brief passage that fell just short of a racial critique, Buck-Morss had also begun a geopolitical reading of Benjamin's critical method with regard to his essay on Naples (1926). In the chaotic, decadent, and theatrical Mediterranean city, she writes, as well as in the archeological ruins throughout Italy, Benjamin saw evidence of the notions of historical transiency and touristically appealing backwardness that would be central to his *Arcades Project*.[25]

The central role of German criticism in contemporary formulations of modernity within cinema studies and cultural studies has carried over the same penchant for concern with temporality, its compressions, and its manipulations. Since "modernity is about the experience of progress through modernization," as Marxist geographer David Harvey eloquently summed it up, "writings on that theme have tended to emphasize temporality, the process of *becoming*, rather than *being* in space and place."[26] For instance, Stephen Kern's oft-cited *The Culture of Time and Space* (1983) treats space mainly in terms of the dynamic breakdown of such categories as "extension," "depth," "form," and "distance."[27] In truth, writings by historians and critical theorists on culture and space are not rare and have their own history.[28] Spatial hermeneutics, for instance, encompasses the works of Gaston Bachelard, Henri Lefebvre, Fredric Jameson, Michel de Certeau, Harvey himself, and even a few short essays by Michel Foucault.[29] Their contributions have also been quite significant. While debating differences and alignments between ideas of space and place, these authors have variously recognized the social, political, and rhetorical significance of geography's material and metaphorical hues. Literary criticism has taken advantage of, and furthered, these Braudelian insights, both within Western contexts (e.g., the work of Kristin Ross and Franco Moretti)[30] and outside of them. Postcolonial criticism, for instance, has made the "struggle over geography," to quote Edward Said's celebrated expression, a central theoretical vector.[31] Spatial and geographic concerns are at the critical center of urban studies, whose dialogue with cinema studies in general, developed in numerous examinations of the visual and narrative exchanges between cinema and the city, is evident.[32] The historiography of early cinema, however, has not been particularly receptive to questions of space and geography. For instance, early film scholarship has had a limited dialogue with the criti-

cism of landscape aesthetics, a scholarly domain that, informed by the British tradition of geography and cultural studies, has looked at poetry, travel literature, painting, and even landscape gardening. Its major exponents, including John Barrell, Denis E. Cosgrove, Stephen Daniels, and Ann Bermingham, have profitably explored the relationships between sociopolitical powers and spatial iconography, and they have done so by focusing on historical periods that precede the conventional time frame of modernity—or, at least, of cinema studies' traditional understanding of it.[33] Their work on the political aestheticization of spaces, places, and geography occurring worldwide in the last three centuries has exerted a notable influence on studies of picturesque aesthetics (such as those by Malcolm Andrews and Sidney K. Robinson).[34] Yet they have only rarely informed the study of the aesthetic relationships between such modern media as photography and film and the transatlantic circulation of people, artworks, and visual forms—pertaining, for instance, to racial and national characterizations.[35]

One major obstacle has been the methodological divide separating media based on mechanical reproduction from those based on manual skills, such as painting, etching, and drawing. This separation, as we have seen, has informed the familiar alignment of photography and early cinema with modernity and has determined what I would refer to as a "geopolitical blind spot." The sustained relationship between the photographic form, temporality, and modernity (itself a temporal or historical category), in fact, has veiled the "new" medium's complicity with space and geography, with notions of geopolitical difference and their nationally and racially specific articulations. When generally addressing such issues as "cinematic form" and "spectator," for instance, "modernist" theorizations of early cinema have tended to elide considerations of geographical distinctions between (and within) European and American contexts. Thus they repeat a recurring feature of Weimar critical culture, which frequently allegorized "America" and "Paris" as different moments of modernity—not as actual places with specific, sociohistorically defined visual cultures and audiences.[36]

Such close linkage between photographic form, temporality, and modernity, I would contend, ought to be looked at more closely both for its own sake and because it pervades a recent set of theoretical positions within early cinema studies whose detractors have called the "moder-

nity thesis." Indebted to the theories and practices of Western artistic modernism, particularly the avant-garde, and the philosophical perspectives of the Frankfurt School, the modernity thesis rethinks, in one of its defenders' words, "cinema's emergence within the sensory environment of urban modernity, its relationship to late nineteenth-century technologies of space and time, and its interactions with adjacent elements in the new visual culture of advanced capitalism."[37] The scholars most explicitly aligned with the "thesis," including Tom Gunning, Miriam Hansen, Anne Friedberg, Ben Singer, and Lynne Kirby, have theorized not only on film language and representation, but also on film spectatorship and cultural consumption.[38] Recurring in their work is an emphasis on the technological, semiotic, sensorial and experiential novelty of the cinematic medium. Cinema's novelty is regularly spelled out in conjunction with the productive and influential notion of the *attraction,* which then defines an earlier phase of filmmaking known as the *cinema of attractions.* Theorized since the mid-1980s by Tom Gunning (in partial collaboration with André Gaudreault), the attraction identifies a particular form of film practice and address, an act of pure and astonishing display, experienced "less as a way of telling stories than as a way of presenting a series of views to an audience, fascinating because of their illusory power . . . and exoticism."[39] In his search for a historiographical space that accounted for cinema's non-narrative dimension, Gunning drew the concept of the attraction from the writings of Sergei Eisenstein (and F. T. Marinetti), where it referred not to motion pictures exclusively, but to a striking spectacle in general, whether a circus performance, a stage routine, or a cinematic show—or to such a spectacle's most outstanding moment. For Gunning, however, the attraction mainly identifies early cinema's capacity to *"mak[e] images seen,"* a capacity that is "best understood if a purpose other than storytelling is factored in."[40]

The emphasis on the illusionary nature of early motion pictures, whether realistic or magical, whether linked to an exotic "view" aesthetic or a locally staged re-creation, hinges on the technological means of representation—that is, on photography. Gunning is explicit about this in a number of his essays. Many forms of entertainment could constitute and function as attractions—public ceremonies, staged scenes, and vaudeville or circus routines. Yet "all such events were absorbed by a cinematic gesture of presentation, and it was this technological means of

representation that constituted the initial fascination of cinema."[41] In asserting the "extremely individualizing processes of photography"[42] in the name of "photography's unique bond with its referent . . . its indexicality," Gunning explicitly uses the language of the work of Charles Sanders Peirce. He thus identifies photography's *indexical aspect* (because of "its exposure to a preexisting entity, it directly bears the entity's imprint") and its *iconic aspect* ("it produces a direct resemblance to its object which allows immediate recognition").[43] In Carroll's words: "Once the relation between the image—the photograph or the cinematic shot—[and its referent] is thought of as some sort of identity relation, the ruling idea of representation becomes *re*-presentation, i.e., the image is thought to *present again* some object or event."[44] No genre, in Gunning's wide-ranging and always remarkable writings, is ultimately exempt. If *actualités* explicitly exhibit the capacity "to capture a view of something that maintains a large degree of independence from the act of filming," Gunning writes,[45] Georges Méliès's trick films are astonishing precisely because of the way they dislodge the "identity relation" between a referent and its images ("appearance, disappearance, transformation and reappearance").[46]

Because of early films' distinct form of optical rendering and vibrant visual rhythm, the attraction enjoys a morphological affinity with the experiential regime and kinesthetic thrills of modern time. "As a major form of mass entertainment employing technological representation and narrative," Gunning recently reasserted, "[early cinema] always engaged the experience of modernity."[47] "Not just one among a number of perceptual technologies," Miriam Hansen earlier contended, cinema "was above all . . . the single most expansive discursive horizon in which the effects of modernity were reflected, rejected or denied, transmuted or negotiated."[48] A certain air of positivist and thus teleological euphoria for the medium suffuses the modernity thesis in its implicit avowal of cinema's semiotic and cultural exceptionalism. When viewed from the standpoint of racial and national representations, this avowal appears problematic. To understand how films were experienced at the time of their first viewing is one thing; it is another to understand how they operated, semiotically and ideologically. In other words, one may acknowledge the degree of realism that filmic attractions held as "windows on the world" in an epoch of wide-ranging realist poetics, without discounting, even implicitly, their semiotic and thus ideological constructedness.[49]

The general problem with the "modernity argument" lies in two debatable premises. The first one is twofold. It holds that, because of their reproductive technology, films' photographic representations fundamentally signify on the basis of an "identity relation" with their referent, and that such an "identity relation" is new. The second premise relies on a stark juxtaposition of form and content, and unsurprisingly privileges the former. It is clearly indebted to a modernist rhetoric that admittedly infuses Gunning's prose and conceptualization. Form, it is implied, is what aesthetically defines a medium's mode of signification and what enables the alleged isomorphism of cinema and modernity. If certain films foreground the modern technology of trains, telephones, and telegraphs, they simply showcase an isomorphism that is always already there and in no need of overdetermination. It follows that, not being form, race (just like gender, class, and sexuality) is simply content or subject matter, and thus "secondary" to any analysis of early films' cinematic signification.[50] This reasoning, of course, conceals the possibility that racial depictions result from a history of formal characterizations that preceded and informed photographic representations. The mirror, as Oliver Wendell Holmes noted, came with a memory.

Two interrelated objections, semiotic and ontological, can be presented to the first "realist" premise (claiming an "identify relation" between referent and representation, and hailing it as new). In 1975, Joel Snyder and Neil Walsh Allen invalidated a range of arguments supporting photographic transparency by critiquing any equation of human perception with the photographic process of optical capture and reproduction. As complex semiotic machines, they contended, photographs make use of determinants that can be easily manipulated and which are never "innocent": framing, mise-en-scène, lighting, multiple exposures, and so forth.[51] From an ontological standpoint, as Kendall Walton and Richard Allen have more recently suggested, the fact that the process of image-making is mechanical and we are in the habit of "seeing reality through" photographs does not imply that the camera has access to an authentically existing world; it could very well reproduce an illusion.[52] Or, we may add, it could reproduce a reality that is already visually and thus ideologically coded—nationally and racially. A photograph or a film of a man in blackface is possibly the most obvious example. Overall, the acknowledgment of the rhetorical charge of the realist attribution and its ideological under-

pinnings opens questions that are both aesthetic and political, related to the formal, material, and social investments in cinema's mass appeal.

Furthermore, if we fully acknowledge the "productive" (and not just mimetic) dimension of the image-making process, we may also question the claim that early films relied on a novel form of representation. The method with which this claim is refuted has a recent name, intermediality, but it identifies an older historiographical practice. The relationships between early films and other media of visual reproduction and staging (e.g., paintings, magic lanterns, lithography, photography, theatre, pyrodramas) account for some of the richest traditions in early cinema history.[53] Without denying cinema's distinct social, economic, and cultural history, an intermedial approach would not identify a single aesthetic feature—the attraction or montage—as the fundamental trait of film's semiotic expression. Instead, it would argue that not only did cinema, from the beginning, adopt visual and narrative formats from other media, but its current compression into a single word elides a historical variety of filmmaking practices. The diversity and plurality of film genres (such as *actualités* as "visual newspapers," travelogues as a vicarious form of tourism, film dramas as "photoplays"), further complicated by national film cultures, are the most obvious indicators of a range of production and reception practices that should alert us to the inherent multiplicity of cinema's aesthetic constituents.[54]

With regard to representations of national and racial differences, the notion of intermediality ought also to apply to photography's multimedia referencing. It would thus question the emphasis on photography's indexical primacy. "Photography," as Peter Galassi has pointed out, "was not a bastard left by science on the doorstep of art, but a legitimate child of the Western pictorial tradition."[55] This reasoning challenges the second premise of the modernity thesis, the strict dichotomy of form versus content. This study has brought various forms of evidence to support this challenge. For example, the one-shot films of Neapolitans eating spaghetti with their bare hands have revealed a formal reliance on similar painterly and lithographic conventions, which were well known to motion picture producers and consumers. Likewise, the study of early film narratives about bandits and brigands has exposed their reworking of nationally and racially "othered" character types circulating in high- and lowbrow literature, vernacular and legitimate theatre, and popular

amusements and featured in the rationalizing narratives of eugenics and anthropology. Against *a posteriori* hypostatizations of early cinema as "cinema," as the holder of a "singular media identity," André Gaudreault and Philippe Marion's conceptual insights into cinema's appearance, emergence, and constitution as a medium are methodologically critical. According to the principle that "it is through intermediality . . . that a medium is understood," Gaudreault and Marion teach us not to conflate the technological novelty of motion pictures with their significance. Early cinema was "a new way of presenting already well-established entertainment 'genres': magic and fairy shows, farce, plays and other kinds of stage performance."[56] In other words, films' unprecedented popularity and their exceptional broadcasting of images of distant lands, eras, and populations hardly implies that the cinematic rendering was fundamentally new in its racial and ideological signification. Rather than insisting on the shock of the new, cinema's inception demands an analysis of continuities, "because representation is always representation of representation," as Rick Altman eloquently argued in his study on silent film sound before concluding that "the only way to understand a new technology is to grasp the methods it employs to convince its users it is no different from its predecessors."[57]

The photographic reproduction of movement embodied in filmic attractions and the development of filmic editing techniques that generated ever more complex narratives were certainly innovative "linguistic" forms. Also, the popular consumption of film images of remote lands, eras, and populations was unprecedented for turn-of-the-century audiences worldwide. Yet the novelty of photographic rendering was not a degree zero mirroring. The euphoria that hails photography and cinema as autonomous media should be read both critically and historically. As a porous adoption and original reworking of a number of past representational forms (painterly, optical, theatrical), photographic reproductions did not wholly replace previous forms of racial and national representation, including picturesque characterizations, just as they did not evade their well-established and much needed ideological function. Instead, photography naturalized past representational forms as timeless, realistic, and even photogenic according to a vaunted aesthetic autonomy that, as we have seen with Gilpin, Price, and Knight, was always already there.[58] "Initial emphasis on the realism and truthfulness of photog-

raphy," as Joan M. Schwartz and James R. Ryan argue, "effectively . . . veiled the power of photography to mediate the human encounter with people and places."[59] Photographic images' rhetoric of iconic accuracy pervaded illustrated periodicals and tourist guidebooks, the ubiquitous picture postcard, newspaper reporting, catalogs of local folklore, criminal portraiture, and motion pictures. Within a positivist framework, "geographical imagination," as David Harvey has shown, imposed itself "with the full force of objective facts, to which all individuals and institutions necessarily respond."[60]

When Bazin writes that "photography embalms time"[61] and when Benjamin aligns cinema with the necessary acceleration of the new, what gets veiled is the "new" medium's complicity with consolidated and widely circulating notions of social and national space. In modernist terms, "Paris," "Berlin," "Naples," and "America" appear as temporal stages of larger historical and universal trajectories, within an idea of modernity based on universally defined perceptual and phenomenological categories, and heavily indebted to the formalist artistic poetics of the early twentieth-century avant-garde.

There has been much to gain, admittedly, in adopting the modernist framework, which has allowed a better understanding of the dense linkages between technology, film form, and the development of film narrative. Yet there is also a pressing geopolitical significance linked to certain "political" film genres, from the Italian historical epics and Southern melodramas to American cinema's Western films and tenement dramas. These films showcase the morphological continuity of representational traditions indebted to older phenomena that non-film historians regard as quintessentially modern: nationalism, imperialism, and the intercontinental movement of people and goods—from slavery to migration. The discipline of cinema studies has been very fond of a formulation of modernity that positions it neatly at the end of the nineteenth century, fittingly coinciding with the emergence of cinema. When it comes to national and racial discourses, however, a longer *durée* of the category of the Modern—one, for instance, adopted by the discipline of history—may expand even further the interdisciplinary heuristics of early cinema history.

NOTES

Abbreviations

AI — *L'araldo italiano* (New York); renamed *Il telegrafo* in 1913

DWGP — Paolo Cherchi Usai, ed., *The Griffith Project* (London: British Film Institute/Le Giornate del Cinema Muto, 1999–2008), 12 vols.

FCMI — Aldo Bernardini and Vittorio Martinelli, *Cinema muto italiano, 1905–31* (Turin: Nuova ERI; Rome: Centro Sperimentale di Cinematografia, 1991–96), 22 vols.

FdNY — *La follia di New York*

MPN — *Motion Picture News* (New York)

MPW — *Moving Picture World* (New York)

MT — *Motography* (Chicago)

NYDM — *New York Dramatic Mirror*

NYPL-TC — Billy Rose Theatre Collection of the New York Public Library for the Performing Arts, Lincoln Center (New York)

NYT — *New York Times*

PIA — *Il progresso italo-americano* (New York)

Introduction

The first epigraph is from Malcolm Andrews, *Landscape and Western Art* (New York: Oxford University Press, 1999), 1. The second epigraph is from James Fenimore Cooper, *Gleanings in Europe: Italy* (1838; reprint, Albany: State University of New York Press, 1981), 132. The third epigraph is from Franco Lo Piparo, "Sicilia linguistica," in *La Sicilia: Storia d'Italia; Le regioni dall'Unità a oggi,* ed. Maurice Aymard and Giuseppe Giarrizzo (Turin: Einaudi, 1987), 794. Lo Piparo suggests that the anonymous actor may have been none other than Angelo Grasso, father of the famous stage and film star Giovanni Grasso.

1. Although musicologist Simona Frasca has discussed some of Francesco Pennino's compositions, not much is known about his life and other activities. He allegedly exhibited a few Italian films in the movie theatres he ran in New York during the silent era, worked as

a songwriter for the Paramount Music-Roll Company, and founded his own music-printing business. The music sheet for "Senza mamma" was printed in 1918 by the New York–based Italian American publisher Antonio Grauso and was republished in 1919 by Standard Music Roll Co. of Orange, N.J. When the backdrop rises and the drama begins, Pennino's music sheet appears in the lower part of the frame, below the stage, on the chief violinist's lectern. See Simona Frasca, "Birds of Passage: La diaspora dei musicisti napoletani a New York (1895–1940)" (Ph.D. diss., University of Rome La Sapienza, 2007), 176ff.

2. John Dixon Hunt, *The Picturesque Garden in Europe* (London: Thames & Hudson, 2002), 6. The critical literature on the picturesque is massive. For a useful orientation, see Hunt's bibliographic essays at the end of the volume (198–202).

3. John Conron, *American Picturesque* (University Park: Pennsylvania State University Press, 2000), xvii.

4. The concept of intermediality originated in media and communication studies in the late 1980s and early 1990s as a descriptive trope of contemporary media practices. It later encompassed art criticism and media pedagogy. The film scholars most explicitly devoted to intermediality have been André Gaudreault and Rick Altman.

5. Leo Marx, foreword to *Views of American Landscapes,* ed. Mick Gidley and Robert Lawson-Peebles (New York: Cambridge University Press, 1989), xvi–xvii.

6. Peter Conrad, *The Art of the City: Views and Versions of New York* (New York: Oxford University Press, 1984), 67.

7. American journalist Viola Roseboro associates the term with Italians in her "Down-Town New York," *Cosmopolitan* 1 (June 1886): 222; and "The Italians of New York," *Cosmopolitan* 4 (January 1888): 396–406. In the 1910s and 1920s, the word "picturesqueness" regularly appears in film reviews and acting manuals in discussions of performing Italian roles.

8. George Beban, *Photoplay Characterization: One of a Series of Lectures Especially Prepared for Student-Members of the Palmer Plan* (Los Angeles: Palmer Photoplay Corp., Department of Education, 1921), 19.

9. The logo appears now on the label of a special series of wine bottles, called "Edizione Pennino," produced by the Niebaum-Coppola Estate Winery. The label describes the two images as "reflections of Pennino's mutual love for America and Italy."

10. Full-fledged (and Foucauldian) methodological recastings, devoted to reading the power-laden instrumentality of images, have been more common in studies of landscape art, photography, and cultural geography, for instance in the works of W. J. T. Mitchell, Allan Sekula, John Tagg, Denis Cosgrove, and Gillian Rose.

11. André Gaudreault, "From 'Primitive Cinema' to 'Kine-Attractography,'" in *The Cinema of Attractions Reloaded,* ed. Wanda Strauven (Amsterdam: Amsterdam University Press, 2006), 87.

12. Charles Musser, "A Cinema of Contemplation, a Cinema of Discernment: Spectatorship, Intertextuality and Attractions in the 1890s," in Strauven, *The Cinema of Attractions,* 172, 176.

1. Picturesque Mode of Difference

The first epigraph is from François-René de Chateaubriand, "Trip to Mount Vesuvius, Thursday January 5, 1804," *Travels in America and Italy* (London: Henry Colburn, 1828), 2:245. The second epigraph is from Roger Ingpen, ed., *The Letters of Percy Bysshe Shelley* (London: G. Bell and Sons, 1914), 2:658. Later epigraphs are from J. W. v. Goethe, *Italian Journey, 1786–1788,* trans. W. H. Auden and Elizabeth Mayer (Harmondsworth: Penguin,

1970), 220, 236; James Thomson, *The Castle of Indolence: An Allegorical Poem; Written in Imitation of Spenser* (London, A. Millar, 1748), I:xxxviii; Augustus von Kotzebue, *Neapel und die Lazzaroni: Ein charakteristiches Gemalde für Liebhaber der Zeitgeschichte* (Frankfurt and Leipzig, 1799), 68 (but see also 85); Goethe, *Italian Journey*, 236; and Stendhal, *Mémoires d'un touriste* (Paris: Michel Lévy frères, 1854 [1838]), 1:87, trans. Allan Seager as *Memoirs of a Tourist* (Evanston, Ill.: Northwestern University Press, 1962), 64.

1. Classic and recent overviews, informing the reader of set debates and original contributions, include Elizabeth Wheeler Manwaring, *Italian Landscape in Eighteenth-Century England* (New York: Oxford University Press, 1925); Christopher Hussey, *The Picturesque: Studies in a Point of View* (London: Frank Cass, 1967 [1927]); Malcolm Andrews, *The Search for the Picturesque* (Aldershot, UK: Scolar, 1989); and Malcolm Andrews, ed., *The Picturesque: Literary Sources and Documents*, 3 vols. (Robertsbridge: Helm Information, 1994), which collects a number of classic critical writings about the picturesque. Since the 1980s, the picturesque has been appreciated for its interlocking of aesthetic, moral, and political connotations in connection with the broader traditions of landscape representation. In this regard, see John Barrell, *The Dark Side of the Landscape: The Rural Poor in English Painting, 1730–1840* (Cambridge: Cambridge University Press, 1980); Denis E. Cosgrove, *Social Formation and Symbolic Landscape* (London: Croom Helm, 1984); Ann Bermingham, *Landscape and Ideology* (London: Thames & Hudson, 1986); Denis Cosgrove and Stephen Daniels, eds., *The Iconography of Landscape: Essays on the Symbolic Representation, Design and Use of Past Environments* (New York: Cambridge University Press, 1988); Sidney K. Robinson, *Inquiry into the Picturesque* (Chicago: University of Chicago Press, 1991); and W. J. T. Mitchell, ed., *Landscape and Power* (Chicago: University of Chicago Press, 1994).

2. Nelson Moe, *The View from Vesuvius: Italian Culture and the Southern Question* (Berkeley: University of California Press, 2002), 13.

3. The first usage of the expression "Grand Tour" is perhaps to be found in the French translation of Richard Lassels's *Voyage to Italy; or, A Compleat Journey through Italy* (Paris: Vincent du Moutier, 1670). The literature on the Grand Tour is extensive. For overviews related to Italy, see Cesare De Seta, "L'Italia nello specchio del 'Grand Tour,'" in *Il paesaggio*, Storia d'Italia: Annali 5, ed. Cesare De Seta (Turin: Einaudi, 1982), 125–263; and Franco Venturi, "L'Italia fuori d'Italia," in *Storia d'Italia*, vol. 3, *Dal primo Settecento all'Unità*, ed. Ruggiero Romano and Corrado Vivanti (Turin: Einaudi, 1973), 987–1481.

4. Mary Louise Pratt, *Imperial Eyes: Travel Writing and Transculturation* (London: Routledge, 1992), 10.

5. Vesuvius had a major eruption in 1631, followed by seven major ones in the eighteenth century and four in the nineteenth century. After 1872, it had continuous lava effusions culminating in the eruptions and earthquakes of 1905–1906. The early twentieth century was characterized by intermittent explosive activity, with another major eruption in 1913. Etna erupted in 1669, sixteen times in the eighteenth century, and nineteen times in the nineteenth century. Disastrous earthquakes regularly hit Sicily, particularly its eastern coast. Tragically memorable were the earthquakes that devastated Calabria in 1905 and Messina and Calabria in 1908. I will discuss eruptions and earthquakes in relationship to photography and films (both fiction and non-fiction) in chapters 2 and 3.

6. Adriano Prosperi, "'Otras Indias': Missionari della Controriforma tra contadini e selvaggi," in *Scienze, credenze occulte, livelli di cultura*, Istituto nazionale di studi sul Rinascimento (Florence: Olschki, 1982), 205–234.

7. Edward Said, *Orientalism* (New York: Vintage, 1978), 49–73. Discussions of this concept with regard to Italy are in Chloe Chard, *Pleasure and Guilt on the Grand Tour: Travel*

Writing and Imaginative Geography, 1600–1830 (Manchester: Manchester University Press, 1999); and Moe, *The View*.

8. Johann Joachim Winckelmann, *Geschichte der Kunst des Altertums* (Weimar: H. Böhlaus Nachf, 1764), 39–40, trans. Harry Francis Mallgrave, *History of the Art of Antiquity* (Los Angeles: Getty Research Institute, 2006), 119.

9. Benedetto Croce, "Il paradiso abitato da' diavoli" (1927), in *Uomini e cose della vecchia Italia*, series 1, 3rd ed. (Bari: Laterza, 1956), 68–87. The expression was also known within American racial discourse. Booker T. Washington made a passing reference to it in his account of the trip he took to Europe in 1910. In "Naples and the Land of the Emigrant," he wrote, "I think the thing that impressed me most about Naples was the contrast between the splendor of its natural surroundings, the elegance and solidity of its buildings, and the dirt, disorder, and squalor in which the masses of the people live." B. T. Washington, *The Man Farthest Down: A Record of Observation and Study in Europe* (New Brunswick: Transaction, 1984 [1912]), 111.

10. Atanasio Mozzillo, "Le ragioni dell'immaginario: Mito e percezione della realtà nei viaggiatori tra Cinquecento e Settecento," in *La Sicilia dei grandi viaggiatori*, ed. Franco Paloscia (Rome: Edizioni Abete, 1988), 1–79.

11. For an overview of the visual use of optical devices as both instruments and subject matter, by both artists and scientists, see Martin Kemp, *The Science of Art: Optical Themes in Western Art from Brunelleschi to Seurat* (New Haven: Yale University Press, 1990).

12. W. J. T. Mitchell, "Imperial Landscape," in W. J. T. Mitchell, *Landscape and Power*, 5. This is true, of course, of all visual arts, including photography. See Rosalind Krauss, "Photography's Discursive Spaces: Landscape/View," *Art Journal* (Winter 1982): 311–319.

13. On this process, see Malcolm Andrews, *Landscape and Western Art* (New York: Oxford University Press, 1999), chapter 1; see also Kenneth Clark, *Landscape into Art* (New York: Harper and Row, 1975); and Peter C. Sutton, ed., *Masters of 17th-Century Dutch Landscape Painting* (Amsterdam: Rijksmuseum, 1987).

14. Stefano Susinno, *La veduta nella pittura italiana* (Florence: Sansoni, 1974), 11ff.

15. Trained in landscape painting in Naples and Rome, Lorrain (1600–82), who was also known as Claude, achieved fame and admiration throughout Europe for his representation of "landscape moods" and, to a much lesser extent, for his rendering of human figures. Active in Rome, Poussin (1594–1665) became a champion of allegorical landscapes infused with quasi-mathematical simplicity and harmony. The brother of Nicolas Poussin's wife, Gaspar Dughet (1615–75) became his adopted son and was in fact better known as Gaspar Poussin.

16. Exposed to the Baroque studies of color and realism of the Spaniard Jusepe Ribera, the flamboyant painter and etcher Rosa (1615–73) was deeply attracted to the representation of the untamed wilderness and imperfect scraps of nature, which he originally rendered with a very dramatic palette of shadows and colors. The rumor that he himself had been a brigand turned out to be a myth, though a most fitting one, largely informing his reputation as a rebellious artist depicting rebellious subjects.

17. For a general discussion of *vedute*, see Giuliano Briganti, *The View Painters of Europe*, trans. Pamela Waley (London: Phaidon, 1970 [1969]); and, with explicit reference to the Grand Tour, see Cesare De Seta, *Vedutisti e viaggiatori in Italia tra Settecento e Ottocento* (Turin: Bollati Boringhieri, 1999).

18. Svetlana Alpers, "The Mapping Impulse in Dutch Art," in *The Art of Describing: Dutch Art in the Seventeenth Century* (Chicago: University of Chicago Press, 1983), 119–168.

19. On the complex etymology, cultural genealogy, and first usages of the word "picturesque" (from the Italian *pitoresco* or *pittoresco* to the Dutch *schilderachtig*), see Walter

John Hipple, *The Beautiful, The Sublime, and the Picturesque in Eighteenth-Century British Aesthetic Theory* (Carbondale: Southern Illinois University Press, 1957), 185–191; and Raffaele Milani, *Il pittoresco: L'evoluzione del gusto tra classico e romantico* (Rome and Bari: Laterza, 1997), 7–10. Early works discussing the picturesque in painting include Marco Boschini's *La carta del navegar pitoresco* (Venice: Per li Baba, 1660); and Giacomo Barri's *Viaggio pittoresco d'Italia* (Venice: Giacomo Herz, 1671).

20. On Van Wittel, see Giuliano Briganti, Laura Laureati, and Ludovica Trezzani, *Gaspar van Wittel* (Milan: Electa, 1996).

21. Venice was also a preferred subject for panoramas. One of the most famous was Henry Aston Barker and John Burford's 1819 topographical *Panorama of Venice*, now held at the British Library. On Venice's dominant topographical paradigm, see Alberto Zotti Minici, "Venezia nell'iconografia degli spettacoli ottici," in *L'immagine di Venezia nel cinema del Novecento*, ed. Gian Piero Brunetta and Alessandro Faccioli (Venice: Istituto Veneto di Scienze, Lettere ed Arti, 2004), 59–74.

22. His work affected the likes of John Constable, Samuel Scott, and J. M. W. Turner. See Michael Liversidge and Jane Farrington, eds., *Canaletto and England* (London: Merrel Holberton with Birmingham Museums & Art Gallery, 1993).

23. Briganti, *View Painters*, 20.

24. Ibid. In the eighteenth century, apart from Giovanni Panini, Van Wittel's artistic heir, other important Rome-based view painters included several members of the city's French Academy, such as Joseph Vernet (1714–89), Jean Claude Richard Abbé de Saint-Non (1727–91), and Fragonard (1732–1806). Saint-Non was the author of the famous illustrated book *Voyage pittoresque; ou, Description des royaumes de Naples et de Sicile* (1781–86), which I shall discuss below.

25. Two of the most renowned urban encyclopedists were Giuseppe Vasi (1710–82) and Giovanni Battista Piranesi (1720–78). Decades later, spectacular panoramas, tourist and artistic photography, and filmed travelogues replicated their work. See Henry Aston Barker and J. Burford, *An Explanation of the View of Rome* (London: J. Adlard, 1817); and Piero Becchetti, *La fotografia a Roma dalle origini al 1915* (Rome: Colombo, 1983).

26. On the history of the representation of Naples and its surroundings, see Raffaello Causa, ed., *Il paesaggio napoletano nella pittura straniera* (Naples: Ente provinciale per il turismo, 1962); Giuliano Briganti, "Il vedutismo e Napoli" and Nicola Spinosa, "La pittura di vedute a Napoli dal ritratto urbano al paesaggio d'emozione," in Silvia Cassani, ed., *All'ombra del Vesuvio: Napoli nella veduta europea dal Quattrocento all'Ottocento* (Naples: Electa Napoli, 1990), xxi–xxiii and 1–24; and Nicola Spinosa, *Vedute napoletane dal Quattrocento all'Ottocento* (Naples: Electa, 1996). For Sicily, see Paloscia, *La Sicilia*.

27. The lowbrow visual production of the gouaches, the extraordinarily popular opaque watercolors manufactured *en masse* by both foreign and Italian painters until the arrival of photography, helped turn the most famous attractions of Naples and its surroundings into commonplace, iconic stereotypes. Tourists appreciated them for their vivid immediacy, portability, and low price, while for decades art historians have ignored them, assuming that they allowed for "a direct and instinctual grasping of their content, not necessarily mediated by cultural or historical-artistic references." Tino Santangelo, "Le gouaches," in *C'era una volta Napoli: Itinerari meravigliosi nelle gouaches del Sette e Ottocento*, ed. Denise Maria Pagano (Naples: Electa, 2002), 15.

28. It was also known, albeit less commonly, as "Lorrain glass" or a "Claude Lorrain mirror." Although Lorrain is credited with its invention, it is still unclear whether the famous French landscape painter ever used it. Lars Kiel Bertelsen, "The Claude Glass: A Modern Metaphor between Word and Image," *Word & Image* 20, no. 3 (July–September

2004): 182–190; and Arnauld Maillet, *The Claude Glass: Use and Meaning of the Black Mirror in Western Art,* trans. Jeff Fort (New York: Zone Books, 2004).

29. Thomas West, *A Guide to the Lakes: Dedicated to the Lovers of Landscape Studies and to All Who Visited or Intend to Visit the Lakes in Cumberland, Westmorland, and Lancashire* (London: Richardson and Urquhart, and W. Pennington, Kendal, 1778), 16.

30. Gray referred to the Claude glass in the *Journal in the Lakes* (1769), his pioneering guide to the Lake District, first written in 1769 as a series of letters to his friend Thomas Wharton. See Paget Toynbee and Leonard Whibley, eds., *Correspondence of Thomas Gray* (Oxford: Clarendon, 1935), 3:1074–1081, 1087–1091. Because of its association with Gray, another name for the Claude mirror was "Gray glass." Maillet, *The Claude Glass,* 35. Claude glasses were not difficult to find: "Mirrors could be purchased from philosophical or scientific instrument-makers, opticians (such as Benjamin Pike of New York), shops selling artists' supplies, and sometimes in tourist establishments themselves." C. S. Matheson, "Essays for an Exhibit," in *Enchanting Ruin: Tintern Abbey and Romantic Tourism in Wales,* exhibition catalog (Ann Arbor: University of Michigan, Special Collection Library, 2008), n.p. Alex McKay, a Canadian multidisciplinary artist, has recently combined the eighteenth-century tool with photography and digital media in a theoretically informed recreation of the tour of the Wye Valley, Wales, where the Claude Glass was widely used. See Suzanne Matheson and Alex McKay, "The Transient Glance: The Claude Mirror and the Picturesque," http://www.claudemirror.com.

31. Writing about the view of a most picturesque waterfall from the windows of a summerhouse in the Lake District, Thomas Gray's biographer drew an explicit comparison between painting and stage design: "This little theatrical scene might be painted as large as the original, on a canvas not bigger than those which are usually dropped in the Opera-house." William Mason, ed., *The Poems of Mr. Gray, to Which Are Prefixed Memoirs of His Life and Writings* (London: J. Dodsley, 1775), 366, quoted in Andrews, *Landscape and Western Art,* 122.

32. Christine L. Oravec, "To Stand outside Oneself: The Sublime in the Discourse of Natural Scenery," in *The Symbolic Earth: Discourse and Our Creation of the Environment,* ed. James G. Cantrill and Christine L. Oravec (Lexington: University Press of Kentucky, 1996), 62.

33. Ibid.

34. Still, Rosa's works were seen as intersecting with Edmund Burke's rearticulation of the antique notion of the sublime, encompassing obscurity (terror), privation (solitude), and vastness, as developed in his *Philosophical Inquiry into the Origin of Our Ideas on the Sublime and Beautiful* (1756).

35. William Gilpin, *An Essay upon Prints: Containing Remarks upon the Principles of Picturesque Beauty* (London: J. Robson, 1768), xii.

36. Robinson, *Inquiry into the Picturesque,* 73, 87.

37. Uvedale Price, *Essays on the Picturesque as Compared with the Sublime and the Beautiful, and on the Use of Studying Pictures, for the Purpose of Improving Real Landscape* (London: J. Robson, 1794), 28.

38. See Nicholas Green, *The Spectacle of Nature: Landscape and Bourgeois Culture in Nineteenth-Century France* (Manchester: Manchester University Press, 1990); and Timothy Mitchell, *Art and Science in German Landscape Painting, 1770–1840* (Oxford: Clarendon, 1993).

39. In an effort to protect the location from tourists and the commotion of modernity, including the railway (which brought hordes of tourists and would-be artists),

Fontainebleau became in 1861 the world's first national preserve, eleven years before the creation of Yellowstone National Park. In addition to influencing the work of Monet, Corbet, and Renoir, the Barbizon school informed the style of French photographers Gustave Le Gray and Eugène Cuvelier, who went to Fontainebleau and whose photographs naturalized the picturesque style of the Barbizon artists. See the exhibition catalog edited by Kimberly A. Jones, *In the Forest of Fontainebleau: Painters and Photographers from Corot to Monet* (Washington, D.C.: National Gallery of Art; New Haven, Conn.: Yale University Press, 2008).

40. Baron Hermann von Riedesel, *Reise durch Sicilien und Grossgriechenland* (Zurich: Orell, Gessner, Fuesslin, and Com, 1771), trans. R. Jo Forster as *Travels through Sicily and That Part of Italy Formerly Called Magna Græcia* (London: Edward and Charles Dilly, 1773); Patrick Brydone, *A Tour through Sicily and Malta in a Series of Letters to William Backford, Esq.* (London: Strahan and Cadell, 1773); Saint-Non, *Voyage pittoresque*; Jean-Pierre-Louis-Laurent Hoüel, *Voyage pittoresque des isles de Sicile, de Malte et de Lipari* (Paris: Imprimerie de Monsieur, 1782–87); Henry Swinburne, *Travels in the Two Sicilies in the Years 1777, 1778, 1779 and 1780* (London: P. Elmsly, 1783–85); Madame de Staël, *Corinne; ou, L'Italie* (Paris: H. Nicolle, 1807); and J. W. v. Goethe, *Italienische Reise* (Stuttgart: J. G. Cotta, 1817).

41. Goethe famously hailed Sicily as Italy's most indicative synecdoche: "To have seen Italy without having seen Sicily is not to have seen Italy at all, for Sicily is the clue to everything." *Italian Journey*, 246.

42. Ibid., 236.

43. J. W. v. Goethe, *Travels in Italy*, trans. Rev. A. J. W. Morrison and Charles Nisbet (London: G. Bell and Sons, 1911), 229, 220. I am using here a different edition, since the Auden-Mayer translation published by Penguin fails to mention Lorrain.

44. Chateaubriand, *Travels in America and Italy*, 260.

45. Madame de Staël, *Corinne; or, Italy*, trans. Sylvia Raphael (New York: Oxford University Press, 1998), 149 (italics mine).

46. Saint-Non's editorial endeavor, consisting of more than 542 etchings, provided a training and teaching ground for generations of French painters, architects, and antiquarians, beginning in the second half of the eighteenth century. On the project, see Petra Lamers, *Il viaggio nel Sud dell'Abbé de Saint-Non: Il "Voyage pittoresque à Naples et en Sicilie"; La genesi, i disegni preparatori, le incisioni* (Naples: Electa Napoli, 1995).

47. Known as Denon after the French Revolution, de Non had already published a *Voyage en Sicile*, which had appeared in 1787 as an appendix to the French translation of Henry Swinburne's *Travels in the two Sicilies*.

48. Consider Jean Hoüel's *Voyage pittoresque des isles de Sicilie, de Malte et de Lipari* (1782–87), Alexandre de Laborde's *Voyage pittoresque et historique de l'Espagne* (1806–20), Charles Nodyer and Baron Isidore-Justin-Séverin Taylor's famous *Voyages pittoresques et romantiques dans l'ancienne France* (1820–70), and de Musset's *Voyage pittoresque en Italie, partie méridionale et en Sicile* (1856). A complete list would also include "picturesque reports" from North and South America, such as Louis Choris, *Voyage pittoresque autour du monde, avec des portraits de sauvages d'Amérique, d'Asie, d'Afrique* (1822); Alcide Dessalines d'Orbigny, *Voyage pittoresque dans les deux Amériques* (1841); and Oscar Comettant, *Voyage pittoresque et anecdotique dans le Nord et le Sud des États-Unis d'Amérique* (1866). I shall return to the North American picturesque in chapter 5.

49. Denon's illustrative classifications figured prominently in the twenty-volume collective enterprise *Description d'Égypte* (Paris: 1809–28), which, with its large format (*grand monde*) and eleven volumes of plates, greatly informed the collection and exhibition

practices of the blossoming French museums. Under Napoleon, Denon became director-general of the nation's museums, minister of arts, and developer and first director of the Louvre.

50. De Non, *Voyage en Sicile*, trans. as *Travels in Sicily and Malta* (London: G. G. J. and J. Robinson, 1789), 184.

51. On the formation of a "pastoral landscape," "Bel Paesaggio," and "Mediterranean Garden" in Italy, see the classic work of Emilio Sereni, *Storia del paesaggio agrario italiano* (Rome and Bari: Laterza, 1961), trans. R. Burr Litchfield as *History of the Italian Agricultural Landscape* (Princeton, N.J.: Princeton University Press, 1997), especially 107–110, 140–154, 210–213.

52. In the preface to his *Voyage pittoresque*, Hoüel attributed the cultural and artistic "degradation" of present-day Sicilians to the countless foreign dominations of the island and to the local populations' resulting enslavement. Still, a few pages later, he contended that Sicilians were utterly responsible for their own "character." "They cannot take advantage of the energy and vitality of their own character and are not at all filled with higher aspirations at the sight of all those antique treasures, of all those natural and artistic wonders surrounding them." Hoüel, *Voyage pittoresque*, 12.

53. Riedesel, *Travels through Sicily*, 86.

54. Brydone, *A Tour through Sicily*, 1:165. Brydone also rehashed the theme of Etna as a "mouth of Hell" (ibid.).

55. Henry Swinburne, *Travels in the Two Sicilies* (London: Cadell and Elmsly, 1790), 4:91, 169.

56. Riedesel, *Travels through Sicily*, 118, 143. On the influence of theories of the effect of climate on European culture (embraced, for instance by Rousseau and Herder), subsequent Italian debates, and even the American Civil War context, see Moe, *The View*, 27–31.

57. Swinburne, *Travels*, 4:74.

58. Staël, *Corinne; or, Italy*, 19. "Ruins diffuse an unusual charm over the Italian countryside. Unlike modern buildings, they do not remind us of man's work and presence; they merge with the trees, with nature" (149).

59. Goethe, *Italian Journey*, 60. "This Italy, so greatly favored by Nature," the German poet later added, "has lagged very badly behind other countries in mechanical and technical matters, which are, after all, the basis of a comfortable, agreeable life" (123).

60. Augustin Creuzé de Lesser, *Voyage en Italie et Sicile, 1801–1802* (Paris: Didot, 1806), 96.

61. Charles Victor de Bonstetten, *L'homme du midi et l'homme du nord; ou, L'influence du climat* (Genève: J. J. Paschoud, 1824), trans. *The Man of the North and the Man of the South, or, The Influence of Climate* (New York: F. W. Christern, 1864), 61, 12.

62. Bonstetten, *The Man of the North*, 11–13, 122, 121. Bonstetten excluded the Southern Italian aristocracy from his generalizations about Southerners' "thirst for Vengeance," calling it "a trait especially noticeable among the inferior classes" (121).

63. Raymond Williams, *The Country and the City* (London: Chatto & Windus, 1973), 60–61; and William George Hoskins, *The Making of the English Landscape* (London: Hoddler and Stoughton, 1955), 139. Marxist and revisionist historians have for years debated the significance of the enclosure movement. Scholars of the picturesque have not.

64. For a discussion of landownership and its representations, see Cosgrove, *Social Formation*, particularly 189–222; Cosgrove and Daniels, *The Iconography of Landscape*; and John Barrell, ed., *Painting and the Politics of Culture: New Essays on British Art, 1700–1850* (New York: Oxford University Press, 1992).

65. English culture's appreciation for Italian views and figures was "a direct result of the Grand Tour fashionable with aristocracy after the isolation of the country from the rest of Europe during the greater part of the 17th century." Hussey, *The Picturesque*, 12.

66. "I admire, / None more admires, the painter's magic skill, / Who shows me that which I shall never see, / Conveys a distant country into mine, / And throws Italian light on English walls." William Cowper, *The Task*, bk. 1, ll. 421–425, quoted in Manwaring, *Italian Landscape*, 57.

67. R. Williams, *The Country and the City*, 61.

68. Alun Howkins, "J. M. W. Turner at Petworth: Agricultural Improvement and the Politics of Landscape," in *Painting and the Politics of Culture: New Essays in British Art, 1700–1850*, ed. John Barrell (Oxford: Oxford University Press, 1992), 239. Significantly, Howkins adds that "deer, as the most wasteful of almost all beasts, were long-established symbols of power" (ibid.).

69. Andrews, *The Search for the Picturesque*, 6ff.

70. R. Williams, *The Country and the City*, 124. Williams adds, "The clearing of parks as 'Arcadian' prospects depended on the completed system of exploitation of the agricultural and genuinely pastoral lands beyond the park boundaries. There, too, an order was being imposed: social and economic but also physical."

71. William Wordsworth, *The Prelude: or, Growth of a Poet's Mind; An Autobiographical Poem*, ed. Ernest de Selincourt, rev. Helen Darbishire (Oxford: Clarendon, 1959), bk. 1, l. 89.

72. William Gilpin, *Observations on the River Wye and Several Parts of South Wales, &c., Relative Chiefly to Picturesque Beauty; Made in the Summer of the Year 1770* (1782; 3rd ed., London: Blamire, 1792), 46.

73. Elizabeth Helsinger, "Land and National Representation in Britain," in *Prospects for the Nation: Recent Essays in British Landscape, 1750–1880*, ed. Michael Rosenthal, Christiana Payne, and Scott Wilcox (London: Yale University Press, 1997), 13–35. On picturesque tours of England, see Andrews, *The Search for the Picturesque*, part 2. On poetry and Englishness within the aesthetic of the picturesque, see John Richard Watson, *Picturesque Landscape and English Romantic Poetry* (London: Hutchinson Educational, 1970).

74. On the notion of land as a medium of political communication, see W. J. T. Mitchell, "Imperial Land," in *Landscape and Power*, 5–34.

75. Jonathan Crary's powerful argument that modern visuality became "lodged onto the body of the observer" (and on discursive powers linked to such an observing subject) in the early nineteenth century ought also to be linked to these late eighteenth-century debates on the picturesque. My discussion here is not primarily aimed at locating ever earlier manifestations of the transition to modernity. Rather, by focusing on the picturesque as one of the emerging components of a modern aesthetic discourse linking space and race, I emphasize the productive continuity that the picturesque has exerted on later scientific, aesthetic, and cultural discourses. See Jonathan Crary, *Techniques of the Observer: On Vision and Modernity in the Nineteenth Century* (Cambridge, Mass.: MIT Press, 1990), 3, 13.

76. William Gilpin, *Three Essays: On Picturesque Beauty; On Picturesque Travel; and On Sketching Landscape: To Which Is Added a Poem on Landscape Painting*, 2nd ed. (London: R. Blamire, 1794), 126, 62–63, 128, and 19 (italics in the original).

77. Price, *Essays on the Picturesque*, 34, 44–45 (italics mine).

78. Richard Payne Knight, *Analytical Inquiry into the Principles of Taste*, 3rd ed. (London: T. Payne, 1806), 69. Quoting Hume, he also added, "Beauty is no quality in things themselves: It exists merely in the mind which contemplates them, and each mind perceives a different beauty" (16).

79. As I discuss in the conclusions of this study, these reflections are of utmost importance for our discussion of racial depictions, as they reveal the degree to which soon-to-be-racialized landscape representations were thought from early on to result from purposeful aesthetic constructions.

80. John Barrell, "The Public Prospect and the Private View: The Politics of Taste in Eighteenth-Century Britain," in *Reading Landscape: Country-City-Capital*, ed. Simon Pugh (Manchester: Manchester University Press, 1990), 29.

81. Ralph Waldo Emerson, *Nature* (1836), in *Essays and Lectures* (New York: Literary Classics of the United States, 1983), 9.

82. Manwaring, *Italian Landscape*, 232.

83. William Gilpin, *Observations Relative Chiefly to Picturesque Beauty, Made in the Year 1772, on Several Parts of England: Particularly the Mountains, and Lakes of Cumberland, and Westmoreland*, 2nd ed., 2 vols. (London: Blamire, 1792), 2:44–45. On the split between morality and the picturesque and on the comparisons between landscapes and political regimes, see, respectively, Barrell, *The Dark Side of the Landscape*, 1–35, and Robinson, *Inquiry into the Picturesque*, 73–89.

84. Baron de Montesquieu, *The Spirit of the Laws*, trans. Thomas Nugent (New York: Hafner Publishing, 1949), 1:224.

85. Anna Jameson, *Diary of an Ennuyée* (Boston: Houghton, Osgood, 1879 [1826]), 277, 322.

86. Foucault, *The Order of Things* (New York: Vintage, 1973), 43. "The relation of the sign to its content [was] not guaranteed by the order of things in themselves. . . . it now reside[d] in a space in which there [was] no longer any intermediary figure to connect them" (63).

2. The Picturesque Italian South as Transnational Commodity

The internal epigraph to this chapter is from Camillo Benso Cavour, *La liberazione del Mezzogiorno e la formazione del Regno d'Italia* (Bologna: Zanichelli, 1952), 3:208. Nelson Moe discusses the correspondence between Count Cavour and the Piedmont envoy in his "'Altro che Italia!' Il Sud dei piemontesi (1860–1861)," *Meridiana*, no. 15 (1992): 53–89.

1. Benedict Anderson, *Imagined Communities: Reflections on the Origin and Spread of Nationalism* (London: Verso, 1991 [1983]): xiv.

2. This was obviously a wider trend, encompassing the French historiography of Jules Michelet and Ernest Renan, the German discipline of *Altertumswissenschaft* ("science of antiquity"), and both the Arnoldian curriculum reforms in England and those of the Boston Latin School and Harvard College in Massachusetts. On historiography and antiquarianism, see Philippa Levine, *The Amateur and the Professional: Antiquarians, Historians, and Archaeologists in Victorian England, 1838–1886* (Cambridge: Cambridge University Press, 1986).

3. Maura O'Connor, *The Romance of Italy and the English Political Imagination* (New York: St. Martin's Press, 1998); Catharine Edwards, ed., *Roman Presences: Reception of Rome in European Culture, 1789–1945* (Cambridge: Cambridge University Press, 1999); and William L. Vance, *America's Rome* (New Haven, Conn.: Yale University Press, 1989).

4. Edward Bulwer Lytton, *The Last Days of Pompeii* (New York: Thomas Crowell, 1922 [1834]), vii. In Britain alone, between 1834 and 1900 the novel and a volume of Bulwer-Lytton's collected works went through sixteen and eleven editions respectively. Similar literary examples include John G. Lockhart's *Valerius, a Roman Story* (1821), Wilkie Collins's *Antonia; or, The Fall of Rome* (1850), and Walter Pater's *Marius the Epicurean* (1885).

5. On the racial and proto-eugenicist connotation of Arnold's pedagogical reform, see Robert J. C. Young, "The Complicity of Culture: Arnold's Ethnographic Politics," in *Colonial Desire: Hybridity in Theory, Culture and Race* (New York: Routledge, 1995), 55–89; and Stefania Arcara's remarkable *Constructing the South: Sicily, Southern Italy and the Mediterranean in British Culture, 1773–1926* (Catania: Università di Catania, Dipartimento di Filologia Moderna, 2000), 107ff.

6. On the inclusion of empire in American historiography, see the classic anthology edited by Amy Kaplan and Donald E. Pease, *Cultures of United States Imperialism* (Durham, N.C.: Duke University Press, 1993).

7. See David Mayer, *Playing Out the Empire: Ben-Hur and Other Toga Plays and Films, 1883–1908: A Critical Anthology* (Oxford: Clarendon, 1994); Miriam Hansen, *Babel and Babylon: Spectatorship in American Silent Film* (Cambridge, Mass.: Harvard University Press, 1991), 163–198; and Kristen Whissel, *Picturing American Modernity: Traffic, Technology, and the Silent Cinema* (Durham, N.C.: Duke University Press, 2008).

8. John Conron, *American Picturesque* (University Park: Pennsylvania State University Press, 2000), xvii.

9. Enrica Di Ciommo, *I confini dell'identità: Teorie e modelli di nazione in Italia* (Rome and Bari: Laterza, 2005), 11.

10. The morphological influence of graphic and photographic reproductions on early Italian cinema has received scant attention. One of the few works that discusses the relationship between Italian cinema and photography is Giovanni Fiorentino's "Dalla fotografia al cinema," in *Storia del cinema mondiale*, ed. Gian Piero Brunetta (Turin: Einaudi, 2001), 5:43–79. Fiorentino is a historian of photography. Antonio Costa's interdisciplinary work *Il cinema e le arti visive* (Turin: Einaudi, 2002) mostly compares cinema with painting. Recent contributions include Elena Dagrada, Elena Mosconi, and Silvia Poli, eds., *Moltiplicare l'istante: Beltrami, Comerio e Pacchioni tra fotografia e cinema* (Milan: Il Castoro, 2007); and my synoptic "Early Italian Cinema and Photography," in Giorgio Bertellini, ed., *Silent Italian Cinema: A Reader* (London: John Libbey, forthcoming).

11. For a discussion of these "enabling institutions," see James Buzard, *The Beaten Track: European Tourism, Literature, and the Ways to Culture, 1800–1918* (Oxford: Clarendon, 1993), 47–79.

12. John Urry, *The Tourist Gaze: Leisure and Travel in Contemporary Societies* (London: Sage, 1990).

13. See Maria Antonella Fusco, "Il 'luogo comune' paesaggistico," in *Il paesaggio*, Storia d'Italia: Annali 5, ed. Cesare De Seta (Turin: Einaudi, 1982), 784ff. For examples of widely circulating daguerreotypes of Venice, Rome, and Pompeii, see John Wood, *The Scenic Daguerreotype: Romanticism and Early Photography* (Iowa City: University of Iowa Press, 1995).

14. The panorama of prominent Italian and foreign photographers and ateliers active in Italy from the 1840s to the turn of the twentieth century is vast. Indispensable overviews and catalogs include Piero Becchetti, *Fotografi e fotografia in Italia (1839–1880)* (Rome: Quasar, 1978); Carlo Bertelli and Giulio Bollati, eds., *L'immagine fotografica, 1845–1945*, 2 vols. (Turin: Einaudi, 1979); Marina Miraglia, "Note per una storia della fotografia italiana (1839–1911)," in *Storia dell'arte Italiana Einaudi*, part 3, vol. 2, bk. 2 (Turin: Einaudi, 1981), 423–543; and Paolo Costantini, ed., *Cultura fotografica in Italia: Antologia di testi sulla fotografia, 1839–1949* (Milan: Franco Angeli, 1985).

15. Giulio Bollati, "Note su fotografia e storia," in Bertelli and Bollati, *L'immagine fotografica*, 1:31.

16. Arturo Carlo Quintavalle, *Gli Alinari* (Florence: Alinari, 2003); and, in English, Monica Maffioli, ed., *Fratelli Alinari: Photographers in Florence* (Florence: Alinari, 2003).

17. Quintavalle, *Gli Alinari*, 289, 303, and passim.

18. Traditionally gathering in the centrally located Caffè Greco in Rome, these painters-photographers included the Venetian Giacomo Caneva, the Frenchman Frédéric Flacheron, the Englishman James Anderson, and the Scot Robert Macpherson (whose oval prints, side views, and irregular perspectives evoked Rosa's paintings). Piero Becchetti, *La fotografia a Roma dalle origini al 1915* (Rome: Colombo, 1983); and Maria Antonella Pelizzari, "Retracing the Outlines of Rome: Intertextuality and Imaginative Geographies in Nineteenth-Century Photographs," in *Picturing Place: Photography and the Geographical Imagination,* ed. Joan M. Schwartz and James R. Ryan (London: I. B. Tauris, 2003), 55–73.

19. On the *Mission héliographique,* see Anne de Mondenard, *La mission héliographique: Cinq photographes parcourent la France en 1851* (Paris: Patrimoine—Monum, 2001); and M. Christine Boyer, "La mission héliographique: Architectural Photography, Collective Memory and the Patrimony of France, 1851," in Schwartz and Ryan, *Picturing Place,* 21–54.

20. See Massimo Ferretti, Alessandro Conti, and Ettore Spalletti, "La documentazione dell'arte," in *Gli Alinari, fotografi a Firenze, 1852–1920,* ed. Wladimiro Settimelli and Filippo Zevi (Florence: Alinari, 1985), 101–174.

21. On Italian historical epics and their international ideology of national glory, see Gian Piero Brunetta, "No Place like Rome: The Early Years of Italian Cinema," *Artforum* 28, no. 10 (Summer 1990): 122–125; and Maria Wyke, *Projecting the Past: Ancient Rome, Cinema and History* (New York: Routledge, 1997).

22. For external views of the Colosseum, consider also the 1841 daguerreotypes of Alexander John Ellis and Lorenzo Suscipj. For the converging painted and photographic representations of Rome, see the exhibition catalog *Pittori e fotografi a Roma, 1845–1870* (Rome: Multigraphica, 1987); Luigi Magni and Wladimiro Settimelli, *Roma e il Lazio negli Archivi Alinari* (Florence: Alinari, 1989); and for the antiquarian aesthetics shared by photographers and architects in Italy, see Monica Maffioli, *Il bel vedere: Fotografi e architetti nell'Italia dell'Ottocento* (Turin: Società Editrice Internazionale, 1996).

23. On the widely exhibited work of Gérôme, whose "Roman" paintings would often end up bought by American collectors and museums, see Gerald M. Ackerman, *The Life and Work of Jean-Léon Gérôme: With a Catalogue Raisonné* (London and New York: Sotheby's Publications, 1986). On Gérôme in Italian historical epics, see Ivo Blom's "*Quo Vadis?* From Painting to Cinema and Everything in Between," in *The Tenth Muse: Cinema and Other Arts,* ed. Leonardo Quaresima and Laura Vichi (Udine: Forum, 2001), 281–296.

24. A notable instance of Alinari picturesque is their photographs of the waterfalls at Tivoli, near Rome. This was a favorite subject of numerous Italian filmed travelogues, widely distributed in Europe. The Cines Bulletin described one such film's subject matter as "the world's most picturesque." Aldo Bernardini, *Cinema delle origini in Italia: I film "dal vero" di produzione estera 1895–1907* (Gemona: La Cineteca del Friuli, 2008), 65.

25. See Mariantonietta Picone Petrusa, "Il ruolo della fotografia nella cultura napoletana," in *Civiltà dell'Ottocento: Le arti a Napoli dai Borbone ai Savoia,* ed. Silvia Cassani (Naples: Electa, 1997), 110; and Giovanni Fiorentino, *Tanta di luce meraviglia arcane: Origini della fotografia a Napoli* (Naples: Di Mauro, 1992).

26. Gaetano Fiorentino, Gennaro Matacena, and Paolo Macry, eds., *Napoli in posa: 1859–1910, crepuscolo di una capitale* (Naples: Electa, 1989).

27. Major exponents of the Portici school included Giuseppe De Nittis (1846–84) and Federico Rossano (1835–1912). See Isabella Valente, "Le forme del reale: Il naturalismo e

l'immaginario storico ed esotico nella pittura napoletana del secondo Ottocento," in *La pittura napoletana dell'Ottocento,* ed. Franco Carmelo Greco, Mariantonietta Picone Petrusa, and Isabella Valente (Naples: Tullio Pironti, 1993), 47–73.

28. Quintavalle, *Gli Alinari,* 413ff. On the relationships between painting and graphic reproductions in Southern Italy see, among others, Mariantonietta Picone Petrusa's crucial essay "Linguaggio fotografico e 'generi' pittorici," in *Immagine e città: Napoli nelle collezioni Alinari e nei fotografi napoletani fra ottocento e novecento,* ed. Mariantonietta Picone Petrusa and Daniela Del Pesco (Naples: Macchiaroli, 1981), 21–63.

29. Bernoud (1820–89) distinguished himself through portraiture and photo reportages. He covered the 1857 earthquake of Basilicata and later introduced the faces of captured and killed *briganti* to Italian and European audiences. Conrad (1827–89) became famous for his stereoscopic landscape views and scenes of local customs.

30. The two best catalogs and critical introductions to his work are Daniela Palazzoli, ed., *Giorgio Sommer, fotografo a Napoli* (Milan: Electa, 1981); and Marina Miraglia and Ulrich Pohlmann, eds., *Un viaggio fra mito e realtà: Giorgio Sommer, fotografo in Italia, 1857–1891* (Rome: Carte Segrete, 1992).

31. Marina Miraglia, "Giorgio Sommer, un tedesco in Italia," in Miraglia and Pohlmann, *Un viaggio fra mito e realtà,* 23.

32. On the popularity of this image, see Becchetti, *Fotografi e fotografia in Italia,* 83; and Picone Petrusa, "Linguaggio fotografico," 39. For similar photographs (including one by Brogi), see Fiorentino, Matacena, and Macry, *Napoli in posa,* 140–144. Hamilton's passion for volcanoes was fictionalized in Susan Sontag's novel *The Volcano Lover: A Romance* (1992). On Hamilton's collections, see Ian Jenkins and Kim Sloan, *Vases and Volcanoes: Sir William Hamilton and His Collection* (London: British Museum Press, 1996). My thanks to Tim Rood for this reference.

33. In 1865, the French photographer Robert Rive traveled throughout the island, compiling an unprecedented catalog of regional views (including stereoscopic ones) that combined archeological monumentality with a picturesque rendering of nature inhabited by idle and solitary figures. See Michele Falzone del Barbarò, Monica Maffioli, and Paolo Morello, eds., *Fotografi e fotografie a Palermo nell'Ottocento* (Florence: Alinari, 1999), 24ff.

34. Other figures active in Palermo included the Tagliarini brothers, who received an award at the 1876 Universal Exposition in Philadelphia. In Catania, the major figures were Giovanni Di Giorgio, who photographed such local theatrical stars as Angelo Musco and Giovanni Grasso, and the Biondi brothers. Vincenzo Mirisola and Giuseppe Vanzella, *Fotografi a Palermo, 1865–1900* (Palermo: Gente di Fotografia, 2001); and Vincenzo Mirisola and Michele Di Dio, *Sicilia Ottocento: Fotografi e Grand Tour* (Palermo: Gente di Fotografia, 2002).

35. For a comparison with Sommer's, see Crupi's photograph in Mirisola and Di Dio, *Sicilia Ottocento,* 99.

36. Karl Baedeker, *Southern Italy and Sicily* (London: Dulau, 1887), 336.

37. The history of the effects of such *topoi* would also include Luchino Visconti's neorealist landmark *La terra trema* (1948), which, funded by the Communist party and overtly inspired by Verga's *I Malavoglia,* included a few scenes featuring the pictorial force of the Cyclops of Aci Trezza.

38. Many photographic ateliers of national significance, such as that of the Vasaris, blatantly copied Sommer and Bernoud's photographs and in the process further popularized the older iconographic types. Marina Miraglia, "Cesare Vasari e il genere nella fotografia napoletana dell'Ottocento," *Bollettino d'Arte* 70, nos. 33–34 (1985): 199–208.

39. Miraglia, "Giorgio Sommer," 24.

40. Dean MacCannell, *The Tourist: A New Theory of the Leisure Class* (New York: Schocken, 1976), 1. Sommer and Bernoud drew their subjects from the engravings of costumes, customs, and social types that various exponents of the Neapolitan school of Posillipo had produced for Francesco de Bourcard's *Usi e costumi di Napoli e contorni descritti e dipinti* (Naples: G. Nobile, 1853–58).

41. Robert Aldrich, *The Seduction of the Mediterranean: Writing, Art and Homosexual Fantasy* (New York: Routledge, 1993), 143–152, 138. On Von Gloeden, a former art student, see Michele Falzone del Barbarò et al., eds., *Le fotografie di von Gloeden* (Milan: TEA, 1996). The same aesthetic approach informed the pictorially stylized portraits of Greek and Arab physiognomic types that illustrated William Agnew Paton's celebrated travel guide, *Picturesque Sicily* (London and New York: Harper & Brothers, 1897).

42. Carlo Del Balzo, *Napoli e i napoletani: Opera illustrata da Armenise, Dalbono e Matania* (Rome: Edizioni dell'Ateneo, 1972 [1885]), 80. In turn, the lithographs of the collection, which included reproductions of Salvatore Rosa's paintings, inspired foreign and Italian photographers, including the Alinari brothers. In the 1890s, the Florentine firm too made photographs of "macaroni sellers." See Fiorentino, Matacena, and Macry, *Napoli in posa*, 222. On the powerful role of these illustrated guides to Naples throughout the nineteenth and early twentieth centuries, see Francesca Amirante, ed., *Libri per vedere: Le guide storico-artistiche della città di Napoli; Fonti, testimonianze del gusto, immagini di una città* (Naples: Edizioni Scientifiche Italiane, 1995).

43. "What is striking and characteristic in the nineteenth-century theater is that its *dramaturgy* was pictorial, not just its *mise-en-scène* . . ." Martin Meisel, *Realizations: Narrative, Pictorial, and Theatrical Arts in Nineteenth-Century England* (Princeton, N.J.: Princeton University Press, 1983), 38–39.

44. In 1908 *Moving Picture World* reviewed *Napoli* (Life and Customs of Naples; Ambrosio, 1906), directed by Italian cinema's master cameraman, Giovanni Vitrotti. The reviewer appreciated the representation of Naples's "quaint streets and interesting inhabitants," known for their love of spaghetti, and marveled at a street scene showing "a line of Italians who guide the stringy delicacy to their hungry mouths with their fingers, disdaining the use of forks." *MPW* 2, no. 18 (2 May 1908): 408.

45. Linda Nochlin, *The Politics of Vision: Essays on Nineteenth-Century Art and Society* (New York: Harper and Row, 1989), 50.

46. David Francis and Joss Martin have devoted several of their magic lantern shows to Charles Dickens's fiction and Victorian temperance narratives in general.

47. See Giorgio Boatti, *La terra trema: Messina 28 dicembre 1908; I trenta secondi che cambiarono l'Italia, non gli italiani* (Milan: Mondadori, 2004).

48. Underwood and Underwood, "Mount Etna Smoking above Its Cloak of Snow, N. from St. Nicolai Church Tower, Catania." Photonegative, 1905, currently held at the Smithsonian Institution.

49. The resulting films, all made in 1909 and often exported to the U.S., included *Disastro di Reggio e Messina* [Disaster of Reggio and Messina, Ambrosio], *Dalla pietà all'amore* (Pity and Love, Saffi-Comerio), *Terremoto di Messina e Calabria* (Messina Earthquake, a.k.a. Messina Disaster, Cines), the three-part series *Il terremoto calabro-siculo* (Great Messina Earthquake, Saffi-Comerio), and the three-part series *Dopo il terremoto calabro-siculo* [After the earthquake in Calabria and Sicily, Croce & Co.]. Within a few years, follow-up productions included *Messina che risorge* [Messina rising from its ruins, Cines, 1910], and *Messina al giorno d'oggi* (Messina as It Is To-day, Cines, 1912). Among the American produc-

tions distributed in 1909, consider *Reggio and Messina Earthquake Scenes* (Vitagraph) and *Messina Earthquake* (Lubin). See *NYDM*, 30 January 1909, 16 and 18. Describing how G. W. Smith Jr. brought "72,000 feet of the earthquake film" to the U.S., the *Kinematograph & Lantern Weekly* (London) reported that "the subject went like hot cakes and proved a very big draw, the vaudeville houses featuring it and booming for all it was worth" (4 March 1909, 1179).

50. See *MPW* 4, no. 24 (12 June 1909): 809; and *MPW* 5, no. 8 (21 August 1909): 255. *L'orfanella di Messina* was shown at the twenty-seventh Pordenone Silent Film Festival, October 2008. Other titles included *L'eruzione dell'Etna* (Ambrosio, 1909), *L'eruzione dell'Etna* (Itala Film, 1910), *L'eruzione dell'Etna* (Croce & Co., 1910), *L'eruzione dell'Etna del 18 settembre* (Ambrosio, 1911), *L'eruzione dell'Etna* (Comerio, 1911), and *L'Etna* (Cines, 1911). Officially, none of them was exported to the U.S. However, a 1910 film by Urban-Eclipse, titled *Volcanic Eruption of Mt. Aetna,* was circulating in the U.S. It is likely that, rather than simply distributing it, Urban-Eclipse had actually filmed it on location, as it had *Romantic Italy* (1909), whose "picturesque features and tonal qualities combin[ed] to make a superb educational picture." *MPW* 5, no. 12 (18 September 1909): 379. Other films depicted these scenes as *actualités,* such as *Isole vulcaniche napoletane* [Neapolitan volcanic islands, Itala Film, 1909].

51. The reviews of *Dalla pietà all'amore,* which told the story of a British seaman liberating a Sicilian girl from the rubble, emphasized the realism of the story, including its "thrilling earthquake effects." See *Bioscope,* 4 March 1909, 15; *Kinematograph and Lantern Weekly,* 4 March 1909, 1197; and *MPW* 4, no. 24 (12 June 1909), which, possibly because of the notoriety of the Neapolitan volcano, placed Messina "at the foot of Vesuvius" (809).

52. Excavations had brought remnants of the temple to light a year before, as the *New York Times* had reported on 24 August 1865.

53. The logo appears in Sebastiano Gesù, *L'Etna nel cinema: Un vulcano di celluloide* (Catania: Giuseppe Maimone Editore, 2005), 17.

54. A straightforward polarization, North versus South, was more ideological than historically accurate. Southern middle classes gained access to the state administration and, unlike the local masses, they enjoyed the fruits of land redistribution policies; after the victory of the Left in the 1876 elections, Southern politicians held high roles in the government. On the inadequacies of this interpretive dualism, see Jonathan Morris's lucid "Challenging *Meridionalismo*: Constructing a New History for Southern Italy," in *The New History of the Italian South: The Mezzogiorno Revisited,* ed. Robert Lumley and Jonathan Morris (Exeter, UK: University of Exeter Press, 1997), 1–19.

55. Among the classic anthologies of essays on the South as a problem, see Antonio Renda, *La questione meridionale: Inchiesta* (Milan and Palermo: Sandron, 1900); Francesco Saverio Nitti, *Scritti sulla questione meridionale* (Bari: Laterza, 1958 [1910]); and Gaetano Salvemini, *Scritti sulla questione meridionale (1896–1955)* (Turin: Einaudi, 1955).

56. Antonio Gramsci, *The Southern Question,* trans. with an introduction by Pasquale Verdicchio (West Lafayette, Ind.: Bordighera, 1995). This essay was first written in 1926 and published in 1930.

57. *Antonio Gramsci: Prison Notebooks,* ed. Joseph A. Buttigieg, trans. Joseph A. Buttigieg and Antonio Callari (New York: Columbia University Press, 1992), 1:144–145.

58. Without formulating the notion of Southernism in the ways I propose it here, several authors have compared the heuristics of the Southern Question to Orientalism. See Beverly Allen and Mary Russo, eds., *Revisioning Italy: National Identity and Global Culture* (Minneapolis: University of Minnesota Press, 1997); and Jane Schneider, *Italy's "Southern Question": Orientalism in One Country* (Oxford and New York: Berg, 1998).

59. For a theoretically informed discussion of European identity's indispensable internal Other, see Roberto M. Dainotto's *Europe (In Theory)* (Durham, N.C.: Duke University Press, 2007).

60. The most outspoken proponent of the Northern/Southern relationship in Italy as "colonial in character" is Pasquale Verdicchio. See his *Bound by Distance: Rethinking Nationalism through the Italian Diaspora* (Teaneck, N.J.: Fairleigh Dickinson University Press, 1997).

61. Maria Todorova drew similar conclusions in her comparisons between Orientalism ("a discourse about an imputed opposition") and Balkanism ("a discourse about an imputed ambiguity") in *Imagining the Balkans* (New York: Oxford University Press, 1997), 17.

62. For discussions of mimesis and identity performance in general and with regard to cinema in particular, see Michael Taussig, *Mimesis and Alterity: A Particular History of the Senses* (New York: Routledge, 1993); and Scott MacKenzie, "Mimetic Nationhood: Ethnography and the National," in *Cinema and Nation,* ed. Mette Hjort and Scott MacKenzie (New York: Routledge, 2000), 241–259.

63. For cogent profiles of Lombroso's work, which has been translated into French and German since the 1880s and into English since the 1890s, see Herman Mannheim, "Lombroso and His Place in Modern Criminology," in *Group Problems in Crime and Punishment and Other Studies in Criminology and Criminal Law* (London: Routledge and Kegan Paul, 1955), 69–85; Stephen Jay Gould, *The Mismeasure of Man* (New York: Norton, 1981), 122–142; and Mary Gibson, *Born to Crime: Cesare Lombroso and the Origins of Biological Criminology* (Westport, Conn.: Praeger, 2002). For overviews of Italian racial ideologies, see Alberto Burgio, ed., *Nel nome della razza: Il razzismo nella storia d'Italia, 1870–1945* (Bologna: Il Mulino, 1999).

64. Gina Lombroso, *Criminal Man, According to the Classifications of Cesare Lombroso* (New York: G. P. Putnam, 1911), 140. Lombroso's daughter Gina Ferrero Lombroso collected and assembled his numerous papers and wrote his biography.

65. For a general discussion of Lombroso and Southern prejudice, see Roberta Passione, "Il Sud di Cesare Lombroso tra scienze e politica," *Il Risorgimento* 52, no. 1 (2000): 133–154; and Delia Castelnuovo Frigessi, *Cesare Lombroso* (Turin: Einaudi, 2003), 353–412. One of the most explicit examples of Lombroso's views on crime and racial differences in Italy appeared in *Corriere della Sera,* the prototypical periodical of the Italian bourgeoisie, on 29 October 1897, under the title "Razze e criminalità in Italia" (Races and Criminality in Italy).

66. Alfredo Niceforo, *L'Italia barbara contemporanea: Studi e appunti* (Milan and Palermo: Sandron, 1898), 247, 250. Sergi contrasted unchanging cranial features with the accidental character of "cutaneous coloration," which he considered "an effect of temperature, of climate, of alimentation, and of the manners of life." Against a bicolor approach to racial difference, he thus argued that "[Mediterranean] stock in its external characters is a *brown* human variety, neither white nor negroid, but pure in its elements, that is to say not a product of the mixture of Whites with Negroes or negroid peoples." Giuseppe Sergi, *Origine e diffusione della stirpe mediterranea: Induzioni antropologiche* (Rome: Dante Alighieri, 1895), 249–250, translated as *The Mediterranean Race: A Study of the Origin of European Peoples* (New York: C. Scribner's Sons, 1901), 250 (italics mine).

67. Niceforo, *L'Italia barbara,* 297. The concept of self-government had emerged in American racial culture, where it identified citizenship with whiteness ("free white persons fit for self-government"); it was also common in Italian political thought. See Giorgio Spini et al., eds., *Italia e America dal Settecento all'Età dell'Imperialismo* (Venice: Marsilio, 1976), 299–450.

68. Napoleone Colajanni, *Per la razza maledetta* (Milan and Palermo: Sandron, 1898), 18; and Gramsci, *The Southern Question*, 20–21 (in this edition "Southernist" translates *meridionalista*). In both instances, the italics are mine.

69. Similarly problematic were the photographic "Physiognomic Tables" that Lombroso's disciple, jurist and criminal sociologist Enrico Ferri (1856–1929), published in his *Atlante antropologico-statistico dell'omicidio* (Turin: Bocca, 1895), 227–239.

70. William Henry Fox Talbot, *The Pencil of Nature* (New York: Da Capo, 1968 [1844]), pl. 3.

71. Darwin's half-cousin, the eugenicist Galton, who had devised an earlier method of fingerprinting for the Bengalese subjects of the British Empire, produced composite portraits of criminals, medical patients, and Jews to conflate their "average" features into "ideal" types, only later realizing that "averaged features" tend to flatten out pathological peculiarities. For discussions of his endeavor, see Allan Sekula, "The Body in the Archive," *October* 39 (Winter 1986): 3–64; and Carlo Ginzburg, "Family Resemblances and Family Trees: Two Cognitive Metaphors," *Critical Inquiry* 30, no. 3 (Spring 2004): 537–556. On the challenges of American racial photography, see Ardis Cameron, "Sleuthing towards America: Visual Detection in Everyday Life," in *Looking for America: The Visual Production of Nation and People* (Malden, Mass.: Blackwell, 2005), 17–41.

72. Tom Gunning, "In Your Face: Physiognomy, Photography, and the Gnostic Mission of Early Film," *Modernism/Modernity* 4, no. 1 (1997): 6, 15.

73. Castelnuovo Frigessi, *Lombroso*, 326–352; and Théodore de Wyzewa, "Le roman italien en 1897," *Revue des deux mondes* 57 (1 December 1897): 699, quoted in Frigessi, *Lombroso*, 332. Lombrosian characterizations pervaded the fictional works of Paolo Mantegazza (*Un giorno a Madera* [1867]; *L'anno 3000* [1897]), the decadent fatalism of Gabriele D'Annunzio (*Il piacere* [1889]; *L'innocente* [1892]), the sinister novellas of Iginio Ugo Tarchetti (*Racconti fantastici* [1869]), and the disturbing profiles of Carlo Dossi (*I mattòidi* [1893]). See Andrea Rondini, *Cose da pazzi: Cesare Lombroso e la letteratura* (Pisa: Istituti editoriali e poligrafici internazionali, 2001).

74. On Sicilian novelists' adoption of Lombroso's ideas about race and degeneration, see Mario Tropea, *Nomi, ethos, follia negli scrittori siciliani tra Ottocento e Novecento* (Caltanissetta: Lussografica, 2000). On the notion of degeneration in European literature, see Daniel Pick, *Faces of Degeneration: A European Disorder, c. 1848–c. 1918* (New York: Cambridge University Press, 1989).

75. Rosario Romeo, *Risorgimento e capitalismo* (Bari: Laterza, 1959). See Lucy Riall, *The Italian Risorgimento: State, Society and National Unification* (New York: Routledge, 1994), chapter 4.

76. Giuseppe Pennacchia, *L'Italia dei briganti* (Rome: Rendina, 1998). For a general study of violence, revolt, and the Southern question, see John A. Davis, *Conflict and Control: Law and Order in Nineteenth-Century Italy* (London: Macmillan, 1988), chapters 3 and 11.

77. Lady Sydney Morgan's admiring biography *The Life and Times of Salvator Rosa* (London: H. Colburn, 1824) had glorified the Neapolitan painter as a charming *bandito*. For Italian bandits and brigands in European art, see Attilio Brilli, *Un paese di romantici briganti: Gli italiani nell'immaginario del grand tour* (Bologna: Mulino, 2003). From a literary standpoint, consider the sensationally popular Heinrich Zschokke's *Abällino, der grosne Bandit* (*The Bravo of Venice*, 1794); Ann Radcliffe's *The Italian; or, The Confessional of the Black Penitents: A Romance* (1797); Stendhal's *L'abbesse de Castro* (1832); and Byron's *The Two Foscari* (1821). By Irving and Douglas, consider, respectively, the novella "The Italian Banditti," in the third volume of Irving's *Tales of a Traveler* (Philadelphia: H. C. Cary and I.

Lee, 1824); and the travel guide *Old Calabria* (Boston: Houghton Mifflin, 1915), reminiscing about Musolino, one of the region's most notorious bandits.

78. For an overview, see Aldo De Jaco, ed., *Il brigantaggio meridionale: Cronaca inedita dell'unità d'Italia* (Rome: Editori Riuniti, 1969); and Francesco Gaudioso, *Il banditismo nel Mezzogiorno moderno tra punizione e perdono* (Galatina, Lecce: Mario Congedo Editore, 2001).

79. On this demonizing rhetoric and extraordinary violence, see Franco Molfese, *Storia del brigantaggio dopo l'Unità* (Milan: Feltrinelli, 1964); and John Dickie, *Darkest Italy: The Nation and Stereotypes of the Mezzogiorno, 1860–1900* (New York: St. Martin's Press, 1999), 25–51. On the images of *briganti* in Italian caricatures, paintings, and photography, see the superb exhibition catalog *Brigantaggio, lealismo, repressione nel Mezzogiorno, 1860–1870* (Naples: Macchiaroli, 1984).

80. Biagio Miraglia, *Parere frenologico sui famosi delinquenti Ciprinao e Giona La Gala, Domenico Papa e Giovanni D'Avanzo* (Aversa, 1864). See Francesco Faeta, *Strategie dell'occhio: Saggi di etnografia visiva*, rev. ed. (Milan: Franco Angeli, 2003), 37.

81. Eric Hobsbawm, *Primitive Rebels: Studies in Archaic Forms of Social Movements in the 19th and 20th Centuries* (New York: Norton, 1959). This heroic literary output famously included also the novella *La Libertà* (Freedom, 1882), by Italy's master realist writer, Giovanni Verga. For overviews, see Vittorio Consoli, *Amori e Tromboni: Briganti siciliani tra storia e leggenda* (Acireale: Bonanno, 1988 [1968]); Alfio Cavoli, *I briganti italiani nelle storie e nei versi dei cantastorie* (Rome: Scipioni, 1991); and *Brigantaggio, lealismo, repressione*, 280–310.

82. These studies began to appear shortly after the state's formation was completed. See Giuseppe Magaldi, *Fatti briganteschi* (Potenza, Santanello, 1862); and Giacomo Oddo, *Il brigantaggio o l'Italia dopo la dittatura di Garibaldi* (Milan: Eugenio Belzini, 1863). At the turn of the twentieth century, a number of famous writers and critics produced polemic essays on the state's treatment of brigandism. See Benedetto Croce, *Angiolillo (Angiolo duce), capo di banditi* (Naples: Pierro, 1892); Luigi Capuana, *La Sicilia e il brigantaggio* (Rome: Perelli, 1892); and Salvatore Di Giacomo, "Per la storia del brigantaggio napoletano," *Emporium* 19, nos. 110–112 (1904): 123–133, 283–295, now published in book form as *Per la storia del brigantaggio del napoletano* (Venosa and Potenza: Osanna Venosa, 1990).

83. The literature on Mafia organizations is massive. For a useful initial overview, compare John Dickie, *Cosa Nostra: A History of the Sicilian Mafia* (New York: Palgrave Macmillan, 2004) with Anton Blok's classic *The Mafia of a Sicilian Village, 1860–1960: A Study of Violent Peasant Entrepreneurs* (Oxford: Blackwell, 1974). On the relationship between the Mafia and brigands, see Rosario Mangiameli, "Banditi e Mafiosi dopo l'Unità," *Meridiana* 7–8 (1990): 73–113; and Mario Siragusa, *Baroni e briganti: Classi dirigenti e mafia nella Sicilia del latifondo, 1861–1950* (Milan: Franco Angeli, 2004). On the Camorra, see Tom Behan, *See Naples and Die: The Camorra and Organised Crime* (New York: Palgrave Macmillan, 2002).

84. In 1889, the famous Sicilian folklorist Giuseppe Pitrè dismissed the Arab, Tuscan, and French etymologies of the word "mafia" as fantasies, detailing instead its Western Sicilian origin and use as a vernacular term for "beauty, grace, perfection, and excellence." Pitrè, *Usi e costumi, credenze e pregiudizi del popolo siciliano* (Palermo: Clausen, 1889), 2:289–90.

85. Almost half a million cases of Sicilian citrus were exported to the United States in 1850, and the number would reach 2.5 million by the mid-1880s. Salvatore Lupo, *Il giardino degli aranci: Il mondo degli agrumi nella storia del Mezzogiorno* (Venice: Marsilio, 1990), 22ff.; Dickie, *Cosa Nostra*, 39. In 1875, Neapolitan historian Pasquale Villari had already linked the emergence of the Mafia to the intense commercial activity in the coastal areas

near Palermo. There, murders and kidnappings were far more frequent than in the inland provinces. Villari, "La Mafia," *Opinione* (March 1875), now in Villari, *I mali dell'Italia: Scritti su mafia, camorra e brigantaggio* (Florence: Vallecchi Editore, 1995), 90ff.

86. Dickie, *Cosa Nostra*, 39.

87. I will return to the issue of the Sicilian Mafia (and Neapolitan Camorra) in North America in chapter 7. It is interesting to note the link between Sicilian oranges and Mafia killings in American cinematic imagery. The attempted assassination of Vito Corleone in Coppola's *The Godfather* (1972) takes place in front of a Lower East Side fruit market. The aging boss had approached it to buy Sicilian oranges in an almost lethal indulgence of his nostalgia. His fall to the ground, shot by rival Mafiosi, causes dozens of oranges to be thrown in all directions, beautifully followed in a crane shot.

88. Antonio Altomonte, *Mafia, briganti, camorra e letteratura* (Milan: Pan Editrice, 1979), 14. See also Donato Calcedonio, *I mafiusi di la Vicaria: Indagine storico-linguistica e strutturale della commedia di G. Rizzotto* (Florence: Sabella, 1979), 7–91.

89. In the popular genre of "true crime" melodrama, consider Salvatore Mannino's novel *I pugnalatori di Palermo* (1862). On the Mafia and literature, see Elena Brancati and Carlo Muscetta, *La letteratura sulla mafia* (Roma: Bonacci, 1988); and Vito Marcadante, ed., *Letteratura sulla mafia: Dal sonno alla speranza; Antologia di letteratura sulla mafia* (Palermo: Rinascita siciliana, 1998).

90. Economists Leopoldo Franchetti and Sidney Sonnino described the Mafia as a modern "industry of violence," cornering the use of force where the land had become a major economic commodity and where the state had failed in its duties. Franchetti and Sonnino, *La Sicilia nel 1876* (Florence: G. Barbera, 1877), 1:158ff.

91. The most influential study linking *brigantaggio* with Mafia criminality on the grounds of shared physical and anthropological conditions was Giuseppe Alongi's *La maffia* (1886). A policeman turned sociologist, Alongi adopted the work of criminal anthropologists Cesare Lombroso and Enrico Ferri to describe brigands as utterly apolitical and instead as "most vulgar[ly] delinquent, inept at the fertile test of labor, unpredictable, somnolent and sensual." At the basis of Sicilian criminality, Alongi placed the impulsive, proud, and individualistic Sicilian character or temperament, molded by climate, the fertility (or lack thereof) of the soil, and a hereditary brutality. Alongi, *La maffia nei suoi fattori e nelle sue manifestazioni: Studio sulle classe pericolose della Sicilia* (Palermo: Sellerio, 1977 [1886]), 63, 36–45.

92. Fifty years later after the 1861 unification, the national illiteracy rate was still 37.9 percent; it was higher than 50 percent in the South. SVIMEZ, *Un secolo di statistiche italiane: Nord e sud 1861–1961* (Rome: Associazione per lo sviluppo dell'industria nel Mezzogiorno, 1961), 795. Not all vernaculars were born equal. Sicilian, Neapolitan, Milanese, and Venetian, for instance, had a literary tradition in addition to their numerous spoken versions.

93. Hermann W. Haller, *The Other Italy: The Literary Canon in Dialect* (Toronto: University of Toronto Press, 1999), 26.

94. See Giovanni Ragone, *Un secolo di libri: Storia dell'editoria in Italia dall'unità al postmoderno* (Turin: Einaudi, 1999), 38–79.

95. In the following years, *Malìa* became one of the most popular Italian dramas exhibited in Italy and in New York. I will return to this point in chapter 7.

96. Nelson Moe, *The View from Vesuvius: Italian Culture and the Southern Question* (Berkeley: University of California Press, 2002), 266. Moe recognizes the picturesque as one of Verga's most dominant aesthetic registers, although not the only one. On Verga's use of anthropology and folklore studies, and on his ill-fated film adaptations, see Lia Gi-

ancristofaro, *Il segno dei vinti: Antropologia e letteratura in Verga* (Lanciano: Rocco Carabba, 2005); and Gino Raya, *Verga e il cinema* (Rome: Herder Editore, 1984).

97. Beginning in 1902, Grasso embodied the notion of a Sicilian theatre in Italy and abroad. His major successes were interpretations of *Malìa, La cavalleria rusticana* (which Martoglio had adapted and translated into vernacular Sicilian), *I mafiusi di la Vicaria,* and *La zolfara*. For a remarkable profile, see Sarah Zappulla Muscarà and Enzo Zappulla, *Giovanni Grasso: Il più grande attore tragico del mondo* (Acireale: La Cantinella, 1995).

98. Pes (Enrico Polese Santarnecchi), "La compagnia Siciliana a Milano," *L'arte drammatica* (Milan), 18 April 1903, quoted in Zappulla-Muscarà, *Giovanni Grasso,* 53–54.

99. Gordon Craig, 'Recollections of a Remarkable Actor," *Listener* 57, no. 1451 (17 January 1957): 105.

100. Keraban, "*Il Capitan Blanco* al Salone Margherita," *La cine-fono* 8, no. 286 (11 July 1914), quoted in *FCMI 1914,* 1:90–91.

101. Influenced by the popular and celebrated tradition of such authors as Victorien Sardou, Alexander Dumas *fils,* and Henrik Ibsen, and a close friend of major contemporary writers such as Maxim Gorky, Bracco wrote comedic plays on marriage and adultery, but also stage plays of social critique, centered on the lives of the Southern lower classes.

102. The chief critic of *La cine-fono* (Naples), Paolo Cacace (known as Keraban), resorted to the familiar picturesque imagery when he rhetorically likened Grasso's acting style to "a ship with its fast-moving sails under the mistral, riding its trawlers on the dangerous but always blue waves of the Mediterranean Sea, near the shores of the Cyclops." Keraban, "*Il Capitan Blanco* al Salone Margherita,"45.

103. A. A. Cavallari, "Sperduti nel buio," *La vita cinematografica* 8:286 (December 1915), now in *FCMI 1914,* 2:235.

104. Keraban, "*Sperduti nel buio* al Salone Margherita," *La cine-fono e la rivista fono-cinematografica* 9, no. 298 (16–29 January 1915): 61, reprint in *Sperduti nel buio,* ed. Alfredo Barbina (Rome: Nuova ERI/Biblioteca di Bianco & Nero, 1987), 145.

105. On Neapolitan music, see Franco Mancini and Pietro Gargano, *Nel segno della tradizione: Piedigrotta; I luoghi le feste le canzoni* (Naples: Guida, 1991); and Marialuisa Stazio, *Osolemio: La canzone napoletana, 1880–1914* (Rome: Bulzoni, 1991).

106. See Giuliana Bruno, *Streetwalking on a Ruined Map: Cultural Theory and the City Films of Elvira Notari* (Princeton, N.J.: Princeton University Press, 1993), especially chapter 12.

107. On Neapolitan cinema, see Stefano Masi and Mario Franco, *Il mare, la luna, i coltelli: Per una storia del cinema muto napoletano* (Naples: Tullio Pironti Editore, 1988). On Dora Film, which produced both *La figlia del Vesuvio* and *A Marechiaro ce sta 'na fenesta,* see Bruno, *Streetwalking.*

108. See Bruno's *Streetwalking,* chapter 10.

109. G. A. R., "Assunta Spina," *Apollon* (Rome), July 1916, now in *FCMI 1915,* 1:52; and E. Caracciolo, "Assunta Spina," *Film* (Naples), 10 November 1915, now in *FCMI 1915,* 1:54.

110. Gulliver, "Assunta Spina," *La rivista cinematografica* (Turin), 10 October 1924, now in *FCMI 1915,* 1:56.

111. A recent reading of her acting style is Gerardo Guccini, "Note intorno all'interpretazione di 'Assunta Spina,'" *Cinegrafie* 6 (1993): 114–118, now in *Francesca Bertini,* ed. Gianfranco Mingozzi (Genoa: Le Mani; Bologna: Cineteca di Bologna, 2003), 82–87.

112. See Umberto Barbaro, "Un film italiano di un quarto di secolo fa" (1936), now in *Servitú e grandezza del cinema* (Rome: Editori Riuniti, 1962), 142–149, 144 ("Southern Romanticism"), and "Soggetto e sceneggiatura," first published as "Film: Soggetto e sceneg-

giatura" in 1939, now in *Il film e il risarcimento marxista dell'arte* (Rome: Editori Riuniti, 1960), 55–176. It is interesting to note that Barbaro, who also contributed to hailing Verga as a model of dramaturgic realism, was not a Northern Italian man charmed by Southern Italian aesthetics and literature. He was born, of all places, in Aci Trezza.

3. Picturesque Views and American Natural Landscapes

The first epigraph is from Thomas Cole's journal entry for 6 July 1835 in Louis Legrand Noble, *The Course of Empire, Voyage of Life, and Other Pictures of Thomas Cole* (New York: Cornish, Lamport, 1853), 202. The second epigraph is from Charles W. Sanders, *The School Reader: Third Book* (New York: Ivison and Phinney, 1853), 171–172, quoted in Ruth Miller Elson, *Guardians of Tradition: American Schoolbooks of the Nineteenth Century* (Lincoln: University of Nebraska Press, 1964), 37. I am grateful to Timothy Rood for pointing out this passage to me. The third epigraph is from "Exporting the American Film," *MT* 6, no. 2 (August 1911): 90. Later ones are from George Wharton James, *Our American Wonderlands* (Chicago: A. C. McClurg, 1915), ix–xxv, quoted in Ann Farrar Hyde, *An American Vision: Far Western Landscape and National Culture, 1890–1920* (New York: New York University Press, 1990), 208; and James Fenimore Cooper, *The Last of the Mohicans,* quoted in Scott Simmon, *The Invention of the Western Film: A Cultural History of the Genre's First Half-Century* (New York: Cambridge University Press, 2003), 15.

1. The literature on these dense cultural exchanges is extensive. See, among others, Beth Lynne Lueck, *American Writers and the Picturesque Tour: The Search for National Identity, 1790–1860* (New York: Garland, 1997); Theodore E. Stebbins, Jr., *The Lure of Italy: American Artists and the Italian Experience, 1760–1910* (Boston: Museum of Fine Arts; New York: Harry N. Abrams, 1992); Leonardo Buonomo, *Backward Glances: Exploring Italy, Reinterpreting America (1831–1866)* (Madison, N.J.: Fairleigh Dickinson University Press, 1996); and Robert K. Martin and Leland S. Person, *Roman Holidays: American Writers and Artists in Nineteenth-Century Italy* (Iowa City: University of Iowa Press, 2002).

2. Roderick Nash, *Wilderness and the American Mind,* rev. ed. (New Haven, Conn.: Yale University Press, 1973), xv; and Leo Marx, *The Machine in the Garden: Technology and the Pastoral Ideal in America* (New York: Oxford University Press, 1964), 11ff. For a broader discussion of Marx's "pastoral ideal," see his "Pastoralism in America," in *Ideology and Classic American Literature,* ed. Sacvan Bercovitch and Myra Jelhen (New York: Cambridge University Press, 1986), 36–69.

3. Barbara Novak, *Nature and Culture: American Landscape and Painting, 1825–1875,* 3rd ed. (New York: Oxford University Press, 2007), 3.

4. Bruce Robertson, "The Picturesque Traveler in America," in *Views and Visions: American Landscape before 1830,* ed. Edward J. Nygren (Washington, D.C.: Corcoran Gallery of Art, 1986), 189–211; and Lueck, *American Writers and the Picturesque Tour,* especially 189–194.

5. Noble, *The Course of Empire,* 114.

6. Oswaldo Rodriguez Roque, "The Exaltation of American Landscape Painting," in *American Paradise: The World of the Hudson River School,* ed. John K. Howat (New York: H. N. Abrams, 1987), 24. Cole himself contributed to the picturesque rendering of Italy: in 1842 he visited Sicily, where he completed several views commonly titled *Mount Aetna from Taormina* (1843–44). A few years earlier, he had produced the scenic *Interior of the Colosseum, Rome* (1832) and the spirited *Salvator Rosa Sketching Banditti* (1832–40), which included the figure of an artist sketching *banditti* resting in a gloomy valley.

7. See Edward Halsey Foster, *The Civilized Wilderness: Background to American Romantic Literature, 1817–1860* (New York: Free Press, 1975), 3–47.

8. Blake Nevius, *Cooper's Landscapes: An Essay on the Picturesque Vision* (Berkeley: University of California Press, 1976), 111. What Cooper wrote about his experiences traveling in Italy is also interesting for this study. He eloquently contrasted the charming light, irregularity, and steep cliffs of the coast of Naples, particularly the towering presence of Vesuvius, with the bursting modern center of commercial utilitarianism that was New York City. James Fenimore Cooper, *Gleanings in Europe: Italy* (Albany: State University of New York Press, 1981 [1831]), 132.

9. Its editor was William Cullen Bryant and its full title was *Picturesque America; or, The Land We Live In: A Delineation by Pen and Pencil of the Mountains, Rivers, Lakes, Water-Falls, Shores, Cañons, Valleys, Cities, and other Picturesque Features of Our Country; With Illus. on Steel and Wood, by Eminent American Artists* (Secaucus, N.J.: Lyle Stuart, 1974 [1872–74]). On this astonishing editorial accomplishment, see Sue Rainey, *Creating "Picturesque America": Monument to the Natural and Cultural Landscape* (Nashville, Tenn.: Vanderbilt University Press, 1994).

10. Rainey, *Creating "Picturesque America,"* 28–29.

11. Bryant, *Picturesque America,* 2:149; and Rainey, *Creating "Picturesque America,"* 268.

12. William H. Truettner, ed., *The West as America: Reinterpreting Images of the Frontier, 1820–1920* (Washington, D.C.: Smithsonian Institution Press, 1991), 47–48.

13. The French actress Madame Céline Céleste (1815–71), a precocious veteran of the Bowery Theater in New York and of the British stage, became famous for her stage interpretations of Miami, The Huntress of the Mississippi, a dangerous Indian woman whose wildness is tamed by her love for an Englishman. The creator of this character was the British playwright John Baldwin Buckstone, who, a few years after visiting the United States, wrote *The Green Bushes*, first performed in England in 1845. British writer Henry Morley wrote, "Madame Céleste should have something melodramatic and picturesque which would enable her to display all the power that is in her." George Taylor, *Players and Performances in the Victoria Theatre* (Manchester: Manchester University Press, 1989), 16. I am grateful to Helen and David Mayer for sharing this information. As for the significance of Grand Tour references in American painterly culture, usually resulting from individual artists' travels, consider George Loring Brown's sights of Vesuvius and the Bay of Naples, Sanford Robinson Gifford's scenes of the Roman Campagna, and Thomas Hiram Hotchkiss's views of the Coliseum.

14. This is how recent authors identified the principles that landscape designer William Kent followed for his celebrated English landscape gardens at Stowe, Buckinghamshire. Laurence Whistler, Michael Gibbon, and George Clark, *Stowe: A Guide to the Gardens* (Buckingham, UK: E. N. Hillier & Sons, 1968), 17.

15. George Catlin, *North American Indians: Being Letters and Notes on Their Manners, Customs, and Conditions, Written during Eight Years' Travel amongst the Wildest Tribes of Indians in North America, 1832–1839* (Philadelphia: Leary, Stuart, 1913), 1:292–293, quoted in Nash, *Wilderness,* 101.

16. Joni Louise Kinsey, *Thomas Moran and the Surveying of the American West* (Washington, D.C.: Smithsonian Institution Press, 1992).

17. Before repeatedly meeting with Olmsted, in the mid-1840s Downing and William Cullen Bryant publicly argued the need for a public park for a city that had endured decades of massive population growth.

18. Andrew Jackson Downing, *Rural Essays* (New York: Geo. A. Leavitt, 1869 [1853]), 123.

19. Andrew Jackson Downing, *The Architecture of Country Houses* (New York: D. Appleton, 1850), iii. In 1870, Olmsted himself spoke of the park's "distinctly harmonizing and refining influence upon the most unfortunate and most lawless classes of the city,—an influence favorable to courtesy, self-control, and temperance." Frederick Law Olmsted and Theodora Kimball, eds., *Frederick Law Olmsted: Landscape Architect, 1822–1903* (New York: Putnam's, 1928), 2:171.

20. Roy Rosenzweig and Elizabeth Blackmar, *The Park and the People: A History of Central Park* (Ithaca, N.Y.: Cornell University Press, 1992), 391–392; see also John Conron, *American Picturesque* (University Park: Pennsylvania State University Press, 2000), 273–288.

21. On this subject, see Robert H. Keller and Michael F. Turek, *American Indians and National Parks* (Tucson: University of Arizona Press, 1998); and Mark David Spence, *Dispossessing the Wilderness: Indian Removal and the Making of the National Parks* (New York: Oxford University Press, 1999).

22. On survey photographs' intersections between painterly qualities and instrumental logic, see Robin Kelsey's brilliant *Archive Style: Photographs and Illustrations for U.S. Surveys, 1850–1890* (Berkeley: University of California Press, 2007).

23. Miles Orvell, *The Real Thing: Imitation and Authenticity in American Culture, 1880–1940* (Chapel Hill: University of North Carolina Press, 1989), 99.

24. For a wider discussion, see Alan Trachtenberg, *Reading American Photographs: Images as History, Mathew Brady to Walker Evans* (New York: Hill and Wang, 1985), 119–163.

25. Weston J. Naef and James N. Wood, *Era of Exploration: The Rise of Landscape Photography in the American West, 1860–1885* (Buffalo, N.Y.: Albright-Knox Art Gallery, 1975), 12.

26. Their work alternated an attention to details of natural objects and scenes with more diffusive and vaporous renderings, whose style, later known as "luminist," evoked religious transcendence and the sublime. See Novak, *Nature and Culture,* 37 and passim.

27. Eugene Ostroff, *Western Views and Eastern Visions* (Washington, D.C.: Smithsonian Institution Traveling Exhibition Service, 1981), 8ff.

28. Naef and Wood, *Era of Exploration,* 34; see also 16. The relationship between painting and photography was not a one-way street. "By the third quarter of the 19th century, only landscape painting could compete successfully with photography for American popular interest. This it did by adopting the aesthetic of the photographer." Elizabeth Lindquist-Cock, *The Influence of Photography on American Landscape Painting, 1839–1880* (New York: Garland, 1977), v.

29. For an insightful and critical discussion of landscape photography, see Daniel Wolf, ed., *The American Space: Meaning in Nineteenth-Century Landscape Photography* (Middletown, Conn.: Wesleyan University Press, 1983). On individual photographers, see Joel Snyder, *American Frontiers: The Photographs of Timothy H. O'Sullivan, 1867–1874* (Millerton, N.Y.: Aperture, 1981); and James L. Sheldon and Jock Reynolds, *Motion and Document, Sequence and Time: Eadweard Muybridge and Contemporary American Photography* (Andover, Mass.: Addison Gallery of American Art, 1991). For a recent, original look at expedition photography, see Kelsey, *Archive Style.*

30. Peter E. Palmquist, *Carleton E. Watkins, Photographer of the American West* (Albuquerque: University of New Mexico Press, 1983), 58.

31. On landscape photography and the Western film, a starting point is Deborah Bright's classic contribution "Of Mother Nature and Marlboro Men: An Inquiry into the

Cultural Meanings of Landscape Photography," which first appeared in *Exposure* 23, no. 1 (1985), and is now in *The Contest of Meaning: Critical Histories of Photography*, ed. Richard Bolton (Cambridge, Mass.: MIT Press, 1989), 125–142.

32. On the racializing exchanges between landscape and characters, see Kevin De-Luca, "In the Shadow of Whiteness: The Consequences of Constructions of Nature in Environmental Politics," in *Whiteness: The Communication of Social Identity*, ed. Thomas K. Nakayama and Judith N. Martin (Thousand Oaks, Calif.: Sage, 1999), 217–246; and Martin A. Berger, *Sight Unseen: Whiteness and American Visual Culture* (Berkeley: University of California Press, 2005), especially 55ff. Berger's work productively comments on the racial culture implicit in American genre paintings, landscape photographs, and early films even when their overt theme is not race. Surprisingly, he fails to link these visual productions with the dense morphological and ideological tradition of the picturesque.

33. The literature on the emergence of the Western genre in literature, illustration, and film is immense. For a magnificent catalog of tropes and forms, see Truettner's *The West as America*. For examples of prints and chromolithographs of picturesque American landscapes decorating the walls of urban lower- and middle-class homes, see Peter C. Marzio, *The Democratic Art: Pictures for 19th Century America; Chromolithography, 1840–1900* (Boston: Godine, 1979), plates 19, 23, 24, 37a, 38, 40, 71–79.

34. Richard Abel, "Our Country/Whose Country? The Americanization Project of Early Westerns, 1907–1910," in *The Red Rooster Scare: Making Cinema American, 1900–1910* (Berkeley: University of California Press, 1999), 151–174; and Charles Musser, "Nationalism and the Beginnings of Cinema: The Lumière Cinématographe in the U.S., 1896–1897," *Historical Journal of Film, Radio and Television* 19, no. 2 (1999): 149–176. Predictably, silent British cinema emphasized a proud sense of national identity through a stylized representation of the natural landscape. See Laraine Porter and Bryony Dixon, eds., *Picture Perfect: Landscape, Place and Travel in British Cinema before 1930* (Exeter, UK: Exeter Press, 2007).

35. Charles Musser, "Before the Rapid Firing Kinetograph: Edison Film Production, Representation and Exploitation in the 1890s," in *Edison Motion Pictures, 1890–1900: An Annotated Filmography* (Pordenone: Le Giornate del Cinema Muto; Washington, D.C.: Smithsonian Institution Press, 1997), 44.

36. Musser, "Nationalism and the Beginnings," 168.

37. On this point, see also Tom Gunning, "The Whole World Within Reach: Travel Images without Borders," in *Cinéma sans frontières 1896–1918: Images Across Borders*, ed. Roland Cosandey and François Albéra (Lausanne and Québec: Nuit Blanche Éditeur, 1995), 21–36; reprinted in Jeffrey Ruoff, ed., *Virtual Voyages: Cinema and Travel* (Durham, N.C.: Duke University Press, 2006), 25–41; and T. C. McLuhan, *Dream Tracks: The Railroad and the American Indian, 1890–1930* (New York: Abrams, 1985). The most systematic account of the encounter between motion pictures and the railroad is Lynne Kirby, *Parallel Tracks: The Railroad and Silent Cinema* (Durham, N.C.: Duke University Press, 1997), which defines the railroad as nothing short of a "*protocinematic* phenomenon" (2, italics in the original). See also John R. Stilgoe, *Metropolitan Corridor: Railroads and the American Scene* (New Haven, Conn.: Yale University Press, 1983).

38. On panoramas in early cinema, see Angela Miller, "The Panorama, the Cinema, and the Emergence of the Spectacular," *Wide Angle* 18, no. 2 (April 1996): 34–69.

39. Iris Cahn, "The Changing Landscape of Modernity: Early Film and America's 'Great Picture' Tradition," *Wide Angle* 18, no. 3 (July 1996): 90. Cahn's essay includes an appendix listing North American landscape films in the Paper Print Collection of the Library of Congress. Among the seventy films listed, which include only surviving copyrighted

productions, "there are at least forty-five films of the American and Canadian West, fifteen of the Niagara Falls area, and nine of the Catskills region, alone" (86).

40. Gordon Hendricks, *Beginnings of the Biograph: The Story of the Invention of the Mutoscope and the Biograph and Their Supplying Camera* (New York: Beginnings of the American Film, 1964), 38. An early film historian and author of a classic volume on the life and work of Eadweard Muybridge, Hendricks wrote also a lengthy study on Muybridge's friend, the landscapist and Grand Tour artist Albert Bierstadt.

41. Katherine Manthorne, "Experiencing Nature in Early Film: Dialogues with Church's *Niagara* and Homer's *Seascapes*," in *Moving Pictures: American Art and Early Film, 1880–1910*, ed. Nancy Mowll Mathews with Charles Musser (Manchester, Vt.: Hudson Hills, 2005), 55–60. In the same outstanding anthology, see also Nancy Mowll Mathews, "Early Film and American Artistic Traditions," 39–54. For a general discussion, see Elizabeth McKinsey, *Niagara Falls: Icon of the American Sublime* (Cambridge: Cambridge University Press, 1985). For a list of Edison films about Niagara Falls, see Musser, *Edison Motion Pictures*, 713–715; and, for those produced by Biograph, see Hendricks, *Beginnings of the Biograph*, 38–39, 48–51. In the Italian and American framework of this study, it is worth noting that Lumière's *Niagara, Horseshoe Falls* was shot by Alexandre Promio, the legendary cameraman who, later that year, took the celebrated "panning shots" of Venice from moving gondolas featured in *Panorama du Grand-Canal pris d'un bateau* and *Panorama de place Saint-Marc pris d'un bateau*.

42. In addition to a "Niagara Series" of travelogues, Edison also produced the fiction films *Captain Nissen Going through the Whirlpool Rapids, Niagara Falls* (1901) and *Crossing Ice Bridge at Niagara Falls* (1903), the latter directed by E. S. Porter.

43. Marguerite Shaffer, *See America First: Tourism and National Identity, 1905–1930* (Washington, D.C.: Smithsonian Institution Press, 2001), 4–5.

44. Suffice it here to mention the British example of the Royal Polytechnic Institution, founded in 1838 and for more than four decades a major player in Europe's magic lantern culture. Its hundreds of slides included a cluster of familiar subjects: Mount Etna, Mount Vesuvius erupting, the earthquake at Messina, and Niagara Falls. See Laurent Mannoni, "Le thème du voyage à travers les plaques de lanterne magique de la Royal Polytechnic," in "Exotica: L'attraction des lointains," special issue of *1895*, numéro hors série, 1996: 23–52, especially 30.

45. Genoa Caldwell, ed., *Burton Holmes Travelogues: The Greatest Traveler of His Time, 1892–1952* (London: Taschen, 2006), 12. One of the earliest films Holmes exhibited, shot in 1897 by his cameraman and collaborator Oscar B. Depue with Demeny's Chronophotographe, was *St. Peter's Cathedral in Rome*, which recorded a flock of sheep passing through Vatican Square in Rome amidst obelisks and statues. See X. Theodore Barber, "The Roots of Travel Cinema: John L. Stoddard, E. Burton Holmes, and the Nineteenth-Century Illustrated Travel Lecture," *Film History* 5, no. 1 (March 1993): 73, 81.

46. On travelogue lecturers, see Rick Altman, "From Lecturer's Prop to Industrial Product: The Early History of Travel Film," in *Virtual Voyages: Cinema and Travel*, ed. Jeffrey Ruoff (Durham, N.C.: Duke University Press, 2006), 61–76. Rarely mentioned among these lecturers is Jacob Riis, whose 1880s stereopticon lectures about the urban poor were widely popular. See Maren Stange, *Symbols of Ideal Life: Social Documentary Photography in America, 1890–1950* (New York: Cambridge University Press, 1989).

47. The film's title was *Scenes and Incidents during the Visit of President Roosevelt at Wilkes-Barre, Pa, August 10th, 1905*. See Charles Musser with Carol Nelson, *High-Class Moving Pictures: Lyman H. Howe and the Forgotten Era of Traveling Exhibition, 1880–1920* (Princeton,

N.J.: Princeton University Press, 1991), 167. Howe's "Great International Spectacle" in-cluded films shot in Italy, such as *The Fury of Vesuvius* (1906). An image of Howe's illus-trated program for this film is in Richard Abel, *Encyclopedia of Early Cinema* (New York: Routledge, 2005), 308.

48. Charles Musser, "The Travel Genre in 1903–1904: Moving toward Fictional Nar-rative," in *Early Cinema: Space, Frame, Narrative,* ed. Thomas Elsaesser (London: British Film Institute Publishing, 1990), 123–132.

49. Jennifer Lynn Peterson, "'The Nation's First Playground': Travel Films and the American West, 1895–1920," in Ruoff, *Virtual Voyages,* 79. See also her "World Pictures: Travelogue Films and the Lure of the Exotic, 1890–1920" (Ph.D. diss., University of Chi-cago, 1999), especially chapter 4, and "Travelogues and Early Nonfiction Film: Education in the School of Dreams," in *American Cinema's Transitional Era: Audiences, Institutions, Practices,* ed. Charlie Keil and Shelley Stamp (Berkeley: University of California Press, 2004), 191–213. Pathé, Edison, Eclipse, and Selig released the majority of travel films in America between 1908 and 1915.

50. Peterson, "'The Nation's First Playground,'" 83.

51. Ibid.

52. Peterson, "World Pictures," 194.

53. George Wharton James, *Our American Wonderlands* (Chicago: A. C. McClurg, 1915), ix–xxv, quoted in Ann Farrar Hyde, *An American Vision: Far Western Landscape and National Culture, 1890–1920* (New York: New York University Press, 1990), 208.

54. Linda Nochlin, *The Politics of Vision: Essays on Nineteenth-Century Art and Society* (New York: Harper and Row, 1989), 50. *Picturesque Yosemite* was how the Biograph catalog listed *Glacier Point,* one of the six *actualités* the company released that year. Three years earlier, Edison had produced similar one-shot *actualités* of Yellowstone. Peterson, "'The Nation's First Playground,'" 83.

55. Musser and Nelson, *High-Class Moving Pictures,* 54.

56. Shaffer, *See America First.*

57. Peterson, "'The Nation's First Playground,'" 86.

58. I am here referring to Hans-Georg Gadamer's celebrated notion of *Wirkungsge-schichte* or "reception history," articulated in his *Wahreit und Methode* (Tübingen: J. C. B. Mahr, 1960), trans. Joel Weinsheimer and Donald G. Marshall as *Truth and Method* (New York: Crossroad, 1989), 300–306.

59. Kristen Whissel, "Placing the Spectator on the Scene of History: The Battle Re-enactment at the Turn of the Century, from Buffalo Bill's Wild West to the Early Cinema," *Historical Journal of Film, Radio and Television* 22, no. 3 (2002): 227–228. See also G. Edward White, *The Eastern Establishment and the Western Experience* (New Haven, Conn.: Yale University Press, 1968); and Richard Slotkin's classic *Gunfighter Nation: The Myth of the Frontier in Twentieth-Century America* (Norman: Oklahoma University Press, 1998 [1992]).

60. Radically different from P. T. Barnum's hoaxes and humbug, Cody's Wild West shows solicited a "spectatorial identification with the star and the process of continental expansion, imperial prowess, and national progress he re-enacted." Whissel, "Placing the Spectator," 232.

61. Ibid., 233.

62. See Kristen Whissel, "The Gender of Empire: American Modernity, Masculinity and Edison's War Actualities," in *A Feminist Reader in Early Cinema,* ed. Jennifer M. Bean and Diane Negra (Durham, N.C.: Duke University Press, 2002), 141–165.

63. David A. Curtis, "The Wild West and What It Lacks," *Criterion*, in Cody Scrapbook, Denver Public Library, vol. 7, 183, quoted in Slotkin, *Gunfighter Nation*, 81; see also Whissel, "Placing the Spectator," 241n31.

64. Wilson Mayer, "Moving Picture Work of the Railroad," *The Nickelodeon* (February 1909): 41, quoted in Peterson, "World Pictures," 193.

65. Alison Griffiths, *Wondrous Difference: Cinema, Anthropology and Turn-of-the-Century Visual Culture* (New York: Columbia University Press, 2002), 194.

66. Fatimah Tobing Rony, *The Third Eye: Race, Cinema, and Ethnographic Spectacle* (Durham, N.C.: Duke University Press, 1996), 38. For a theoretical discussion of the exchanges between tourism and ethnography, see Catherine Russell, "Beyond Authenticity: The Discourse of Tourism in Ethnographic and Experimental Film," *Visual Anthropology* 5 (1992): 131–145.

67. See James Gilbert, "Fixing the Image: Photography at the World's Columbian Exposition," in *Grand Illusions: Chicago's World's Fair of 1893*, ed. Neil Harris et al. (Chicago: Chicago Historical Society, 1993), 99–140; Eric Breitbart, *A World on Display: Photographs from the St. Louis World's Fair, 1904* (Albuquerque: University of New Mexico Press, 1997); and Griffiths, *Wondrous Difference*, chapter 2.

68. Ira Jacknis, "The Picturesque and the Scientific: Franz Boas's Plan for Anthropological Filmmaking," *Visual Anthropology* 1, no. 1 (1987): 61.

69. The notion of taxidermic cinema is from Rony, *The Third Eye*, 91 and passim. The description of Curtis's "pictorialist style" is from Griffiths, *Wondrous Difference*, 238.

70. Vachel Lindsay, *The Art of the Moving Picture* (New York: Liveright, 1970 [1915; rev. 1922], 114. On Curtis's work, see Susan Applegate Krouse, "Photographing the Vanishing Race," *Visual Anthropology* 3, nos. 2–3 (1990): 213–233; and Christopher Lyman, *The Vanishing Race and Other Illusions: Photographs of Indians by Edward Curtis* (Washington, D.C.: Smithsonian Institution Press, 1982).

71. As different figures as the high-class Burton Holmes (1898), Thomas Edison (1898–1901), and Teddy Roosevelt (1913) arranged to film a Moki snake dance in Arizona.

72. Alison Griffiths, "Playing at Being Indian: Spectatorship and the Early Western," *Journal of Popular Film & Television* 29, no. 3 (Fall 2001): 101.

73. Scott Simmon, *The Invention of the Western Film: A Cultural History of the Genre's First Half-Century* (New York: Cambridge University Press, 2003), 4. Nanna Verhoeff devotes significant attention to the importance of the American landscape without making it a central concern of her otherwise remarkable discussion. See her *The West in Early Cinema: After the Beginning* (Amsterdam: Amsterdam University Press, 2006), 250–269 and passim.

74. Andrew Brodie Smith, *Shooting Cowboys and Indians: Silent Western Films, American Culture, and the Birth of Hollywood* (Boulder: University of Colorado Press, 2003), 31. The two Chicago-based companies were also following the lesson of commercial photographer Harry H. Buckwalter, Selig's first cinematographer and, later, western agent. Loyal to the boosters of the Colorado railway and commercial development, Buckwalter famously considered the sensationalist narratives of many crime-based Westerns merely "vehicle[s] for getting attention paid to the scenic surroundings." Harry H. Buckwalter, "Stage Coach Held-up Within Mile of the City," *Colorado Springs Gazette*, 3 October 1904, quoted in Smith, *Shooting Cowboys*, 22. See also Musser, *The Emergence of Cinema: The American Screen to 1907* (New York: Scribner, 1990), 399.

75. Smith, *Shooting Cowboys*, 43.

76. Simmon, *The Invention of the Western Film*, 4.

77. Smith, *Shooting Cowboys*, 64.

78. Abel, "Our Country/Whose Country?" in *The Red Rooster Scare*, 154.

79. Ibid., 155.

80. "What Is an American Subject?" *MPW*, 22 January 1910, 82, quoted in Abel, "Our Country/Whose Country?" in *The Red Rooster Scare*, 164.

81. Abel, "Our Country/Whose Country?" in *The Red Rooster Scare*, 165. Among the companies that specialized in these productions were Kalem, Biograph, and the New York Motion Picture Corporation. Kalem emphasized the ethnographic authenticity of shooting location, mise-en-scène, costuming, and props in several of its productions, from *The Red Man's Way* (1907) and *Fighting the Iroquois in Canada* (1910) to *The Cliff Dwellers* (1913). For a cogent overview of the representations of Native Americans in American cinema, one that, however, does not differentiate films by their shooting locations, see Armando José Prats, *Invisible Natives: Myth and Identity in the American Western* (Ithaca, N.Y., and London: Cornell University Press, 2002), especially chapters 1 and 2.

82. Simmon, *The Invention of the Western Film*, 15.

83. Gunning, *D. W. Griffith*, 209.

84. Simmon, *The Invention of the Western Film*, 38.

85. Susan Hegeman, "Landscapes, Indians, and Photography in the Age of Scientific Exploration," in *The Big Empty: Essays on Western Landscapes as Narrative*, ed. Leonard Engel (Albuquerque: University of New Mexico Press, 1994), 49–74,

86. Karl Brown, *Adventures with D. W. Griffith*, ed. and with an introduction by Kevin Brownlow (New York: Farrar, Straus and Giroux, 1973), 59.

87. Roosevelt was the author of the four-volume *The Winning of the West* (New York: Putnam, 1889–96). On the fortune of the imagery of the "Last Stand," captured by Remington, see Edward Buscombe, "Painting the Legend: Frederic Remington and the Western," *Cinema Journal* 23, no. 4 (Summer 1984): 12–27.

88. Simmon, *The Invention of the Western Film*, 53.

89. Ibid., 66. The U.S. cavalry often filled these spaces, as Karl Brown wrote in recounting his experience of watching Griffith's *The Battle at Elderbush Gulch*: "What's that long shot of empty land doing here, cut right into the height of the battle? But it isn't empty, after all, because off in the distance something is moving, coming closer and closer, until finally it becomes the United States Cavalry, sabers flashing, pistols at the ready, pennons flying, and horses pounding hell-for-leather as fast as horses ever ran before." Brown, *Adventures with D. W. Griffith*, 5.

90. Smith, *Shooting Cowboys*, 60. In Oklahoma, Selig was able to cast members of the Miller Brothers 101 Ranch Wild West Show, the famous Wild West reenactment team.

91. Smith, *Shooting Cowboys*, 136, 134.

92. Chon A. Noriega, "Birth of the Southwest: Social Protest, Tourism, and D. W. Griffith's *Ramona*," in *The Birth of Whiteness: Race and the Emergence of U.S. Cinema*, ed. Daniel Bernardi (New Brunswick, N.J.: Rutgers University Press, 1996), 222. See also, in the same anthology, Virginia Wright Wexman's discussion of how the land figures prominently in the aesthetics and ideology of 1910s and 1920s Western films, "The Family on the Land: Race and Nationhood in Silent Westerns," 129–169. Bernardi's remarkable and groundbreaking anthology on race in silent American film strictly identifies race with color. By focusing only on non-white groups, the anthology, including Bernardi's own contribution on Griffith's Biograph films (103–128), excludes any discussion of the racial representation of Irish, Jewish, and Italian immigrants. I address the relationship between race and color at the beginning of chapter 5.

93. Richard Abel, *Americanizing The Movies and "Movie-Mad" Audiences, 1910–1914* (Berkeley: University of California Press, 2006), 70, 72.

94. The author of the script of *The Invaders*, C. Gardner Sullivan, also wrote the scripts of the Western film *The Aryan* (1916) and, the year before, of *The Italian*, the 1915 masterpiece starring George Beban which captured the life of picturesque Italian immigrants living in New York. On Sullivan, see also note 44 to chapter 6.

95. Simmon, *The Invention of the Western Film*, 66.

96. John R. Stilgoe, *Common Landscape of America, 1580–1845* (New Haven, Conn.: Yale University Press, 1982), 3.

97. Ibid., 52, 66. For a different perspective on the landscape and early Westerns, one that does not refer to the picturesque, see Paula Marantz Cohen, *Silent Film and the Triumph of the American Myth* (New York: Oxford University Press, 2001), 71–96.

98. Louis Reeves Harrison, "The Invaders," *MPW*, 9 November 1912, 542. See also Abel, *Americanizing the Movies*, 113ff.

99. "Exporting the American Film," *MT* 6, no. 2 (August 1911): 90.

100. "The Make-Believe 'Indian,'" *MPW* 8, no. 9 (March 4, 1911): 473, quoted in Griffiths, *Wondrous Difference*, 246. Two prominent exceptions were the Native American actors James Young Deer and Lillian Red Wing. On the complexity of their performances and reception, see Smith, *Shooting Cowboys*, 71–103. Deer's *White Fawn's Devotion* (Pathé Frères, 1910) has been recently restored and is included in the DVD boxed set *Treasures from American Film Archives: 50 Preserved Films* (San Francisco: National Film Preservation Foundation; Los Angeles: Image Entertainment, 2000).

101. Slotkin, *Gunfighter Nation*, 91–92.

102. On the commodification of the image of the Indian, see Elizabeth Bird, *Dressing in Feathers: The Construction of the Indian in American Popular Culture* (Boulder, Colo.: Westview, 1996). On minstrelsy, see Eric Lott, *Love and Theft: Blackface Minstrelsy and the American Working Class* (New York: Oxford University Press, 1995), chapter 2.

103. Benedict Anderson, *Imagined Communities: Reflections on the Origin and Spread of Nationalism*, rev. ed. (London: Verso, 1991), 15.

104. Sara Suleri, *The Rhetoric of English India* (Chicago: University of Chicago Press, 1992), 76. Similarly, Eric Lott has described minstrel-show mimicry as "a nearly insupportable fascination and a self-protective derision with respect to black people." Lott, *Love and Theft*, 6.

105. In his autobiography, Billy Bitzer describes how Griffith came to visit him and shared the plot of his film: "On the lawn of a country residence we find Father, Mother, and little Dollie. In front of the grounds there flows a picturesque stream to which Mother and Dollie go to watch the boys fishing." Billy Bitzer, *Billy Bitzer: His Story* (New York: Farrar, Straus and Giroux, 1973), 65.

106. Tom Gunning, "The Message," in *The Griffith Project*, ed. Paolo Cherchi Usai, vol. 2, *Films Produced in January–June 1909* (London: British Film Institute/Le Giornate del Cinema Muto, 1999), 160; and Bitzer, *Billy Bitzer*, 65. For Gunning, *The Message* presents pastoral sequences that anticipate later features such as *A Romance of Happy Valley* (1919), *True Heart Susie* (1919), and *Way Down East* (1920).

107. Jean Mottet, "Toward a Genealogy of the American Landscape: Notes on Landscapes in D. W. Griffith (1908–1912)," in *Landscape and Film*, ed. Martin Lefebvre (New York: Routledge, 2006), 67. A few years earlier, Mottet authored an outstanding study of the landscape in early American cinema which traces several of the trajectories of my own work, as I later discovered, but which does not link them to a transatlantic articulation

of racial difference. See Jean Mottet, *L'invention de la scène américaine: Cinéma et paysage* (Paris: L'Harmattan, 1998).

108. On the notion of pastoralism and on the rhetoric of populist thought in relationship to Griffith, see Scott Simmon, *The Films of D. W. Griffith* (New York: Cambridge University Press, 1993), 39ff. The homestead was also a major icon in the lives of freed slaves, thanks to the Homestead Act, which Lincoln signed into law in 1862 and which enabled the distribution of undeveloped land to African Americans. The leading black film director of the silent era, Oscar Micheaux (1884–1951), successfully homesteaded a farm in South Dakota as a young man and wrote an autobiographical novel about his experience, *The Homesteader* (1917), which he turned into a film in 1919. On the film, see Gerald R. Butters, "Portrayals of Black Masculinity in Oscar Micheaux's *The Homesteader*," *Literature-Film Quarterly* 28, no. 1 (2000): 54–59.

109. Mottet, "Toward a Genealogy," 65, 66.

110. Gunning, *D. W. Griffith*, 276.

111. Bitzer, *Billy Bitzer*, 4.

112. On the "Lost Cause" and its vast literature, see David W. Blight, *Race and Reunion: The Civil War in American Memory* (Cambridge, Mass.: Harvard University Press, 2001), 255–299; and David Glassberg, *American Historical Pageantry: The Uses of Tradition in the Early Twentieth Century* (Chapel Hill: University of North Carolina Press, 1990), 209–211.

113. Abel, *Americanizing the Movies,* chapter 4. David Mayer has listed twenty-eight Civil War films produced between 1905 and 1925. David Mayer, "Opening a Second Front: The Civil War, the Stage, and D. W. Griffith," in *The Tenth Muse: Cinema and the Other Arts,* ed. Leonardo Quaresima and Laura Vichi (Udine: Forum, 2001), 491–502.

114. Eileen Bowser, *The Transformation of Cinema, 1907–1915* (New York: Scribner, 1990), 178.

115. Francis Trevelyn Miller, ed., *Photographic History of the Civil War* (New York: Review of Reviews, 1911), 1:16. For a discussion of this work, see Nina Silber, *The Romance of Reunion: Northerners and the South, 1865–1900* (Chapel Hill: University of North Carolina Press, 1993), 172–182.

116. Mayer, "Opening a Second Front," 492. Mayer notes another important convention: in these stage melodramas and films the villain is not a soldier, but a civilian (496).

117. Brown, *Adventures with D. W. Griffith,* 64.

118. Ibid., 63. On the tradition of the "Tom" show, see Thomas F. Gossett, *Uncle Tom's Cabin and American Culture* (Dallas, Tex.: Southern Methodist University Press, 1985), 367–387; and Linda Williams, *Playing the Race Card: Melodramas of Black and White from Uncle Tom to O. J. Simpson* (Princeton, N.J.: Princeton University Press, 2001), chapter 2.

119. Jean Mottet, "Mise en scène de l'Histoire, recherché de paysages symboliques et apologie des valeurs familiales," in *L'invention de la scène américaine,* 171–227.

120. As a photographer-impresario, Mathew Brady organized corps of often uncredited field photographers, including the later famous Alexander Gardner, Timothy O'Sullivan, and George Barnard. His views of encampments, wrecked cities, and battlefields strewn with corpses, beginning with the 1862 *Brady's Photographic Views of the War,* offered what the *New York Times* defined as "a panorama of the war"—a reference to the "larger-than-life scrolls of historic battles and famous landscapes." Trachtenberg, *Reading American Photographs,* 88. On the pictorially effective choreography of corpses in Brady's images, see William A. Frassanito, *Antietam: The Photographic Legacy of America's Bloodiest Day* (New York: Scribner, 1978), especially 29–32.

121. For a recent synthesis of critical positions on and discussions of Griffith's sources, see Melvyn Stokes, *D. W. Griffith's "The Birth of a Nation": A History of the Most Controversial Motion Picture of All Time* (New York: Oxford University Press, 2007), chapter 7.

122. Brown, *Adventures with D. W. Griffith*, 55. The scene of Gus's attempted rape of Little Sister was shot at Big Bear Valley, while the clan members' chasing sequences were set around the riverbanks of the shallow Rio Hondo. Ibid., 67, 76–77.

123. Harry C. Carr, "Griffith, Maker of Battle Scenes, Sees Real War," *Photoplay,* May 1918, quoted in Richard Schickel, *D. W. Griffith: An American Life* (New York: Simon and Schuster, 1984), 354–355. The expression "romantic and picturesque" must have been commonly used for iconic battlefields. In 1891 *Harper's Monthly* had attached it to the renowned march of General Sherman, which, in the words of editorialist George William Curtis, was "the most romantic and picturesque of the many renowned events of that time." George William Curtis, "Editor's Easy Chair," *Harper's Magazine* 82, no. 492 (May 1891): 963. Amy Kaplan suggests that the Spanish-American War influenced *The Birth of a Nation* on the basis of the "prior history of war on film, and the Thomas Dixon novels on which Griffith based his film." Kaplan, *The Anarchy of Empire in the Making of U.S. Culture* (Cambridge, Mass.: Harvard University Press, 2002), 161–164.

124. On this point, see also Michael Rogin, "'The Sword Became a Flashing Vision': D. W. Griffith's *The Birth of a Nation,*" *Representations* 9 (Winter 1985): 150–195, reprinted in *The Birth of a Nation: D. W. Griffith, Director,* ed. Robert Lang (New Brunswick, N.J.: Rutgers University Press, 1994), 250–293. See also Harold R. Shurtleff's dated but remarkable *The Log Cabin Myth: A Study of the Early Dwellings of the English Colonists in North America* (Cambridge, Mass.: Harvard University Press, 1939).

125. Brown, *Adventures with D. W. Griffith*, 120. Ben's falling in love with Elsie, or, better, with her photograph, occurs also in the pastoral setting of the plantation.

126. Lindsay, *The Art of the Moving Picture*, 153.

4. Picturesque New York

The first epigraph is from Viola Roseboro, "The Italians of New York," *The Cosmopolitan* 4 (January 1888): 396. The second epigraph is from Joseph Pennell, "The Pictorial Possibilities of Work," *Journal of the Royal Society of Arts* 61 (20 December 1912): 121. Later ones are from Jacob Riis, *How the Other Half Lives: Studies among the Tenements of New York* (1890; New York: Dover, 1971), 52; and William Dean Howells, "New York Streets" (1894), *Impressions and Experiences* (New York: Harper, 1896), 252.

1. Between 1870 and January 1898, just before the incorporation of the city's five boroughs, the population of New York City had almost doubled to 1.5 million. In 1898, it reached 3.4 million.

2. Historian Carol Marks reports that 168,000 Black people moved from the South between the 1890s and 1900, 170,000 between 1900 and 1910, and 453,000 between 1910 and 1920. See Carole Marks, *Farewell—We're Good and Gone: The Great Black Migration* (Bloomington: Indiana University Press, 1989), 2.

3. Josiah Strong, *The Challenge of the City* (New York: Missionary Education Movement of the United States and Canada, 1911 [1907]), 100. For general statistical data on immigration, see U.S. Bureau of the Census, *Historical Statistics of the United States, Colonial Times to 1957* (Washington, D.C.: Government Printing Office, 1960), 56ff.

4. Such novels as Catharine Sedgwick's *Clarence* (1830), Joseph Holt Ingraham's *Frank Rivers; or, The Dangers of the Town* (1843), and Herman Melville's *Pierre* (1852) cap-

tured and mythologized the deadly and mysterious hazards of New York's dark urban depths in terms of a degenerate interracial mingling of diseased-looking men and women of all colors. Ned Buntline adapted Eugene Sue's classic *Les mystères de Paris* (1842–43) for his *The Mysteries and Miseries of New York* (1848), which was promoted in small-town America with sensationalist illustrations of urban wickedness and crime. Among the non-fiction, gothic exposés of the city's dangers, see George Lippard's *The Quaker City* (1845) and George Foster's *New York by Gaslight* (1850). On the racial and class overtones of American popular literature of the nineteenth century, see Shelley Streeby's fundamental *American Sensations: Class, Empire, and the Production of Popular Culture* (Berkeley: University of California Press, 2002).

5. Helen Campbell, Thomas Knox, and Thomas Byrnes, *Darkness and Daylight; or, Lights and Shadows of New York Life* (Hartford, Conn.: A. D. Worthington, 1892), 213, quoted in Lee Grieveson, "Gangsters and Governance in the Silent Era," in *Mob Culture: Hidden Histories of the American Gangster Film*, ed. Lee Grieveson, Esther Sonnet, and Peter Stanfield (New Brunswick, N.J.: Rutgers University Press, 2005), 35n17. See also Rosalind Williams, *Notes on the Underground: An Essay on Technology, Society, and the Imagination* (Cambridge, Mass.: MIT Press, 1990), 52–53, 70–73.

6. Angela Blake, *How New York Became American, 1890–1924* (Baltimore, Md.: Johns Hopkins University Press, 2006), 19. On these social and political movements, see the classic work by Paul S. Boyer, *Urban Masses and Moral Order in America, 1820–1920* (Cambridge, Mass.: Harvard University Press, 1978); and, more recently, Daniel T. Rodgers, *Atlantic Crossings: Social Politics in a Progressive Age* (Cambridge, Mass.: Belknap, 1998).

7. Anna L. Meeker, *Lend-a-Hand* (1886), quoted in Nathan Irvin Huggins, *Protestants against Poverty: Boston's Charities, 1870–1900* (Westport, Conn.: Greenwood, 1971), 73. For a similar rhetoric, see also S. Humphreys Gurteen, *A Handbook of Charity Organization* (Buffalo, N.Y.: 1882).

8. By the mid-1890s, the New York City Charity Organization Society had data on 170,000 families or individuals. See Roy Lubove, *The Professional Altruist: The Emergence of Social Work as a Career* (Cambridge, Mass.: Harvard University Press, 1965), 17ff.

9. An eloquent and harsh criticism of the moral righteousness of charity organizations' methods and a move toward an examination of the environment in which immigrants found themselves was Jane Adams's *Democracy and Social Ethics* (1902).

10. Roy Lubove, *The Progressives and the Slums: Tenement House Reform in New York City, 1890–1917* (Pittsburgh, Penn.: University of Pittsburgh Press, 1962), 88–89, 91.

11. Boas developed his ideas in a number of works which appeared before 1900, culminating in his *Changes in Bodily Form of Descendants of Immigrants* (New York: Columbia University Press, 1912). Robert E. Park's contribution was linked to his classic and influential essay "The City: Suggestions for the Investigation of Human Behavior in the City Environment," *American Journal of Sociology* 20, no. 5 (March 1915): 577–612, which he later republished, in a revised form, in *The City: Suggestions for the Study of Human Nature in the Urban Environment,* by Robert E. Park, Ernest Watson Burgess, and Roderick Duncan McKenzie (Chicago: University of Chicago Press, 1925), 1–46.

12. For a general discussion of the "paradigm shift" from inheritance to environment in American social sciences, see Dorothy Ross, *The Origins of American Social Science* (Cambridge: Cambridge University Press, 1991). For an exemplary discussion of the relationship between American urban sociology and criminology on one side and films' crime narratives on the other, see Grieveson, "Gangsters and Governance."

13. Blake, *How New York Became American,* 50.

14. Ibid., 54. For a brilliant overview of the culture of pleasurable views of New York in this period, and especially of their artistic traditions, see Rebecca Zurier's *Picturing the City: Urban Vision and the Ashcan School* (Berkeley: University of California Press, 2006).

15. New York Information Agency, *The Hints for Strangers, Shoppers, and Sight See-ers in the Metropolis*, no page number given, quoted in Blake, *How New York Became American*, 71.

16. Comparing the new Singer Building with the taller Eiffel Tower, *Harper's Weekly* noted that the latter "was not constructed as an office-building or living space. It was merely a freak for temporary advertising purposes." George Ethelbert Walsh, "Modern Towers of Babel in New York," *Harper's Weekly* 151 (12 January 1907): 68. On the construction of the New York skyline, see Mona Domosh, *Invented Cities: The Creation of Landscape in Nineteenth-Century New York and Boston* (New Haven, Conn.: Yale University Press, 1996), 65–98. For a comparison with European "vertical culture," see Stephen Daniels, *Fields of Vision: Landscape Imagery and National Identity in England and the United States* (Princeton, N.J.: Princeton University Press, 1993).

17. Pennell visited Italy many times, beginning in the early 1880s, when *Century* sent him there to illustrate a series of articles written by William Dean Howells and titled "Florentine Mosaic." He provided the illustrations for the new editions of William Dean Howells's *Italian Journeys* (1907), Maurice Hewlett's *The Road in Tuscany* (1904), and Henry James's *Italian Hours* (1908). On his Italian drawings and illustrations, see Attilio Brilli and Simonetta Neri, eds., *An American Artist in Tuscany: Joseph Pennell (1858–1926)* (Cinisello Balsamo, Milan: Silvana Editoriale, 1999). On his New York illustrations, see Frederick Keppel, *Mr. Pennell's Etchings of New York "Sky Scrapers"* (New York: F. Keppel, 1905); and Edward Bryant, ed., *Pennell's New York Etchings: 90 Prints by Joseph Pennell* (New York: Dover Publications; Hamilton, N.Y.: Picker Art Gallery of Colgate University, 1980).

18. Pennell, "The Pictorial Possibilities of Work," 121; and Pennell, *The Adventures of an Illustrator* (Boston: Little, Brown, 1925), 271. The quotation is from "The Road in Tuscany," an essay Pennell wrote in 1901. One of his etchings from 1921 shows the Lower East Side masonry pier of the Manhattan Bridge, surrounded by a bustling immigrant community. Because of the scene's similarity to Castel Nuovo, Naples, the etching was significantly titled "Not Naples, but New York."

19. Blake, *How New York Became American*, 95.

20. Pennell, "The Pictorial Possibilities of Work," 121. For a broader discussion, see Manfredo Tafuri, "The Disenchanted Mountain: The Skyscraper and the City," in *The American City: From the Civil War to the New Deal*, ed. Giorgio Ciucci et al. (Cambridge, Mass.: MIT Press, 1983), 389–528.

21. Giles Edgerton [Mary Fanton Roberts], "How New York Has Redeemed Herself from Ugliness—An Artist's Revelation of the Beauty of the Skyscraper," *Craftsman* 11 (January 1907): 458, quoted in Blake, *How New York Became American*, 109.

22. Blake, *How New York Became American*, 102.

23. Many more are listed in Charles Musser, ed. *Edison Motion Pictures, 1890–1900: An Annotated Filmography* (Gemona: Le Giornate del Cinema Muto; Washington, D.C.: Smithsonian Institution Press, 1997).

24. Skyscrapers were attractive not just for their heights, but also for the depth of the excavations necessary for their foundations—a feature shared by other major construction enterprises, including the subway system. By American Mutoscope & Biograph, consider *Beginning of a Skyscraper* (1902), *Excavating for a New York Foundation* (1903), and *Pennsylvania Station Excavation* (1905), which were also subjects of contemporary paintings, such as

George Bellows's *Pennsylvania Excavation* (1907). There were also, of course, films devoted to New York's emblematic monuments, such as Edison's *Statue of Liberty* (1898) and *New Brooklyn to New York via Brooklyn Bridge* (1899).

25. If, with its slow, low-angle, tilting camera movement, *Panorama of the Flat Iron Building* can be likened to a travelogue, *At the Foot of the Flatiron* (AM&B, 1903) is both a filmed *actualité* and a humorous revelation of the effects of nature on one of the city's most recognizable sites: on windy days, the gusts were particularly strong at the corner of Broadway and Fifth Avenue. "Just why this corner should show such remarkable eccentricity of windiness has never been fully decided," wrote humorist writer Ellis Parker Butler, the most published author of the pulp fiction era, in his "The Windiest Corner in the World," *Brown Book of Boston* 7, no. 3 (July 1903): 86.

26. John C. Van Dyke, *The New New York: A Commentary on the Place and the People* (New York: Macmillan, 1909), vii.

27. Carl Sadakichi Hartmann, "Plea for the Picturesqueness of New York," *Camera Notes* 4, no. 2 (October 1900): 94.

28. Mariana Griswold Van Rensselaer, "Picturesque New York," *Century Magazine* 45, no. 2 (December 1892): 164.

29. Van Dyke, *The New New York*, 11.

30. Van Rensselaer, "Picturesque New York," 168. She also added, "You stand at the corner of Twenty-third Street. Here you will be happiest in winter, for then a carpet of snow may give a key-note of color repeated in the white fronts of certain big shops. . . . This is not a beautiful view, but it is a picturesque one, and picturesque in a bold, careless, showy way quite characteristic of New York" (169–170).

31. Consider, for instance, Childe Hassam's *Winter in Union Square* (1889–90), *Late Afternoon, New York, Winter* (1900), *Snowstorm, Madison Square* (1900), and *October Haze: Manhattan* (ca. 1911); John Sloan's *The Wake of the Ferry II* (1907) and *Six O'Clock, Winter* (1912); Robert Henry's *Street Scene with Snow (57th Street, New York City)* (1902); and George Bellows's *A Morning Snow—Hudson River* (1910). On the subject of snow in the paintings of the Ashcan school, see Zurier, *Picturing the City*, 162–170.

32. John Corbin, "The Twentieth-Century City," *Scribner's Magazine* 33 (March 1903): 259. Other weather-related occurrences, for instance the presence of strong winds blowing in the city, could link up different types of visual works, including the AM&B films *At the Foot of the Flatiron* (1903) and *A Windy Day on the Roof* (1904) and John Sloan's painting *Sun and Wind on the Roof* (1915).

33. Van Rensselaer, "Picturesque New York," 172.

34. Van Dyke, *The New New York*, 11.

35. See Bryan F. Le Beau, *Currier & Ives: America Imagined* (Washington, D.C.: Smithsonian Institution Press, 2001), especially 215–256 on the firm's "burlesqued" or "apelike" representations of African Americans and Irish individuals. For a wider sample, see John Grafton, *New York in the Nineteenth Century: 317 Engravings from Harper's Weekly and Other Contemporary Sources*, 2nd ed. (New York: Dover, 1980).

36. Peter B. Hales, *Silver Cities: The Photography of American Urbanization, 1839–1915* (Philadelphia: Temple University Press, 1984), 185. On the exoticization of the poor in *Street Life in London*, see Richard L. Stein, "Street Figures in Victorian Urban Iconography," in *Victorian Literature and the Victorian Visual Imagination*, ed. Carol T. Christ and John O. Jordan (Berkeley: University of California Press, 1995), 233–262. For a profile of Rogers, see Robert Taft, *Artists and Illustrators of the Old West, 1850–1900* (New York: Charles Scribner's Sons, 1953), 162–172.

37. Nicolas Baker and Margaret Brentano, *The World on Sunday: Graphic Art in Joseph Pulitzer's Newspaper (1898–1911)* (New York: Bulfinch, 2005), 5. I am grateful to Richard Abel for bringing this wonderful volume to my attention. New York's busy streets, bustling with human traffic and advertisements, were also seen as picturesque, as shown in "Picturesque America," *Life* (25 June 1908), included in Ben Singer, *Melodrama and Modernity: Early Sensational Cinema and Its Contexts* (New York: Columbia University Press, 2001), 122.

38. Van Rensselaer, "Picturesque New York," 172.

39. Carl Sadakichi Hartmann [Sidney Allan, pseud.], "Picturesque New York in Four Papers: The Esthetic Side of Jewtown," *Camera Notes* 6, no. 3 (February 1903): 145 (the first italics are original; the second are mine). The essay was illustrated with splendid photographs by Edward and E. C. Heim.

40. Ibid., 145–146.

41. Douglas Tallack, *New York Sights: Visualizing Old and New New York* (New York: Berg, 2005), 32.

42. Peter Conrad, *The Art of the City: Views and Versions of New York* (New York: Oxford University Press, 1984), 67.

43. Regarding Stieglitz's experience at a major tourist attraction on the mountains of the Black Forest, Katherine Hoffman has written that "his description of Gutach as a 'picture' suggests his predisposition for the pictorial and the picturesque." Hoffman, *Stieglitz: A Beginning Light* (New Haven, Conn.: Yale University Press, 2004), 30.

44. "Alfred Stieglitz and His Latest Work," *Photographic Times* 28, no. 4 (April 1896): 161.

45. J. Nilsen Laurvik, "Alfred Stieglitz, Pictorial Photographer," *International Studio* 44, no. 174 (August 1911): xxv. The image first appeared in Stieglitz's *Picturesque Bits of New York and Other Studies* (New York: H. R. Russell, 1897) and later in *Camera Work* 12 (October 1905).

46. Photogravures produced a higher standard of expression than halftones. Their richness made photogravure the preferred reproductive process for both original fine art prints and photo-reproductions of paintings. Consider, for instance, Adolph Wittemann, *Picturesque New York: Photo-Gravures* (Brooklyn, N.Y.: Albertype, 1899); and Charles F. W. Mielatz, *Picturesque New York: Twelve Photogravures from Monotypes* (New York: Society of Iconophiles, 1908).

47. Tallack, *New York Sights,* 25.

48. Ibid., 35.

49. Ibid.

50. Stieglitz recounted the shooting and developing of the photo in "How *The Steerage* Happened," *Twice a Year* 8–9 (1942): 175–178, now in *Stieglitz on Photography: His Selected Essays and Notes,* ed. Richard Whelan (New York: Aperture, 2000), 194–197. The quotation is reproduced, unreferenced and undated, by Whelan in "Notes" to Stieglitz's letter (197). See also Hoffman, *Stieglitz,* 233–238.

51. Alan Sekula, "On the Invention of Photographic Meaning," in *Thinking Photography,* ed. Victor Burgin (London: Macmillan, 1982), 99. The essay had originally appeared in *Artforum* 13 (January 1975): 37–45. Sekula juxtaposes Stieglitz's late aestheticism with Lewis Hine's social commitment. Alan Trachtenberg enacts a similar comparison in his *Reading American Photographs: Images as History, Mathew Brady to Walker Evans* (New York: Hill and Wang, 1985), 164–230 ("Camera Work/Social Work").

52. A disciple of Lewis Hine, Strand befriended Stieglitz in the 1910s and in his career embodied both the abstract expressionism of American and European modernism—evi-

dent, for instance, in his photograph *Wall Street* (1915)—and the social commitment of his first mentor. His photographic Grand Tour of Europe often took peasants and workers as subjects. Many pictures featured the Italian country peasants of Luzzara, Cesare Zavattini's home town.

53. Carrie Tirado Bramen, "The Urban Picturesque and the Spectacle of Americanization," *American Quarterly* 52, no. 3 (2000): 446. This remarkable essay is also reproduced, with some variations, in her *The Uses of Variety: Modern Americanism and the Quest for National Distinctiveness* (Cambridge, Mass.: Harvard University Press, 2000), 157–198.

54. The book had two precedents. Since January 1888, Riis had been presenting a lantern slide show titled "The Other Half: How It Lives and Dies in New York," to church and YMCA audiences in New York and the Northeast. In December 1889, he published in *Scribner's Magazine* a lengthy article, "How the Other Half Lives: Studies among the Tenements," which, illustrated by both halftones and fine-line wood engravings based upon his photographs, constituted a précis of the book to come. The famous 1890 volume (*How the Other Half Lives: Studies among the Tenements of New York* [New York: Charles Scribner's Sons, 1890]) was the first American book to include photographic images, and not just drawings, of the immigrants' enclaves. The newly developed halftone process, which allowed photographs to be transferred directly to the printing plate, was cheaper than hiring artists and engravers to turn photographs into illustrations, as Riis had previously done for his newspaper and magazine pieces. Neil Harris, "Iconography and Intellectual History: The Halftone Effect," in *New Directions in American Intellectual History* (Baltimore, Md.: Johns Hopkins University Press, 1979), 196–211; and Michael L. Carlebach, *The Origins of Photojournalism in America* (Washington D.C.: Smithsonian Institution Press, 1992), 151–165. For a discussion of reformist social critique in popular illustrated monthlies, see Matthew Schneirov, *The Dream of a New Social Order: Popular Magazines in America, 1893–1914* (New York: Columbia University Press, 1994).

55. Riis collected his lectures to middle-class audiences of church and charitable groups in several anthologies, including *The Children of the Poor* (1892), *Out of Mulberry Street: Stories of Tenement Life in New York* (1898), and *The Battle with the Slum* (1902). On Riis as a writer and photographer, see Keith Gandal, *The Virtues of the Vicious: Jacob Riis, Stephen Crane and the Spectacle of the Slum* (New York: Oxford University Press, 1997); Bonnie Yochelson, *Jacob Riis* (New York: Phaidon, 2001); and Bonnie Yochelson and Daniel Czitrom, *Rediscovering Jacob Riis: Exposure Journalism and Photography in Turn-of-the-Century New York* (New York: New Press, 2007); as a popular stereopticon lecturer, see Maren Stange, *Symbols of Ideal Life: Social Documentary Photography in America, 1890–1950* (New York: Cambridge University Press, 1989). A former curator of prints and photographs at the Museum of the City of New York, Yochelson has cogently challenged Riis's alleged photographic expertise and uncovered the true authorship of a number of photographs initially advertised and long hailed as his. See her "Jacob A. Riis, Photographer 'After a Fashion,'" in Yochelson and Czitrom, *Rediscovering Jacob Riis*, 121–227.

56. Riis, *How the Other Half Lives*, 43 (citations are to the 1971 reprint). "Picturesqueness" was also often used in the British press to describe Italian immigrants living in London. See, for instance, "Little Italy: Picturesque Colony to Be Broken Up," *News of the World*, 27 August 1905. I am grateful to Pierluigi Ercole for this reference.

57. This distinction was widely popularized by a series of articles appearing in *Harper's Weekly* beginning in 1890, titled "The Foreign Element in New York City," and by an influential 1891 anti-immigration essay written by Senator Henry Cabot Lodge for the *North American Review*, in which he described Southern Italians in terms of anarchism and an-

tistate brigandage. Lodge, "The Restriction of Immigration," *North American Review* 152 (January 1891): 27–35.

58. Jacob Riis, *The Battle with the Slum* (New York: Macmillan, 1902), 176, 177.

59. Yochelson, "Photographer 'After a Fashion,'" 134. For his lantern-slide lectures as well as for some of his articles, Riis also relied on professional photographers, including A. D. Fisk and a certain Collins of the *Evening Sun*. Little is known of either of them, including their first names.

60. The review was of Riis's *The Making of an American* (1901) and is quoted in Gandal, *Virtues*, 12. For similar comments on his talent for entertaining, which was apparent in his lantern-slide lectures, and which mixed statistics and reformism with race-based humor, see Daniel Czitrom, "Jacob Riis's New York," in Yochelson and Czitrom, *Rediscovering Jacob Riis*, 86–97.

61. Quoted in Stange, *Symbols of Ideal Life*, 16. See also Joseph. P. Cosco, *Imagining Italians: The Clash of Romance and Race in American Perceptions, 1880–1910* (New York: State University of New York Press, 2003), 42.

62. Gandal, *Virtues*, 79.

63. On Hine, see Judith Mara Gutman, *Lewis W. Hine and the American Social Conscience* (New York: Walker, 1967); and Vicki Goldberg, *Lewis W. Hine: Children at Work* (New York: Prestel, 1999).

64. Between 1892 and 1893, *Scribner's Magazine* ran a series of articles (including one by Riis) about urban destitution, grouped under the title "The Poor in Great Cities." This literature is indebted to, without coinciding with, the cheap literature produced for artisans and laborers that emerged in the 1830s and 1840s and told tales of the cities' criminal underworlds and urban squalor and of the decadence of the leisure classes. On these literary productions, at times engaged in depicting racial confrontations and channeling nativist feelings, see Michael Denning, *Mechanic Accents: Dime Novels and Working-Class Culture in America*, rev. ed. (London: Verso, 1998 [1987]).

65. Howells was editor of the *Atlantic Monthly* between 1871 and 1881. After moving to New York to direct *Harper's Weekly*, he fully realized the dramatic linguistic and cultural differences between old and new Americans. On this issue in his work, see Elsa Nettels, *Language, Race, and Social Class in Howells's America* (Lexington: University Press of Kentucky, 1988), 87–104.

66. William Dean Howells, "Editor's Easy Chair," *Harper's Monthly* 80 (January 1890): 314; and *A Hazard of New Fortunes* (New York: Oxford University Press, 1990 [1890]), 161.

67. Howells, *A Hazard of New Fortunes*, 44. The novel is filled with correlations of physiognomic traits with national and racial identities, which the sensitive Basil finds attractive and stimulating for his literary work: "The small eyes, the high cheeks, the broad noses, the puff lips, the bare, cue-filleted skulls, of Russians, Poles, Czechs, Chinese; the furtive glitter of Italians . . . were aspects that he identified, and that gave him abundant suggestion for the personal histories he constructed" (162). Warning against the dangerous temptation to aestheticize the city's immigrant quarters and their population into picturesque views, Howells noted that when one considers the "stenches of the neglected street" and the "fouler and dreadfuller poverty-smell which breathes from the open doorways," it is more honest to admit that "there is no kindliness in the quaintness." Howells, "New York Streets," in *Impressions and Experiences*, 253, 279.

68. Howells, *A Hazard of New Fortunes*, 162.

69. Ibid. Similarly, in his introduction to the American edition of Giovanni Verga's *I malavoglia*, Howells commented on the novelist's Sicilian subjects: "It is of the far South

that he writes, and of people whose passions are elemental and whose natures are simple."
G. Verga, *The House by the Medlar Tree*, trans. Mary A. Craig (New York: Harper, 1890), iv.
On Neapolitans, see Howells's *Italian Journeys* (Boston and New York: Houghton Mifflin,
1907 [1867]), 65–77. The entire volume was graced by Joseph Pennell's illustrations.

70. William Dean Howells, "American Letter: Some Books of Short Stories," *Literature*
3 (December 31, 1898): 629; and "Editor's Easy Chair," *Harper's Magazine* 102 (February
1901): 480. For more on the so-called literary genre of "tenement melodrama," on- and off-
stage, see David M. Fine, *The City, the Immigrant and American Fiction, 1880–1920* (Metuchen,
N.J.: Scarecrow, 1977); and Sabine Haenni, "Visual and Theatrical Culture, Tenement
Fiction, and the Immigrant Subject in Abraham Cahan's *Yekl*," *American Literature* 71, no.
3 (1999): 493–527. On Italians' literary and poetic production in America, see Martino
Marazzi's crucial *Voices of Italian America: A History of Early Italian American Literature with
a Critical Anthology*, trans. Ann Goldstein (Madison and Teaneck, N.J.: Fairleigh Dickinson
University Press, 2004 [2001]).

71. William Dean Howells, "Mr. Harben's Georgia Fiction," *North American Review*
191 (March 1910): 357. Howells maintained that he admired writers like Cahan because they
were capable of creating foreign-born characters seeking to become Americans.

72. W. D. Howells, "New York Low Life in Fiction," *New York World*, 26 July 1896, 2:18,
quoted in Nettels, *Language, Race, and Social Class*, 98.

73. Michael Novak, *The Rise of the Unmeltable Ethnics: The New Political Force of the
Seventies* (New York: Macmillan, 1971).

74. See Gandal, *Virtues*, and Cosco, *Imagining Italians*, for an initial critical and bib-
liographical orientation.

75. Amy Kaplan, *The Social Construction of American Realism* (Chicago: University of
Chicago Press, 1988), 10.

76. A class of plays regularly featured the Italian "wop" or "dago," speaking in stage-
Italian dialect and often wearing the soft pointed hat later made famous by Chico Marx.
Consider, for instance, Leonard Grover's *Our Boarding House*, first performed in 1877,
which provides a paradigmatic setting for a number of eccentric, yet typically "national"
characterizations. One of the better sources of images for this recurring role is in the male
cabinet-photo files of the Harry Ransom Center in Austin, Texas. A wealth of music and
songs about Italian characters—e.g., *De Dago, de Org and de Monk*, 1901; *My Mariucca Take
a Steamboat*, 1906; and *Cedro, My Italian Romeo*, 1913—is preserved at the Morris E. Dry
Collection of the American Music Research Center at Boulder, Colorado. I am grateful to
Helen Day-Meyer and David Mayer for kindly sharing this information.

77. On racial burlesque and vaudeville, see Paul Antonie Distler, "Exit the Racial
Comics," *Educational Theatre Journal* 18, no. 3 (October 1966): 247–254, and "Ethnic Com-
edy in Vaudeville and Burlesque," in *American Popular Entertainment*, ed. Myron Matlaw
(Westport, Conn.: Greenwood, 1979), 127–131; Joseph Boskin and Joseph Dorinson, "Eth-
nic Humor: Subversion and Survival," *American Quarterly* 37, no. 1 (Spring 1985): 81–97;
and Robert W. Snyder, *The Voice of the City: Vaudeville and Popular Culture in New York* (New
York: Oxford University Press, 1989), 43ff. For discussions of the intense media exchanges
between cinema and vaudeville, see the work of Musser and Robert C. Allen, beginning
with Allen's *Vaudeville and Film, 1895–1915: A Study in Media Interaction* (New York: Arno,
1980). A lively exchange between them appeared in *Studies in Visual Communication* 10, no. 4
(1984): 24–44, 45–50, 51–52. See also the wonderfully illustrated essays included in Patricia
McDonnell, ed., *On the Edge of Your Seat: Popular Theater and Film in Early Twentieth-Century
American Art* (New Haven, Conn.: Yale University Press, 2002).

78. *Italian Dialect Joke Book* (Baltimore, Md.: I. & M. Ottenheimer, 1909), 74. For an insightful overview, see Laura Browder, *Slippery Characters: Ethnic Impersonators and American Identities* (Chapel Hill: University of North Carolina Press, 2000); and for a specific discussion of literary and cinematic "ethnic" humor, see Mark Winokur, *American Laughter: Immigrants, Ethnicity, and 1930s Hollywood Film Comedy* (New York: St. Martin's Press, 1996), 23–73.

79. For the 1890s, however, consider Musser's excellent "Before the Rapid Firing Kinetograph," in *Edison Motion Pictures, 1890–1900: An Annotated Filmography* (Pordenone: Le Giornate del Cinema Muto; Washington, D.C.: Smithsonian Institution Press, 1997), 19–50; and, methodologically, his "Toward a History of Theatrical Culture: Imagining an Integrated History of Stage and Screen," in *Screen Culture: History and Textuality*, ed. John Fullerton (Eastleigh, UK: John Libbey, 2004), 3–19. Two important anthologies have variously addressed the question of early cinema and racial representations: Lester D. Friedman, ed., *Unspeakable Images: Ethnicity and the American Cinema* (Urbana: University of Illinois Press, 1991); and Daniel Bernardi, ed., *The Birth of Whiteness: Race and the Emergence of U.S. Cinema* (New Brunswick, N.J.: Rutgers University Press, 1996). In the next chapter I shall make reference to more studies in this area.

80. Musser, "Before the Rapid Firing Kinetograph," 40.

81. Carrie Tirado Bramen, "William Dean Howells and the Failure of the Urban Picturesque," *New England Quarterly* 73, no. 1 (2000): 87.

82. Bramen, "The Urban Picturesque," 446. Against the nativist perspectives, the progressive writer and public intellectual Randolph Bourne (1886–1918) had clearly distinguished the idea of Americanism from that of Anglo-Saxonism. In his 1916 article "Trans-national America," Bourne argued that the U.S. should accommodate immigrants' cultures into a "cosmopolitan America," rather than forcing them to assimilate into an Anglophilic American culture. Randolph Bourne, "Trans-national America, " *Atlantic Monthly* 118, no. 1 (July 1916), reprint in *War and the Intellectuals,* ed. Carl Resek (New York: Harper and Row, 1964), 107–123.

83. William Gilpin, *Three Essays: On Picturesque Beauty; On Picturesque Travel; and On Sketching Landscape: To Which Is Added a Poem on Landscape Painting,* 2nd ed. (London: R. Blamire, 1794), 42–43.

84. Roseboro, "The Italians of New York," 396. This, of course, did not stop her and other writers, journalists, and tourists from doing just that. Two years earlier she had defined the Italians as "delightfully picturesque." Roseboro, "Down-Town New York," *Cosmopolitan* 1 (June 1886): 222, quoted in Bramen, "The Urban Picturesque," 444.

85. Hutchins Hapgood, "Picturesque Ghetto," *Century Magazine* 94 (July 1917): 469–473. Hapgood had already written about picturesque Jewish life years before in his *The Spirit of the Ghetto: Studies of the Jewish Quarter in New York* (New York: Funk and Wagnalls, 1909).

86. Riis, *How the Other Half Lives,* 77, 50, 78.

87. "President Harrison Recommends Restrictions of Immigration. Uncle Sam—'If we must draw the line, let us draw it at these immigrants! We should not cease to be hospitable to immigration, but we should cease to be careless as to the character of it. These are men of all races whose coming is necessarily a burden upon our public revenues, or a threat to social order. These should be identified and excluded.'" *Judge* 15, no. 389 (March 1889): 708–709.

88. Georg Simmel, "The Metropolis and Mental Life," in *The Sociology of Georg Simmel,* ed. and trans. Kurt Wolff (New York: Free Press, 1950), 410.

89. Jean Mottet, *L'invention de la scène américaine: Cinéma et paysage* (Paris: L'Harmattan, 1998), 121.

90. Gandal, *Virtues*, 70.

5. Black Hands, White Faces

The first epigraph is from Mark Twain, *A Tramp Abroad* (New York: Modern Library, 2003 [1880]), 282. The second is from "Romance of Brigandage," *NYT*, 25 September 1892, 12. The third is from Edward Alsworth Ross, "Italians in America," *Century Magazine* 87 (July 1914): 440. Later ones are from "Our Summer Boarder: A Rural Cut-Up in One Act," in Harry L. Newton, *Vaudevillainies: A Series of "Acts" against the Public Peace and Decorum* (Boston: W. H. Baker, 1915), 42; and "Petrosini [sic], Detective and Sociologist," *NYT*, 30 December 1906, 21.

1. Matthew Frye Jacobson, *Whiteness of a Different Color: European Immigrants and the Alchemy of Race* (Cambridge, Mass.: Harvard University Press, 1998), 41.

2. Eric Hobsbawm, *The Age of Empire, 1875–1914* (New York: Vintage, 1989 [1987]), 62.

3. On the notion of racialness in early and silent American film, see Jane Gaines, "*The Scar of Shame*: Skin Color and Caste in Black Silent Melodrama," *Cinema Journal* 26, no. 4 (Summer 1987): 3–21; for a brief discussion of the central role of immigration in early American cinema, see my entry "Migration/Immigration," in *Encyclopedia of Early Cinema*, by Richard Abel (New York: Routledge, 2005), 432–435.

4. Recent significant contributions to African American film production and the representation of African Americans in film include Jacqueline Najuma Stewart, *Migrating to the Movies: Cinema and Black Urban Modernity* (Berkeley: University of California Press, 2005); and Pearl Bowser, Jane Gaines, and Charles Musser, eds., *African-American Filmmaking and Race Cinema of the Silent Era: Oscar Micheaux and His Circle* (Bloomington: Indiana University Press, 2001). A remarkable work on the formation of African American film discourse is Anna Everett's *Returning the Gaze: A Genealogy of Black Film Criticism, 1909–1945* (Durham, N.C.: Duke University Press, 2001).

5. The distinction between whiteness and non-whiteness mattered a great deal on- and off-screen (as it still does), since it defined, in legal, social, and representational terms, who held and did not hold certain civil entitlements, including the right to acquire citizenship, contract loans, purchase real estate, and freely choose a spouse.

6. W. E. B. Du Bois famously referred to the "color line" in "The Forethought," the foreword to his *The Souls of Black Folk* (Chicago: A. C. McClurg, 1903). Lothrop Stoddard referred to the same notion by the term "bi-racialism" in his *Re-forging America: The Story of Our Nationhood* (New York: Scribner's, 1927), 86, 284ff. A biracial framework belonged also to the very different works of Madison Grant and Marcus Garvey. On biracialism, see Matthew Pratt Guterl's excellent *The Color of Race in America, 1900–1940* (Cambridge, Mass.: Harvard University Press, 2001), 6, 12ff. Methodologically, a biracial framework is at the basis of most studies on African American filmmaking and representations, including Jane Gaines, *Fire and Desire: Mixed-Race Movies in the Silent Era* (Chicago: University of Chicago Press, 2001); Linda Williams, *Playing the Race Card: Melodramas of Black and White from Uncle Tom to O. J. Simpson* (Princeton, N.J.: Princeton University Press, 2001); and Stewart, *Migrating to the Movies*.

7. Significant texts on the historical dynamics of whiteness include David R. Roediger, *The Wages of Whiteness: Race and the Making of the American Working Class* (London:

Verso, 1991), *Towards the Abolition of Whiteness: Essays on Race, Politics, and Working Class History* (London: Verso, 1994), and *Working toward Whiteness: How America's Immigrants Became White; The Strange Journey from Ellis Island to the Suburbs* (New York: Basic Books, 2005); Jacobson, *Whiteness of a Different Color*; Noel Ignatiev, *How the Irish Became White* (New York: Routledge, 1995); and Karen Brodkin, *How Jews Became White Folks and What That Says about Race in America* (New Brunswick, N.J.: Rutgers University Press, 1998).

 8. Roediger, *Working toward Whiteness*, 12. On "inbetweeness," see also Robert Orsi, "The Religious Boundaries of an Inbetween People: Street 'Feste' and the Problem of the Dark-Skinned Other in Italian Harlem, 1920–1990," *American Quarterly* 44, no. 3 (September 1992): 313–347; and James R. Barrett and David Roediger, "Inbetween Peoples: Race, Nationality and the 'New Immigrant' Working Class," *Journal of American Ethnic History* 16, no. 3 (Spring 1997): 3–44. John Higham had already mentioned and discussed the term in the mid-1950s in his classic *Strangers in the Land: Patterns of American Nativism, 1860–1925* (New Brunswick, N.J.: Rutgers University Press, 1994 [1955]): 168–169, but see also 66.

 9. Thomas Guglielmo, *White on Arrival: Italians, Race, Color, and Power in Chicago, 1890–1945* (New York: Oxford University Press, 2003). Viewing race as "about location in a social system and its consequences," Guglielmo has argued that Italians were "largely accepted as white by . . . naturalization laws and courts, the U.S. census, race science, anti-immigrant racialisms, newspapers, unions, employers, neighbors, realtors, settlement houses, politicians, and political parties" (6–7).

 10. Guglielmo's legal formulation of the differences between color and race appears to disavow historical variance. When he hails color as a social and not a physical category, he refers to the binary legal language of social and economic institutions that ideologically postures as impervious to historical variance.

 11. Peter Kolchin, "Whiteness Studies: The New History of Race in America," *Journal of American History* 89, no. 1 (June 2002): 163 (italics in the original). Consider, for instance, what the American phrenologist brothers Lorenzo Niles Fowler and Orson Squire Fowler noted in 1863: "We find, in the uncultured classes of the white, the protrusive mouth (jaws and teeth) and the retreating forehead, such as commonly appear in the Negro." Quoted in Madeleine B. Stern, *Heads and Headlines: The Phrenological Fowlers* (Norman: Oklahoma University Press, 1971), 204.

 12. For a recent assessment of the historiography of whiteness, see Alistair Bonnett, "White Studies Revisited," *Ethnic and Racial Studies* 31, no. 1 (January 2008): 185–196.

 13. Roediger, *Working toward Whiteness*, 7, 8, 53.

 14. In their works, for instance, Roediger and Jacobson refer to a number of labels for Italians that seem to occupy a range of color-coded racial positions, from "greaser," "hunky," and "guinea" to "White Chinese," "padrone coolie," and "white nigger." See Jacobson, *Whiteness of a Different Color*, 56–62; and Roediger, *Working toward Whiteness*, 75, 87, 129. The acknowledgment that whiteness includes racial differences is at the basis of my critique of Daniel Bernardi's pioneering anthology *The Birth of Whiteness: Race and the Emergence of U.S. Cinema* (New Brunswick, N.J.: Rutgers University Press, 1996), which focuses mostly on the representation of non-white populations, namely Native Americans, African Americans, Mexicans, and Asians. A discussion of race in American cinema, as this study seeks to show, ought to include groups that enjoyed the legal perks of whiteness. See also Richard Abel, *Americanizing The Movies and "Movie-Mad" Audiences, 1910–1914* (Berkeley: University of California Press, 2006).

 15. G. W. Stocking, "The Turn-of-the-Century Concept of Race," *Modernism/Modernity* 1, no. 1 (1994): 6 (emphasis in the original). At the end of the nineteenth century,

Stocking argues, "'blood'—and by extension 'race'—included numerous elements that we would today call cultural" (6).

16. The conflation of biological and cultural traits in the notion of race forces us to reflect on both past and current linguistic habits. A mere discussion of social mores and intellectual traditions, divorced from bioracial make-up—as the modern, pluralistic, and relativistic formulations of "culture" and "ethnicity" suggest—did not exist in this period. "Writers before 1930," Roediger argues, "seldom used 'ethnic' to suggest that race and ethnicity were competing concepts or that 'ethnic' might clarify the difference between the nation-race of new immigrants and the color-race of, for example, blacks and Asians. Nor did the term signal a firm reorientation to culture instead of biology as a source of difference among Europeans." Roediger, *Working toward Whiteness*, 23.

17. John Kasson, *Rudeness and Civility: Manners in Nineteenth-Century America* (New York: Hill and Wang, 1990), 70–111.

18. Phrenology exerted an impressive political and multidisciplinary influence: it became an important research method in most of the biological sciences and was used by their most illustrious figures, including comparative anatomy and biology (Georges Cuvier), medicine and psychiatry (Philippe Pinel, Jean-Etienne-Dominique Esquirol, Etienne-Jean Georget, Benedict Augustin Morel), physical and criminal anthropology (Arthur De Gobineau, Pierre Paul Broca, Paul Topinard, Cesare Lombroso, Giuseppe Sergi), craniometry (Samuel George Morton), and eugenics (Francis Galton). For a general discussion of phrenology, its ideological biases, and its popularity in Europe and in America, see Jay Gould, *The Mismeasure of Man* (New York: Norton, 1981); and Stern, *Heads and Headlines*. The anatomist Franz Joseph Gall, who was both Stendhal's friend and his physician, believed that artists, illustrators, and writers needed to understand "cerebral topography" to better render their subjects' character and feelings. He even lent his skills to the preparation of the *Voyage pittoresque* of painter and explorer Louis Choris. Louis Choris et al., *Voyage pittoresque autour du monde, avec des portraits de sauvages d'Amérique, d'Asie, d'Afrique, et des îles du Grand océan; Des paysages, des vues maritimes, et plusieurs objets d'histoire naturelle* (Paris: Didot, 1822).

19. David De Giustino, *Conquest of Mind: Phrenology and Victorian Social Thought* (London: Croom Helm, 1975), 69.

20. On the subject, see Robert E. Riegel, "The Introduction of Phrenology to the United States," *American Historical Review* 39, no. 1 (October 1933): 73–78; and Stern, *Heads and Headlines*.

21. Orson Squire Fowler and Lorenzo Niles Fowler, *Phrenology: A Practical Guide to Your Head* (New York: Chelsea House, 1969), 56.

22. Even W. E. B. Du Bois, wanting to offer an alternative to white visual culture's stereotypical images of blacks, created a huge "counterarchive" of types for the American Negro Exhibit at the 1900 Paris Exposition. The goal of the resulting three-volume *Types of American Negroes, Georgia, U.S.A.* was to represent the "human face of blackness." Shawn Michelle Smith, *Photography on the Color Line: W. E. B. Du Bois, Race, and Visual Culture* (Durham, N.C.: Duke University Press, 2004), 42–76.

23. Joshua Brown, *Beyond the Lines: Pictorial Reporting, Everyday Life, and The Crisis of Gilded Age America* (Berkeley: University of California, 2002), 78, 79, 171. Although caricatures were borrowing poses and physiognomic codes from classic sculpture, their satirical approach clashed with the "stiffened countenances" of pictorial and photographic representations. For a survey of the influence of physiognomy in the *beaux arts*, see John S. Crawford, "Physiognomy in Classical and American Portrait Busts," *American Art Journal*

9, no. 1 (May 1977): 49–60. Physiognomy, particularly the work of Johann Caspar Lavater, was quite significant for American racial culture. For an early, influential assessment, see "Physiognomy," *Anthropological Review* 6, no. 21 (April 1868): 137–154.

24. On cartoons and caricatures in America, see several of the essays included in Harry Katz, ed., *Cartoon America: Comic Art in the Library of Congress* (New York: Abrams, 2006); and Amon Carter Museum of Western Art, *The Image of America in Caricature and Cartoon* (Fort Worth, Tex.: The Museum, 1975).

25. Brown, *Beyond the Lines*, 78–79. On mid-nineteenth-century America's regional characters and "ethnic" types, see Sarah Burns, *Pastoral Inventions: Rural Life in Nineteenth-Century American Art and Culture* (Philadelphia: Temple University Press, 1989); and James H. Dormon, "Ethnic Stereotyping in American Popular Culture: The Depiction of American Ethnics in the Cartoon Periodicals of the Gilded Age," *Amerikastudien* 30, no. 4 (1985): 489–507.

26. Brown, *Beyond the Lines*, 162.

27. Ibid., 167. On the dependency of photography's mimetic codes on other textualities, including written commentaries, see Dan Schiller, "Realism, Photography and Journalistic Objectivity in Nineteenth-Century America," *Studies in the Anthropology of Visual Communication* 4, no. 2 (Winter 1977): 86–98, especially 92.

28. For recent studies of caricatures of African Americans and of Irish, Jewish, and Chinese immigrants, see Francis John Martin, Jr., "The Image of Black People in American Illustration from 1825 to 1925" (Ph.D. diss., University of California, Los Angeles, 1986); John and Selma Appel, eds., *Pat-Riots to Patriots: American Irish in Caricature and Comic Art* (East Lansing: Michigan State University Museum and Michigan State University, 1990); Shearer West, "The Construction of Racial Type: Caricature, Ethnography, and Jewish Physiognomy in Fin-de-Siècle Melodrama," *Nineteenth Century Theatre* 21, no. 1 (Summer 1993): 5–40; and Philip P. Choy, Lorraine Dong, and Marlon K. Hom, eds., *The Coming Man: Nineteenth-Century American Perceptions of the Chinese* (Seattle: University of Washington Press, 1995). While there is no systematic overview of Italians in American caricature, a remarkable sample is in Salvatore LaGumina, *Wop! A Documentary History of Anti-Italian Discrimination in the United States* (Toronto: Guernica, 1999 [1973]).

29. *Frank Leslie's Illustrated Newspaper*, July 14, 1888, cover (341); see also "Italian Immigration," ibid., 343 (editorial), both quoted in Brown, *Beyond the Lines*, 199.

30. *Frank Leslie's Illustrated Newspaper*, October 25, 1884, 151, in Brown, *Beyond the Lines*, 186.

31. Eugenics in America owed its success to the scientific and logistical work of a New England zoologist, Charles Davenport, who, with the crucial support of the Carnegie Institute, established the Eugenics Record Office in Cold Spring Harbor, New York. On the scientific and popular appeal of eugenics, see William H. Tucker, *The Science and Politics of Racial Research* (Urbana: University of Illinois Press, 1994); and Marouf Arif Hasian, Jr., *The Rhetoric of Eugenics in Anglo-American Thought* (Athens: University of Georgia Press, 1996).

32. One of the volumes of the 1911 Dillingham Commission's Report on Immigration identified forty-five races among immigrants coming to the United States, with thirty-six of them from Europe. Jacobson, *Whiteness of a Different Color*, 72 and passim.

33. On eugenics and popular culture, see Chloe S. Burke and Christopher J. Castaneda, eds., "The Public and Private History of Eugenics," special issue, *Public Historian* 29, no. 3 (Summer 2007). On eugenics and visual culture, see Anne Maxwell, *Picture Imperfect: Photography and Eugenics, 1879–1940* (Brighton, UK: Sussex Academic Press, 2008). "If the

mystery of birth were understood, crime would be wiped out," boasted one of the protagonists of Lois Weber's antiabortion drama *Where Are My Children?* (Universal, 1913), a district attorney and a "great believer in eugenics," played by a young Tyrone Power. Adopted by Theodore Roosevelt in his political rhetoric, eugenics was also lampooned, as in the 1904 Edison comedy *The Strenuous Life; or, Anti-race Suicide.*

34. On cinema and illustrated periodicals, see Charles Musser, *Before the Nickelodeon: Edwin S. Porter and the Edison Manufacturing Company* (Berkeley: University of California Press, 1991), 162–167, and his entry on "Illustrated Magazines" in Abel, *Encyclopedia*, 308–310.

35. A kiss was the title and theme of an 1886 Rodin sculpture and an 1892 Edward Munch painting, and repeated kisses were the great attraction of the 1895–96 American stage adaptation of *Carmen* as well as the 1896 Edison film, which inspired mocking handmade frame enlargements in newspapers and spawned imitations and remakes. See Charles Musser, "A Cornucopia of Images: Comparison and Judgment across Theater, Film and the Visual Arts during the Late Nineteenth Century," in *Moving Pictures: American Art and Early Film, 1880–1910*, ed. Nancy Mowll Mathews with Charles Musser (Manchester, Vt.: Hudson Hills, 2005), 33ff.

36. On this production, see Gunning, "Facial Expression Films," in Abel, *Encyclopedia*, 225–226, and "In Your Face: Physiognomy, Photography, and the Gnostic Mission of Early Film," *Modernism/Modernity* 4, no. 1 (1997): 1–29.

37. William Lord Wright, "For Photoplay Authors, Real and Near," *NYDM*, 24 March 1915, 30.

38. William Lord Wright, "For Photoplay Authors Real And Near," *NYDM*, 15 September 1915, 35. Wright was also the author of the 1922 *Photoplay Writing* (New York: Falk, 1922). Charles Musser has shown that after the mid-1910s humorous silent films often did not present recognizable racial caricatures (the "supra-ethnic comedy") and often featured all-American figures, including the unsophisticated country bumpkin and the "bad boy." Musser, "Ethnicity, Role-Playing, and American Film Comedy: From *Chinese Laundry Scene* to *Whoopee* (1894–1930)," in *Unspeakable Images: Ethnicity and the American Cinema*, ed. Lester D. Friedman (Urbana: University of Illinois Press, 1991), especially 39–60.

39. See Michael Quinn, "Distribution, the Transient Audience and the Transition to the Feature Film," *Cinema Journal* 40, no. 2 (Winter 2001): 35–56; and Eileen Bowser, *The Transformation of Cinema, 1907–1915* (New York: Scribner, 1990), 191–215.

40. Cathy Boeckmann, *A Question of Character: Scientific Racism and the Genres of American Fiction, 1892–1912* (Tuscaloosa and London: University of Alabama Press, 2000).

41. On the relationship between America's topological imagery and photography, see Ardis Cameron, "Sleuthing towards America: Visual Detection in Everyday Life," in *Looking for America: The Visual Production of Nation and People* (Malden, Mass.: Blackwell, 2005), 17–41,

42. Boeckmann, *A Question of Character*, 4.

43. Against the standard contentions of racial formalism and biological determinism, Boas showed that such physical traits as stature, weight, and cephalic index changed, or in his words "improved," in the American environment. Boas, *Changes in Bodily Form of Descendants of Immigrants* (New York: Columbia University Press, 1912).

44. Stephen Daniels, *Humphry Repton: Landscape Gardening and the Geography of Georgian England* (New Haven, Conn., and London: Yale University Press, 1999), 2. See also Denis Cosgrove, "Modernity, Community and the Landscape Idea," *Journal of Material Culture* 11, nos. 1–2 (2006): 49–66, particularly 55–57.

45. Francis Galton, *Memories of My Life* (London: Methuen, 1908), 321.

46. Michael Freeden, "Eugenics and Progressive Thought: A Study in Ideological Affinity," *Historical Journal* 22, no. 3 (September 1979): 645–671.

47. For a general overview of Jewish characters in American cinema, see Patricia Erens, *The Jew in American Cinema* (Bloomington: Indiana University Press, 1984), 29–73; and Jay Hoberman, *Bridge of Light: Yiddish Film between Two Worlds* (New York: MoMA/Schocken, 1991).

48. Quite original, instead, was the figure of the Yiddisher Cowboy, which represented a subversive continuation of the stereotype of the urban Jew. On Jewish stereotypes in early film comedy, especially in relationship to other racial groups, particularly the Irish, see Musser, "Ethnicity, Role-Playing, and American Film Comedy"; and Erens, *The Jew in American Cinema,* 33–42.

49. In 1913, Louis Reeves Harrison of *Moving Picture World* loudly praised the practice. Harrison wrote, "It is a pleasure to see Jewish people play Hebrew roles of comedy and sympathy, especially after so many sickening caricatures have affronted vaudeville audiences for years." *MPW,* 9 July 1913, 300, quoted in Erens, *The Jew in American Cinema,* 44.

50. See Rebecca Zurier, *Picturing the City: Urban Vision and the Ashcan School* (Berkeley: University of California Press, 2006), chapters 6 and 7.

51. Jean Mottet, *L'invention de la scène américaine: Cinéma et paysage* (Paris: L'Harmattan, 1998), 130–138. Among the most famous early crime films which exploited the locations of the ghetto and Lower East Side, but not necessarily the racial identity of the criminals, were Thomas Ince's *The Gangster and the Girl* (Kay-Bee, 1914), directed by Scott Sidney and shot in Los Angeles, and Raul Walsh's *Regeneration* (1915), starring the half-Irish, half-French 1890 Bowery gang leader Owen Kildare and actually shot on the Bowery and featuring local hoodlums. See Kevin Brownlow, *Behind the Mask of Innocence* (London: Jonathan Cape, 1990), 378, 189ff.

52. Theodore A. Bingham, "Foreign Criminals in New York," *North American Review* 188, no. 634 (September 1908): 383. Among "the predatory criminals of all nations," Bingham also included "the Armenian Hunchakist, the Neapolitan Camorra, the Sicilian Mafia, [and] the Chinese Tongs" (384).

53. For a succinct discussion of Cahan's *Yekl* (1893; translated into English in 1895) in the context of Jewish-American literature, see Matthew Frye Jacobson, "'The Quintessence of the Jew': Polemics of Nationalism and Peoplehood in Turn-of-the-Century Yiddish Fiction," in *Multilingual America: Transnationalism, Ethnicity, and the Languages of American Literature,* ed. Werner Sollors (New York: New York University Press, 1998), 103–111. On Jewish representations in the 1920s, see, in addition to Erens's study, Brownlow, *Behind the Mask,* 379–423; and on Russians, often associated with nihilist anarchists, ibid., 353–374.

54. I will discuss Italian literary and theatrical production with reference to film production and spectatorship in chapter 7.

55. Even a cursory examination of the American Film Institute's reference volume *Within Our Gates: Ethnicity in American Feature Films, 1911–1960,* ed. Alan Gevinson (Berkeley: University of California Press, 1997) encourages this conclusion. A number of undergraduate students at the University of Michigan have systematically scanned early trade periodicals from 1907 to 1916 in search of film reviews, illustrations, news, and commentaries centered on race and national difference. Their findings have confirmed the representational prominence of Native and African Americans, Mexicans, and Italians.

56. On Americans on the Grand Tour, see Paul R. Baker, *The Fortunate Pilgrims: Americans in Italy, 1800–1860* (Cambridge, Mass.: Harvard University Press, 1964); Beth Lynne Lueck, *American Writers and the Picturesque Tour: The Search for National Identity, 1790–1860*

(New York: Garland, 1997); and Theodore E. Stebbins, Jr., *The Lure of Italy: American Artists and the Italian Experience, 1760–1910* (Boston: Museum of Fine Arts; New York: Harry N. Abrams, 1992).

57. Richard H. Brodhead, "Strangers on a Train: The Double Dream of Italy in the American Gilded Age," *Modernism/Modernity* 1, no. 2 (1994): 1–19; see also John Paul Russo, "From Italophilia to Italophobia: Representations of Italian American in the Early Gilded Age," *Differentia* 6–7 (Spring–Autumn 1994): 45–75.

58. Samuel Willard, *The Popular Reader; or, Complete Scholar* (Greenfield, Mass.: A Phelps, 1834), 101, quoted in Ruth Miller Elson, *Guardians of Tradition: American Schoolbooks of the Nineteenth Century* (Lincoln: University of Nebraska Press, 1964), 149.

59. Henry James, "The American Scene," in *Collected Travel Writing: Great Britain and America* (New York: Library of America, 1993), 462 (first italics mine). At the same time, like many artists and cultural ethnographers (including Hutchins Hapgood), he lamented the fact that the vulgarity of the modern American way of life could render Italians "colorless" like a "huge white-washing brush" (ibid.).

60. Madison Grant, *The Passing of the Great Race; or, The Racial Basis of European History* (New York: Charles Scribner's Sons, 1916), 139.

61. Brodhead, "Strangers on a Train," 6.

62. Jacob Riis, *How the Other Half Lives: Studies among the Tenements of New York* (New York: Dover, 1971 [1890]), 43.

63. Margaret Malamud, "The Greatest Show on Earth: Roman Entertainments in Turn-of-the-Century New York City," *Journal of Popular Culture* 35, no. 3 (Winter 2001): 43–58.

64. For a discussion of the transatlantic traffic and mutual influences of films and staged Roman and toga plays, see David Mayer's groundbreaking *Playing Out the Empire: Ben Hur and Other Toga Plays and Films, 1883–1908; A Critical Anthology* (Oxford: Clarendon, 1994).

65. Ibid., 55; and Malamud, "The Greatest Show," 57n9. Over the years other disasters played out at Coney Island; they included the burning of Rome, the eruption of Mount Pelée of Martinique, the San Francisco earthquake, and the Texas Galveston Flood—all topics that early films captured in *actualités* or fiction films.

66. I explored the ties between Italian historical epics and the nationalistic narratives of early U.S. cinema in "Epica spettacolare e splendore del vero: L'influenza del cinema storico italiano in America (1908–1915)," in *Storia del cinema mondiale,* ed. Gian Piero Brunetta, vol. 2, *Gli Stati Uniti* (Turin: Einaudi, 1999), 1:227–265.

67. I included an image of the theatre in "Italian Imageries, Historical Feature Films, and the Fabrication of Italy's Spectators in Early 1900s New York," in *American Movies Audiences: From the Turn of the Century to the Early Sound Era,* ed. Richard Maltby and Melvin Stokes (London: British Film Institute, 1999), 39.

By December, Kleine had thirty-three positive prints of *Quo Vadis?* circulating throughout the country, and thirty-eight of Ambrosio's *The Last Days of Pompeii.* At the Astor the film played for twenty-two consecutive weeks, and that summer it also played at the Alhambra Theatre (2110 Seventh Avenue, at W. 126th Street), in the Bronx, and in Brooklyn. See Library of Congress, Kleine Papers, box 32, "*The Last Days of Pompeii* and *Quo Vadis?* Distribution in the U.S., 1912; 1926," and box 69, "Schedule of Releases, 1913–1918."

68. "The Camorra and Mafia," *NYT,* 15 December 1878, 4. Interestingly, the newspaper maintained that change was possible, though slow: "Till the character of the southern population has been changed, the position of Italy will be insecure; and to do this will require many years' time" (ibid.).

69. The author of the memoir was William John Charles Moens. Within weeks of its publication, Alfred H. Guernsey gave it a ten-page, highly romanticized review in *Harper's Monthly*—"Three Months with Italian Brigands," August 1866, 286–296. Similar accounts included "The Brigands of South Italy—How Their Ranks Are Kept Full—Their Romantic Life," *NYT*, 16 October 1868, 5; "The Brigands of Sicily: A Land of Crime and Courtesies," *NYT*, 23 February 1878, 3; and "The Brigand Lovers," *Harper's Weekly*, 23 August 1879, 678–680.

70. "Romance of Brigandage," *NYT*, 25 September 1892, 12.

71. "Our Brigands," *NYT*, 1 January 1884, 4. See also "The Harlem Brigands," *NYT*, 12 June 1878, 2; and "Brigands in New Jersey," *NYT*, 26 August 1878, 1. On South Brooklyn vendettas, see "A Study of the Latest Mysterious Italian Tragedy," *Brooklyn Eagle*, 7 June 1896, 5.

72. "Our Italians," *NYT*, 12 November 1875, 4.

73. "The Seeds of Revolution: Social Volcanoes in Europe," *NYT*, 15 December 1878, 10.

74. Ross, "Italians in America," 440. "With the dusk of Saracenic or Berber ancestors showing in their cheeks," Ross added in another article in the same issue, "they lack the conveniences for thinking." Ross, "Racial Consequences of Immigration," *Century Magazine* 87 (July 1914): 619. For a larger discussion, see Peter D'Agostino, "Craniums, Criminals, and the 'Cursed Race': Italian Anthropology in American Racial Thought, 1861–1924," *Comparative Studies in Society and History* 44, no. 2 (2002): 319–343.

75. For excerpts of and references to the national press coverage of the events, see H. S. Nelli, *The Business of Crime: Italians and Syndicated Crime in the United States* (Chicago: University of Chicago Press, 1976), chapters 2 and 3; and Richard Gambino, *Vendetta: A True Story of the Worst Lynching in America* (Garden City, N.Y.: Doubleday, 1977).

76. Guido Sacerdote, "Prejudice against Italians: Race Should Not Be Judged by Crimes of the Few," *NYT*, 19 August 1904, 6; and Gino C. Speranza, "Italians and the Law: Not Accorded Justice Guaranteed by the Constitution," *NYT*, 28 August 1904, FS4. An attorney, journalist, and author, in 1897 Speranza (1872–1927) became legal counselor to the Italian Consulate General in New York.

77. "'Barrel' Murder Plot and Victim Known," *NYT*, 21 April 1903, 1; see also "Eight Sicilians held for Barrel Murder," *NYT*, 16 April 1903, 1.

78. "Black Hand Band in Extortion Plot," *New York Herald*, 14 September 1903, 7. The article also suggested alternative names for the "bands of blackmailers," including "Mafia, the Mala Vita, and the Società Camorriati [sic]." See also "One More Threat by 'Black Hands,'" *New York Herald*, 19 September 1903, 7. For a study of the phenomenon, see Thomas Monroe Pitkin and Francesco Cordasco, *The Black Hand: A Chapter in Ethnic Crime* (Totowa, N.J.: Rowman and Littlefield, 1977), especially chapter 1. See also Nelli, *The Business of Crime*, 8–17; and, for a larger contextualization, David R. Colburn and George E. Pozzetta, "Crime and Ethnic Minorities in America: A Bibliographic Essay," *History Teacher* 7, no. 4 (August 1974): 597–609.

79. "Swindle of the 'Black Hand'; Famous Fiction Which Has Cloaked Many Crimes," *NYT*, 27 September 1903, 32. See also "True Story of Origin of 'The Black Hand:' The Ominous Emblem Invented by a Spanish Chief of Police," *NYT*, 8 January 1905, SM7; and "Is 'The Black Hand' a Myth or a Terrible Reality?" *NYT*, 3 March 1907, SM10.

80. "'The Black Hand' Myth," *North American Review* 182 (April 1908): 544. A friend of Petrosino and former president of the United Italian Societies of New York, Gaetano D'Amato also demystified both the organizational complexity and the newness of the Black Hand by emphasizing its links with the Mafia and Camorra.

81. As Nelli writes, "Although Black Handers worked on all levels of immigrant society, they limited themselves geographically to Italians living or working in the colonies." Out of 141 instances of Black Hand activity in America's major cities in 1908, "not one Black Hand case reported in the press took place outside an immigrant district." Nelli, *The Business of Crime,* 79.

82. The fame of the Black Hand was troublesome to the Italian community, which vehemently opposed the unremitting representations of Italians as transferring to America the Old World criminal workings of the Mafia and Camorra. In 1908, Alessandro Mastro-Valerio, publisher and editor of Chicago's *La tribuna italiana transatlantica,* suggested that Carlo Barsotti, editor of the largest Italian American paper, the New York–based *Il progresso italo-americano,* had coined the term to better explain how Italian American crime was a response to the American environment rather than a continuation of age-old Southern Italian customs. See Humbert S. Nelli, "Italians and Crime in Chicago: The Formative Years, 1890–1920," *American Journal of Sociology* 74, no. 4 (January 1969): 375n.

83. See *Chicago Record-Herald,* April 19 and 26 and May 3, 1914. My thanks to Richard Abel for bringing these articles to my attention.

84. For a discussion of early cinema and representations of crime and criminals in general in the context of the new social and economic forces of America's industrialized modernity, see Lee Grieveson, "Gangsters and Governance in the Silent Era," in *Mob Culture: Hidden Histories of the American Gangster Film,* ed. Lee Grieveson, Esther Sonnet, and Peter Stanfield (New Brunswick, N.J.: Rutgers University Press, 2005), 13–40.

85. On this notion and on the relationship between moving pictures and newspapers at the turn of the century, see Musser, *Before the Nickelodeon,* 162–167; and Jonathan Auerbach, "McKinley at Home: How Early American Cinema Made News," *American Quarterly* 51, no. 4 (1999): 797–832, now published, in a slightly revised version, in Auerbach, *Body Shots: Early Cinema's Incarnations* (Berkeley: University of California Press, 2007), 15–41.

86. *The Black Hand* was the second crime film released by Biograph within a short time, a few weeks after *The Silver Wedding,* which was also based on a recent police round-up and thus on newspaper reports. Dealing with a gang of thieves in the subterranean world, it does not seem to have focused on Italian criminals. For official description of the films, see *Biograph Bulletin,* nos. 65–66 (17 and 29 March 1906) in Kemp R. Niver, ed., *Biograph Bulletins, 1896–1908* (Los Angeles: Locare Research Group, 1971), 240–241. The subtitle of *The Black Hand* in the *Bulletin* actually reads, "A Story of Italian Brigandage Recently Exploited in New York City."

87. See "M'adoo Aroused by Police Conditions," *NYT,* 14 September 1904, 1; and "A Secret Service Squad to Hunt the Black Hand," *NYT,* 20 December 1906, 16. McAdoo explained that the new force would discourage a common practice among "honest Italians," who "believe it a sort of patriotic duty" to allow Italian criminals to seek "refuge behind racial and national sympathy." In his memoir, *Guarding a Great City* (New York: Harper & Brothers, 1906), he further noted that "the very existence of this secret service among the Italians had a deterring effect on the professional criminals" (154). Because of the rise in Black Hand crimes, on December 1906 a successor of McAdoo upgraded the force to a "secret service squad."

88. "They Cooly Watched," *NYT,* 17 February 1906, 16.

89. On this point, see Scott Simmon's notes on the film included in the booklet accompanying the DVD boxed set *Treasures III: Social Issues in American Film, 1900–1934* (San Francisco: National Film Preservation Foundation, 2007). The set includes a stunning restored version of the film. I am grateful to Simmon for sharing the drawing with me.

90. Riis too had emphasized that Italians did not generally trust the American justice system. When an Italian is wounded in a fight, he wrote, "he wards off all inquiries with a wicked 'I fix him myself,' and there the matter rests until he either dies or recovers." *How the Other Half Lives*, 47.

91. The Italian-born Robert Vignola (1882–1953) was a stage actor who performed in several Shakespeare plays and also worked in moving pictures. He played Judas in Sidney Olcott's *From the Manger to the Cross* (Kalem, 1913) and himself in the Italian American drama *The Alien* (Kalem, 1913). He also directed several films from the mid-1910s to the mid-1930s, including *Seventeen* (Famous Players Film Co., 1916), which had Rudolph Valentino as an uncredited extra. Terry Ramsaye once wrote that "Vignola could be both kinds of heavy character, the mean spirited and the strong man." Ramsaye, *A Million and One Nights: A History of the Motion Picture* (New York: Simon and Schuster, 1926), 460–461. For an updated profile of Vignola, see Giuliana Muscio, *Piccole Italie, grandi schermi: Scambi cinematografici tra Italia e Stati Uniti 1895–1945* (Rome: Bulzoni, 2004), 47–50 and passim. Anthony O'Sullivan (died 1920) made a career of playing unsympathetic Americans and Italians at Biograph: a burglar in *The Lonely Villa* (1909), a peddler in *In Little Italy* (1909), and a worker in *The Violin Maker of Cremona* (1909), all directed by Griffith.

92. Restrictions on immigration through literacy tests, first proposed in 1894–97 and repeatedly attempted in 1902–1903, 1906–1907, and 1911–15, were finally passed into law in February 1917. See Higham, *Strangers in the Land*, 103–105, 106–108, 111–112, 128–129.

93. Stephen Bonsal, "Maria Partello, the Mysterious: Are Women Used as Lures in the Murder Plots of the Italian Mafia?" *New York Herald*, 4 October 1903, MS, 3.

94. "Brigandage in Italy," *Harper's Weekly*, 23 July 1881, 503.

95. Niver, *Biograph Bulletins*, 241.

96. Fooled by an intelligent little girl, the delinquents of the Biograph film resemble other Black Handers whose screen treatment was both sinister and comedic. In connection with an antiradical attitude, especially with regard to Italians, a few films equated criminality with radical political activism and emphasized the foolhardiness, hotheadedness, and, ultimately, ludicrousness of common gangsters and bomb-throwing agitators. Two examples of what Michael Slade Shull has called "genre intermingling" are *A Bum and a Bomb* (Champion, 1912) and *Giovanni's Gratitude* (Mutual, 1913), which combined the gang film genre with the bomb parody routine. Michael Slade Shull, *Radicalism in American Silent Films, 1909–1929: A Filmography and History* (Jefferson, N.C.: McFarland, 2000), 22.

97. In one such profile, Petrosino was described as having "a strong and determined jaw," a firm mouth, and "lips set in a straight line, suggesting purpose rather than severity," with the result that "you can readily imagine that you are talking to some gentle and thoughtful person who has your interests at heart." See "Petrosini [*sic*], Detective and Sociologist," *NYT*, 30 December 1906, 21.

98. "He was a stout, strong man. His clean shaven face was coarse-featured, and marred by light pocking; at first sight he did not attract. But in that butcher's face there was the impress of a stubborn will and of courage, something that made one think of a mastiff." Luigi Barzini, *The Italians* (New York: Atheneum, 1964), 41.

99. For an overview of Petrosino's figure and career, see Arrigo Petacco, *Joe Petrosino*, trans. Charles Lam Markmann (New York: Macmillan, 1974 [1972]); and George E. Pozzetta, "Another Look at the Petrosino Affair," *Italian Americana* 1 (Fall 1974): 81–92.

100. "New York Is Full of Italian Brigands," *NYT*, 15 October 1905, 28. See also "Petrosino Asks Aid to Catch Brigands," *NYT*, 18 October 1905, 20, in which he maintains that "there are 30,000 Italian thieves in America."

101. "Petrosini [*sic*], Detective and Sociologist," *NYT*, 30 December 1906, 21.

102. *MPW*, 30 January 1909, 125.

103. "Petrosino Buried with High Honors," *NYT*, 13 April 1909, 1–2. The mayor of New York City declared the day of his burial a holiday to allow its citizens to pay their respects. A small plaza just north of the old New York Police Department headquarters at 240 Center Street in Manhattan was renamed in his memory. Kenneth T. Jackson, *The Encyclopedia of New York City* (New York: The New-York Historical Society; New Haven, Conn.: Yale University Press, 1995), 895.

104. Gambino, *Blood of my Blood: The Dilemma of the Italian-Americans* (Toronto: Guernica, 2000 [1974]), 283.

105. Public interest was kept high by news that the Black Hand had used threatening letters to discourage performers and audiences from attending nightly shows for the benefit of Petrosino's widow and infant daughter. Great attention was also given to the "greatest criminal trial of the age," the trial in Italy of Petrosino's alleged assassins. See "Black Hand Mars Petrosino Benefit," *NYT*, 3 May 1909, 1; and Walter Littlefield, "Criminal Band That Murdered Petrosino in Police Coils," *NYT*, 11 September 1910, SM1–2.

106. The death of Petrosino inspired both Italian and Italian American filmmaking initiatives. In 1909 the Palermo-based photographer Giuseppe Gabriella, founder of Sicula Film (not to be confused with the company of the same name from Catania), produced *I funerali del poliziotto Petrosino*, which was distributed in the U.S. by the Empire Film Co. as *The Funeral of Joe Petrosino: The American Detective in Merino, Italy*. In the records of the New York–based Dora Film of America, Giuliana Bruno has found a reference to a film about "the adventure of the famous Italian American detective," titled *Joe Petrosino*. See Nino Genovese and Sebastiano Gesù, *E venne il cinematografo: Le origini del cinema in Sicilia* (Catania: Giuseppe Maimone Editore, 1995), 65; and Giuliana Bruno, *Streetwalking on a Ruined Map: Cultural Theory and the City Films of Elvira Notari* (Princeton, N.J.: Princeton University Press, 1993), 122–123.

107. *MPN* 4, no. 4 (28 January 1911): 16. The identification with Sherlock Holmes was not new. In 1909, immediately after Petrosino's murder, an Italian publisher launched weekly installments of *Giuseppe Petrosino: Il Sherlock Holmes d'Italia*, a highly fictionalized version of his life. In 1910, Yankee released *The Italian Sherlock Holmes*, which *Moving Picture World* described as "one of those melodramatic detective stories . . . possessing a fascination from which it is impossible to escape." *MPW*, 12 November 1910, 1119.

108. I am here relying on a Dutch print of the film, apparently the only surviving copy, preserved at the Netherlands Museum (Amsterdam) and titled *Een slachtoffer der camorra* (The Victim of the Camorra). The film was also known as *The Life and Death of Lieutenant Petrosino*.

109. An advertisement and a review appeared, respectively, in *MPW*, 23 November 1912, 821, and *MPW*, 16 November 1912, 668.

110. *MT* 8, no. 13 (27 March 1915): 510; and *MPW*, 20 March 1915, 1784.

111. *MPW*, 20 March 1915, 1784. Similar juxtapositions of virtuous Italian Americans and vicious Italians are in *The Confession* (Warner Features, 1914) and *The Padrone's Ward* (Powers Co., 1914).

112. Other examples of intra-Italian conflict are *The Padrone's Ward* (Powers Co., 1914), in which divisions disrupt a family from within, and *The Padrone's Plot* (Kalem, 1913), which showcases how the Black Hand blackmails Italian laborers and employers. In other cases, films depicting Mafia-related urban crimes and vendettas opposed Italian gangsters to racially uncoded victims, as in *The Cord of Life* (Biograph, 1909), or did not specify the na-

tional identity of either, as in Griffith's *The Musketeers of Pig Alley* (Biograph, 1912). Other "Black Hand" titles include the *Trailing the Black Hand* (Atlas Film Co., 1910), *The Black Hand* (Kalem, 1913), *A Blackhand Elopement* (Selig Poliscope, 1913), *Black Hand Conspiracy* (Apollo, 1914), *The Black Hand* (Royal, 1914), and *Kamorra* (production company unknown, 1916), featuring "a number of exceptional types from the Italian quarter." *MPN* 13, no. 13 (1 April 1916): 1894.

113. Among the French films on the subject, consider *The Black Hand* (Stella, 1909), *Blopps in Search of the Black Hand* (Lux, 1910), *The Black Hand* (Éclair, 1912), and *The Bomb Throwers* (Pathé Frères, 1915).

114. The distinction between good, assimilated immigrants and bad, unassimilable ones was also common in the films starring Sessue Hayakawa as a Japanese (or other Asian) immigrant. He may have been more an exception than the rule, however, given the public sympathy that his stardom granted him after 1915. See Daisuke Miyao, *Sessue Hayakawa: Silent Cinema and Transnational Stardom* (Durham, N.C.: Duke University Press, 2007), 88ff.

115. Among the few comedies, often based on gastronomic customs, pride, and vulgar manners, consider *Spaghetti à la Mode* (Lubin, 1915) and *Count Macaroni* (Edison, 1915).

116. Similarly, the imported Italian films dealing with the Mafia and brigandism, mostly from the early 1910s, relied on criminal narratives that *Moving Picture World* believed appealed to American audiences through their ethnographic and touristic display of local customs and landscapes. If, for the trade periodical, *Il brigante e il carabiniere* (The Brigand; Cines, 1912) was "a rather operatic picture of Sicily," *Il brigante* (The Brigand; Ambrosio, 1913) turned out to be "a drama of Italian banditi [that] will win friends for its interesting settings." *MPW*, 20 April 1912, 230; and *MPW*, 18 October 1913, 265.

6. White Hearts

The opening epigraph is from George Beban, *Photoplay Characterization; One of a Series of Lectures Especially Prepared for Student-Members of the Palmer Plan* (Los Angeles: Palmer Photoplay Corp., Department of Education, 1921), 19 (italics mine). Later ones are from "Silent and Spoken Drama," *The Theatre* (August 1915): 62; and George Beban, interview, *Los Angeles Evening Herald,* 19 November 1919.

1. Once again, Griffith's extant and available films, mostly shot in New York and Fort Lee, New Jersey, constitute a significant sample of the American films of the time about urban immigrants.

2. *Los Angeles Express,* 8 March 1919, Beban's file, NYPL-TC.

3. *Biograph Bulletin,* 9 January 1911, in *The Biograph Bulletins: 1908–1912,* ed. Eileen Bowser (New York: Octagon, 1973), 263.

4. *Biograph Bulletin,* 23 December 1909, in Bowser, *Biograph Bulletins,* 153.

5. Roberta E. Pearson has examined Walthall's range of acting styles in a number of Biograph films released between 1909 and 1913. See her *Eloquent Gestures: The Transformation of Performance Style in the Griffith Biograph Films* (Berkeley: University of California Press, 1992), 99–119; on *In Little Italy,* see 116–117.

6. *Moving Picture World* was quite explicit about this: "One doesn't need to be told that the workman's wife in this picture is Italian, or at least of Southern blood." *MPW,* 21 October 1911, 208. Other titles that center on the theme of sentimental jealousy are *An Infernal Triangle* (Vitagraph, 1913); *Italian Love* (Reliance, 1913); *The Price of Sacrilege* (IMP-Universal, 1914), directed by Herbert Brenon; *Mario* (Reliance, 1914); *Italian Love* (Essanay,

344 · NOTES TO PAGES 207–211

1914); *The Ladder of Fortune* (Rex Motion Picture Company, 1915); and *The Gilded Spider,* or *The Full Cup* (Universal, 1916), starring a young Lon Chaney who, said *Motion Picture News,* "carries the story through a one-man vendetta that starts in Italy and finishes in New York." *MPN* 13, no. 17 (29 April 1916): 2529.

7. *MPW,* 5 July 1913, 83–84.

8. *MPN* 9, no. 1 (10 January 1914): 42.

9. This was the expression used by *Moving Picture News* to describe the style "obvious in the acting of the players," in its review of the Italian film *Il bandito di Port-Aven* (The Bandit of Port Avon, Aquila Films, 1914). *MPW,* 12 September 1914, 46.

10. Kristin Thompson, "The Cord of Life," in *DWGP,* 2:12.

11. Steven Higgins, "The Lure of the Gown," in *DWGP,* 2:46.

12. On acting style, in addition to Pearson's *Eloquent Gestures,* see David Mayer, "Acting in Silent Film: Which Legacy of the Theatre," in *Screen Acting,* ed. Alan Lovell and Peter Krämer (London: Routledge, 1999), 10–30.

13. Two of the most famous vaudeville songs of the time were devoted to these singers: "My Cousin Caruso" (New York: Gus Edwards Music, 1909) and "My Sist' Tetrazin'" (New York: Trebuhs, 1909).

14. For Southern Italian vernacular theatre, New York was a larger and busier stage than the whole South of Italy. On this tradition, see Emelise Aleandri and Maxine Schwartz Seller, "Italian-American Theatre," in *Ethnic Theatre in the United States,* ed. Maxine Schwartz Seller (London: Greenwood, 1983), 237–276; and Emelise Aleandri, *The Italian-American Immigrant Theatre of New York City* (Charleston, S.C.: Arcadia, 1999).

15. John Corbin, "How the Other Half Laughs," *Harper's New Monthly Magazine* 98 (December 1898): 30–48; and Carl Van Vechten, "A Night with Farfariello," *Theatre Magazine* 29, no. 215 (January 1919): 32, 34.

16. *MPN* 6, no. 14 (5 October 1912): 25.

17. *MPN* 8, no. 1 (5 July 1913): 30.

18. *MPW,* 30 December 1916, 1974 and 2006.

19. *Exhibitors Herald* 2, no. 36 (26 February 1916): 9; *MPN* 13, no. 9 (4 March 1916): 1316. The film was originally seven reels, though is was later distributed in five. I examined the print preserved at the George Eastman House, Rochester, N.Y.

20. Kevin Brownlow, *Mary Pickford Rediscovered: Rare Pictures of a Hollywood Legend* (New York: Harry N. Abrams/Academy of Motion Picture Arts and Sciences, 1999), 118.

21. *NYDM,* 26 February 1916, 24.

22. *NYT,* 21 February 1916, 9. The film was a tremendous success. "Never in the history of the Broadway Theater," *Moving Picture World* noted, "has any film approached the record made by Peppina." "'Peppina' Causes Riot at Theatre," *MPW,* 11 March 1916, 1629.

23. Brownlow, *Mary Pickford,* 118–119. See also Giuliana Muscio, *Piccole Italie, grandi schermi: Scambi cinematografici tra Italia e Stati Uniti, 1895–1945* (Rome: Bulzoni, 2004), 127–141. Muscio also mentions the plot lines of a number of other comparable, yet unfortunately lost films, including *The Nightingale* (All Star Feature Corporation, 1914), which marked Ethel Barrymore's film debut, and Herbert Brenon's *Sin* (Fox, 1915), starring Theda Bara in the role of an Italian peasant girl whose sensual appeal induces two Italian men to steal jewels from a local church.

24. Scott Simmon, "The Violin Maker of Cremona," *DWGP,* 2:118.

25. "Through this information she is restored and the organ grinder receives the reward for his service." *MPW,* 30 January 1909, 125.

26. *MPW,* 7 October 1911, 42.

27. *MPW*, 24 February 1912, 698.

28. *MPN* 7, no. 19 (10 May 1913): 32; and *NYDM*, 24 March 1915, 31.

29. Early film historians have disagreed about the class and racial affiliations of early film audiences in America and in New York City in particular. Against the long-standing position of scholars who contended that the majority of film patrons were members of the working class, "revisionist historians" (a self-employed term of honor) have more recently set out to accentuate and document a large attendance among the bourgeois, and thus a middle-class dimension to the silent film exhibition scene. A most perceptive discussion of the historiographical dimension of the debate is Robert Sklar's "Oh Althusser! Historiography and the Rise of Cinema Studies," in *Resisting Images: Essays on Cinema and History*, ed. Robert Sklar and Charles Musser (Philadelphia: Temple University Press, 1990 [1988]), 12–35. The debate became quite animated in the mid-1990s, when *Cinema Journal* published a lively exchange on historical findings and methodology related to nickelodeons and movie theatres in New York City. See "Dialogue," *Cinema Journal* 35, no. 3 (Spring 1996): 72–128.

30. Laura Browder, *Slippery Characters: Ethnic Impersonators and American Identities* (Chapel Hill: University of North Carolina Press, 2000), 5, 6.

31. Werner Sollors, *Beyond Ethnicity: Consent and Descent in American Culture* (New York: Oxford University Press, 1986), 6ff.

32. Browder, *Slippery Characters*, 10.

33. Ibid., 49 and passim. My only criticism of Browder's crucial work is her use of the term "ethnic," which, as I discussed above, should instead be replaced with the more historically accurate "racial."

34. *MPW*, 9 March 1912, 868.

35. Miriam Hansen has aptly discussed the mystification behind the call for a universal language, a "self-evident, irrefutable proof of the cinema's manifest destiny" which made "social conflict, like ethnic and cultural heterogeneity, evaporat[e] under the light rays of uplift and human brotherhood." Hansen, *Babel and Babylon: Spectatorship in American Silent Film* (Cambridge, Mass.: Harvard University Press, 1991), 78.

36. Before Beban's feature character performances, other, shorter films had explicitly explored the narrative possibility of humanizing Italians as victims of injustice. They included *Out of the Past* (Vitagraph, 1910), "A Special Two-Part Feature Drama of Italian American Life"; *Trials of an Immigrant* (Reliance, 1911) about the "piteous trials of an Italian woman, wife of a drunken immigrant"; and *The District Attorney's Conscience* (Lubin, 1913). See *MPW*, 4 June 1910, 941; *MPW*, 8 July 1911, 1588; and *MPW*, 2 April 1913, 570.

37. Although Beban had told the press that he was of respectable Scotch-Irish background, we now know that not to be the whole story. Richard Beban, the actor's great-grandnephew, has kindly informed me that his great-granduncle was the son of an Irish mother, Johanna Dugan, and a Dalmatian father, Rocco Beban, who had migrated from the island of Zlarin, in Southern Dalmatia, now part of Croatia (correspondence, 20 July 2008). In his numerous interviews George Beban never mentioned his father's background or the origins of his last name. What newspapers were fond of reporting, particularly in the late 1910s, was that Beban was *not* of Italian origin. For years his description as "the greatest portrayer of Italian character" conflated actor and character, and added realism to his film and stage productions. But in 1919 the Los Angeles *Evening Herald* bannered an interview with Beban with the his true nationality. See "Italian Star of Films Confesses to Being Scotch-Irish," *Los Angeles Evening Herald*, 19 November 1919; "Beban Unable to Speak Italian," *Boston Herald*, 22 August 1926 (in Beban's clipping file, NYPL-TC). Beban himself

never claimed to be Italian. In a 1920 one-page autobiographical essay for the *New York Dramatic Mirror,* he wrote, "Although the motion picture public think of me in connection with Venetian sunsets, Mafia vendettists and banana peddlers, and notwithstanding the fact that fully one-third of my letters are from Italians and in many instances written in Italian, I have no Latin blood in my veins. I am Scotch-Irish, was born in San Francisco." George Beban, "100% Italian—In Plays," *NYDM,* 4 December 1920, 1067.

38. See Kevin Brownlow, *Behind the Mask of Innocence* (London: Jonathan Cape, 1990), 319. Brownlow probably refers to the *Los Angeles Evening Herald and Express,* 19 November 1919, section 2, pp. 1, 22. According to the *Annals of the New York Stage,* Beban was cast in 1892 in the vaudeville act *Cristofero Colombo,* playing at the London Theatre, an established vaudeville house located on the Bowery. George C. D. Odell, ed., *Annals of the New York Stage* (New York: AMS Press, 1970 [1949]), 15:419.

39. George Beban, "Taking a Comedian Seriously," *The Green Book Album,* September 1911, 513.

40. The play opened at the Orpheum Theatre in Brooklyn in early June. See *Vanity Fair,* 1 July 1909, and *New Jersey Mirror,* 12 June 1909, (Beban's clipping file, NYPL-TC). Perhaps because of the long-standing influence of Venice on Dalmatia, Beban seems to have had a keen interest in Italian American affairs. In May 1909, he attended a benefit for the Petrosino family, two months after the assassination of the famous Italian detective. *NYT,* 13 April 1909.

41. "George Beban Pleases: The Sign of the Rose Makes a Hit," *New York Dramatic News,* 21 October 1911. Beban traveled the country with the playlet, collecting rave reviews. Winthrop Chamberlain of the *Minneapolis Journal* said that his performance brought out "the sunny, sympathetic Latin temperament." "A New Star and His Masterpiece," *Minneapolis Journal,* 6 October 1911. Both references are from Beban's clipping file, NYPL-TC.

42. Beban was not the only performer of Italian roles to move from theatre to cinema, although he was certainly the most famous. On 6 December 1913, *Moving Picture World* reported that an actor of Italian origin, Claude Seixas, whom it called "the delineator of Italian types in vaudeville," had moved to film (1158). The term "delineator" clearly reveals the long-standing relationship between print caricatures on the one side and stage and film impersonations on the other.

43. For many years an incomplete version of this film was held at the Library of Congress. In 1987, three hundred reels of nitrate film were found in a barn near Temperance, Michigan. They included a more complete version of *The Italian,* which is now included in the Library of Congress Film Registry, in the company of other 1915 films, Griffith's *The Birth of a Nation* and DeMille's *The Cheat.* See "Ince's 'The Italian' among Silent Films Discovered in Barn," *Variety,* 27 May 1987, 36. Recently, Film Preservation Associates, Inc., in cooperation with Flicker Alley, has released a two-DVD collection titled *Perils of the New Land: Films of the Immigrant Experience (1910–1915),* whose new version of *The Italian* merges some footage from previously known prints held at the Library of Congress and the George Eastman House with an original tinted 35mm nitrate print found in a Maryland barn in 1974 and belonging to a private collector. This version, for which I provided the audio commentary, includes previously unseen colored sequences, including images of the Italian countryside, an encounter between Beppo and a woman who may be Black or Native American, and the "Italian-American ghetto" (figs. 6.4, 6.5, 6.6, and 6.7).

44. Sullivan belonged to a small circle of authors working together, often on Italian racial representations. He had already collaborated on William C. DeMille's playlet *The Land of the Free* (1906), whose 1917 staging DeMille himself adapted into *One More American*

(1918), starring George Beban. As a screenwriter, C. Gardner Sullivan had worked on *The Wop* (IMP, 1913) and *The Invaders* (NYMPC, 1912) and would work on *Civilization* (Thomas H. Ince, 1916), directed by Thomas H. Ince and Reginald Barker. As a director, Barker launched the career of Sessue Hayakawa with *The Wrath of the Gods* and *The Typhoon,* both produced in 1914 by the New York Motion Picture Corporation.

45. *Motion Picture Magazine,* April 1916, 141.

46. Clara Williams, who played Annette, was a dark Mediterranean type who became famous playing Naneta in *The Criminal* (NYMPC, 1916) and Nina in *Three of Many* (NYMPC, 1916), both directed by Barker, whom she married in 1920. Playing her father was J. Frank Burke, who had a career at Inceville and who played the owner of the flower shop in Beban's other 1915 film, *The Sign of the Rose* (a.k.a. *The Alien*). The monastery of the first sequence was in reality a California mission located in Santa Ynez Canyon, the site of the Ince studios before their move to Culver City.

47. I am here referring to "Makes the Whole World Kin," which was included in O. Henry's posthumous *Sixes and Sevens* (New York: Doubleday, 1911). In England, the Ideal Film Renting Company actually distributed the film under the title *One Touch of Nature,* possibly to make it more appealing to British audiences. The British *Kinematograph and Lantern Weekly* (10 August 1916, 61) regarded the Shakespearean line as an "old adage," exuding a truth "so strong that every man, woman and child, irrespective of nationality, may follow it with ease and perfect understanding."

48. The vast openness of the panoramic landscape contrasts greatly with the visual rendering of the New York Italian slum, where a regime of closer shots is the rule.

49. "The photography, from its lyrical style in the romantic opening to its anticipation of neorealist methods in the slum sequences, is both artistically and technically well in advance of its period." William K. Everson, *American Silent Film* (New York: Da Capo, 1998 [1978]), 65.

50. The classic shot of the Statue of Liberty from the point of view of a passing ship, already present in Edison's *actualités* (e.g., *Statue of Liberty,* 1898), is here so completely absorbed into the narrative that it becomes part of the grammar of the immigrant's encounter with the New World, as is evident, for instance, in *The Godfather Part II* (1974).

51. A similar juxtaposition of Italian and black characters is evident in *His Sweetheart* (1917). The mother of Beban's character is unjustly imprisoned in a cell which, to her dismay, she has to share with a young black woman.

52. Everson, *American Silent Film,* 64. Beban himself recounted the experience of beginning shooting in "the Italian section of San Francisco on a blistering August day" amidst "children crowded in swarms," barking dogs, shouting boys, and unsavory odors. See his ironic tale of how Ince persuaded him to leave the stage in Beban, "How I Was Induced to Become a Motion Picture Star," *Paramount Magazine,* January 1915, 14.

53. K. Owen, "The High Cost of Poverty," *Photoplay,* March 1917, 32, 33. After new buildings were erected, "all that was required was to dim the newness of the *ensemble,* supply well equipped clotheslines, beer kegs, ash cans and other impedimenta of the perfect slum and flavor with the sort of humanity that accompanies such props."

54. "The Italian," *NYDM,* 30 December 1914, 26; and Vachel Lindsay, *The Art of the Moving Picture* (New York: Liveright, 1970 [1915; rev. 1922], 70.

55. "A Tammanist, Before and After the Elections," *FdNY,* 11 November 1909, 4.

56. "Wop" was one of the many conventional derogatory terms for Italians. There are different interpretations of its meaning. Some suggest that the term is an acronym for "without papers," an earlier epithet identifying illegal immigrants. Another interpretation

suggests that "wop" is the English pronunciation of the Italian-Neapolitan word *guappo*, which identifies a male individual belonging to the *guapperia* or Camorra. According to this second view, "wop" is simply a synonym for "criminal."

57. *NYDM*, 30 December 1914, 26. "In *The Italian*, [Ince] gives another sample of plot expansion, which should be studied carefully by scenario writers who are anxious to achieve work of *feature* importance" (26).

58. Linda Williams, *Playing the Race Card: Melodramas of Black and White from Uncle Tom to O. J. Simpson* (Princeton, N.J.: Princeton University Press, 2001), 46–47.

59. In one of the rare studies of the film, Charles Keil has emphasized its "heterogeneous audience address" by arguing that "the film enfolds the material of its core narrative (which would seem to possess particular appeal for a working-class/immigrant audience) within a narrative frame which seems to work toward the cultivation of middle-class taste." Charles Keil, "Reframing *The Italian*: Questions of Audience Address in Early Cinema," *Journal of Film and Video* 42, no. 1 (Spring 1990): 37–38. On the drive to both represent the working class and immigrants' underprivileged lives and maintain a bourgeois sense of decorum and moral respectability, see, among others, Lary May, *Screening Out the Past: The Birth of Mass Culture and the Motion Picture Industry* (Chicago: University of Chicago Press, 1980), chapter 3; and Steven J. Ross, *Working-Class Hollywood: Silent Film and the Shaping of Class in America* (Princeton, N.J.: Princeton University Press, 1998), chapters 2 and 7.

60. *NYDM*, 30 December 1914, 26.

61. *MPN*, 2 January 1915, 81. Other reviews similarly emphasized Beban's poignant and realistic acting style: *MPN*, 14 November 1914, 36; *MPW*, 21 November 1914, 1060; and *MT* 13, no. 2 (9 January 1915): 77.

62. "*Sign of the Rose* Presented," *MPW*, 24 April 1915, 535. Reviews raved about the continuity between "screen" and "flesh" performances. Others, however, noted that although the staging allowed the audience to hear Beban's "voice of wonderful appeal," that did not "counterbalance the loss of the appeal made by his expressive face." See "*Sign of the Rose* Premiere Is a Success," *MPN* 11, no. 17 (1 May 1915): 43; and Kitty Kelly, "Flickerings from Film Land," *Chicago Daily Tribune*, 23 April 1915, 16. On the combination of photodrama and theatrical stagings, Kelly noted, "This production and its decidedly novel ending marks a new era in the joining of the two most popular forms of amusement." In the 1920s George Beban repeated the experiment of the hybrid finale for the premieres of his last three films: the remake of *The Sign of the Rose* (1922), *The Greatest Love of All* (1924), and *The Loves of Ricardo* (1926). See Alan Gevinson, ed., *Within Our Gates: Ethnicity in American Feature Films, 1911–1960*, American Film Institute Catalog (Berkeley: University of California Press, 1997), 19, 924.

63. "*Sign of the Rose* Presented," *MPW*, 24 April 1915, 535.

64. George Blaisdell, "The Sign of the Rose," *MPW*, 1 May 1915, 740.

65. A year later, Eleanor Brewster of *Motion Picture Classic* remarked, "Americanize George Beban on the screen and you have robbed pictures of a great artist.... Everybody stuck for the picturesque, colorful peasant types Mr. Beban has made us look for and love ever since the days of the 'The Sign of the Rose.'" "A Roman Rotogravurist," *Motion Picture Classic*, March 1918, 36–37.

66. "*The Sign of the Rose* teems with crowd scenes," Ince wrote, referring to Beban's efforts to reproduce the distinct urban atmosphere of New York, and "this is one of Beban's particular fortes—these East Side rucks of romantic-looking Latins with a fair sprinkling of other East Siders of different and nondescript nationalities. To get a certain amount of vim in the pictures, I sent to New York for some typical East Side denizens.... In *The Sign*

of the Rose . . . the difficulty lay not with the principal players but with those engaged in the superficial parts. For example, it was very difficult to convince the crowd that it should be an excited, surging, crowding crowd." *MPW*, 24 April 1915, 561.

67. "The scene between the police inspector and Pietro when the former tries to drag Pietro to headquarters has in art and realism never been surpassed on any stage at any time. . . . All I can say is that the screen when in the hands of a master like Thomas H. Ince yields nothing to the stage." Stephen Bush, "The Alien," *MPW*, 12 June 1915, 1789.

68. *NYDM*, 3 February 1917, 27. Similarly, *Moving Picture World* noted, "In the annals of stage and screen there is no star who has won distinction in the portrayal of a racial type in quite the degree that George Beban has, as an interpreter of the Italian." "Beban in Paramount Program," *MPW*, 3 February 1917, 713.

69. *Photoplay*, June 1915, 32.

70. Beban, "Taking a Comedian Seriously," 516. Beban had already recounted this story, detailing for instance that he had gone to meet Italians at the sites of the "excavating tunnels" of the subway, in an uncredited daily newspaper article titled "The Italian Role," published on 8 September 1910 and included in Beban's clipping files at NYPL-TC.

71. Beban had written *Photoplay Characterization* for the Palmer Photoplay Corporation, an organization headed by Frederick Palmer that, by posing as "a liaison between Hollywood and the American public," sold thousands of copies of screenwriting manuals and booklets as part of its "Complete Course and Service in Photoplay Writing." By exploiting Hollywood's rhetoric as a democratic institution, the Palmer Photoplay Corporation profitably commercialized a "Taylorization of self-expression" among America's aspiring screenwriters. See Anne Morey, *Hollywood Outsiders: The Adaptation of the Film Industry, 1913–1934* (Minneapolis: University of Minnesota Press, 2003), 73, 72. On the alignment of Palmer's instructions and Hollywood screenwriting practices, see David Bordwell, Janet Staiger, and Kristin Thompson, *The Classical Hollywood Cinema: Film Style and Mode of Production to 1960* (New York: Columbia University Press, 1985), 15, 177.

72. Beban, *Photoplay Characterization*, 3, 22, 3, 4, 14 (italics in the original).

73. Ibid., 22, 19, 15 (italics mine).

74. "Vesuvius Conquered," *Kinematograph Weekly*, 22 June 1922, 17. My thanks to Pierluigi Ercole for suggesting this source.

75. "Beban on Paramount Program," *MPW*, 3 February 1917, 713.

76. Eleanor Brewster, "A Roman Rotogravurist," *Motion Picture Classic*, March 1918, 36–37.

77. The Library of Congress owns a reference print of *Pasquale* (1916) and incomplete versions of *His Sweetheart* (1917) and *The Bond Between* (1917), the Museum of Modern Art has a copy of *The Marcellini Millions* (1917), and the Gosfilmofond of Moscow owns a print of *The Greatest Love of All* (1925). For one of Beban's obituaries, see *NYT*, 6 October 1928, 12.

78. While contributing substantially to the scenarios of his films, until 1918 Beban worked within the studio rules set by Thomas Ince and the Oliver Morosco Photoplay Company, whose films were distributed by Paramount. That year he decided to exercise full control over his productions. *Hearts of Men* (1919) was his production. See "Beban Makes Debut as Cinema Producer," *Los Angeles Express*, 8 March 1919.

79. *NYDM*, 3 February 1917, 27. Similarly, *Moving Picture World* praised his "sincere portrayal of the temperamental, excitable, and lovable Italian in America." *MPW*, 3 February 1917, 713.

80. Several films in this period associated American virtue with pacifism and juxtaposed these values to the aggressive war campaigns conducted by some European nations.

Consider, for instance, *Civilization* (1916), by Thomas H. Ince and Reginald Barker, respectively the producer and director of *The Italian*.

81. Brewster, "A Roman Rotogravurist," 36.

82. In the spirit of keeping the tragic Italian in his own place, Stephen Bush noted, "Frugal, honest, tender-hearted, full of that child-like simplicity which has always been a charming characteristic of southern Italians, Pietro is quite content with his lot in the new world, lowly and humble as it must needs be." "The Alien," *MPW*, 12 June 1915, 1789.

83. Brewster, "A Roman Rotogravurist," 36.

84. Matthew Pratt Guterl, *The Color of Race in America, 1900–1940* (Cambridge, Mass.: Harvard University Press, 2001), 6. Guterl has argued (12) that the success of Griffith's film "southernized" the American racial discourse; Jacobson places this biracialist emphasis in the 1920s. Matthew Frye Jacobson, *Whiteness of a Different Color: European Immigrants and the Alchemy of Race* (Cambridge, Mass.: Harvard University Press, 1998), chapter 3.

85. Michael Rogin partly addressed this development in his *Blackface, White Noise: Jewish Immigrants in the Hollywood Melting Pot* (Berkeley: University of California Press, 1998), particularly in chapters 4 and 5. Yet, by limiting his analysis to four race movies relatively distant in time from one another—*Uncle Tom's Cabin* (1902–1903), *The Birth of a Nation* (1915), *The Jazz Singer* (1927), and *Gone with the Wind* (1939)—his study gives a rather curtailed account of the range, dynamics, and workings of American cinema's racial representations.

86. Since the scenario department was in the mid-1910s the least gender-segregated of all studio divisions, these women screenwriters were able to have a creative impact. Levien, the editor of *Cosmopolitan,* wrote *Salome of the Tenements* (1925), adapted from Anja Yezierska's famous novel. Frances Marion, who started in 1912 as a poster artist for the theatrical company of Oliver Morosco (which produced a number of Beban films), wrote *The Social Highwayman* (1916), *Poor Little Peppina* (1916), and *The Love Light* (1921), a love story set in Italy during World War I, the last two starring Mary Pickford. Her interest in narratives culminated in *Potash and Perlmutter* (1923), a Jewish comedy and one of the most daring love stories of the period. June Mathis wrote numerous tenement melodramas, including *Dawn of Love* (1916), *Her Great Price* (1916), *Purple Lady* (1916), *Magdalene of the Hills* (1917), *Threads of Fate* (1917), and *Lombardi, Ltd.* (1919), before launching Valentino's career in 1921 by casting him (then only a bit player) as the protagonist of *The Four Horsemen of the Apocalypse* and mentoring him for years. See Lizzie Francke, *Script Girls: Women Screenwriters in Hollywood* (London: British Film Institute, 1994); and Karen Ward Mahar, *Women Filmmakers in Early Hollywood* (Baltimore, Md.: Johns Hopkins University Press, 2006).

87. Beban, "100% Italian—In Plays," 1067.

88. I have examined Valentino's popularity in early 1920s American and Italian American culture in "Duce/Divo: Displaced Rhetorics of Masculinity, Racial Identity, and Politics among Italian-Americans in 1920s New York City," *Journal of Urban History* 31, no. 5 (2005): 685–726.

7. Performing Geography

The first epigraph is from Annette Michelson, ed., *Kino-Eye: The Writings of Dziga Vertov* (Berkeley: University of California Press, 1984), 62. The second epigraph is from Tony Ardizzone, *In the Garden of Papa Santuzzu* (New York: Picador, 1999), 81. The internal one is taken from "The Moving Picture and the National Character," *American Review of Reviews* 42, no. 3 (September 1910): 320.

1. Of course, more studies of Italian film spectatorship in places other than New York City are necessary for a wider scenario. They ought to focus both on large cities such as Chicago, Philadelphia, and San Francisco and on smaller centers such as Youngstown, Ohio, and Providence, Rhode Island.

2. Charlotte Gower Chapman, *Milocca: A Sicilian Village* (Cambridge: Schenkman, 1971), 27.

3. "Wideopenness," *NYT*, 28 January 1899, 6.

4. Lewis E. Palmer, "The World in Motion," *Survey* 22, no. 10 (5 June 1909): 355.

5. John Collier, "Cheap Amusements," *Charities and the Commons* 20, no. 2 (11 April 1908): 75. The People's Institute was a progressive institute working to improve workers' lives, which saw leisure time as a catalyst for social progress and a deterrent of crime.

6. Mary Heaton Vorse, "Some Picture Show Audiences," *Outlook* 98 (24 June 1911): 441, 442, 445. This essay has been reprinted in several recent works, including Gregory A. Waller, *Moviegoing in America: A Sourcebook in the History of Film Exhibition* (Malden, Mass.: Blackwell, 2002), 50–53.

7. In a famous essay on New York's amusement scene, Michael Davis, a researcher for the Russell Sage Foundation, wrote, "One drama of the right sort may mean more for the education and unification of Italian, Jew, and American than fifty lectures, a hundred editorials, or a thousand sermons." Michael Davis, *The Exploitation of Pleasure* (New York: Russell Sage Foundation, 1911), 57.

8. Vachel Lindsay, *The Art of the Moving Picture* (New York: Liveright, 1970 [1915; rev. 1922]), 199 and chapter 13.

9. See the remarkable essay by David A. Hollinger, "Ethnic Diversity, Cosmopolitanism and the Emergence of the American Liberal Intelligentsia," *American Quarterly* 27, no. 2 (May 1975): 133–151.

10. Terry Ramsaye, *A Million and One Nights: A History of the Motion Picture* (New York: Simon and Schuster, 1926); Benjamin B. Hampton, *A History of the Movies* (New York: Covici-Friede, 1931); Lewis Jacobs, *The Rise of the American Film: A Critical History* (New York: Harcourt, Brace, 1939); and Paul Rotha, *The Film till Now: A Survey of World Cinema* (New York: Funk & Wagnalls, 1949).

11. See Robert Sklar, *Movie-Made America: A Social History of American Movies* (New York: Random House, 1975), especially 14–17, and his fundamental "Oh Althusser! Historiography and the Rise of Cinema Studies," in *Resisting Images: Essays on Cinema and History*, ed. Robert Sklar and Charles Musser (Philadelphia: Temple University Press, 1990), 12–35; Garth Jowett, *Film, The Democratic Art: A Social History of American Film* (Boston: Little, Brown, 1976), especially 38–42; Charles Musser, *The Emergence of Cinema*, 430–433, and *Before the Nickelodeon: Edwin S. Porter and the Edison Manufacturing Company* (Berkeley: University of California Press, 1991), chapter 9; and Ben Singer, "Manhattan Nickelodeons: New Data on Audiences and Exhibitors," *Cinema Journal* 34, no. 3 (1995): 5–35.

12. Russell Merritt, "Nickelodeon Theatres, 1905–1914: Building an Audience for the Movies," in *The American Film Industry*, ed. Tino Balio (Madison: University of Wisconsin Press, 1976), 59–79; Douglas Gomery, *Shared Pleasures: A History of Movie Presentation in the United States* (Madison: University of Wisconsin Press, 1992); and Robert C. Allen, *Vaudeville and Film, 1895–1915: A Study in Media Interaction* (New York: Arno, 1980), and "Motion Picture Exhibition in Manhattan, 1906–1912: Beyond the Nickelodeon," *Cinema Journal* 17, no. 2 (1979): 2–15, now in *Film before Griffith*, ed. John L. Fell (Berkeley: University of California Press, 1983), 162–175.

13. Robert C. Allen, "Manhattan Myopia; or, Oh! Iowa!" and Ben Singer, "New York, Just Like I Pictured It . . . ," *Cinema Journal* 35, no. 3 (Spring 1996): 75–103 and 104–128. In the same issue, see also the essays by Roberta Pearson and William Uricchio, Judith Thissen, and Sumiko Higashi.

14. A glaring example of this subsuming is Steven J. Ross, *Working-Class Hollywood: Silent Film and the Shaping of Class in America* (Princeton, N.J.: Princeton University Press, 1998).

15. Allen, *Vaudeville and Film*, 202–203. Such a small-time vaudeville culture, however, emerged a bit earlier, in the years between 1901 and 1905. See Richard Abel, *The Red Rooster Scare: Making Cinema American, 1900–1910* (Berkeley: University of California Press, 1999), especially 4–5.

16. The master text of this teleological historiography has long been Nicholas Vardac's *Stage to Screen* (Cambridge, Mass.: Harvard University Press, 1949).

17. Miriam Hansen, *Babel and Babylon: Spectatorship in American Silent Film* (Cambridge, Mass.: Harvard University Press, 1991), 88, 99. Her quotation of Koszarski is taken from a talk he delivered at the Columbia Seminar on Cinema and Interdisciplinary Interpretation in December 1986, which was also a draft of a chapter of his *An Evening's Entertainment*. The italics are hers.

18. A similar historical indeterminacy belongs to Judith Mayne's pioneering "Immigrants and Spectators," first published in *Wide Angle* 5, no. 2 (Summer 1982): 32–40, and revised in her *Private Novels/Public Films* (Athens: University of Georgia Press, 1988), 68–94.

19. Hansen, *Babel and Babylon*, 103.

20. Kathy Peiss, *Cheap Amusements: Working Women and Leisure in Turn-of-the-Century New York* (Philadelphia: Temple University Press, 1986), 149.

21. Janet Staiger, "Class, Ethnicity, and Gender: Explaining the Development of Early American Film Narrative," *Iris* 11 (1990): 13–26, and *Interpreting Films: Studies in the Historical Reception of American Cinema* (Princeton, N.J.: Princeton University Press, 1992), chapters 1 and 5; Lauren Rabinovitz, *For the Love of Pleasure: Women, Movies, and Culture in Turn-of-the-Century Chicago* (New Brunswick, N.J.: Rutgers University Press, 1998); Shelley Stamp, *Movie-Struck Girls: Women and Motion Picture Culture after the Nickelodeon* (Princeton, N.J.: Princeton University Press, 2000); and Elizabeth Ewen, "City Lights: Immigrant Women and the Rise of the Movies," *Signs: Journal of Women in Culture and Society* 5, no. 3, supplement (Spring 1980): S45–S65, and *Immigrant Women in the Land of Dollars: Life and Culture on the Lower East Side, 1890–1925* (New York: Monthly Review Press, 1985).

22. A similar class-centered and monolingual approach informs the otherwise remarkable historical accounts included in Waller, *Moviegoing in America*.

23. Roy Rosenzweig, *Eight Hours for What We Will: Workers and Leisure in an Industrial City, 1870–1920* (New York: Cambridge University Press, 1983); Ewen, *Immigrant Women*; and Kathy Peiss, *Cheap Amusements*.

24. William Uricchio and Roberta Pearson, "Dante's Inferno and Caesar's Ghost: Intertextuality and Conditions of Reception in Early American Cinema," in *Silent Film*, ed. Richard Abel (New Brunswick, N.J.: Rutgers University Press, 1996), 218–219.

25. Janet Staiger, *Bad Women: Regulating Sexuality in Early American Cinema* (Minneapolis: University of Minnesota Press, 1995), xii. See also her *Interpreting Films*, especially chapters 5 and 6.

26. Lee Grieveson, "Why the Audience Mattered in Chicago in 1907," in *American Movie Audiences: From the Turn of the Century to the Early Sound Era*, ed. Melvyn Stokes and Richard Maltby (London: British Film Institute, 1999), 88n7.

27. Hansen, *Babel and Babylon*, 101.

28. Ben Brewster and Lea Jacobs, *Theatre to Cinema: Stage Pictorialism and the Early Feature Film* (London: Oxford University Press, 1997) focuses primarily on legitimate theatre and on modalities of representation.

29. Sherman C. Kingsley, "The Penny Arcade and the Cheap Theatre," *Charities and the Commons* 18, no. 1 (8 June 1907): 296.

30. Collier, "Cheap Amusements," 74 and passim. See also Davis, *The Exploitation of Pleasure*, 33.

31. "Unusually among ethnic groups in New York, the Jews of the Lower East Side had a thriving ethnic culture, based on Yiddish theatre and music halls, before the arrival of the cinema." Stokes and Maltby, *American Movie Audiences*, 5. One of the first overviews of Yiddish theatre was Paul Klapper, "The Yiddish Music Hall," *University Settlement Studies* 2, no. 4 (December 1906): 19–23. Most discussions of the Jewish presence in the development of cinema in America have focused on the Jewishness of early film distributors and producers. See Neal Gabler, *An Empire of Their Own: How the Jews Invented Hollywood* (New York: Crown, 1988).

32. Nina Warnke, "Immigrant Popular Culture as Contested Sphere: Yiddish Music Halls, the Yiddish Press, and the Processes of Americanization, 1900–1910," *Theatre Journal* 48, no. 3 (1996): 322.

33. Judith Thissen, "Jewish Immigrant Audiences in New York City, 1905–14," in Stokes and Maltby, *American Movie Audiences*, 17–18 and passim. See also her dissertation, "Moyshe Goes to the Movies: Jewish Immigrants, Popular Entertainment, and Ethnic Identity in New York City (1880–1914)" (Ph.D. diss., Utrecht University, 2001).

34. Eventually the *prominenti* crowded the ranks of Italian American Fascist organizations. See Philip V. Cannistraro, "The Duce and the Prominenti: Fascism and the Crisis of Italian American Leadership," *Altreitalie* 31 (July–December 2005): 76–86.

35. Of the innumerable studies on religion among Italian Americans in this period, see Silvano M. Tomasi, *Piety and Power: The Role of the Italian Parishes in the New York Metropolitan Area, 1880–1930* (New York: Center for Migration Studies, 1975); and Gian Fausto Rosoli, "Chiesa e comunità italiane negli Stati Uniti (1880–1940)," *Studium* 75 (January–February 1979): 25–47.

36. Robert Anthony Orsi, *The Madonna of 115th Street: Faith and Community in Italian Harlem, 1880–1950* (New Haven, Conn.: Yale University Press, 1985), 165, xviii.

37. Denise M. DiCarlo, "The History of Italian Festa in New York City, 1880 to the Present" (Ph.D. diss., New York University, 1990), 233–234.

38. Rudolph Vecoli, "Prelates and Peasants: Italian Immigrants and the Catholic Church," *Journal of Social History* 2, no. 3 (Spring 1969): 259.

39. One of the first American exhibitions of the film series *Giornale della guerra d'Italia* (The Italian Battlefront, Regio Esercito–Sezione Cinematografica, 1917) occurred at the New York parish of Our Lady of Pompeii. See "Arte e patriottismo: La cinematografia ufficiale della nostra guerra," *FdNY*, 19 July 1917, 1.

40. Such creative solutions as "collective reading" overcame the burden of widespread illiteracy, as several historians have pointed out. See Gary R. Mormino and George E. Pozzetta, *The Immigrant World of Ybor City* (Urbana: University of Illinois Press, 1987), 102ff.

41. *L'araldo italiano* merged with *Il telegrafo* in 1913. For overviews, see George E. Pozzetta, "The Italian Immigrant Press of New York City: The Early Years, 1880–1915," *Journal of Ethnic Studies* 1 (Fall 1973): 32–46; and Pietro Russo, *Catalogo collettivo della stampa periodica italo-americana (1836–1980)* (Rome: CSER, 1983).

42. Author of *I misteri di Mulberry Street* (The Mysteries of Mulberry Street, 1893) and *I misteri di Bleecker Street* (The Mysteries of Bleecker Street, 1899), Ciambelli also wrote stage plays, including *Il martire del dovere, ovvero Giuseppe Petrosino* (The Martyr of Duty, or Giuseppe Petrosino). For an overview of Italian American literary figures and genres, which included autobiographies of chauvinism and proletarian denunciation, see Martino Marazzi, *Voices of Italian America: A History of Italian American Literature with a Critical Anthology*, trans. Ann Goldstein (Teaneck, N.J.: Fairleigh Dickinson University Press, 2004); and Francesco Durante, *Italoamericana: Storia e letteratura degli Italiani negli Stati Uniti, 1776–1880* (Milan: Mondadori, 2001).

43. Stanley Jackson, *Caruso* (New York: Stein, 1972), 115; and T. R. Ybarra, *Caruso, the Man of Naples and the Voice of God* (New York: Harcourt Brace, 1953), 106, 115.

44. Henry James, "Tommaso Salvini: In London (1884)," in *The Scenic Art: Notes on Acting and the Drama, 1872–1901*, ed. Allan Wade (New Brunswick, N.J.: Rutgers University Press, 1948), 189. For a general discussion, see Marvin Carlson, *The Italian Shakespearians: Performances by Ristori, Salvini, and Rossi in England and America* (Washington, D.C.: Folger Shakespeare Library, 1985).

45. John Corbin, "How the Other Half Laughs," *Harper's New Monthly Magazine*, December 1898, 31.

46. Vorse, "Some Picture Show Audiences," 446. See Italo Carlo Falbo, "Figure e scene del teatro popolare italiano a New York," *PIA*, 3, 10, 17 and 24 May; 7, 14, and 21 June; 5 and 12 July; and 13 September 1942); and Emile Aleandri, *The Italian-American Immigrant Theatre of New York City* (Charleston, S.C.: Arcadia, 1999), 27.

47. Famous for his characterizations of Calabrian brigand Giuseppe Musolino, Ricciardi played stereotypical roles on the Orpheum vaudeville circuit and in the Belasco theatres of New York, toured Europe, and even worked in Hollywood between 1922 and 1937, where he was typecast in Italian, Italian American, and Middle Eastern character roles. See Giuliana Muscio, *Piccole Italie, grandi schermi: Scambi cinematografici tra Italia e Stati Uniti, 1895–1945* (Rome: Bulzoni, 2004), 35–38, 282–283, and passim.

48. Maiori represented the attempt (which would soon fail) to bring the best of Italy's and Europe's legitimate stage repertoire not just into the colony but also to the city's audience. His performances as Shylock in *The Merchant of Venice* were regularly compared to those of the celebrated Yiddish actor Jacob P. Adler, because the two actors often alternated their performances at the Grand Theater (255 Grand Street), one of the city's most famous venues of Yiddish theatre. When his highbrow ambition expired, Maiori began performing *I mafiusi di la Vicaria* at his own theatrical venue, the Teatro di Varietà A. Maiori (235–237 Bowery), which also regularly showed moving pictures. His film career was limited, though. Most notably, he played the role of the mafioso Soldo in Sidney Olcott's *Poor Little Peppina* (1916).

49. By the early twentieth century Aguglia was the star of a large dialect theatre group, the Compagnia Drammatica Siciliana, directed by her soon-to-be husband, Vincenzo Ferraù, and performing in theatres throughout Europe and the Americas. Her film career spanned four decades, from the 1920s to the 1960s, during which she played Italian, Spanish, and Native American roles.

50. In the 1910s, the Partenope Publishing Co. (262 Williams Street) specialized in music sheets not just of famous Neapolitan songs but also of Neapolitan songs composed in America, such as Riccardo Cordiferro's "Luntananza" ("Distance"), which was made famous by Enrico Caruso's American performances. *FdNY*, 11 February 1917, 4. For a systematic overview of such music productions, see Simona Frasca, "Birds of Passage: La

diaspora dei musicisti napoletani a New York (1895–1940)" (Ph.D. diss., University of Rome La Sapienza, 2007).

51. A brief, but enthusiastic review of *The Alien*, translated as *Lo straniero*, is in *PIA*, 3 June 1915, 3.

52. Corbin, "How the Other Half Laughs," 31.

53. Hutchings Hapgood, "The Foreign Stage in New York: III. The Italian Theatre," *Bookman* 11 (August 1900): 547. See also A. Richard Sogliuzzo, "Notes for a History of the Italian-American Theatre of New York," *Theatre Survey* 14, no. 3 (1973): 61–62, 66.

54. Carl Van Vechten, "In Defense of the Art of Acting, and a Demand for a Truce to Actor-Baiting," *Vanity Fair* 9, no. 3 (November 1917): 144.

55. I have discussed how the Italian American press dealt with the rise of moving pictures in Giorgio Bertellini, "Shipwrecked Spectators: Italy's Immigrants at the Movies in New York, 1906–1916," *Velvet Light Trap* 44 (Fall 1999): 39–53.

56. Ben Singer kindly provided me with a detailed listing of all New York movie theatres for which he had found direct evidence, upon which he based his essay "Manhattan Nickelodeons." Of the thirty-two Italian venues, it appears that nineteen of them were located downtown (with five along the Bowery), ten uptown, and three in midtown. Most of them are listed without names.

57. *FdNY*, 21 April 1907, 5; 12 May 1907, 3; 2 June 1907, 4; 13 September 1908, 3; and 20 June 1909, 5. Other venues included the Teatro di Varietà A. Maiori, the Grand Theatre, the Thalia Theatre, the Jefferson Theater, the Teatro Garibaldi, the Bijou, and the Florence Theater. The famous tenor Caruso did not own a stake in Cinematografo Caruso, which simply capitalized on his fame.

58. "Keith and Proctor Going Strong for Cinematography," *MPW*, 22 February 1908, 137.

59. Allen, *Vaudeville and Film*, 244.

60. According to Aldo Bernardini, ed., *Archivio del cinema muto italiano* (Rome: ANICA, 1991), 8 Italian films were distributed in the U.S. in 1906; 35 in 1907; 105 in 1908; 191 in 1909; 255 in 1910; 254 in 1911; 277 in 1912; 293 in 1913; 173 in 1914; 32 in 1915; and none in 1916. More recently, Aldo Bernardini, ed., *Cinema muto italiano: I film "dal vero," 1895–1914* (Gemona: La Cineteca del Friuli, 2002), has listed a few dozen more Italian documentaries and non-fiction films distributed in the U.S.

61. *MPW* 2, no. 18 (2 May 1908): 401; *MPW* 12, no. 19 (9 May 1908): 423; Bernardini, *Archivio del cinema italiano*, 1:31; and Bernardini, *Cinema muto italiano: I film "dal vero," 77*. Other titles touched upon the familiar combination of tourism and ethnography: *Napoli e il Vesuvio* (Life and Customs of Naples, Ambrosio, 1907), *Sardegna Pittoresca* (Picturesque Sardinia, Milano Films, 1911), *Sorrento* (Picturesque Sorrento, Cines, 1912), *Fra i monti della Calabria* (Among the Mountains of Calabria, Cines, 1912), and *Napoli* (Glimpses of Naples and Vicinity, Cines, 1912). While clearly more research ought to be done on the distribution of these "picturesque" productions in America's Little Italies, newspapers' patriotic accounts of Italy's natural and architectural marvels reveal a widespread familiarity with the trope of Italy as *Bel paese*.

62. Similarly, the press seldom mentioned the distribution of comedies and modern dramas, unless they were inspired by such popular authors as Carolina Invernizio and Gabriele D'Annunzio.

63. See "Anti-Plague Posters," *New York Daily Tribune*, 28 June 1908, 5 (italics mine). On the same page, the newspaper printed a view of the Venetian canal.

64. Cines advertisement, *MPW*, 11 April 1908, 309.

65. Consider Cines's *Otello* (Othello, 1906), *Amleto* (Hamlet, 1908), and *Romeo e Giulietta* (Romeo and Juliet, 1908). Italian nationalist culture emphasized Shakespeare's debt to Italy. See "Il debito di Shakespeare verso l'Italia," *Il carroccio* 3, no. 4 (April 1916): 197–201. *Il carroccio* was a nationalist weekly founded in 1915.

66. W. Stephen Bush, "Gauging the Public Taste," *MPW*, 11 May 1912, 505. For discussions of the critical reception of Italian films in the U.S., see William Uricchio and Roberta Pearson, "Italian Spectacle and the U.S. Market," in *Cinéma sans frontières*, ed. Roland Cosandey and François Albéra (Montreal: Nuit Blanche, 1995), 95–105. I have examined the influence of Italian historical films on American cinema in "Epica spettacolare e splendore del vero: L'influenza del cinema storico italiano in America (1908–1915)," in *Storia del cinema mondiale*, vol. 2, *Gli Stati Uniti*, ed. Gian Piero Brunetta (Turin: Einaudi, 1999), 1:227–265. For a wider perspective on foreign films in America, see Abel's crucial works, *The Red Rooster Scare* and *Americanizing the Movies and "Movie-Mad" Audiences, 1910–1914* (Berkeley: University of California Press, 2006).

67. *PIA*, 19 October 1913, 3.

68. *FdNY*, 7 June 1914, 2. The paper compared *Cabiria* with other Italian film epics and reported on its success in New Jersey, California, and Ohio. See *FdNY*, 18 June 1914, 6; and 19 July 1914, 4.

69. Emelise Aleandri, "A History of Italian-American Theatre: 1900 to 1905" (Ph.D. diss., City University of New York, 1983), 73.

70. *FdNY*, 17 March 1907, 3.

71. Martin Meisel, *Realizations: Narrative, Pictorial, and Theatrical Arts in Nineteenth-Century England* (Princeton, N.J.: Princeton University Press, 1987).

72. David Mayer, *Playing Out the Empire: Ben Hur and Other Toga Plays and Films, 1883–1908; A Critical Anthology* (Oxford: Clarendon, 1994), 12.

73. "La giornata epica alla camera" [The epic day at the chamber], *FdNY*, 2 August 1908, 7.

74. The film is not listed, at least under this title, in the filmographies included in Anthony Slide, *The Big V: A History of the Vitagraph Company* (Metuchen, N.J.: Scarecrow, 1987); and Paolo Cherchi Usai, ed., *Vitagraph Co. of America: Il cinema prima di Hollywood* (Pordenone: Edizioni Studio Tesi, 1987). It was either *War*, a one-reeler released on 8 December 1911, or one of the monthly newsreels launched by Vitagraph on 18 August 1911 and titled *The Vitagraph Monthly of Current Events*. The series was to become the *Hearst-Vitagraph Weekly News Feature*. On Italian atrocities in Libya, see Lino Del Fra, *Sciara Sciat: Genocidio nell'oasi; L'esercito italiano a Tripoli* (Rome: Datanews, 1995).

75. "Un comizio contro i diffamatori d'Italia," *AI*, 17 December 1911, 9.

76. Similar results followed in Baltimore, in Massachusetts, and in Canada. See *AI*, 14 December 1911, 4; and 2 January 1912, 5.

77. *FdNY*, 10 December 1911, 3.

78. Classic engravings, complete with Latin inscriptions, appeared in the press. See *FdNY*, 24 December 1911, 8; "Color Pictures about War between Italy and Turkey," *AI*, 7 February 1912, 2; and "Book on Italy in Tripoli," *AI*, 7 April 1912, 7.

79. *AI*, 7 February 1912, 2.

80. *PIA*, 4 January 1913, 4.

81. Editorials against the American press, especially the *New York Times*, appeared in 1915 in the bilingual *Il cittadino/The Citizen: An Independent Weekly Newspaper for the Italians in the U.S.* and in *Il carroccio*, founded in 1915 by Agostino Di Biasi, who was also the founding father of Italian American fascism. Public defense against anti-Italian prejudice in the

media had become particularly outspoken in 1913. On 7 October of that year, *Il progresso italo-americano* protested vehemently at the release of a film, *The Message to Headquarters* (Thanhouser, 1913), that told the story of a rich American man who was robbed in Italy by brigands, in a way that made the assault seem emblematic and predictable.

82. The film continued its American tour in Cleveland, St. Louis, Kansas City, New Orleans, Philadelphia, and San Francisco. On these exhibitions, see Gian Piero Brunetta, "La guerra vicina," in *Il Cinematografo al campo: L'arma nuova nel primo conflitto mondiale,* ed. Renzo Renzi (Ancona: Transeuropa, 1993), 11-24.

83. "*Italian Battlefront:* A Remarkable Film," *MPW,* 25 August 1917, 1201.

84. "La 'premiere' della cinematografia ufficiale della guerra italiana," *FdNY,* 12 August 1917, 6; and "La cinematografia della guerra italiana," *FdNY,* 19 August 1917, 4.

85. "La cinematografia della guerra italiana," *FdNY,* 19 August 1917, 4.

86. Armando Cenerazzo, "Doppo Nu Suonno," *FdNY,* 14 February 1909, 3.

87. Well-educated and having been active as a professional actor in Sicily, De Rosalia (1864-1934) arrived in America in 1903, where he was intensely committed to preserving a Sicilian cultural and linguistic worldview. See Aleandri, "A History of Italian-American Theatre," 222-230; and Joseph J. Accardi, "Giovanni DeRosalia: Playwright, Poet, and 'Nofrio,'" *Italian Americana* 19, no. 2 (Summer 2001): 176-200.

88. For Nofrio a phone conversation is nothing but "words walking, walking, walking" along wires. Giovanni De Rosalia, *Nofrio al telefono* (New York: Italian Book Co., 1918), 8-9. In Howard Hawks's *Scarface* (1932), a foolish companion of the protagonist, Tony Camonte, confuses the technologically mediated conversation with a real one. The character is engaged in a series of skits underlining his inability to answer the phone and take messages, which results in his attempt to shoot the person speaking on the phone by aiming at the phone. In *The Sopranos,* the barman of the Bada Bing! strip club exhibits similar difficulties with the phone.

89. Frank Milazzo, "Pi lu tiatru sicilianu," *FdNY,* 26 July 1908, 6.

90. Giovanni De Rosalia, "Scene siciliane," *FdNY,* 7 November 1909, 4.

91. Nanè, "Lu cinematurru," *FdNY,* 29 August 1910; 4; *FdNY,* 12 December 1909, 6.

92. Giovanni de Rosalia, "Cinematografu," *FdNY,* 30 October 1910, 4.

93. His serious works include the social dramas *L'onore perduto* (Lost Honor, 1901) and the colonial sketch *Il poliziotto italo-americano* (The Italian American Detective, 1902). He also produced self-reflexive sketches about Italian American theatre and wrote poetry, comedies, and songs that his friend Farfariello often performed. He authored the lyrics of the song "Core 'ngrato," made famous by Enrico Caruso. He signed his columns with the pen names Riccardo Cordiferro (Richard Ironheart) or Il Turco di Ritorno (The Returning Turk).

94. In 1914, Sisca attacked Booker T. Washington's *The Man Farthest Down: A Record of Observation and Study in Europe* (1912) for his use of racist anti-Southern stereotypes to "proclaim the superiority of blacks over the peoples of Naples and the peasants of Sicily!" Il Turco di Ritorno, "Negri, Napoletani e Siciliani," *FdNY,* 5 January 1914, 4.

95. Il Turco di Ritorno, "Moving Pictures," *FdNY,* 30 January 1910, 8. On the same position, see "Rubrica dei lettori (Readers' column)," *FdNY,* 6 February 1910, 8; and "Moving Pictures," *FdNY,* 6 March 1910, 8.

96. "Cinematografi, canzonettisti e … cose affini!" *FdNY,* 7 May 1911, 1.

97. See the works of Kathy Peiss, Lauren Rabinovitz, and Shelley Stamp on the subject, especially Stamp, *Movie-Struck Girls,* 5-7.

98. The classic essay on the gender positioning associated with the emergence of mass culture is Andreas Huyssen, "Mass Culture as Woman: Modernism's Other," in *Studies of*

Entertainments: Critical Approaches to Mass Culture, ed. Tania Modleski (Bloomington: Indiana University Press, 1986), 188–207.

99. The Fascist government censored these productions for their constant adoption of sensationalist narratives of violent and passionate love, their association with the criminal underworld of the Camorra, and their use of intertitles in the vernacular instead of the national language. After 1928, a more effective censorship system and the introduction of synchronized sound forced Neapolitan film production to decline irreversibly. Vittorio Martinelli, "The Evolution of Neapolitan Cinema to 1930," in *Napoletana: Images of a City,* ed. Adriano Aprà (New York: MoMA/Bompiani, 1993), 71ff. Anthony Henry Guzman's comprehensive "The Exhibition and Reception of European Films in the United States during the 1920s" (Ph.D. diss., UCLA, 1993) provides little information about the minor and non-institutional commerce in Neapolitan films.

100. These included *La nave* (The Ship, Ambrosio–UCI, 1920), *Dante nella vita e nei tempi suoi* (Dante's Inferno, V.I.S. Florence, 1922), *Messalina* (Guazzoni Film, 1923), and a new version of *Quo Vadis?* (UCI, 1924). See Guzman, "The Exhibition and Reception of European Films."

101. Among these songs, consider "Torna a Surriento," "Lacreme Napuletane," "Addio mia bella Napoli," and "Santa Lucia Luntana." On the subject, see Emilio Franzina, "Le canzoni dell'emigrazione," in *Storia dell'emigrazione italiana: Partenze,* ed. Pietro Bevilacqua, Angelina De Clementi, and Emilio Franzina (Rome: Donzelli Editore, 2001), 537–562; and Frasca, "Birds of Passage."

102. Martinelli, "The Evolution of Neapolitan Cinema," 64.

103. Titles include *A Piedigrotta* [At Piedigrotta, 1920], *'O festino e 'a legge* [The Feast and the Law, 1920], *Il miracolo della Madonna di Pompeii* (Mary the Crazy Woman, 1922), and *Scugnizza* (Orphan of Naples, 1923).

104. Giuliana Bruno, *Streetwalking on a Ruined Map: Cultural Theory and the City Films of Elvira Notari* (Princeton, N.J.: Princeton University Press, 1993), 122 and passim.

105. See, for instance, *PIA,* 9 July 1921 and 1 September 1924.

106. See Martinelli, "The Evolution of Neapolitan Cinema," 66.

107. For a wider discussion, see Giorgio Bertellini, "Storia, cultura e linguaggio italiani fuori d'Italia: Il caso di due film italo-americani da poco restaurati" in *Narrare la storia: dal documento al racconto* (Milan: Mondadori, 2006), 304–319.

108. Until coming to the U.S. in 1897, Migliaccio had no theatrical training. In turn-of-the-twentieth-century New York, he learned and honed his talent at local *cafés-chantants,* where spectators began calling him Farfariello after the refrain of his signature song "Femmene-Fe" (Women). "Farfariello" has two meanings: a literal one, "little butterfly," and an idiomatic one, "womanizer." For a detailed overview of Migliaccio's figure, see Esther Romeyn, "Worlds in between Worlds: Italian-Americans and Farfariello, Their Comic Double" (Ph.D. diss., University of Minnesota, 1990), 115–162.

109. Emelise Aleandri, "Italian-American Theatre," in *Il sogno italo-americano: Realtà e immaginario dell'emigrazione negli Stati Uniti,* ed. Sebastiano Martelli (Naples: CUEN, 1998), 125–126.

110. Migliaccio made use of the full spectrum of modern American media. His skits were recorded by the Victor Company, published by the Italian Book Company, and appeared regularly in *La follia di New York.* He toured the Northeast and often visited the Italian American theatrical communities in Chicago and San Francisco. After the war, his performances expanded into full-length plays, and in the 1930s he began doing radio broadcasts. His sketches about American women and about changing gender relationships

within the colony were especially famous, such as "Ammore d'oggi" (Today's Love), "La donna ultra moderna" (The Ultra-modern Woman), and "Le donne a cunailando" (Coney Island Women). On the strategic notion of mimicry and identity construction, see Homi K. Bhabha, "Of Mimicry and Man: The Ambivalence of Colonial Discourse," in *The Location of Culture* (New York: Routledge, 1994), 85–92.

111. The Aurora Film Co. was an actual film company, located at 243 West 42nd Street, and was headed by the aforementioned Rosario Romeo. Romeo must have been a friend of Migliaccio's, since *L'attore cinematografico* was regularly exhibited (under its English title *The Movie Actor*) with Romeo's feature *Amore e morte*.

112. "'A lengua 'taliana," music by G. Del Colle, lyrics by E. Migliaccio, Immigration History Research Center, Migliaccio Collection, box 7, folder 5. It has also been published in Sandra Rainero, "Farfariello e gli altri: Inediti di Eduardo Migliaccio," *Forum Italicum* 32 (Spring 1998): 202–204.

113. *The Movie Actor* was exhibited in midtown Manhattan, at the Selwyn Theatre, and in the Little Italies of East Harlem and the Lower East Side, always with *Amore e morte*. See *PIA*, 16 October 1932, 7S; and 6 November 1932, 7S.

114. On Migliaccio's linguistic registers, see Hermann W. Haller, *Tra Napoli e New York: Le macchiette italo-americane di Eduardo Migliaccio* (Rome: Bulzoni Editore, 2006), 27–67.

115. Esther Romeyn, "Juggling Italian-American Identities: Farfariello, King of the Character Clowns," *Italian American Review* 9, no. 2 (Fall–Winter 2002): 118.

116. Ibid., 114, 115.

117. For reviews of Migliaccio and Renard on stage, see *PIA*, 6 March 1932, 7S; 20 March 1932, 7S. As Martino Marazzi kindly informs me, the film was shown in Pittston, Pennsylvania, in the fall of 1933, according to the Italian leftist paper *Il minatore/The Miner* (Scranton), 13 November 1933.

118. *PIA*, 17 April 1932, 7S.

119. Many films needed to refer to a familiar Southern Italian landscape in this way. The *New York Times* wrote that *Amore e morte* tried to look unambiguously Sicilian by relying on a familiar aestheticization of its landscapes and props: "A location in a difficultly cultivated region of New Jersey, within sight of the Watchung Mountain, with stone house and isolated barn, with orchard and grape trellises, provides a striking illusion of the approaches to Etna in Eastern Sicily. This illusion is further emphasized by a 'carretto siciliano,' the high, two-wheel cart with pictured side-boards." W. L., "A Tragedy in Italian," *NYT*, 4 October 1932, 26.

120. See Philip V. Cannistraro, *Blackshirts in Little Italy: Italian Americans and Fascism, 1921–1929* (West Lafayette, Ind.: Bordighera, 1999); and Emilio Franzina and Matteo Sanfilippo, eds., *Il fascismo e gli emigrati: La parabola dei Fasci italiani all'estero (1920–1943)* (Rome and Bari: Laterza, 2003).

121. Duilio Marazzi, "La cinematografia italiana in America," in *Senza maschera: Storie e pensieri di Duilio Marazzi* (New York: 1934), 44–48. Immigration History Research Center, Migliaccio Collection, box 10.

122. In the early 1930s, the film provoked an intense correspondence between the Italian embassy in Washington and the Italian State Department because of its heroic characterization of the renowned brigand. There are apparently no traces of the film in Italian official filmographies. See Martinelli, "The Evolution of Neapolitan Cinema," 68–69.

123. Marazzi, "La cinematografia italiana in America," 45.

124. Franco Lo Piparo, "Sicilia linguistica," in *La Sicilia: Storia d'Italia; Le regioni dall'Unità a oggi*, ed. Maurice Aymard and Giuseppe Giarrizzo (Turin: Einaudi, 1987), 794.

125. Tony Ardizzone, *In the Garden of Papa Santuzzu* (New York: Picador, 1999), 81–82. During an interview conducted on 26 June 2008, Ardizzone identified the writings of Jerre Mangione as particularly influential on his fiction in general, and on this novel in particular. Mangione was the author of *Mount Allegro: A Memoir of Italian American Life* (New York: Columbia University Press, 1981 [1942]) and (with Ben Morreale) of *La Storia: Five Centuries of the Italian American Experience, 1492–1992* (New York: HarperCollins, 1992). I am grateful to Tony Ardizzone for his time and generosity.

Afterword

The first epigraph is from Carl Chiarenza, "Notes toward an Integrated History of Picturemaking," *Afterimage* 7, nos. 1–2 (Summer 1979): 37. The second epigraph is from Oliver Wendell Holmes, "The Stereoscope and the Stereograph," *Atlantic Monthly* 3, no. 20 (June 1859): 738–748, now in Alan Trachtenberg, *Classic Essays on Photography* (New Haven, Conn.: Leete's Island Books, 1980), 73–74. Later ones are from André Bazin, "An Aesthetic of Reality," *What Is Cinema?*, vol. 2 (Berkeley: University of California Press, 1971), 28; and Michel Foucault, "L'oeil du pouvoir," preface to *La panoptique,* by Jeremy Bentham (Paris: Belfond, 1977), trans. as "The Eye of Power," in *Power/Knowledge: Selected Interviews and Other Writings, 1972–1977* (London: Harvester Wheatsheaf, 1980), 149 (italics in the original).

1. The best starting point is Tom Gunning, "In Your Face: Physiognomy, Photography, and the Gnostic Mission of Early Film," *Modernism/Modernity* 4, no. 1 (1997): 1–29.

2. See his essays "Medium Specificity Arguments and the Self-Consciously Invented Arts: Film, Video, and Photography," "The Specificity of Media in the Arts," and "Concerning Uniqueness Claims for Photographic and Cinematographic Representation," all included in Noël Carroll, *Theorizing the Moving Image* (New York: Cambridge University Press, 1996).

3. Recent studies addressing the ontological differences between analog and digital modes of image-making have displayed a renewed attention to questions of realism, indexicality, and visual reproduction. See, among others, William Uricchio, "Storage, Simultaneity, and the Media Technologies of Modernity," in *Allegories of Communication: Intermedial Concerns from Cinema to the Digital,* ed. John Fullerton and Jan Olsson (Rome: John Libbey, 2004), 123–138; and D. N. Rodowick, *The Virtual Life of Film* (Cambridge, Mass.: Harvard University Press, 2007).

4. Walter Benjamin, "The Work of Art in the Age of Mechanical Reproduction," trans. Harry Zohn, in Walter Benjamin, *Illuminations: Essays and Reflections,* ed. Hannah Arendt (New York: Schocken, 1968), 218.

5. Antony Griffiths, *Prints and Printmaking: An Introduction to the History of Techniques* (Berkeley: University of California Press, 1996), 9.

6. Benjamin, "The Work of Art," 219 (italics mine).

7. William M. Ivins, Jr., *Prints and Visual Communication* (Cambridge, Mass.: Harvard University Press, 1953), 2.

8. Ibid., 3. Ivins's position with regard to photographic reproductions is problematic, however, as he conflates the perception of their accuracy (*ad hominem*) with their objectivity (*ad rem*). He refers to them as "truthful" and "exceptional" because their printed translation "had not been reduced to the syntax and the blurring technical necessities of a manufacturing trade and craft," but it operated, to put it in Benjamin's terms, "without the intervention of either the draughtsman or the engraver." Benjamin, "The Work of Art," 176–177.

9. On this point see also Ivins, *Prints and Visual Communication*, 132–133. Archeologists of so-called precinematic devices and practices have tended to focus on the mechanisms and principles of the production of the film image, which are linked to the reproduction of movement or the practice of image projection. Traditionally, however, they have subscribed to an overt or covert teleological rhetoric, one that sees cinema as the most modern and perfected technology. Notable exceptions include Charles Musser, "Toward a History of Screen Practice," in *The Emergence of Cinema: The American Screen to 1907* (New York: Scribner, 1990), 15–54, in which Musser criticizes historians of the precinema period for hailing "technology as a determining practice, not as a component part of this practice" (17), and the exemplary anthology edited by Nancy Mowll Mathews with Charles Musser, *Moving Pictures; American Art and Early Film, 1880–1910* (Manchester, Vt.: Hudson Hills, 2005).

10. Charles Baudelaire, "The Salon of 1859," trans. Jonathan Mayne, in *Photography in Print: Writings from 1816 to the Present*, ed. Vicki Goldberg (Albuquerque: University of New Mexico Press, 1988), 125. On this influential Baudelairean view, see Aaron Sharf, *Art and Photography* (London: Penguin, 1968), particularly 145. For a cogent rebuttal to the notion that photography meant a radical reframing of visual perception and artistic representation, see Kirk Varnedoe, "The Artifice of Candor: Impression and Photography Reconsidered," *Art in America* 68, no. 1 (January 1980): 66–78.

11. Goldberg, *Photography in Print*, 67, quoting a comment in the *Edinburgh Review*, January 1843.

12. The proponents of "straight photography" were in direct opposition to the exponents of pictorialism or "photo-painting," who instead identified photography with the painterly arts and rejected the "transparency fallacy" by emphasizing its controllable semiotic arrangements (e.g., framing, blurring, and multiple exposures).

13. Supporters of cinematic realism, such as André Bazin and Siegfried Kracauer, located the essence of the cinematic medium in its photographic representation and, on this ground, defended cinema's artistic—that is, realist—possibilities. Another cluster of theorists, beginning with the formalist exponents of the Soviet montage, claimed instead that it was editing that defined cinema's essence and true artistic nature. Here I focus on the earlier, more resilient stance.

14. Walter Benjamin, "The Work of Art in the Age of Mechanical Reproduction," trans. Harry Zohn, in *Illuminations*, 236; André Bazin, "The Ontology of the Photographic Image" (1945), in *What Is Cinema?*, vol. 1, ed. and trans. Hugh Grey (Berkeley: University of California Press, 1967), 14; and Erwin Panofsky, "Style and Medium in the Motion Pictures," in *Film Theory and Criticism: Introductory Readings*, ed. Gerald Mast and Marshall Cohen (New York: Oxford University Press, 1979), 263.

15. Siegfried Kracauer, *Theory of Film* (New York: Oxford University Press, 1960), ix, and "Photography" (1927), trans. Thomas Y. Levin, *Critical Inquiry* 19 (Spring 1993): 421–436; Christian Metz, *Film Language: A Semiotics of the Cinema*, 1968, trans. Michael Taylor (New York: Oxford University Press, 1974), 43; Stanley Cavell, *The World Viewed* (New York: Viking, 1971), 23, and *The World Viewed*, rev. ed. (Cambridge, Mass.: Harvard University Press, 1979), 24 (italics in the original); Rudolph Arnheim, "On the Nature of Photography," *Critical Inquiry* 1, no. 1 (September 1974): 155; and Roland Barthes, *Camera Lucida*, 1980, trans. Richard Howard (London: Jonathan Cape, 1981), 88–89.

16. Miriam Hansen, "'With Skin and Hair': Kracauer's Theory of Film, Marseille 1940," *Critical Inquiry* 19, no. 3 (Spring 1993): 446.

17. Analytical film theory has been the most actively engaged in discussing transparency theories, starting with Kendall L. Walton's "seeing through" thesis and the challenges

to it raised by Nigel Warburton, Gregory Currie, and Jerrold Levinson. For a cogent discussion of these positions, see C. Paul Sellors, "Representing Fictions in Film" (Ph.D. diss., New York University, 2002), particularly chapter 3.

18. Even Angela Dalle Vacche's skillful exploration of the past and future alliances between art history and film studies identifies "access to [the] fourth dimension" as "the most fundamental problem of modernity" before arguing that it is the photographic medium, rather than painting or theatre, that "is most crucial to the specificity of cinema," because of its "special kinship with capturing an otherwise unstoppable, death-bound, indifferent time." Dalle Vacche, "Cinema and Art History: Film Has Two Eyes," in *The Sage Handbook of Film Studies,* ed. James Donald and Michael Renov (New York: Sage, 2008), 185, 190. This important anthology includes a section on "Film and History," but not one on "Film and Geography."

19. Carroll, *Theorizing,* 37–38 (italics mine); and Bazin, "The Ontology of the Photographic Image," in *What Is Cinema?,* 14. Susan Sontag and Roland Barthes have variously and notoriously written about the value of photography's memorializing effect.

20. Kracauer, "Photography," 425. Whereas Kracauer had privileged a historiographical reading of history as *historia rerum gestarum* in "Photography," he drew a parallelism between "historical reality" and "camera reality" in *History: The Last Things before the Last* (Princeton, N.J.: Princeton University Press, 1995 [1969]): 3. On this point, see Carlo Ginzburg, "Particolari, primi piani, microanalisi: In margine a un libro di Siegfried Kracauer," *Paragone* 54, nos. 48–50 (August–December 2003): 20–37, reprinted as "Minutiae, Close-up, Microanalysis," *Critical Inquiry* 34, no. 1 (Autumn 2007): 174–189. For a more general contextualization, see Hansen, ""With Skin and Hair."

21. Kracauer, *History,* 60–163.

22. George Steinmetz, "Decolonizing German Theory: An Introduction," *Postcolonial Studies* 9, no. 1 (2006): 3. "What would postcolonial analysis be without Hegel's discussion of the lord-bondsman relation and the 'struggle for recognition'; Marx's theory of the runaway dynamics of capitalist accumulation and its assault on practices that do not belong to capital's 'life world' . . . ; Heidegger's corrosive critique of European modernity; Freud's theories of fetishism, narcissism, double consciousness and identification; Adorno's negative dialectics; and Carl Schmitt's analysis of the European *Nomos* and its collapse?" (4).

23. See, for instance, David Brion Davis, *The Problem of Slavery in the Age of Revolution, 1770–1823* (Ithaca, N.Y.: Cornell University Press, 1975).

24. Susan Buck-Morss, "Hegel and Haiti," *Critical Inquiry* 26, no. 4 (Summer 2000): 821–865.

25. Susan Buck-Morss, *The Dialectics of Seeing: Walter Benjamin and the Arcades Project* (Cambridge, Mass.: MIT Press, 1995), 26–27. First published in the *Frankfurter Zeitung* in 1926, "Naples" is now included in Walter Benjamin, *Selected Writings,* vol. 1, 1913–26, ed. Marcus Bullock and Michael W. Jennings (Cambridge, Mass.: Harvard University Press, 1996), 414–421.

26. David Harvey, *The Conditions of Postmodernity* (Oxford: Blackwell, 1990), 205 (italics in the original). Andrew Thacker makes a similar point with regard to the scholarship on modernism in his *Moving through Modernity: Space and Geography in Modernism* (Manchester: Manchester University Press, 2003), 2.

27. Stephen Kern, *The Culture of Time and Space, 1880–1918* (Cambridge, Mass.: Harvard University Press, 1983), 131–258.

28. The best reference text on the subject is John Agnew, David N. Livingstone, and Alisdair Rogers, eds., *Human Geography: An Essential Anthology* (Cambridge: Blackwell, 1996).

29. See Gaston Bachelard, *The Poetics of Space*, trans. Maria Jolas (New York: Orion, 1964 [1957]); Henri Lefebvre, *The Production of Space*, trans. Donald Nicholson-Smith (Malden, Mass.: Blackwell, 1991 [1974]); Fredric Jameson, *The Political Unconscious: Narrative as a Socially Symbolic Act* (Ithaca, N.Y.: Cornell University Press, 1981), and *The Geopolitical Aesthetic: Cinema and Space in the World System* (Bloomington: Indiana University Press; London: British Film Institute, 1992); Michel de Certeau, *The Practice of Everyday Life* (Berkeley: University of California Press, 1984); Michel Foucault, "Questions of Geography" (1977) and "The Eye of Power" (1978), in *Power/Knowledge: Selected Interviews and Other Writings, 1972–1977* (London: Harvester Wheatsheaf, 1980), 63–77 and 146–175, and "Des Espaces Autres," in *Architecture-Mouvement-Continuité,* October 1984, trans. as "Of Other Spaces," *Diacritics* 16, no. 1 (Spring 1986): 22–27.

30. Kristin Ross, *The Emergence of Social Space: Rimbaud and the Paris Commune* (Minneapolis: University of Minnesota Press, 1988); and Franco Moretti, *Atlas of the European Novel, 1800–1900* (London: Verso, 1998 [1997]). I am obviously referring to the outstanding novelty of Fernand Braudel's historical work on the relevance of geography as a tool of historiographical analysis, beginning with his *The Mediterranean and the Mediterranean World in the Age of Philip II* (London: Collins, 1972 [1949]).

31. Edward Said, *Culture and Imperialism* (New York: Knopf, 1993), 7. In this vein, see the inspiring anthology edited by Laura Doyle and Laura Winkel, *Geomodernisms: Race, Modernism, Modernity* (Bloomington: Indiana University Press, 2005), whose contributions open up and "un-discipline" Anglo-European modernist narratives to include African, Atlantic, and subaltern modernities (7ff).

32. A brief overview of such studies, mostly concerned with sound films, includes Mark Shiel and Tony Fitzmaurice, eds., *Cinema and the City: Film and Urban Societies in a Global Context* (Malden, Mass.: Blackwell, 2001); Mark Shiel, *Screening the City* (London: Verso, 2003); and Edward Dimendberg, *Film Noir and the Spaces of Modernity* (Cambridge, Mass.: Harvard University Press, 2004). For a broad and succinct outline of urban studies' interdisciplinary convergences, see Philip J. Ethington and Vanessa R. Schwartz, "Introduction: An Atlas of the Urban Icons Project," *Urban History* 33, no. 1 (2006): 5–19 (and the entire special issue). For an important example of a study of space (geography) and race that does not intersect with film studies, see Richard H. Schein, ed., *Landscape and Race in the United States* (New York: Routledge, 2006).

33. See John Barrell, *The Dark Side of the Landscape: The Rural Poor in English Painting, 1730–1840* (Cambridge: Cambridge University Press, 1980); Denis E. Cosgrove, *Social Formation and Symbolic Landscape* (London: Croom Helm, 1984); Denis Cosgrove and Stephen Daniels, eds., *The Iconography of Landscape: Essays on the Symbolic Representation, Design and Use of Past Environments* (New York: Cambridge University Press, 1988); and Ann Bermingham, *Landscape and Ideology* (London: Thames & Hudson, 1986). These works depart, often polemically, from such classics as T. J. Clark's *Landscape into Art* (New York: Harper and Row, 1949), but expand on insights advanced in John Berger's classic *Ways of Seeing* (London: British Broadcasting Corporation, 1972).

34. Malcolm Andrews, *The Search for the Picturesque: Landscape Aesthetics and Tourism in Britain, 1760–1800* (Aldershot, UK: Scolar, 1989); and Sidney K. Robinson, *Inquiry into the Picturesque* (Chicago: University of Chicago Press, 1991).

35. In previous chapters I have discussed a number of works that constitute notable exceptions to this assessment. They include Giuliana Bruno, *Streetwalking on a Ruined Map: Cultural Theory and the City Films of Elvira Notari* (Princeton, N.J.: Princeton University Press, 1993); Fatimah Tobing Rony, *The Third Eye: Race, Cinema, and Ethnographic*

Spectacle (Durham, N.C.: Duke University Press, 1996); Jennifer Lynn Peterson, "World Pictures: Travelogue Films and the Lure of the Exotic, 1890–1920" (Ph.D. diss., University of Chicago, 1999); Richard Abel, *The Red Rooster Scare: Making Cinema American, 1900–1910* (Berkeley: University of California Press, 1999); and Scott Simmon, *The Invention of the Western Film: A Cultural History of the Genre's First Half-Century* (New York: Cambridge University Press, 2003). For an example of a study on photography and picturesque aesthetics within a postcolonial setting, see Krista A. Thompson's *An Eye for the Tropics: Tourism, Photography, and Framing the Caribbean Picturesque* (Durham, N.C.: Duke University Press, 2006). Among the remarkable, often inspiring studies on cinema and the pictorial arts, consider Anne Hollander's *Moving Pictures* (New York: Knopf, 1993), despite its treatment of the picturesque as "anti-cinematic" (265); and Giuliana Bruno's *Atlas of Emotion: Journeys in Art, Architecture, and Film* (London: Verso, 1998), which detects the formal modernity of the picturesque, although, like the work of Yve-Alain Bois that Bruno draws on, it does not address the question of the social and racial power inherent in the picturesque's actual or pictorial design (192–195). See Yve-Alain Bois, "A Picturesque Stroll around *Clara-Clara,*" *October* 29 (Summer 1984): 32–62.

36. Although she herself is not fully immune to this methodological penchant, Hansen recognizes its unique critical intensity in Benjamin, whose "concept of the masses as the subject of cinema passes over the actual and unprecedented mixture of classes—and genders and generations—[and] remains a philosophical, if not aesthetic, abstraction." Hansen, "America, Paris, the Alps: Kracauer (and Benjamin) on Cinema and Modernity," in *Cinema and the Invention of Modern Life,* ed. Leo Charney and Vanessa Schwartz (Berkeley: University of California Press, 1995), 381–382. A recent book-length example of the modernist (and thus time-oriented) approach to early cinema is Mary Ann Doane, *The Emergence of Cinematic Time: Modernity, Contingency, the Archive* (Cambridge, Mass.: Harvard University Press, 2002), which symptomatically opens with a quotation from Kracauer's 1927 essay on photography. Another major contribution furthering the correlation of cinematic indexicality with temporality is Philip Rosen, *Change Mummified: Cinema, Historicity, Theory* (Minneapolis: University of Minnesota Press, 2001), especially 167–178 and 301–314.

37. Ben Singer, *Melodrama and Modernity: Early Pulp Cinema and the Social Contexts of Sensationalism* (New York: Columbia University Press, 2001), 102.

38. For an in-depth discussion of the "thesis," see the essays by Tom Gunning, Ben Singer, and Charlie Keil in Charlie Keil and Shelley Stamp, eds., *American Cinema's Transitional Era: Audiences, Institutions, Practices* (Berkeley: University of California Press, 2004).

39. Tom Gunning, "The Cinema of Attractions: Early Film, Its Spectator and the Avant-Garde" (1986), in *Early Cinema: Space, Frame, Narrative,* ed. Thomas Elsaesser (London: British Film Institute, 1990), 56–57. Gunning developed the notion of the attraction in collaboration with André Gaudreault, with whom he also authored a 1986 essay, "Le cinéma des premiers temps: Un défi à l'histoire du cinéma?," now included in an excellent anthology edited by Wanda Strauven, *The Cinema of Attractions Reloaded* (Amsterdam: Amsterdam University Press, 2006), 365–380. Charles Musser has forcefully counterargued that, "while cinema of attractions provides a way to conceptualize cinema's links to modernity via novelty, one can also be struck by the ways in which cinema also resisted this." Musser, "A Cinema of Contemplation, a Cinema of Discernment: Spectatorship, Intertextuality and Attractions in the 1890s," in Strauven, *The Cinema of Attractions,* 172.

40. Tom Gunning, "'Now You See It, Now You Don't': The Temporality of the Cinema of Attraction," *Velvet Light Trap* 32 (Fall 1993): 4. Gunning acknowledged borrowing the expression from Fernand Léger.

41. Ibid.

42. Gunning, "In Your Face," 5.

43. Tom Gunning, "Tracing the Individual Body: Photography, Detectives, and Early Cinema," in Charney and Schwartz, *Cinema and the Invention of Modern Life,* 20.

44. Carroll, *Theorizing,* 37 (italics in the original).

45. Tom Gunning, "Before Documentary: Early Nonfiction Films and the 'View' Aesthetic," in *Uncharted Territory: Essays on Early Nonfiction Film,* ed. Daan Hertogs and Nico De Klerk (Amsterdam: Stichting Nederlands Filmmuseum, 1997), 14.

46. Tom Gunning, "Attractions, truquages et photogénie: L'explosion du présent dans les films à truc français produits entre 1896 et 1907," in *Les vingt premières années du cinéma français,* ed. Jean A. Gili et al. (Paris: Sorbonne Nouvelle/AFRHC, 1995), 185.

47. Tom Gunning, "Systematizing the Electric Message: Narrative Form, Gender, and Modernity in *The Lonedale Operator,*" in Keil and Stamp, *American Cinema's Transitional Era,* 44.

48. Hansen, "America, Paris, the Alps," 365.

49. A number of essays have emphasized the ideological implications of the attraction in terms of gender discourse, stressing the long representational tradition of women as a form of visual spectacle. See Judith Mayne, *The Woman at the Keyhole* (Bloomington: Indiana University Press, 1990), 157–183; Linda Williams, "Film Bodies: Gender, Genre, and Excess," *Film Quarterly* 44, no. 4 (Summer 1991): 2–13; and Constance Balides, "Scenarios of Exposure in the Practice of Everyday Life: Women in the Cinema of Attractions," *Screen* 34, no. 1 (1993): 19–37.

50. Kracauer admitted films' photographic indexicality, even while challenging it: "My book ... rests upon the assumption that film is essentially an extension of photography and therefore shares with this medium a marked affinity for the visible world around us." Preface to his *Theory of Film,* xlix.

51. Joel Snyder and Neil Walsh Allen, "Photography, Vision, and Representation," *Critical Inquiry* 2, no. 1 (Autumn 1975): 149.

52. Kendall L. Walton, "Transparent Pictures: On the Nature of Photographic Realism," *Critical Inquiry* 11, no. 2 (1984): 252 and passim; and Richard Allen, *Projecting Illusion: Film Spectatorship and the Impression of Reality* (New York: Cambridge University Press, 1995), 87ff.

53. Interest in cross-media concerns has informed the agendas of conferences and new periodicals. See the proceedings of the sixth Domitor conference, edited by Leonardo Quaresima and Laura Vichi, *The Tenth Muse: Cinema and Other Arts* (Udine: Forum, 2001); and the journal *Early Popular Visual Culture* (formerly known as *Living Pictures*), edited by Simon Popple and Vanessa Toulmin. The film scholars most explicitly devoted to these concerns have been André Gaudreault and Rick Altman. By Gaudreault, see *Cinema delle origini o della "cinematografia-attrazione"* (Milan: Il Castoro, 2004), *Cinéma et attraction: Pour une nouvelle histoire du cinématographe* (Paris: CNRS Éditions, 2008), and, with Philippe Marion, "A Medium Is Always Born Twice ...," *Early Popular Visual Culture* 3, no. 1 (May 2005): 3–15. By Altman, see "Technologie et textualité de l'intermédialité," *Sociétés & Représentations* 9 (2000): 11–19. See also the Spring 2000 issue of *CiNéMAS: Revue d'études cinématographiques* 10, nos. 2–3, which is entirely devoted to "Intermédialité et cinéma" and includes bibliographies.

54. Gaudreault, "From 'Primitive Cinema' to 'Kine-Attractography,'" in Strauven, *The Cinema of Attractions,* 86–87.

55. Peter Galassi, *Before Photography: Painting and the Invention of Photography* (New York: Museum of Modern Art, 1981), 13.

56. Gaudreault and Marion, "A Medium is Always Born Twice . . . ," 7, 4.

57. Rick Altman, *Silent Film Sound* (New York: Columbia University Press, 2004), 18. Similarly, in the section on the picturesque in her 1981 essay "The Originality of the Avant-Garde," Rosalind Krauss indicates that within picturesque representations "landscape becomes a reduplication of a picture which preceded it." Krauss, *The Originality of the Avant-Garde and Other Modernist Myths* (Cambridge, Mass.: MIT Press, 1995), 163.

58. Understood as a non-narrative or a-narrative form of visualization, capable of producing revelations and inducing contemplation, *photogénie* came to dominate French film theory of the 1910s and 1920s, particularly the works of Louis Delluc and Jean Epstein. It is quite significant that one of Epstein's texts on *photogénie* was *Le cinématographe vu de l'Etna* (1926), which took shape after his filming of *La montagne infidèle* (1923), on the erupting Sicilian volcano.

59. Joan M. Schwartz and James R. Ryan, "Photography and the Geographical Imagination," in Schwartz and Ryan, eds., *Picturing Place: Photography and the Geographical Imagination* (London: I. B. Tauris, 2003), 3.

60. David Harvey, "Between Space and Time: Reflections on the Geographical Imagination," *Annals of the Association of American Geographers* 80, no. 3 (September 1990): 418.

61. Bazin, "The Ontology of the Photographic Image," in *What Is Cinema?*, 14.

FILMOGRAPHY

The titles and release dates of most American films listed below are drawn from trade periodicals, the American Film Institute's multivolume filmographies, and specialized sources, such as Charles Musser, ed., *Edison Motion Pictures, 1890–1900: An Annotated Filmography* (Gemona: Giornate del cinema muto; Washington, D.C.: Smithsonian Institution Press, 1997). Throughout this study I have adopted the following procedure to identify English-language translations of Italian film titles. If a film was distributed with an English title, I give it: for instance, *La caduta di Troia* (The Fall of Troy, Itala Film, 1912), unless the two titles coincide, as in the case of *Cabiria* (Itala Film, 1914). When no English title is available, either because the film was never distributed in the U.S. or because no English title is currently known, I have included a literal translation in square brackets, not capitalized as a title, for instance, *L'ultima battaglia* [The last battle, 1914]. I have used the same system for the titles of Italian-American productions. For American titles of Italian films (and foreign productions in general), my main sources have been Aldo Bernardini, *Cinema muto italiano: I film "dal vero," 1895–1914* (Gemona: La Cineteca del Friuli, 2002); Aldo Bernardini, ed., *Archivio del cinema italiano,* vol. 1, *Il cinema muto, 1905–1931* (Rome: ANICA, 1991); *Catalog of Copyright Entries, Cumulative Series: Motion Pictures, 1912–1939* (Washington, D.C.: Library of Congress, Copyright Office, 1951); Annette M. D'Agostino, ed., *An Index to Short and Feature Film Reviews in the "Moving Picture World": The Early Years, 1907–1915* (Westport, Conn.: Greenwood, 1995); Rita Horwitz and Harriet Harrison, *The George Kleine Collection of Early Motion Pictures in the Library of Congress: A Catalog* (Washington, D.C.: Library of Congress, Motion Pictures, Broadcasting, and Recorded Sound Division, 1980); and Howard Lamarr Walls, *Motion Pictures, 1894–1912* (Washington, D.C.: Library of Congress, Copyright Office, 1953).

A Marechiaro ce sta 'na fenesta [At Marechiaro there is a window, Dora Film, 1913]

A Piedigrotta [At Piedigrotta, Dora Film, 1920]

'A Santanotte (The Holy Night, Dora Film, 1922)

The Adventures of Dollie (American Mutoscope & Biograph, 1908)

The Adventures of Lieutenant Petrosino
(Feature Photoplay Co., 1912)

The Alien (Kalem, 1913)

Amleto (Hamlet, Cines, 1908)

Among the Mountains of Calabria, see *Fra i monti della Calabria*

Amore e morte (Love and Death, Aurora Film Co., 1932)

The Aryan (Triangle, 1916)

Assunta Spina (Caesar Film, 1915)

At the Altar (Biograph, 1909)

At the Foot of the Flatiron (American Mutoscope & Biograph, 1903)

At Piedigrotta, see *A Piedigrotta*

At the Top of Brooklyn Bridge (American Mutoscope Co., 1897)

L'attore cinematografico (The Movie Actor, Roman Film Corp., 1932)

The Bandit of Port Avon, see *Il bandito di Port-Aven*

Il bandito di Port-Aven (The Bandit of Port Avon, Aquila Films, 1914)

The Bargain (New York Motion Picture Corp., 1914)

The Battle at Elderbush Gulch (Biograph, 1913)

Battle of the Red Men (Bison-101, 1912)

The Beautiful Lady (Biograph, 1915)

Beginning of a Skyscraper (American Mutoscope & Biograph, 1902)

The Birth of a Nation (David W. Griffith Corp., 1915)

The Black Hand (American Mutoscope & Biograph, 1906)

The Black Hand (Stella, 1909)

The Black Hand (Éclair, 1912)

The Black Hand (Kalem, 1913)

The Black Hand (Royal, 1914)

The Black Hand, see *Condemned to Death*

Black Hand Conspiracy (Apollo, 1914)

A Blackhand Elopement (Selig Poliscope, 1913)

The Blizzard (American Mutoscope & Biograph, 1899)

Blopps in Search of the Black Hand (Lux, 1910)

The Bomb Throwers (Pathé Frères, 1915)

The Brigand, see *Il brigante e il carabiniere* and *Il brigante*

Il brigante (The Brigand, Ambrosio, 1913)

Il brigante e il carabiniere (The Brigand, Cines, 1912)

Broadway and Union Square, New York (American Mutoscope & Biograph, 1903)

Brother's Heart, see *Core 'e frate*

Cabiria (Itala Film, 1914)

La Caduta di Troia (The Fall of Troy, Itala Film, 1911)

La Camorra [The Camorra, Troncone Film, 1905]

Captain Nissen Going through the Whirlpool Rapids, Niagara Falls (Edison, 1901)

The Cattle Rustlers (Selig, 1908)

A Child of Mystery (Universal, 1916)

A Child of the Ghetto (Biograph, 1910)

The Circle of Fate (Kay-Bee, 1914)

The City of Tears (Bluebird Photoplays, 1918)

Civilization (Thomas H. Ince, 1916)

Cohen and Coon (Vitagraph, 1906)

Cohen's Advertising Scheme (Edison, 1904)

The Confession (Warner Features, 1914)

The Cord of Life (Biograph, 1909)

Core 'e frate (Brother's Heart, Dora Film, 1923)

Core furastiero [Foreign heart, Any Film, 1924]

Corrispondenza cinematografica dal teatro della guerra italo-turca (Scenes of the Italian-Turkish War, Cines, 1911)

Cosi' è la vita [Thus is life, Thalia Amusement Corp, 1931]

Count Macaroni (Edison, 1915)

The Country Doctor (Biograph, 1909)

Country about Rome (Urban, 1908)

The Criminal (New York Motion Picture Corp.–Kay-Bee, 1916)

The Criminals (Mecca, 1913)

Crossing Ice Bridge at Niagara Falls (Edison, 1903)

Dalla pietà all'amore (Pity and Love, Saffi-Comerio, 1909)

Dante's Inferno, see *L'Inferno* and *Dante nella vita e nei tempi suoi*

Dante nella vita e nei tempi suoi (Dante's Inferno, V.I.S. Florence, 1922)

The Detectives of the Italian Bureau (Kalem, 1909)

Disastro di Reggio e Messina [Disaster of Reggio and Messina, Ambrosio, 1909]

The District Attorney's Conscience (Lubin, 1913)

Dopo il terremoto calabro-siculo [After the earthquake in Calabria and Sicily, Croce & Co., 1909]

The Earth Trembles, see *La terra trema (Episodio del mare)*

Eating Macaroni in the Streets of Naples (Edison, 1903)

Environs of Naples (Urban, 1908)

The Eruption of Mt. Vesuvius (American Mutoscope & Biograph, 1906)

Eruzione del Vesuvio [Eruption of Vesuvius, Ambrosio, 1906]

Eruzione del Vesuvio [Eruption of Vesuvius, Fratelli Troncone, 1906]

L'eruzione dell'Etna [The eruption of Mt. Etna, Ambrosio, 1909]

L'eruzione dell'Etna [The eruption of Mt. Etna, Croce & Co., 1910]

L'eruzione dell'Etna [The eruption of Mt. Etna, Itala Film, 1910]

L'eruzione dell'Etna [The eruption of Mt. Etna, Comerio, 1911]

L'eruzione dell'Etna del 18 settembre [The eruption of Mt. Etna, September 18, Ambrosio, 1911]

L'Etna [Mt. Etna, Cines, 1911]

European Rest Cure (Edison, 1904)

Excavating for a New York Foundation (American Mutoscope & Biograph, 1903)

Facial Expressions (Edison, 1902)

The Fall of Troy, see *La caduta di Troia*

La fanciulla di Pompei [The young woman from Pompeii, Italian Star Film, 1932]

A Female Fagin (Kalem, 1913)

Fenesta che lucive! [Lighted window, Partenope Film, 1914]

La figlia del Vesuvio [The daughter of Vesuvius, Dora Film, 1912]

Filipinos Retreat from Trenches (Edison, 1899)

Foiling the Camorra (Yankee Film Co., 1911)

The Four Horsemen of the Apocalypse (Metro Pictures, 1921)

Fra i monti della Calabria (Among the Mountains of Calabria, Cines, 1912)

From the Manger to the Cross (Kalem, 1913)

The Fugitive (Biograph, 1910)

The Funeral of Joe Petrosino: The American Detective in Merino, Italy, see *I funerali del poliziotto Petrosino*

I funerali del poliziotto Petrosino (The Funeral of Joe Petrosino: The American Detective in Merino, Italy, Sicula Film, 1909)

Le geste del brigante Musolino (The Life of Giuseppe Musolino, the Famous Italian Bandit, a.k.a. Musolino, the Famous Italian Bandit, Regina & Co., ca. 1924–27)

The Gilded Spider, or *The Full Cup* (Universal, 1916)

Giornale della guerra d'Italia, or *Al fronte d'Italia* (The Italian Battlefront, or The Italian Front, Regio Esercito–Sezione Cinematografica, 1917)

Glimpses of Naples and Vicinity, see *Napoli*

The Godfather Part II (Paramount Pictures, 1974)

Gone with the Wind (Selznick International Pictures, 1939)

Goo-goo Eyes (Edison, 1903)

Great Messina Earthquake, see *Il terremoto calabro-siculo*

The Greatest Love of All (George Beban Productions, 1924)

Guerra in Tripolitania (Italian-Turkish War, Cines, 1911)

La guerra italo-turca (The Italian-Turkish War, Ambrosio, 1911)

La guerra italo-turca (The Italian-Turkish War, Comerio, 1911)

Messina as It Is To-day, see *Messina al giorno d'oggi*

Messina che risorge [Messina rising from its ruins, Cines, 1910]

Messina Earthquake, or *Messina Disaster,* see *Terremoto di Messina e Calabria*

Messina Earthquake (Lubin, 1909)

The Mexican Faith (Essanay, 1910)

The Microbe (Metro Film Corporation, 1919)

Il miracolo della Madonna di Pompeii (Mary the Crazy Woman, Dora Film, 1922)

The Monroe Doctrine (Raff & Gammon, 1896)

The Movie Actor, see *L'attore cinematografico*

The Musketeers of Pig Alley (Biograph, 1912)

Musolino, the Famous Italian Bandit, see *Le geste del brigante Musolino*

Napoli (Life and Customs of Naples, Ambrosio, 1906)

Napoli (Glimpses of Naples and Vicinity, Cines, 1912)

Napoli che canta (When Naples Sings, Cines-Pittaluga, 1926)

Napule e Surriento [Naples and Sorrento, Any Film, 1929]

La nave (The Ship, Ambrosio–UCI, 1920)

Neapolitan Dance at the Ancient Forum of Pompeii (Mutoscope and Biograph Syndicate Ltd., 1898)

Nero; or, The Burning of Rome, see *Nerone*

Nerone (Nero; or, The Burning of Rome, Ambrosio, 1909)

New Brooklyn to New York via Brooklyn Bridge, nos. 1 and 2 (Edison, 1899)

New York, Broadway at Union Square (Lumière, 1896)

New York City "Ghetto" Fish Market (Edison, 1903)

New York Underworld after Dark (Dora Film of America, date unknown)

'O festino e 'a legge, or *'A Legge* [The feast and the law, or The law, Dora Film, 1920]

Old Isaacs, The Pawnbroker (Biograph, 1908)

One Man in a Million (Sol Lesser Productions, 1921)

One More American (Famous Players–Lasky Corp., 1918)

The Ordeal of Rosetta (Select Pictures, 1918)

L'orfanella di Messina (The Orphan of Messina, Ambrosio, 1909)

The Organ Grinder (Kalem, 1909)

The Organ Grinder's Ward (Reliance, 1912)

The Orphan of Messina, see *L'orfanella di Messina*

Orphan of Naples, see *Scugnizza*

Otello (Othello, Cines, 1906)

Othello, see *Otello*

Out of the Past (Vitagraph, 1910)

The Padrone's Plot (Kalem, 1913)

The Padrone's Ward (Powers Co., 1914)

Panorama di Venezia (Panorama of Venice, Ambrosio, 1906)

Panorama from the Tower of the Brooklyn Bridge (American Mutoscope & Biograph, 1899)

Panorama of Brooklyn Bridge, River Front, and Tall Buildings from the East River (Edison, 1901)

Panorama of the Flat Iron Building (American Mutoscope & Biograph, 1903)

Panorama of Venice, see *Panorama di Venezia*

Pasquale (Oliver Morosco Photoplay Co., 1916)

Pennsylvania Station Excavation (American Mutoscope & Biograph, 1905)

Pet of the Big Horn Ranch (Selig, 1909)

Picturesque Colorado (Rex Motion Picture Co., 1911)

Picturesque Sardinia, see *Sardegna pittoresca*

Picturesque Sorrento, see *Sorrento*

Picturesque Yosemite (American Mutoscope & Biograph, 1902)

Pippa Passes; or, The Song of Conscience (Biograph, 1909)

Pity and Love, see *Dalla pietà all'amore*

Poor Little Peppina (Famous Players–Mary Pickford Co., 1916)

The Price of Sacrilege (Independent Moving Picture Co.–Universal, 1914)
Pupatella [Little doll, Miramar, 1923]

Quo Vadis? (Cines, 1913)
Quo Vadis? (UCI, 1924)

Ramona (Biograph, 1910)
Reggio and Messina Earthquake Scenes (Vitagraph, 1909)
Reginella [Little queen, Miramar, 1923]
A Romance of Happy Valley (D. W. Griffith, 1919)
Romance of a Jewess (Biograph, 1908)
Romeo and Juliet, see *Romeo e Giulietta*
Romeo e Giulietta (Romeo and Juliet, Cines, 1908)
Roosevelt's Rough Riders (American Mutoscope & Biograph, 1898)

The Sands of Dee (Biograph, 1912)
Santa Lucia Luntana (Memories of Naples, Cinema Productions, 1931)
Sardegna pittoresca (Picturesque Sardinia, Milano Films, 1911)
Scarface (Caddo Co., 1932)
Scene on Lower Broadway (American Mutoscope & Biograph, 1902)
Scenes and Incidents during the Visit of President Roosevelt at Wilkes-Barre, Pa, August 10th, 1905 (Lyman H. Howe, 1905)
Scenes of the Italian-Turkish War, see *Corrispondenza cinematografica dal teatro della guerra italo-turca*
The Scheme That Failed (Lubin, 1907)
Scugnizza (Orphan of Naples, Dora Film of America, 1923)
Senza Mamma 'e nnamurato [Without mother and in love, Cinema Production Inc., 1932]
Seventeen (Famous Players Film Co., 1916)
The Sheik (Famous Players–Lasky Corp., 1921)
The Ship, see *La nave*
Sicilia illustrata (Sicily Illustrated, Ambrosio, 1907)
Sicily Illustrated, see *Sicilia illustrata*
The Sign (Essanay, 1913)

The Sign of the Rose, or The Alien (New York Motion Picture Corp., 1915)
The Sign of the Rose (George Beban Productions, 1922)
Sorrento (Picturesque Sorrento, Cines, 1912)
Spaghetti à la Mode (Lubin, 1915)
Spartacus (Pasquali & Co., 1913)
Sperduti nel buio [Lost in darkness, Morgana Film, 1914]
St. Peter's Cathedral in Rome (Burton Holmes, 1897)
Statue of Liberty (Edison, 1898)

Te lasso! [I am leaving you!, Any Film, 1925]
The Tell-Tale Step (Edison, 1917)
Teodora (Theodora, Ambrosio–UCI, 1919)
La terra trema (Episodio del mare) (The Earth Trembles, Ar.Te.As. Film–Universalia Produzione, 1948)
Il terremoto calabro-siculo (Great Messina Earthquake, Saffi-Comerio, 1909)
Terremoto di Messina e Calabria (Messina Earthquake, or Messina Disaster, Cines, 1909)
Theodora, see *Teodora*
Three of Many (New York Motion Picture Corp., 1916)
Tony the Tenor (Pilot, 1913)
Tourists Arriving at Wawona Hotel (American Mutoscope & Biograph, 1902)
Tourist Train Leaving Livingston, Mont. (Edison, 1897)
Traffic in Souls (Independent Moving Picture Co., 1913)
Trailing the Black Hand (Atlas Film Co., 1910)
Trials of an Immigrant (Reliance, 1911)
True Heart Susie (D. W. Griffith, 1919)
The Typhoon (New York Motion Picture Corp., 1914)

Gli ultimi giorni di Pompeii (The Last Days of Pompeii, Ambrosio, 1908).
Gli ultimi giorni di Pompeii (The Last Days of Pompeii, Ambrosio, 1913).

Uncle Tom's Cabin (Edison, 1902–1903)
U.S. Troops and Red Cross in the Trenches before Caloocan (Edison, 1899)

Vesuvius Conquered! (Fox Film Ltd., 1922)
The Violin Maker of Cremona (Biograph, 1909)
Vita napoletana [Neapolitan life, Capri Film Co., 1932]
Volcanic Eruption of Mt. Aetna (Urban-Eclipse, 1910)

War on the Plains (Bison 101–Universal, 1912)
Way Down East (D. W. Griffith, Inc., 1920)

Western Justice (Selig, 1907)
When Naples Sings, see *Napoli che canta*
Who Will Marry Me? (Bluebird Photoplays, 1919)
A Windy Day on the Roof (American Mutoscope & Biograph, 1904)
Wolves of New York (Dora Film of America, date unknown)
A Woman's Honor (Fox, 1916)
The Woman and the Beast (Graphic Features, 1917)
The Wop (Independent Moving Picture Co., 1913)
The Wrath of the Gods (New York Motion Picture Corp., 1914)

The Yiddish Boy (Lubin, 1908)

BIBLIOGRAPHY

PRIMARY SOURCES

Manuscript and Special Collections

Archivio Centrale dello Stato (Rome)

Banca di Roma, Archivio Storico (Rome)

Biblioteca Nazionale Centrale (Florence)

Center for Migration Studies (Staten Island, N.Y.)

Centro Nazionale delle Ricerche (Rome)

Cineteca Nazionale (Rome)

Fondazione Giovanni Agnelli (Turin)

Immigration History Research Center (St. Paul, Minnesota)

Library of Congress, Manuscript Division and Motion Picture, Broadcasting, and

Recorded Sound Division (Washington, D.C.)

Ministero degli Affari Esteri. Commissariato Generale dell'Emigrazione (Rome)

Ministero di Agricoltura, Industria e Commercio (Rome)

Museo Nazionale del Cinema (Turin)

New-York Historical Society (New York, N.Y.)

New York Public Library (New York, N.Y.)

Newspapers and Periodicals

L'araldo della cinematografia (Turin)

L'araldo italiano (New York; renamed *Il telegrafo* in 1913)

L'asino (New York)

Il café-chantant e la rivista fono-cinematografica (Naples)

Chantecler siciliano (Catania)

Charities (New York; renamed *Charities and the Commons* in 1905, then *Survey* in 1912)

La cine-fono e la rivista fono-cinematografica (Naples)

Il cinema-chantant (Naples; renamed *Il programma* in 1908)

La cinematografia italiana ed estera (Turin)

Exhibitors Herald (New York; incorporated into *Moving Picture World* in 1907)

La follia di New York (New York)

Harper's Weekly: A Journal of Civilization (New York)

Il maggese cinematografico (Turin)

Motion Picture Magazine (Brooklyn, New York)

Motion Picture Classic (Brooklyn, New York)
Motion Picture News (New York)
Moving Picture World (New York)
New York Clipper (New York)
New York Dramatic Mirror (New York)
New York Times (New York)
Nickelodeon (Chicago; renamed *Motography* in 1911)

Photoplay (Chicago)
Il progresso italo-americano (New York)
Il proletario (New York and Chicago)
Views and Film Index (New York; incorporated into *Moving Picture World* in 1911)
La vita cinematografica (Turin)

Books and Articles

"Alfred Stieglitz and His Latest Work." *Photographic Times* 28, no. 4 (April 1896): 161–169.

Alongi, Giuseppe. *La maffia nei suoi fattori e nelle sue manifestazioni: Studio sulle classe pericolose della Sicilia.* Turin: Bocca, 1886. Reprint, Palermo: Sellerio, 1977.

Antin, Mary. *The Promised Land.* Boston: Houghton Mifflin, 1912.

Arias, Gino. *La questione meridionale. I. Le fondamenta geografiche e storiche del problema; L'emigrazione.* Bologna: Nicola Zanichelli, 1921.

Aronovici, C. "Italian Immigration." *University Settlement Studies* 2, no. 3 (October 1906): 26–31.

Baedeker, Karl. *Southern Italy and Sicily.* London: Dulau, 1887.

Balzo, Carlo del. *Napoli e i napoletani: Opera illustrata da Armenise, Dalbono e Matania.* Milan: Treves, 1885. Reprint, Rome: Edizioni dell'Ateneo, 1972.

Barker, Henry Aston, and J. Burford. *An Explanation of the View of Rome.* London: J. Adlard, 1817.

Barri, Giacomo. *Viaggio pittoresco d'Italia.* Venice: Giacomo Herz, 1671.

Beban, George. "100% Italian—In Plays." *New York Dramatic Mirror,* 4 December 1920: 1067.

———. "How I Was Induced to Become a Motion Picture Star." *Paramount Magazine,* January 1915, 13–15.

———. *Photoplay Characterization: One of a Series of Lectures Especially Prepared for Student-Members of the Palmer Plan.* Los Angeles: Palmer Photoplay Corp., Department of Education, 1921.

———. "Taking a Comedian Seriously." *The Green Book Album,* September 1911, 511–518.

Bingham, Theodore A. "Foreign Criminals in New York." *North American Review* 188, no. 634 (September 1908): 383–394.

Boas, Franz. *Changes in Bodily Form of Descendants of Immigrants.* New York: Columbia University Press, 1912.

Bonstetten, Charles Victor de. *L'homme du midi et l'homme du nord; ou, L'influence du climat.* Geneva: J. J. Paschoud, 1824. Translated as *The Man of the North and the Man of the South; or, The Influence of Climate* (New York: F. W. Christern, 1864).

Boschini, Marco. *La carta del navegar pitoresco.* Venice: Per li Baba, 1660.

Bourcard, Francesco de. *Usi e costumi di Napoli e contorni descritti e dipinti.* Naples: G. Nobile, 1853–58.

Bourne, Randolph. "Trans-national America." In *War and the Intellectuals,* ed. Carl Resek, 107–123. New York: Harper and Row, 1964. Previously published in *Atlantic Monthly* 118, no. 1 (July 1916): 86–97.

Bracco, Roberto. *Opere.* Lanciano: Carabba, 1935–42.

Brandt, Lilian. "A Transplanted Birthright: The Development of the Second Generation of the Italian in an American Environment." *Charities* 12, no. 18 (7 May 1904): 494–499.

Brewster, Eleanor. "A Roman Rotogravurist." *Motion Picture Classic*, March 1918, 36–37.

Brooks, Van Wyck. *The Wine of the Puritans: A Study of Present-Day America*. 1908. Reprint, Folcroft, Pa.: Folcroft Press, 1969.

Bryant, William Cullen, ed. *Picturesque America; or, The Land We Live In: A Delineation by Pen and Pencil of the Mountains, Rivers, Lakes, Water-Falls, Shores, Cañons, Valleys, Cities, and other Picturesque Features of Our Country; With Illus. on Steel and Wood, by Eminent American Artists*. 2 vols. New York: D. Appleton, 1872–74. Reprint, Secaucus, N.J.: Lyle Stuart, 1974.

Brydone, Patrick. *A Tour through Sicily and Malta in a Series of Letters to William Backford, Esq.* London: Strahan and Cadell, 1773.

Burke, Edmund. *Philosophical Inquiry into the Origin of Our Ideas on the Sublime and Beautiful*. London R. and J. Dodsley, 1757 [1756].

Campbell, Helen, Thomas Knox, and Thomas Byrnes. *Darkness and Daylight; or, Lights and Shadows of New York Life*. Hartford, Conn.: A. D. Worthington, 1892.

Capuana, Luigi. *Malia*. Rome: Sinimberghi, 1891. First dialect edition in Luigi Capuana, *Teatro dialettale siciliano* (Palermo: Reber, 1911). Reprint, ed. Delia Morea, Naples: Bellini Editrice, 1995.

———. *La Sicilia e il brigantaggio*. Rome: Perelli, 1892.

———. *Studi sulla letteratura contemporanea*. 2nd series. Milan: G. Brigola, 1882.

———. *Teatro italiano contemporaneo*. Palermo: L. Pedone Lauriel, 1872.

Catlin, George. *North American Indians: Being Letters and Notes on Their Manners, Customs, and Conditions, Written during Eight Years' Travel amongst the Wildest Tribes of Indians in North America, 1832–1839*. 2 vols. Philadelphia: Leary, Stuart, 1913.

Cautela, Giuseppe. "The Italian Theatre in New York." *American Mercury* 12, no. 45 (September 1927): 106–112.

Cavour, Camillo Benso, conte di. *La liberazione del Mezzogiorno e la formazione del Regno d'Italia*. 5 vols. Bologna: Zanichelli, 1949–54.

Chateaubriand, François-René, vicomte de. "Trip to Mount Vesuvius, Thursday, January 5, 1804." In *Travels in America and Italy*, 235–245. London: Henry Colburn, 1828.

Choris, Louis. *Voyage pittoresque autour du monde, avec des portraits de sauvages d'Amérique, d'Asie, d'Afrique, et des îles du Grand océan; Des paysages, des vues maritimes, et plusieurs objets d'histoire naturelle*. Paris: Didot, 1822.

Colajanni, Napoleone. *Latini e Anglo-Sassoni (Razze inferiori e razze superiori)*. Rome and Naples: Rivista Popolare, 1903.

———. *Per la razza maledetta*. Biblioteca della Rivista popolare 1. Milan and Palermo: Sandron, 1898.

———. *Settentrionali e meridionali: Agli italiani del Mezzogiorno*. Milan and Palermo: Sandron, 1898.

Coletti, Francesco. *Dell'emigrazione italiana*. Milan: Hoepli, 1912.

Collier, John. "Cheap Amusements." *Charities and the Commons* 20, no. 2 (11 April 1908): 73–76.

Collins, Wilkie. *Antonia; or, The Fall of Rome*. 1850. Reprint, London: Chatto & Windus, 1896.

Commissariato generale dell'emigrazione. *Annuario statistico della emigrazione italiana dal 1876 al 1925*. Rome: Edizione del commissariato dell'emigrazione, 1926.

Cooper, James Fenimore. *Gleanings in Europe: Italy*. Philadelphia: Carey, Lea and Blanchard, 1838. Reprint, Albany: State University of New York Press, 1981.

———. *The Leatherstocking Tales*, ed. Blake Nevius. 2 vols. New York: Library of America, 1985.

Corbin, John. "How the Other Half Laughs." *Harper's New Monthly Magazine* (December 1898): 30–48. Reprint in *The Land of Contrasts, 1880–1901*, ed. Neil Harris (New York: George Braziller, 1970), 160–179.

———. "The Twentieth-Century City." *Scribner's Magazine* 33 (March 1903): 259–272.

Creuzé de Lesser, Augustin. *Voyage en Italie et Sicile, 1801–1802*. Paris: Didot, 1806.

Croce, Benedetto. *Angiolillo (Angiolo duce), capo di banditi*. Naples: Pierro, 1892.

———. "Il paradiso abitato da' diavoli." 1927. Reprint in *Uomini e cose della vecchia Italia*, series 1, 3rd ed. (Bari: Laterza, 1956), 68–87.

Davenport, Charles B. *Heredity in Relation to Eugenics*. New York: H. Holt, 1911.

Davis, Michael. *The Exploitation of Pleasure*. New York: Russell Sage Foundation, 1911.

De Non, Dominique Vivant. *Voyage en Sicile*. 1788. Reprint in English as *Travels in Sicily and Malta* (London: G. G. J. and J. Robinson, 1789).

De Rosalia, Giovanni. *Lu socialisimu e lu ciarlatanu*. New York: Società Libraria Italiana, n.d.

———. *Nofrio al telefono*. New York: Italian Book Co., 1918.

Di Giacomo, Salvatore. "Per la storia del brigantaggio napoletano." *Emporium* 19, nos. 110–112 (1904): 123–133, 283–295. Reprint as *Per la storia del brigantaggio nel napoletano* (Venosa and Potenza: Osanna Venosa, 1990).

———. *Poesie e prose*. Ed. Elena Croce and Lanfranco Orsini. Milan: Mondadori, 1981.

Douglas, Norman. *Old Calabria*. Boston: Houghton Mifflin, 1915.

Downing, Andrew Jackson. *The Architecture of Country Houses*. New York: D. Appleton, 1850.

———. *Rural Essays*. New York: G. P. Putnam, 1853. Reprint, New York: G. A. Leavitt, 1869.

Du Bois, W. E. B. *The Souls of Black Folk*. Chicago: A. C. McClurg, 1903. Reprint, ed. David W. Blight and Robert Gooding-Williams, New York: Bedford, 1997.

———. "To the Nations of the World." 1900. Reprint in *Writings by W. E. B. Du Bois in Non-periodical Literature*, ed. Herbert Aptheker (Millwood, N.Y.: Kraus-Thomson, 1982), 11–12.

Eliot, Ada. "Two Italian Festivals." *Charities* 7, no. 16 (1901): 321–322.

Emerson, Ralph Waldo. *Nature*. Boston: J. Munroe, 1836. Reprint in *Essays and Lectures* (New York: Literary Classics of the United States, 1983), 5–49.

Fabbri, Gualtiero. *Al cinematografo*. Milan: 1907. Reprint, ed. Sergio Raffaelli, Rome: Associazione Italiana per le ricerche di storia del cinema, 1993.

Falorsi, Vittorio. *Problemi dell'emigrazione: Dal primo Congresso degli Italiani all'estero alla legge Johnson*. Bologna: Nicola Zanichelli, 1924.

Ferreri, G. *Gli Italiani in America: Impressioni di un viaggio negli Stati Uniti*. Rome: 1907.

Ferri, Enrico. *Atlante antropologico-statistico dell'omicidio*. Turin: Bocca, 1895.

Firkins, Ina Ten Eyck, ed. "Italians in the United States." *Bulletin of Bibliography and Quarterly Dramatic Index* 8, no. 5 (January 1915): 129–132.

Foerster, Robert F. *The Italian Emigration of Our Times*. Cambridge, Mass.: Harvard University Press, 1919. Reprint, New York: Arno, 1969.

Fortunato, Giustino. *Il Mezzogiorno e lo Stato italiano: Discorsi politici*. 2 vols. Bari: Laterza, 1911.

Fowler, Orson Squire, and Lorenzo Niles Fowler. *Phrenology: A Practical Guide to Your Head*. New York: Chelsea House, 1969.

Franchetti, Leopoldo. *Le condizioni economiche e amministrative delle provincie napoletane*. Rome: Tipografia della Gazzetta d'Italia, 1875.

Franchetti, Leopoldo, and Sidney Sonnino. *La Sicilia nel 1876*. Florence: G. Barbera, 1877. Reprint as *Inchiesta in Sicilia* (Florence: Vallecchi, 1974).

Franchetti, Leopoldo, and Umberto Zanotti-Bianco. *Mezzogiorno e colonie: Con saggio storico su L. F. di Umberto Zanotti-Bianco.* Florence: La Nuova Italia, 1950.

Galton, Francis. *Memories of My Life.* London: Methuen, 1908.

Gebhart, John Charles. *The Growth and Development of Italian Children in New York City.* New York: Association for Improving the Conditions of the Poor, 1924.

Giacosa, Giuseppe. *Impressioni d'America.* Milan: L. F. Cogliati, 1898.

Gilpin, William. *An Essay upon Prints: Containing Remarks upon the Principles of Picturesque Beauty.* London: J. Robson, 1768.

———. *Observations on the River Wye and Several Parts of South Wales, &c., Relative Chiefly to Picturesque Beauty: Made in the Summer of the Year 1770.* 1782. 3rd ed., London: Blamire, 1792.

———. *Observations Relative Chiefly to Picturesque Beauty, Made in the Year 1772, on Several Parts of England; Particularly the Mountains, and Lakes of Cumberland, and Westmoreland.* 1786. 2nd ed. 2 vols. London: Blamire, 1792.

———. *Three Essays: On Picturesque Beauty; On Picturesque Travel; and on Sketching Landscape: To Which Is Added a Poem on Landscape Painting.* 1792. 2nd ed. London: R. Blamire, 1794.

Gissing, George. *By the Ionian Sea: Notes of a Ramble in Southern Italy.* 1892. London: Chapman and Hall, 1901.

Goethe, Johann Wolfgang von. *Italienische Reise.* Stuttgart: J. G. Cotta, 1817. Reprint as *Travels in Italy,* trans. A. J. W. Morrison and Charles Nisbet (London: G. Bell and Sons, 1911); and as *Italian Journey, 1786–1788,* trans. W. H. Auden and Elizabeth Mayer (Harmondsworth: Penguin, 1970).

Grant, Madison. *The Passing of the Great Race; or, The Racial Basis of European History.* New York: Charles Scribner's Sons, 1916.

Grau, Robert. *The Business Man in the Amusement World.* New York: Broadway, 1910.

Gray, Thomas. *The Correspondence of Thomas Gray,* ed. Paget Toynbee and Leonard Whibley. 3 vols. Oxford: Clarendon, 1935.

Guernsey, Alfred H., and Henry M. Alden, eds. *Harper's Pictorial History of the Civil War.* New York: Fairfax, 1866. Reprint, New York: Gramercy, 1996.

Hapgood, Hutchins. "The Foreign Stage in New York: III. The Italian Theatre." *Bookman* 11 (August 1900): 545–553.

———. "Picturesque Ghetto." *Century Magazine* 94 (July 1917): 469–473.

———. *The Spirit of the Ghetto: Studies of the Jewish Quarter in New York.* New York: Funk and Wagnalls, 1909.

———. *Types from City Streets.* New York: Funk and Wagnalls, 1910. Reprint, New York: Garrett, 1970.

Hartmann, Carl Sadakichi. [Sidney Allan, pseud.] "Picturesque New York in Four Papers: The Esthetic Side of Jewtown." *Camera Notes* 6, no. 3 (February 1903): 143–149.

———. "Plea for the Picturesqueness of New York." *Camera Notes* 4, no. 2 (October 1900): 91–97.

Hartt, Rollin Lynde. "Made in Italy: The Story of What Is Happening in the Largest Italian City in the World—New York." *Independent* 106 (23 July 1921): 19–20, 36–37.

Holmes, Oliver Wendell. "The Stereoscope and the Stereograph." *Atlantic Monthly* 3, no. 20 (June 1859): 738–748.

Henry, O. *Sixes and Sevens.* Garden City, N.Y.: Doubleday, 1911.

Hoüel, Jean-Pierre-Louis-Laurent. *Voyage pittoresque des isles de Sicile, de Malte et de Lipari, où l'on traite des antiquités qui s'y trouvent encore; des principaux phénomènes que la nature*

y offre; du costume des habitans, & de quelques usages. Paris: Imprimerie de Monsieur, 1782–87.

Howard, George Elliott, "Social Psychology of the Spectator." *American Journal of Sociology* 18, no. 1 (July 1912): 33–50.

Howells, William Dean. *A Hazard of New Fortunes.* 1890. Reprint, New York: Oxford University Press, 1990.

———. *Impressions and Experiences.* New York: Harper, 1896.

———. *Italian Journeys.* 1867. New and enlarged ed., Boston and New York: Houghton Mifflin, 1907.

———. "Mr. Harben's Georgia Fiction." *North American Review* 191 (March 1910): 356–363.

Hughes, Rupert. *The Real New York.* New York: Smart Set, 1904.

Ingpen, Roger, ed. *The Letters of Percy Bysshe Shelley.* 2 vols. London: G. Bell and Sons, 1914.

Irving, Washington. *Tales of a Traveler.* 4 parts in 2 vols. Philadelphia: H. C. Cary and I. Lee, 1824.

Irwin, Elisabeth. "Where the Players Are Marionettes, and the Age of Chivalry Is Born Again in a Little Italian Theatre in Mulberry St." *Craftsman* 12 (1907): 667–669.

Istituto Coloniale Italiano. *Atti del primo congresso degli italiani all'estero.* Vol. 1, *Relazioni e documenti.* Rome: 1910.

Italian Dialect Joke Book. Baltimore, Md.: I. & M. Ottenheimer, 1909.

"Italian Festivals in New York." *Chautauquan* 34 (1901): 228–229.

James, George Wharton. *Our American Wonderlands.* Chicago: A. C. McClurg, 1915.

James, Henry. *Collected Travel Writing: Great Britain and America.* New York: Library of America, 1993.

———. "A Study of Salvini." *Pall Mall Gazette* (London), 27 March 1884. Reprint as "Tommaso Salvini: In London (1884)" in *The Scenic Art: Notes on Acting and the Drama, 1872–1901,* ed. Allan Wade (New Brunswick, N.J.: Rutgers University Press, 1948), 185–191.

Jameson, Anna. *Diary of an Ennuyée.* 1826. Reprint, Boston: Houghton, Osgood, 1879.

Kelly, Kitty. "Flickerings from Film Land." *Chicago Daily Tribune,* 23 April 1915, 16.

Kimball, Charlotte. "An Outline of Amusements among Italians in New York." *Charities* 5, no. 12 (18 August 1900): 1–8.

Kingsley, Sherman C. "The Penny Arcade and the Cheap Theatre." *Charities and the Commons* 18, no. 10 (8 June 1907): 295–297.

Kiralfy, Imre. *Nero; or, The Burning of Rome.* Buffalo, N.Y.: Courier, 1890.

Klapper, Paul. "The Yiddish Music Hall." *University Settlement Studies* 2, no. 4 (December 1906): 19–23.

Knight, Richard Payne. *Analytical Inquiry into the Principles of Taste.* 3rd ed. London: T. Payne, 1806.

Kotzebue, Augustus von. *Neapel und die Lazzaroni: Ein charakteristiches Gemalde für Liebhaber der Zeitgeschichte.* Frankfurt and Leipzig, 1799.

Lassels, Richard. *Voyage to Italy; or, A Compleat Journey through Italy.* Paris: Vincent du Moutier, 1670.

Laurvik, John Nilsen. "Alfred Stieglitz, Pictorial Photographer." *International Studio* 44, no. 174 (August 1911): xxi–xxviii.

LeBon, Gustave. *Psychologie des foules.* Paris: F. Alcan 1895. Reprint as *The Crowd: A Study of the Popular Mind* (New York: Viking, 1960).

Lenormant, F. *La grande Grèce: Paysages et histoire.* 3 vols. Paris: A Lévy, 1881–84.

Lockhart, John G. *Valerius, a Roman Story.* Boston: Wells and Lilly, 1821.

Lodge, Henry Cabot. "The Restriction of Immigration." *North American Review* 152 (January 1891): 27–35.

Lombroso, Cesare. *L'uomo delinquente studiato in rapporto all'antropologia, alla medicina e alle discipline carcerarie.* Milan: Hoepli, 1876. Reprint, Rome: Napoleone, 1971.

Lombroso, Gina. *Criminal Man, According to the Classifications of Cesare Lombroso.* New York: G. P. Putnam, 1911.

Lytton, Edward Bulwer. *The Last Days of Pompeii.* London: R. Bentley, 1834. Reprint, New York: Thomas Crowell, 1922.

Magaldi, Giuseppe. *Fatti briganteschi.* Potenza: Santanello, 1862.

Mangano, Antonio. "The Associated Life of the Italians in New York City." *Charities* 12, no. 18 (7 May 1904): 476–482.

———. *Sons of Italy: A Social and Religious Study of the Italians in America.* 1917. New York: Russell & Russell, 1972.

Mantegazza, Paolo. *Le estasi umane.* 2 vols. Milan: Mantegazza, 1887.

———. *Fisiologia del dolore.* Florence: Felice Paggi, 1880.

———. *Fisiologia del piacere.* Milan: Rebeschini, 1890.

———. *La medicina delle nostre donne: La psicologia delle superstizioni.* Città di Castello: S. Lapi, 1892.

———. *Physiognomy and Expression.* New York: Charles Scribner's Sons, 1892. Originally published as *Fisionomia e Mimica* (Milan: Fratelli Dumolard, 1881).

Marazzi, Duilio. *Senza maschera: Storie e pensieri di Duilio Marazzi.* New York, 1934.

Martoglio, Nino. *Centona.* 1921. Reprint, Messina and Florence: D'Anna, 1965.

Masini, M. U., and G. Vidoni. "Il cinematografo nel campo delle malattie mentali e della criminalità." *Antropologia criminale, psichiatria e medicina legale* 36, no. 6 (1915): 3–15. Reprint, Turin: Fratelli Bocca, 1915.

Mason, William, ed. *The Poems of Mr. Gray, to Which Are Prefixed Memoirs of His Life and Writings.* London: J. Dodsley, 1775.

McAdoo, William. *Guarding a Great City.* New York: Harper & Brothers, 1906.

Mielatz, Charles F. W. *Picturesque New York: Twelve Photogravures from Monotypes.* New York: Society of Iconophiles, 1908.

Miraglia, Biagio. *Parere frenologico sui famosi delinquenti Cipriano e Giona La Gala, Domenico Papa e Giovanni D'Avanzo.* Aversa, 1864.

Montesquieu, Charles de Secondat, baron de. *The Spirit of the Laws.* Trans. Thomas Nugent. 2 vols. New York: Hafner, 1949.

Morgan, Lady Sydney. *The Life and Times of Salvator Rosa.* London: H. Colburn, 1824.

Mottelay, Paul Fleury. *The Soldier in Our Civil War.* New York: J. H. Brown, 1884–85.

"The Moving Picture and the National Character." *American Review of Reviews* 42, no. 3 (September 1910): 315–320.

Newton, Harry L. *Vaudevillainies: A Series of "Acts" against the Public Peace and Decorum.* Boston: W. H. Baker, 1915.

Niceforo, Alfredo. *L'Italia barbara contemporanea: Studi e appunti.* Milan and Palermo: Sandron, 1898.

———. *Italiani del nord e Italiani del sud: Con 133 tavole numeriche e 31 tavole grafiche.* Turin: Bocca, 1901.

Nicotri, Gaspare. *Dalla Conca d'Oro al "Golden Gate": Studi e impressioni di viaggi in America.* New York: Canorma, 1928.

Nigra, Costantino. *Canti popolari del Piedmonte.* Turin: Loescher, 1888. Reprint, Turin: Einaudi, 1957.

———. "La poesia popolare italiana." *Romania* 5, no. 20 (1876): 427–452.

Nitti, Francesco Saverio. *Nord e Sud: Prime linee di una inchiesta sulla ripartizione territoriale delle entrate e delle spese dello Stato in Italia*. Turin: Roux and Viarengo, 1900.

———. *Scritti sulla questione meridionale*. 1910. Reprint, Bari: Laterza, 1958.

Noble, Louis Legrand. *The Course of Empire, Voyage of Life, and Other Pictures of Thomas Cole*. New York: Cornish, Lamport, 1853.

Oddo, Giacomo. *Il brigantaggio o l'Italia dopo la dittatura di Garibaldi*. Milan: Eugenio Belzini, 1863.

Owen, K. "The High Cost of Poverty." *Photoplay*, March 1917, 32–33.

Palmer, Lewis E. "The World in Motion." *Survey* 22, no. 10 (5 June 1909): 355–365.

Papini, Giovanni. "La filosofia del cinematografo." *La stampa*, 18 May 1907.

Park, Robert Ezra. "The City: Suggestions for the Investigation of Human Behavior in the Urban Environment." *American Journal of Sociology* 20, no. 5 (March 1915): 577–612. Reprinted with revisions in *The City: Suggestions for the Study of Human Nature in the Urban Environment*, Robert E. Park, Ernest Watson Burgess, and Roderick Duncan McKenzie (Chicago: University of Chicago Press, 1925), 1–46.

———. "Human Migration and the Marginal Man." *American Journal of Sociology* 33, no. 6 (May 1928): 881–893. Reprint in *Race and Culture: Essays in the Sociology of the Contemporary Man* (New York: Free Press of Glencoe, 1964), 345–356.

———. *Race and Culture: Essays in the Sociology of the Contemporary Man*. New York: Free Press of Glencoe, 1964.

Pater, Walter. *Marius the Epicurean: His Sensations and Ideas*. London: Macmillan, 1885.

Paton, William Agnew. *Picturesque Sicily*. London and New York: Harper & Brothers, 1897.

Pennell, Joseph. *The Adventures of an Illustrator*. Boston: Little, Brown, 1925.

———. "The Pictorial Possibilities of Work." *Journal of the Royal Society of Arts* 61 (20 December 1912): 111–126.

Pennino, Francesco. *Senza Mamma*. New York: A. Grauso, 1918. Reprint, Orange, N.J.: Standard Music Roll Co., 1919.

Perri, Francesco. *Emigranti*. Milan: Mondadori, 1928. Reprint, Cosenza: Lerici, 1976.

Pesce-Maineri, Piero. *I pericoli sociali del cinematografo*. Turin and Genoa: S. Lattes, 1922.

Pisani, Pietro. *L'emigrazione: Avvertimenti e consigli agli emigranti*. Florence: Ufficio Centrale dell'Unione Popolare fra i Cattolici d'Italia, 1907.

Pitrè, Giuseppe. *Studi di poesia popolare*. 1872. Reprint, Palermo: Il Vespro, 1978.

Porter, Horace. *Campaigning with Grant*. New York: Century, 1897. Reprint, Lincoln: University of Nebraska Press, 2000.

Preziosi, Giovanni. *Gli italiani degli Stati Uniti del Nord*. Milan: Libreria Editrice Milanese, 1909.

Price, Uvedale. *Essays on the Picturesque as Compared with the Sublime and the Beautiful, and on the Use of Studying Pictures, for the Purpose of Improving Real Landscape*. London: J. Robson, 1794.

Renda, Antonio. *La questione meridionale: Inchiesta*. Milan and Palermo: Sandron, 1900.

Riedesel, Baron Hermann von. *Reise durch Sicilien und Grossgriechenland*. Zurich: Orell, Gessner, Fuesslin, and Com, 1771. Reprint in English as *Travels through Sicily and That Part of Italy Formerly Called Magna Græcia*, trans. J. Ro Forster (London: Edward and Charles Dilly, 1773).

Riegel, Robert E. "The Introduction of Phrenology to the United States." *American Historical Review* 39, no. 1 (October 1933): 73–78.

Riis, Jacob A. *The Battle with the Slum*. New York: Macmillan, 1902.

———. "Feast-Days in Little Italy." *Century Magazine* 58, no. 4 (August 1899): 491–499.

———. *How the Other Half Lives: Studies among the Tenements of New York*. New York: Charles Scribner's Sons, 1890. Reprint, New York: Dover, 1971.

Roseboro, Viola. "Down-Town New York." *Cosmopolitan* 1 (June 1886): 222.

———. "The Italians of New York." *Cosmopolitan* 4 (January 1888): 396–406.

Ross, Edward Alsworth. "Italians in America." *Century Magazine* 87 (July 1914): 439–445.

———. *The Old World in the New: The Significance of Past and Present Immigration to the American People*. New York: Century, 1914.

———. "Racial Consequences of Immigration." *Century Magazine* 87 (July 1914): 615–622.

Saint-Non, Jean Claude Richard de. *Voyage pittoresque; ou, Description des royaumes de Naples et de Sicile*. 4 vols. Paris: Imprimerie de Clousier, 1781–86.

Salvemini, Gaetano. *Scritti sulla questione meridionale (1896–1955)*. Turin: Einaudi, 1955.

Salzano, Achille. *Verso l'ignoto: Il romanzo dell'emigrante*. Naples: Errico, 1903.

Sanders, Charles W. *The School Reader—Third Book*. New York: Ivison and Phinney, 1853.

Sergi, Giuseppe. *Arî e italici: Attorno all'Italia preistorica*. Turin: Bocca, 1898.

———. *Origine e diffusione della stirpe mediterranea: Induzioni antropologiche*. Rome: Dante Alighieri, 1895. Reprint in English as *The Mediterranean Race: A Study of the Origin of European Peoples* (New York: C. Scribner's Sons, 1901).

———. *The Varieties of the Human Species: Principles and Method of Classification*. Washington, D.C.: Smithsonian Institution, 1894.

Speranza, Gino. "How It Feels to Be a Problem." *Charities* 12, no. 18 (7 May 1904): 457–463.

Staël, Madame de. *Corinne; ou, L'Italie*. Paris: H. Nicolle, 1807. Reprint in English as *Corinne; or, Italy*, trans. Sylvia Raphael (New York: Oxford University Press, 1998).

Steele, Asa. "The Moving Picture Show." *World's Work* (February 1911): 1423–1424.

Stieglitz, Alfred. "How *The Steerage* Happened." *Twice a Year* 8–9 (1942): 175–178. Reprint in *Stieglitz on Photography: His Selected Essays and Notes,* ed. Richard Whelan (New York: Aperture, 2000), 194–197.

———. *Picturesque Bits of New York and Other Studies*. New York: H. R. Russell, 1897.

Stoddard, Lothrop. *Re-forging America: The Story of Our Nationhood*. New York: Scribner's, 1927.

Strong, Josiah. *The Challenge of the City*. 1907. Reprint, New York: Missionary Education Movement of the United States and Canada, 1911.

Swinburne, Henry. *Travels in the Two Sicilies*. 4 vols. London: Cadell and Elmsly, 1790.

———. *Travels in the Two Sicilies in the Years 1777, 1778, 1779 and 1780*. London: P. Elmsly, 1783–85.

Talbot, William Henry Fox. *The Pencil of Nature*. London: Longman, Brown, Green and Longmans, 1844. Reprint, New York: Da Capo, 1968.

Todd, A. J. "Moving Pictures vs. the Saloon." *Journal of the American Institute of Criminal Law and Criminology* 5, no. 4 (November 1914): 485.

Trinchera, Francesco. *La quistione napolitana: Ferdinando Borbone e Luciano Murat* (Turin: Tipografia Economica, 1855).

United States. Bureau of the Census. *Historical Statistics of the United States, Colonial Times to 1957*. Washington, D.C.: Government Printing Office, 1960.

United States. Immigration Commission (1907–10). *Reports of the Immigration Commission, 1896, 1897*. Washington, D.C.: Government Printing Office, 1911.

Van Dyke, John C. *The New New York: A Commentary on the Place and the People.* New York: Macmillan, 1909.

Van Rensselaer, Mariana Griswold. "Picturesque New York." *Century Magazine* 45, no. 2 (December 1892): 164–175.

Van Vechten, Carl. "In Defense of the Art of Acting, and a Demand for a Truce to Actor-Baiting." *Vanity Fair* 9, no. 3 (November 1917): 144.

———. "A Night with Farfariello." *Theatre Magazine* 29, no. 215 (January 1919): 32–34.

Verga, Giovanni. *The House by the Medlar Tree.* Trans. Mary A. Craig. New York: Harper, 1890.

Villari, Pasquale. "Le lettere meridionali." *L'opinione* (March 1875). Reprint in *Lettere meridionali e altri scritti sulla questione sociale in Italia* (Florence: Le Monnier, 1878). Second expanded edition, Turin: Bocca, 1885; reprint, Naples: Guida, 1979.

———. *Scritti sull'emigrazione e sopra altri argomenti vari.* Bologna: Zanichelli, 1909.

Vorse, Mary Heaton. "Some Picture Show Audiences." *Outlook* 98 (24 June 1911): 441–448.

Wald, Lillian D. *The House on Henry Street.* New York: Henry Holt, 1915. Reprint with an introduction by Eleanor L. Brilliant, New Brunswick, N.J.: Transaction, 1991.

Washington, Booker T. *The Man Farthest Down: A Record of Observation and Study in Europe.* Garden City, N.Y.: Doubleday, Page, 1912. Reprint, New Brunswick: Transaction, 1984.

West, Thomas. *A Guide to the Lakes: Dedicated to the Lovers of Landscape Studies and to All Who Visited or Intend to Visit the Lakes in Cumberland, Westmorland, and Lancashire.* London: Richardson and Urquhart, and W. Pennington, Kendal, 1778.

Willard, Samuel. *The Popular Reader; or, Complete Scholar.* Greenfield, Mass.: A Phelps, 1834.

Winckelmann, Johann Joachim. *Geschichte der Kunst des Altertums.* Weimar: H. Böhlaus Nachf, 1764. Reprint in English as *History of the Art of Antiquity,* trans. Harry Francis Mallgrave (Los Angeles: Getty Research Institute, 2006).

Wittemann, Adolph. *Picturesque New York: Photo-Gravures.* Brooklyn, N.Y.: Albertype, 1899.

Wordsworth, William. *The Prelude; or, Growth of a Poet's Mind: An Autobiographical Poem.* Edited by Ernest de Selincourt, revised by Helen Darbishire. Oxford: Clarendon, 1959.

Zangwill, Israel. *The Melting-Pot: A Drama in Four Acts.* New York: Macmillan, 1909.

SECONDARY SOURCES

Abel, Richard. *Americanizing the Movies and "Movie-Mad" Audiences, 1910–1914.* Berkeley: University of California Press, 2006.

———. *Encyclopedia of Early Cinema.* New York: Routledge, 2005.

———. "The Perils of Pathé, or the Americanization of Early American Cinema." In *Cinema and the Invention of Modern Life,* ed. Leo Charney and Vanessa R. Schwartz, 183–223. Berkeley: University of California Press, 1995.

———. *The Red Rooster Scare: Making Cinema American, 1900–1910.* Berkeley: University of California Press, 1999.

———, ed. *Silent Film.* New Brunswick, N.J.: Rutgers University Press, 1996.

Abel, Richard, Giorgio Bertellini, and Rob King, eds. *Early Cinema and the National.* London: John Libbey, 2008.

Abrams, Ann Uhry. *The Valiant Hero: Benjamin West and Grand-Style History Painting.* Washington, D.C.: Smithsonian Institution Press, 1985.

Abulafia, Davide. *Le due Italie: Relazioni economiche fra il Regno Normanno di Sicilia e i comuni settentrionali.* Naples: Guida, 1991.

Accardi, Joseph J. "Giovanni De Rosalia: Playwright, Poet, and 'Nofrio.'" *Italian Americana* 19, no. 2 (Summer 2001): 176–200.

Ackerman, Gerald M. *The Life and Work of Jean-Léon Gérôme: With a Catalogue Raisonné.* London and New York: Sotheby's Publications, 1986.

Affron, Mirella Jona. "The Italian-American in American Films, 1918–1971." *Italian Americana* 3 (Spring–Summer 1977): 232–255.

Agnew, John, David N. Livingstone, and Alisdair Rogers, eds. *Human Geography: An Essential Anthology.* Cambridge: Blackwell, 1996.

Ahlquist, Karen. *Democracy at the Opera: Music, Theater, and Culture in New York City, 1815–1860.* Urbana and Chicago: University of Illinois Press, 1996.

Ahmad, Aijaz. *In Theory: Classes, Nations, Literatures.* London: Verso, 1992.

Alba, Richard. *Ethnic Identity: The Transformation of White America.* New Haven, Conn.: Yale University Press, 1990.

———. *Italian Americans: Into the Twilight of Ethnicity.* Englewood Cliffs, N.J.: Prentice-Hall, 1985.

Aldrich, Robert. *The Seduction of the Mediterranean: Writing, Art and Homosexual Fantasy.* New York: Routledge, 1993.

Aleandri, Emelise. "A History of Italian-American Theatre: 1900 to 1905." Ph.D. diss., City University of New York, 1983.

———. *The Italian-American Immigrant Theatre of New York City.* Charleston, S.C.: Arcadia, 1999.

———. "Italian-American Theatre." In *Il sogno italo-americano: Realtà e immaginario dell'emigrazione negli Stati Uniti,* ed. Sebastiano Martelli, 117–131. Naples: CUEN, 1998.

Aleandri, Emelise, and Maxine Schwartz Seller. "Italian-American Theatre." In *Ethnic Theatre in the United States,* ed. Maxine Schwartz Seller, 237–276. London: Greenwood, 1983.

Alighieri, Dante. *The Divine Comedy: Inferno.* Translated and with a commentary by Charles A. Singleton. 1970. Reprint, Princeton, N.J.: Princeton University Press, 1980.

Alland, Alexander, Sr. *Jacob A. Riis: Photographer and Citizen.* 1973. Reprint, New York: Aperture Foundation, 1993.

Allen, Beverly, and Mary Russo, eds. *Revisioning Italy: National Identity and Global Culture.* Minneapolis: University of Minnesota Press, 1997.

Allen, Richard. *Projecting Illusion: Film Spectatorship and the Impression of Reality.* New York: Cambridge University Press, 1995.

Allen, Robert C. "Manhattan Myopia; or, Oh! Iowa!" *Cinema Journal* 35, no. 3 (Spring 1996): 75–103.

———. "Motion Picture Exhibition in Manhattan, 1906–1912: Beyond the Nickelodeon." In *Film before Griffith,* ed. John L. Fell, 162–175. Berkeley: University of California Press, 1983.

———. *Vaudeville and Film, 1895–1915: A Study in Media Interaction.* New York: Arno, 1980. Originated as Allen's Ph.D. diss., University of Iowa, 1977.

Alovisio, Silvio. "The 'Pastrone System': Itala Film from the Origins to World War I." In "Early Italian Cinema," ed. Giorgio Bertellini, special issue of *Film History* 12, no. 3 (Fall 2000): 250–261.

Alpers, Svetlana. *The Art of Describing: Dutch Art in the Seventeenth Century.* Chicago: University of Chicago Press, 1983.

Altman, Rick. *Silent Film Sound.* New York: Columbia University Press, 2004.

———. "Technologie et textualité de l'intermédialité." *Sociétés & Représentations* 9 (April 2000): 11–19.

Altomonte, Antonio. *Mafia, briganti, camorra e letteratura.* Milan: Pan Editrice, 1979.

Amirante, Francesca, ed. *Libri per vedere: Le guide storico-artistiche della città di Napoli; Fonti, testimonianze del gusto, immagini di una città.* Naples: Edizioni Scientifiche Italiane, 1995.

Amon Carter Museum of Western Art. *The Image of America in Caricature and Cartoon.* Fort Worth, Tex.: The Museum, 1975.

Anderson, Benedict. *Imagined Communities: Reflections on the Origins and Spread of Nationalism.* Rev. ed. London: Verso, 1991.

Anderson, Robert. "The Role of the Western Film Genre in Industry Competition, 1907–1911." *Journal of the University Film Association* 31, no. 2 (Spring 1979): 19–26.

Andrews, Malcolm. *Landscape and Western Art.* New York: Oxford University Press, 1999.

———, ed. *The Picturesque: Literary Sources and Documents.* 3 vols. Robertsbridge, UK: Helm Information, 1994.

———. *The Search for the Picturesque: Landscape Aesthetics and Tourism in Britain, 1760–1800.* Aldershot, UK: Scolar, 1989.

Angelini, Franca, ed. *Petrolini: La maschera e la storia.* Rome and Bari: Laterza, 1984.

Angelini, Valerio, and Fiorangelo Pucci, eds. *1896–1914, materiali per una storia del cinema delle origini.* Turin: Studio Forma, 1981.

Appel, John, and Selma Appel, eds. *Pat-Riots to Patriots: American Irish Caricature and Comic Art.* East Lansing: Michigan State University Museum and Michigan State University, 1990.

Aprà, Adriano, ed. *Napoletana: Images of a City.* New York: MoMA/Bompiani, 1993.

Aptheker, Herbert, ed. *Writings by W. E. B. Du Bois in Non-periodical Literature.* Millwood, N.Y.: Kraus-Thomson, 1982.

Arcara, Stefania. *Constructing the South: Sicily, Southern Italy and the Mediterranean in British Culture, 1773–1926.* Catania: Università di Catania, Dipartimento di Filologia Moderna, 2000.

Ardizzone, Tony. *In the Garden of Papa Santuzzu.* New York: Picador, 1999.

Arnheim, Rudolph. "On the Nature of Photography." *Critical Inquiry* 1, no. 1 (September 1974): 149–161.

Ashyk, Dan, Fred L. Gardaphé, and Anthony Julian Tamburri, eds. *Shades of Black and White: Conflict and Collaboration between Two Communities.* Staten Island, N.Y.: American Italian Historical Association, 1999.

Asor Rosa, Alberto. "La cultura (Dall'Unità all'età giolittiana)." *Storia d'Italia* 4. Turin: Einaudi, 1975.

———. *Letteratura italiana.* Vol. 2, *Produzione e consumo.* Turin: Einaudi, 1983.

Auerbach, Jonathan. *Body Shots: Early Cinema's Incarnations.* Berkeley: University of California Press, 2007.

———. "McKinley at Home: How Early American Cinema Made News." *American Quarterly* 51, no. 4 (1999): 797–832.

Aymard, Maurice, and Giuseppe Giarrizzo, eds. *La Sicilia: Storia d'Italia; Le regioni dall'Unità a oggi.* Turin: Einaudi, 1987.

Bachelard, Gaston. *The Poetics of Space.* 1957. Translated by Maria Jolas. New York: Orion, 1964.

Baker, Nicolas, and Margaret Brentano. *The World on Sunday: Graphic Art in Joseph Pulitzer's Newspaper (1898–1911).* New York: Bulfinch, 2005.

Baker, Paul R. *The Fortunate Pilgrims: Americans in Italy, 1800–1860.* Cambridge, Mass.: Harvard University Press, 1964.

Bakhtin, Mikhail M. *The Dialogical Imagination.* Translated by Caryl Emerson and Michael Holquist. Austin: University of Texas Press, 1981.

———. *Rabelais and His World.* Translated by Helene Iswolsky. Bloomington: Indiana University Press, 1984.

———. *Speech Genres and Other Late Essays.* Translated by Vern W. McGee. Austin: University of Texas Press, 1986.

Balides, Constance. "Scenarios of Exposure in the Practice of Everyday Life: Women in the Cinema of Attractions." *Screen* 34, no. 1 (1993): 19–37.

Barbaro, Umberto. *Il film e il risarcimento marxista dell'arte.* Rome: Editori Riuniti, 1960.

———. *Servitù e grandezza del cinema.* Rome: Editori Riuniti, 1962.

Barber, X. Theodore. "The Roots of Travel Cinema: John L. Stoddard, E. Burton Holmes, and the Nineteenth-Century Illustrated Travel Lecture." *Film History* 5, no. 1 (March 1993): 68–84.

Barbina, Alfredo. *Capuana inedito.* Bergamo: Minerva Italica, 1974.

———, ed. *Sperduti nel buio.* Rome: Nuova ERI/Biblioteca di Bianco & Nero, 1987.

Barrell, John. *The Dark Side of the Landscape: The Rural Poor in English Painting, 1730–1840.* Cambridge: Cambridge University Press, 1980.

———, ed. *Painting and the Politics of Culture: New Essays on British Art, 1700–1850.* New York: Oxford University Press, 1992.

Barrett, James R. "Americanization from the Bottom Up: Immigration and the Remaking of the Working Class in the United States, 1880–1930." *Journal of American History* 79, no. 3 (December 1992): 996–1020.

Barrett, James R., and David Roediger. "Inbetween Peoples: Race, Nationality and the 'New Immigrant' Working Class." *Journal of American Ethnic History* 16, no. 3 (Spring 1997): 3–44.

Barthes, Roland. *Camera Lucida.* 1980. Translated by Richard Howard. London: Jonathan Cape, 1981.

Barzini, Luigi. *The Italians.* New York: Atheneum, 1964.

Basso, Alberto, ed. *Musica in Scena: Storia dello spettacolo musicale.* Vol. 6, *Dalla musica di scena allo spettacolo rock.* Turin: UTET, 1997.

Baudelaire, Charles. "The Salon of 1859." Translated by Jonathan Mayne. In *Photography in Print: Writings from 1816 to the Present,* ed. Vicki Goldberg, 123–126. Albuquerque: University of New Mexico Press, 1988.

Bazin, André. *What Is Cinema?* 2 vols. Berkeley: University of California Press, 1967–71.

Bean, Jennifer M., and Diane Negra, eds. *A Feminist Reader in Early Cinema.* Durham, N.C.: Duke University Press, 2002.

Beard, Charles A., and Mary Beard. *The Rise of American Civilization.* 2 vols. New York: Macmillan, 1927.

Becchetti, Piero. *Fotografi e fotografia in Italia (1839–1880).* Rome: Quasar, 1978.

———. *La fotografia a Roma dalle origini al 1915.* Rome: Colombo, 1983.

Bechelloni, Giovanni, ed. *Il mutamento culturale in Italia (1945–1985).* Naples: Liguori, 1989.

Behan, Tom. *See Naples and Die: The Camorra and Organised Crime.* New York: Palgrave Macmillan, 2002.

Belardelli, Giovanni, Luciano Cafagna, Ernesto Galli della Loggia, and Giovanni Sabbatucci, eds. *Miti e storia dell'Italia unita.* Bologna: Il Mulino, 1999.

Bellò, C. "Scalabrini, Bonomelli e l'emigrazione italiana." *Studi Emigrazione* 12, no. 37 (March 1975): 3–46.

Benjamin, Walter. *Illuminations: Essays and Reflections.* Edited by Hannah Arendt. New York: Schocken, 1968.

———. *Selected Writings.* Edited by Marcus Bullock and Michael W. Jennings. 4 vols. Cambridge, Mass.: Harvard University Press, 1996.

Bercovitch, Sacvan, and Myra Jelhen, eds. *Ideology and Classic American Literature.* New York: Cambridge University Press, 1986.

Berger, John. *Ways of Seeing.* London: British Broadcasting Corporation, 1972.

Berger, Martin A. *Sight Unseen: Whiteness and American Visual Culture.* Berkeley: University of California Press, 2005.

Bermingham, Ann. *Landscape and Ideology.* London: Thames & Hudson, 1986.

Bernabei, Franca. "Little Italy's Eugene Sue: The Novels of Bernardino Ciambelli." In *Adjusting Sites: New Essays in Italian American Studies,* Filibrary 16, ed. William Boelhower and Rocco Pallone, 3–56. Stony Brook, N.Y.: Forum Italicum.

Bernardi, Daniel, ed. *The Birth of Whiteness: Race and the Emergence of U.S. Cinema.* New Brunswick, N.J.: Rutgers University Press, 1996.

Bernardini, Aldo, ed. *Archivio del cinema italiano.* Vol. 1, *Il cinema muto, 1905–1931.* Rome: ANICA, 1991.

———. *Cinema delle origini in Italia: I film "dal vero" di produzione estera 1895–1907.* Gemona: La Cineteca del Friuli, 2008.

———. "Le cinéma français et la naissance du cinéma en Italie: Modéles et limites." In *Les vingt premières années du cinéma français,* ed. Aldo Bernardini and Jean Gili, 329–336. Paris: Presses de la Sorbonne Nouvelle, 1995.

———. *Il cinema muto italiano, 1905–1909: I film dei primi anni.* Rome: CSC, 1996.

———. *Cinema muto italiano: I film "dal vero," 1895–1914.* Gemona: La Cineteca del Friuli, 2002.

———. *Cinema muto italiano.* 3 vols. Rome and Bari: Laterza, 1980–82.

———. "*L'Inferno* della Milano-Films." *Bianco e Nero* 46, no. 2 April–June 1985, 91–111.

Bernardini, Aldo, and Vittorio Martinelli. *Cinema muto italiano* (1905–31) 22 vols. Rome: Nuova ERI/Centro Sperimentale di Cinematografia, 1991–96.

Bernstein, Matthew, and Gaylyn Studlar, eds. *Vision of the East: Orientalism in Film.* New Brunswick, N.J.: Rutgers University Press, 1997.

Bertelli, Carlo, and Giulio Bollati, eds. *L'immagine fotografica, 1845–1945.* 2 vols. Storia d'Italia: Annali 2. Turin: Einaudi, 1979.

Bertellini, Giorgio. "Black Hands and White Hearts: Italian Immigrants as 'Urban Racial Types' in Early American Film Culture." *Urban History* 31, no. 3 (2004): 375–399.

———. "Dubbing *L'Arte Muta*: 'Cinema under Fascism' and the Expressive Layerings of Italian Early Sound Cinema." In *Re-viewing Fascism: Italian Cinema, 1922–1943,* ed. Jacqueline Reich and Piero Garofalo, 30–82. Bloomington: Indiana University Press, 2002.

———. "Duce/Divo: Displaced Rhetorics of Masculinity, Racial Identity, and Politics among Italian-Americans in 1920s New York City." *Journal of Urban History* 31, no. 5 (2005): 685–726.

———. "Epica spettacolare e splendore del vero: L'influenza del cinema storico italiano in America (1908–1915)." In *Storia del cinema mondiale,* vol. 2, *Gli Stati Uniti,* ed. Gian Piero Brunetta, 1:227–265. Turin: Einaudi, 1999.

———. "Ethnic Self-Fashioning at the Cafè-Chantant: Italian Immigrants at the Movies in New York, 1906–1916." In *Public Space/Private Lives: Race, Gender, Class and Citizenship*

in New York, 1890–1929, ed. William Boelhower and Anna Scacchi (Amsterdam: VU University Press, 2004), 39–66.

―――. "Italian Imageries, Historical Feature Films, and the Fabrication of Italy's Spectators in Early 1900s New York." In *American Movie Audiences: From the Turn of the Century to the Early Sound Era,* ed. Melvyn Stokes and Richard Maltby, 29–45. London: British Film Institute, 1999.

―――. "National and Racial Landscapes and the Photographic Form." In *Early Cinema and the "National,"* ed. Richard Abel, Giorgio Bertellini, and Rob King, 27–41. London: John Libbey, 2008.

―――. "Restoration, Genealogy, and Palimpsests: On Some Historiographical Questions." *Film History* 7, no. 3 (Autumn 1995): 277–290. Reprint in *Fritz Lang's Metropolis: Cinematic Visions of Technology and Fear,* ed. Michael Minden and Holger Bachman (Rochester, N.Y.: Camden House, 2000), 140–157.

―――. "Shipwrecked Spectators: Italy's Immigrants at the Movies in New York, 1906–1916." *Velvet Light Trap* 44 (Fall 1999): 39–53.

―――, ed. *Silent Italian Cinema: A Reader.* London: John Libbey, forthcoming.

―――. "Storia, cultura e linguaggio italiani fuori d'Italia: Il caso di due film italo-americani da poco restaurati." In *Narrare la storia: Dal documento al racconto,* Fondazione Maria e Goffredo Bellonci, 304–319. Milan: Mondadori, 2006.

Bertelsen, Lars Kiel. "The Claude Glass: A Modern Metaphor between Word and Image." *Word & Image* 20, no. 3 (July–September 2004): 182–190.

Bertetto, Paolo, and Gianni Rondolino, eds. *Cabiria e il suo tempo.* Turin: Museo Nazionale del Cinema/Editrice il Castoro, 1998.

Bertini, Francesca. *Il resto non conta.* Pisa: Giardini, 1969.

Bertini Malgarini, Patrizia. "L'italiano fuori d'Italia." In *Storia della lingua italiana,* vol. 3, *Le altre lingue,* ed. Luca Serianni and Pietro Trifone, 893–922. Turin: Einaudi, 1994.

Bertone, Giorgio. "La partenza, il viaggio, la patria: Appunti su letteratura e emigrazione tra Ottocento e Novecento." *Movimento operaio e socialista* 2, nos. 1–2 (1980): 91–107.

Bertonelli, Elena, and Luigi M. Lombardi Satriani, eds. *Emigrazione e immigrazione: Catalogo.* Milan: Jaca Book, 1991.

Bertozzi, Marco. "La città europea nel primo cinema." In *Storia del cinema mondiale,* vol. 1, *L'Europa: Miti, luoghi, divi,* ed. Gian Piero Brunetta, 147–173. Turin: Einaudi, 1999.

―――. "Visualizing the Past: The Italian City in Early Cinema." In "Early Italian Cinema," ed. Giorgio Bertellini, special issue of *Film History* 12, no. 2 (Summer 2000): 322–329.

Bevilacqua, Cristina. "Interview with Tony Ardizzone." *Italian Americana* 19, no. 2 (Summer 2001): 207–213.

Bevilacqua, Piero. "Catastrofi, continuità, rotture nella storia del Mezzogiorno." *Laboratorio Politico* 5, no. 6 (September–December 1981): 177–219.

Bevilacqua, Piero, Andreina De Clementi, and Emilio Franzina, eds. *Storia dell'emigrazione italiana: Partenze.* Rome: Donzelli Editore, 2001.

Bevilacqua, Piero, and Augusto Placanica, eds. *Storia d'Italia: Le regioni dall'Unità a oggi; La Calabria.* Turin: Einaudi, 1985.

Bhabha, Homi. *The Location of Culture.* New York: Routledge, 1994.

Bird, Elizabeth. *Dressing in Feathers: The Construction of the Indian in American Popular Culture.* Boulder, Colo.: Westview, 1996.

Bitzer, Billy. *Billy Bitzer: His Story.* New York: Farrar, Straus and Giroux, 1973.

Blake, Angela. *How New York Became American, 1890–1924.* Baltimore, Md.: Johns Hopkins University Press, 2006.

Blanchard, Paul, ed. *Blue Guide: Southern Italy.* London and New York: Ernest Benn, 1982.

Blight, David W. *Race and Reunion: The Civil War in American Memory.* Cambridge, Mass.: Harvard University Press, 2001.

Blok, Anton. *The Mafia of a Sicilian Village, 1860–1960: A Study of Violent Peasant Entrepreneurs.* Oxford: Blackwell, 1974.

Blunt, Alison, and Gillian Rose, eds. *Writing Women and Space: Colonial and Postcolonial Geographies.* New York: Guilford, 1994.

Boatti, Giorgio. *La terra trema: Messina 28 dicembre 1908; I trenta secondi che cambiarono l'Italia, non gli italiani.* Milan: Mondadori, 2004.

Boeckmann, Cathy. *A Question of Character: Scientific Racism and the Genres of American Fiction, 1892–1912.* Tuscaloosa and London: University of Alabama Press, 2000.

Bois, Yve Alain. "A Picturesque Stroll around *Clara-Clara.*" *October* 29 (Summer 1984): 32–62.

Bollati, Giulio. *L'Italiano: Il carattere nazionale come storia e come invenzione.* Turin: Einaudi, 1996.

Bonnett, Alistair. "White Studies Revisited." *Ethnic and Racial Studies* 31, no. 1 (January 2008): 185–196.

Booth, Michael R. *Victorian Spectacular Theatre, 1850–1910.* London: Routledge & Kegan Paul, 1981.

Bordwell, David, Janet Staiger, and Kristin Thompson. *The Classical Hollywood Cinema: Film Style and Mode of Production to 1960.* New York: Columbia University Press, 1985.

Boskin, Joseph, and Joseph Dorinson. "Ethnic Humor: Subversion and Survival." *American Quarterly* 37, no. 1 (Spring 1985): 81–97.

Bowser, Eileen, ed. *The Biograph Bulletins: 1908–1912.* New York: Octagon, 1973.

———. *The Transformation of Cinema, 1907–1915.* New York: Scribner, 1990.

Bowser, Pearl, Jane Gaines, and Charles Musser, eds. *African-American Filmmaking and Race Cinema of the Silent Era: Oscar Micheaux and His Circle.* Bloomington: Indiana University Press, 2001.

Boyer, Paul S. *Urban Masses and Moral Order in America, 1820–1920.* Cambridge, Mass.: Harvard University Press, 1978.

Bramen, Carrie Tirado. "The Urban Picturesque and the Spectacle of Americanization." *American Quarterly* 52, no. 3 (2000): 444–477.

———. *The Uses of Variety: Modern Americanism and the Quest for National Distinctiveness.* Cambridge, Mass.: Harvard University Press, 2000.

———. "William Dean Howells and the Failure of the Urban Picturesque." *New England Quarterly* 73, no. 1 (2000): 82–99.

Brancati, Elena, and Carlo Muscetta. *La letteratura sulla mafia.* Rome: Bonacci, 1988.

Brantlinger, Patrick. *Bread and Circuses: Theories of Mass Culture as Social Decay.* Ithaca and London: Cornell University Press, 1983.

Breitbart, Eric. *A World on Display: Photographs from the St. Louis World's Fair, 1904.* Albuquerque: University of New Mexico Press, 1997.

Brewster, Ben, and Lea Jacobs. *Theatre to Cinema: Stage Pictorialism and the Early Feature Film.* London: Oxford University Press, 1997.

Briani, Vittorio. *La stampa italiana all'estero dalle origini ai nostri giorni.* Rome: Istituto Poligrafico dello Stato, 1977.

Brigantaggio, lealismo, repressione nel Mezzogiorno, 1860–1870. Catalog of an exhibition held at Museo Diego Aragona Pignatelli Cortes, Naples, 30 June–18 November 1984. Naples: Macchiaroli, 1984.

Briganti, Giuliano. *The View Painters of Europe.* Translated by Pamela Waley. London: Phaidon, 1970. Originally published as *I vedutisti* (Milan: Bompiani/Electa, 1969).

Briganti, Giuliano, Laura Laureati, and Ludovica Trezzani. *Gaspar van Wittel.* Milan: Electa, 1996.

Briggs, John W. *An Italian Passage: Immigrants to Three American Cities, 1890–1930.* New Haven, Conn.: Yale University Press, 1978.

Bright, Deborah. "Of Mother Nature and Marlboro Men: An Inquiry into the Cultural Meanings of Landscape Photography." *Exposure* 23, no. 1 (1985). Reprint in *The Contest of Meaning: Critical Histories of Photography,* ed. Richard Bolton (Cambridge, Mass.: MIT Press, 1989), 125–142.

Brilli, Attilio. *Un paese di romantici briganti: Gli italiani nell'immaginario del grand tour.* Bologna: Mulino, 2003.

Brilli, Attilio, and Simonetta Neri, eds. *An American Artist in Tuscany: Joseph Pennell (1858–1926).* Cinisello Balsamo, Milan: Silvana Editoriale, 1999.

Brodhead, Richard H. "Strangers on a Train: The Double Dream of Italy in the American Gilded Age." *Modernism/Modernity* 1, no. 2 (1994): 1–19.

Brodkin, Karen. *How Jews Became White Folks and What That Says about Race in America.* New Brunswick, N.J.: Rutgers University Press, 1998.

Brooks, Peter. *The Melodramatic Imagination: Henry James, Melodrama, and the Mode of Excess.* 1976. Reprint, New York: Columbia University Press, 1984.

Browder, Laura. *Slippery Characters: Ethnic Impersonators and American Identities.* Chapel Hill: University of North Carolina Press, 2000.

Brown, Joshua. *Beyond the Lines: Pictorial Reporting, Everyday Life, and the Crisis of Gilded Age America.* Berkeley: University of California Press, 2002.

Brown, Karl. *Adventures with D. W. Griffith.* Edited and with an introduction by Kevin Brownlow. New York: Farrar, Straus and Giroux, 1973.

Brownlow, Kevin. *Behind the Mask of Innocence.* London: Jonathan Cape, 1990.

———. *Mary Pickford Rediscovered: Rare Pictures of a Hollywood Legend.* New York: Harry N. Abrams/Academy of Motion Picture Arts and Sciences, 1999.

———. *The Parade's Gone By . . .* Berkeley: University of California Press, 1968.

Brunetta, Gian Piero. "La guerra vicina." In *Il Cinematografo al campo: L'arma nuova nel primo conflitto mondiale,* ed. Renzo Renzi, 11–24. Ancona: Transeuropa, 1993.

———. "No Place like Rome: The Early Years of Italian Cinema." *Artforum* 28, no. 10 (Summer 1990): 122–125.

———. "Un popolo di artisti, pugili, mafiosi." *Altreitalie* 3, no. 6 (November 1991): 130–139.

———. *Storia del cinema italiano.* 2nd rev. ed. 4 vols. Rome: Editori Riuniti, 1993.

———, ed. *Storia del cinema mondiale.* 5 vols. Turin: Einaudi, 1999–2001.

Bruno, Giuliana. *Atlas of Emotion: Journeys in Art, Architecture, and Film.* London: Verso, 1998.

———. *Streetwalking on a Ruined Map: Cultural Theory and the City Films of Elvira Notari.* Princeton, N.J.: Princeton University Press, 1993.

Bryant, Edward, ed. *Pennell's New York Etchings: 90 Prints by Joseph Pennell.* New York: Dover Publications; Hamilton, N.Y.: Picker Art Gallery of Colgate University, 1980.

Buck-Morss, Susan. *The Dialectics of Seeing: Walter Benjamin and the Arcades Project.* Cambridge, Mass.: MIT Press, 1995.

———. "Hegel and Haiti." *Critical Inquiry* 26, no. 4 (Summer 2000): 821–865.

Buonomo, Leonardo. *Backward Glances: Exploring Italy, Reinterpreting America (1831–1866).* Madison, N.J.: Fairleigh Dickinson University Press, 1996.

Burgio, Alberto, ed. *Nel nome della razza: Il razzismo nella storia d'Italia, 1870–1945.* Bologna: Il Mulino, 1999.

Burke, Chloe S., and Christopher J. Castaneda, eds. "The Public and Private History of Eugenics." Special issue, *Public Historian* 29, no. 3 (Summer 2007): 5–17.

Burns, Sarah. *Pastoral Inventions: Rural Life in Nineteenth-Century American Art and Culture.* Philadelphia: Temple University Press, 1989.

Buscombe, Edward. "Painting the Legend: Frederic Remington and the Western." *Cinema Journal* 23, no. 4 (Summer 1984): 12–27.

Butters, Gerald R. "Portrayals of Black Masculinity in Oscar Micheaux's *The Homesteader.*" *Literature-Film Quarterly* 28, no. 1 (2000): 54–59.

Buzard, James. *The Beaten Track: European Tourism, Literature, and the Ways to Culture, 1800–1918.* Oxford: Clarendon, 1993.

Cahn, Iris. "The Changing Landscape of Modernity: Early Film and America's 'Great Picture' Tradition." *Wide Angle* 18, no. 3 (July 1996): 85–100.

Caizzi, Bruno. *Nuova antologia della questione meriodionale.* Milan: Edizione di Comunità, 1962.

Calcedonio, Donato. *I mafiusi di la Vicaria: Indagine storico-linguistica e strutturale della commedia di G. Rizzotto.* Florence: Sabella, 1979.

Caldwell, Genoa, ed. *Burton Holmes Travelogues: The Greatest Traveler of His Time, 1892–1952.* London: Taschen, 2006.

Cameron, Ardis, ed. *Looking for America: The Visual Production of Nation and People.* Malden, Mass.: Blackwell, 2005.

Cannistraro, Philip V. *Blackshirts in Little Italy: Italian Americans and Fascism, 1921–1929.* West Lafayette, Ind.: Bordighera, 1999.

———. "The Duce and the Prominenti: Fascism and the Crisis of Italian American Leadership." *Altreitalie* 31 (July–December 2005): 76–86.

Canosa, Michele, ed. *1905: La presa di Roma: Alle origini del cinema italiano; Beginning of Italian Cinema.* Recco and Genoa: Le Mani; Bologna: Cineteca di Bologna, 2006.

Cantrill, James G., and Christine L. Oravec, eds. *The Symbolic Earth: Discourse and Our Creation of the Environment.* Lexington: University Press of Kentucky, 1996.

Carlebach, Michael L. *The Origins of Photojournalism in America.* Washington, D.C.: Smithsonian Institution Press, 1992.

Carlson, Marvin. *The Italian Shakespearians: Performances by Ristori, Salvini, and Rossi in England and America.* Washington, D.C.: Folger Shakespeare Library, 1985.

Carroll, Noël. *Theorizing the Moving Image.* New York: Cambridge University Press, 1996.

Casella, Paola. *Hollywood Italian: Gli italiani nell'America di celluloide.* Milan: Baldini & Castoldi, 1998.

Cassani, Silvia, ed. *All'ombra del Vesuvio: Napoli nella veduta europea dal Quattrocento all'Ottocento.* Naples: Electa Napoli, 1990.

———, ed. *Civiltà dell'Ottocento: Le arti a Napoli dai Borbone ai Savoia.* Naples: Electa, 1997.

Castelnuovo Frigessi, Delia. *Cesare Lombroso.* Turin: Einaudi, 2003.

Causa, Raffaello, ed. *Il paesaggio napoletano nella pittura straniera.* Naples: Ente provinciale per il turismo, 1962.

Cavell, Stanley. *The World Viewed.* New York: Viking, 1971. Rev. ed., Cambridge, Mass.: Harvard University Press, 1979.

Cavoli, Alfio. *I briganti italiani nelle storie e nei versi dei cantastorie.* Rome: Scipioni, 1991.

Centro Studi Emigrazione. *Catalogo della biblioteca: II parte.* Rome: CSER, 1980.

————. *Migrations: Catalogue of the Library of the Center for Migration Studies—Rome.* Edited by L. Bertelli, G. Corcagnani, and G. F. Rosoli. Rome: CSER, 1972.

Certeau, Michel de. *The Practice of Everyday Life.* Berkeley: University of California Press, 1984.

Chapman, Charlotte Gower. *Milocca: A Sicilian Village.* Cambridge, Mass.: Schenkman, 1971.

Chard, Chloe. *Pleasure and Guilt on the Grand Tour: Travel Writing and Imaginative Geography, 1600–1830.* Manchester: Manchester University Press, 1999.

Charney, Leo, and Vanessa R. Schwartz, eds. *Cinema and the Invention of Modern Life.* Berkeley: University of California Press, 1995.

Cherchi Usai, Paolo, ed. *The Griffith Project.* 12 vols. London: British Film Institute/Le Giornate del Cinema Muto, 1999–2008.

————. "Maciste all'Hell's Kitchen: Il cinema muto torinese negli Stati Uniti." In *Cabiria e il suo tempo,* ed. Paolo Bertetto and Gianni Rondolino, 132–148. Turin: Museo Nazionale del Cinema/Editrice il Castoro, 1998.

————, ed. *Vitagraph Co. of America: Il cinema prima di Hollywood.* Pordenone: Edizioni Studio Tesi, 1987.

Chianese, Gloria. "Donne e Mezzogiorno: Qualche riflessione." In *Donne tra memoria e storia,* ed. Laura Capobianco, 95–106. Naples: Liguori, 1993.

Chiarenza, Carl. "Notes toward an Integrated History of Picturemaking." *Afterimage* 7, nos. 1–2 (Summer 1979): 35–41.

Choy, Philip P., Lorraine Dong, and Marlon K. Hom, eds. *The Coming Man: Nineteenth-Century American Perceptions of the Chinese.* Seattle: University of Washington Press, 1995.

Cipolla, Gaetano, ed. and trans. *The Poetry of Nino Martoglio: Selections from "Centona."* New York: Legas, 1993.

Ciucci, Giorgio, et al., eds. *The American City: From the Civil War to the New Deal.* Cambridge, Mass.: MIT Press, 1983.

Clark, Kenneth. *Landscape into Art.* New York: Harper and Row, 1975.

Clifford, James, and George E. Marcus, eds. *Writing Culture: The Poetics and Politics of Ethnography.* Berkeley: University of California Press, 1986.

Cocchiara, Giuseppe. *Storia del folklore in Italia.* 1947. Reprint, Palermo: Sellerio, 1981.

Cohen, Miriam. *Workshop to Office: Two Generations of Italian Women in New York City, 1900–1950.* Ithaca, N.Y.: Cornell University Press, 1992.

Cohen, Paula Marantz. *Silent Film and the Triumph of the American Myth.* New York: Oxford University Press, 2001.

Colburn, David R., and George E. Pozzetta. "Crime and Ethnic Minorities in America: A Bibliographic Essay." *History Teacher* 7, no. 4 (August 1974): 597–609.

Comparato, Vittorio Ivo. "Viaggiatori inglesi in Italia tra Sei e Settecento: La formazione di un modello interpretativo." *Quaderni Storici* 42 (September–December 1979): 850–886.

Conrad, Peter. *The Art of the City: Views and Versions of New York.* New York: Oxford University Press, 1984.

Conron, John. *American Picturesque.* University Park: Pennsylvania State University Press, 2000.

Consoli, Vittorio. *Amori e Tromboni: Briganti siciliani tra storia e leggenda.* 1968. Reprint, Acireale: Bonanno, 1988.

Cordasco, Francesco, and Michael Vaughn Cordasco. *The Italian Emigration to the United States, 1880–1930: A Bibliographical Register of Italian Views.* Fairview, N.J.: Junius, 1990.

————, eds. *Italians in the United States: An Annotated Bibliography of Doctoral Dissertations Completed at American Universities.* Fairview, N.J.: Junius, 1981.

Cordasco, Francesco, and Salvatore LaGumina, eds. *Italians in the United States: A Bibliography of Reports, Texts, Critical Studies, and Related Materials.* New York: Oriole, 1972.

Correnti, Santi. *Martoglio inedito: Un ignoto canzoniere italiano della Catania "fin de siècle."* Catania: C.U.E.C.M., 1993.

Cortés, Carlo E. "The Hollywood Curriculum on Italian Americans: Evolution of an Icon of Ethnicity." In *The Columbus People: Perspectives in Italian Immigration to the Americas and Australia,* ed. Lydio F. Tomasi, Piero Gastaldo, and Thomas Row, 89–108. New York: Center for Migration Studies, 1994.

Cosandey, Roland, and François Albéra, eds. *Cinéma sans frontières, 1896–1918: Aspects de l'internationalité dans le cinéma mondial; Images across Borders.* Lausanne, Switzerland: Editions Payot; Québec: Nuit Blanche Éditeur, 1995.

Cosandey, Roland, André Gaudreault, and Tom Gunning, eds. *Une invention du diable? Cinéma des premier temps et religion; An Invention of the Devil? Religion and Early Cinema.* Lausanne, Switzerland: Editions Payot, 1992.

Cosco, Joseph P. *Imagining Italians: The Clash of Romance and Race in American Perceptions, 1880–1910.* New York: State University of New York Press, 2003.

Cosgrove, Denis E. "Modernity, Community and the Landscape Idea." *Journal of Material Culture* 11, nos. 1–2 (2006): 49–66.

———. *Social Formation and Symbolic Landscape.* London: Croom Helm, 1984.

Cosgrove, Denis E., and Stephen Daniels, eds. *The Iconography of Landscape: Essays on the Symbolic Representation, Design and Use of Past Environments.* New York: Cambridge University Press, 1988.

Costa, Antonio. *Il cinema e le arti visive.* Turin: Einaudi, 2002.

———, ed. *La meccanica del visibile: Il cinema delle origini in Europa.* Florence: La Casa Usher, 1983.

———. "Paesaggio e cinema." In *Paesaggio: immagine e realtà,* catalog of an exhibition held in Rome in 1981–82, 339–357. Milan: Electa, 1981.

Costantini, Paolo, ed. *Cultura fotografia in Italia: Antologia di testi sulla fotografia, 1839–1949.* Milan: Franco Angeli, 1985.

Craig, Gordon. "Recollections of a Remarkable Actor." *Listener* 57, no. 1451 (17 January 1957): 105.

Crary, Jonathan. *Techniques of the Observer: On Vision and Modernity in the Nineteenth Century.* Cambridge, Mass.: MIT Press, 1990.

Crawford, John S. "Physiognomy in Classical and American Portrait Busts." *American Art Journal* 9, no. 1 (May 1977): 49–60.

Cripps, Thomas. *Slow Fade to Black.* New York: Oxford University Press, 1977.

D'Agostino, Annette M., ed. *An Index to Short and Feature Film Reviews in the Moving Picture World: The Early Years, 1907–1915.* Westport, Conn.: Greenwood, 1995.

D'Agostino, Peter. "Craniums, Criminals, and the 'Cursed Race': Italian Anthropology in American Racial Thought, 1861–1924." *Comparative Studies in Society and History* 44, no. 2 (2002): 319–343.

Dagrada, Elena, Elena Mosconi, and Silvia Poli, eds. *Moltiplicare l'istante: Beltrami, Comerio e Pacchioni tra fotografia e cinema.* Milan: Il Castoro, 2007.

Dainotto, Roberto M. *Europe (In Theory).* Durham, N.C.: Duke University Press, 2007.

Dalle Vacche, Angela. "Cinema and Art History: Film Has Two Eyes." In *The Sage Handbook of Film Studies,* ed. James Donald and Michael Renov, 180–198. New York: Sage, 2008.

Daniels, Stephen. *Fields of Vision: Landscape Imagery and National Identity in England and the United States.* Princeton, N.J.: Princeton University Press, 1993.

————. *Humphry Repton: Landscape Gardening and the Geography of Georgian England*. New Haven, Conn., and London: Yale University Press, 1999.

Davis, David Brion. *The Problem of Slavery in the Age of Revolution, 1770–1823*. Ithaca, N.Y.: Cornell University Press, 1975.

Davis, John A. *Conflict and Control: Law and Order in Nineteenth-Century Italy*. London: Macmillan, 1988.

De Angelis, Rodolfo. *Café-Chantant: Personaggi e interpreti*. Edited by Stefano De Matteis. Florence: La Casa Usher, 1984.

De Berti, Raffaele. "Milano Films: An Exemplary Story of a 1910s Film Company." In "Early Italian Cinema," ed. Giorgio Bertellini, special issue of *Film History* 12, no. 3 (Fall 2000): 276–287.

————, ed. *Un secolo di cinema a Milano*. Milan: Il Castoro, 1996.

De Clementi, Andreina. *Di qua e di là dall'Oceano: Emigrazione emercati nel Meridione (1860–1930)*. Rome: Carocci, 1999.

De Giustino, David. *Conquest of Mind: Phrenology and Victorian Social Thought*. London: Croom Helm, 1975.

De Jaco, Aldo, ed. *Il brigantaggio meridionale: Cronaca inedita dell'unità d'Italia*. Rome: Editori Riuniti, 1969.

Del Fra, Lino. *Sciara Sciat: Genocidio nell'oasi; L'esercito italiano a Tripoli*. Rome: Datanews, 1995.

DeLuca, Kevin. "In the Shadow of Whiteness: The Consequences of Constructions of Nature in Environmental Politics." In *Whiteness: The Communication of Social Identity*, ed. Thomas K. Nakayama and Judith N. Martin, 217–246. Thousand Oaks, Calif.: Sage, 1999.

De Matteis, Stefano, Martina Lombardi, and Marilea Somarè, eds. *Follie del Varietà: Vicende, memorie personaggi, 1890–1970*. Milan: Feltrinelli, 1980.

De Mauro, Tullio. *Storia linguistica dell'Italia Unita*. Bari: Laterza, 1963.

Denning, Michael. *Mechanic Accents: Dime Novels and Working-Class Culture in America*. Rev. ed. London: Verso, 1998.

Deschamps, Bénédicte. "De la presse 'coloniale' à la presse Italo-Américaine: Le parcours de six périodiques italiens aux États-Unis (1910–1935)." Ph.D. diss., University of Paris VII, 1996.

————. "La letteratura d'appendice nei periodici italo-americani (1910–1935)." In *Il sogno italo-americano: Realtà e immaginario dell'emigrazione negli Stati Uniti*, ed. Sebastiano Martelli, 279–294. Naples: CUEN, 1998.

De Seta, Cesare. "L'Italia nello specchio del 'Grand Tour.'" In *Il paesaggio*, ed. Cesare De Seta, 125–263. Storia d'Italia: Annali 5. Turin: Einaudi, 1982.

————. *Vedutisti e viaggiatori in Italia tra Settecento e Ottocento*. Turin: Bollati Boringhieri, 1999.

DiCarlo, Denise M. "The History of Italian Festa in New York City, 1880 to the Present." Ph.D. diss., New York University, 1990.

Di Ciommo, Enrica. *I confini dell'identità: Teorie e modelli di nazione in Italia*. Rome and Bari: Laterza, 2005.

Dickie, John. *Cosa Nostra: A History of the Sicilian Mafia*. New York: Palgrave Macmillan, 2004.

————. *Darkest Italy: The Nation and Stereotypes of the Mezzogiorno, 1860–1900*. New York: St. Martin's Press, 1999.

————. "Stereotypes of the Italian South, 1860–1900." In *The New History of the Italian South: The Mezzogiorno Revisited*, ed. Robert Lumley and Jonathan Morris, 114–147. Exeter, UK: University of Exeter Press, 1997.

Dimendberg, Edward. *Film Noir and the Spaces of Modernity.* Cambridge, Mass.: Harvard University Press, 2004.

Distler, Paul Antonie. "Ethnic Comedy in Vaudeville and Burlesque." In *American Popular Entertainment,* ed. Myron Matlaw, 127–131. Westport, Conn.: Greenwood, 1979.

———. "Exit the Racial Comics." *Educational Theatre Journal* 18, no. 3 (October 1966): 247–254.

Doane, Mary Ann. *The Emergence of Cinematic Time: Modernity, Contingency, the Archive.* Cambridge, Mass.: Harvard University Press, 2002.

Doherty, Robert. *The Complete Photographic Work of Jacob A. Riis.* New York: Macmillan, 1981.

Domosh, Doma. *Invented Cities: The Creation of Landscape in Nineteenth-Century New York and Boston.* New Haven, Conn.: Yale University Press, 1996.

Dore, Grazia, ed. *Bibliografia per la storia dell'emigrazione italiana in America.* Rome: Ministero Affari Esteri/Direzione Generale dell'Emigrazione, 1956.

———. *La democrazia italiana e l'emigrazione in America.* Brescia: La Scuola, 1964.

Dormon, James H. "Ethnic Stereotyping in American Popular Culture: The Depiction of American Ethnics in the Cartoon Periodicals of the Gilded Age." *Amerikastudien* 30, no. 4 (1985): 489–507.

Doyle, Laura, and Laura Winkel, eds. *Geomodernisms: Race, Modernism, Modernity.* Bloomington: Indiana University Press, 2005.

Durante, Francesco. "'Farfariello': Due 'macchiette coloniali.'" *Ácoma* 6, no. 16 (Spring 1999): 54–60.

———. *Italoamericana: Storia e letteratura degli Italiani negli Stati Uniti, 1776–1880.* Milan: Mondadori, 2001.

Edwards, Catharine, ed. *Roman Presences: Reception of Rome in European Culture, 1789–1945.* Cambridge: Cambridge University Press, 1999.

Elson, Ruth Miller. *Guardians of Tradition: American Schoolbooks of the Nineteenth Century.* Lincoln: University of Nebraska Press, 1964.

Engel, Leonard, ed. *The Big Empty: Essays on Western Landscapes as Narrative.* Albuquerque: University of New Mexico Press, 1994.

Erenberg, Lewis A. *Steppin' Out: New York Nightlife and the Transformation of American Culture, 1890–1930.* Chicago: University of Chicago Press, 1981.

Erens, Patricia. *The Jew in American Cinema.* Bloomington: Indiana University Press, 1984.

Ethington, Philip J., and Vanessa R. Schwartz. "Introduction: An Atlas of the Urban Icons Project." *Urban History* 33, no. 1 (2006): 5–19.

Everett, Anna. *Returning the Gaze: A Genealogy of Black Film Criticism, 1909–1945.* Durham, N.C.: Duke University Press, 2001.

Everson, William K. *American Silent Film.* 1978. New York: Da Capo, 1998.

Everson, William K., and George N. Fenin. *The Western: From Silents to Cinerama.* New York: Bonanza, 1962.

Ewen, Elizabeth. "City Lights: Immigrant Women and the Rise of the Movies." *Signs: Journal of Women in Culture and Society* 5, no. 3, supplement (Spring 1980): S45–S65. Reprint in *Channels of Desire: Mass Images and the Shaping of American Consciousness,* by Stuart Ewen and Elizabeth Ewen (New York: McGraw-Hill, 1982), 53–73.

———. *Immigrant Women in the Land of Dollars: Life and Culture on the Lower East Side, 1890–1925.* New York: Monthly Review Press, 1985.

Faeta, Francesco. *Strategie dell'occhio: Saggi di etnografia visiva.* Rev. ed. Milan: Franco Angeli, 2003.

Falzone del Barbarò, Michele, Monica Maffioli, and Paolo Morello, eds. *Fotografi e fotografie a Palermo nell'Ottocento*. Florence: Alinari, 1999.

Falzone del Barbarò, Michele, et al., eds. *Le fotografie di von Gloeden*. Milan: TEA, 1996.

Fanon, Frantz. *Black Skin, White Masks*. New York: Grove, 1967.

Fantina, Livio. *Tempo e Passatempo: Pubblico e spettacolo a Treviso fra Otto e Novecento*. Padua: Il Poligrafo, 1988.

———. *Le trincee dell'immaginario: Spettacoli e spettatori nella grande guerra*. Sommacampagna, Verona: Cierre Edizioni, 1998.

Farassino, Alberto, and Tatti Sanguinetti, eds. *Gli uomini forti*. Milan: Mazzotta, 1983.

Fell, John L. *Film before Griffith*. Berkeley: University of California Press, 1983.

Filippuzzi, Angelo. *Il dibattito sull'emigrazione: Polemiche nazionali e stampa veneta (1861–1914)*. Florence: Le Monnier, 1976.

Fine, David M. *The City, the Immigrant and American Fiction, 1880–1920*. Metuchen, N.J.: Scarecrow, 1977.

Fiorentino, Gaetano, Gennaro Matacena, and Paolo Macry, eds. *Napoli in posa: 1859–1910, crepuscolo di una capitale*. Naples: Electa, 1989.

Fiorentino, Giovanni. "Dalla fotografia al cinema." In *Storia del cinema mondiale*, ed. Gian Piero Brunetta, 5:43–79. Turin: Einaudi, 2001.

———. *L'Ottocento fatto immagine*. Palermo: Sellerio Editore, 2007.

———. *Tanta di luce meraviglia arcane: Origini della fotografia a Napoli*. Naples: Di Mauro, 1992.

Fondazione, Brodolini. *Gli Italiani fuori d'Italia: Gli emigrati italiani nei movimenti operai dei paesi d'adozione (1880–1940)*. Edited by Bruno Bezza. Milan: Franco Angeli, 1983.

Forgacs, David, and Robert Lumley, eds. *Italian Cultural Studies: An Introduction*. New York: Oxford University Press, 1996.

Foster, Edward Halsey. *The Civilized Wilderness: Background to American Romantic Literature, 1817–1860*. New York: Free Press, 1975.

Foucault, Michel. "Des espaces autres." *Architecture-Mouvement-Continuité*, October 1984. Reprint in English as "Of Other Spaces," trans. Jay Miskowiec, *Diacritics* 16, no. 1 (Spring 1986): 22–27.

———. *The Order of Things*. New York: Vintage, 1973.

———. *Power/Knowledge: Selected Interviews and Other Writings, 1972–1977*. London: Harvester Wheatsheaf, 1980.

Francke, Lizzie. *Script Girls: Women Screenwriters in Hollywood*. London: British Film Institute, 1994.

Franzina, Emilio. "Le canzoni dell'emigrazione." In *Storia dell'emigrazione italiana: Partenze*, ed. Pietro Bevilacqua, Angelina De Clementi, and Emilio Franzina, 537–562. Rome: Donzelli Editore, 2001.

———. *Dall'Arcadia all'America: Attività letteraria ed emigrazione transoceanica in Italia (1850–1940)*. Turin: Fondazione Agnelli, 1996.

———. *L'immaginario degli emigranti: Miti e raffigurazioni dell'esperienza italiana all'estero frai i due secoli*. Treviso: Pagus, 1992.

———. *Gli italiani al nuovo mondo: L'emigrazione Italiana in America, 1492–1942*. Milan: Mondadori, 1995.

Franzina, Emilio, and Matteo Sanfilippo, eds. *Il fascismo e gli emigrati: La parabola dei Fasci italiani all'estero (1920–1943)*. Rome and Bari: Laterza, 2003.

Frasca, Simona. "Birds of Passage: La diaspora dei musicisti napoletani a New York (1895–1940)." Ph.D. diss., University of Rome La Sapienza, 2007.

Frassanito, William A. *Antietam: The Photographic Legacy of America's Bloodiest Day.* New York: Scribner, 1978.

Freeden, Michael. "Eugenics and Progressive Thought: A Study in Ideological Affinity." *Historical Journal* 22, no. 3 (September 1979): 645–671.

Friedman, Lester D., ed. *Unspeakable Images: Ethnicity and the American Cinema.* Urbana and Chicago: University of Illinois Press, 1991.

Fuller, Kathryn H. *At the Picture Show: Small-Town Audiences and the Creation of Movie Fan Culture.* Washington, D.C.: Smithsonian Institution Press, 1996.

Fullerton, John, ed. *Celebrating 1895: The Centenary of Cinema.* London: John Libbey, 1998.

———, ed. *Screen Culture: History and Textuality.* Eastleigh, UK: John Libbey, 2004.

Fusco, Maria Antonella. "Il 'luogo comune' paesaggistico." In *Il paesaggio,* ed. Cesare De Seta, 753–801. Storia d'Italia: Annali 5. Turin: Einaudi, 1982.

Gabaccia, Donna. *From Sicily to Elizabeth Street: Housing and Social Change among Italian Immigrants, 1880–1930.* Albany: State University of New York, 1984.

———. *From the Other Side: Women, Gender, and Immigrant Life in the U.S., 1820–1990.* Bloomington: Indiana University Press, 1994.

Gabler, Neal. *An Empire of Their Own: How the Jews Invented Hollywood.* New York: Crown, 1988.

Gadamer, Hans-Georg. *Wahrheit und Methode.* Tübingen: J. C. B. Mahr, 1960. Reprint in English as *Truth and Method,* trans. Joel Weinsheimer and Donald G. Marshall (New York: Crossroad, 1989).

Gaines, Jane. *Fire and Desire: Mixed-Race Movies in the Silent Era.* Chicago: University of Chicago Press, 2001.

———. "*The Scar of Shame:* Skin Color and Caste in Black Silent Melodrama." *Cinema Journal* 26, no. 4 (Summer 1987): 3–21.

Galassi, Peter. *Before Photography: Painting and the Invention of Photography.* New York: Museum of Modern Art, 1981.

Gambino, Richard. *Blood of My Blood: The Dilemma of the Italian-Americans.* Garden City, N.Y.: Doubleday, 1974. Reprint, Toronto: Guernica, 2000.

———. *Vendetta: A True Story of the Worst Lynching in America.* Garden City, N.Y.: Doubleday, 1977. Second ed. as *Vendetta: The True Story of the Largest Lynching in U.S. History* (Toronto: Guernica, 2000).

Gandal, Keith. *The Virtues of the Vicious: Jacob Riis, Stephen Crane and the Spectacle of the Slum.* New York: Oxford University Press, 1997.

Gaudioso, Francesco. *Il banditismo nel Mezzogiorno moderno tra punizione e perdono.* Galatina, Lecce: Mario Congedo Editore, 2001.

Gaudreault, André. *Cinema delle origini o della "cinematografia-attrazione."* Milan: Il Castoro, 2004.

———. *Cinéma et attraction: Pour une nouvelle histoire du cinématographe.* Paris: CNRS Éditions, 2008.

———. "From 'Primitive Cinema' to 'Kine-Attractography.'" In *The Cinema of Attractions Reloaded,* ed. Wanda Strauven, 85–104. Amsterdam: Amsterdam University Press, 2006.

Gaudreault, André, and Tom Gunning. "Le cinema des premiers temps: Un défi à l'histoire du cinema?" In *Histoire du cinema: Nouvelle approches,* ed. Jacques Aumont, André Gaudreault, and Michel Marie, 49–63. Paris: Sorbonne, 1989. Reprint in English as "Early Cinema as a Challenge to Film History," in *The Cinema of Attractions Reloaded,* ed. Wanda Strauven (Amsterdam: Amsterdam University Press, 2006), 365–380.

Gaudreault, André, and Philippe Marion. "A Medium Is Always Born Twice . . ." *Early Popular Visual Culture* 3, no. 1 (May 2005): 3–15.

Geertz, Clifford. *The Interpretation of Cultures.* London: Hutchinson, 1975.

Genovese, Nino, and Sebastiano Gesù. *E venne il cinematografo: Le origini del cinema in Sicilia.* Catania: Giuseppe Maimone Editore, 1995.

Gesù, Sebastiano. *L'Etna nel cinema: Un vulcano di celluloide.* Catania: Giuseppe Maimone Editore, 2005.

Gevinson, Alan, ed. *Within Our Gates: Ethnicity in American Feature Films, 1911–1960.* American Film Institute Catalog. Berkeley: University of California Press, 1997.

Giammattei, Emma. "La cultura della regione 'napolitana': I modelli, le forme, i temi." In *Storia d'Italia: Le regioni dall'Unità a oggi; La Campania,* ed. Paolo Macry and Pasquale Villani, 793–841. Turin: Einaudi, 1990.

Giancristofaro, Lia. *Il segno dei vinti: Antropologia e letteratura in Verga.* Lanciano: Rocco Carabba, 2005.

Gibson, Mary. *Born to Crime: Cesare Lombroso and the Origins of Biological Criminology.* Westport, Conn.: Praeger, 2002.

Gidley, Mick, and Robert Lawson-Peebles, eds. *Views of American Landscapes.* New York: Cambridge University Press, 1989.

Ginzburg, Carlo. "Family Resemblances and Family Trees: Two Cognitive Metaphors." *Critical Inquiry* 30, no. 3 (Spring 2004): 537–556.

———. "Particolari, primi piani, microanalisi: In margine a un libro di Siegfried Kracauer." *Paragone* 54, nos. 48–50 (August–December 2003): 20–37. Reprint in English as "Minutiae, Close-up, Microanalysis," *Critical Inquiry* 34, no. 1 (Autumn 2007): 174–189.

Glassberg, David. *American Historical Pageantry: The Uses of Tradition in the Early Twentieth Century.* Chapel Hill: University of North Carolina Press, 1990.

Goldberg, Vicki. *Lewis W. Hine: Children at Work.* New York: Prestel, 1999.

———. *Photography in Print: Writings from 1816 to the Present.* Albuquerque: University of New Mexico Press, 1988.

Gomery, Douglas. *Shared Pleasures: A History of Movie Presentation in the United States.* Madison: University of Wisconsin Press, 1992.

Gossett, Thomas F. *Uncle Tom's Cabin and American Culture.* Dallas, Tex.: Southern Methodist University Press, 1985.

Gould, Stephen Jay. *The Mismeasure of Man.* New York: Norton, 1981.

Grafton, John. *New York in the Nineteenth Century: 317 Engravings from Harper's Weekly and Other Contemporary Sources.* 2nd ed. New York: Dover, 1980.

Gramsci, Antonio. *Prison Notebooks.* Edited by Joseph A. Buttigieg. Translated by Joseph A. Buttigieg and Antonio Callari. 2 vols. New York: Columbia University Press, 1992–96.

———. *Selections from Cultural Writings.* Edited by David Forgacs and Geoffrey Nowell-Smith. Cambridge, Mass.: Harvard University Press, 1985.

———. *The Southern Question.* 1926. Translated with an introduction by Pasquale Verdicchio. West Lafayette, Ind.: Bordighera, 1995.

Grano, Enzo. *La sceneggiata.* Naples: Attività Bibliografica Editoriale, 1976.

Gray, David. "Irish Apes and Italian Rats: The Role of Popular Media Cartoons in Negotiating Inclusion and Exclusion to American National Identity of Irish-Americans and Italian-Americans, 1840–1914." Senior thesis, University of Minnesota, 1998.

Greco, Franco Carmelo, Mariantonietta Picone Petrusa, and Isabella Valente, eds. *La pittura napoletana dell'Ottocento.* Naples: Tullio Pironti, 1993.

Green, Nicholas. *The Spectacle of Nature: Landscape and Bourgeois Culture in Nineteenth-Century France.* Manchester: Manchester University Press, 1990.

Green, Rose Basile. *The Italian-American Novel: A Document of the Interaction of Two Cultures.* Rutherford, N.J.: Fairleigh Dickinson University Press, 1974.

Greenfeld, Howard. *Caruso*. New York: G. P. Putnam's Sons, 1983.

Gribaudi, Gabriella. "Images of the South." In *Italian Cultural Studies: An Introduction*, ed. David Forgacs and Robert Lumley, 72–87. New York: Oxford University Press, 1996.

———. "Images of the South: The *Mezzogiorno* as Seen by Insiders and Outsiders." In *The New History of the Italian South*, ed. Robert Lumley and Jonathan Morris, 83–113. Exeter, UK: University of Exeter Press, 1997.

Grieveson, Lee. "Gangsters and Governance in the Silent Era." In *Mob Culture: Hidden Histories of the American Gangster Film*, ed. Lee Grieveson, Esther Sonnet, and Peter Stanfield, 13–40. New Brunswick, N.J.: Rutgers University Press, 2005.

———. "Why the Audience Mattered in Chicago in 1907." In *American Movie Audiences: From The Turn of the Century to the Early Sound Era*, ed. Melvyn Stokes and Richard Maltby, 79–91. London: British Film Institute, 1999.

Grieveson, Lee, Esther Sonnet, and Peter Stanfield, eds. *Mob Culture: Hidden Histories of the American Gangster Film*. New Brunswick, N.J.: Rutgers University Press, 2005.

Griffiths, Alison. "Playing at Being Indian: Spectatorship and the Early Western." *Journal of Popular Film & Television* 29, no. 3 (Fall 2001): 100–111.

———. *Wondrous Difference: Cinema, Anthropology and Turn-of-the-Century Visual Culture*. New York: Columbia University Press, 2002.

Griffiths, Alison, and James Latham, "Film and Ethnic Identity in Harlem, 1896–1915." In *American Movie Audiences: From The Turn of the Century to the Early Sound Era*, ed. Melvyn Stokes and Richard Maltby, 46–63. London: British Film Institute, 1999.

Griffiths, Antony. *Prints and Printmaking: An Introduction to the History of Techniques*. Berkeley: University of California Press, 1996.

Guccini, Gerardo. "Note intorno all'interpretazione di 'Assunta Spina.'" *Cinegrafie* 6 (1993): 114–118. Reprint in *Francesca Bertini*, ed. Gianfranco Mingozzi (Genoa: Le Mani; Bologna: Cineteca di Bologna, 2003), 82–87.

Guglielmo, Thomas. *White on Arrival: Italians, Race, Color, and Power in Chicago, 1890–1945*. New York: Oxford University Press, 2003.

Gunning, Tom. "An Aesthetic of Astonishment: Early Film and the Incredulous Spectator." *Art & Text* 34 (Spring 1989). Reprint in *Viewing Positions: Ways of Seeing Film*, ed. Linda Williams (New Brunswick, N.J.: Rutgers University Press, 1995), 114–133.

———. "Attractions, truquages et photogénie: L'explosion du présent dans les films à truc français produits entre 1896 et 1907." In *Les vingt premières années du cinéma français*, ed. Jean A. Gili et al., 177–193. Paris: Sorbonne Nouvelle/AFRHC, 1995.

———. "Before Documentary: Early Nonfiction Films and the 'View' Aesthetic." In *Uncharted Territory: Essays on Early Nonfiction Film*, ed. Daan Hertogs and Nico de Klerk, 9–24. Amsterdam: Stichting Nederlands Filmmuseum, 1997.

———. "The Cinema of Attractions: Early Film, Its Spectator and the Avant-Garde." *Wide Angle* 8, nos. 3–4 (Fall 1986): 63–70. Reprint in *Early Cinema: Space, Frame, Narrative*, ed. Thomas Elsaesser (London: British Film Institute, 1990), 56–62.

———. *D. W. Griffith and the Origins of American Narrative Film: The Early Years at Biograph*. Urbana: University of Illinois Press, 1991.

———. "In Your Face: Physiognomy, Photography, and the Gnostic Mission of Early Film." *Modernism/Modernity* 4, no. 1 (1997): 1–29.

———. "'Now You See It, Now You Don't': The Temporality of the Cinema of Attraction." *Velvet Light Trap* 32 (Fall 1993): 3–12.

———. "Systematizing the Electric Message: Narrative Form, Gender, and Modernity in *The Lonedale Operator*." In *American Cinema's Transitional Era: Audiences, Institutions,*

Practices, ed. Charlie Keil and Shelley Stamp, 15–50. Berkeley: University of California Press, 2004.

———. "Tracing the Individual Body: Photography, Detectives, and Early Cinema." In *Cinema and the Invention of Modern Life*, ed. Leo Charney and Vanessa Schwartz, 15–45. Berkeley: University of California Press, 1995.

———. "The Whole World within Reach: Travel Images without Borders." In *Cinéma sans frontières, 1896–1918: Aspects de l'internationalité dans le cinéma mondial; Images across Borders*, ed. Roland Cosandey and François Albéra, 21–36. Lausanne, Switzerland: Editions Payot; Québec: Nuit Blanche Éditeur, 1995.

Guterl, Matthew Pratt. *The Color of Race in America, 1900–1940*. Cambridge, Mass.: Harvard University Press, 2001.

Gutman, Herbert G. *Power and Culture: Essays on the American Working Class*. Edited by Ira Berlin. New York: Pantheon, 1987.

Gutman, Judith Mara. *Lewis W. Hine and the American Social Conscience*. New York: Walker, 1967.

Guzman, Anthony Henry. "The Exhibition and Reception of European Films in the United States during the 1920s." Ph.D. diss., UCLA, 1993.

Haenni, Sabine. "Visual and Theatrical Culture, Tenement Fiction, and the Immigrant Subject in Abraham Cahan's *Yekl*." *American Literature* 71, no. 3 (1999): 493–527.

Hales, Peter B. *Silver Cities: The Photography of American Urbanization, 1839–1915*. Philadelphia: Temple University Press, 1984.

Haller, Hermann W. *Una lingua perduta e ritrovata: L'italiano degli italo-americani*. Florence: La Nuova Italia, 1993.

———. *The Other Italy: The Literary Canon in Dialect*. Toronto: University of Toronto Press, 1999.

———. *Tra Napoli e New York: Le macchiette italo-americane di Eduardo Migliaccio*. Rome: Bulzoni Editore, 2006.

Hampton, Benjamin B. *A History of the Movies*. New York: Covici-Friede, 1931.

Hansen, Miriam. "America, Paris, the Alps: Kracauer (and Benjamin) on Cinema and Modernity." In *Cinema and the Invention of Modern Life*, ed. Leo Charney and Vanessa Schwartz, 381–382. Berkeley: University of California Press, 1995.

———. *Babel and Babylon: Spectatorship in American Silent Film*. Cambridge, Mass.: Harvard University Press, 1991.

———. "Universal Language and Democratic Culture: Myths of Origin in Early American Cinema." In *Myth and Enlightenment in American Literature: In Honor of Hans-Joachim Lang*, ed. Dieter Meindl and Friedrich W. Horlacher, 321–351. Erlangen, Germany: University of Erlangen-Nürberg, 1985.

———. "'With Skin and Hair': Kracauer's Theory of Film, Marseille 1940." *Critical Inquiry* 19, no. 3 (Spring 1993): 437–469.

Hanson, Patricia King, and Alan Gevinson, eds. *The American Film Institute Catalog of Motion Pictures Produced in the United States: American Films, 1911–1920; Film Entries*. Berkeley: University of California Press, 1988.

Harris, Neil. *New Directions in American Intellectual History*. Baltimore, Md.: Johns Hopkins University Press, 1979.

Harris, Neil, et al., eds. *Grand Illusions: Chicago's World's Fair of 1893*. Chicago: Chicago Historical Society, 1993.

Harvey, David. "Between Space and Time: Reflections on the Geographical Imagination." *Annals of the Association of American Geographers* 80, no. 3 (September 1990): 418–434.

——. *The Conditions of Postmodernity*. Oxford: Blackwell, 1990.

Hasian, Marouf Arif, Jr. *The Rhetoric of Eugenics in Anglo-American Thought*. Athens: University of Georgia Press, 1996.

Haskell, Francis, and Nicholas Penny. *Taste and the Antique: The Lure of Classical Sculpture, 1500–1900*. New Haven, Conn.: Yale University Press, 1981.

Hendricks, Gordon. *Albert Bierstadt: Painter of the American West*. New York: Harry N. Abrams, 1974.

——. *Beginnings of the Biograph: The Story of the Invention of the Mutoscope and the Biograph and Their Supplying Camera*. New York: Beginnings of the American Film, 1964.

Higashi, Sumiko. "Dialogue: Manhattan's Nickelodeons." *Cinema Journal* 35, no. 3 (Spring 1996): 72–74.

Higgs, Robert. "Race, Skills, and Earnings: American Immigrants in 1909." *Journal of Economic History* 31, no. 2 (1971): 420–428.

Higham, John. *Strangers in the Land: Patterns of American Nativism, 1860–1925*. 1955. Reprint, New Brunswick, N.J.: Rutgers University Press, 1994.

Hipple, Walter John. *The Beautiful, the Sublime, and the Picturesque in Eighteenth-Century British Aesthetic Theory*. Carbondale: Southern Illinois University Press, 1957.

Hoberman, Jim. *Bridge of Light: Yiddish Film between Two Worlds*. New York: MoMA/ Schocken, 1991.

Hobsbawm, Eric. *The Age of Empire, 1875–1914*. 1987. New York: Vintage, 1989.

——. *Primitive Rebels: Studies in Archaic Forms of Social Movement in the 19th and 20th Centuries*. New York: Norton, 1959.

Hobsbawm, Eric, and Terence Ranger, eds. *The Invention of Tradition*. Cambridge: Cambridge University Press, 1983.

Hoffman, Katherine. *Stieglitz: A Beginning Light*. New Haven, Conn.: Yale University Press, 2004.

Hollander, Anne. *Moving Pictures*. New York: Knopf, 1993.

Hollinger, David A. "Ethnic Diversity, Cosmopolitanism and the Emergence of the American Liberal Intelligentsia." *American Quarterly* 27, no. 2 (May 1975): 133–151.

Horsman, Reginald. *Race and Manifest Destiny: The Origins of American Racial Anglo-Saxonism*. Cambridge, Mass.: Harvard University Press, 1981.

Hoskins, William George. *The Making of the English Landscape*. London: Hoddler and Stoughton, 1955.

Howat, John K., ed. *American Paradise: The World of the Hudson River School*. New York: H. N. Abrams, 1987.

Howkins, Alun. "J. M. W. Turner at Petworth: Agricultural Improvement and the Politics of Landscape." In *Painting and the Politics of Culture: New Essays in British Art, 1700–1850*, ed. John Barrell (Oxford: Oxford University Press, 1992), 231–251.

Huggins, Nathan Irvin. *Protestants against Poverty: Boston's Charities, 1870–1900*. Westport, Conn.: Greenwood, 1971.

Hunt, John Dixon. *The Picturesque Garden in Europe*. London: Thames & Hudson, 2002.

Hussey, Christopher. *The Picturesque: Studies in a Point of View*. 1927. Reprint, London: Frank Cass, 1967.

Huyssen, Andreas. "Mass Culture as Woman: Modernism's Other." In *Studies of Entertainments: Critical Approaches to Mass Culture*, ed. Tania Modleski, 188–207. Bloomington: Indiana University Press, 1986.

Hyde, Ann Farrar. *An American Vision: Far Western Landscape and National Culture, 1890–1920*. New York: New York University Press, 1990.

Ignatiev, Noel. *How the Irish Became White.* New York: Routledge, 1995.

Ivins, William M., Jr. *Prints and Visual Communication.* Cambridge, Mass.: Harvard University Press, 1953.

Jacknis, Ira. "The Picturesque and the Scientific: Franz Boas's Plan for Anthropological Filmmaking." *Visual Anthropology* 1, no. 1 (1987): 59–64.

Jackson, Kenneth T. *The Encyclopedia of New York City.* New York: New-York Historical Society; New Haven, Conn.: Yale University Press, 1995.

Jackson, Stanley. *Caruso.* New York: Stein, 1972.

Jacobs, Lewis. *The Rise of the American Film: A Critical History.* New York: Harcourt, Brace, 1939.

Jacobson, Matthew Frye. *Barbarian Virtues: The United States Encounters Foreign Peoples at Home and Abroad, 1876–1917.* New York: Hill and Wang, 2000.

——. *Special Sorrows: The Diasporic Imagination of Irish, Polish, and Jewish Immigrants in the United States.* Cambridge, Mass.: Harvard University Press, 1995.

——. *Whiteness of a Different Color: European Immigrants and the Alchemy of Race.* Cambridge, Mass.: Harvard University Press, 1998.

Jameson, Fredric. *The Geopolitical Aesthetic: Cinema and Space in the World System.* Bloomington: Indiana University Press; London: British Film Institute, 1992.

——. *The Political Unconscious: Narrative as a Socially Symbolic Act.* Ithaca, N.Y.: Cornell University Press, 1981.

Jenkins, Ian, and Kim Sloan. *Vases and Volcanoes: Sir William Hamilton and His Collection.* London: British Museum Press, 1996.

Jenkyns, Richard. *Dignity and Decadence: Victorian Art and the Classical Inheritance.* London: HarperCollins, 1991.

Jona, Alberto. "Lo spettacolo di intrattenimento: Café-chantant, cabaret, music-hall e altre forme." In *Musica in scena: Storia dello spettacolo musicale,* ed. Alberto Basso, vol. 6, *Dalla musica di scena allo spettacolo rock,* 197–262. Turin: UTET, 1997.

Jones, Kimberly A. *In the Forest of Fontainebleau: Painters and Photographers from Corot to Monet.* Washington, D.C.: National Gallery of Art; New Haven, Conn.: Yale University Press, 2008.

Jones, Maldwyn Allen. *American Immigration.* 1960. Second ed., Chicago: University of Chicago Press, 1992.

Jowett, Garth. *Film, The Democratic Art: A Social History of American Film.* Boston: Little, Brown, 1976.

Kaplan, Amy. *The Anarchy of Empire in the Making of U.S. Culture.* Cambridge, Mass.: Harvard University Press, 2002.

——. *The Social Construction of American Realism.* Chicago: University of Chicago Press, 1988.

Kaplan, Amy, and Donald E. Pease, eds. *Cultures of United States Imperialism.* Durham, N.C.: Duke University Press, 1993.

Kasson, John. *Rudeness and Civility: Manners in Nineteenth-Century America.* New York: Hill and Wang, 1990.

Katz, Harry, ed. *Cartoon America: Comic Art in the Library of Congress.* New York: Abrams, 2006.

Keil, Charles. "Reframing The Italian: Questions of Audience Address in Early Cinema." *Journal of Film and Video* 42, no. 1 (Spring 1990): 36–48.

Keil, Charlie, and Shelley Stamp, eds. *American Cinema's Transitional Era: Audiences, Institutions, Practices.* Berkeley: University of California Press, 2004.

Keller, Robert H., and Michael F. Turek. *American Indians and National Parks.* Tucson: University of Arizona Press, 1998.

Kelsey, Robin. *Archive Style: Photographs and Illustrations for U.S. Surveys, 1850–1890.* Berkeley: University of California Press, 2007.

Kemp, Martin. *The Science of Art: Optical Themes in Western Art from Brunelleschi to Seurat.* New Haven, Conn.: Yale University Press, 1990.

Keppel, Frederick. *Mr. Pennell's Etchings of New York "Sky Scrapers."* New York: F. Keppel, 1905.

Kern, Stephen. *The Culture of Time and Space, 1880–1918.* Cambridge, Mass.: Harvard University Press, 1983.

Kestner, Joseph. *Mythology and Misogyny: The Social Discourse of Nineteenth-Century British Classical-Subject Painting.* Madison: University of Wisconsin Press, 1989.

Kinsey, Joni Louise. *Thomas Moran and the Surveying of the American West.* Washington, D.C.: Smithsonian Institution Press, 1992.

Kirby, Lynne. *Parallel Tracks: The Railroad and Silent Cinema.* Durham, N.C.: Duke University Press, 1997.

Kolchin, Peter. "Whiteness Studies: The New History of Race in America." *Journal of American History* 89, no. 1 (June 2002): 154–173.

Koszarski, Richard. *An Evening's Entertainment: The Age of the Silent Feature Picture, 1915–1928.* Berkeley: University of California Press, 1990.

Kracauer, Siegfried. *History: The Last Things before the Last.* 1969. Reprint, Princeton, N.J.: Princeton University Press, 1995.

———. "Photography." 1927. Reprint, trans. Thomas Y. Levin, *Critical Inquiry* 19 (Spring 1993): 421–436.

———. *Theory of Film.* New York: Oxford University Press, 1960.

Krauss, Rosalind. *The Originality of the Avant-Garde and Other Modernist Myths.* Cambridge, Mass.: MIT Press, 1995.

———. "Photography's Discursive Spaces: Landscape/View." *Art Journal* (Winter 1982): 311–319.

Krouse, Susan Applegate. "Photographing the Vanishing Race." *Visual Anthropology* 3, nos. 2–3 (1990): 213–233.

LaGumina, Salvatore. *Wop! A Documentary History of Anti-Italian Discrimination in the United States.* New York: Arrow, 1973. Reprint, Toronto: Guernica, 1999.

LaGumina, Salvatore, Frank J. Cavajoli, Salvatore Primeggia, and Joseph A. Varacalli, eds. *The Italian American Experience: An Encyclopedia.* New York: Garland, 2000.

Lamers, Petra. *Il viaggio nel Sud dell'Abbé de Saint-Non: Il "Voyage pittoresque à Naples et en Sicilie"; La genesi, i disegni preparatori, le incisioni.* Naples: Electa Napoli, 1995.

Lasi, Giovanni. "Recapturing Rome." In *1905: La presa di Roma: Alle origini del cinema italiano; Beginning of Italian Cinema,* ed. Michele Canosa, 157–232. Recco and Genoa: Le Mani; Bologna: Cineteca Bologna, 2006.

Lawrence, Robert. *A Rage for Opera: Its Anatomy as Drawn from Life.* New York: Dodd, Mead, 1971.

Le Beau, Bryan F. *Currier & Ives: America Imagined.* Washington, D.C.: Smithsonian Institution Press, 2001.

Lefebvre, Henri. *La production de l'espace.* Paris, Éditions Anthropos, 1974. Reprint in English as *The Production of Space,* trans. Donald Nicholson-Smith (Malden, Mass.: Blackwell, 1991).

Lefebvre, Martin, ed. *Landscape and Film.* New York: Routledge/American Film Institute, 2006.

Levine, Lawrence. *Highbrow/Lowbrow: The Emergence of Cultural Hierarchy in America.* Cambridge, Mass.: Harvard University Press, 1988.

Levine, Philippa. *The Amateur and the Professional: Antiquarians, Historians, and Archaeologists in Victorian England, 1838–1886.* Cambridge: Cambridge University Press, 1986.

Light, Ivan Hubert. *Italians in America: Annotated Guide to New York Times Articles, 1890–1940.* Monticello, Ill.: Council of Planning Libraries, 1975.

Li Gotti, Ettore. *Il teatro dei pupi.* Florence: Sansoni, 1957.

Lindquist-Cock, Elizabeth. *The Influence of Photography on American Landscape Painting, 1839–1880.* New York: Garland, 1977.

Lindsay, Vachel. *The Art of the Moving Picture.* 1915, rev. ed. 1922. Reprint, New York: Liveright, 1970.

Liversidge, Michael, and Jane Farrington, eds. *Canaletto and England.* London: Merrel Holberton with Birmingham Museums & Art Gallery, 1993.

Lo Piparo, Franco. "Sicilia linguistica." In *La Sicilia: Storia d'Italia; Le regioni dall'Unità a oggi,* ed. Maurice Aymard and Giuseppe Giarrizzo, 735–807. Turin: Einaudi, 1987.

Lott, Eric. *Love and Theft: Blackface Minstrelsy and the American Working Class.* New York: Oxford University Press, 1995.

Lubomyr, Wynar R. *Encyclopedic Directory of Ethnic Newspapers and Periodicals in the United States.* Littleton, Colo.: Libraries Unlimited, 1972.

Lubove, Roy. *The Professional Altruist: The Emergence of Social Work as a Career.* Cambridge, Mass.: Harvard University Press, 1965.

———. *The Progressives and the Slums: Tenement House Reform in New York City, 1890–1917.* Pittsburgh, Penn.: University of Pittsburgh Press, 1962.

Lueck, Beth Lynne. *American Writers and the Picturesque Tour: The Search for National Identity, 1790–1860.* New York: Garland, 1997.

Lumley, Robert, and Jonathan Morris, eds. *The New History of the Italian South: The Mezzogiorno Revisited.* Exeter, UK: University of Exeter Press, 1997.

Lupo, Salvatore. *Il giardino degli aranci: Il mondo degli agrumi nella storia del Mezzogiorno.* Venice: Marsilio, 1990.

Lyman, Christopher. *The Vanishing Race and Other Illusions: Photographs of Indians by Edward Curtis.* Washington, D.C.: Smithsonian Institution Press, 1982.

MacCannell, Dean. *The Tourist: A New Theory of the Leisure Class.* New York: Schocken, 1976.

MacKenzie, Scott. "Mimetic Nationhood: Ethnography and the National." In *Cinema and Nation,* ed. Mette Hjort and Scott MacKenzie, 241–259. New York: Routledge, 2000.

Macry, Paolo, and Pasquale Villani, eds. *Storia d'Italia: Le regioni dall'Unità a oggi; La Campania.* Turin: Einaudi, 1990.

Maffioli, Monica. *Il bel vedere: Fotografi e architetti nell'Italia dell'Ottocento.* Turin: Società Editrice Internazionale, 1996.

———, ed. *Fratelli Alinari: Photographers in Florence.* Florence: Alinari, 2003.

Magni, Luigi, and Wladimiro Settimelli. *Roma e il Lazio negli Archivi Alinari.* Florence: Alinari, 1989.

Mahar, Karen Ward. *Women Filmmakers in Early Hollywood.* Baltimore, Md.: Johns Hopkins University Press, 2006.

Maiden, Martin. *A Linguistic History of Italian.* New York: Longman, 1994.

Maiden, Martin, and Mair Parry, eds. *The Dialects of Italy.* New York: Routledge, 1997.

Maillet, Arnauld. *The Claude Glass: Use and Meaning of the Black Mirror in Western Art.* Translated by Jeff Fort. New York: Zone Books, 2004.

Malamud, Margaret. "The Greatest Show on Earth: Roman Entertainments in Turn-of-the-Century New York City." *Journal of Popular Culture* 35, no. 3 (Winter 2001): 43–58.

Maltby, Richard. "The Social Evil, the Moral Order and the Melodramatic Imagination, 1890–1915." In *Melodrama: Stage, Picture, Screen*, ed. Jacky Bratton, Jim Cook, and Christine Gledhill, 214–230. London: British Film Institute, 1994.

Mancini, Franco, and Pietro Gargano. *Nel segno della tradizione: Piedigrotta; I luoghi le feste le canzoni*. Naples: Guida, 1991.

Mangano, Attilio. *Le cause della questione meridionale*. Milan: Istituto Editoriale Internazionale, 1976.

Mangiameli, Rosario. "Banditi e Mafiosi dopo l'Unità." *Meridiana* 7–8 (1990): 73–113.

Mangione, Jerre. *Mount Allegro: A Memoir of Italian American Life*. Boston: Houghton Mifflin, 1942. Reprint, New York: Columbia University Press, 1981.

Mangione, Jerre, and Ben Morreale. *La Storia: Five Centuries of the Italian American Experience, 1492–1992*. New York: HarperCollins, 1992.

Mannheim, Hermann. *Group Problems in Crime and Punishment and Other Studies in Criminology and Criminal Law*. London: Routledge and Kegan Paul, 1955.

Mannoni, Laurent. "Le thème du voyage à travers les plaques de lanterne magique de la Royal Polytechnic." In "Exotica: L'attraction des lointains," special issue of *1895*, numéro hors série (May 1996): 23–52.

Manwaring, Elizabeth Wheeler. *Italian Landscape in Eighteenth-Century England*. New York: Oxford University Press, 1925.

Marazzi, Martino. *Little America: Gli Stati Uniti e gli scrittori italiani del Novecento*. Milan: Marcos y Marcos, 1997.

———. *Misteri di Little Italy: Storie e testi della letteratura italoamericana*. Milan: Franco Angeli, 2001. Reprint in English as *Voices of Italian America: A History of Early Italian American Literature with a Critical Anthology*, trans. Ann Goldstein (Teaneck, N.J.: Fairleigh Dickinson University Press, 2004).

Marcadante, Vito, ed. *Letteratura sulla mafia: Dal sonno alla speranza; Antologia di letteratura sulla mafia*. Palermo: Rinascita siciliana, 1998.

Marchand, Jean-Jacques, ed. *La letteratura dell'emigrazione: Gli Scrittori di lingua italiana nel mondo*. Turin: Fondazione Agnelli, 1991.

Marini, Quinto. *I misteri d'Italia*. Pisa: ETS, 1993.

Marks, Carole. *Farewell—We're Good and Gone: The Great Black Migration*. Bloomington: Indiana University Press, 1989.

Martellone, Anna Maria. *La "questione" dell'immigrazione negli Stati Uniti*. Bologna: Il Mulino, 1980.

———. "'La 'rappresentazione' dell'identità italo-americana: Teatro e feste nelle Little Italy statunitensi." In *La chioma della Vittoria*, ed. Sergio Bertelli, 357–391. Florence: Ponte delle Grazie, 1997.

Martin, Francis John, Jr. "The Image of Black People in American Illustration from 1825 to 1925." Ph.D. diss., University of California, Los Angeles, 1986.

Martin, Robert K., and Leland S. Person. *Roman Holidays: American Writers and Artists in Nineteenth-Century Italy*. Iowa City: University of Iowa Press, 2002.

Martindale, Charles, and Michelle Martindale. *Shakespeare and the Uses of Antiquity: An Introductory Essay*. New York: Routledge, 1990.

Martinelli, Vittorio. "The Evolution of Neapolitan Cinema to 1930." In *Napoletana: Images of a City*, ed. Adriano Aprà, 29–73. New York: MoMA/Bompiani, 1993.

———. "Simm'e Napule e avimma fa' 'o cinema de napulitane!" *Cahiers de la cinématheque* 49 (April 1988): 42–50.

Marx, Karl. *Grundrisse der Kritik der politischen Ökonomie.* East Berlin: Dietz, 1953. Reprint in English as *Foundations of the Critique of Political Economy (Rough Draft),* trans. Martin Nicolaus (London: Penguin, 1973), another reprint 1993.

Marx, Leo. Foreword to *Views of American Landscapes,* ed. Mick Gidley and Robert Lawson-Peebles, xv–xxii. New York: Cambridge University Press, 1989.

———. *The Machine in the Garden: Technology and the Pastoral Ideal in America.* New York: Oxford University Press, 1964.

Marzio, Peter C. *The Democratic Art: Pictures for Nineteenth-Century America; Chromolithography, 1840–1900.* Boston: Godine, 1979.

Masi, Stefano, and Mario Franco. *Il mare, la luna, i coltelli: Per una storia del cinema muto napoletano.* Naples: Tullio Pironti Editore, 1988.

Massara, Giuseppe. *Americani.* Palermo: Sellerio, 1984.

Massarese, Ettore. "La memoria di 'Assunta Spina.'" *Cinegrafie,* no. 6 (1993): 109–113.

Mast, Gerald, and Marshall Cohen, eds. *Film Theory and Criticism: Introductory Readings.* New York: Oxford University Press, 1979.

Matheson, C. S., ed. *Enchanting Ruin: Tintern Abbey and Romantic Tourism in Wales.* Exhibition catalog. Ann Arbor: University of Michigan, Special Collection Library, 2008.

Mathews, Nancy Mowll, with Charles Musser, eds. *Moving Pictures: American Art and Early Film, 1880–1910.* Manchester, Vt.: Hudson Hills, 2005.

Maxwell, Anne. *Picture Imperfect: Photography and Eugenics, 1870–1940.* Brighton, UK: Sussex Academic Press, 2008.

May, Lary. *Screening Out the Past: The Birth of Mass Culture and the Motion Picture Industry.* Chicago: University of Chicago Press, 1980.

Mayer, David. "Acting in Silent Film: Which Legacy of the Theatre." In *Screen Acting,* ed. Alan Lovell and Peter Krämer, 10–30. London: Routledge, 1999.

———. "Opening a Second Front: The Civil War, the Stage, and D. W. Griffith." In *The Tenth Muse: Cinema and the Other Arts,* ed. Leonardo Quaresima and Laura Vichi, 491–502. Udine: Forum, 2001.

———. *Playing Out the Empire: Ben Hur and Other Toga Plays and Films, 1883–1908; A Critical Anthology.* Oxford: Clarendon, 1994.

Mayer, Grace M. *Once upon a City.* New York: Macmillan/Museum of the City of New York, 1958.

Mayne, Judith. *Cinema and Spectatorship.* London: Routledge, 1993.

———. "Immigrants and Spectators." *Wide Angle* 5, no. 2 (Summer 1982): 32–40.

———. *Private Novels, Public Films.* Athens: University of Georgia Press, 1988.

———. *The Woman at the Keyhole.* Bloomington: Indiana University Press, 1990.

McConachie, Bruce A. *Melodramatic Formations: American Theatre and Society, 1820–1870.* Iowa City: University of Iowa Press, 1992.

McDonnell, Patricia, ed. *On the Edge of Your Seat: Popular Theater and Film in Early Twentieth-Century American Art.* New Haven, Conn.: Yale University Press, 2002.

McKinsey, Elizabeth. *Niagara Falls: Icon of the American Sublime.* Cambridge: Cambridge University Press, 1985.

McLuhan, T. C. *Dream Tracks: The Railroad and the American Indian, 1890–1930.* New York: Abrams, 1985.

McNamara, Brooks. "The Scenography of Popular Entertainments." *Drama Review* 18, no. 1 (March 1974): 16–24.

Meisel, Martin. *Realizations: Narrative, Pictorial, and Theatrical Arts in Nineteenth-Century England*. Princeton, N.J.: Princeton University Press, 1987.

Merritt, Russell. "Nickelodeon Theatres, 1905–1914: Building an Audience for the Movies." In *The American Film Industry*, ed. Tino Balio, 59–79. Madison: University of Wisconsin Press, 1976.

Metz, Christian. *Film Language: A Semiotics of the Cinema*. Translated by Michael Taylor. New York: Oxford University Press, 1974.

Michelson, Annette, ed. *Kino-Eye: The Writings of Dziga Vertov*. Berkeley: University of California Press, 1984.

Milani, Raffaele. *Il pittoresco: L'evoluzione del gusto tra classico e romantico*. Rome and Bari: Laterza, 1997.

Miller, Angela. "The Panorama, the Cinema, and the Emergence of the Spectacular." *Wide Angle* 18, vol. 2 (April 1996): 34–69.

Miller, Francis Trevelyn, ed. *Photographic History of the Civil War*. 10 vols. New York: Review of Reviews, 1911.

Mingozzi, Gianfranco, ed. *Francesca Bertini*. Genoa: Le Mani; Bologna: Cineteca di Bologna, 2003.

Miraglia, Marina. "Cesare Vasari e il genere nella fotografia napoletana dell'Ottocento." *Bollettino d'Arte* 70, nos. 33–34 (1985): 199–208.

———. "Giorgio Sommer, un tedesco in Italia." In *Un viaggio fra mito e realtà: Giorgio Sommer, fotografo in Italia, 1857–1891*, ed. Marina Miraglia and Ulrich Pohlmann, 11–32. Rome: Carte Segrete, 1992.

———. "Note per una storia della fotografia italiana (1839–1911)." In *Storia dell'arte Italiana Einaudi*, part 3, vol. 2, bk 2:423–543. Turin: Einaudi, 1981.

Miraglia, Marina, and Ulrich Pohlmann, eds. *Un viaggio fra mito e realtà: Giorgio Sommer, fotografo in Italia, 1857–1891*. Rome: Carte Segrete, 1992.

Mirisola, Vincenzo, and Michele Di Dio. *Sicilia Ottocento: Fotografi e Grand Tour*. Palermo: Gente di Fotografia, 2002.

Mirisola, Vincenzo, and Giuseppe Vanzella. *Fotografi a Palermo, 1865–1900*. Palermo: Gente di Fotografia, 2001.

Mitchell, Timothy. *Art and Science in German Landscape Painting, 1770–1840*. Oxford: Clarendon, 1993.

Mitchell, W. J. T., ed. *Landscape and Power*. Chicago: University of Chicago Press, 1994.

Miyao, Daisuke. *Sessue Hayakawa: Silent Cinema and Transnational Stardom*. Durham, N.C.: Duke University Press, 2007.

Modleski, Tania, ed. *Studies in Entertainment: Critical Approaches to Mass Culture*. Bloomington.: Indiana University Press, 1986.

Moe, Nelson. "'Altro che Italia!' Il Sud dei piemontesi (1860–1861)." *Meridiana*, no. 15 (1992): 53–89.

———. *The View from Vesuvius: Italian Culture and the Southern Question*. Berkeley: University of California Press, 2002.

Mohl, Raymond. *The New City: Urban America in the Industrial Age, 1860–1920*. Arlington Heights, Ill.: H. Davidson, 1985.

Molfese, Franco. *Storia del brigantaggio dopo l'Unità*. Milan: Feltrinelli, 1964.

Mondenard, Anne de. *La mission héliographique: Cinq photographes parcourent la France en 1851*. Paris: Patrimoine—Monum, 2001.

Moretti, Franco. *Atlas of the European Novel, 1800–1900*. 1997. London: Verso, 1998.

Morey, Anne. *Hollywood Outsiders: The Adaptation of the Film Industry, 1913–1934*. Minneapolis: University of Minnesota Press, 2003.

Mormino, Gary R., and George Pozzetta. *The Immigrant World of Ybor City*. Urbana: University of Illinois Press, 1987.

Morosco, Helen M., and Leonard Paul Dugger. *Life of Oliver Morosco: The Oracle of Broadway, Written from His Own Notes and Comments*. Caldwell, Ohio: Caxton Printers, 1944.

Mostra Internazionale del Nuovo Cinema. *Tra una film e l'altra: Materiali sul cinema muto italiano, 1907–1920*. Venice: Marsilio Editori, 1980.

Mottet, Jean. *L'invention de la scène américaine: Cinéma et paysage*. Paris: L'Harmattan, 1998.

———. "Toward a Genealogy of the American Landscape: Notes on Landscapes in D. W. Griffith (1908–1912)." In *Landscape and Film*, ed. Martin Lefebvre, 61–90. AFI Film Readers. New York: Routledge, 2006.

Mozzillo, Atanasio. "Le ragioni dell'immaginario: Mito e percezione della realtà nei viaggiatori tra Cinquecento e Settecento." In *La Sicilia dei grandi viaggiatori*, ed. Franco Paloscia, 1–79. Rome: Edizioni Abete, 1988.

Muscio, Giuliana. "Girls, Ladies, Stars: Stars and Women Screenwriters in Twenties America." *Cinegrafie* 13 (2000): 177–220.

———. *Piccole Italie, grandi schermi: Scambi cinematografici tra Italia e Stati Uniti, 1895–1945*. Rome: Bulzoni, 2004.

Musser, Charles. *Before the Nickelodeon: Edwin S. Porter and the Edison Manufacturing Company*. Berkeley: University of California Press, 1991.

———. "Before the Rapid Firing Kinetograph: Edison Film Production, Representation and Exploitation in the 1890s." In *Edison Motion Pictures, 1890–1900: An Annotated Filmography* (Gemona: Le Giornate del Cinema Muto; Washington, D.C.: Smithsonian Institution Press, 1997), 19–50.

———. "A Cinema of Contemplation, a Cinema of Discernment: Spectatorship, Intertextuality and Attractions in the 1890s." In *The Cinema of Attractions Reloaded*, ed. Wanda Strauven, 159–179. Amsterdam: Amsterdam University Press, 2006.

———, ed. *Edison Motion Pictures, 1890–1900: An Annotated Filmography*. Gemona: Le Giornate del Cinema Muto; Washington, D.C.: Smithsonian Institution Press, 1997.

———. *The Emergence of Cinema: The American Screen to 1907*. New York: Scribner, 1990.

———. "Ethnicity, Role-Playing, and American Film Comedy: From *Chinese Laundry Scene* to *Whoopee*, 1894–1930." In *Unspeakable Images: Ethnicity and the American Cinema*, ed. Lester D. Friedman, 39–81. Urbana and Chicago: University of Illinois Press, 1991.

———. "Nationalism and the Beginnings of Cinema: The Lumière Cinématographe in the U.S., 1896–1897." *Historical Journal of Film, Radio and Television* 19, no. 2 (1999): 149–176.

———. "The Travel Genre in 1903–1904: Moving toward Fictional Narrative." In *Early Cinema: Space, Frame, Narrative*, ed. Thomas Elsaesser, 123–132. London: British Film Institute Publishing, 1990.

Musser, Charles, with Carol Nelson. *High-Class Moving Pictures: Lyman H. Howe and the Forgotten Era of Traveling Exhibition, 1880–1920*. Princeton, N.J.: Princeton University Press, 1991.

Naef, Weston J., and James N. Wood. *Era of Exploration: The Rise of Landscape Photography in the American West, 1860–1885*. Buffalo, N.Y.: Albright-Knox Art Gallery, 1975.

Nasaw, David. *Going Out: The Rise and Fall of Public Amusements*. New York: Basic Books, 1993.

Nash, Roderick. *Wilderness and the American Mind*. 1967. Rev. ed. New Haven, Conn.: Yale University Press, 1973.

Negra, Diane. *Off-White Hollywood: American Culture and Ethnic Female Stardom*. New York: Routledge, 2001.

Nelli, Humbert S. *The Business of Crime: Italians and Syndicated Crime in the United States.* Chicago: University of Chicago Press, 1976.

———. "Italians and Crime in Chicago: The Formative Years, 1890–1920." *American Journal of Sociology* 74, no. 4 (January 1969): 373–391.

Nettels, Elsa. *Language, Race, and Social Class in Howells's America.* Lexington: University Press of Kentucky, 1988.

Nevius, Blake. *Cooper's Landscapes: An Essay on the Picturesque Vision.* Berkeley: University of California Press, 1976.

Niver, Kemp R., ed. *Biograph Bulletins, 1896–1908.* Los Angeles: Locare Research Group, 1971.

———. *Motion Pictures from the Library of Congress: Paper Print Collection, 1894–1912.* Berkeley: University of California Press, 1967.

Nochlin, Linda. *The Politics of Vision: Essays on Nineteenth-Century Art and Society.* New York: Harper and Row, 1989.

Novak, Barbara. *Nature and Culture: American Landscape and Painting, 1825–1875.* 1980. 3rd ed., New York: Oxford University Press, 2007.

Novak, Michael. *The Rise of the Unmeltable Ethnics: The New Political Force of the Seventies.* New York: Macmillan, 1971.

Nygren, Edward J., ed. *Views and Visions: American Landscape before 1830.* Washington, D.C.: Corcoran Gallery of Art, 1986.

O'Connor, Maura. *The Romance of Italy and the English Political Imagination.* New York: St. Martin's Press, 1998.

Odell, George Clinton Densmore, ed. *Annals of the New York Stage.* 15 vols. New York: Columbia University Press, 1927–49. Reprint, New York: AMS Press, 1970.

Olmsted, Frederick Law, and Theodora Kimball, eds. *Frederick Law Olmsted: Landscape Architect, 1822–1903.* 2 vols. New York: Putnam's, 1922–28.

Orsi, Robert Anthony. "The Religious Boundaries of an Inbetween People: Street 'Feste' and the Problem of the Dark-Skinned Other in Italian Harlem, 1920–1990." *American Quarterly* 44, no. 3 (September 1992): 313–347.

Orvell, Miles. *The Real Thing: Imitation and Authenticity in American Culture, 1880–1940.* Chapel Hill: University of North Carolina Press, 1989.

Ostroff, Eugene. *Western Views and Eastern Visions.* Washington, D.C.: Smithsonian Institution Traveling Exhibition Service, 1981.

Pagano, Denise Maria, ed. *C'era una volta Napoli: Itinerari meravigliosi nelle gouaches del Sette e Ottocento.* Naples: Electa, 2002.

Palazzoli, Daniela, ed. *Giorgio Sommer, fotografo a Napoli.* Milan: Electa, 1981.

Paliotti, Vittorio, and Enzo Grano. *Napoli nel cinema.* Naples: Azienda Autonoma Soggiorno Cura e Turismo, 1969.

Palmquist, Peter E. *Carleton E. Watkins, Photographer of the American West.* Albuquerque: University of New Mexico Press, 1983.

Paloscia, Franco, ed. *La Sicilia dei grandi viaggiatori.* Rome: Edizioni Abete, 1988.

Panofsky, Erwin. "Style and Medium in the Motion Pictures." 1934. Reprint in *Film Theory and Criticism: Introductory Readings,* ed. Gerald Mast and Marshall Cohen (New York: Oxford University Press, 1979), 243–263.

Parisi, Pasquale. *Roberto Bracco: La sua vita, la sua arte, i suoi critici.* Palermo: Sandron, 1923.

Park, Robert E. "The City: Suggestions for the Investigation of Human Behavior in the City Environment." *American Journal of Sociology* 20, no. 5 (March 1915): 577–612. Reprint with revisions in *The City: Suggestions for the Study of Human Nature in the Urban Environment,*

by Robert E. Park, Ernest Watson Burgess, and Roderick Duncan McKenzie (Chicago: University of Chicago Press, 1925), 1–46.

———. *The Immigrant Press and Its Control*. New York: Harper & Brothers, 1922.

Passione, Roberta. "Il Sud di Cesare Lombroso tra scienze e politica." *Il Risorgimento* 52, no. 1 (2000): 133–154.

Pearson, Roberta. *Eloquent Gestures: The Transformation of Performance Style in the Griffith Biograph Films*. Berkeley: University of California Press, 1992.

Peiss, Kathy. *Cheap Amusements: Working Women and Leisure Time in Turn-of-the-Century New York*. Philadelphia: Temple University Press, 1986.

Pennacchia, Giuseppe. *L'Italia dei briganti*. Rome: Rendina, 1998.

Petacco, Arrigo. *Joe Petrosino*. Milan: Mondadori, 1972. Reprint in English, trans. Charles Lam Markmann, New York: Macmillan, 1974.

Peterson, Jennifer Lynn. "'The Nation's First Playground': Travel Films and the American West, 1895–1920." In *Virtual Voyages: Cinema and Travel*, ed. Jeffrey Ruoff, 79–98. Durham, N.C.: Duke University Press, 2006.

———. "World Pictures: Travelogue Films and the Lure of the Exotic, 1890–1920." Ph.D. diss., University of Chicago, 1999.

Pick, Daniel. *Faces of Degeneration: A European Disorder, c. 1848–c. 1918*. New York: Cambridge University Press, 1989.

Picone Petrusa, Mariantonietta. "Linguaggio fotografico e 'generi' pittorici," In *Immagine e città: Napoli nelle collezioni Alinari e nei fotografi napoletani fra ottocento e novecento*, ed. Mariantonietta Picone Petrusa and Daniela Del Pesco, 21–63. Naples: Macchiaroli, 1981.

Picone Petrusa, Mariantonietta, and Daniela Del Pesco, eds. *Immagine e città: Napoli nelle collezioni Alinari e nei fotografi napoletani fra ottocento e novecento*. Naples: Macchiaroli, 1981.

Pitkin, Thomas Monroe, and Francesco Cordasco. *The Black Hand: A Chapter in Ethnic Crime*. Totowa, N.J.: Rowman and Littlefield, 1977.

Pitrè, Giuseppe. *Usi e costumi, credenze e pregiudizi del popolo siciliano*. 4 vols. Palermo: Clausen, 1889.

Porter, Laraine, and Bryony Dixon, eds. *Picture Perfect: Landscape, Place and Travel in British Cinema before 1930*. Exeter, UK: Exeter Press, 2007.

Possenti, Eligio. "Mimì Aguglia." In *Le Muse: Enciclopedia di tutte le arti*, vol. 1 (Novara: De Agostini, 1964), 84.

Pozzetta, George E. "Another Look at the Petrosino Affair." *Italian Americana* 1 (Fall 1974): 81–92.

———. "The Italian Immigrant Press of New York City: The Early Years, 1880–1915." *Journal of Ethnic Studies* 1 (Fall 1973): 32–46.

Prats, Armando José. *Invisible Natives: Myth and Identity in the American Western*. Ithaca, N.Y., and London: Cornell University Press, 2002.

Pratt, Mary Louise. *Imperial Eyes: Travel Writing and Transculturation*. London: Routledge, 1992.

Prolo, Maria Adriana. "Francesi nel cinema italiano muto." *Bianco e Nero* 14, nos. 8–9 (1953): 69–74.

———. *Storia del cinema muto italiano*. Milan: Poligono, 1951.

Prosperi, Adriano. "'Otras Indias': Missionari della Controriforma tra contadini e selvaggi." In *Scienze, credenze occulte, livelli di cultura*, Istituto nazionale di studi sul Rinascimento, 205–234. Florence: Olschki, 1982.

Puccini, Sandra, ed. *L'uomo e gli uomini: Scritti di antropologi italiani dell'Ottocento*. Rome: CISU, 1991.

Pugh, Simon, ed. *Reading Landscape: Country-City-Capital.* Manchester: Manchester University Press, 1990.

Quaresima, Leonardo, and Laura Vichi, eds. *The Tenth Muse: Cinema and Other Arts.* Udine: Forum, 2001.

Quargnolo, Mario. "Bracco e il cinema: Primo e secondo tempo." *Immagine,* n.s. no. 4 (Winter 1986–87): 25–29.

Quinn, Michael. "Distribution, the Transient Audience, and the Transition to the Feature Film." *Cinema Journal,* 40, no. 2 (Winter 2001): 35–56.

Quintavalle, Arturo Carlo. *Gli Alinari.* Florence: Alinari, 2003.

Rabinovitz, Lauren. *For the Love of Pleasure: Women, Movies, and Culture in Turn-of-the-Century Chicago.* New Brunswick, N.J.: Rutgers University Press, 1998.

Raffaelli, Sergio. *Cinema, film, regia: Saggi per una storia linguistica del cinema italiano.* Rome: Bulzoni, 1978.

———. *Lingua filmata: Didascalie e dialoghi nel cinema italiano.* Florence: Le Lettere, 1992.

Ragone, Giovanni. *Un secolo di libri: Storia dell'editoria in Italia dall'unità al post-moderno.* Turin: Einaudi, 1999.

Rainero, Sandra. "Farfariello e gli altri: Inediti di Eduardo Migliaccio." *Forum Italicum* 32, no. 1 (Spring 1998): 196–209.

Rainey, Sue. *Creating "Picturesque America": Monument to the Natural and Cultural Landscape.* Nashville, Tenn.: Vanderbilt University Press, 1994.

Ramsaye, Terry. *A Million and One Nights: A History of the Motion Picture.* New York: Simon and Schuster, 1926.

Raya, Gino. *Verga e il cinema.* Rome: Herder Editore, 1984.

Redi, Riccardo. *Cinema muto italiano, 1896–1930.* Rome: Biblioteca di Bianco & Nero, 1999.

———, ed. *Cinema Scritto: Il catalogo delle riviste italiane di cinema, 1907–1944.* Rome: Associazione italiana per le ricerche di storia del cinema, 1992.

Reim, Riccardo, ed. *L'Italia dei misteri: Storie di vita e malavita nei romanzi d'appendice.* Rome: Editori Riuniti, 1989.

Reinhold, Meyer. *Classica Americana: The Greek and Roman Heritage in the United States.* Detroit, Mich.: Wayne State University Press, 1984.

Ricciardi, Guglielmo. *Ricciardiana: Raccolta di scritti, racconti, memorie, ecc., del veterano attore e scrittore.* New York: Eloquent Press, 1955.

Richard, Carl J. *The Founders and the Classics: Greece, Rome, and the American Enlightenment.* Cambridge, Mass.: Harvard University Press, 1994.

Robinson, Sidney K. *Inquiry into the Picturesque.* Chicago: University of Chicago Press, 1991.

Rodgers, Daniel T. *Atlantic Crossings: Social Politics in a Progressive Age.* Cambridge, Mass.: Belknap, 1998.

Rodowick, D. N. *The Virtual Life of Film.* Cambridge, Mass.: Harvard University Press, 2007.

Roediger, David. *Towards the Abolition of Whiteness: Essays on Race, Politics, and Working-Class History.* London: Verso, 1994.

———. *The Wages of Whiteness: Race and the Making of the American Working Class.* London: Verso, 1991.

———. *Working toward Whiteness: How America's Immigrants Became White; The Strange Journey from Ellis Island to the Suburbs.* New York: Basic Books, 2005.

Rogin, Michael. *Blackface, White Noise: Jewish Immigrants in the Hollywood Melting Pot.* Berkeley: University of California Press, 1998.

———. "'The Sword Became a Flashing Vision': D. W. Griffith's *The Birth of a Nation.*" *Representations* 9 (Winter 1985): 150–195. Reprint in *The Birth of a Nation: D. W. Griffith, Director*, ed. Robert Lang (New Brunswick, N.J.: Rutgers University Press, 1994), 250–293.

Romeo, Rosario. *Risorgimento e capitalismo.* Bari: Laterza, 1959.

Romeyn, Esther. "Juggling Italian-American Identities: Farfariello, King of the Character Clowns." *Italian American Review* 9, no. 2 (Fall–Winter 2002): 95–128.

———. "Worlds in between Worlds: Italian-Americans and Farfariello, Their Comic Double." Ph.D. diss., University of Minnesota, 1990.

Rondini, Andrea. *Cose da pazzi: Cesare Lombroso e la letteratura.* Pisa: Istituti editoriali e poligrafici internazionali, 2001.

Rony, Fatimah Tobing. *The Third Eye: Race, Cinema, and Ethnographic Spectacle.* Durham, N.C.: Duke University Press, 1996.

Rose, Gillian. *Feminism and Geography: The Limits of Geographical Knowledge.* Minneapolis: University of Minnesota Press, 1993.

Rosen, Philip. *Change Mummified: Cinema, Historicity, Theory.* Minneapolis: University of Minnesota Press, 2001.

Rosenfeld, Lulla. *Bright Star of Exile: Jacob Adler and the Yiddish Theater.* New York: Thomas Y. Crowell, 1977.

Rosenthal, Michael, Christiana Payne, and Scott Wilcox, eds. *Prospects for the Nation: Recent Essays in British Landscape, 1750–1880.* London: Yale University Press, 1997.

Rosenzweig, Roy. *Eight Hours for What We Will: Workers and Leisure in an Industrial City, 1870–1920.* New York: Cambridge University Press, 1983.

Rosenzweig, Roy, and Elizabeth Blackmar. *The Park and the People: A History of Central Park.* Ithaca, N.Y.: Cornell University Press, 1992.

Rosoli, Gian Fausto. "Chiesa e comunità italiane negli Stati Uniti (1880–1940)." *Studium* 75 (January–February 1979): 25–47.

———. "L'emigrazione italiana negli Stati Uniti: Un bilancio storiografico." *Affari Sociali Internazionali*, no. 6 (1978): 75–103.

Ross, Dorothy. *The Origins of American Social Science.* Cambridge: Cambridge University Press, 1991.

Ross, Kristin. *The Emergence of Social Space: Rimbaud and the Paris Commune.* Minneapolis: University of Minnesota Press, 1988.

Ross, Stephen J. *Working-Class Hollywood: Silent Film and the Shaping of Class in America.* Princeton, N.J.: Princeton University Press, 1998.

Rotha, Paul. *The Film till Now: A Survey of World Cinema.* New York: Funk & Wagnalls, 1949.

Ruoff, Jeffrey, ed. *Virtual Voyages: Cinema and Travel.* Durham, N.C.: Duke University Press, 2006.

Russell, Catherine. "Beyond Authenticity: The Discourse of Tourism in Ethnographic and Experimental Film." *Visual Anthropology* 5 (1992): 131–145.

Russo, John Paul. "From Italophilia to Italophobia: Representations of Italian Americans in the Early Gilded Age." *Differentia* 6–7 (Spring–Autumn 1994): 45–75.

Russo, Pietro. *Catalogo collettivo della stampa periodica italo-americana (1836–1980).* Rome: CSER, 1983.

Said, Edward W. *Culture and Imperialism.* New York: Knopf, 1993.

———. *Orientalism.* New York: Vintage, 1978.

Salvadori, Massimo L. *Il mito del buongoverno: La questione meridionale da Cavour a Gramsci.* Turin: Einaudi, 1960.

Schein, Richard H., ed. *Landscape and Race in the United States.* New York: Routledge, 2006.

Schickel, Richard. *D. W. Griffith: An American Life.* New York: Simon and Schuster, 1984.

Schiller, Dan. "Realism, Photography and Journalistic Objectivity in Nineteenth-Century America." *Studies in the Anthropology of Visual Communication* 4, no. 2 (Winter 1977): 86–98.

Schlitzer, Franco, ed. *Salvatore Di Giacomo: Ricerche e note bibliografiche.* Edited after Schlitzer's death by Gino Doria and Cecilia Ricottini. Florence: Sansoni, 1966.

Schneider, Jane, ed. *Italy's "Southern Question": Orientalism in One Country.* Oxford and New York: Berg, 1998.

Schneirov, Matthew. *The Dream of a New Social Order: Popular Magazines in America, 1893–1914.* New York: Columbia University Press, 1994.

Schwartz, Joan M., and James R. Ryan, eds. *Picturing Place: Photography and the Geographical Imagination.* London: I. B. Tauris, 2003.

Sekula, Allan. "The Body in the Archive." *October* 39 (Winter 1986): 3–64.

———. "On the Invention of Photographic Meaning." *Artforum* 13 (January 1975): 37–45. Reprint in *Thinking Photography,* ed. Victor Burgin (London: Macmillan, 1982), 84–109.

Sellors, C. Paul. "Representing Fictions in Film." Ph.D. diss., New York University, 2002.

Settimelli, Wladimiro, and Filippo Zevi, eds. *Gli Alinari, fotografi a Firenze, 1852–1920.* Florence: Alinari, 1985.

Shaffer, Marguerite. *See America First: Tourism and National Identity, 1905–1930.* Washington, D.C.: Smithsonian Institution Press, 2001.

Shankman, Arnold. "The Image of the Italian in the Afro-American Press, 1886–1936." *Italian Americana* 4, no. 1 (Fall–Winter 1978): 30–49.

———. "This Menacing Influx: Afro-Americans on Italian Immigration to the South, 1880–1915." *Mississippi Quarterly* 31, no. 1 (Winter 1977–78): 67–88.

Sharf, Aaron. *Art and Photography.* London: Penguin, 1968.

Sheldon, James L., and Jock Reynolds. *Motion and Document, Sequence and Time: Eadweard Muybridge and Contemporary American Photography.* Andover, Mass.: Addison Gallery of American Art, 1991.

Shiel, Mark. *Screening the City.* London: Verso, 2003.

Shiel, Mark, and Tony Fitzmaurice, eds. *Cinema and the City: Film and Urban Societies in a Global Context.* Malden, Mass.: Blackwell, 2001.

Shohat, Ella, and Robert Stam. *Unthinking Eurocentrism: Multiculturalism and the Media.* London and New York: Routledge, 1994.

Shull, Michael S. *Radicalism in American Silent Films, 1909–1929: A Filmography and History.* Jefferson, N.C.: McFarland, 2000.

———. "Silent Agitators: Militant Labor in the Movies, 1909–1919." *Labor's Heritage* 9, no. 3 (Winter 1998): 58–77.

———. "Tinted Shades of Red: The Popular American Cinematic Treatment of Militant Labor, Domestic Radicalism and Russian Revolutionaries, 1909–1929." Ph.D. diss., University of Maryland, 1994.

Shurtleff, Harold R. *The Log Cabin Myth: A Study of the Early Dwellings of the English Colonists in North America.* Cambridge, Mass.: Harvard University Press, 1939.

Silber, Nina. *The Romance of Reunion: Northerners and the South, 1865–1900.* Chapel Hill: University of North Carolina Press, 1993.

Simmel, George. "The Metropolis and Mental Life." In *The Sociology of Georg Simmel,* ed. and trans. Kurt Wolff, 409–424. New York: Free Press, 1950.

Simmon, Scott. *The Films of D. W. Griffith.* New York: Cambridge University Press, 1993.

———. *The Invention of the Western Film: A Cultural History of the Genre's First Half-Century.* New York: Cambridge University Press, 2003.

Singer, Ben. "Manhattan Melodrama." *Cinema Journal* 36, no. 4 (Summer 1997): 107–112.

———. "Manhattan Nickelodeons: New Data on Audiences and Exhibitors." *Cinema Journal* 34, no. 3 (1995): 5–35.

———. *Melodrama and Modernity: Early Sensational Cinema and Its Contexts.* New York: Columbia University Press, 2001.

———. "New York, Just Like I Pictured It . . ." *Cinema Journal* 35, no. 3 (Spring 1996): 104–128.

Siragusa, Mario. *Baroni e briganti: Classi dirigenti e mafia nella Sicilia del latifondo, 1861–1950.* Milan: Franco Angeli, 2004.

Sklar, Robert. *Movie-Made America: A Social History of American Movies.* New York: Random House, 1975. Revised and updated as *Movie-Made America: A Cultural History of American Movies* (New York: Vintage, 1994).

———. "Oh Althusser! Historiography and the Rise of Cinema Studies." *Radical History Review* 41 (Spring 1988): 10–35. Reprint in *Resisting Images: Essays on Cinema and History,* ed. Robert Sklar and Charles Musser (Philadelphia: Temple University Press, 1990), 12–35.

———. *The Plastic Age, 1917–1930.* New York: George Braziller, 1970.

Sklar, Robert, and Charles Musser, eds. *Resisting Images: Essays on Cinema and History.* Philadelphia: Temple University Press, 1990.

Slide, Anthony. *The Big V: A History of the Vitagraph Company.* Metuchen, N.J.: Scarecrow, 1987.

———. *The Encyclopedia of Vaudeville.* Westport, Conn.: Greenwood, 1994.

Slotkin, Richard. *Gunfighter Nation: The Myth of the Frontier in Twentieth-Century America.* 1992. Reprint, Norman: Oklahoma University Press, 1998.

Smith, Andrew Brodie. *Shooting Cowboys and Indians: Silent Western Films, American Culture, and the Birth of Hollywood.* Boulder: University of Colorado Press, 2003.

Smith, Shawn Michelle. *Photography on the Color Line: W. E. B. Du Bois, Race, and Visual Culture.* Durham, N.C.: Duke University Press, 2004.

Snyder, Joel. *American Frontiers: The Photographs of Timothy H. O'Sullivan, 1867–1874.* Millerton, N.Y.: Aperture, 1981.

Snyder, Joel, and Neil Walsh Allen. "Photography, Vision, and Representation." *Critical Inquiry* 2, no. 1 (Autumn 1975): 143–169.

Snyder, Robert W. *The Voice of the City: Vaudeville and Popular Culture in New York.* New York: Oxford University Press, 1989.

Sogliuzzo, A. Richard. "Notes for a History of the Italian-American Theatre of New York." *Theatre Survey* 14, no. 3 (1973): 61–66.

Sollors, Werner. *Beyond Ethnicity: Consent and Descent in American Culture.* New York: Oxford University Press, 1986.

———, ed. *The Invention of Ethnicity.* New York: Oxford University Press, 1989.

———, ed. *Multilingual America: Transnationalism, Ethnicity, and the Languages of American Literature.* New York: New York University Press, 1998.

Sollors, Werner, and Marc Shell, eds. *The Multilingual Anthology of American Literature.* New York: New York University Press, 2000.

Sommaiolo, Paolo. *Il café chantant: Artisti e ribalte nella Napoli belle époque.* Naples: Tempo Lungo, 1998.

Sontag, Susan. *The Volcano Lover: A Romance*. New York: Farrar, Straus and Giroux, 1992.

Spence, Mark David. *Dispossessing the Wilderness: Indian Removal and the Making of the National Parks*. New York: Oxford University Press, 1999.

Spini, Giorgio, et al., eds. *Italia e America dal Settecento all'Età dell'Imperialismo*. Venice: Marsilio, 1976.

Staiger, Janet. *Bad Women: Regulating Sexuality in Early American Cinema*. Minneapolis: University of Minnesota Press, 1995.

———. "Class, Ethnicity, and Gender: Explaining the Development of Early American Film Narrative." *Iris* 11 (1990): 13–26.

———. *Interpreting Films: Studies in the Historical Reception of American Cinema*. Princeton, N.J.: Princeton University Press, 1992.

Stamp, Shelley. *Movie-Struck Girls: Women and Motion Picture Culture after the Nickelodeon*. Princeton, N.J.: Princeton University Press, 2000.

Stange, Maren. *Symbols of Ideal Life: Social Documentary Photography in America, 1890–1950*. New York: Cambridge University Press, 1989.

Stazio, Marialuisa. *Osolemio: La canzone napoletana, 1880–1914*. Rome: Bulzoni, 1991.

Stebbins, Theodore E., Jr. *The Lure of Italy: American Artists and the Italian Experience, 1760–1910*. Boston: Museum of Fine Arts; New York: Harry N. Abrams, 1992.

Stein, Richard L. "Street Figures in Victorian Urban Iconography." In *Victorian Literature and the Victorian Visual Imagination*, ed. Carol T. Christ and John O. Jordan, 233–262. Berkeley: University of California Press, 1995.

Steinmetz, George. "Decolonizing German Theory: An Introduction." *Postcolonial Studies* 9, no. 1 (2006): 3–13.

Steinorth, Karl, ed. *Lewis Hine: Passionate Journey; Photographs, 1905–1937*. Zurich: Edition Stemmle, 1996.

Stendhal. *Memoirs of a Tourist*. 1838. Trans. Allan Seager. Evanston, Ill.: Northwestern University Press, 1961.

Stern, Madeleine B. *Heads and Headlines: The Phrenological Fowlers*. Norman: Oklahoma University Press, 1971.

Stewart, Jacqueline Najuma. *Migrating to the Movies: Cinema and Black Urban Modernity*. Berkeley: University of California Press, 2005.

Stilgoe, John R. *Common Landscape of America, 1580–1845*. New Haven, Conn.: Yale University Press, 1982.

———. *Metropolitan Corridor: Railroads and the American Scene*. New Haven, Conn.: Yale University Press, 1983.

Stocking, G. W. "The Turn-of-the-Century Concept of Race." *Modernism/Modernity* 1, no. 1 (1994): 4–16.

Stokes, Melvyn. *D. W. Griffith's "The Birth of a Nation": A History of the Most Controversial Motion Picture of All Time*. New York: Oxford University Press, 2007.

Stokes, Melvyn, and Richard Maltby, eds. *American Movie Audiences: From the Turn of the Century to the Early Sound Era*. London: British Film Institute, 1999.

Strauven, Wanda. *The Cinema of Attractions Reloaded*. Amsterdam: Amsterdam University Press, 2006.

Streeby, Shelley. *American Sensations: Class, Empire, and the Production of Popular Culture*. Berkeley: University of California Press, 2002.

Studlar, Gaylyn. *This Mad Masquerade: Stardom and Masculinity in the Jazz Age*. New York: Columbia University Press, 1996.

Suleri, Sara. *The Rhetoric of English India*. Chicago: University of Chicago Press, 1992.

Susinno, Stefano. *La veduta nella pittura italiana.* Florence: Sansoni, 1974.

Sutton, Peter C., ed. *Masters of 17th-Century Dutch Landscape Painting.* Amsterdam: Rijksmuseum, 1987.

SVIMEZ (Associazione per lo sviluppo dell'industria nel Mezzogiorno). *Un secolo di statistiche italiane: Nord e sud, 1861–1961.* Rome: 1961.

Taft, Robert. *Artists and Illustrators of the Old West, 1850–1900.* New York: Charles Scribner's Sons, 1953.

Tagg, John. *The Burden of Representation: Essays on Photographies and Histories.* Amherst: University of Massachusetts Press, 1988.

Tallack, Douglas. *New York Sights: Visualizing Old and New New York.* New York: Berg, 2005.

Taussig, Michael. *Mimesis and Alterity: A Particular History of the Senses.* New York: Routledge, 1993.

Taylor, George. *Players and Performances in the Victoria Theatre.* Manchester: Manchester University Press, 1989.

Teatro Stabile di Catania. *Opera dei pupi: Tradizione e prospettive.* Catania: Assessorato alla Pubblica Istruzione della Regione Siciliana, 1977.

Teti, Vito, ed. *La razza maledetta: Origini del pregiudizio antimeridionale.* Rome: ManifestoLibri, 1993.

Thacker, Andrew. *Moving through Modernity: Space and Geography in Modernism.* Manchester: Manchester University Press, 2003.

Thissen, Judith. "Jewish Immigrant Audiences in New York City, 1905–14." In *American Movie Audiences: From the Turn of the Century to the Early Sound Era,* ed. Melvyn Stokes and Richard Maltby, 15–28. London: British Film Institute, 1999.

———. "Moyshe Goes to the Movies: Jewish Immigrants, Popular Entertainment, and Ethnic Identity in New York City (1880–1914)." Ph.D. diss., Utrecht University, 2001.

———. "Oy, Myopia!" *Cinema Journal* 36, no. 4 (Summer 1997): 102–107.

Thompson, Krista A. *An Eye for the Tropics: Tourism, Photography, and Framing the Caribbean Picturesque.* Durham, N.C.: Duke University Press, 2006.

Thompson, Kristin. *Exporting Entertainment: America in the World Film Market, 1907–1934.* London: British Film Institute, 1985.

Todorova, Maria. *Imagining the Balkans.* New York: Oxford University Press, 1997.

Tomasi, Silvano M. *Piety and Power: The Role of the Italian Parishes in the New York Metropolitan Area, 1880–1930.* New York: Center for Migration Studies, 1975.

Trachtenberg, Alan. *Classic Essays on Photography.* New Haven, Conn.: Leete's Island Books, 1980.

———. *Reading American Photographs: Images as History, Mathew Brady to Walker Evans.* New York: Hill and Wang, 1985.

Troianelli, Enza. *Elvira Notari: Pionera del cinema napoletano (1875–1946).* Rome: La Goliardica, 1989.

Tropea, Mario. *Nomi, ethos, follia negli scrittori siciliani tra Ottocento e Novecento.* Caltanissetta: Lussografica, 2000.

Truettner, William H., ed. *The West as America: Reinterpreting Images of the Frontier, 1820–1920.* Washington, D.C.: Smithsonian Institution Press, 1991.

Tsivian, Yuri. *Early Cinema in Russia and Its Cultural Reception.* Edited by Richard Taylor. Translated by Alan Bodger. 1991. Reprint, New York: Routledge, 1994.

Tucci, Nicholas. "The Underground Settlers." *New Yorker,* August 1951, 24–27.

Tucker, William H. *The Science and Politics of Racial Research.* Urbana: University of Illinois Press, 1994.

Turconi, Davide. "I film storici italiani e la critica americana dal 1910 alla fine del muto." *Bianco e Nero* 24, nos. 1–2 (January–February 1963): 40–56.

———, ed. *La stampa cinematografica in Italia e negli Stati Uniti d'America dale origini al 1930.* Pavia: Amministrazione Provinciale di Pavia, 1977.

Turner, Frederick Jackson. *The Frontier in American History.* New York: H. Holt, 1920.

Turner, Kay F. "The Virgin of Sorrows Procession: A Brooklyn Inversion." *Folklore Papers of the University Folklore Association* 9, ed. K. Turner, 1–26. Austin: Center for Intercultural Studies in Folklore and Ethnomusicology, 1980.

Uricchio, William. "Storage, Simultaneity, and the Media Technologies of Modernity." In *Allegories of Communication: Intermedial Concerns from Cinema to the Digital*, ed. John Fullerton and Jan Olsson, 123–138. Rome: John Libbey, 2004.

Uricchio, William, and Roberta E. Pearson. "Dante's Inferno and Caesar's Ghost: Intertextuality and Conditions of Reception in Early American Cinema." *Journal of Communication Inquiry* 14, no. 2 (1990): 71–85. Reprint in *Silent Film*, ed. Richard Abel (New Brunswick, N.J.: Rutgers University Press, 1996), 217–233.

———. "Dialogue: Manhattan's Nickelodeons: New York? New York!" *Cinema Journal* 36, no. 4 (Summer 1997): 98–102.

———. "Italian Spectacle and the U.S. Market." In *Cinéma sans frontieres, 1896–1918: Aspects de l'internationalité dans le cinéma mondial*, ed. Roland Cosandey and François Albéra (Montreal: Nuit Blanche, 1995), 95–105.

———. *Reframing Culture: The Case of the Vitagraph Quality Films.* Princeton, N.J.: Princeton University Press, 1993.

Urry, John. *The Tourist Gaze: Leisure and Travel in Contemporary Societies.* London: Sage, 1990.

Valperga, E. G. "Splendori del cinema muto." In *Cultura e lavoro in Piemonte*, 157–162. Turin: Eda, 1984.

Vance, William L. *America's Rome.* New Haven, Conn.: Yale University Press, 1989.

Van Kleeck, M. *Artificial Flower Makers.* New York: Surveys Associates, 1913.

Varacalli, Joseph A. "The Changing Nature of the 'Italian Problem' in the Catholic Church of the United States." *Faith and Reason* no. 12 (1986): 38–73.

Varacalli, Joseph A., Salvatore Primeggia, Salvatore J. LaGumina, and Donald J. D'Elia, eds. *The Saints in the Lives of Italian-Americans: An Interdisciplinary Investigation.* Filibrary 14. New York: Forum Italicum, 1999.

Vardac, Nicholas. *Stage to Screen.* Cambridge, Mass.: Harvard University Press, 1949.

Varnedoe, Kirk. "The Artifice of Candor: Impression and Photography Reconsidered." *Art in America* 68, no. 1 (January 1980): 66–78.

Vecoli, Rudolph. "Are Italian Americans Just White Folks?" In *Through the Looking Glass: Italian and Italian/American Images in the Media*, ed. Mary Jo Bona and Anthony Julian Tamburri, 3–17. Staten Island, N.Y.: American Italian Historical Association, 1996.

———. "Ethnicity: A Neglected Dimension of American History." In *The State of American History*, ed. Herbert J. Brass, 70–88. Chicago: Quadrangle, 1970.

———. "Prelates and Peasants: Italian Immigrants and the Catholic Church." *Journal of Social History* 2, no. 3 (Spring 1969): 217–268.

Velikonja, Joseph, ed. *Italians in the United States (Bibliography).* Carbondale: Southern Illinois University, 1963.

Venturi, Franco. "L'Italia fuori d'Italia." In *Storia d'Italia*, vol. 3, *Dal primo Settecento all'Unità*, ed. Ruggiero Romano and Corrado Vivanti, 987–1483. Turin: Einaudi, 1973.

———. *Italy and the Enlightenment: Studies in a Cosmopolitan Century.* London: Longman, 1972.

Verdicchio, Pasquale. *Bound by Distance: Rethinking Nationalism through the Italian Diaspora*. Teaneck, N.J.: Fairleigh Dickinson University Press, 1997.

Verga, Giovanni. *I Malavoglia*. Milan: Treves, 1881. Reprint in English as *The House by the Medlar Tree*, trans. Mary A. Craig (New York: Harper & Bros., 1890).

———. *Lettere a Luigi Capuana*. Edited by Gino Raya. Florence: F. Le Monnier, 1975.

Verhoeff, Nanna. *The West in Early Cinema: After the Beginning*. Amsterdam: Amsterdam University Press, 2006.

Vezzosi, Elisabetta. "L'immigrata italiana: Alla ricerca di un'identità femminile nell'America del primo Novecento." *Movimento operaio e socialista* 7, no. 3 (September–December 1984): 305–319.

Villa, Renzo. *Il deviante e i suoi segni: Lombroso e la nascita dell'antropologia criminale*. Milan: Franco Angeli, 1985.

Villari, Pasquale. *I mali dell'Italia: Scritti su mafia, camorra e brigantaggio*. Florence: Vallecchi Editore, 1995.

Waller, Gregory A. *Main Street Amusements: Movies and Commercial Entertainment in a Southern City, 1896–1930*. Washington, D.C.: Smithsonian Institution Press, 1995.

———. *Moviegoing in America: A Sourcebook in the History of Film Exhibition*. Malden, Mass.: Blackwell, 2002.

Walton, Kendall L. "Transparent Pictures: On the Nature of Photographic Realism." *Critical Inquiry* 11, no. 2 (1984): 246–277.

Warnke, Nina. "Immigrant Popular Culture as Contested Sphere: Yiddish Music Halls, the Yiddish Press, and the Processes of Americanization, 1900–1910." *Theatre Journal* 48, no. 3 (1996): 321–335.

Warshow, Robert. *The Immediate Experience. Movies, Comics, Theatre and Other Aspects of Popular Culture*. New York: Atheneum, 1970.

Washington, Booker T. *The Man Farthest Down: A Record of Observation and Study in Europe*. New York: Doubleday, 1912. Reprint, New Brunswick: Transaction, 1984.

Watson, John Richard. *Picturesque Landscape and English Romantic Poetry*. London: Hutchinson Educational, 1970.

Weinberg, H. Barbara. *The American Pupils of Jean-Léon Gérôme*. Fort Worth, Tex.: Amon Carter Museum, 1984.

Weiner, Richard. *Webster's New World Dictionary of Media and Communication*. 1990. New York: Macmillan, 1996.

West, Elliott, and Paula Petrik, eds. *Small Worlds: Children and Adolescents in America, 1850–1950*. Lawrence: University Press of Kansas, 1992.

West, Shearer. "The Construction of Racial Type: Caricature, Ethnography, and Jewish Physiognomy in Fin-de-Siècle Melodrama." *Nineteenth-Century Theatre* 21, no. 1 (Summer 1993): 5–40.

Whissel, Kristen. "The Gender of Empire: American Modernity, Masculinity and Edison's War Actualities." In *A Feminist Reader in Early Cinema*, ed. Jennifer M. Bean and Diane Negra, 141–165. Durham, N.C.: Duke University Press, 2002.

———. *Picturing American Modernity: Traffic, Technology, and the Silent Cinema*. Durham, N.C.: Duke University Press, 2008.

———. "Placing the Spectator on the Scene of History: The Battle Re-enactment at the Turn of the Century, from Buffalo Bill's Wild West to the Early Cinema." *Historical Journal of Film, Radio and Television* 22, no. 3 (2002): 225–243.

Whistler, Laurence, Michael Gibbon, and George Clark. *Stowe: A Guide to the Gardens*. Buckingham, UK: E. N. Hillier & Sons, 1968.

White, G. Edward. *The Eastern Establishment and the Western Experience.* New Haven, Conn.: Yale University Press, 1968.

Williams, Alan. *Republic of Images: A History of French Filmmaking.* Cambridge, Mass.: Harvard University Press, 1992.

Williams, Linda. "Film Bodies: Gender, Genre, and Excess." *Film Quarterly* 44, no. 4 (Summer 1991): 2–13.

———. *Playing the Race Card: Melodramas of Black and White from Uncle Tom to O. J. Simpson.* Princeton, N.J.: Princeton University Press, 2001.

———, ed. *Viewing Positions: Ways of Seeing Film.* New Brunswick, N.J.: Rutgers University Press, 1995.

Williams, Ohyllis H. *South Italian Folkways in Europe and America: A Handbook for Social Workers, Visiting Nurses, School Teachers, and Physicians.* New York: Russell & Russell, 1938.

Williams, Raymond. *The Country and the City.* London: Chatto & Windus, 1973.

Williams, Rosalind. *Notes on the Underground: An Essay on Technology, Society, and the Imagination.* Cambridge, Mass.: MIT Press, 1990.

Winokur, Mark. *American Laughter: Immigrants, Ethnicity, and 1930s Hollywood Film Comedy.* New York: St. Martin's Press, 1996.

Wolf, Daniel, ed. *The American Space: Meaning in Nineteenth-Century Landscape Photography.* Middletown, Conn.: Wesleyan University Press, 1983.

Wood, John. *The Scenic Daguerreotype: Romanticism and Early Photography.* Iowa City: University of Iowa Press, 1995.

Wyke, Maria. *Projecting the Past: Ancient Rome, Cinema and History.* New York: Routledge, 1997.

Ybarra, T. R. *Caruso, the Man of Naples and the Voice of God.* New York: Harcourt Brace, 1953.

Yochelson, Bonnie. *Jacob Riis.* New York: Phaidon, 2001.

———. "Jacob A. Riis, Photographer 'After a Fashion.'" In *Rediscovering Jacob Riis: Exposure Journalism and Photography in Turn-of-the-Century New York,* ed. Bonnie Yochelson and Daniel Czitrom, 121–227. New York: New Press, 2007.

Yochelson, Bonnie, and Daniel Czitrom. *Rediscovering Jacob Riis: Exposure Journalism and Photography in Turn-of-the-Century New York.* New York: New Press, 2007.

Young, Robert J. C. *Colonial Desire: Hybridity in Theory, Culture and Race.* New York: Routledge, 1995.

Zappulla, Enzo, ed. *Angelo Musco e il teatro del suo tempo.* Catania: Giuseppe Maimone Editore, 1991.

———. *Nino Martoglio capocomico.* Catania: C.U.E.C.M., 1985.

Zappulla Muscarà, Sarah. "Contributi per una storia dei rapporti tra letteratura e cinema muto (Verga, De Roberto, Capuana, Martoglio e la settima arte)." *Rassegna della letteratura italiana* 86, no. 3 (September–December, 1982): 501–560.

Zappulla Muscarà, Sarah, and Enzo Zappulla. *Giovanni Grasso: Il più grande attore tragico del mondo.* Acireale: La Cantinella, 1995.

———. *Martoglio Cineasta.* Rome: Editalia, 1995.

Zotti Minici, Alberto. "Venezia nell'iconografia degli spettacoli ottici." In *L'immagine di Venezia nel cinema del Novecento,* ed. Gian Piero Brunetta and Alessandro Faccioli, 59–74. Venice: Istituto Veneto di Scienze, Lettere ed Arti, 2004.

Zurier, Rebecca. *Picturing the City: Urban Vision and the Ashcan School.* Berkeley: University of California Press, 2006.

INDEX

Italicized page numbers indicate illustrations.

Picturesque Colorado (1911), 8, 111, *112*, 114
"Picturesque New York" (Van Rensselaer), 145
Picturesque Yosemite (1902), 8, 111
Piedigrotta, 86–87
Piedmont, S.C., 130
Piedmont region, 78, 185
Piffard, Henry G., 156
Piot, Eugène, 57
Pippa Passes; or, The Song of Conscience (1909), 210
Pirandello, Luigi, 81, 248
Piranesi, Giovanni Battista, 27, 53, 297n25
Pitrè, Giuseppe, 310n84
"Plea for the Picturesqueness of New York" (Hartmann), 145
Pocahontas, 202
Poe, Edgar Allan, 170, 240
poetry: and the Grand Tour, 31, 39–41; and homestead imagery, 127; and immigrant subjects, 178–80; and the picturesque aesthetic, 31, 39–41; and vernacular culture, 258–61
"pogrom films," 178
Poliorama pittoresco, 54
Polish immigrants, 177
Pollice Verso (Gérôme), 54, 253
Pompeii, 22, *29,* 55
Poor Little Peppina (1916), 208–209, *210,* 350n86
popular culture: and early film narratives, 289–90; and Italian characters, 181; and Jewish immigrants, 244; and racial characterizations, 170–71; and racial typing, 166–67; and reproduction in the arts, 279; role of cinema in, 244. *See also* vernacular culture and language
Porter, Horace, 131
Portici school, 55
portraiture, 55, 59–60, *77, 78*
positivism, 287, 291
Potash and Perlmutter (1923), 350n86
Pound, Ezra, 240
Poussin, Gaspar, 39, 296n15
Poussin, Nicolas, 23, 25, 31, 37, 99, 296n15

poverty: Howells on, 329n67; and *The Italian,* 222; and media coverage, 147–50; and physiognomy, 172; and the picturesque aesthetic, 164; and Riis's photography, 155, 157, 162; *Scribner's* articles on, 329n64; and social reformism, 138; staging poverty scenes, 347n53; and Van Wittel's *vedute,* 27; and Verga films, 83
Pratt, Mary Louise, 21
The Prelude (Wordsworth), 41
presepi, 55
press, 11, 80. *See also specific publications*
Price, Uvedale, 32, 42, 43–44, 290
Primitive Rebels (Hobsbawm), 78
primitivism: and "anthropological novels," 81–92; Native Americans, 101–102; and Neapolitan film, 91; and Southernism, 50, 83–84, 274
printing and printmaking, 7, 19, 38, 51, 231, 278–79
Prints and Visual Communication (Ivins), 279
Proctor, F. F., 250
prominenti, 245, 246, 254
Puck, 172
Pulcinella (character), 260
Pupatella (1923), 263
puppet theater, 260
Purple Lady (1916), 350n86
pyrodramas, 289. *See also The Last Days of Pompeii* (Pain)

Quo Vadis? (1904), 253
Quo Vadis? (1913), 54, 183, 252, *255*

race and racial characterizations: and African Americans, 233; and American cinema, 333n14; and the "battle of civilization," 8; and Beban films, 227, 232; and *briganti* war, 77–78, 80–81; and caricatures, 172–73, 334n23; and character acting, 228–30; and Civil War films, 128; and color distinctions, 166, 170; color markers, 166, 170; and criminals, *184,* 185–86; and definition of "picturesque," 162; and Du Bois, 334n22; and environment, 336n43;

slavery, 283–84, 322n108

"The Slaves of the 'Sweaters'" (Rogers), 146

Slavic immigrants, 170, 177

Sloan, John, 145

Small Parks Advisory Committee, 154

Smith, Adolphe, 147

Smith, Andrew Brodie, 116–17

Snyder, Joel, 288

social Darwinism, 70, 72, 136, 166, 173–74

The Social Highwayman (1916), 350n86

social photography, 103, 153–64

social reformism, 137–39, 176–77

Society for the Prevention of Cruelty to Children, 138

sociology: and Alongi, 311n91; and criminal anthropology, 183; and environmental factors, 11, 139; and eugenics, 174; and film history, 15; and metric photography, 75; and Petrosino, 197, 239; and Riis, 156; and the "urban picturesque," 153, 164

The Soldier in Our Civil War (Mottelay), 131

Sollors, Werner, 213

"Some Picture Show Audiences" (Vorse), 239

Sommer, Giorgio: and landscape photography, 53, 55–58, 56, 58; and Mount Etna images, 67; and the picturesque aesthetic, 7; and Riis's photography, 157; and street scenes, 60, 63

Sonnino, Sidney, 80

The Sopranos, 275, 357n88

Southern California, 116

Southern Europe, 166, 168, 177

Southern Italy: and American culture, 244; and the "Bowery stage," 248; and criminal stereotypes, 155, 185–87, 199; and the Grand Tour, 6; and literacy, 242; and natural disasters, 65–66; and pastoralism, 35–36; and primitivism, 50; and racial characterizations, 155, 164, 173; and socioeconomics, 50; and vernacular culture, 11–12, 82, 258. *See also* Naples, Italy; Sicily

Southernism, 69–75; described, 236; and Farfariello, 268–69; and film dialogue, 265, 268–69; and the Lower East Side, 50; and multiple identities of Italian immigrants, 237–38; and Neapolitan film, 87–88, 91; and New York City, 248; and Orientalism, 71; and the picturesque aesthetic, 7, 276; and primitivism, 274; and *Santa Lucia Luntana*, 271; and *Sperduti nel buio*, 86; and Verga films, 83; and vernacular culture, 248, 258–60

Southwest (U.S.), 107, 111

Spanish-American War, 49, 113, 140–41

Spartacus (1913), 54

Sperduti nel buio (1914), 7, 83–86, 85, 87, 90–91, 259

The Spirit of the Laws (Montesquieu), 37

Staël, Madame de, 33, 37

stage design, 298n31

Staiger, Janet, 242

Statue of Liberty, 2, 13, 220

Statue of Liberty (1898), 143

The Steerage (Stieglitz), 152

Steichen, Edward J., 142, 152

Steiner, Edward A., 160, 179

Stendhal, 38, 76

stereographs, 57, 66, 104, 156

stereotypes: and acting style, 208; and Beban, 11, 225; in burlesque and vaudeville, 160–61; and criminals, 191–93; and film, 206, 208–209; and the Grand Tour, 180; and "Italian types," 212–28; and phrenology, 171; and physiognomy, 78; and positive characterizations, 205; and self-determination, 213; and Sommer, 57; and violence, 204. *See also* race and racial characterizations

Stieglitz, Alfred, 136, 142, 143–44, 150–52, 193

Stilgoe, John, 123

Stocking, George W., 170

Stoddard, John L., 109

Stowe, Harriet Beecher, 133

Strand, Paul, 153

Street Life in London (Thomson and Smith), 65, 147

Suleri, Sara, 125

Giorgio Bertellini is Assistant Professor of Screen Arts and Cultures and of Romance Languages and Literatures at the University of Michigan. He is the author of *Emir Kusturica* (1996). His edited and co-edited volumes include *The Cinema of Italy* (2004), *Early Cinema and the "National"* (2008), and the forthcoming *Silent Italian Cinema: A Reader.*